THE
FLORENTINE
TONDO

ROBERTA J. M. OLSON

OXFORD

UNIVERSITY PRESS

Great Clarendon Street, Oxford OX2 6DP
Oxford University Press is a department of the University of Oxford.
It furthers the University's objective of excellence in research, scholarship,
and education by publishing worldwide in

Oxford New York

Athens Auckland Bangkok Bogotá Bombay Buenos Aires Calcutta
Cape Town Chennai Dar es Salaam Delhi Florence Hong Kong Istanbul
Karachi Kuala Lumpur Madrid Melbourne Mexico City Mumbai
Nairobi Paris São Paolo Singapore Taipei Tokyo Toronto Warsaw
and associated companies in Berlin Ibadan

Oxford is a registered trade mark of Oxford University Press
in the UK and certain other countries

Published in the United States
by Oxford University Press Inc., New York

British Library Cataloguing in Publication Data
Data available

Library of Congress Cataloging in Publication Data
Data applied for

ISBN 0–19–817425–X

1 3 5 7 9 10 8 6 4 2

Typeset in Garamond by Selwood Systems, Frome
Printed in Great Britain
on acid-free paper by
Butler & Tanner Limited

Gira, gira tondo
Quant'è bel il mondo . . .

Marcello Mastroiani, 'Used People'

[My colleague in the Italian Studies Program of Wheaton College, Tommasina Gabriele, reports that 'Gira, gira tondo' is the Italian version of the English 'Ring around the rosie'—or 'ring-a-ring-a-rosey', or 'ring-a-ring o' roses'—the children's song (nursery rhyme), in which the children go around in a circle until the end. Then they 'all fall down'. She notes that the English rhyme may date back to the plague, which supposedly was the real theme of the song. The more usual Italian version is:

> Gira, gira tondo
> Casca il mondo
> Casca la terra
> Tutti giù per terra!

The English version seems to have a connection with the rosary. See Chapter 4, where the rhyme is linked more broadly to a general cycle of life, death, and resurrection as well as to tondi.]

ACKNOWLEDGEMENTS

I should like to thank the following individuals for their generous help and advice, always graciously given. Gino Corti adeptly assisted me in the Archivio di Stato di Firenze, while Ellen Callmann provided constant scholarly insights and read selections of the manuscript. I owe a special note of gratitude to Alexander Johnson for assistance in the Archivio di Stato and various museums, for editorial advice, but most of all for his constant encouragement and support. There were numerous other people who were helpful in countless ways and who were always willing to share their knowledge with me. Among them were: David Acton, Diane Cole Ahl, Daphne Barbour, George Bisacca, Annette Blood, Etienne Breton, Virginia Budny, Wolgar Bulst, Maddalena Brugioni, Niccolò Capponi, Jill Capobianco, Sister Eleanor Carr, Mark Chalfant, Keith Christiansen, Linda Collins, Pat Coman, Dario A. Covi, James D. Draper, Alice Levy Duncan, David Ekserdjian, Samuel Y. Edgerton, Jr., Marvin Eisenberg, Caroline Elam, Kim Emerich, Adriana Fabbricatore, Everett Fahy, Carrie Fake, Ronnie Fein, Larry Feinberg, Mary Fitzgerald, Tommasina Gabriele, Alison Gallup, Creighton Gilbert, Rona Goffen, William Griswold, Lucile Herbert, Emma Hoops, Erica Indelicato, Larry Kanter, Martin Kemp, Benita Lehmann, Kent Lydecker, Sally E. Marshall, Mario Masserelli, Silvia Meloni Trikulja, Peta Motture, Jacqueline Musacchio, Giovanni Nencioni, Patrizio Osticresci, Jay M. Pasaschoff, Nicholas Penny, Chris Pepper, Ruth R. Philbrick, Doralynn Pines, Valentina Polidori, John Raggio, Simonetta Prosperi Valenti Rodinò, Peter Rohowsky, Nikolai Rubinstein, Erich Schleier, Linda Seckelson, Samuel Shriqui, Joseph M. Silva, Ronald R. Smith, Lapo Sodini, Ken Soehner, Joo Mee Song, Nicola Spinosa, Leo Steinberg, Fiorella Superbi, Anchise Tempestini, Albert Torres, Kirsti Veilleux, Lisa Venturini, Timothy Verdon, Grazia Visintainer, Dean Walker, William Walker, Karen Weinberger, Rose Whitehill, John Wilson, Nancy Yeide, and Roberta Zampini. Part of the early research on this subject involved two senior seminars at Wheaton College. While all the students contributed to the two groups' understanding of individual tondi, I should especially like to single out the work of Phoebe Witchell and Tina Khayat. I also extend warm thanks to the Old Master Paintings Departments and staffs of: Christie's, London, especially Dot Hendler, Robbin Nevins, and Robert McIntyre; Christie's, New York, especially Marla Lombard; Sotheby's, London, especially Alexander Bell; Sotheby's, Milan; and Sotheby's, New York, especially Leslie Rutherford and Heidi Chin. Through their generosity many photographs that would otherwise be very difficult to locate were made available. The willingness of all these individuals to share their expertise was gratifying. In addition, I should like to communicate my sincere thanks to the following persons involved with the creation of the book itself: several anonymous readers of the manuscript who made valuable suggestions; the designers, Clare Hofmann and Sue Tipping; Bonnie Blackburn for her judicious and wise copy-editing; and especially Anne Ashby, the editor, whose advice, patience, and faith in this project are much appreciated. Valuable contributions of

other persons are also recognized in footnotes, but it is difficult to cite all the people who helped in different aspects of this book's evolution.

In addition, I am most grateful for grants allowing me to pursue the research on this topic from the American Council of Learned Societies, the American Philosophical Society, and the Committee on Faculty Scholarship of Wheaton College. I am honoured to have also been awarded the A. Howard Meneely Faculty Chair at Wheaton College, which provided me leave time and funds to complete the early research on this volume, and the Mary L. Heuser Faculty Chair in the Arts, which allowed me to continue work on the book and to acquire photographic material. Moreover, the Samuel H. Kress Foundation generously contributed two grants toward the purchase of colour plates and photographs as well as the production of these colour plates, thus enriching the reader's visual experience. To them all I owe a great debt of gratitude. Without the facilities, staffs, and valuable collections of the Thomas J. Watson Library of the Metropolitan Museum of Art, New York, the Kunsthistorisches Institut, Florence, the Archivio di Stato, Florence, and the Frick Art Reference Library, New York, this study would not have been possible.

Finally, I remain for ever grateful to each and every one of the helpful individuals and institutions mentioned above and in the notes for facilitating both my research and the realization of this volume.

R.J.M.O.

CONTENTS

LIST OF COLOUR PLATES

Between pages 96 and 97

LIST OF BLACK AND WHITE PLATES

PHOTOGRAPHIC CREDITS

The author wishes to thank the following individuals and collections for their kind permission to reproduce the following illustrations. Photographs not listed were supplied by the author.

Fototeca of the Kunsthistorisches Institut, Florence: 4.3, 5.19, 5.20, 6.7, 6.29, 6.36, A7, A9, A14, A32, A41, A95, A102, A108, A134

Galleria Luigi Bellini, Florence: A50

Gianfranco Luzzetti Antichità: 7.7

Gilman and Soame: A105

Giraudon/Art Resource, NY: 5.1

Glasgow Museums: Art Gallery and Museum, Kelvingrove: A31

Governing Body, Christ Church, Oxford: A15, A35

Graphische Sammlung Albertina, Vienna: A43

Haboldt & Co., Inc., New York: 5.23

Hessisches Landesmuseum Darmstadt: 7.31

Honolulu Academy of Arts. Gift of the Samuel H. Kress Foundation, 1961: A61

Huntington Library, Art Collections, and Botanical Gardens, San Marino, Calif.: A52

Indianapolis Museum of Art. Gift of Mr. and Mrs. William H. Ball. Photograph © 1990 Indianapolis Museum of Art: A99

Institut de France—Musée Jacquemart-André, Paris: A69

Isabella Stewart Gardner Museum, Boston: 6.33, 6.34

John and Mable Ringling Museum of Art, the State Art Museum of Florida. Bequest of John Ringling: A91

Joslyn Art Museum, Omaha, Nebr.: A57

J. Paul Getty Museum, Los Angeles: 1.20

Kunsthistorisches Museum, Vienna: 5.21, 6.4

Kustodieva, *The Hermitage Catalogue of Western European Painting: Italian Painting, Thirteenth to Sixteenth Centuries*: A49, A58, A103

L. Artini: 3.9

Lowe Art Museum, University of Miami. Gift of the Samuel H. Kress Foundation: 1.17, A78

Manchester City Art Galleries: A112

Marquess of Bath, Longleat House, Warminster, Wiltshire, Great Britain; photograph Courtauld Institute of Art: A65

Martin von Wagner-Museum der Universität Würzburg und Mainfränkisches Museum Würzburg: A106

Ministero per i Beni Culturali e Ambientali: A128

Mint Museum of Art, Charlotte, NC. Gift of Mr. Samuel H. Kress: A111

Musée du Louvre, Département des Arts Graphiques: A74

Musées de la Ville de Strasbourg: 7.29

Museo Poldi Pezzoli, Milan: A92

Museu de Arte, São Paulo: A45

Museum of Fine Arts, Boston. Centennial Gift of Mr. and Mrs. Charles S. Lipson: 1.6. Helen and Alice Colburn Fund: 1.1

National Gallery, London: A5, A16, A36

National Gallery of Art, Washington, DC. Andrew W. Mellon Collection, © 1998 Board of Trustees: 6.14, 7.34. Samuel H. Kress Collection, © 1998 Board of Trustees: 1.23, 3.1, A18, A46. Samuel H. Kress Foundation and the Photographic Archives, and St. John's Evangelical Lutheran Church: A133. Photographic Archives: A39

Nationalmuseum, Stockholm: 5.18

Nelson–Atkins Museum of Art, Kansas City, Missouri. Purchase: Nelson Trust: 6.37, A100

New-York Historical Society: 1.16

Nivaagaard Picture Gallery, Denmark: A101

ABBREVIATIONS

ASF	Archivio di Stato, Firenze
exh. cat.	exhibition catalogue
FKI	Fototeca, Kunsthistorisches Institut, Florence
PG	J. P. Migne, *Patrologiae Cursus Completus, sive bibliotheca universalis. . . . Series Greca*, 157 vols. in 159 (Paris, 1857–66)
PL	J. P. Migne, *Patrologiae Cursus Completus, sive bibliotheca universalis. . . . Series Latina*, 221 vols. (Paris, 1844–66)
Vasari (Milanesi)	G. Vasari, *Le vite de' più eccellenti pittori scultori ed architettori*, ed. G. Milanesi, 9 vols. (Florence, 1906)
Vasari (Bettarini and Barocchi)	G. Vasari, *Le vite de' più eccellenti pittori scultori e architettori nelle redazioni del 1550 e 1568*, ed. R. Bettarini and P. Barocchi, 7 vols. (Florence, 1971)

INTRODUCTION

DURING the course of the fifteenth century the tondo became one of the most popular formats for painting in Florence, where it was used for relief sculpture as well. It is the thesis of this study that specific cultural, social, intellectual, and religious trends in Florence encouraged the flourishing of the form, and that when they ceased to exist as dominating forces its popularity declined. (Its apogee lasted from roughly 1480 to 1515.)

This book charts the development of the tondo and investigates the reasons for its popularity. While the documentary evidence is fragmentary at best (see Ch. 3), where it exists, it indicates that most tondi were commissioned for locations that had a secular and frequently a domestic dimension rather than for churches. These include homes, guild halls, government buildings with residential quarters, and monastic and conventual buildings. In subsequent chapters, the different kinds of tondo commissions will be discussed; while some were special and highly individualized, others were more modest, sometimes ready-made, objects for commercial sale.

A great many of the most inventive examples were painted by major Florentine painters and their *botteghe*, including the innovative master *tondai*, Sandro Botticelli, Piero di Cosimo, and Filippino Lippi. (*Tondaio*, pl. *tondai*, was coined to mean maker of tondi—as a *ghirlandaio* is a maker of garlands—and used when a significant portion but not all of an artist's production consisted of tondi.) Less well-known artists, such as those in the workshop of Domenico Ghirlandaio, who in collaboration with members of his *bottega* and Sebastiano Mainardi is credited with repeating one tondo composition in at least sixteen extant variations, also produced tondi. Many more of these versions may have once existed, since a conservative estimate (which varies with different types of objects) is that around 10 per cent of all art works from the Renaissance survive today. If we add to all these painted tondi the sculpted examples, which in terracotta and stucco were frequently mass-produced in moulds, most notably by the Della Robbia family, the count may well run into the thousands.

During the last two decades of their popularity, tondi were executed by a variety of artists, including all three stellar artists of the High Renaissance who worked in Florence. Raphael was responsible for a number that span his career.[1] Michelangelo executed his only documented and securely attributed independent panel painting in the format, the *Doni Holy Family* (Fig. 7.37), while simultaneously carving two marble tondi (Figs. 6.40–1).[2] Even Leonardo, the universal man, whose drawings and notes are filled with circular diagrams and sketches, is reputed to have painted a now-lost tondo. Moreover, the smaller stars in the Florentine High Renaissance constellation— among them Fra Bartolomeo and Andrea del Sarto—painted tondi before the decline in popularity

[1] See Jones and Penny, *Raphael*; Ch. 7 below; App.
[2] See Tolnay, *The Youth of Michelangelo*; L. Berti *et al.*, *Il Tondo Doni di Michelangelo e il suo restauro*.

of the form (see App.). While tondi enjoyed a special currency in Florence, they were also produced during the late fifteenth and early sixteenth centuries in Siena and other Tuscan cities, as well as occasionally in other regions, such as Umbria, where there was a Florentine connection.

The only comprehensive treatment of tondi is the pioneering, formalistically oriented study by Moritz Hauptmann (1936).[3] Why then has no one attempted to investigate more profoundly this significant Florentine art form that spread to other centres of Tuscany? Perhaps one reason is that tondi were objects made primarily for the domestic sphere. Moreover, since few documents have been located for them, and because most extant tondi lack early provenances linking them with patrons, they generally have been overlooked, except within monographs, where frequently they receive less attention than more public, documented works. In addition, many are stylistically problematic, for they betray shop collaboration involving multiple and/or anonymous hands, so that their attributions may never be solved. (Attribution problems belong more properly within monographs and are not discussed in depth in the present study.) Since a percentage of tondi are variations, pastiches, or derivations—at times quite inventive in their own right—of popular compositions, many individuals have dismissed them as lesser works cranked out to satisfy market demand. As with similar subjects in rectangular formats, this is not always the case. The time is now ripe for a synthetic re-evaluation of the fascinating and important tondo phenomenon and its imagery, collating material that has come to light over the years with new evidence and ideas.

As a preliminary step we turn briefly to nomenclature. 'Tondo', the Italian word meaning round, sphere, or circle, is loosely applied to roundels, medallions, and, in fact, to any circular form. More specifically, it functions either as a noun (referring to such objects as a tray, plate, globe, circle, or a circular painting or sculpture) or as an adjective or adverb (signifying round, circular, simple, or clear). 'Tondo' derives from the Latin word *rotundus*, as well as from *rota*, meaning wheel or round.[4] Although it is difficult to reconstruct its precise quattrocento meaning, 'tondo' can be traced back to a dictionary of 1612.[5] In the past, the term 'tondo' has been applied rather haphazardly to different types of objects, but for the purpose of clarity in this study, a circular form within a larger context will be referred to as a roundel, while 'tondo', when used as a noun, will be reserved for an autonomous object. The word 'medallion' will be used to signify a round relief larger than a medal but smaller than the average tondo.[6] Although it is clear that this distinction was not always made in the Renaissance, it is helpful in our consideration of the objects.

Before turning to the genesis of the tondo, some initial comments on their predominantly devotional nature should be made. The majority feature the Madonna and Child, frequently in the company of assorted holy persons and only rarely with a donor. Nevertheless, portraits, allegories, and narrative themes are also occasionally depicted in a tondo format. Thus German art historians have classed most tondi as *Andachtsbilder*, paintings intended to allow the pious observer to engage

[3] Hauptmann, *Der Tondo: Ursprung, Bedeutung und Geschichte des italienischen Rundbildes in Relief und Malerei*. See also Preussner, *Ellipsen und Ovale in der Malerei des 15. und 16. Jahrhunderts*, with ideas applicable to the circle; Kecks, *Madonna und Kind*, 43–50.

[4] Lewis and Short, *A Latin Dictionary*, 1601. They also cite Pliny's description (*Natural History* 37. 11) of a 'gemma rotunditatis absolutae'.

[5] Accademia della Crusca, *Vocabulario degli Accademici della Crusca* (see Olson, 'Lost and Partially Found: The Tondo, a Signifi-

cant Florentine Art Form, in Documents of the Renaissance', 53 n. 6 for the four meanings listed, none of which is a round devotional painting). See also Rebora, *Cassell's Italian Dictionary*, 532; Reynolds, *Cambridge dizionario italiano-inglese, inglese-italiano Signorelli*, 923; when applied to sculpture, it has a different cast: 'mezzo tondo' is half of 'tutto tondo', thus relief.

[6] *Oxford English Dictionary*, xiv. 156–7, for roundel; ix. 540, for medallion.

in extreme empathetic contemplation of God to the point of oblivion and mystical union.[7] Drawing on the ideas of other scholars and the traditional epithet of the Virgin as a window into heaven, Gary Vikan has commented colloquially that an image 'is like a window or door to heaven. It is defined by its impact, not by its physical form'.[8] Tondi were literally like windows into the heavenly realm because round windows or oculi were features of Florentine Renaissance architecture. Although Belting does not consider tondi *per se*, they seem to fall between his view of powerful icons (where the image was taken as a visible manifestation of the sacred person) and the changes in attitude he observes in Raphael's *Sistine Madonna* (where art was subject to the same laws of nature as other sensory perceptions).[9] While tondi are transitional between older icons and artful religious images, they are closer in time to the latter, while in attitude they fall between the two. As will be demonstrated, it was their circular form that emphasized their heavenly content and the theological relevance of their imagery; it immediately connoted a sacred space within a more secular environment. Therefore, painters and sculptors of tondi were free to capture lifelike qualities in the mirror of their art, while at the same time revealing higher theological truths. This attitude is understandable because tondi developed during the complex and often contradictory privatization of the devotional image that accompanied the laicization of religious experience and a growing cultural pluralism. Further, it has been suggested that owners acquired domestic icons, including tondi, not only for devotion but also for certification of a pious disposition, and practised devotion in order to compensate for the holiness otherwise denied urban dwellers.[10]

The iconographies of most devotional tondi are more complex than those of traditional icons, and they can only be understood in a profound manner within a Florentine context. Their evolution in an environment of Christian humanism helps to explain both their function and form.[11] Tondi—from the most complex to the simplest—are integrally related to the Italian Renaissance obsession with the circle and to a number of assumptions associated with the form that permeated Florentine life and thought.[12] They are, therefore, linked with the period's fascination with antiquity, whose art is filled with symbolic circles, as well as with notions of the cosmological structure inherited by the Renaissance. These concepts also found expression in other household objects, like mirrors, and in public artistic commissions, such as those of centrally planned churches. Concomitant with and necessary to the rise of the tondo was an economic prosperity that encouraged the trend towards the interior embellishment of the Florentine palazzo and its *sanctum sanctorum*, the chamber of the householder, with a proliferation of objects, the highest form of which was the painted picture.[13] The tondo was one of these new art forms for the private sphere, as detailed in subsequent chapters. In this setting tondi also provided role models for emulation, as recorded by writers such as St Antoninus and Fra Giovanni Dominici, that were tangential to their

[7] Ringbom, 'Devotional Images and Imaginative Devotions: Notes on the Place of Art in Late Medieval Private Piety'; id., *Icon to Narrative: The Rise of the Dramatic Close-Up in Fifteenth-Century Devotional Painting*.

[8] G. Vikan, Shippee Memorial Lecture, Wheaton College, Norton, Mass., 1994.

[9] Belting, *Das Bild und sein Publikum im Mittelalter*; id., *Likeness and Presence: A History of the Image Before the Era of Art*.

[10] Ibid. 409–47. Other more general studies pertinent to devotional art include: Camille, *The Gothic Idol: Ideology and Image-Making in Medieval Art*; D. Freedberg, *The Power of Images: Studies in the History and Theory of Response*.

[11] See Verdon and Henderson, *Christianity and the Renaissance: Images and Religious Imagination in the Quattrocento*, esp. Henderson, 'Penitence and the Laity in Fifteenth-Century Florence', as well as id., *Piety and Charity in Late Medieval Florence*.

[12] See O. Hall, 'Kreis'; Lurker, *Der Kreis als Symbol im Denken, Glauben, und künstlerischen Gestalten der Menschheit*.

[13] Goldthwaite, *Wealth and the Demand for Art in Italy, 1300–1600*, esp. 212 ff., and earlier studies by the same author.

devotional function.[14] Since most devotional tondi contain intimate scenes involving the Holy Family and/or saints that are more relaxed in their composition than rigorously structured altarpieces, the holy persons portrayed served as *exempla*, inviting Florentines to mirror these members of the paradigmatic Holy Family and the extended family of saints. That is one of the reasons why the patron saint of Florence, St John the Baptist, is nearly always present in tondi as a toddler or an adolescent: he served as an *exemplum* for youths of the city.

While tondi resulted from the period's fascination with the philosophical, theological, and sociological symbolism inherent in the circle, this format presented compositional challenges for artists. Owing to the basic incompatibility of rectangular architectural elements with the tondo shape, architectural settings are not usually developed as they are, often illusionistically, in rectangular paintings of the period. Rather, they usually are included only in a fragmentary manner to suggest the environment—a palatial building, the Nativity stable—or to perform a symbolic function, such as assuming a cruciform shape alluding to Christ's Sacrifice and triumph over death. Instead, it is the figures of tondi that are the dominant elements in these varied compositions, even when architectural elements are present. The artistic solutions to the compositional problem presented by the format are numerous and varied and will be demonstrated in later chapters.

From these introductory comments it is apparent that this study is intended as a beginning rather than an end. If it stimulates further research and thought, it will have served its purpose. Even though an entire chapter could be devoted to each of the more complex tondi—or in the case of a few, such as Michelangelo's *Doni Tondo* (Fig. 7.37), even a book—that amount of detail is not desirable. This volume, therefore, frequently deals prismatically with partial aspects of a tondo's symbolism. However, these analyses, coupled with the bibliography, enable the reader to continue an exploration of the ideas presented.[15]

The book—which is intended to be a forum in which to examine the state of research on tondi in conjunction with pertinent areas of Italian Renaissance art and culture and to characterize different artists' contributions to the form—is structured in the following manner.[16] The first four chapters explore the background and origins of the tondo. They establish the unique cultural and artistic reasons for the type's flourishing as an alternative to devotional works in rectangular formats. They also consider the function of tondi as well as some of the societal concerns that find expression in them. Chapters 5 through 7 chart the patterns of production and the phases of development of three categories of tondi in a roughly chronological fashion by artists and shops, highlighting the most complex and revealing examples. This approach affords an opportunity to treat individual tondi as objects and allows for an amplification of the ideas presented in the earlier chapters. Chapter 5, which concerns portraits in a round format, represents a departure from the devotional mode, while Chapter 6 deals with examples in sculptural media. Chapter 7, which addresses painted tondi, highlighting significant examples, should be read in consultation with the Appendix and its characterizations of the tondo production of various artists and their *botteghe*. These discussions are meant to supplement monographic studies that, when they exist, do not

[14] See Büttner, *Imitatio Pietatis: Motive der christlichen Ikonographie als Modelle zur Verähnlichung*; Falkenburg, *The Fruit of Devotion*, 80.

[15] Because the subject could function as a microcosm to study the Florentine Renaissance, the bibliography cited here is necessarily restricted.

[16] Some of the problems inherent in an attempt to be definitive include the fact that unknown tondi continuously surface, while others cannot be traced. In addition, the attributions of some—frequently studio products and/or collaborations among unidentified personalities—are more often than not in flux, rendering a definitive listing chimeral.

examine profoundly either artists' approaches to the format or their role in the evolution of the form. Naturally, tondi with more complicated iconographies, such as Signorelli's *Medici Madonna* and the *Doni Tondo* (Figs. 7.32 and 7.37), are discussed more completely, while less complex or repetitious works are noted briefly. Similarly, artists who specialized in tondi are considered in more detail, and the ramifications of their production noted as succinctly as possible. Many of the in-depth analyses provide answers to previously puzzling issues regarding these works. In order to facilitate the identification of each tondo, useful but skeletal information—e.g. museum inventory/accession numbers, auction sale listings, diameters, bibliography, etc.—is provided whenever available.[17]

In sum, *The Florentine Tondo* analyses the rise of one of the most viable devotional types of the Florentine Renaissance, establishes its meaning contextually, and charts its development. Finally, the study explains the iconographies of specific tondi to illuminate another facet of Renaissance culture and to reveal significant conclusions about its concerns and aspirations.

[17] Accession/inventory numbers are given for tondi and for all other works that are reproduced. The footnotes contain abbreviated citations of books and articles—full citations are given in the Bibliography. The footnotes usually offer one or two illustrative sources for each work, although every source included is not labelled as to whether it contains a reproduction. Auction catalogues are not cited in the Bibliography; where they are cited in the notes the work is reproduced unless the contrary is stated (no ill.). Sale dates are by day, month, and year, followed by lot number: 4/IV/94, no. 104.

I

BEFORE THE FACT: THE VISUAL BACKGROUND AND PROTOTYPES OF TONDI

BECAUSE the circle is ubiquitous in Western art, the possible prototypes and sources for tondi are multiple, if not legion. Therein lies the problem of dealing concretely with valid forerunners of tondi, which are more diverse than heretofore imagined. In his study, Hauptmann only scratched the surface of this fertile territory, which forms a continuum from ancient through medieval cultures, when he concluded that tondi derive from two basic forms: the medallion and the glory.[1] In this chapter we shall explore the prototypes for tondi and designate those that were most significant to its development.

Complicating the issue is the fact that sometimes there are specialized antecedents for different subjects and types—painted devotional panels, sculpted tondi, and portraits. These will be related to relevant tondi in later chapters whenever appropriate. What makes an investigation of them so fascinating is that each prototype functioned like a related petal of a flower that blossomed in mid-fifteenth-century Florence. Nevertheless, it is possible to trace a clear path from antiquity to the Renaissance.

ANCIENT ROOTS

The conceptual roots of the tondo ultimately can be traced back to Greek ideals and that culture's exploration of perfect forms. One of the most enduring Greek contributions to Western civilization was the formation of rational geometry, which enshrined the circle as the most perfect form. Thereafter, a veneration of the circle gained currency during various periods and was readily adopted, then expanded, by the Renaissance (see Ch. 2).

Some Greek objects with round compositions reflecting these ideals would have been accessible to early quattrocento Florentine humanists, who were becoming involved with classical Greek texts. Coins, mirrors, shields, and pottery, such as plates and cups (kylikes), are among these plentiful objects.[2] In them, the Greeks' relentless pursuit of perfection through rules of design is

[1] Hauptmann, *Der Tondo*, 11 ff. Kecks, *Madonna und Kind*, 46–7, notes that Hauptmann fails to explain the origin of the halo and why the round form was chosen for religious paintings, especially those with the Madonna, and calls for a systematic iconographic study.

[2] Webster, 'Tondo Composition in Archaic and Classical Greek Art', notes they are seldom larger than a foot in diameter.

apparent, especially in the ever more sophisticated treatment of vase compositions between the sixth century and 470 BC. (An analogous evolution occurs in fifteenth-century tondi.) In order to adapt the form to narrative demands, Greek artists frequently indicated a base line with a space below, similar to an exergue on coins, as in the medallion with a Dionysiac narrative from an architectural context shown in Fig. 1.1.[3] Frequently this same formula was adopted by quattrocento artists to solve problems inherent in the tondo format. In addition, objects such as Greek and Etruscan mirrors may also have inspired Renaissance artists' interest in round compositions. And it was precisely during the fifteenth century that Etruscan artifacts began to be discovered and appreciated by Florentine humanists.[4]

The types of ancient circular forms available in the Renaissance were plentiful, but in sheer numbers, Roman objects predominated over those from other cultures. It was Roman coins, round gems, and medallions that were most familiar to Renaissance individuals. They were treasures prized by humanists and Renaissance collectors alike, and some were eminently affordable, such as the one representing a satyr and the young Dionysos owned by the Medici (Fig. 1.2).[5] These objects were rich sources for the authority of the round format as well as a treasure trove for motifs (many, such as Fig. 1.2, were oval but easily adapted to a round format). A well-known instance of their influence is the series of roundels decorating the Medici Palace courtyard, which depended heavily on gems in the family's collection, as demonstrated by the composition of one roundel in Fig. 1.3, deriving from that of Fig. 1.2.[6] A large round cameo owned by Lorenzo de' Medici, the so-called 'Tazza Farnese',[7] not only inspired artists to borrow motifs (like Botticelli for his *Birth of Venus*); its fame may also have encouraged the popularity of the tondo form itself.[8] Ancient coins were also influential on the limited development of portraits in a round format—as were the rarer medallions with visages of gods or individuals produced from the time of Alexander the Great—but these impacted more significantly on the Renaissance medal (see Ch. 5).[9]

Even more than the Greeks, the Romans used roundels in architectural decoration, and Roman remains littered the Italian peninsula during the Renaissance. Fragments also existed as *spoglie*, embedded in buildings, and were unearthed whenever new roads were constructed and marble quarried during the great economic boom of the thirteenth and early fourteenth centuries. In addition, the Hadrianic roundels on the Arch of Constantine, which were always visible, drew much attention and were recorded by Renaissance artists, some of whom were prolific painters of tondi.[10] Moreover, sacral plates on altars and in squinches of Roman buildings provided quasi-ubiquitous prototypes for both tondi and roundels. Renaissance humanists would have related

[3] Inv. no. 37.1152 in the Museum of Fine Arts, Boston, Pentelic (?) marble with a 26.2 cm. diameter. Comstock and Vermeule, *Sculpture in Stone: The Greek, Roman, and Etruscan Collection of the Boston Museum of Fine Arts*, 72, no. 114, ill.

[4] Greenhalgh, *Donatello and his Sources*, 2 ff., 19–22.

[5] Inv. no. 25880 in the Museo e Gallerie Nazionali di Capodimonte, Naples, onyx sardonyx measuring 2.9 × 2 cm. and noted in the 1465 Medici inventory (Müntz, *Les Collections des Médicis au XVᵉ siècle*, 191). Dacos, *Il tesoro di Lorenzo il Magnifico: le gemme*, 54–5, no. 23, ill. The production of gems continued in medieval times, including round ones with Christian subjects (e.g. Wentzel, 'Mittelalterliche Gemmen in den Sammlungen Italiens', fig. 28).

[6] Wester and Simon, 'Die Reliefmedallions im Hofe des Palazzo Medici zu Florenz', 15 ff.; Caplow, *Michelozzo*, ii. 550 ff.

[7] Inv. no. 27611 in the Museo e Gallerie Nazionali di Capodimonte, Naples, a sardonyx agate with a 20 cm. diameter. Dacos, *Il tesoro*, 69–72, no. 43, ill.

[8] Bober and Rubinstein, *Renaissance Artists and Antique Sculpture*, 104–5, no. 68, ill. Dacos, *Il tesoro*, 91–3, reproduces works with quotations from it.

[9] Segall, 'Two Hellenistic Gold Medallions from Thessaly', 5 ff., believes that medallion portraiture derived from Persian representations of Ahura Mazda. Hanfmann, *The Season Sarcophagus in Dumbarton Oaks*, ii. 10, no. 55, argues against this thesis and in favour of forerunners such as gorgonea.

[10] See Bober and Rubinstein, *Renaissance Artists*, 181–3, no. 182, ill.

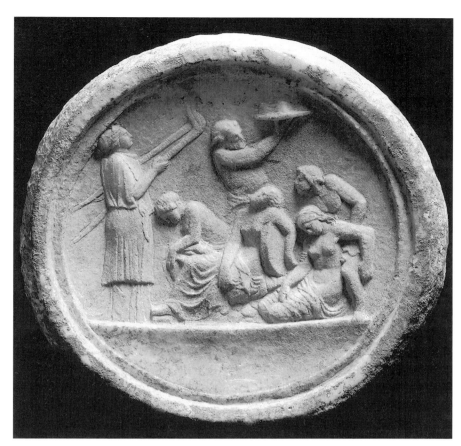

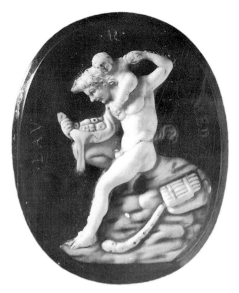

FIG. 1.1 (*left*). Dionysiac relief, first or second century BC. Museum of Fine Arts, Boston

FIG. 1.2 (*above*). Ancient gem from the Medici Collection: *Satyr and the Young Dionysos*. Museo e Gallerie Nazionali di Capodimonte, Naples

FIG. 1.3 (*below*). Michelozzo Michelozzi (?) and others, Courtyard with Satyr and Young Dionysus roundel, *c*.1452. Palazzo Medici, Florence

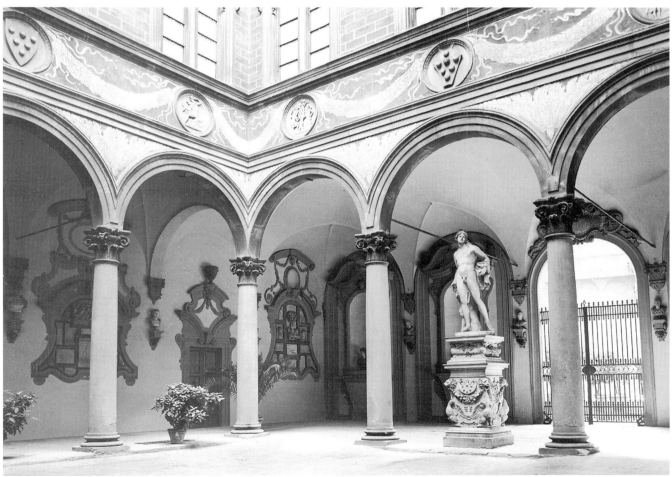

their sacrificial function to the themes depicted on tondi in which the Christ Child's ultimate sacrifice for humanity is paramount. Many other fragments may have been influential, such as a Hadrianic sacrificial relief in the Uffizi in which two nude youths hold up a *clipeus* surrounded by a wreath that resembles both tondi and roundels.[11]

IMAGINES CLIPEATAE, APOTHEOSIS, HEAVEN, AND DIVINITY

The most significant and direct ancient prototype for Renaissance tondi, for both devotional paintings and portraits, is the Roman shield or *clipeus*. This word refers to the disk of the sun as well as to a round form with a portrait of a god or person (an *imago clipeata*) or an inscription.[12] This pivotal ancient type was used for representations of both the living and the dead to signify apotheosis. Moreover, since it could be independent, or quasi-autonomous, of any sculptural or architectural context, it played a significant role in the evolution of both the medallion and the Renaissance tondo.

While the history of the Roman medallion remains to be written, from the time of Augustus, portraits in a round format (usually bust-length and togate) or *imagines clipeatae* became increasingly popular and were linked to cosmic ideas.[13] Imperial images enclosed in medallions adorned the standards of Roman legions from the first century AD, as depicted on the Arch of Trajan at Benevento. Further, portrait medallions flanked by Victories were placed on Roman funerary altars of the early Empire, and there were impressive portrait medallions in architectural sculpture by the end of the second century AD.[14]

By the beginning of the third century *imagines clipeatae* replaced the round *clipei* with inscriptions, sometimes surrounded by wreaths, on the main side of sarcophagi. Depending on their context, they were flanked by *amorini*, nereids, Victories, Dionysiac figures, or strigulated patterns.[15] These *clipei* frequently occupy the highest plane of the relief, a fact which would have impressed quattrocento artists, who were keyed to an interest in three-dimensional, physical reality.[16] Very prominent or quasi-autonomous ones are found on a number of sarcophagi, including the late third-century example shown in Fig. 1.4.[17] Some of these are pagan, while others

[11] Pope-Hennessy, *Luca della Robbia*, 249, fig. 7.

[12] Bolten, *Die Imago Clipeata: Ein Beitrag zur Portrait- und Typengeschichte*; Heintze, 'Imago Clipeata'; Winkes, *Clipeata Imago: Studien zu einer römischen Bildnisform*, esp. pls. I–VI; Belting, *Likeness and Presence*, 109.

[13] Bolten, *Die Imago Clipeata*; L'Orange, *Apotheosis in Ancient Portraiture*; id., *Studies in the Iconography of Cosmic Kingship*; id., *Likeness and Icon: Selected Studies in Classical and Medieval Art*, 320–4.

[14] See Strong, *La scultura romana da Augusto a Costantino*, figs. 28, 79, 83.

[15] Hanfmann, *The Season Sarcophagus in Dumbarton Oaks*, ii. 25. See p. 10, ill., for the lid of an Antonine sarcophagus in the Museo Nazionale, Rome, with a bust of the deceased framed by a wreath supported by victories, which seems to precede medallion sarcophagi, as well as all volumes of the series begun by Robert, *Die antiken Sarkophag-Reliefs im Auftrage des Kaiserlich Deutschen*

Archaeologischen Instituts, esp.: Rumpf, *Die Meerwesen auf den antiken Sarkophagreliefs*; Matz, *Die Dionysischen Sarkophage*; Kranz, *Jahreszeiten-Sarkophage*; Sichtermann, *Die mythologischen Sarkophage*. See also Wilpert, *I sarcofagi cristiani antichi*.

[16] A direct usurpation in quattrocento Florence occurs on the tomb of Neri Capponi by the Rossellino shop in Santo Spirito (Fig. 5.7); Avery, *Florentine Renaissance Sculpture*, fig. 92. Earlier, *c*.1421–33, Il Buggiano decorated the sarcophagus of Giovanni de' Medici and Piccarda de' Bueri in the Old Sacristy of San Lorenzo with two putti holding a wreath with Medici arms (Fig. 2.10) to imply the family's apotheosis. There are many others, including the tomb of Nofri Strozzi in Santa Trinita by Niccolò di Piero Lamberti, *c*.1418–19, whose sarcophagus has two putti holding the Strozzi arms.

[17] Inv. no. 38.1 in the Albright–Knox Art Gallery, Buffalo, NY, marble measuring 62 × 71 × 214.6 cm. Kranz, *Jahreszeiten-Sarkophage*, 192–3, ill.

are Christian, produced in the era when Christianity was adapting motifs from the pagan repertoire. Hauptmann correctly—but missing significant nuances—stated that the flanking Victories of pagan sarcophagi changed into angels in a Christian context, while the medallion itself metamorphosed into a glory (aureole).[18]

It is precisely because the *clipeus* circumscribing a bust implies an apotheosis of the person portrayed that it was so pivotal for the development of Renaissance tondi, although adjacent motifs on sarcophagi reinforced the idea of resurrection. For example, beginning *c.*210–20, portraits of the deceased, usually in a circular shell, appear on marine sarcophagi with tritons and nereids, wherein the shell itself is symbolic of apotheosis, resurrection, and of leaving the terrestrial sphere.[19] Around 220–50, roundels with portraits first appear on Season sarcophagi, again an allusion to renewal, with the *clipeus* signifying heaven and immortal glory.[20] The zodiacal circle around the double portrait of a married couple on the *Season Sarcophagus* in Dumbarton Oaks (Fig. 1.5) carries a further cosmic, heavenly dimension that is especially germane to quattrocento tondi.[21] In fact, Panofsky has stated that 'the ubiquitous *imago clipeata* also symbolizes an ascent to the heavens', and the zodiacal circle of the *clipeus* implies that the deceased is transported literally *ad astra*.[22] Thus, round forms on sarcophagi are infused with transcendental ideas concerning victory over death and regeneration. Renaissance individuals, on the inspiration of ancient examples, transmitted similar associations to religious images as well as to rarer portraits in round formats.

A more unusual Graeco-Roman *imago clipeata* conveys related concepts (Fig. 1.6), although its autonomous nature renders it closer to tondi. It has a peg at the bottom for insertion into a rectangular base as part of a larger monument.[23]

In addition to the *clipeus*, Roman remnants, including sarcophagi, featured another motif that was influential on Renaissance tondi, the wreath, which inspired the garland frames of many. Generally the wreath connoted fertility and was adopted by the Romans as a symbol of supreme imperial power and, in a funerary context, apotheosis or spiritual victory. A case in point is the relief in the portico of SS. Apostoli, Rome, whose wreath surrounds an eagle symbolic of Jupiter.[24] Like the *imago clipeata*, the wreath was appropriated by Christians for their repertoire of symbolic forms. As Christian art matured, wreaths incorporated various types of fruit, alluding to the fruits of Paradise obtained by the faithful. Renaissance artists, who enshrined Roman funeral motifs in their visual repertoire, continued this tradition, as we shall see, by employing wreaths as tondi frames to imply the heavenly or perfected status of the individuals enclosed in it.

During the later Roman Empire, various motifs referred to the cycle of creation, renewal, and

[18] Hauptmann, *Der Tondo*, 12.

[19] J. Hall, *Dictionary of Subjects and Symbols*, 263. For others, see Hanfmann, *The Season Sarcophagus*, ii. 17–20, no. 49, ill.; McCann, *Roman Sarcophagi in the Metropolitan Museum of Art*, 118–21, ill.; Baratte and Metzger, *Musée du Louvre: catalogue des sarcophages en pierre d'époques romaine et paléochrétienne*, 158–64, nos. 77–8, ill. See also Panofsky, *Tomb Sculpture*, 35 ff., fig. 115, where the medallion is held by Sleep and Death.

[20] Hanfmann, *The Season Sarcophagus*, i. 26, ill.; ii, pls. 31 ff. See also Arias and Cristiani, *Camposanto monumentale di Pisa: le antichità*, i, pls. 1–2.

[21] Inv. no. 36.65 in the Dumbarton Oaks collection, Washington, DC. Hanfmann, *The Season Sarcophagus*, i. 12 ff., 64 ff.

[22] Panofsky, *Tomb Sculpture*, 36. On some sarcophagi Eros functions as the conductor of the souls to the other world and holds

up a medallion of the deceased; L'Orange, 'Eros psychophoros et sarcophages romaines', 41 ff.

[23] Inv. no. 67.948 in the Museum of Fine Arts, Boston, stone measuring *c.*80 cm. in height. The tenon may have supported an inscribed metal plaque that would have determined whether the relief was commemorative or funerary. Its half-length heroicized athlete with symbols of his victory is characteristic of Hadrianic sculpture (AD 117–38). Comstock and Vermeule, *Sculpture in Stone*, 174, no. 278, ill. See also Winkes, *Clipeata Imago*, 84 ff. (for bibliography on funeral monuments in a round form), 144–5, ill.

[24] Bober and Rubinstein, *Renaissance Artists*, 219–20, no. 186, ill. The eminent Florentine citizen Giovanni Rucellai admired it in 1450, although it was known by artists before that date. For one of the numerous sarcophagi with wreaths see Baratte and Metzger, *Catalogue des sarcophages*, 244–5, no. 158, ill.

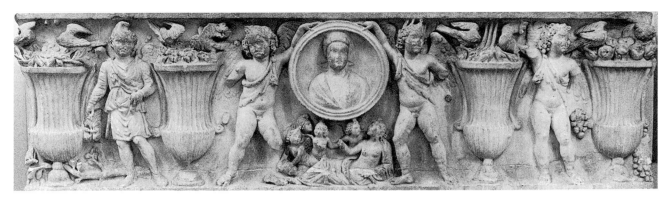

FIG. 1.4. Roman *Season Sarcophagus*, late third century. Albright–Knox Art Gallery, Buffalo, NY

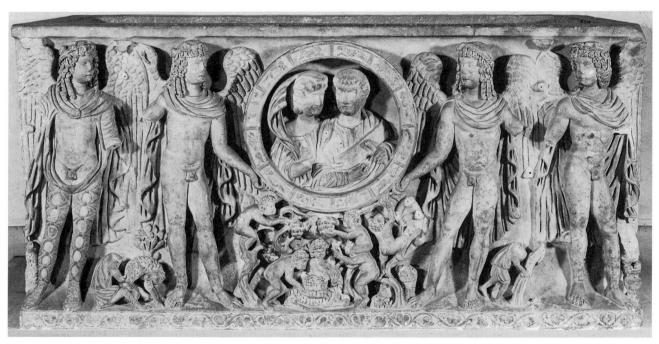

FIG. 1.5. Roman *Season Sarcophagus*, early fourth century. Dumbarton Oaks, Washington, DC

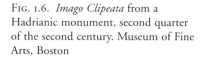

FIG. 1.6. *Imago Clipeata* from a Hadrianic monument, second quarter of the second century. Museum of Fine Arts, Boston

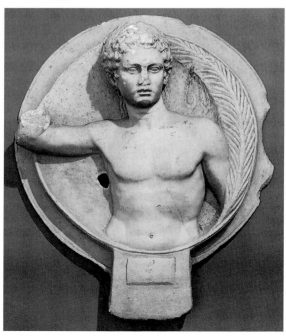

apotheosis (pagan) or the Resurrection of the Dead (Christian), while the heavenly associations of the circle were amplified to become more pronounced as Christianity developed towards otherworldly abstraction. Pagan types persisted along with Christian derivations, even after the Edict of Milan in 313 and later when Christianity became the official Roman religion.

CHRISTIAN CONTINUITY

Both the *clipeus* and the wreath had transferred directly from pagan sepulchral and imperial contexts into developing Christian iconography. Portraits in a *clipeus* continued to be produced, and when combined with images of imperial majesty, they helped to create theophanic images, the representation of Christ in a circle.[25] Examples include medallions with the head of Christ (from *sacrae imagines*), sometimes mounted on a cross as in military standards, which were replaced eventually by an abstract symbol, either the Chi Rho or the cross, as well as paintings in catacombs.[26] During the Byzantine period these forms continued as theme and variations. At times they gained more monumentality, as in the Baptism of Christ mosaic in San Giovanni in Fonte, Ravenna (*c.*450–75), where the roundel appears to be almost autonomous. Their continuity from antiquity lent authority to these bust-length representations of prophets, rulers, angels, or Christ in roundels that prefigure the tondo.[27] Sometimes these round images were flanked by angels, suggesting derivation from the *imago clipeata*, who in later devotional tondi would migrate inside the frame/circle of the work to interact with the other holy persons. The simplest expression of the circle's symbolic import—holiness, power, heavenliness, and apotheosis—is the halo or aureole, which appears at least by the late fourth or early fifth century on saintly and divine figures, including rulers. Noteworthy are the mosaics of San Vitale, Ravenna, where Theodora and Justinian wear haloes (*c.*535–47).[28] While round forms appear in the art of many countries, they are especially numerous in Italy, preparing the way for the development of the tondo. Their use in both secular and religious contexts enabled them to serve as prototypes for tondi with portraits of individuals as well as tondi with representations of holy personages.

[25] See Grabar, *Christian Iconography: A Study of its Origins*, esp. 77 ff.; Schiller, *Ikonographie der christlichen Kunst* (*Iconography of Christian Art*); Belting, *Likeness and Presence*, 8 ff., 102–14.

[26] In catacomb paintings circles most frequently enclosed images of Christ and portraits of the deceased. See Venturi, *Storia dell'arte italiana*, i. 10–2, figs. 9–14; Volbach, *Early Christian Art*, fig. 7; Tronzo, *The Via Latina Catacomb: Imitation and Discontinuity in Fourth-Century Roman Painting*, figs. 5, 39, 47. They also inscribed the Annunciation, as in the catacomb of Priscilla, which foreshadows trecento roundels (e.g. one with a 19.2 cm. diameter by Bicci di Lorenzo; Brejon de Lavergnée and Thiébaut, *Catalogue sommaire illustré des peintures du Musée du Louvre*, ii. 153, ill.) and

quattrocento tondi, such as Fig. 3.2.

[27] See Calkins, *Monuments of Medieval Art*, figs. 54, 83; Volbach, *Early Christian Art*, figs. 100, 106–7; Belting-Ihm, 'Theophanic Images of Divine Majesty in Early Medieval Italian Church Decoration' (her fig. 13, the apse mosaic of Santi Primo e Feliciano, is most interesting; its roundel image of Christ abuts the circle of heaven). Also noteworthy is the Altar of Duke Ratchis (ibid., fig. 22) in San Giovanni in Fonte, Cividale, where Christ and angels in a roundel are supported by four other angels.

[28] J. Hall, *Dictionary of Subjects and Symbols*, 144, notes that in the East the halo was linked with power.

THE FLORENTINE BAPTISTERY AND ROUND STAINED-GLASS WINDOWS OF THE DUOMO

It was during the economic prosperity of the late twelfth and thirteenth centuries, which engendered a return to large-scale church decoration featuring prominent circular compositions, that the foundation was laid for the genesis of the tondo. For example, in cosmati work and mosaics in Rome and other centres viewers saw swirls of inlaid circles, while representations of prophets in roundels and huge depictions of Christ as Pantokrator inside circular forms in apses kept *au courant* the tradition of the *imago clipeata*. A similar image in the Last Judgement mosaic of the Florentine Baptistery certainly played a seminal role in the development of tondi (Fig. 1.7). Dominating the interior of the building, this commanding Christ is seated on the rings of heaven like an emperor inside the celestial circle that appears to float illusionistically as an quasi-independent entity. Further, the overwhelming sensation upon entering the Baptistery is of being engulfed by circular forms. They bombard the viewer from the inlaid marble walls, the mosaic decoration, and the floor of the centralized octagonal building with an unrelenting echo, reinforcing the notion that Christ's perfection is like that of the circle.

Moreover, late Romanesque and Gothic Italian versions of rose windows, including those on the façades of the cathedrals of Orvieto, Siena, and Florence, helped to perpetuate this infatuation with circular compositions on a large scale and prepare the ground for tondi. And it was in 1404–5 that Lorenzo Ghiberti and others began the quattrocento cycle of round stained-glass windows for the Florentine Duomo, dedicated to St Mary of the Flower (Santa Maria del Fiore), with the Assumption and Coronation of the Virgin (Fig. 1.8).[29] It is significant that these, like the window over the entrance of the Sienese Duomo, were simple round designs that were different from the many-faceted northern rose windows, although their connection with the Virgin and rose symbolism was not *sub rosa*. The stained-glass decoration of the Florentine cathedral continued from 1412 through the 1440s.[30] Thus, by the early fifteenth century circular forms were prominent in commissions and the cultural consciousness of the city and frequently allied with the Virgin.

TRECENTO PAINTED AND SCULPTED PROTOTYPES OF TONDI

Autonomous devotional tondi with the Madonna and Child theme had their most immediate antecedents in the trecento Roman school's visualization of the theophany, the visible manifestation of God.[31] A case in point is a votive mosaic by Pietro Cavallini that honours the brother of Cardinal Gaetano Stefaneschi, Bertoldo di Pietro. It features a Madonna and Child

[29] It measures 620 cm. in diameter. See Krautheimer, *Lorenzo Ghiberti*, i, p. xi ff.; Bellosi *et al.*, *Lorenzo Ghiberti: 'materia e ragionamenti'*, 144; Marchini, 'Ghiberti pittore di vetrate', 140, pl. C. XII.1.

[30] M. Bacci, 'Le vetrate del tamburo della cupola; le vetrate della cupola'; ead., 'La Porta Nord: le vetrate'. It is interesting that a later smaller window of a Madonna and Child from an unknown context

by Francesco del Cossa resembles a painted tondo (Blondel, 'Les peintures italiennes de la Renaissance', fig. 8).

[31] There were earlier depictions of the Madonna and Child in a round format—e.g. in a medallion in the Museum, Aquileia, as well as another in San Zenone, Rome (Grabar, *Christian Iconography*, 36, figs. 92, 94). See also Hauptmann, *Der Tondo*, pls. VI–VII; Matthiae, *Pittura romana del medioevo*.

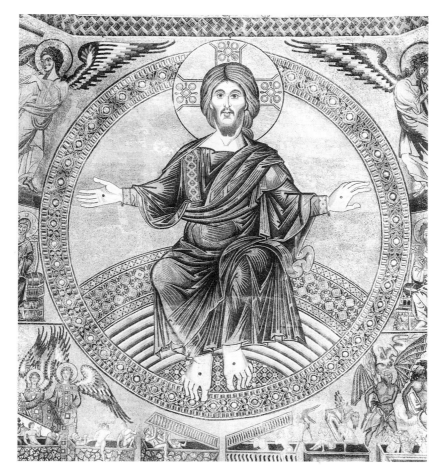

FIG. 1.7. Attributed to Coppo di Marcovaldo, detail of the *Last Judgement*, second half of thirteenth century. Baptistery, Florence

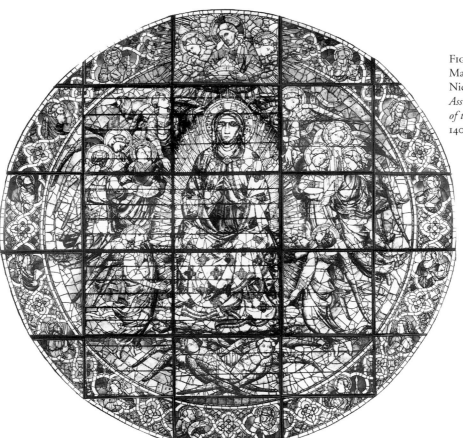

FIG. 1.8. Lorenzo Ghiberti, Mariotto di Nardo, and Niccolò di Pietro, *Assumption and Coronation of the Virgin Window*, 1404–5. Cathedral, Florence

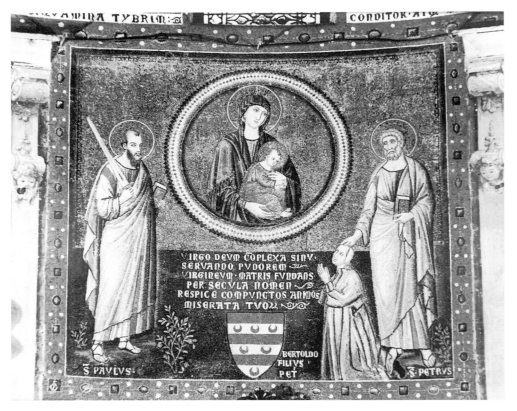

FIG. 1.9. Pietro Cavallini, *Madonna and Child with St Peter, St Paul, and Bertoldo di Pietro Stefaneschi*, 1290s. Santa Maria in Trastevere, Rome

FIG. 1.11. *Monument of Pope Boniface VIII* (d. 1303). Formerly Old St Peter's, The Vatican, preserved in a drawing by Jacopo Grimaldi (MS Barb. lat. 2733). Biblioteca Apostolica Vaticana

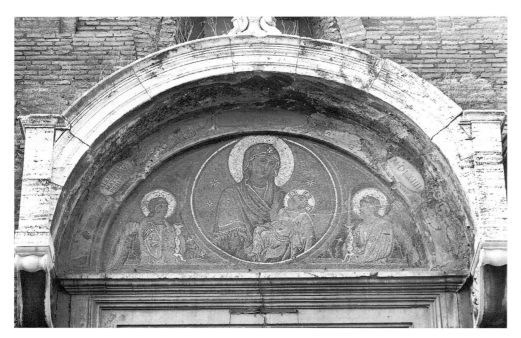

FIG. 1.10. Circle of Jacopo Torriti, Lunette mosaic with the Madonna and Child and two angels, *c*.1300. Santa Maria d'Aracoeli, Rome

within a dominant roundel as a prominent rather than a subsidiary motif hovering illusionistically over the scene (Fig. 1.9).[32] Another influential example is the contemporary lunette mosaic above the right lateral door of Santa Maria d'Aracoeli (Fig. 1.10); its Madonna and Child in a roundel flanked by angels holding candelabra depends on an imperial motif. The work recreates a heavenly vision supposedly shown to Augustus by the Tiburtine Sibyl on the very spot.[33] It seems that Jacopo Torriti, a Franciscan who has been linked with this mosaic and the resuscitation of Byzantine (i.e. antique) ideas, was pivotal in the development of the monumental Madonna and Child roundel.[34] The related but destroyed *Monument of Boniface VIII* (d. 1303), formerly in Old St Peter's (Fig. 1.11), featured above the effigy a mosaic with a similar Madonna and Child roundel, as preserved in two drawings.[35] These examples reveal that the *imago clipeata* survived underground in Christian art but surfaced with new force in the Trecento.

Torriti brought this tradition to the major pilgrimage church of San Francesco at Assisi and hence assured its dissemination in central Italy. Around 1270–80 he painted a half-length Virgin in a roundel flanked by two angels, a descendant of the *imago clipeata*, in one of the triangular vaulted compartments of the Upper Church.[36] However, the most important image for this study is a large roundel with the Virgin and Child, flanked by two smaller ones with angels, on the wall over the double portal entrance (Fig. 1.12).[37] The absence of frontality—together with the Child's relaxed posture, intimate gesture, and friendly expression—argues for a late date despite the retardataire nature of the visages.

The Assisi roundel is an example of the trecento rise of vernacular art, spurred on in part by the Franciscans and the naturalistic ideals of their founder.[38] The more human attitude resulting was expressed frequently, as here, in a more emotional relationship between the Madonna and Child. The roundel itself subtly reflects otherworldly ideas, for its frame disappears behind the fictively painted *trompe l'œil* door frames. As in the two flanking roundels with angels, its gold background, symbolic of the holiest heaven, accentuates its autonomy and distinguishes it from the lesser roundels with blue backgrounds containing prophets. Because the Madonna and Child roundel is linked via physical proximity and illusionism to the space of the viewer, it represents the relevance of heaven for the earthly realm. This distinction is of paramount importance, especially since it is the vision the worshipper takes with her/him upon leaving the great church.

When the Assisi image is compared with two roundels frescoed by Giotto on the ceiling of the

[32] Tomei, *Iacobus Torriti Pictor*, 128, ill.

[33] For the narrative of this vision related by Jacobus de Voragine (*The Golden Legend*), see below, Ch. 2 n. 26. For devotional works of art related to it, Verdier, 'A Medallion of the "Aracoeli" and Netherlandish Enamels of the Fifteenth Century'; id., 'La Naissance à Rome de la vision de l'Ara Coeli'.

[34] An anonymous master, associated with both Torriti and Cavallini, probably executed the Aracoeli mosaic (Matthiae, *Pittura romana*, ii. 209–10, fig. 202; Tomei, *Iacobus Torriti*, 144). Torriti also set the Coronation of the Virgin inside the rings of heaven and below the canopy of heaven in his apse mosaic in Santa Maria Maggiore, Rome; Tronzo, 'Apse Decoration, the Liturgy and the Perception of Art in Medieval Rome', 170, dates it 1295; Tomei, *Iacobus Torriti*, 45, 99 ff., assigns it to 1296. Other heavenly roundels include: a bust-length Madonna and Child held by four angels on the former façade mosaic of Santa Maria Maggiore (Hauptmann,

Der Tondo, fig. 28); a half-length Christ in a roundel carried by angels on the mosaic vault of the Sancta Sanctorum, Rome (Tomei, *Iacobus Torriti*, fig. 166); two angels holding a medallion with a bust by Fra Guglielmo (*c.*1270) in San Giovanni Fuorcivitas, Pistoia (Middeldorf-Kosegarten, 'Nicola and Giovanni Pisano', 73, fig. 38).

[35] One is by Jacopo Grimaldi and the other by Domenico Tasselli da Lugo; Tomei, *Iacobus Torriti*, 127–9, figs. 139, 141.

[36] Ibid. 45–55, fig. 5. In the Upper Church in a Creation scene there is also a bust-length Christ in concentric circles of heaven (ibid., fig. 52).

[37] Ibid., pl. 129. Its position near the illusionistic cornice has led to naming its artist the Master of the Second Modillon Border; Edgerton, *The Heritage of Giotto's Geometry*, 74–5. Todini, 'Un'opera romana di Giotto', 29, fig. 12, attributes it to Giotto.

[38] See Stubblebine, *Assisi and the Rise of Vernacular Art*.

Scrovegni Chapel,[39] Giotto's figures appear more progressive, albeit frontal, while their setting seems less advanced. His roundel with a Madonna and Child (Fig. 1.13) faces the entering viewer from the barrel vault. (The adjacent roundel with a bust of Christ blessing likewise engages the worshipper and is surrounded by four prophet roundels.) Despite their frontality, the plasticity and naturalism of Giotto's figures are advanced beyond those of the Assisi roundel. As at Assisi, Giotto's roundel has a gold background, enabling it to float against the blue lapis lazuli ceiling decorated with gold stars symbolizing heaven. Its trencher-like frame looks surprisingly like that of Donatello's later *Chellini Madonna* (Fig. 3.14), accentuating its semi-independence, and makes Giotto's Madonna and Child a prime antecedent of devotional tondi with related subjects.

Although Giotto's modelling in his Madonna and Child roundel is forward-looking, the Assisi roundel is, in many ways, closer to fifteenth-century tondi, for it has migrated from the ceiling to the wall, where it is encountered more directly by the viewer. Moreover, its setting is more illusionistic and physical, appearing as though it were hanging on the wall (it actually hangs in limbo, abutting two illusionistic architectural elements).

Images related to the Assisi roundel were produced into the fifteenth century as, for example, the one attributed to Pisanello in a family chapel (Fig. 1.14). This fresco, which contains an even more independent roundel enclosing a full-length Madonna of Humility seated in a garden before a wattled fence, points to the next step in the development of the autonomous tondo, a panel hanging on a wall.[40]

While Paatz posited that Giotto's Madonna and Child roundel marked the beginning of the independent tondo, Hauptmann believed that it, as well as a marble medallion in Empoli attributed to Giovanni Pisano (Fig. 6.1), played an important role in the evolution of the form.[41] In fact, the latter is one of several trecento sculpted roundels that reveal, like their counterparts in painting, a trend towards autonomy. It was formerly in the wall of the Sacristy of Sant'Andrea near the lavabo, although its original location is unknown. To ascertain the radical nature of this sculpture, it can be compared with a less three-dimensional Madonna and Child roundel on a Neapolitan sarcophagus from the third quarter of the fourteenth century.[42] Clearly, the roundel form is monumentalized in the Pisano example as it is in Giotto's fresco and in a fragment attributed to the shop of Tino da Camaino (Fig. 6.2).[43]

At one point in his study, Hauptmann claims that a late trecento Madonna and Child panel in the Certosa del Galluzzo (Fig. 1.15) is the first independent tondo extant.[44] It has been attributed to the Master of the Ashmolean Museum and dated *c*.1350–60.[45] The work was first documented in

[39] See Basile, *Giotto, la Cappella degli Scrovegni*. Olson, 'Giotto's Portrait of Halley's Comet'; ead., '. . . And They Saw Stars: Renaissance Representations of Comets and Pretelescopic Astronomy'; ead. and Pasachoff, 'New Information on Comet P/Halley as Depicted by Giotto di Bondone and Other Western Artists', offer a celestial solution for dating the cycle. It should be mentioned that the Paduan Baptistery has a cupola fresco by Giusto da Padova featuring a circular heaven with a roundel of Christ blessing (Van Marle, *The Development of the Italian Schools of Painting*, iv. 171, fig. 85).

[40] Pisanello painted this Madonna within six heavenly rings, which have a 150 cm. diameter. Paccagnini, *Pisanello alla corte dei Gonzaga*, 43, no. 25, ill. Other quasi-autonomous roundels also foreshadow the tondo, such as a Madonna in a circle of light in Lorenzo Monaco's Miracle of the Snow scene in the Bartolini

Salimbeni Chapel, Santa Trinita, Florence (Eisenberg, *Lorenzo Monaco*, fig. 114).

[41] Paatz, *The Arts of the Italian Renaissassance: Painting, Sculpture, and Architecture*, 120 (*Die Kunst der Renaissance in Italien*, 95); Kecks, *Madonna und Kind*, 45, repeats Paatz's idea. Hauptmann, *Der Tondo*, 113–18. See also below, Ch. 6 n. 2.

[42] Pope-Hennessy, *Catalogue of Italian Sculpture in the Victoria and Albert Museum*, i. 45, no. 40, ill.

[43] See below, Ch. 6 n. 3.

[44] Hauptmann, *Der Tondo*, 117.

[45] Inv. no. 170 in the Pinacoteca, Certosa del Galluzzo, tempera and gold on panel (supposedly of three planks, although six major cracks are evident) with a 116 cm. diameter. Boskovits, *Pittura fiorentina alla vigilia del Rinascimento 1370–1400*, 373 ff.; Chiarelli and Leoncini, *La Certosa del Galluzzo a Firenze*, 232, no. 2, ill.

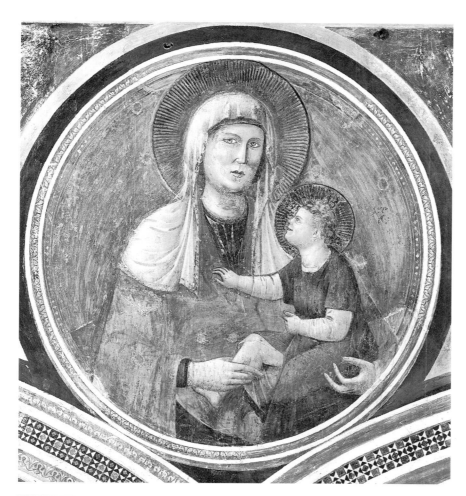

FIG. 1.12. Anonymous, Madonna and Child roundel, *c*.1330. San Francesco, Assisi

FIG. 1.13. Giotto di Bondone, Madonna and Child roundel, *c*.1303–6. Scrovegni Chapel, Padua

FIG. 1.14. Antonio Pisanello, *Madonna with a Blessing Child and an Angel*, after 1415. Aliprandi Chapel, Santuario di Santa Maria delle Grazie, Curtatone (Mantua)

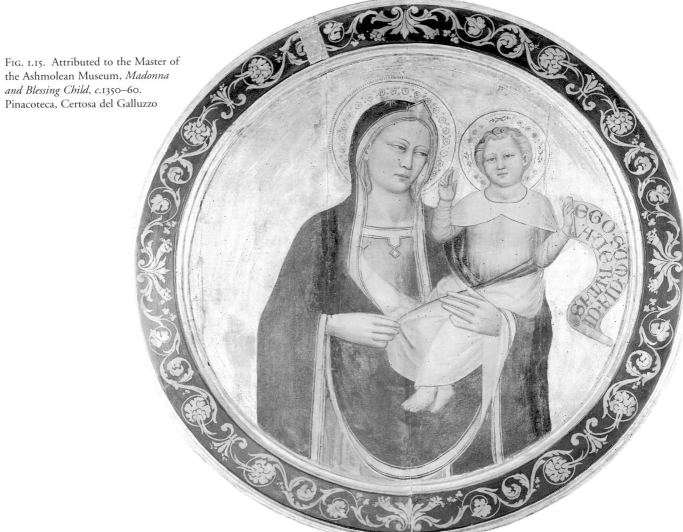

FIG. 1.15. Attributed to the Master of the Ashmolean Museum, *Madonna and Blessing Child*, c.1350–60. Pinacoteca, Certosa del Galluzzo

1808 in the Cappella di Santa Maria in Santa Maria degli Angeli. Because of its round shape, it may be significant to note that the convent's church, commissioned from Brunelleschi in 1433 after the architect's second trip to Rome, was centralized in plan.

If the *Certosa Madonna and Child* was intended as autonomous, it is indeed an early example of the tondo form. However, the answer to that question remains in limbo. The panel's original frame resembles not only the trencher-like one of Donatello's *Chellini Madonna* but also more importantly that of Giotto's Madonna and Child roundel. The frame's interior decoration has been repainted at least once with what seems to be a later pattern of an unknown date and needs to be examined to determine if it is original. Nevertheless, a decided circular cracking around the circumference of the gilded panel, where it meets the applied frame, suggests that it is part of the original construction. Yet the craquelure of the frame's surface is different from that of the panel, with its original tooling. This decoration extends only to the frame's upper surface and does not cover the raw wood along the side, as though the whole was inserted into another framing device. In sum, the frame has an unfinished quality.[46] Until panel and frame are restored, it is impossible to answer the questions regarding its construction, and thus its nature. If the *Certosa Madonna and Child* is a transitional, independent work, it is understandable why it resembles roundels, like those by Giotto and the Assisi master, from which it was derived. Since no documentation about its commission is known, there is no way of ascertaining its original location. Its large size (116 cm.) argues that it may have been independent, although it could have been inserted into a larger setting, a hypothesis supported by its unfinished exterior edge. Regardless of whether it was once in another context, the *Certosa Madonna and Child* is pivotal in a discussion about the origins of the tondo. Since it resembles so closely early trecento illusionistically frescoed roundels yet is painted on a panel, it provides physical proof of a gradual evolution towards the tondo.

A large fresco fragment in a round form with St Anne and the Expulsion of the Duke of Athens (*c.*1343/4) supports the case in favour of the Certosa panel being an autonomous work.[47] This allegorical work, which once decorated the Stinche prison, is one of several that reveals a mid-trecento evolution towards the nascent large-scale tondo.

However, lacking documentation and scientifically sound information about the anomalous Certosa panel, the earliest definitely independent tondo panel known today is probably Domenico Veneziano's *Adoration of the Magi* (Fig. 7.2). It is dated after 1439 on the basis of the hats worn by some of its *dramatis personae* that resemble those of eastern visitors to the Council of Florence in 1438–9 (see Ch. 7).[48]

Prior to that date and the genesis of the tondo, a general awareness of the significance of circular forms also appears in the small subsidiary roundels of late trecento and early quattrocento polyptychs, such as Lorenzo Monaco's *Annunciation* of *c.*1409 in the Florentine Accademia, or painted crosses, such as in the one in the Museo del Bigallo.[49] Moreover, roundels were occasionally placed in the predelle of some altarpieces.

[46] Ibid. 232.

[47] See Kreytenberger, 'Bemerkungen zum Fresko der Vertrei-bung des Duca d'Atene', ill.; see also below, Ch. 3 n. 68.

[48] Wohl, *The Paintings of Domenico Veneziano*, 120. Kecks, *Madonna und Kind*, 46, states that tondi appeared during the 1430s in the art of Lippi and Veneziano, and that Hauptmann neglected many examples of their origin, for otherwise his argument about their development would have toppled.

[49] See Eisenberg, *Lorenzo Monaco*, 103–4, ill.; Kiel, *Il Museo del Bigallo a Firenze*, 117, no. 1, ill., respectively. Among the sculptural examples is a Christ in Glory from the *Monument of Rainaldo Brancacci* in Sant'Angelo a Nilo, Naples (*c.*1426). There are other round motifs such as two medallions with the Virgin and St Dominic, each surrounded by four angels, on the later 'La Piagnona' (1464), the bell from San Marco attributed to Verrocchio (Rosenauer, 'Proposte per il Verrocchio giovane', 101–5, figs. 56, 59). Many are

DESCHI DA PARTO AND THEIR RELATIONSHIP TO TONDI

It is not known how or exactly when independent tondi became differentiated from engaged or frescoed roundels during a gradual evolution that Renaissance individuals, unlike us, may not have recognized; part of the answer to the conundrum may lie with a different but related form, the two-sided *desco da parto* (birth salver). The earliest extant *deschi* are multi-sided and frequently dodecagonal or sixteen-sided, and only later round in format. Because representations on *deschi* celebrate matrimony, maternity, and a pronounced natalism, they are a commemorative genre. Like *cassoni* and tombs, they were integral to the family and its life cycle, and like portraits, which reached a great popularity by mid-century, *deschi* participated in the Renaissance emphasis on the individual, though more generally, by alluding to the perpetuation of the family's lineage and its extension via marriage bonds. In the past too little study has been directed at *deschi* as well as domestic, devotional paintings like tondi. At present this oversight is being redressed by scholars who have articulated ideas about the function and patronage of *deschi*, although the last word on the subject has not been written.[50]

It is generally thought that *deschi da parto* served as salvers to bring food and gifts to women after childbirth, a conclusion supported by evidence of these rituals depicted on them, as on the earliest dated one by Bartolomeo di Fruosino (Fig. 1.16). In addition, some of these customs are preserved in large-scale frescos depicting the births of the Virgin or John the Baptist, where contemporary confinement practices lent a veracity to biblical events. For example, Paolo Uccello depicted a large *desco* in his Birth of the Virgin in the Cappella dell'Assunta in the Duomo, Prato (1433–5), although it is impossible to ascertain whether the tray is actually a *desco da parto* or just a plain simple serving tray (*desco*).

In the past, there has been a debate about when *deschi* were commissioned. Some scholars have suggested that *deschi* with representations of subjects like the Meeting of Solomon and Sheba and the Garden of Love were given on the occasion of marriage.[51] Yet philologically, *deschi da parto* should be connected with births. And, from documentary evidence, *deschi* were associated with

removed from their original contexts, e.g. a God the Father, formerly attributed to Masaccio (M. Davies, *The Earlier Italian Schools*, 189); a Madonna and Child by Sano di Pietro of *c*.1447 (Pope-Hennessy, *The Robert Lehman Collection*, i: *Italian Painting*, 144, no. 60, ill.). Further, a panel with the Tree of the Life of Christ by Pacino di Buonaguida with forty-eight roundel scenes demonstrates the popularity of the form (Bonsanti, *La Galleria della Accademia*, 55–7, ill.). There are also roundels with the half-length Man of Sorrows (see Rossi, *Il Museo Horne a Firenze*, 137, ill.; Lloyd, *A Catalogue of the Earlier Italian Paintings in the Ashmolean Museum*, 44–5, ill.). An unusual later panel of the theme (Christ in a sarcophagus with roundels, held up by the Madonna, Mary Magdalene, and St John)—whereabouts unknown, whose unpublished diameter appears to be larger than a subsidiary roundel and whose frame resembles the flange of a trencher—suggests a connection with autonomous forms (Berenson, *Homeless Paintings of the Renaissance*, fig. 352, gives it to Alunno di Benozzo; Diane Cole Ahl, pers. comm. 22 Oct. 1996, believes it is by Alesso, son of Benozzo Gozzoli).

[50] See Pope-Hennessy and Christiansen, 'Secular Painting in

Fifteenth-Century Tuscany: Birth Trays, Cassone Panels, and Portraits'; Ahl, 'Renaissance Birth Salvers and the Richmond Judgment of Solomon'; Fitzgerald, ' "Deschi da parto": Birth Trays of the Florentine "Quattrocento" '; Musacchio, 'The Art & Ritual of Childbirth in Renaissance Italy', 76 ff., who dates their inception to *c*.1370 and notes (p. 87) that round *deschi* appear in documents in the 1380s and the first extant example dates *c*.1430. She states that sixty-four painted trays (*deschi*) associated with childbirth exist (p. 94) and divides wooden childbirth trays and bowls into four types: *deschi*, *tarsie*, *legni*, and *tafferie*. See also Däubler, ' "Deschi e Scodelle da Parto": Wöchnerinnengeschenke in der Kunst der italienischen Renaissance'; De Carli, *I deschi da parto e la pittura del primo rinascimento toscano*, who reproduces many birthing scenes, some with *deschi* and others on *deschi*. J. Musacchio has a book on the subject in press, *The Art & Ritual of Childbirth in Renaissance Italy* (New Haven and London, 1999).

[51] See Ahl, 'Birth Salvers', 163 n. 3. Their connection with marriage is evident, while their relevance to childbirth resides in the couple's offspring, Menyelek, a great king. Watson, 'The Queen of Sheba in Christian Tradition'.

FIG. 1.16(*a*). Bartolomeo di Fruosino, *Desco da parto*, dated 1428. Private collection, London, on loan to the Metropolitan Museum of Art, New York

FIG. 1.16(*b*). Reverse of Fig. 1.16(*a*)

FIG. 1.17(*a*). Bacchiacca, *Desco da parto*; *Ghismonda with the Heart of Guiscardo*, *c.*1520. Lowe Art Museum, University of Miami, Coral Gables, Fla.

FIG. 1.17(*b*). Reverse of Fig. 1.17(*a*)

childbirth, which was, after all, the focus of marriage in the Renaissance.[52] Most probably the wife received a *desco* either at the time of her marriage, in hopes that she would produce an heir, or after conception, or following the birth. *Deschi* are now known to have been popular with all social classes and to have been bought as ready-made objects, whose heraldry could be customized or, in rarer cases, commissioned.[53] Inventories and diaries suggest that some *deschi da parto* were sold and thus obtained second-hand at a lower price, while others were inherited and remained within the family.[54] Sometimes they are found in inventories of childless couples, the most famous of which is that of Francesco di Marco Datini of Prato.[55]

It would seem logical that some salvers were given, not only upon pregnancy, but also on the occasion of marriage, when the household was equipped, in hopes of fecundity and progeny, helping to explain the appropriateness of some themes painted on them.[56] For example, the *desco* by Bacchiacca of *c.*1520 whose obverse is painted with the grisly story of Ghismonda with the heart of Guiscardo from Fiammetta's story in Boccaccio's *Decameron* (Fig. 1.17). Its theme, constant love, seems appropriate for the occasion, but a strange choice for a birth (while the bedroom setting is appropriate for both).[57] When discussing this panel, however, a note of caution should be raised. Its late date and unusual subject could be misleading in an investigation of earlier *deschi*, because Florentine art and society had changed from that of the early Quattrocento.

After the birth *deschi* were displayed in the home, but where and how we do not know because to date no representation of their installation has been located.[58] There seems to have been no consistent pattern for their placement. Some were hung in bedrooms, one of the most private chambers, least accessible to those outside the family, where they might have had a special, quasi-magical function for childbirth (see Ch. 4), while others were placed in unspecified rooms, and a few were recorded in closets or storage.[59] Their construction and decoration was allied with that of household furniture. The side with the narrative was considered the main side, for in the lion's share of both polygonal and round *deschi*, the lip of the frame is raised on that side. Moreover, in the large *desco* of Lorenzo il Magnifico in the Metropolitan Museum of Art, only the narrative side of the frame with the Triumph of Fame is lavishly decorated with a twisted gold rope and richly painted

[52] Vasari, the earliest source to describe their function (in his life of Francesco Salviati), states they were given after the birth (Vasari (Milanesi), vii. 20–1). Callmann, 'The Growing Threat to Marital Bliss as Seen in Fifteenth-Century Florentine Paintings', 80, believes that there is no evidence they were commissioned for marriages. She observes that *deschi* were given to the mother in recognition of her achievement in presenting her husband with an offspring (preferably a *figlio maschio*). However, evidence indicates that neither the patron/purchaser nor the time of purchase was necessarily exacting, although we know that they could be ordered by a grandparent (Ahl, 'Birth Salvers', 167 n. 43; Callmann, *Apollonio di Giovanni*, 36, 79, no. 108; ead., 'Marital Bliss', 80). The tradition that *deschi* were exclusively for the birth of a first child has been challenged. Pupilli inventories reveal that some families owned more than one, while a document of 1494 (CS-V 1468, fol. 129) lists a *desco* commissioned by Luigi d'Ugolino Martelli while his wife was pregnant with their last child, born after his death (Lydecker, 'The Domestic Setting of the Arts in Renaissance Florence', 128 n. 107).

[53] Musacchio, 'Art & Ritual', 76 ff.

[54] Ibid. 114–15; Ahl, 'Birth Salvers', 164 n.6. Moreover, Pupilli citations occasionally specify that *deschi* or *deschi da parto* are old or 'triste', in bad condition.

[55] In a 1398 inventory of Datini's possessions, one salver is reported in 'uno armario', perhaps because of his childless state. Another *desco* is listed among the possessions of his natural daughter after she had given birth (ibid. 164 n. 10). See also Origo, *The Merchant of Prato*.

[56] In passages in Alberti's *Della famiglia* concerned with the selection of a wife, one of the primary criteria was her fitness for bearing children (Alberti, *The Albertis of Florence: Leon Battista Alberti's Della Famiglia*, 55 ff.). Watson, '*Virtù* and *Voluptas* in Cassone Painting', 35, cites a *desco* listed among the wedding gifts for a couple in 1494 (Biagi, *Due corredi nuziali fiorentini 1320–1493, da un libro di ricordanze dei Minerbetti*, 18). Others were definitely before birth, as in a notice in the Archivio di Stato, Siena, Notarile antecosimiano 739, 4 Feb. 1483/4, 161ʳ: 'desco: pro domina Camilla uxore domini Bartholomei ser Mariani, adprehensio pro dotibuso [*sic*]' (Ahl, 'Birth Salvers', 167 n. 43).

[57] See App. n. 301.

[58] At least one is listed in 42 per cent of all the Pupilli inventories Ahl studied (Ahl, 'Birth Salvers', 158). Däubler, '"Deschi"', discusses *deschi* after their presentation.

[59] Ahl, 'Birth Salvers', 164 n. 10.

with emblematic feathers highlighted in gold.[60] It is curious that the reverse sides of *deschi*, like that of Lorenzo, containing the two families' coats of arms, are sometimes more damaged, suggesting either that they were hung against a damp wall or that the heraldic side was displayed outdoors. Since two sides were decorated, unlike one-sided tondi, it seems that both sides were intended for display as decoration and as a pointed reminder of the family, of its past as well as of the necessity to perpetuate it through childbirth. In these qualities *deschi* are more like medals than tondi.

We must now question whether *deschi da parto*, philologically connected with tondi (see Ch. 3), were a direct prelude to them and whether the two forms had more in common than merely similar shapes and imagery of women and children. *Deschi* were certainly part of the ceremonial gift-giving endemic to this patriarchal society. It seems from internal evidence in works of art that *deschi* were both functional and ceremonial gifts for potential and new mothers. At this time, marriage was a social contract and not a romantic institution. Most marriages were consummated with the express purpose of engendering children to carry on the husband's lineage. Because of the numbers of women who died in childbirth (not to mention infant mortality rates), the celebrations for bringing to life a successful heir were pronounced and lively. The practice of presenting *deschi* was a custom unique at first to Florence and its environs, but which later spread to other areas of Tuscany. Moreover, the emphasis on birth and its rituals grew out of special circumstances in Florentine society, demography, and family life during the late fourteenth and early fifteenth centuries. Because of repeated bouts of the plague from the 1340s through 1400, Florence suffered decimating blows to its population. This high death rate necessitated marriages, fertility, and procreation, resulting in a pronounced natalism. In this climate, the family unit became even more important, and humanist writers like Coluccio Salutati and Leonardo Bruni publicly extolled marriage and the family.[61] *Deschi* were one of the novel domestic genres of art developed to encourage and celebrate fertility and birth in the Trecento after the ravages of the Black Death, and I believe that tondi continued these ideas in a round format within a devotional context. Tondi, like *deschi*, held an important message for the domestic context and the woman of the household, whose value was measured in her fertility and ability to provide heirs.

During this time, the Florentine family evolved towards nuclearization, that is, the gradual dissolution of extended family structures, reinforcing the idea that the Renaissance can be characterized by the rise of the individual (but not to the extreme hypothesized by Jakob Burckhardt). Although there were diverse practices for different classes, the emergence of the nuclear family in the fifteenth century coincided with a new interest in domestic life and childhood as well as individualism in politics and business.[62] With this evolving family structure and its stress on lineage, the desire for *deschi*, as well as tondi with the Christ Child and his mother, is understandable (see Ch. 4).

By the early sixteenth century, the use of *deschi* was challenged and later eclipsed by maiolica birth ware. These objects, which had become popular in the late fifteenth century, are sometimes

[60] It has a 92 cm. diameter. See Ventrone, *Le tems revient*, 155–6, no. 2.7, ill.; De Carli, *I deschi da parto*, 126–9, no. 28, ill.

[61] Herlihy and Klapisch-Zuber, *Tuscans and their Families: A Study of the Florentine Catasto of 1427*, 228 ff.; Fitzgerald, '"Deschi da parto"', 40 ff.; Musacchio, 'Art & Ritual', 35 ff.

[62] Goldthwaite, *Private Wealth in Renaissance Florence: A Study of*

Four Families, believes it was accompanied by an awareness of familial descent and genealogy, large-scale architecture, and family monuments. On the contrary, Martines (*The Social World of the Florentine Humanists, 1390–1460*), Kent (*Household and Lineage in Renaissance Florence: The Family Life of the Capponi, Ginori, and Rucellai*), and others think that extended families continued.

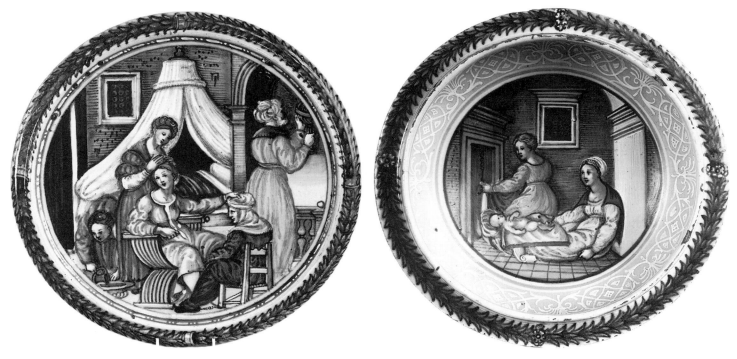

Fig. 1.18. Trencher (*tagliere*) and broth bowl (*scodella*) from a parturition (*impagliata*) set, *c*.1524–30. Victoria and Albert Museum, London

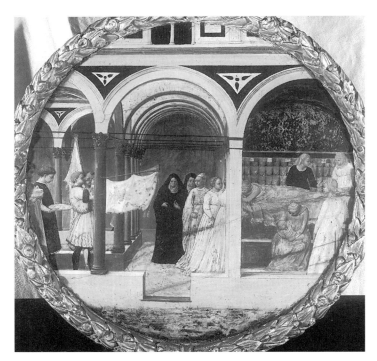

Fig. 1.19(*a*). Circle of Masaccio, *Desco da parto*, 1426–7. Gemäldegalerie, Staatliche Museen zu Berlin—Preußischer Kulturbesitz

Fig. 1.19(*b*). Reverse of Fig. 1.19(*a*)

referred to as *impagliata* vessels and in documents designated as *da parto* (Fig. 1.18).[63] Representations of them include a late quattrocento predella by Signorelli in the Musée du Louvre with the Birth of St John the Baptist, where they rest on the headboard of the bed.[64] They were clearly related in iconography and round form to *deschi*, but only distantly to tondi. However, since sets usually included a *tagliere* (trencher), it is interesting to note that early tondi—like Donatello's *Chellini Madonna*—and transitional examples, such as Giotto's Scrovegni roundel and the Certosa panel, have a framing device that resembles the flange of a trencher.[65] And it was the trencher that was most like both *deschi* and tondi. While the interiors of these maiolica pieces are usually painted with confinement or childcare scenes, the undersides often have nude winged male putti floating in the sky that relate to the reverse of *deschi*. Some contain intimate and graphic birth scenes reminiscent of vernacular midwifery manuals, and one maiolica *tagliere* is actually inscribed *MASCHIO*, a declaration of the hoped-for goal in this natalistically oriented patrilineal culture.[66] Two bowl-like objects attributed to Pontormo (App., Figs. A115–16) and two others of this genre (*tafferie da parto*) reflect the growing popularity of parturition sets in the early Cinquecento, especially the *scodella* or broth bowl. They are a hybrid of a *desco* and a *scodella*, combining elements of the narrative with the bowl shape.[67] Like *deschi* they bear some relationship to tondi and ideas of the family, but a more distant one.

The themes depicted on *deschi* emphasize family, lineage, love, marriage, and birth, articulated in different ways on the two sides. The obverse contains a narrative, usually a secular scene, while the less elaborate reverse contains the coat of arms of the two conjoined families together with a larger *impresa* of the husband (rarely in later examples surrounded by a wreath), or a chessboard, or naked putti with allegorical meanings of fertility and prosperity and certainly embodying the hoped-for male progeny. Just how graphic they could be is recorded in the inscription around the rim of the reverse of the *desco* attributed to Bartolomeo di Fruosino with a nude little boy urinating (Fig. 1.16).[68] It seems likely that these were talismanic, a fact reinforced by the coral necklaces worn by some of the putti (and by the Child in contemporary paintings). Sometimes the putto urinates or holds attributes symbolic of fertility or achievement. We know that fertility charms were an important part of public rituals in Renaissance Florence. For example, a child was frequently placed in a new bride's arms as a stimulus to conception, or the bride was offered life-size terracotta or stucco babies. A popular Venetian saying, 'Quel che se fissa, se fa' ('What she looks at, she makes'),

[63] Inv. no. 2258-1910 in the Victoria and Albert Museum, London; the broth bowl (*scodella*) has a 23 cm. diameter, the trencher cover (*tagliere*) a 19 cm. diameter. Rackham, *Victoria and Albert Museum: Catalogue of Italian Maiolica*, i. 185–6, no. 551, ill.; Piccolpasso, *The Three Books of the Potters' Art*, pl. 16. See also Crainz, *La tazza del parto*; Musacchio, 'Art & Ritual', 130–63; Däubler, 'La Tazza da parto nella collezione Pringsheim'.

[64] Paolucci, *Luca Signorelli*, 19, fig. 22.

[65] Another trencher-like work is a bronze Florentine plaquette with the Holy Family (one of several casts) from the early 16th c. in the Victoria and Albert Museum, London (with a 12.2 cm. diameter). Its gilded frame is inscribed: *PVER NATVS. EST. NOBIS.* [et filius datus est] ('For a child is born to us and a son is given to us'), Isai. 9:6, appropriately the Introit for the Mass of Christmas Day. Pope-Hennessy, *Renaissance Bronzes from the Samuel H. Kress Collection*, 83, no. 288, illustrates a version with an 8.2 cm. diameter and notes others, including one in *cartapesta*.

[66] Musacchio, 'Art & Ritual', 188, for the *tagliere* of *c*.1530 in the Museo Civico Medievale, Bologna.

[67] For the two *tafferie* from Pontormo's shop, see Ferrazza and Bruschi, *Un Pontormo ritrovato*; Costamagna, *Pontormo*, 281–3, nos. A30, A30a, ill.; and below, App. nn. 303–4. Musacchio, 'Art & Ritual', 121–8, 136–7, identifies these and two other *tafferie*, noting that the earliest *tafferia* she knows is in an inventory of 1493, the latest in 1622.

[68] Private Collection, London, on loan to the Metropolitan Museum of Art. The obverse is inscribed on the platform below the figures with a rubbed passage: *QUEST SI FE A DI XXV DAPRILE NEL MILLE QUATTROCENTO VENTOTTO*. Watson, 'Virtù', 193–2; Kanter *et al.*, *Painting and Illumination in Early Renaissance Florence, 1300–1450*, 311–14, no. 43, ill.; De Carli, *I deschi da parto*, 98–101, no. 15, ill. Similar meanings are on the reverses of other *deschi* and in later wedding paintings; Callmann, *Apollonio*, 59–60, no. 16, ill.; Christiansen, 'Lorenzo Lotto and the Tradition of Epithalamic Paintings', 171 ff., fig. 8.

illustrates this idea. Later, the custom developed of presenting newly-wed couples with a box of confections containing a sugar doll, intended as a focus for the bride during pregnancy in order to engender something like it.[69] Pregnancy and the perpetuation of the male line was glorified in the aforementioned birth scenes painted in churches, which also spoke to the devotional needs of Renaissance women as well as idealizing a potentially dangerous event. These same motivations lay behind representations of the Christ Child placed in the home, especially those on tondi, whose association with the birth of progeny would have been accelerated by their round shape and its association with *deschi*.

This type of sympathetic magic, which is also pertinent to tondi, had a long history, for texts in circulation during the late Middle Ages and the Renaissance reveal superstitions about the influence of the maternal imagination on the unborn child. Both the writings of St Augustine and the gynecological treatise of Soranus (*On Mid-wifery and the Diseases of Women*, the source of many works on obstetrics) recount the revealing story of a deformed Cyprian tyrant who made his wife look at beautiful statues when they made love to guarantee that he would not father an equally deformed child.[70] It is clear from other quattrocento literature, including Marsilio Ficino's humanist astrological treatise *The Book of Life* (1489), that anything the mother looked at during conception could influence her offspring. One finds a reflection of this attitude in Alberti (1452): 'Wherever man and wife come together, it is advisable only to hang portraits of men of dignity and handsome appearance; for they say that this may have a great influence on the fertility of the mother and the appearance of future offspring.'[71] Therefore, it is understandable why individuals took pains that the ideal male child, which they hoped to engender, would be helped along by representations like those on *deschi* and on tondi, which were frequently hung in *camere*.

Tellingly, the putti found on the reverses of *deschi* (Figs. 1.16, 1.19) are related to ancient prototypes as well as to images of the Child on Renaissance tondi.[72] Their roots have been traced to classical *erotes* or *amorini*[73] who carry a *clipeus*, symbolic of heaven, thus truly connecting them with tondi. Via an association with Victories, who performed a similar function, *erotes* metamorphosed into Christian angels, frequently found on tondi, transporting souls to heaven. Thus, the connections come full circle.

Because *deschi* were displayed in households, they created a precedent for tondi in a secular environment, whose appearance coincides with the artistic and humanistic infatuation with the circle. As discussed in Chapter 3, a *desco* was at times referred to as a *tondo da parto*, an abbreviation of *desco tondo*. At the very least this suggests that the development of the devotional tondo was accelerated by an association with *deschi*. Because of a similar form and related subject matter, *deschi* and painted tondi can be linked. During this age of great changes in household decor, less hieratic

[69] Another instance of 'positive' thinking about birthing a masculine child is the image of a baby in wax and gesso meant to engender male offspring; Marcotti, *Un mercante fiorentino e la sua famiglia nel secolo XV*, 121 n. 43. See Klapisch-Zuber, *Women, Family, and Ritual in Renaissance Italy*, 310–29; and especially Musacchio, 'Art & Ritual', 164–201.

[70] Ibid. 169–70.

[71] Alberti, *On the Art of Building in Ten Books*, 299.

[72] Fig. 1.19 is inv. no. 58 C in the Staatliche Museen zu Berlin — Preußischer Kulturbesitz, Gemäldegalerie, panel with a 65 cm. diameter, whose gessoed surface measures 56.5 cm. Berlin, Staatliche

Museen — Preußischer Kulturbesitz, *Picture Gallery, Berlin. Catalogue of Paintings*, 262–3, ill. Unlike what many have claimed, this *desco* was not meant to appear round. Its reverse has traces of the red confining lines of a twelve-sided picture field, clinching its transitional, important nature. Erich Schleier also informed me that the present frame is later (letter of 18 Jan. 1991). While most scholars believe it was only influenced by Masaccio, Berti and Foggi, *Masaccio*, 197, attribute it to him with assistance. See De Carli, *I deschi da parto*, 94–7, no. 14, ill.

[73] Kunstmann, *The Transformation of Eros*.

Madonna and Child tondi became a serious alternative to household tabernacles or rectangular devotional panels. Perhaps tondi, while maintaining the religious functions of devotional panels, assumed some of the decorative and didactic functions of *deschi* but shifted the emphasis from the family of the household to members of the Holy Family. Thus, tondi became the perfect domestic devotional picture, combining some associations from both secular *deschi* and religious images to form a new type of object whose very shape harmonized both with religious ideas and current trends in humanism. In this equilibrium tondi embody the essence of the Renaissance. In fact, vestiges of the *desco* tradition can be seen in Lippi's mid-century *Pitti Tondo* (Fig. 7.3), where in the background, like a footnote, is the Birth of the Virgin. This vignette is similar to the delivery scenes on *deschi*, while the reverse contains a never-completed heraldic design, again seemingly linked to *deschi*.

An unusual tondo from the 1490s, attributed to the Master of the Lathrop Tondo (Michelangelo di Pietro Mencherini), contains further evidence linking *deschi* with tondi (Fig. 1.20).[74] It features a Madonna and Child with St Catherine of Alexandria, St Jerome, and a kneeling donor, who has removed his hat out of reverence. Since two small escutcheons in the entablature with the Guinigi and Buonvisi arms crown the composition, it has been suggested that these devices enshrine the union of the two Lucchese families through the marriage of Michele Guinigi and Caterina Buonvisi in 1496, a date that coincides with the stylistic date of the tondo.[75] Fredericksen is correctly sceptical about this interesting proposal, and the donor cannot be absolutely identified as Michele Guinigi unless further documentary evidence surfaces, as pointed out by Tazartes.[76] If this panel records a marriage, it is strange that the wife is not portrayed. Her absence reminds one of Piero della Francesca's *Brera Altarpiece*, where that of Battista Sforza, marked by an empty place in the *sacra conversazione*, underlines the fact that the Duke's wife is deceased. In addition, the donor prays to St Catherine holding a fragment of her wheel of martyrdom, Caterina Buonvisi's onomastic saint, not to the Madonna, while there is an empty space before her.[77] Perhaps the intense communication between the two indicates that the work was executed either after the death of the wife in successful childbirth or before the marriage and the hoped-for heirs. In the latter scenario, St Catherine would be a 'stand-in' for the bride-to-be. It may have been considered indecorous for a betrothed woman to be in the company of her future husband. Either interpretation can be supported by the iconography of the central *Madonna del Latte*, who reinforces the idea of hoped-for progeny. It is also significant that the cardinal saint behind the donor (without attributes) has been identified as St Jerome, the saint of Michele's father, Girolamo.[78] His position and posture are synchronous with the donor's reverent pose to reinforce the dynastic associations of the tondo and the succession of the male line (all three males, including the Child, are on one side). This interpretation is further supported by the two escutcheons that represent a link to the arms on the reverse of *deschi*. Moreover, other quirky features of this panel demonstrate that the artist and patron were capable of iconographic innovation. For example, an apple, traditionally held by the

[74] Inv. no. 68.PB.4 in the J. Paul Getty Museum, Los Angeles, tempera on panel with a 101.5 cm. diameter. Fredericksen, *Catalogue of the Paintings in the J. Paul Getty Museum*, 21–2, ill.

[75] Arrighi, *Il Nuovo Corriere*, 4; Fahy, 'A Lucchese Follower of Filippino', 9–10, 19.

[76] Fredericksen, *Catalogue*, 25–6; Tazartes, 'Michele Angelo (del fu Pietro "Mencherini"): Il Maestro del Tondo Lathrop', 38 n. 21,

notes that the marriage between the two families was that of Lucia di Benedetto Buonvisi and Francesco Guinigi, whose names do not correspond to the saints in the panel.

[77] Ellen Callmann suggested in a written communication of 15 May 1995 that St Catherine might be a portrait of the patron's wife.

[78] Frederickson, *Catalogue*, 21–2.

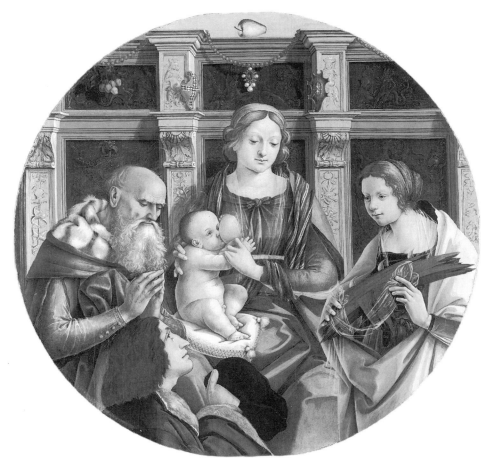

FIG. 1.20. Master of the Lathrop
Tondo/Michelangelo di Pietro
Mencherini, *Madonna and Child
with Saints and a Donor*, *c*.1496.
J. Paul Getty Museum, Los Angeles

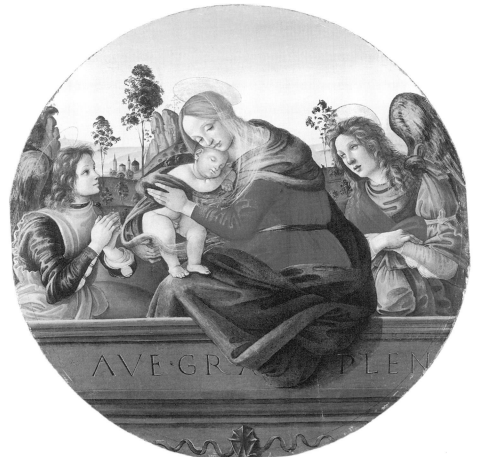

FIG. 1.21. Filippino Lippi and
Workshop, *Madonna and Sleeping
Child with Angels; 'Ave Gratia Plena'*,
c.1485–90. Whereabouts unknown

Child, is positioned as an unorthodox filler motif in the architecture. It symbolically signals Christ as the second Adam, while the cherries hanging from coral beads are a more general allusion to the fruits of Paradise.

Not many painted tondi have the explicit heraldry encountered on *deschi*, while none, save Lippi's problematic *Pitti Tondo*, with an unrelated and unfinished escutcheon on its reverse, are double-sided. Only a few, like Fig. 1.20 and another from the shop of Filippino Lippi (Fig. 1.21) are emblazoned with escutcheons. The latter has a generic coat of arms painted illusionistically as though carved on a *pietra serena* balustrade in the exergue.[79] A rubbed but more specific coat of arms occurs in an analogous position in a tondo depicting the Madonna and Child with saints Jerome and Francis attributed to the Circle of Raffaellino del Garbo (Fig. 1.22).[80] The white escutcheon with a red diagonal band is encircled by a diamond ring, which may indicate a Medici connection, although other individuals and families also employed the diamond ring in their devices. These rare tondi with familial heraldry may preserve a general echo of earlier associations between tondi and *deschi*, although they may only relate to the cultural stress on the family. Occasionally quattrocento altarpieces also have arms in either their lower or upper zones, their predella, or frame.

ADDITIONAL INFLUENCES

While we have considered the most direct prototypes, tondi became popular when many circular forms and objects were in vogue, thereby accelerating their development and appeal. We have only to recall the round stained-glass windows of the Duomo, which reveal the status accorded to the circle as well as its association with the Madonna (Santa Maria del Fiore was named for the Madonna). Moreover, initials in manuscript illuminations provided windows for representations that frequently assumed a rounded format.[81] More significantly, during the second quarter of the fifteenth century, Antonio Pisanello elevated the art of the medal to a high plateau, thereby gaining much status for contemporary examples (Fig. 1.23).[82] Together with prized ancient coins and medals, influential on Pisanello and widely collected by humanists, these works participated in the increasing proliferation of the round form that is germane to portraits. However, since medals are small two-sided objects, frequently produced in multiples and intended to be held, they are different from tondi (see Ch. 5). There were also round seals and coins with images of the Virgin and Child in circulation at the time.[83]

Maiolica objects with representations of roundels—for example, a mid-fifteenth-century

[79] Formerly Barbara Piasecka Johnson Collection, Princeton, tempera on panel with a 94 cm. diameter. Grabski, *Opus Sacrum: Catalogue of the Exhibition from the Collection of Barbara Piasecka Johnson*, 104–5, ill.; Christie's, New York, sale cat., 3/II/97, no. 132.

[80] Inv. no. 21 in the Gemäldegalerie, Dresden, tempera on panel measuring 76 × 75 cm. with an area around the circumference that once may have been outlined in dark pigment. Woerman, *Katalog der königlichen Gemäldegalerie zu Dresden*, 18. A similar tondo without the ring, reproduced as homeless in Berenson, *Italian Pictures of the Renaissance: Florentine School*, ii, fig. 1167, demonstrates that it was customized.

[81] See Kanter *et al.*, *Painting and Illumination*. Significantly, these books are directly related to worship and devotions.

[82] Inv. no. 1957.14.a & b (A-753)/SC in the Samuel H. Kress Collection, the National Gallery of Art, Washington, DC, in lead with an 8.6 cm. diameter.

[83] See Bellosi *et al.*, *Ghiberti*, 51–2, 717, pl. A.XVIII, the round bronze seal—with a standing Madonna holding the Child and a 46 cm. diameter (*c.*1385)—of Francesco Mormile, Bishop of Siena, in the Museo di Palazzo Venezia, Rome. For others, see Beissel, *Geschichte der Verehrung Marias in Deutschland während des Mittelalters*, figs. 17, 92, 127, 129.

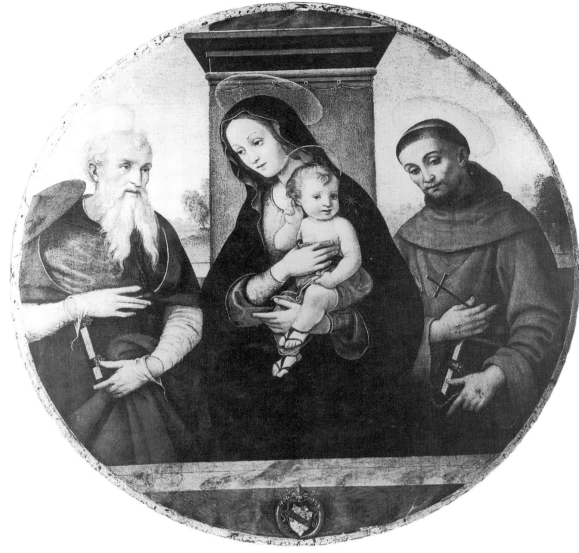

FIG. 1.22. Circle of Raffaellino del Garbo, *Madonna and Child with St Jerome and St Francis*, *c.*1500–4. Gemäldegalerie, Dresden

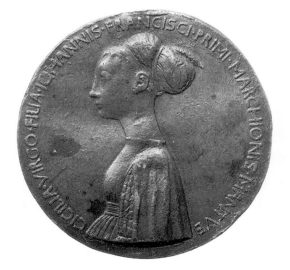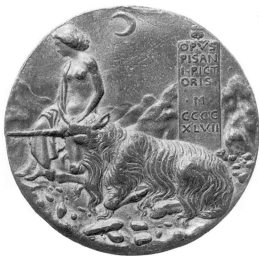

FIG. 1.23. Antonio Pisanello, *Medal of Cecilia Gonzaga*, reverse with Innocence and a unicorn in moonlit landscape, 1447. Samuel H. Kress Collection, National Gallery of Art, Washington, DC

Hispano-Moresque dish with the circular emblem of Christ used as a monogram by St Bernardino of Siena—also disseminated circular forms in households.[84] By the late fifteenth century, plates, which were double-sided luxury items, like *deschi* were hung as decorative objects and given as prized gifts.[85] During the later fifteenth century a whole class of maiolica was known as 'tondini'; these small, round bowls with wide, flat rims were related to the tondo phenomenon.[86] (Later sixteenth-century narrative maiolica really had no impact on tondi.) Many of the earlier maiolica forms were made to service social practices and to honour ideas involving courtship, matrimony, and childbearing and suggest connections with tondi as well as *deschi*.[87] At the very least, the round formats of maiolica, not only plates and bowls but also the roundels painted on them, are evidence of the artistic infatuation with circles and their presence in a domestic context.

Even earlier, beginning *c.*1200, pottery bowls/plates called 'bacini' were used to decorate the façades of some Tuscan churches.[88] A few remain *in situ*, while holes record where many others were once applied like roundels. Their importance for this study resides in the fact that *bacini* were superficial applications to the wall and were viewed as independent of the wall surface and its material. Thus, they provided a precedent for both sculptural and painted roundels and eventually for tondi.

Finally, in passing, we should mention the ephemeral quattrocento gift boxes produced in the ubiquitous round shape. They were decorated with amatory subjects, garlands, and even round mirrors.[89] This genre was associated with courtship and thus with the family cycle so important for all household objects, including tondi.

In conclusion, there is neither a simple explanation for the genesis of the tondo nor one prototype behind the appearance of the form. Rather, the tondo has a mixed lineage, including its links to the roundel inherited by the Renaissance. While a variety of objects form a rich background tapestry that records an excitement with the circular shape and serves as a prelude to the tondo phenomenon, the *imago clipeata* is the dominant prototype. Since its own genesis in antiquity, the *imago clipeata* exerted a sustained, though sometimes differing, influence, carrying with it subtly shifting ideas of apotheosis, resurrection, power, perfection, and holiness. It was given new life and reinvigorated in the Quattrocento by a more objective examination of Roman monuments and ideas. In the tondo it was supplemented by a familial, domestic dimension (found in a more pronounced fashion in *deschi*), where it always carried the connotation of perfection and eternity.

[84] In the J. Paul Getty Museum, Los Angeles, with a 49.5 cm. diameter. Hess, *Italian Maiolica: Catalogue of the Collection of the J. Paul Getty Museum*, 14–15, no. 2, ill. Wilson, *Ceramic Art of the Italian Renaissance*, 28–9, ill., dates two similar dishes with Florentine family arms *c.*1420–80.

[85] Their inspiration came from the Islamic world and ancient Rome. Many have holes, proving that they were displayed. Wilson *et al.*, *La donazione Galeazzo Cora: Museo Internazionale delle Ceramiche in Faenza*.

[86] Hess, *Italian Maiolica*, 8. For maiolica love cups and plates with images of *belle donne*, see Ch. 5. For a Deruta plate (*c.*1500) with the image of the Madonna and Child that was influenced by tondi,

see Becherer *et al.*, *Pietro Perugino: Master of the Italian Renaissance*, 216–19, ill.

[87] In Filippino's tondo of the Annunciate Virgin (Fig. 3.2) maiolica vessels are depicted in a domestic setting together with objects like a rosary.

[88] G. Berti and Tongiorgi, *I bacini ceramici del Duomo di S. Miniato (ultimo quarto del XII secolo)*.

[89] For an example, a round engraving of *c.*1472 with music-making putti, lovers, and a couple dancing, see Cole, *The Renaissance Artist at Work: From Pisano to Titian*, 111, fig. 53; see also below, Chs. 2 n. 3 and 4 n. 88.

2

IN SEARCH OF AN IDEAL FORM: GEOMETRY, COSMOLOGY, DANTE, AND THE CENTRAL PLAN

TURNING from the visual prototypes for tondi, which present an embarrassment of riches, we shall now focus on a condensed consideration of the associations—cosmological, theological, literary, and theoretical—that the circle held for quattrocento minds. Despite their seemingly deceptive simplicity, these highly complex and frequently interrelated ideas provided the essential cultural matrix for the development of the tondo. Exploring them will enable us to understand some of the associations quattrocento individuals brought, albeit sometimes subconsciously, to the tondi they commissioned, created, and/or viewed.

GEOMETRY: THE CIRCLE AS PERFECTION AND A SYMBOL OF GOD

Since Greek civilization and the advent of Pythagorean thought, the circle was viewed as the most perfect geometrical form. Thus it became synonymous with divinity and eternity, both of which have no beginning or end (for Christians Christ was the alpha, the beginning, and the omega, the end). The writings of the Greek philosopher Plato served as a concrete link to these concepts and a great catalyst to Renaissance thinkers.

The serious quattrocento interest in Greek studies can be gauged by the fact that in 1463 Cosimo de' Medici ensconced the humanist physician Marsilio Ficino near his villa of Careggi to translate from Greek the dialogues of Plato (as well as to study Plotinus and Neoplatonists of late antiquity). Thereafter, fifteenth-century Neoplatonism represented an avenue for humanists to harmonize pagan thought and philosophy with Christianity.[1] Quattrocento Neoplatonists circulated Platonic ideas among the intellectual elite,[2] while Platonism's stress on abstract ideas filtered down to lend an otherworldly character to elements of the culture at large.[3] Its mystical and syncretistic

[1] See Robb, *Neoplatonism of the Italian Renaissance*; De Gandillac, 'Neoplatonism and Christian Thought in the Fifteenth Century (Nicholas of Cusa and Marsilio Ficino)', 143–68; Kristeller, *Marsilio Ficino and his Work after Five Hundred Years*; Field, *The Origins of the Platonic Academy of Florence*; Hankins, *Plato in the Italian Renaissance*.

[2] e.g. passages in Ficino, *Theologia Platonica de immortalite*

animorum, depend on Plato's *Alcibiades I*, on the immortality of the soul.

[3] The prevalence of the circle in Neoplatonic ideas on a popular level appears in a circular amorous design with a supposed representation of Lorenzo de' Medici (one of the Otto prints) engraved by Baccio Baldini *c*.1465 (Langedijk, *The Portraits of the Medici: 15th–18th Centuries*, ii. 1152–3; Figline Valdarno, Vecchio

components increased and it was more widely accepted as the century matured. Moreover, with its convoluted nature and stress on layers of meaning, Neoplatonism created an intellectual environment in which the symbolism associated with tondi, especially the complex painted ones, could thrive.

Since Ficino's translations opened up direct access to Plato for the first time in the West, Plato's attempts to explain rationally the creation of the universe in terms of geometry and numbers (an outgrowth of Pythagorean thought) in the *Timaeus* became available. Plato reasoned that the creator chose the circle as the model of the universe because he would not have created anything short of perfection. Plato's connection of the circle with God reinforced its symbolic character.[4] Later, Christian writers and theologians connected the circle and its perfection (also the tondo) with not only God and the structure of the universe but also with Christian virtue.[5]

Thus it was in the dawning years of the Quattrocento, with the escalation both in quality and quantity of humanistic endeavours, that the circle regained primary status as an ideal form in the visual arts. In this environment, a tondo's shape immediately connoted the mathematical perfection of God and the harmonic universe, the macrocosm.

COSMOLOGY: THE CIRCLE AS A SYMBOL OF THE UNIVERSE AND HEAVEN

Inextricably allied to the religious symbolism of the circle was the ancient cosmological system inherited by the Renaissance, which also transferred to the tondo. In this construct, religious ideas reinforced cosmological beliefs and vice versa, as in the image of Christ, enthroned on the rings of heaven like a Roman emperor, in the role of the Kosmokrator in the Florentine Baptistery mosaic (Fig. 1.7). Since the Death–Resurrection and theophanic aspects of Christ made Christianity unique among the religions, it was essential to depict him in a heavenly environment. To that end, the circle became a shorthand indication of divine status and heavenly abode. A tondo's circular format, therefore, symbolized in a more naturalistic, aesthetically appealing fashion what the gold background of earlier panels had symbolized: heaven.

The vision of heaven was one of the fundamental artistic expressions of Church thought, a concept that has received more focused attention in recent years.[6] An exploration of the background of the Christian dome/canopy of heaven reveals an unbroken continuity from ancient monuments. The vision of heaven appears not only in ceiling paintings but also in the architectural

Palazzo Comunale, *Il lume del sole: Marsilio Ficino, medico dell'anima*, 103, fig. 33; Dempsey, *The Portrayal of Love: Botticelli's 'Primavera' and Humanist Culture at the Time of Lorenzo the Magnificent*; and below, Ch. 4 n. 88). See also Chastel, *Marsile Ficin et l'art*, 136 ff.; id., *Art et humanisme à Florence au temps de Laurent le Magnifique*, 320–2.

[4] Ideas in Plato (e.g. *Timaeus, The Dialogues of Plato*, iii. 437 ff.) were continued by Ficino, who wrote: 'God is goodness, beauty, and justice; beginning, middle, and end' (*De Amore*, II. i—Ficino, *Commentary on Plato's Symposium on Love*, 45). For Ficino, a circle forms the heart of the universe (*Theologia Platonica*, II. x. 105) and

the world soul and other souls move in a circular manner (*Convito*, VII. xviiii, and *De Amore*, II. iii). See also Ficino, *The Letters of Marsilio Ficino*, ii, no. 65.

[5] St Gregory, in his *Moralia in Job*, XXXIII, comments: 'Per circulum divinae virtutis omnipotentia designatur.' Bolten, *Die Imago Clipeata*, 46.

[6] Lehmann, 'The Dome of Heaven', 1. See also Zahlten, '*Creatio Mundi*': *Darstellungen der sechs Schöpfungstage und naturwissenschaftliche Weltbild im Mittelalter*; Murdoch, *Album of Science*, 240 ff.; Belting-Ihm, 'Theophanic Images'; Tronzo, 'Apse Decoration'; Miziolek, 'When Our Sun is Risen: Observations on the Eschatological Visions in the Art of the First Millennium, II'.

dome or apse (a half dome),[7] which flourished in the Renaissance. Thus, an allusion to the canopy of heaven covered with stars and associated with royalty and then Christ lies behind apses and the occasional chivalric tents depicted in tondi, such as Botticelli's *Madonna of the Baldacchino* (Fig. 7.21).[8] These depictions of Christ were intended as vivid epiphanies of a numinous presence.[9] Similar quasi-magical qualities were transferred in shorthand fashion to more secular tondi by the very shape of the circle.

In addition, as discussed in the first chapter, one of the cosmic symbols of the ancient world was the *clipeus* or the world ring.[10] Its associations not only with the cosmos but also with immortality and apotheosis were transmitted to both secular and devotional tondi in quattrocento Florence.

THE PTOLEMAIC UNIVERSE

The geocentric cosmological view inherited by the Renaissance, which informed tondi, was Ptolemaic. Its roots lay in the Platonic Academy of the Ancient World from which issued Eudoxus of Cnidus' mathematical astronomy and his ideas about the concentric heavenly spheres. It was followed by Aristotle's cosmology,[11] which in turn led to Hellenistic astronomy. One of its most significant figures was Claudius Ptolemaeus, called 'Ptolemy', the Alexandrian astronomer and geometer of the second century AD, whose ideas were transmitted via his *Almagest*.[12] Over the centuries his Aristotelian synthesis acquired a biblical, Christian slant that held sway until long after Copernicus postulated his heliocentric scheme in the second decade of the sixteenth century (*De revolutionibus orbium coelestium* was published in 1543).

Renaissance individuals, therefore, believed the universe to be constructed in Ptolemaic nested circles with the earth at the centre. While cosmological schemes based on these concepts were first illustrated in manuscripts, these diagrams began to appear on a larger scale in religious contexts in trecento Italy. Well-known examples include a fresco by Piero di Puccio da Orvieto (Fig. 2.1);[13] a panel by Giovanni di Paolo (*Creation and the Expulsion from Paradise*) in the Metropolitan Museum of Art;[14] and a fresco by Domenico di Michelino (*Dante with his 'Commedia'*) in the Florentine Duomo.[15] So pervasive was the circle that in the woodcuts of the *Nuremberg Chronicle* (1493) each

[7] Lehmann, 'Dome', 2 ff., notes pertinent decorations.

[8] While Botticelli's image seems influenced by festival or tournament tents, the concept of celestial royalty remains relevant.

[9] Shearman, *Only Connect*, 158–9.

[10] L'Orange, *Likeness and Icon*, 320 ff., traces the motif from Assyrian and Achaemenian sun symbols which had an inner circle with a plastically projecting rim that assumed the form of a *clipeus*. He believes that the image of the sun was thereby transformed into an image of the world circle, the cosmos, the revolving All, frequently linked to the relationship between heaven and earth. Its cosmic significance is made clear when it is bordered by the zodiac, becoming the *clipeus caelestis*. In actual Roman rituals, the emperor, not his *imago*, was placed on the *clipeus*, which at times was adorned with stars. In his coronation ceremony, the *clipeus* and he were elevated together, foreshadowing cosmic images of Christ in a *clipeus* decorated with stars.

[11] In Aristotle's phrase, the sphere is 'the primary shape in nature' (*De caelo*, 286[b] II).

[12] Between the dates of Eudoxus and Ptolemy, Aristarchus of Samos and Hipparchus, among others, formulated astronomical ideas. Since most of their works are lost, the history of celestial-motion diagrams is essentially Ptolemaic.

[13] It has between twenty and twenty-two concentric circles (including nine orders of angels) with a central mappamondo. Zahlten, 'Creatio Mundi', 181, cites Bonaventura, 'Brevilogium', *Opera omnia*, v (1891), 220 ff., for a description of a similar diagram.

[14] Lippincott, 'Giovanni di Paolo's "Creation of the World" and the Tradition of the "Thema Mundi" in Late Medieval and Renaissance Art', ill. See also Heninger, *The Cosmological Glass*; Murdoch, *Album of Science*, 137–45, 328–45; Dixon, 'Giovanni di Paolo's Cosmology'; Grant, *Planets, Stars, and Orbs: The Medieval Cosmos, 1200–1687*.

[15] Schubring, *Illustrationen zu Dantes göttlicher Komödie*, fig. 5.

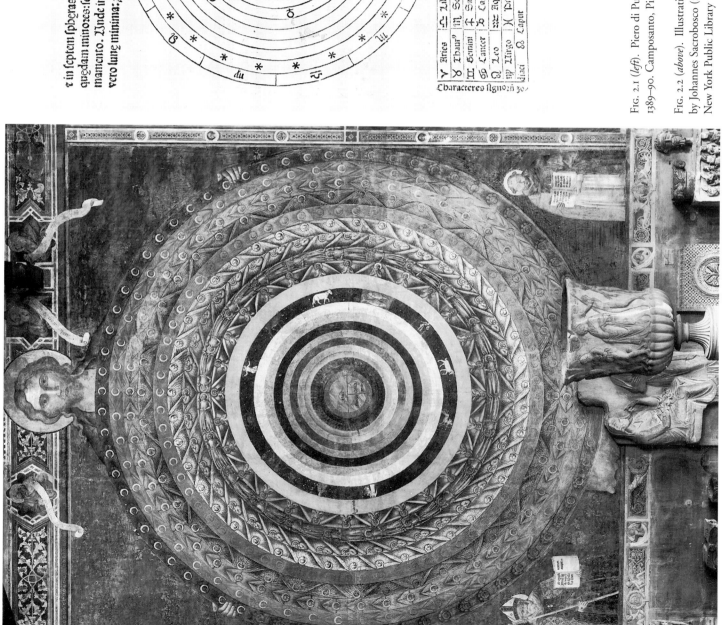

FIG. 2.1 (*left*). Piero di Puccio da Orvieto, *Creation of the Universe*, 1389–90. Camposanto, Pisa

FIG. 2.2 (*above*). Illustration of the geometric universe from *De Sphaera* by Johannes Sacrobosco (14th edn., 1482), fol. 92ᵛ. Rare Books Division, New York Public Library

day of the world's creation was illustrated by a circle.[16] Furthermore, astrology, horology, and astronomy were all intimately connected,[17] so that the conception of the cosmos literally revolved around circular forms.[18] In these schemes, the finite universe was divided into two parts, heaven and earth, comprised of celestial and elemental forms, respectively.

This attempt to render the heavenly hierarchy of the planetary bodies, stars, and zodiac presented problems when combined with the Christian heaven. In this scheme, after the stationery, central earth, around which were positioned the four elements, were: the heavenly bodies, the seven planets in concentric revolving spheres, and finally, the firmament of fixed stars bounded by the zodiac (sometimes represented as the ninth crystalline sphere).[19] The medieval Christian modification of the Aristotelian–Ptolemaic system extended beyond with the *Primum Mobile*, the first moved, and then the empyrean heaven, home of God and the angels. When a view of the heavens from the earth was required, concentric circles, minus the earth and the elements, were depicted with God at its centre, a scheme implied in devotional tondi.[20] These concepts were disseminated on a popular level by *De Sphaera* of Johannes Sacrobosco (Fig. 2.2), which was written in the early thirteenth century as a condensation and simplification of Greek, Arabic, and Christian traditions. The book's illustrated publication in the fifteenth century further increased its influence. Sacrobosco's digest was the most frequently used textbook on astronomy and cosmography from the thirteenth to the seventeenth century and had such a wide influence that it affected artists and patrons alike.[21] It may have informed works of art with rings of heaven, such as Filippo Lippi's *Coronation of the Virgin* (1467–9), with its purple and blue background stripes, or Ghiberti's Creation vignette on his '*Paradise*' Doors, where concentric circles inscribe God the Father.[22]

While the tondo form itself was shorthand for the Ptolemaic heavens, further celestial elements from an abbreviated Ptolemaic cosmological scheme occasionally are included in tondi, especially those in sculptural media, to intimate the divine nature and heavenly setting of the enframed

Others include frescoes of the late Trecento by Giusto de' Menebuoi in the Baptistery, Padua, and Bartolo di Fredi in the Collegiata, San Gimignano (Norman, *Siena, Florence, and Padua: Art, Society, and Religion 1280–1400*, i, pls. 224, 226).

[16] Schedel, *Liber cronicarum*, pls. II[r]–V[v].

[17] Astrolabes, a forerunner of astronomical clocks, are circular in form and determine time by the position of the stars at a given latitude. During the 15th c. there was an increase in the incidence of public clocks, like the one in the Florentine Duomo, whose face (Fig. 5.17) was painted by Paolo Uccello with prophet heads in roundels at the corners; Borsi and Borsi, *Paolo Uccello*, 116–19, ill. Reti, *The Unknown Leonardo*, 241 ff., discusses Leonardo's involvement with clocks, including one marking the moveable feast days of the Church.

[18] One example occurs in a manuscript illustration by Simon Marmion in the Bibliothèque Royale, Brussels, with the spheres and the signs of the zodiac (Baltrušaitis, 'Cercles astrologiques et cosmographiques à la fin du Moyen Âge', fig. 16; also fig. 6, a diagram of the Seven Joys of the Virgin). Another with four angels holding up a roundel with the rings of heaven and the zodiac, inside which is a swirling checquerboard pattern framing the Nativity of Christ, is part of the *Bamberg Altar*, c.1460–70, in the Städischen Museen, Bamberg (Bellm, *Wolgemuts Skizzenbuch im Berliner Kupferstichkabinett*, frontispiece, 75 ff.).

[19] So pervasive were these ideas that inlaid in the pavement of the Florentine Baptistery is a zodiacal wheel surrounding a solar disk that was used for calculating the summer solstice and showing the eternal motion of the cosmos (Cox-Rearick, *Dynasty and Destiny in Medici Art*, fig. 125; see Ximenes, *Del vecchio e nuovo gnomone fiorentino*, XVI–XX; Paolucci, *Il Battistero di San Giovanni a Firenze*, ii, pl. 824).

[20] See also Neri di Bicci's *Coronation of the Virgin* in the Walters Art Gallery (Zeri, *Italian Paintings in the Walters Art Gallery*, i. 86–7, no. 54, ill.). Neri di Bicci painted many roundels and celestial circles, such as the large gold disk, incised with concentric lines for the circles of heaven and oblique lines for the rays of light, behind the holy personages in this panel. Gregori, Paolucci, and Acidini Luchinat, *Maestri e botteghe: pittura a Firenze alla fine del Quattrocento*, 118–20, no. 3.6, ill., record at least six other versions of the theme by him.

[21] Thorndike, *History of Magic and Experimental Science during the First Thirteen Centuries*, 118. See also Sacrobosco, '*On the Sphere*'; Heninger, *The Cosmological Glass*, 40.

[22] Ruda, *Fra Filippo Lippi*, pl. 77. A more diagrammatic influence from Sacrobosco is found in Giovanni di Paolo's illustration of Dante's *Paradiso*, Canto II, with a lunar eclipse (Brieger, Meiss, and Singleton, *Illustrated Manuscripts of the Divine Comedy*, ii. 431, ill.).

elements. For example, the idea of heaven was reinforced by the presence of seraphim, the highest order of angels, and/or stars (Figs. 6.11–13) in the border of the frame nearest the Madonna and Child.[23] Further, Luca and Andrea della Robbia represented a more extensive Ptolemaic system in five roundels for the Pazzi Chapel. The four on the interior altar wall and the roundel of the portico (St Andrew or God the Father) have backgrounds consisting of four variegated blue concentric circles, abbreviations of the rings of heaven, whose celestial status is reinforced by the gilded lips of the *pietra serena* mouldings and the gilt rays of the background.[24] These cosmic forms echo ideas in the adjacent dome above the altar frescoed with the constellations (to be discussed later). Rarely, other works of art featured more complete Ptolemaic schemes, such as in Francesco Botticini's illuminated manuscript of Matteo Palmieri's *Città di vita* of *c.*1473, which includes not only the celestial spheres but also the constellations.[25] Further comments about tondi with these celestial characteristics combined with earthly ones appear beginning in Chapter 6.

AUGUSTUS' VISION OF THE DIVINE CHILD

Paramount in any discussion of Renaissance tondi containing images of the Madonna and Child is the celestial apparition of a mother and divine child to Augustus and the Tiburtine Sibyl on the site of the Aracoeli church in Rome the day of Christ's birth. Both the *Mirabilia*, the most common guidebook of Rome, whose earliest redaction is twelfth-century, and Jacobus de Voragine, in *The Golden Legend*, popularized this legendary vision of messianic prophecy. It was first articulated in the *Eclogues* of Virgil (IV. 50–3), where it was allied with the return of the Golden Age. It also enjoyed a visual tradition, which had two distinctive features: a golden circle with a mother and child at the centre and a rainbow.[26] As the fifteenth century matured and antique prototypes for Christian phenomena became an increasingly desirable humanistic feature, knowledge of Augustus' vision lent a certain cachet to images of the Madonna and Child in a circle. For example,

[23] See Ch. 6. Kecks, *Madonna und Kind*, pls. LXIV–LXVI.

[24] Pope-Hennessy, *Luca della Robbia*, 236–8, pls. VI–VIII, figs. 47, 51, 54–5, 59.

[25] See Gregori, Paolucci, and Acidini Luchinat, *Maestri e botteghe*, 254, 258, fig. 10; Venturini, *Francesco Botticini*, 114, no. 38, ill. The artist's *Assumption and Coronation of the Virgin* in the National Gallery, London, commissioned by Palmieri, also has a panoramic depiction of these spheres (ibid. 112–13, no. 35, ill.).

[26] Brentano, *Rome before Avignon*, 79–80; Voragine, *The Golden Legend: Readings on the Saints*, i. 40–1, narrates:

Eusebius in his chronicles puts it after the death of Julius Caesar. The emperor Octavian (as Pope Innocent says) had brought the whole world under Roman rule, and the Senate was so well pleased that they wished to worship him as a god. The prudent emperor, however, knowing full well that he was mortal, refused to usurp the title of immortality. The senators insisted that he summon the sibylline prophetess and find out, through her oracles, whether someone greater than he was to be born into the world. When, therefore, on the day of Christ's birth, the council was convoked to study this matter and the Sibyl, alone in a room with the emperor, consulted her oracles, at midday a golden circle appeared around the sun, and in the middle of the circle a most beautiful virgin holding a child in her lap. The Sibyl showed them to Caesar, and while the emperor marveled at the vision, he heard a voice saying to him: 'This is the altar of Heaven.' The Sibyl then told him: 'This child is greater than you, and it is he that you must worship.' That same room was dedicated to the honor of the Holy Mary and to this day is called Santa Maria Ara Coeli.

The emperor, understanding that the child he had seen was greater than he, offered incense to him and refused to be called god. With reference to this Orosius says: 'In Octavian's day: about the third hour, in the limpid, pure, serene sky a circle that looked like a rainbow surmounted the orb of the sun, as if to show that One was to come who alone had made the sun and the whole world and ruled it . . .'.

For Ghirlandaio's depiction in the Sassetti Chapel, Santa Trinita, Florence, and the literary tradition, see Borsook and Offerhaus, *Francesco Sassetti and Ghirlandaio at Santa Trinita, Florence*, 30–2. Shearman, *Only Connect*, 177, fig. 139, reproduces a now-destroyed representation of it on the dome of the Cappella Acconci, San Biagio, Forlì, by Marco Palmezzano (*c.*1500).

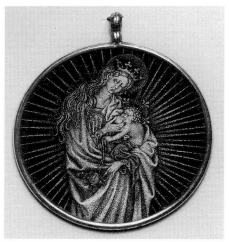

FIG. 2.4. Anonymous Flemish, Enamel with the Vision of Augustus (*Ara Coeli*), *c.*1420–30. Walters Art Gallery, Baltimore

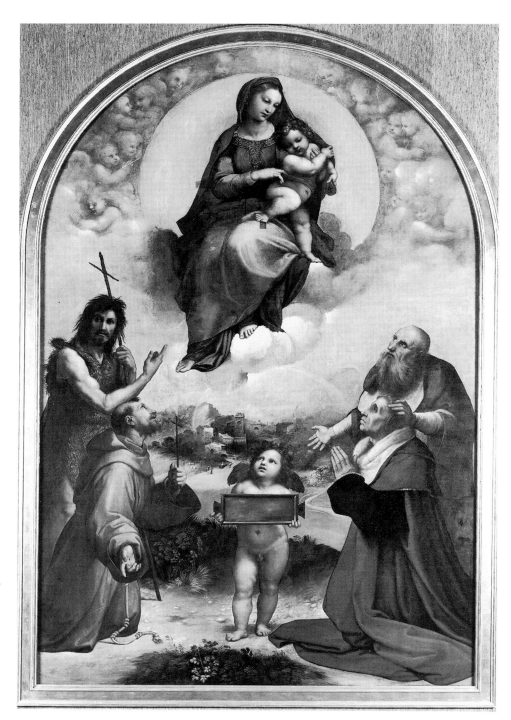

FIG. 2.3. Raphael, *Madonna of Foligno*, 1512. Pinacoteca Vaticana

in the early sixteenth century, Raphael depicted the vision in his *Madonna of Foligno* (Fig. 2.3) (see also App.). Earlier representations, such as in a Flemish enamel medallion (Fig. 2.4), also employed a circle to denote the pair's heavenly status.[27]

While trecento artists had utilized circular forms as a general indication of the celestial status of the Virgin and Child, some of these images can be directly linked to Augustus' vision. A case in point is the fresco above the *gisant* on the funeral monument of Federico da Lavellongo that represents the deceased praying with saints before the image of a crowned Madonna of Humility/*Madonna del Latte* with her babe (Fig. 2.5). In this cosmic vision, the Madonna and Child are surrounded by two gold circles in a figure-eight configuration above a crescent moon replete with its occluded area.[28] In a second example (Fig. 2.6), which is explicitly identified by its inscriptions as illustrating the vision, the painted circle assumes the appearance of a visionary tondo.[29]

MONOGRAM OF ST BERNARDINO

The emblem of St Bernardino of Siena (1380–1444), while not directly applicable to most tondi, should be mentioned briefly as a barometer of the widespread belief in the circle as a symbol of Christ's divinity and the prevalence of circular cosmic visions. St Bernardino, who had a particular devotion to the sacred name of Jesus, was canonized in 1450, close in time to the advent of tondi. The Franciscan saint's visionary emblem consists of a disk inscribing the letters IHS (an abbreviation of the medieval spelling Ihesus that has been misinterpreted as *Jesus Hominum Salvator*),[30] which at times takes on an autonomous appearance, much like a tondo, surrounded by rays of light. The saint is usually shown holding this emblem, although it is occasionally represented alone, as in a large fifteenth-century *cartapesta* relief with an integral garland frame of fruit and flowers, similar to those of Madonna and Child tondi, which was probably meant to be hung for festival occasions.[31] St Bernardino's device also decorates the ceiling of the Medici Palace Chapel, where it is found inside the Medici heraldic diamond ring allied with their motto SEMPER. This placement testifies not only to the family's devotion to the name of Jesus but also to its interest in circular forms, and no doubt implies a cosmic pun on the name of Cosimo de' Medici.

ROTAE

In addition to the illustrations of the hierarchy of the universe and the visionary devices considered

[27] Inv. no. 44.462 in the Walters Art Gallery, Baltimore, silver and gold with enamel and a 5.2 cm. diameter. The reverse has a bust of Augustus wearing a laurel wreath. See Verdier, 'A Medallion'; id., *The Walters Art Gallery. Catalogue of the Painted Enamels of the Renaissance*, 1–2, ill.; id., 'La Naissance'; Baumstark *et al.*, *Schatzkammerstücke aus der Herbstzeit des Mittelalters*, 144–6, no. 16, ill., who also reproduces as fig. 30 the Limbourg Brothers' illumination of the event in the *Très Riches Heures*.

[28] Vertova, 'La mano tesa: contributo alle ipotesi di ricostruzione

dell'altare di Donatello a Padova', 216, fig. 13.

[29] Inv. no. 90 in the Staatsgalerie, Stuttgart, mixed media on panel with a gold background. Rettich, Klapproth, and Ewald, *Staatsgalerie Stuttgart. Alte Meister*, 469–70, ill.

[30] Kaftal, *Iconography of the Saints in Tuscan Painting*, 195–9; Ferguson, *Signs and Symbols in Christian Art*, 150.

[31] In the Museo Stibbert, Florence, with a 68 cm. diameter. Ventrone, *Le tems revient*, 209–10, no. 5.1, ill., dates it *c.*1475–1500.

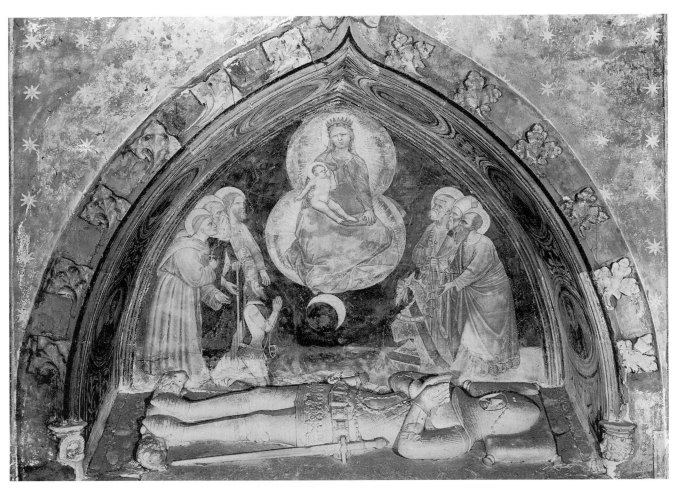

Fig. 2.5. Anonymous, *Monument of Federico da Lavellongo*, *c*.1373. Il Santo, Padua

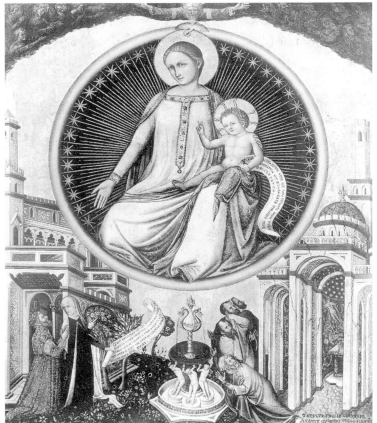

Fig. 2.6. Anonymous Venetian (?), *Victory of Christianity over the Pagans*, *c*.1370–1400. Staatsgalerie, Stuttgart

FIG. 2.7. Anonymous, *Rota computistica*, (MS 17, fol. 27ʳ), twelfth century. St. John's College, Oxford

FIG. 2.8. Sandro Botticelli, *Drawing for Dante's 'Paradiso', Canto II*. Kupferstichkabinett, Staatliche Museen zu Berlin—Preußischer Kulturbesitz

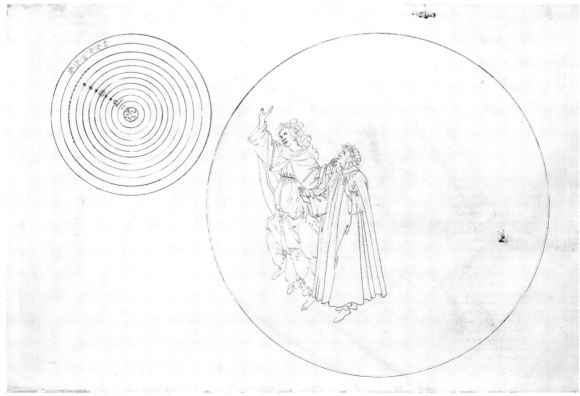

above, two other kinds of circular visual artefacts need to be examined in conjunction with tondi: tables and geometric diagrams. Both were predominant in ancient and medieval mathematical and astronomical systems, where they were used to illustrate aspects of the Ptolemaic system over and above the general layout of the universe. Originally, they were applied to specific problems and were not meant to be gathered together in an all-embracing system, as attempted in later centuries.[32]

In fact, these forms, called 'rotae' or wheels, and thus integrally linked to the word 'tondo' (*rotundo*), as discussed in Chapter 3, became the primary vehicle for diagramming any conceptual structure in medieval times, when the habit of employing two-dimensional, geometric *schema* determined scientific attitudes. There were scores of treatises on topics concerning calendar calculation, the natural sciences, and astronomy that employed them. Such was the authority of the circle that its use signalled absolute certainty! However, *rotae* were not meant to depict all-encompassing ideas like the circles of the Ptolemaic universe but were intended to illustrate specific arguments set forth in one segment of a text, as in mathematics.[33]

Rotae were ubiquitous in early medieval handbooks of learning, making it easier to comprehend how everything in God's universe was engendered from, as Edgerton has phrased it, 'the circular *Urform*'.[34] *Rotae* were so well-received that at times they even stood on their own without any text. Since their circular shape harmonized with the explanation of the medieval universe, they were especially appropriate when setting forth doctrines about phenomena related to the earth, the vault of heaven, or cycles.[35] Their purpose was to set ideas or elements of a larger doctrine within an easily groupable sequence, although many were intended to explain ideas that did not have such a neat containment. They functioned as tools to classify and order or to reveal a contrariety between elements. Some were more active, such as the *rota computistica* for calculating the calendar, the cycle of the months, the seasons, and the factors involved in the proper dating of Easter, fixed in the lunar calendar but not in the solar, and other moveable ecclesiastical feast days (Fig. 2.7).[36] Thus to churchmen, *rotae* certainly could have connoted Easter, a most appropriate association for tondi.[37] In the light of this information, it is strange that to date no one has allied *rotae* and tondi.[38]

Although *rotae* served as salient features in religious and moral writings in particular, they were also used for the technical aspects of logic and syllogisms. Thus they had a broad intellectual appeal, both secular and ecclesiastical, and signalled that an argument was being made. Their schematic nature would have been understood by patrons and painters alike, educated in the tradition of the *abbaco* school.[39] At their extreme, some *rotae* became so schematic, like the abbreviated cosmos of some tondi, that they merely illustrated concentric circles, and could be neither identified without their inscriptions nor used to calculate anything.[40]

[32] Murdoch, *Album of Science*, 141.

[33] Ibid. 288.

[34] Edgerton, *Giotto's Geometry*, 30. See also Evans, 'The Geometry of the Mind'.

[35] Murdoch, *Album of Science*, 52. It is important to note that the *mappamondo* in the Collegiata, San Gimignano, as well as the one in the Camposanto, Pisa (Fig. 2.1), resemble *rotae* of the planets (ibid. 55, no. 49, ill.). The trecento frescoes in the Abbey of Tre Fontane with diagrams of the senses and ages of man, perhaps part of an old calendar cycle, are examples of *rotae* in monumental art (Matthiae, *Pittura romana*, ii. 353 ff., figs. 31–2).

[36] MS 17, fol. 27ʳ, St John's College, Oxford. Murdoch, *Album of Science*, 56.

[37] There were also *rotae* of consanguinity to diagram one's

ancestors, a fact which might have a deeper bearing on the interpretation of the *Doni Tondo* by Hayum, 'Michelangelo's *Doni Tondo*'; see below, Ch. 7.

[38] The closest is Hayum (ibid. 217), who associated the so-called 'T-O' maps with the *Doni Tondo*, while Tolnay compared the painting to a 'globe of the world', concluding that its shape was more than decorative (Tolnay, *Youth*, 165).

[39] Baxandall, *Painting and Experience in Fifteenth-Century Italy*, 86–108, states that artists included geometrical shapes in their works because their patrons were schooled in studies that understood geometry, a concept that may also explain one aspect of the appeal of tondi.

[40] Murdoch, *Album of Science*, 54, ill.

In a sense tondi, like *rotae*, are diagrams of theological ideas, where opposites—human and divine as well as terrestrial and celestial—are synthesized and visually portrayed. But were tondi, like *rotae*, intended to diagram a theological argument? Were they meant to argue certain 'truths' and to harmonize the problematical theological doctrine that Christ became flesh to save humankind from certain death? Perhaps this line of reasoning helps to explain why the settings of tondi seem to partake of both earthly and heavenly elements, all framed within the perfection of the cosmic circle. Because of their surroundings, the figures in some tondi are definitely placed in heaven but are linked with the viewer (Figs. 7.1, 7.19), while others combine the two realms with varying degrees of worldliness (Figs. 3.2, 7.15). The Virgin was usually placed centrally not only for compositional reasons but also because for fifteenth-century Christians she was considered the consummate perfection of created nature and the sole source through which divine grace provided by her son was dispersed to the angels, then to the Church, and to earth.[41] It is these cosmological/theological assumptions, many no longer valid in today's world view, that would have been instantaneously understood by individuals of the time. They will be explored in relationship to specific works of art in succeeding chapters.

DANTE

The *Divina Commedia* of Dante Alighieri, which was, after the Bible, one of the most esteemed and influential books in the late fourteenth and fifteenth centuries, employs a Ptolemaic cosmology and concepts related to tondi. Dante verbally diagrams his regions—the *Inferno*, *Purgatorio*, and *Paradiso*—in terms of geometry and a series of concentric circles. Similarly, he envisages God as a circle of ineffable light, while his text is peppered with circular visions.[42] Illustrated versions of the *Commedia* began around a decade after the poet's death, and surviving examples in manuscript form are numerous. However, it is only in the illustrations of the *Paradiso*, where the circle is synonymous with divinity and heaven, that it becomes a dominant visual motif producing a complete unity of form and content. It is important to note that the circles of the *Paradiso* are not merely formalistic but are the settings for Dante's course of spiritual instruction, just as tondi were intended for devotion and spiritual improvement. The wide circulation of Dante's writings lent a vernacular familiarity to circular celestial forms and underlined their significance. His visions, which were based on theological doctrines, put a popular slant on the circle that was accessible. Because of the abstract nature of the *Paradiso*, it is not surprising that no elaborate iconographic correlation can be found between any tondi and its text. However, the tondi of Botticelli, a noted illustrator of the poem, contain images whose essential spirit approximates the mood and meaning of Dante's images.[43]

[41] As in St Bernardino's sermons on the Annunciation (Pope-Hennessy, *Essays on Italian Sculpture*, 168).

[42] See Moore, 'The Astronomy of Dante'; Brieger, Meiss, and Singleton, *Illuminated Manuscripts*, ii, pls. 54–5, 400, for Ptolemaic images.

[43] e.g. Canto XXXII of the *Paradiso* must have influenced the conception of Botticelli's *Madonna of the 'Magnificat'* (Fig. 7.17):

Look now upon the face that is most like the face of Christ, for

only through its brightness can you prepare your vision to see Him . . . I saw such gladness rain down upon her, born in the holy minds created to fly through those heights, that all I had seen before had not held me in such wonder and suspense nor shown me such likeness to God and that Loving Spirit that had first descended on her saying 'Ave Maria, gratia plena' . . . On all sides the court sang responses to the divine canticle, so that every face turned brighter for it . . .

In this case the canticle would have been the 'Magnificat'.

Botticelli's unfinished illustrations of the *Commedia*, specifically those of the *Paradiso*, relate to his tondi. These large sheets have been linked to a commission recorded for Lorenzo di Pierfrancesco de' Medici, begun by Botticelli *c.*1490 and worked on until his death in 1510.[44] Moreover, according to Vasari, the artist had been engaged on an earlier illustrative project involving the *Commedia*.[45] From his paintings it is patently clear that Botticelli was obsessed with Dante's masterpiece throughout his mature years. He shared this passion with his brother Simone, with whom he lived late in his life.[46] Not coincidentally, Botticelli together with his shop produced one of the largest groups of tondi. One may wonder, therefore, whether his Dante illustrations were influenced by his experience with the form or, more cogently, did his study of Dante, coupled with his own abstract style, contribute to his inspired artistry with the tondo?

Unlike earlier illustrators of Dante, who frequently concentrated on the *Inferno*, Botticelli's illustrations for the *Paradiso* depict each canto and represent a pictorial commentary on the text. Each illustration for Cantos II through XXIV is composed of a single circle in which Dante and Beatrice interact. The others feature foreshortened, swirling concentric circles, endowing the *Paradiso* with a wonderful visual unity. Unlike earlier illustrations, where the circular visions hovering above landscapes are only one of many pictorial elements, Botticelli's abstract conceptions feature these circles as the dominant form. The artist also portrayed the Ptolemaic system, which underlies both Dante's and his own mode of thought, in Canto II (Fig. 2.8), where Dante's spiritual guide, Beatrice, explains how the spheres are turned by the *Primum Mobile*.

Furthermore, the structure of the *Commedia* depends on a harmony resulting from a reconciliation of opposites and a resolution of paradoxes,[47] not unlike that found in *rotae*. This similarity leads one to speculate whether tondi were also meant to harmonize the basic Christian paradox (which Dante resolved in *Paradiso*, Canto XXXI, 1–3): how human and divine natures were melded in Christ. For Dante, Paradise is the realm of resolved paradoxes and God, the ultimate reconciliation of opposites, envisaged as a circle of light.[48]

On both a structural and ideological level, tondi reflect ideas encountered in the text of Dante's epic poem, suggesting that it helped to create a cultural climate in which the tondo could thrive.

[44] In silverpoint on parchment with redrawing in ink (a few are coloured, most likely not by the artist). Lippmann, *Drawings by Sandro Botticelli for Dante's Divina Commedia*; Clark, *The Drawings by Sandro Botticelli for Dante's Divine Comedy*; Lightbown, *Sandro Botticelli*, ii. 172 ff. (i. 147 ff.); Gizzi, *Botticelli e Dante*. The Anonimo Magliabechiano records them: 'Dipinse et storico vn Dante in cartapecora al^{zo} dip^{ro} franc^o de Medicj, il che fu cosa marauigliosa tenuto.' Lightbown, *Botticelli*, i. 56–7, 147–51, believes the citation refers to a different, finished manuscript and that the Berlin–Vatican drawings were intended for the artist himself. However, this is doubtful; they are large and on costly parchment. See also Yuen, 'New Aspects of Botticelli's Late Works'.

[45] Vasari (Bettarini and Barocchi), ii. 516–17.

[46] Horne, *Alessandro Filipepi, commonly Called Sandro Botticelli, Painter of Florence*, 271, deduces from Simone's chronicle that Simone was a lover of books and a student of Dante. He cites a manuscript in the Biblioteca Nazionale Centrale, Florence, which once belonged to him. This anonymous commentary on a *canzone* by Dante is numbered 31, indicating that Simone possessed a considerable library for that time, with at least thirty-one volumes.

[47] Ferrante, 'Words and Images in the Paradiso: Reflections of the Divine', 129. Dante's journey in the *Commedia* is a return to God, symbolized by the circle.

[48] Ibid. 128–9. Canto XXXIII contains a contradiction: 'Vergine madre, figlia del tuo Figlio'. The line, based on St Bernard's hymn to the Virgin, is lettered in roman capitals on the base of the Madonna's throne in Botticelli's *St Barnabas Altarpiece* (Olson, 'Studies in the Later Works of Sandro Botticelli', 286 ff.). The last lines of the poem conclude that Theology, like Geometry, has its insoluble problems. Dante wanted to know how the image was fitted to the circle, i.e. how human nature was fitted to the divine in the person of Christ. To this he could not attain by any flight of the wings of intellect, but for a moment it flashed before him:

> tal era io a quella vista nova:
> veder volea come si convenne
> l'imago al cerchio e come vi s'indova;
> ma non eran da ciò le proprie penne:
> se non che la mia mente fu percossa
> da un fulgore in che sua voglia venne.
> A l'alta fantasia qui mancò possa;
> ma già volgeva il mio disio e 'l *velle*,
> sì come rota ch'igualmente è mossa,
> l'amor che move il sole e l'altre stelle.

Moreover, the round form connoted not only heaven but also, as in the *Paradiso*, the celestial Paradise (eternal life), which for the Christian believer is obtainable only through Christ's Sacrifice. Herein, the circle becomes a metaphor of Paradise and eternity through salvation, a conclusion echoed in tondi and reinforced by the garland wreaths that frequently frame them. Thus the tondo format in conjunction with the Madonna and Child theme—a fusion of form and content—underlines the theological doctrine that Paradise is attainable only through this holy pair.

Botticelli's *Madonna of the 'Magnificat'* (Fig. 7.17) contains a refined statement of similar ideas. Like the artist's Dante drawings, it reveals a sensitivity to the problems of circular compositions, especially in its upper circumference, painted to resemble *pietra serena* mouldings of contemporary window frames—including oculi, such as in the Chapel of the Cardinal of Portugal in San Miniato al Monte.[49] These mouldings harmonize with the concept of the Queen of Heaven (*Regina Coeli*) articulated in Canto XXXIII of the *Paradiso*, as well as with the Madonna's association with the Apocalyptic Woman, signalled in the painting by the gold disk of heaven and also implied in Dante's text. They suggest not only a round window but also the Ptolemaic rings of heaven, thereby creating a formal and intellectual double entendre. Certainly this multi-layered symbol is not without allusions to the *fenestra coeli* and perhaps to the vision of Augustus as well.[50]

In conclusion, Botticelli's prolonged study of Dante contributed to the visionary quality of his tondi, positioning them among the finest ever executed. It is the abstract, Dantesque thought underlying their conceptions that lends to them a wistful resonance (complimented by the artist's abstract, linear style), which is not present in tondi by other artists. While Dante's *Commedia* may have helped create a cultural climate conducive to the development of tondi, it is only in the art of Botticelli that a relationship between his text and an artist's paintings can be ascertained. Although Botticelli's tondi do not illustrate the poem, nevertheless they approach it in spirit.

Finally, it must be noted that Dante's masterpiece could also have encouraged the rose symbolism found in many tondi. In his *Paradiso*, the poet fashioned a picture of Paradise as the Symbolic Rose, basing his construction on an amalgamation of theological and popular love imagery.[51] As we shall see in Chapter 4, rose symbolism is correlated with devotional practices and the escalating popularity of the rosary in the Quattrocento.

THE CENTRAL PLAN

The Renaissance idea of the perfect church—rooted in Plato's cosmology, the idea that the microcosm should reflect the macrocosm, and the belief in the comprehension of God through

[49] Lightbown, *Botticelli*, i. 54, states that the moulding is a window. Kecks, *Madonna und Kind*, 50, believes that tondi themes demanded this type of frame to separate their space from the viewer and to create the effect of gazing through a window.

[50] The moulding suggests the rainbow, as in Augustus' vision (complementing the gold disk), as well as Dante's Canto XXXIII:

> Ne la profonda e chiara sussistenza
> de l'alto lume parvemi tre giri
> di tre colori e d'una contenenza;
> e l'un da l'altro, come iri da iri

parea reflesso, e 'l terzo parea foco . . .
che quinci e quindi igualmente si spiri . . .
Qual è 'l geomètra che tutto s'affige
per misurar lo cerchio, e non ritrova,
pensando, quel principio ond'elli indige . . .

The Madonna was also likened to the rainbow in theological texts, the visible bridge which stretches from the earth to heaven, as well as the *fenestra coeli*, the hyphen between heaven and earth; Hirn, *The Sacred Shrine*, 364.

[51] Di Scipio, *The Symbolic Rose in Dante's 'Paradiso'*, 163.

mathematical and abstract symbols—is the most tangible proof of the singular status of the circle in the Quattrocento.[52] Moreover, an understanding of the importance of the central plan sheds light on the significance of tondi and their symbolism. Plato's connection of the circle and God was pivotal for Renaissance architects. By creating a circular plan, architects believed that they could relate their structure formally to God and also create buildings *all'antica*. It is through the writings of the humanist Leon Battista Alberti, who paradigmatically embodied the concept of the Renaissance man, that we can concretely discern this theoretical obsession with the circle. Alberti's *De re aedificatoria* (*c.*1450) contains the first full Renaissance programme for the ideal church or 'temple'. Alberti believed that the circle was ideal because it was the basic shape in nature and was used historically by the Ancients. His ideas were inspired by a range of classical structures in which the concepts of mathematical reduction used by Plato lent an aesthetic appeal. He begins his discussion—based on a manuscript of Vitruvius' treatise discovered in 1414—of desirable shapes for temples with a eulogy of the circle.[53] Vitruvius himself (I. 2) had explained that the form should be analogous to the character of the divinity.[54] Alberti believed that without an organic geometrical equilibrium, where all parts are harmoniously related like the members of a body, divinity could not reveal itself.[55] Thus the symbolism of absolute geometry made the central plan, especially the circle, theoretically suitable for a church. By imitating God's creation, a person could approach God; therefore, the central plan served as a catalyst in the process. A similar symbolism lay behind the tondo format.

Prior to Alberti, the octagonal Florentine Baptistery, thought by many Renaissance individuals to have been a Roman temple of Mars, maintained a constant visual argument for the superiority of the central plan in the city on the Arno. Moreover, the architectural legacy of Filippo Brunelleschi, who did not write a treatise, reveals that a central plan was already considered ideal in the early Quattrocento.[56] From his Roman studies, Brunelleschi developed his mathematical module, which related to Pythagorean–Platonic principles.[57] Brunelleschi not only thought that the central plan, as he designed for Santa Maria degli Angeli, was desirable for an ecclesiastical building but also made copious use of roundels and oculi as embellishments in his religious buildings and in the Palazzo di Parte Guelfa.

Brunelleschi's Old Sacristy of San Lorenzo (Fig. 2.9) was a crucial building in the evolution of the central plan, and its symbolism relates directly to tondi. In fact, a grasp of the concepts behind it is essential to comprehending ideas that Renaissance individuals brought to tondi. Thus this short, albeit related, detour from the main subject of the study is relevant to a deeper understanding of tondi. The structure was begun under Medici patronage (probably *c.*1420–1)[58] as a sacristy and as a

[52] See Wittkower, 'The Centrally Planned Church and the Renaissance', esp. p. 29. Also Krautheimer, 'Introduction to an "Iconography of Medieval Architecture"', 9.

[53] Alberti, *L'Archittetura*, VII. 4. 548 ff. Wittkower, 'Centrally Planned Church', 27–8, comments on Nicholas of Cusa, who wrote in *De ludo globi* that 'God is a circle whose center is everywhere', as quoted by Wilkins, *The Rose-Garden Game*, 86.

[54] See also Sinding-Larsen, 'Some Functional and Iconographic Aspects of the Centralized Church in the Italian Renaissance'.

[55] Alberti, *L'Archittetura*, VII. 5. 558–9. See also Mancini, *Vita di Leon Battista Alberti*; Rome, Accademia dei Lincei, *Convegno internazionale indetto nel V centenario di Leon Battista Alberti*; Westfall, *In This Most Perfect Paradise*, 59 ff.

[56] Wittkower, 'Centrally Planned Church', 27. C. Gilbert, 'The Earliest Guide to Florentine Architecture', 45, notes that in a guide of *c.*1423, the Baptistery is described as 'ritondo in otto facce'.

[57] Manetti, *The Life of Brunelleschi*, 54.

[58] See Battisti, *Filippo Brunelleschi*, 175 ff.; Elam, 'Brunelleschi and Donatello in the Old Sacristy', 9 ff.; Baldini *et al.*, *Brunelleschi e Donatello nella Sagrestia Vecchia di S. Lorenzo*; Ruschi, 'Una collaborazione interrotta: Brunelleschi e Donatello nella Sagrestia Vecchia di San Lorenzo'; id., 'La Sagrestia Vecchia'. See also Paatz and Paatz, *Die Kirchen von Florenz*, ii. 464 ff.; Blumenthal, 'The Science of the Magi: The Old Sacristy of San Lorenzo and the Medici'. The 1428 date on the lantern is the date of completion.

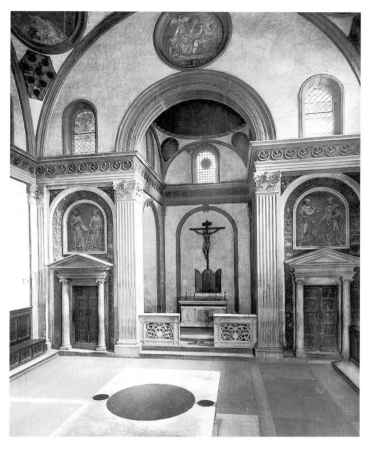

Fig. 2.9(*a*). Filippo Brunelleschi, Old Sacristy, after 1420. San Lorenzo, Florence

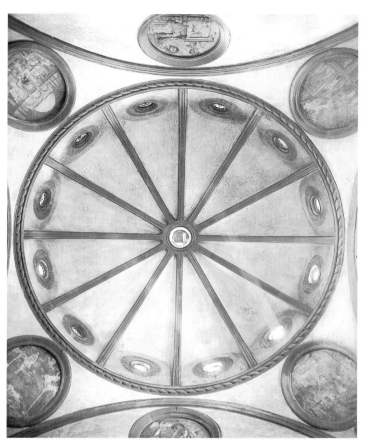

Fig. 2.9(*b*). Filippo Brunelleschi, Old Sacristy Dome, after 1420. San Lorenzo, Florence

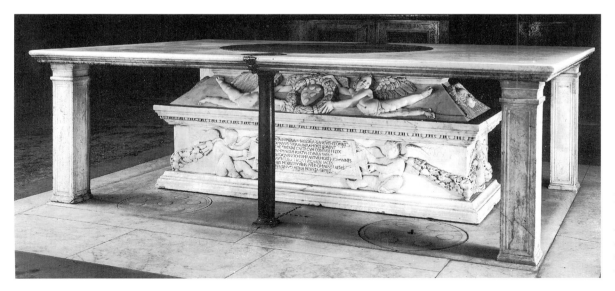

Fig. 2.10. Il Buggiano, *Tomb of Giovanni di Bicci de' Medici and Piccarda de' Bueri*, *c*.1429. Old Sacristy, San Lorenzo, Florence

burial chamber for Giovanni di Bicci de' Medici (d. 1429) and Piccarda de' Bueri, parents of Cosimo de' Medici, and other family members.[59] It was dedicated to Giovanni's patron saint, John the Evangelist, and was seminal in the development of the Medici family myth, initiating the Medici dynasty tombs. Most likely, Brunelleschi and his patron chose a central plan not only to suit its site but also to relate the building's functions to centrally planned mausolea and ancient buildings, especially martyria combining tombs and churches.[60]

The plan of the Old Sacristy is based on the circle (the heavens, the universe) and the square (the earth, with its four elements, regions, corners, or points of the compass). This thematic combination of heaven and earth, which also surfaces in tondi, alludes to the cosmos, a pun on its patron's name, Cosimo, as well as to the dual nature of Christ, divine and human. Moreover, its interior is conceived with harmonious mathematical proportions, pivoting around the numbers three, symbolic of the Trinity and thus heaven, and four, symbolic of earth (the four regions and the four arms of the cross indicative of Christ's earthly nature).[61] The square main room is covered by a circular dome, which is echoed in the smaller *scarsella* dome frescoed with a diagram of the heavens. It has been observed that the round lantern crowning the major dome recalls the structure over the Holy Sepulchre in Jerusalem to symbolize the Resurrection of Christ.[62] It is poised directly above the sarcophagus of Giovanni di Bicci and his wife (Fig. 2.10), alluding to the hoped-for resurrection of the couple.

Covering the sarcophagus is the marble sacramental table, at whose centre is a large, red porphyry circle or *rota*, flanked by two smaller bronze circles with Medici *palle* (balls).[63] It follows a tomb type traditionally reserved for saints and *beati*. Below the table and flanking the sarcophagus on the white marble floor are four circles carved in relief with seven heraldic *palle* circling a central *palla*; they once may have been painted red. The two facing the entrance wall are removable to function as *chiusini* for depositing bodies of other family members in the pier crypt below. They are separated from the two facing the altar by cruciform shapes inlaid with dark material to echo formally the cruciform allusions (four sides) found throughout the Old Sacristy.

The dominant red disk of the sacristy table is a complex linking symbol that can be associated with tondi. It stands not only for the Sacrifice of Christ (his Passion and Death) but also connotes the *palle* of Medici heraldry and the cosmos. In addition, porphyry, which was associated first with Roman emperors and then with Christ, is a sign of honour to rulers.[64] The disk is located where the

[59] See Ruschi *et al.*, *Donatello e la Sagrestia Vecchia di San Lorenzo*; Elam, 'Cosimo de' Medici and San Lorenzo'.

[60] For prototypes, see Krautheimer, *Early Christian and Byzantine Architecture*, 11; id., *Studies in Early Christian, Medieval and Renaissance Art*, 69–114. Moreover, mausolea and sacristies were connected with baptisteries because of the relationship of Baptism, Death, and Resurrection; Krautheimer, 'Iconography', 25–7. Some scholars, such as Battisti (*Brunelleschi*, 53), Burns ('Quattrocento Architecture and the Antique: Some Problems', 279), and Heydenreich and Lotz (*Architecture in Italy, 1400–1600*, 328) state that it derived from the Paduan Baptistery.

[61] J. Hall, *Dictionary*, 128–31. A unique interpretation of four by St Gregory (*Homilia VI*, on Ezek. 1: 16, in *PL* 76, 834), states that there were two parts to the New and Old Testaments. Covi, *The Inscription in Fifteenth Century Florentine Painting*, 587, links this idea with Fra Angelico's *Vision of Ezekiel* and its wheel, neatly joining the number four with the circle (*rota*). Other numerical associations with four include the words IESV, Jesus, and IHVH, Jehovah, uniting the two Testaments. For a discussion of further

relevant proportional/numerical relationships, see De Angelis d'Ossat, 'Brunelleschi e il problema delle proporzione', 225.

[62] Heydenreich and Lotz, *Architecture*, 329 n. 29. French, 'Journeys to the Center of the Earth: Medieval and Renaissance Pilgrimages to Mount Calvary', 45–82, notes that in round schematic T-O maps and thematic maps Jerusalem became the centre of the world, wherein the Holy Sepulchre as well as Mount of Calvary were the *umbilicus* and *axis mundi*.

[63] *Palle*, allied to the sphere, were a cosmic pun on Cosimo (Cardini, 'Le insegne Laurenziane', 59).

[64] For porphyry, see McKillop, 'Dante and *Lumen Christi*: A Proposal for the Meaning of the Tomb of Cosimo de' Medici', 289–91; Sheard, 'Verrocchio's Medici Tomb and the Language of Materials'; Beyer, 'Funktion und Repräsentation, Die Porphyr-rotae der Medici'; Butterfield, 'The Funerary Monument of Cosimo de' Medici *Pater Patriae*', 163–4; Butters, *The Triumph of Vulcan: Sculptors' Tools, Porphyry, and the Prince in Ducal Florence*. For a political interpretation of the Medici Palace Chapel involving porphyry, see Ahl, *Benozzo Gozzoli*, 83–5.

Eucharist, the *Corpus Domini* and the vehicle for obtaining salvation, was placed.[65] These associations are linked to the Medici, citing the position of honour occupied by the ancestors of their dynasty interred below in a manner to argue that their salvation rested on the Christian miracle. Since the porphyry circle is directly below the lantern and its diameter equal to that of the base of the lantern, the Sacrament of the Eucharist is conceptually and physically related to the Resurrection.[66]

Under the sacramental table, perhaps by Brunelleschi,[67] is the free-standing white marble sarcophagus by Andrea di Lazzaro Cavalcanti, called 'Il Buggiano', which also has connections with tondi.[68] Putti *all'antica* on its lid hold up the Medici arms emblazoned with *palle* within circular wreaths like the *imago clipeata*. They imply the apotheosis not only of the deceased husband and wife but also of the ensuing dynasty. By sheltering the sarcophagus with the consecrated sacramental table, Brunelleschi implied that the Christian mystery of Transubstantiation as well as the Crucifixion and the Resurrection encompassed the deceased couple. With this form, he also created a rare free-standing tomb on the model of ancient monuments to point to the singularity of the family.

The structure had two prestigious free-standing ancient prototypes: Constantine's Tomb in the Church of the Apostles in Constantinople and the Holy Sepulchre in Jerusalem.[69] Constantine, a prominent layman, had himself buried in the centre of the church-sepulchre surrounded by cenotaphs of the twelve apostles (a number emphasized in the Old Sacristy). Cosimo, who originally intended himself to be buried in the Sacristy, would have been intensely interested in Constantine not only because he was a Christian from the antique world, but also because he was a Christian ruler.[70] Thus, a reference to Constantine's tomb was a way of escalating the status of the Medici. It emphasized the family's devotion to Christianity and antiquity and quite pointedly their political aspirations. Moreover, it was under Constantine that the Church of the Holy Sepulchre was begun, so that a reference to Constantine would further connote this more important martyrium on whose existence pivoted both the hopes of Constantine and Cosimo, as well as all other Christians, for salvation and eternal life. Therefore, the two prototypes reinforced each other in the Old Sacristy and no doubt were part and parcel of its Christian/humanist allusions.

The altar is located in the adjacent trefoil *scarsella*, whose plan resembles that of the Anastasis Rotunda, built by Constantine over the site of the Holy Sepulchre.[71] The base of its dome, as well as that of the larger dome, features a twisted circular motif resembling a thin wreath—with funerary and divine symbolism—bound with a twisted, gilded ribbon. Even more explicitly, this motif

[65] During the Renaissance, the host was in a round shape and often was displayed in round monstrances. Quattrocento ciboria to contain it are frequently decorated with circles, e.g. two by Mino da Fiesole (Sciolla, *La scultura di Mino da Fiesole*, figs. 28, 38).

[66] De Angelis d'Ossat, 'Brunelleschi', 225. The frieze by Luca della Robbia of seraphim and cherubim enclosed in roundels adds to the interior's heavenly symbolism, while the triumphal arch of the altar wall echoes the Resurrection theme.

[67] Saalman, *Filippo Brunelleschi*, 132–3, implies that the sacristy table as well as the sarcophagus were made by Buggiano.

[68] For this monument, see Ruschi, 'Andrea di Lazzaro Cavalcanti nella Sacrestia Vecchia di San Lorenzo'; Elam, 'Cosimo de' Medici and San Lorenzo', 9; Butterfield, 'Social Structure and the Typology of Funerary Monuments in Early Renaissance Florence', 54.

[69] Saalman, *Brunelleschi*, 132–44, favours the former and rejects the Holy Sepulchre as 'liturgically inadmissible'. He believes that

the Medici learned about Constantine's interment from Eusebius (his *Vita Constantini*), but it is not recorded in the Medici collection. See Heikel, *Kritische Beiträge zu den Constantin-Schriften des Eusebius*; Downey, 'The Builders of the Original Church of the Apostles at Constantinople', 53–80. Nevertheless it is possible that Cosimo and Brunelleschi knew about the description, although Saalman overlooks the reason why Cosimo would have been attracted to the tomb of Constantine.

[70] Krautheimer, *Studies*, 30 ff., notes that Constantine kept secret his intended burial with the apostles because it implied a cult of personality. This is also probably why the Medici veiled some of their funerary symbolism.

[71] Brooks, 'The Sepulcher of Christ in Art and Liturgy', 9 ff. Even though it was destroyed in 616, it symbolized the Resurrection and became a prototype for sepulchral architecture.

approximates a rolled canopy or curtain—like the one used by Nero to cover the Colosseum.[72] A similar *velum* was associated in the Roman empire not only with heaven but also with rulers and gods, an allusion that the Medici may have cultivated. Its symbolism is further illuminated by the astronomical imagery painted on the *scarsella* dome: a literal representation of the firmament, expanding the cosmic implications of the structure. While the link between the dome and heaven occurred from antiquity onwards in stylized medieval representations,[73] only in the Renaissance, when people again began to record what they saw within a naturalistic aesthetic, could such an accurate image be created on this scale. It has been suggested that the astronomer Paolo dal Pozzo Toscanelli, with whom Vespasiano da Bisticci notes Cosimo studied astrology,[74] served as adviser, while its artist is not established.[75] A wide range of dates has been offered for this astronomical clock.[76] Computer-based astronomical computations date it to either 4 or 5 July 1442 (a *terminus post quem*),[77] and it has been connected historically to the Florentine visit of René of Anjou, King of Naples, Sicily, and Jerusalem, in July of 1442. The interest in this event coincided with the growing fervour for the Crusades (as in the copy of the Holy Sepulchre erected by Giovanni di Paolo Rucellai in San Pancrazio).[78] This historical connection supplements the Old Sacristy's iconographic alliance with the Holy Sepulchre.

As previously stated, the numerical symbolism of the Old Sacristy revolves around the numbers three, connoting the Trinity (heaven), and four, symbolizing the world (earth, the death of Christ on the cross), similar to the numerology that appears in tondi. Three (the number of windows in the altar wall) times four (the Evangelists in roundels or the roundels with scenes of St John the Evangelist in the pendentives) equals twelve, the number of ribs and oculi in the large dome and of the apostles (depicted on one of the bronze doors). With the central oculus of the lantern, the large dome has thirteen oculi, the number of the apostles and Christ. (The apostles spread the gospel of the Trinity to the four regions of the world.) Twelve also symbolizes the months and the fruits of the tree of life, as well as the Church.[79] Hartt believes that the dome is a vision of the New Jerusalem

[72] Lehmann, 'Dome', 11 n. 74, cites Dio Cassius, *Hist.* 63. 2, who describes Nero's use of a *velum* in the amphitheatre; Ruschi, 'Una collaborazione', 28, in a caption. In the Old Sacristy these veils may have demarcated the zones of heaven and earth, like the garlands on ceilings of Etruscan tombs. It is interesting to note that the adjacent Chapel of the Sacrament, linked to the Old Sacristy physically by the tomb of Giovanni and Piero de' Medici (see below), during Holy Week had its ceiling draped with a blue canopy, symbolic of heaven (Butterfield, *Verrocchio*, 49).

[73] Lehmann, 'Dome', 19 ff., records those described in Varro, which Alberti commended in his architectural treatise (VII, esp. ch. 9), and others, most documented in Italian libraries by the third decade of the Quattrocento. See also Fenzi, 'Di alcuni palazzi, cupole, e planetari nella letteratura classica e medievale nell' "Africa" del Petrarca'; Murdoch, *Album of Science*, 240 ff.

[74] Vespasiano da Bisticci, *Le vite*, ii. 19. Cox-Rearick, *Dynasty*, 167–8, identifies the man with an armillary sphere in the Adoration of the Magi fresco in Cosimo's San Marco cell as a portrait of Cosimo. Because he points to the sphere, I believe that it is a cosmic pun (Cox-Rearick does not).

[75] Brockhaus (*Michelangelo und die Medici-Kapelle*, 26 ff.) first attributed it to Pesello (Giuliano d'Arrigo). Beck ('Leon Battista Alberti and the "Night Sky" at San Lorenzo') believes it is by Alberti, who was known as an astrologer [i.e. astronomer].

[76] By Warburg, 'Berichte über die Sitzungen des Instituts', 34–6 (see also the posthumous edition of Warburg's text—with G. Bing

and the astronomer A. Beer—'Eine astronomische Himmelsdarstellung in der Alten Sakristei von S. Lorenzo in Florenz'); Fortini Brown, '*Laetentur Caeli*: The Council of Florence and the Astronomical Fresco in the Old Sacristy'; Parronchi, 'L'emisfero della Sacrestia Vecchia: Giuliano Pesello?', and others.

[77] Ballerini, 'The Celestial Hemisphere of the Old Sacristy and its Reconstruction'; Forti *et al.*, 'Un planetario del XV secolo', 5 ff.; Ballerini, 'Gli emisferi celesti della Sagrestia Vecchia e della Cappella Pazzi'; ead., 'Considerazioni a margine del restauro della "cupolina" dipinta nella Sagrestia Vecchia'; ead., 'Il planetario della Sagrestia Vecchia'.

[78] Ballerini, 'Considerazioni', 102 ff.; ead., 'Il planetario', 115 ff. She suggests that the repetition of the fresco a decade later in the Pazzi Chapel was because the Pazzi were tied to René by ancient bonds of friendship. The circle, cross, and square of the Old Sacristy approach those in the arms of René, as in a relief in the Musée du Louvre, Paris (inv. no. Revoil 394). It consists of a square inscribing a circle divided into four parts with cross-like forms, topped by a crown and surrounded by fifteen rosary beads.

[79] Krautheimer, 'Iconography', 11; Ferguson, *Signs and Symbols*, 154; J. Hall, *Dictionary*, 174. Twelve refers to St John, termed the 'Lignum vitae afferens fructus' with twelve kinds of fruit in Rev. 22: 2. In addition, the wreaths/veils of the domes are twisted with a ribbon 108 times in the large and 36 times in the small (both multiples of twelve), a ratio of one to three, symbolizing the Trinity (Dezzi Bardeschi, 'Sole in Leone. Leon Battista Alberti', 46–8).

and its twelve gates because John the Evangelist beheld it in a vision.[80] By associating his dome with this vision, Brunelleschi not only related the building to its patron saint, but also added to its resurrection symbolism. Importantly, fifteenth-century Florence was dubbed the 'New Jerusalem', endowing the Old Sacristy with a civic dimension. Since the Medici were involved in promoting New Jerusalem imagery, Brunelleschi's Sacristy made a political statement about Giovanni di Bicci, Cosimo, and the apotheosis of the Medici dynasty via an analogy in art, the first in a long line. Here, the Medici reign is linked to the Christian Roman Empire and Constantine, equated with the rise of Florence as the New Jerusalem, while the Resurrection of its souls is hoped for like that of Christ in old Jerusalem. Moreover, the type of symbolism used provides an insight into that in contemporary tondi. In fact, some of the earliest painted examples seem to have been commissioned and sponsored by the Medici.

The Medici commitment to these themes and related iconographies continues in the two successive funerary monuments in San Lorenzo by Andrea del Verrocchio, which also feature prominent circular motifs relating to tondi. Both allude to the earlier Old Sacristy tomb and are physically and symbolically linked to it by use of the circle and porphyry. The first is the seemingly modest but powerful marker of Cosimo at the crossing directly before the main altar (after 1464).[81] Like the Sacristy complex, it utilizes symbolic red porphyry, combined with green porphyry and white marble in the triad of Medici heraldic colours (also those of the theological Virtues). This exceptional tomb placement was a conscious alliance with the Sacrament, the Resurrection of Christ on Easter, and the hope for life eternal, this time for Cosimo. Directly on a left lateral axis from this tomb is the next Medici sepulchral monument (1469–72) by Verrocchio, appropriately double-sided to commemorate Cosimo's two sons, Giovanni and Piero. One side faces the Old Sacristy and the other (the main side of the inscriptions) the former Chapel of the Sacrament. It separates the two but forms a physical and conceptual link between them via its bronze rope-like grillwork, reminiscent of the *fenestella confessionis* of Early Christian tombs, an allusion perhaps made in the original grills of Cosimo's floor tomb. Again, Medici colours and circular forms abound, mixed with more decorative and sophisticated devices emblematic of the growing dynasty and late quattrocento taste.[82] The tomb's numerical significances include fifty-two diamond rings, Medici heraldry symbolizing durability and strength, whose presence on the framing marble arch signifies a cosmic allusion to the number of the weeks in a year. Moreover, fifty-two is the product of four, the earth—the number of bronze tortoises (a complex symbol of the cosmos and resurrection, connected with the motto *Festina lente* used by both Augustus and Constantine, and most likely part of the *impresa* of Cosimo)[83] supporting the structure—times thirteen, the number of Christ and the apostles as well as the number of oculi in the dome of the Sacristy (symbolizing heaven). The four shell cornucopia filled with fruit on the sarcophagus (crowned by a large diamond), allude to the fruits of the beneficent Medici rule on earth and the fruits of Paradise enjoyed by the Medici in heaven. They complement the inscriptions and the luxuriant acanthus

[80] Hartt, *History of Italian Renaissance Art*, 158.

[81] See Elam, 'Cosimo de' Medici'; McKillop, 'Tomb of Cosimo'; G. Monti *et al.*, *L'architettura di Lorenzo il Magnifico*, 117–21, 297 ff.; Sheard, 'Verrocchio's Medici Tomb'; Butterfield, 'The Funerary Monument'; id., *The Sculptures of Andrea del Verrocchio*, 34–44 (published after the writing of this book). See also Clearfield, 'The Tomb of Cosimo de' Medici in San Lorenzo'; Olson, *Italian Renaissance Sculpture*, 115; Sperling, 'Verrocchio's Medici Tomb', 54,

who notes Paolo Giovio's comment in the 16th c. that *all* San Lorenzo could be regarded as Cosimo's tomb.

[82] Ruschi, 'Il Monumento di Piero e Giovanni'; Sperling, 'Verrocchio's Medici Tomb', 55–61; Sheard, 'Verrocchio's Medici Tomb'; Butterfield, *Verrocchio*, 33–55.

[83] See Sheard, 'Verrocchio's Medici Tomb', 86–90; Butterfield, *Verrocchio*, 51–4.

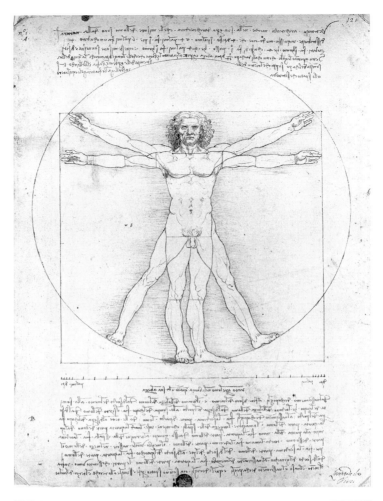

FIG. 2.11. Leonardo da Vinci, *Drawing of the Vitruvian Man*, *c*.1487–90. Galleria della Accademia, Venice

FIG. 2.12. Giuliano da Sangallo, *Drawing of a Tondo with the Standing Virgin, Child, and Angels* (MS Barb. lat. 4424, fol. 4v), late fifteenth century. Biblioteca Apostolica Vaticana

plants associated with death and resurrection as well as the Golden Age (Virgil). They also harmonize with the alternating palm fronds and olive branches of Palm Sunday that refer to the Resurrection and are intertwined with diamond rings in the decoration of the arch (implying triumph). Moreover, the monument is crowned by a large diamond (embedded in a rosette, also a family emblem),[84] carrying to a new extreme earlier themes of the Old Sacristy and suggesting significant ideas about the complicated symbolism present in tondi.

LATER QUATTROCENTO ARCHITECTURAL THEORY AND PRACTICE

Later fifteenth-century architectural theory continued to enshrine the central plan and its cosmic and philosophical associations with God, as in the treatises of Filarete (Antonio Averlino), *Trattato d'architettura* (c.1457–64), and Francesco di Giorgio Martini, *Trattati di architettura ingegneria e arte militare* (c.1482). Francesco di Giorgio also underlined his allegiance to the perfection of geometry in a design that has become an emblem of the Renaissance where a human figure is inscribed in a circle and square.[85] Both he and Leonardo, in his better-known rendition (Fig. 2.11), based their designs on Vitruvius' idea that the proportions of the human figure should be reflected in those of the temple.[86] This image seems linked to a passage in Dante's *Paradiso* where the author relates himself to a geometer, one who tries to 'square the circle and finds not in pondering the principle of which he is in need' (Canto XXXIII, 133–8). The popularity of the Vitruvian figure continued into the sixteenth century because it symbolized the mathematical sympathy between the microcosm and the macrocosm, as did tondi.[87]

A correlation between tondi and centrally planned structures is reflected in the drawing of a tondo (Fig. 2.12) by the architect Giuliano da Sangallo, who favoured centralized churches. The recto of this sheet features a building in the Forum of Augustus with a blind *occhio* in the central arch below which is a sarcophagus or relief with an *imago clipeata* in a niche, suggesting a high probability that Giuliano made the connection between the tondo on the verso and these forms.[88]

Because of practical problems, the building activity of the Quattrocento reflected only partially the theoretical preference for centralized churches. It was in private spaces attached to churches— such as the Old Sacristy and the Chapel of the Cardinal of Portugal in San Miniato al Monte (1460–2)—rather than more public buildings where they found partial expression. The latter chapel, designed by the mathematician Antonio Manetti, is a brilliant exercise in the circle and square, whose symbolism alludes to the resurrection of the deceased young cardinal.[89] The five

[84] Cardini, 'Le insegne', 63, ill.

[85] Bellosi, *Francesco di Giorgio e il Rinascimento a Siena 1450–1500*, 314–17, no. 61, ill.

[86] Wittkower, 'Centrally Planned Church', 13 ff. (referring to Vitruvius, III. 1).

[87] Ibid. 16.

[88] Biblioteca Apostolica Vaticana, MS Barb. lat. 4424, fol. 4ᵛ (2ᵛ), silverpoint with redrawing in pen and brown ink on parchment measuring 445 × 390 mm. See Fabriczy, 'Giulianos da Sangallo

figürliche Kompositionen'; Hülsen, *Il libro di Giuliano da Sangallo: Codice Vaticano Barberiniano Latino 4424*, ii, pl. 4ᵛ, ill.; Morello, *Raffaelle e la Roma dei Papi*, 46, ill. See also Olson, 'Studies in the Later Works of Sandro Botticelli', 91 ff., who comments on Botticelli's influence on this tondo.

[89] Hartt, Corti, and Kennedy, *The Chapel of the Cardinal of Portugal, 1434–1459, at San Miniato in Florence*; Hausmann, 'Die Kappelle des Kardinals von Portugal in S. Miniato al Monte'.

roundels of the ceiling have complicated frames with nine zones, including three tones of sonorous blue scales with gilded rays that connote abbreviated rings of heaven. The chapel also has oculi on three walls at the same height (the entrance has a triumphal arch), two of which are windows with leaded glass roundels that reveal the sky and earth outside the chapel. The third oculus is different, although on the exterior it is expressed identically as a blind window framed in the same manner. On the interior it encircles Antonio Rossellino's Madonna and Child relief above the Cardinal's tomb (Fig. 6.11), which illusionistically appears to be autonomous, floating free from any architectural constraints of the wall tomb. Its white marble stands out against a pattern of gold stars on the painted blue background of the celestial realm. The multiple profile projections of all three *pietra serena* mouldings of the chapel's oculi are difficult to count, but formalistically and in their number (between nine and twelve) they suggest the rings of heaven. The windows allow in light from the real world, the elemental, while the Madonna and Child roundel lets in celestial light. Taken as a group, these three unite heavenly and earthly light in a timeless equilibrium that plays into the scheme of the chapel, which pivots around circular and square forms as theme and variations (see Ch. 6), ideas also found in tondi.[90]

The first independent centrally planned Florentine structure of the Quattrocento was Brunelleschi's ill-fated design for Santa Maria degli Angeli (1434; not completed in the Renaissance). The sixteen-sided building was begun as an oratory dedicated to the Virgin and the twelve apostles, a fact which helped to dictate its special configuration.[91] It is interesting to note that many would-be centralized Renaissance churches were dedicated to the Virgin, who herself was a symbol of the Church, just as Roman round temples frequently were dedicated to female deities.[92] The popularity of round churches was associated with the cult of the Virgin. From early times, the Virgin was glorified as the Queen of Heaven, Protectress of the whole Universe, a concept that harmonized with centralized plans and their 'divine harmony' and perfect beauty as well as with tondi. It is significant, therefore, that Signorelli painted a round structure in the background of his *Medici Madonna* (Fig. 7.32), where it probably also alludes to a baptistery—associated with the Christian chain of Baptism, Death, and Resurrection, as well as with Jerusalem, and other ideas expressed in the Old Sacristy.[93] Not coincidentally, Signorelli's building resembles a round tomb drawn by Giuliano da Sangallo on another sheet in his Barberini codex.[94] By including a round structure Signorelli articulated the correlation among tondi, round buildings, and the Madonna.

The conceptual link between centrally planned buildings of the fifteenth century and tondi is strong. Because the circle was such a pervasive symbol of divinity, it was employed by painters, sculptors, and architects alike. Further, the inception of the tondo is chronologically related to the advent of centrally planned Renaissance structures. It is no coincidence that the first such church begun in quattrocento Florence, Santa Maria degli Angeli, dates from the same time as the earliest

[90] Renaissance cosmography consists of two simple divisions, celestial and elemental (four elements); Heninger, *The Cosmological Glass*, 31 ff.

[91] Heydenreich and Lotz, *Architecture*, 14–16.

[92] Wittkower, 'The Centrally Planned Church', 31. Krautheimer, *Studies*, 107 ff., discusses round churches, like Santa Maria Rotunda and Santa Maria della Febbre dedicated to the Virgin, and how they related to the round structure over Mary's martyrium in the Valley of Josaphat.

[93] Signorelli's three-storeyed round building resembles the Dome of the Rock as well as the Anastasis, implying that Florence was the New Jerusalem, an idea championed by the Medici. See Ch. 7.

[94] On fol. 8r. Hülsen, *Giuliano da Sangallo*, pl. 8, ill.; S. Borsi, *Giuliano da Sangallo*, 71 ff. The theme of this sheet is the centrally planned structure.

extant autonomous tondi in sculptural and painterly media. While in theory the ideal church plan was perfectly expressed in the form of a circle, the ideal posed extreme functional/liturgical difficulties that curtailed its adoption. The urge towards circular perfection did, however, find explicit expression in sculpted and painted tondi and in roundels that decorated many ecclesiastical structures of the Renaissance.

3

LOST AND PARTIALLY FOUND: DOCUMENTARY EVIDENCE

THE documentary material related to tondi, which sheds new light on the origin of this quintessentially Renaissance form, falls into three basic categories: philological evidence; records and inventories; and works of art. This material contains not only clues about the origin, patronage, placement, and function of tondi, but also hints about the meanings that these objects held for Florentines of the Renaissance.[1]

PHILOLOGICAL BACKGROUND

A further examination of the etymology of the word 'tondo' facilitates an understanding of the art form known by that name. The first appearance of a seemingly related word from the verb 'tondere', meaning to cut, in the analytical, unpublished computerized records of the Accademia della Crusca—housed in the Villa of Castello near Florence—is in the Duecento; hence it can be associated with the rise of the *volgare* in literature. The reference occurs in an anonymous manuscript of proverbs on the nature of women.[2] However, it is with the poets of the *dolce stil novo [nuovo]* that the word 'tondo', meaning round, became more common.

In the Trecento 'tondo' occurs more frequently as an adjective or an adverb than as a noun. One has only to think of Boccaccio, who employs the adjective 'tondo' on three occasions in *The Decameron*, once to describe a priest of a rather portly physique.[3] Dante clearly had an impact on the development of the word. He uses it eighteen times in the *Commedia*, only twice as a noun and three times as an adverb. When he employs the word as a noun, it is synonymous with the word 'circle' and lacks an article, implying that no specific class of object was then connected with it.[4] Nevertheless, Dante's emphasis on the circle, coupled with the nature of medieval–Renaissance cosmology, encouraged the development of the object later known as a tondo. As an adjective,

[1] This chapter is an abridged version of Olson, 'The Tondo', 31–65, to which new material has been added.

[2] Manoscritti avalle Fusi, *Proverbia que dicuntur super natura feminarum*, S. Prov. 450, fol. 107ʳ, l. 18 (in G. Contini, *Poete del Duecento*, i (Milan and Naples, 1960)): 'à la femena ge li omini confonde, / sença rasor e forfese con qual'li rad' e tonde / con soi losenge e planti e . . .'. This citation and several others in nn. 6–8 are given in the form recorded in Accademia della Crusca and are not

included in the bibliography.

[3] Barbina, *Concordanze de' Decameron*, ii. 1962: (1) II, 3, 32; Olson, 'The Tondo', 54 n. 18.

[4] Lovera *et al.*, *Concordanza della Commedia di Dante Alighieri*, 2397–8. It appears twice as a noun in the *Paradiso*: (1) Canto XIII, 51: 'nel verso farsi come centro in tondo'; (2) Canto XIV, 102: 'che fan giunture di quadranti in tondo'.

it sometimes modifies or is connected to the word for circle in a redundant manner.[5] One of the important instances of this redundancy is St Catherine of Siena's description (*c.*1378) of a vision, featuring a round circle (a *cerchio tondo*) containing a male child, which reflects established visual conventions for visions with celestial beings in circles or mandorlas, signifying holiness.[6]

'Tondo' had been first used as a noun, according to the records of the Accademia della Crusca, between 1281 and 1300 in an anonymous work.[7] In 1321 Bosone da Gubbio employed it as a noun in a poem.[8] Other instances follow in the literature of the *dolce stil novo*. Many times one feels that the word is employed because of its rhyming potential as well as its cosmic form and associations. Interestingly, Antonio Pucci in his *Centiloquio*, *c.*1388, links 'tondo' to the idea of *renovatio* and renaissance in Florence.[9] By the end of the Trecento, based on its usage by Pucci and the False Boccaccio, the incidence of 'tondo' is on the increase, and its alliance with the concept of completeness or perfection is clear.[10]

DOCUMENTS AND INVENTORIES

Although they have been neglected in the past, inventories and other documents provide more tangible information about all aspects of works of art known as 'tondi'. In his pioneering study, Hauptmann theorized, without actually considering commission documents, that the lion's share of tondi were produced for domestic settings. On the basis of later reports, including those of Giorgio Vasari, he also assigned a few tondi to more public locations (guild headquarters, other civic buildings, and more informal rooms of ecclesiastical complexes).[11] Wackernagel summarized this material and added substantial weight to the importance of tondi by noting that the vast number of surviving examples suggests the former enormous extent of this genre.[12] He also speculated on the provenances of some, remarking that they 'served as household devotional images and had perhaps come into the church as a bequest . . . for the religious painting in a round format occurs otherwise only in private devotional contexts'.[13] Most of these remarks, while generally correct, were based on a quick survey rather than on an examination of documentary evidence, such as the one which follows.

[5] See Olson, 'The Tondo', 53 n. 9.

[6] Caterina da Siena (Santà), *Libro della divina dottrina* (Bari, 1928), ch. 10, 23 ff.: '. . . come se tu avessi uno cerchio tondo posto sopra la terra; e nel mezzo del cerchio escisse uno arbore con uno figliuolo dallato el quale cognoscimento di sé è unito in me che non ho né principio né fine, si come el cerchio è tondo . . .'.

[7] *Il Novellino*, ed. G. Favati (Genoa, 1970), novella 28, p. 195, l. 19: 'scienza: non trovaro ne ente. Allora dissero: "Matto è colui ch'è si ardito che la mente metta di fuori dal tondo." '

[8] 'Duo lumi son di novo spenti al mondo', in *Poeti giocosi del tempo di Dante*, ed. M. Marti (Milan, 1956), 321:

> Duo lumi son di novo spenti al mondo,
> in cui virtù e bellezza si vedea;

> piange la mente mia, che già ridea,
> di quel che di saper toccava il fondo.
> Pianga la tua del bel viso giocondo,
> di cui tua lingua tanto ben dicea;
> omè dolente, che pianger devea
> ogni omo che sta dentro a questo tondo . . .

[9] Olson, 'The Tondo', 55 n. 14 (7).

[10] Ibid. 55 n. 15.

[11] Hauptmann, *Der Tondo*, 22 ff.

[12] Wackernagel, *The World of the Florentine Renaissance Artist*, 103.

[13] Ibid. 138.

INVENTORIES OF THE MAGISTRATO DEI PUPILLI

Much of the early information about Florentine domestic objects, specifically tondi, is found in household inventories, including those preserved in the records of the Florentine Ufficio or Magistrato dei Pupilli Avanti il Principato in the Archivio di Stato di Firenze. This office inventoried the possessions of those who died intestate or were deemed incompetent to manage their own affairs, for example, minor children or the insane, or persons who elected to have their estates handled by the magistrates. Their inventories (hereafter referred to as MPAP), beginning in 1386 (with some earlier entries), constitute the largest collection of household inventories ever assembled in early modern European history. It is through a study of them that trends concerning tondi can be established.

From his examination of them, Lydecker supports earlier contentions that the tondo was essentially a domestic form of painting.[14] During the Quattrocento and the early Cinquecento, tondi together with painted chests (*forzieri, cassoni*), *deschi da parto*—all distinctive forms which evolved in the fifteenth century—and portraits were generally located, as one would expect, in the private domestic chamber called a *camera* or in an adjacent antechamber or study. Lydecker thinks that tondi—typically representing religious subjects like the Madonna and Child or the Adoration of the Magi—were the most prized work of art in the house, judging from his observation that they are the first objects cited in listing the contents of the room, which in the inventories of this civic agency frequently included other religious images.[15] However, tondi were noted and placed with more variety than Lydecker claims. From my survey of the Pupilli records, a great percentage of the inventories of smaller households are not divided by room. In some of these, an image of the Madonna and Child is among the first items listed, although more often the inventories begin with an enumeration of *botti* (barrels), while other images of the Madonna and Child, including tondi, are scattered throughout, especially in larger households. Further, in the Medici inventories tondi are never the first objects inventoried in a room, although they are always located in a *camera* or *anticamera*.[16] Moreover, the conclusion that only religious tondi were located in chambers, while non-religious tondi were in other rooms, is not entirely supportable.[17] In sum, Lydecker, who only

[14] Lydecker, 'The Domestic Setting', 64 ff.

[15] Ibid. 65–6, 165 ff.; Olson, 'The Tondo', 54 n. 24. All the dates in the Pupilli records will be given as recorded in Florentine style (when the year changed on 25 March).

[16] Müntz, *Les Collections*, published incompletely the inventories of 15 Sept. 1456 (fols. 2–21), 1463–4 (fols. 23–46), 1465 (fols. 60–8), 1492 (fols. 3–119). They are in ASF (Archivio di Stato di Firenze), MAP (Mediceo Avanti il Principato), filza CLXII, fols. 20 ff. (1456 and 1463); MAP, filza CLXIII, fols. 60 ff. (20 Jan. 1464, NS 1465); MAP, filza CLXV, fols. 1 ff. (1492; a copy of 1512). Spallanzani, *Inventari Medicei, 1417–1465*, and Spallanzani and Bertelà, *Libro d'inventario dei beni di Lorenzo il Magnifico*, follow Müntz with minor differences, together with additional citations. Moreover, Spallanzani's 1996 volume includes the 1417 inventory of Giovanni di Bicci (filza CXXIV), which includes 'tondo' once on fol. 60ᵛ ('Uno descho tondo da parto dipinto'; Spallanzani, *Inventari Medicei*, 19). Because Müntz is more readily available, his study will be quoted for the inventories, although both versions will be cited

when significant differences or omissions occur.

[17] Lydecker, 'The Domestic Setting', 66. The Pupilli list several non-religious tondi in other rooms, e.g. one in gesso depicting a lion in the first hall (*sala prima*) of Conte Vanni d'Andrea de' Medici's house (1467, MPAP 173, fol. 166ʳ: '1º tondo di giesso ch'una testa di lione'), and another with Romulus and Remus in a study in the house of Marco d'Ugolino Bonsi (1497, MPAP 180, fol. 170ᵛ: '1º tondo dentrovi Romolo e Remolo'). Further, there are non-religious tondi listed in *camere*, e.g. in the 1492 Medici inventory (Müntz, *Les Collections*, 62–3; Spallanzani and Bertelà, *Libro d'inventario*, 21): in the 'camera delle dua letta' is 'Uno tondo grande dipintovi uno universale [could it be a Last Judgement or a universe?] chon uno festone di nocie intagliato intorno diametro . . .'; in the 'camera della sala grande detta di Lorenzo' is 'Uno tondo di musaico entrovi la [i]mpronta [*sic*; *impresa*? or impression?] di Giuliano di Lorenzo, . .'. This citation demonstrates that *imprese*, like the Madonna and Child, were frequently placed in round formats that had symbolic connections with immortality.

records some of the tondi in the Pupilli,[18] believes that the more private quarters were the principal locus for religious art, and indeed all art, and that tondi were the decorative and spatial centrepieces of the chamber, a conclusion adopted by Thornton.[19]

Certainly the incidence of devotional tondi, as well as other devotional works, recorded in *camere* relates to the fact that most Florentine homes during the fifteenth and early sixteenth centuries did not have chapels. It was the round shape of tondi, like the architectonic Gothic shrines of earlier tabernacles, that instantly connoted a holy place. The Palazzo Medici seems to have been an exception, however, revealing that once again the Medici were in the vanguard of developing ideas. It had two chapels, as revealed in the 1492 inventory, with a second small one, most likely for personal devotions, housing an expensive *colmo* depicting the Adoration of the Magi by Fra Angelico as its altarpiece.[20] The lack of widespread family chapels explains why special attention was paid to the installation of selected devotional objects within *camere*, both rectangular and round. For example, some tondi were set in elaborate frames with candleholders or with a veil covering the object in a show of respect, implying the sacred, devotional function of the images.[21] Thus, tondi, like all larger devotional objects, seem to have played a part in the evolution towards family chapels and represent an early expression of the desire for them. Nevertheless, additional information about chapels is needed before definitive conclusions can be reached about the locations for devotion in fifteenth-century Florentine palaces.

TONDI AND DESCHI DA PARTO IN THE PUPILLI

It is difficult to determine from the MPAP inventories when the first tondo was recorded, because every scribe or inventory-taker has not only a distinctive script but also an individual descriptive writing style and nomenclature. Nevertheless, after perusal of the volumes through the early 1490s, a number of conclusions can be reached. Before the concept of a tondo existed, and thus could be categorized as such, tondi may have been inventoried under vague descriptions, such as 'tavola di Nostra Donna', or even more general designations, such as 'tavola tonda' (usually meaning a round table, although it could mean a round panel).

The adjective 'tondo' is present already by 1387, modifying the word for a small tray (*deschetto*

[18] Among them are the four in the large household of Giovanni di Francesco Tornabuoni (1497, MPAP 181, fols. 141ʳ–150ʳ): (1) '1° tondo chon chornicione d'oro di Nostra Donna e magi che oserfrono a Christo' (the first item in the *camera* [which the scribe transcribes throughout as 'chamera'] 'di L° [Lorenzo] bello in su la sala in palco'), fol. 148ʳ; (2) '1° Vergine Maria di giesso in 1° tondo di diamante', fol. 148ʳ; (3) '1° tondo chon festone messo d'oro dov'è Nostra Donna e San Giovanni' (the first object in the 'camera del palcho d'oro'), fol. 148ᵛ; (4) '1° tondo chon chornicione d'oro e dipinto da donna di parto' (in the 'camera di Giovanni V [vecchia] in su la sala', the fifth object and probably a *desco da parto*), fol. 149ʳ. Lydecker, 'The Domestic Setting', 62–9; Olson, 'The Tondo', 55 n. 28.

[19] Lydecker, 'The Domestic Setting', 65; Thornton, *The Italian Renaissance Interior 1400–1600*, 264.

[20] Fol. 41ᵛ; Müntz, *Les Collections*, 85; Spallanzani and Bertelà,

Libro d'inventario, 78. See also Bulst, 'Uso e trasformazione del Palazzo Mediceo fino ai Riccardi', 115. According to several personal communications from Creighton Gilbert, Philip Mattox (forthcoming) has discovered evidence of other early Florentine family chapels. Ahl, *Gozzoli*, 294 n. 28, points out two in the palace of Olivieri di Cerchi (documented 1291) and Giovanni de' Medici (established 1422).

[21] Lydecker, 'The Domestic Setting', 65 ff.: (1) '1° tondo di Nostra donna cornicione e candeliere meso d'oro' (1511, MPAP 182, fol. 319ʳ, in the *camera* of the householder); (2) '1° tondo di Nostra Donna con festone dorato con 1ᵃ cortina biancha dina'zi con chandeliere d'ottone' (1512, MPAP 182, fol. 335ʳ, in a *camera*); (3) '1° tondo di Nostra Donna con ornamento meso a oro bello, 1° chandeliere di legno doratto da pie con 1° vello di levante' (1513, MPAP 185, fol. 5 [cited by Lydecker, 'The Domestic Setting', 68–9 n. 94, without a recto or verso] in the 'camera in sula sala'). See also below, n. 54.

tondo), and appears with increasing frequency during the course of the fifteenth century. By 1413–14 the word frequently modifies *desco da parto*, probably in order to differentiate round *deschi* from those in a polygonal format, which may have been the first form of *deschi*.[22] While *deschi* crop up frequently in Pupilli inventories, occasionally with two or more in a household, they are never as widespread as *cassoni* or *forzieri*. In the 1430s even more ambiguous references to round objects appear, such as 'uno descho tondo chopinti', which may signify a round, painted tray, or a round *descho da parto*—or may be a vague description of the object we classify as a tondo.[23]

Philological evidence in these sketchy inventories strongly suggests a direct link between tondi and *deschi da parto*, whether it be solely on account of their similar formats or also due to their allied functions and/or associations, supporting the visual evidence in Chapter 1. For example, in 1449 there is a citation of '1° descho tondo daparto dipinto'; then, in 1468, a notation of '1° descho tondo, dadone da parto', and importantly in 1472 '1° tondo dpinto da donna dparto';[24] similar references continue through the century. A citation of 1483 similarly describes what seems to be an abbreviation of a *desco tondo da parto*, dropping the 'desco', to suggest that the development of the tondo may have been accelerated by its association with *deschi*.[25] It and similar entries suggest an evolution, wherein 'tondo' replaces 'desco' as the first word to imply that by the late 1480s the tondo had superseded the *desco da parto* and that *deschi* had become identified with the more pervasive and frequently larger tondo.[26] In view of the variety of citations describing similar objects, however, one should exercise caution with regard to this conclusion.

Tondi, like *deschi*, must have been displayed in the household and handed down from generation to generation. Because of the similar form and subject matter of early tondi—the first contain elaborate representations of the Adoration of the Magi, whose courtly elegance resembles the lavish scenes on *deschi*—it was natural to associate the two. Tondi, therefore, may have assumed some of the decorative and didactic functions of *deschi* but shifted the emphasis from the family of the household to that of the Holy Family. Tondi also partially replaced rectangular devotional panels or tabernacles with a less hieratic but still symbolic form. Thus they became the perfect domestic devotional picture, merging some of the familial associations of *deschi* (including their cyclical implications and their talismanic, occasionally heraldic, and fertility functions) together with a primarily devotional function. Moreover, since they were frequently but not always (see Ch. 7) larger than many *deschi*, they were more in scale with the increasing size of Florentine palazzi and their rooms in the latter Quattrocento.

[22] The term 'deschetto tondo' is found in 1387, MPAP 1, fol. 29ʳ; see Olson, 'The Tondo', 56 n. 34. Musacchio, 'Art & Ritual', 85, notes that the earliest known documentary reference to a *desco* is in the first volume (1382, MPAP 1, fol. 47ᵛ): '1 deschum rutundum lignaminum pro parte pictam'.

[23] 1430, MPAP 166, fol. 96ʳ.

[24] 1449, MPAP 170, fol. 200ᵛ; 1468, MPAP 173, fol. 174ᵛ; 1472, MPAP 172, fol. 264ʳ.

[25] 1483, MPAP 177, fol. 273ʳ: '1° tondo dparto'.

[26] 1489, MPAP 179, fols. 172ᵛ: '1° tondo dadoña dparto'; 204ᵛ: '1°

tondo dipinto da donna dipto [or 'dapto']'; 1497, MPAP 181, fol. 148ʳ: '1° tondo chon chornicione d'oro e dipinto da donna dparto'. Physical proof of this theory finds reflection in a late 15th-c. polygonal *desco da parto* with a 58 cm. diameter and the representation of the Madonna and Child enthroned with two saints. It is the only *desco* with this type of subject known to this author and has been influenced by tondi. Its reverse contains only a central small circle with a surrounding ring, underlining the importance of the circle (in the Alberto Bruschi di Grassina Collection, Florence; De Carli, *I deschi da parto*, 172–3, no. 46, ill.).

THE MATURE TONDO IN THE PUPILLI

It is only in 1470s and 1480s that the concept of a tondo as a distinct entity—but not yet connected with an image of the Madonna and Child—emerges. However, the Pupilli inventories seem to be conservative, since the first known citations of autonomous tondi occur two and three decades earlier in other documents. It is significant that the first of these refer to objects containing heraldic devices, also found on the reverse sides of *deschi da parto*, and to objects that are really *deschi*.[27]

Other 'tondo' citations refer to various round objects, for example, one to a gem in a round shape and another to a tondo painted for use as a mirror.[28] A crucial reference in the inventory of the Inghirami family refers to a tondo of lead with the head of Cosimo.[29] However, a perusal of the Pupilli makes it clear that 'tondo' does not always signal images in a round format, but can refer to a round tray for eating or a wooden cover for a vase.[30]

Finally, in 1482 there is the listing of what art historians normally associate with the word 'tondo', a Madonna and Child devotional work: 'I° Nostra Donna in tondo'.[31] Yet this phrase refers to the round format and not to an object *per se*. This late appearance of the term in the Pupilli accords with the normal time gap one would expect for households established in mid-century, when tondi first appear to have been produced. The 1482 reference is followed in 1483 by other 'tondi' that are not devotional works; in 1489 a scribe or inventory-taker appears who likes to apply 'tondo' to any round object, as though it had only recently become a household word for him.[32] This implies that the nomenclature was still in flux but suggests the growing popularity of the word.

While tondi with images of the Madonna and Child are listed in the MPAP inventories from the 1480s on, usually specifically as a tondo with the Madonna, they occur occasionally rather than frequently. It is no surprise, therefore, that the greatest number of the hundreds of extant painted tondi can be dated between 1480 and 1510, while notably fewer examples in sculptural media have a somewhat different evolution.

MEDICI INVENTORIES

To obtain a better understanding of what is meant by the word 'tondo', let us examine another control group: the four quattrocento inventories of the Palazzo Medici, especially the famous one from 1492, conducted at the height of the popularity of tondi. They are especially valuable because they allow us to compare the type and number of goods in the possession of the same family over a span of decades. These inventories, which were carried out for the purpose of valuation, reveal facts about the collecting habits of the family and perhaps of wealthy, patrician Florentine families in

[27] 1473, MPAP 173, fol. 325ᵛ: 'I° tondo digiesso ch'una testa d'lione' (the Marzocco?); 1472, MPAP 172, fol. 250ʳ: 'I° tondo di rame cho' l'arme de' Bilotti', and fol. 264ʳ: 'I° tondo dpinto dadonna dparto'; 1476, MPAP 172, fol. 360ʳ: 'I° tondo chome istello, cho' 2 arme a oro'; 1512, MPAP 182, fol. 337ʳ: 'I° tondo di Nostra Donna di terra dipinta col'arme' (presumably of the householders, the Albizegli).

[28] 1476, MPAP 174, fol. 159ʳ: 'I° tondo d'cristallo chon ariento

intorno'; 1477, MPAP 175, fol. 156ᵛ: 'I° tondo dipinto per I° ispecchio'.

[29] 1471, MPAP 173, fol. 267ʳ: 'I° Tondo di biomba [*piombo*, lead] 'ove latesta diCosimo'.

[30] See Olson, 'The Tondo', 34, 56 n. 44.

[31] 1482, MPAP 177, fol. 259ᵛ.

[32] See Olson, 'The Tondo', 56 n. 47.

general, although, like all inventories, they may be incomplete and tempered by selectivity. The earlier ones contain few devotional or art objects, as compared with the numbers listed in the 1492 inventory, implying that earlier there were fewer material goods in the Palazzo Medici, as Goldthwaite has hypothesized.[33]

An analysis of this information sheds light on what 'tondo' meant in the Quattrocento, although it too is skewed by the style and nomenclature of the individuals who compiled these inventories. The nature of these listings must be acknowledged: they were intended only to enumerate (not to describe fully) items and, therefore, contain highly superficial descriptions. Thus the margin for error is great, since it would have been easy for the compilers to have employed words interchangeably or mistakenly in their haste. Be that as it may, the word 'tondo' occurs only twice in the 1456 inventory as a noun signifying a round gem.[34] In the short 1463–4 inventory, 'tondo' appears once as an adjective to modify a round trencher or cutting board.[35] In the third Medici inventory of 1465, 'tondo' appears four times; once it is used as a noun referring to an independent circular form ('a tondo') in niello in a larger context.[36] It also functions three times as an adjective describing round trenchers.[37] An evolution is, therefore, apparent in these Medici inventories despite all the possible variables. But because the 1465 citation of an identifiable circular entity called a 'tondo' still does not allude to the unique devotional object that we associate with the word, we can conclude that either tondi were not common by 1465 or the term had not been applied to these objects, or a combination of both.

It is only with the inventory of 1492 that the word is used with any frequency, sometimes describing an autonomous object (see below). The word appears eight times as a noun in Müntz's transcription of the inventory and twelve times in the more recent one, while it is used to describe an autonomous object six times in the former and nine times in the latter, although in each tally two of the citations in the recent transcription are repetitions.[38]

Considered in conjunction with the MPAP evidence, the Medici inventories strongly indicate that the inventory-takers were partly responsible for nomenclature. Further, the objects which they describe were more prevalent in the Medici household by the end of the century,[39] when the words to identify them were in the *lingua franca*. Moreover, the 1492 inventory tends to include lengthier descriptions than the previous ones, a fact pointing to a more exacting individual. (In later Medici inventories, including those of the collateral branch, there are citations of a few other tondi.[40])

Despite the brief descriptions, it is possible nevertheless to identify with reasonable accuracy two extant tondi from the 1492 inventory, made during the heyday of tondi. The *Adoration of the Magi* by Fra Angelico has been convincingly identified as the tondo formerly attributed to both Fra

[33] Goldthwaite, 'The Florentine Palace as Domestic Architecture'; id., *The Building of Renaissance Florence: An Economic and Social History*.

[34] Fol. 4 (without a recto or verso indication): 'Uno tondo ovale d'amatisto piano / Uno tondo di cristallo'—Müntz, *Les Collections*, 18; Spallanzani, *Inventari Medicei*, 97, transcribes two other similar items ('Uno tondo di cristallo' and 'Uno tondo di cristallo').

[35] Fol. 46ᵛ: 'Uno taglieri tondo'. Müntz, *Les Collections*, 34.

[36] Fol. 61ᵛ: 'Una tavola d'ariento dorato con uno quadro smaltato et uno tondo niellato'. Ibid. 39.

[37] Fol. 63ʳ: 'Dodici taglieri tondi col brusciolo'; fol. 63ᵛ: 'Dodici taglieri tondi con l'orlo dorato'; fol. 64ʳ: 'Dodici taglieri tondi'. Ibid. 42–3.

[38] See Olson, 'The Tondo', 57 n. 58.

[39] A conclusion bolstered by a study of Piero de' Medici's collecting: Ames-Lewis, *The Library and Manuscripts of Piero di Cosimo de' Medici*.

[40] Müntz, *Les Collections*, 100 ff., published a list of property confiscated in 1494; it contains three references to tondi that are gems. The inventory of Lorenzo di Pierfrancesco and the heirs of Giovanni di Pierfrancesco (1498) is ASF, MAP, filza CXXIX, fols. 480–528. For partial transcriptions of inventories of this Medici branch, see Shearman, 'The Collections of the Younger Branch of the Medici', and W. Smith, 'On the Original Location of the *Primavera*'.

Angelico and Fra Filippo Lippi and now generally given to the latter (Fig. 3.1).[41] The panel's evolution is problematic and dates anywhere from the late 1430s through the 1450s. Another tondo in this inventory has been identified as the *Adoration of the Magi* by Domenico Veneziano (Fig. 7.2).[42] It may be the earliest tondo panel extant, for it is usually dated shortly after 1438–9 on the basis of style and costume detail, although it has been dated as late as 1450.[43] It is extremely significant that these two Adorations, which are related in their lavish and courtly style to the visual conventions of *deschi*, are believed to be the earliest surviving painted examples of the genre (see Ch. 7). Ironically, whereas *deschi da parto* were used for bringing gifts to the new mother, in these two tondi the Magi bring gifts to the Christ Child. Further, they not only demonstrate the Medici family's connection with the rise of this format, as well as with the Compagnia de' Magi (emphasizing their social status), but also link early tondi to the secular domestic sphere.

ARTISTS' INVENTORIES

Two artists' inventories—those of Benedetto da Maiano and Filippino Lippi—testify to the proliferation of tondi at the end of the Quattrocento. The invaluable documents made after Benedetto's death in 1497 list a number, including one in his house, and demonstrate his involvement with their production. They supplement our knowledge about the marble, stucco, and terracotta tondi attributed to him and his shop.[44] Four tondi (three painted panels) are listed in the inventory of Filippino Lippi's shop, made at the artist's death in 1504. They offer tantalizing hints about the range of his activity as a painter of tondi over and above the extant tondi by his hand.[45]

[41] It is cited on fol. 6ʳ: 'Uno tondo grande cholle cornicie atorno messe d'oro dipintovi la nostra Donna e el nostro Signore e e' Magi che vanno a offerire, di mano di fra Giovanni [Fra Angelico], f. 100.' Müntz, *Les Collections*, 60; Spallanzani and Bertelà, *Libro d'inventario*, 12. This work has been linked with a panel in the National Gallery of Art; see Ch. 7 n. 20. Shapley, *Paintings from the Samuel H. Kress Collection. Italian Schools*, i. 95–7, ill.; Ruda, *Filippo Lippi Studies*, 40–76; id., *Fra Filippo Lippi*, 210–15, 316–25, 437–41, ill.

[42] First proposed by Pudelko, 'Studien über Domenico Veneziano', 166 n. 2; repeated in id., 'Per la datazione delle opere di Fra Filippo Lippi', 68.

[43] Fol. 16ᵛ: 'Uno tondo alto braccia 2 entrovi la storia di Magi di mano di Pesello, f. 2.' (Müntz, *Les Collections*, 64; Spallanzani and Bertelà, *Libro d'inventario*, 33). See Wohl, *Veneziano*, 120, and below, Ch. 7 n. 12. See also Hatfield, 'The Three Kings and the Medici', i, no. 27; id., 'The Compagnia de' Magi', 107–61.

[44] They are: (1) '1 mezzo tondo di braccia 2, consegnato addì detto per libbre 730 c. 5' (lunette-shaped); (2) '1 tondo di braccia 1° grosso 1/3, consegnato addì detto per libbre 430—'; (3) '1 tondo di 2/3, consegnato in 2 pezzi addì detto per libbre 400 c. 5'; (4) '1°

tondo di 1/2 braccio'; (5) '1 tondo bozzato di Nostra Donna di braccia 1 1/4'; (6) '1° tondo di gesso di una Nostra Donna a sedere'; (7) '4 Vangelisti in tondo di 2/3 . . .'. (Cèndali, *Giuliano and Benedetto da Maiano*, 178–86; C. Gilbert, *Italian Art, 1450–1500: Sources and Documents*, 42–7, an annotated English translation). Virginia Budny shared information from the copy of the lost 1497 inventory made in the mid-16th c. (ASF, Compagnia poi magistrato del Bigallo 1219, Atti diversi, fascicolo 4, 99–108), which includes an eighth 'tondo', really a lunette: (8) '1° mezzo tondo di braccia 1', in the shop in Via del Castellaccio. An original inventory of 1498 lists a ninth in the 'camera terrena' of the Da Maiano house in Via di San Gallo (ASF, Notarile anticosimiano 16033, fol. 310ᵛ): (9) 'Una nostra Donna di terracotta in un tondo intagliato'. Budny, 'Benedetto da Maiano'.

[45] Carl, 'Das Inventar der Werkstatt von Filippino Lippi aus dem Jahre 1504', 384–9: (1) no. 70: 'uno tom[n]do di Nostra Donna con fornito, di Filippo del Pugliese'; (2) no. 76: 'uno tom[n]do principiatovi uno batteximo, dissono di Donato Tornabuoni'; (3) no. 79: 'uno tom[n]do grande chominiciato, di Giovanni Vespucci'; (4) in the *scrittoio*, and thus a personal possession, no. 237: 'uno tom[n]do di marmo intagliato da uno specchio'.

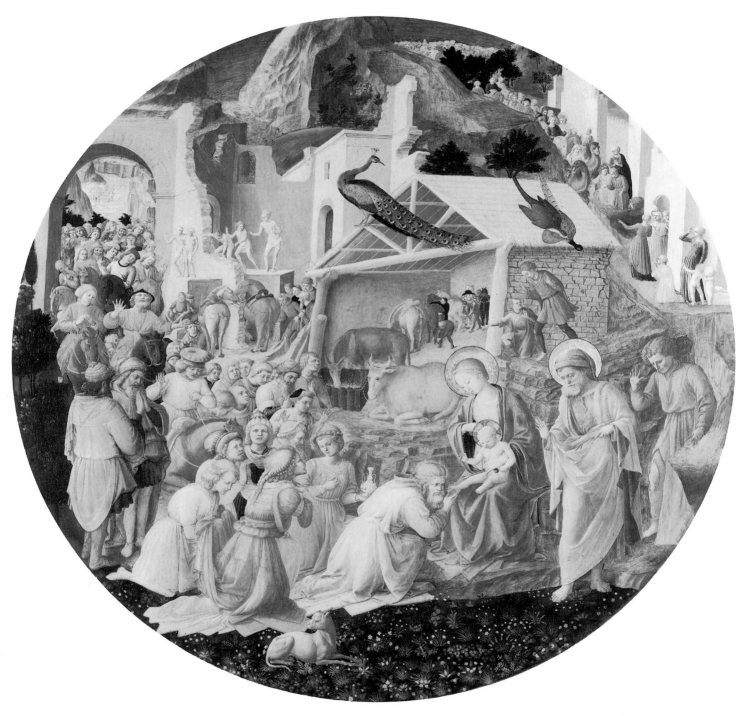

FIG. 3.1. Filippo Lippi and Workshop, *Adoration of the Magi*, *c.*1430s–50s. Samuel H. Kress Collection, National Gallery of Art, Washington, DC

COMMISSION, PAYMENT, AND ESTATE DOCUMENTS

Surprisingly few commission or payment documents for tondi have been published. The eleven following notices, however, all refer to devotional tondi and significantly date from the last quarter of the Quattrocento. They provide tantalizing, albeit incomplete, information about the patrons of tondi and how they were commissioned.

Three of them concern tondi by Botticelli. The first involves a single-entry payment to Botticelli for a tondo of 'Nostra Donna' for Cardinal Francesco Gonzaga in 1477–8; its description is too vague to identify the tondo in question.[46] The second Botticelli reference is in a document of 28 February 1486 (1487 NS), recording the payment for a tondo with the Virgin (the Child implied) for the audience hall of the Massai della Camera; it may refer to his *Madonna della Melagrana* (Fig. 7.19).[47] The third Botticelli notice consists of a series of payments for an unidentified tondo commissioned in 1489 by Luigi d'Ugolino Martelli.[48] Despite the fact that the description does not allow its identification, this series of notices is one of the most extensive about a work commissioned from Botticelli and reveals much about its production. Furthermore, from the Martelli entries we learn that Botticelli painted the tondo expeditiously: it was begun on 31 January 1489 and the final payment was made on 4 November 1489.

The next two documents record civic commissions. The fourth deals with a 1482 order by the Comune of San Gimignano for a pair of tondi of the Annunciation for the Palazzo Comunale, the residence of the priors. It and several other documents have been connected with twin tondi by Filippino Lippi (Fig. 3.2).[49] While no artist's name appears, the singular nature of the pair, their stylistic date, and their provenance almost conclusively link them with the citations. They are in restored frames, shaped like unusually narrow wreaths (of fruit, flowers, and laurel and oak leaves, decorated in oxidized silver and gold pigment, and bound by red ribbons) with separate gold liners. However, it is not known if these are original or how the now-warped panels were first displayed in

[46] Covi, 'A Documented Tondo by Botticelli', 270–2. Archivio dello Spedale degli Innocenti, Florence, Quaderno di cassa secondo segnato F, fol. 385, left page: 'la tavola tomda di Nostra Donna de'nostri di chorte de'dare adì 23 setembre f. quaramta larghi, portò Samdro di Mariano Boticelo dipimtore, per manifatura di detta tavola . . . f. 40 . . . piccioli, paghati a l° fachino per portatura d'l[a] Vergine Maria da botegha di Samdro di Boticelo a q(ui). f. 9.' Covi connects it with Fig. A17; Lightbown, *Botticelli*, ii. 40–1, 215, implies it is lost.

[47] ASF, Camera del Comune, Deliberazioni dei Provveditori o Massai della Camera e ufficiali di Banco, 56, fol. 69ʳ, lists the date as: 'Dicta Die XXVIII mensis februarii'; fol. 69ᵛ reads: 'Sandro botticelli pictori L. trigintaduas. S. XVI. d. III p[ro] uno tondo virginis marie p[ro] audentia d[ic]ti massarii L. 32 S 16 d 4.' See Olson, 'An Old Mystery Solved: The 1487 Payment Document to Botticelli for a Tondo'; see below, nn. 63–6 and Ch. 7 nn. 84–8.

[48] Lydecker, 'The Domestic Setting', 125–8, 289–90. The documents are: ASF, Carte Strozziane-V, 1463 (yellow ledger 'A' of Luigi d'Ugolino Martelli, 1484–8), fol. 49; Carte Strozziane -V, 1468 (red ledger 'B' of Luigi d'Ugolino Martelli, 1489–92), fol. 14. He paid 26.5.7 *fiorini larghi* (27.18.6 *grossi*) for the entire tondo, 19.0.0 *fiorini larghi* (21.4.4 *grossi*) of which went to Botticelli. Other amounts went to his brother Mariano, for the gold, and to

Francesco di Niccolò, for applying the gold to the tondo, leading Lydecker to infer that Botticelli provided the frame.

[49] See App. n. 89. The first document is in the Deliberazioni e provvisioni del comune, no. 133, fol. 230ʳ, 'Pro figura Annuntiationis beate Virginis, facienda in audientia, + Die. XIII. Jan. [1482/1483 NS]', it reads: 'primo . . . Cum alias fuerit provisum et ordinatum quod in audientia presentis palatii, pro honore communitatis et in commemorationem glorississime Virginis Marie matris domini nostri Yesu Christi fieri deberet quedam figura Annuntiationis eiusdem, et adhuc nichil actum sit, consilio prudentis viri Nicholay Angeli de Abracciabenis, unius de numero dictorum collegiorum, sit provisum et reformatum quod presentes magnifici domini priores et spectabilis capitaneus faciant fieri in dicta eorum audientia dictam figuram Annuntiationis glorississime Virginis Marie in duabus videlicet tabulis quadris vel tondis, prout eis videbitur melius convenire. Pro qua quidem figura facienda possint expendere ultra libras 50 alias pro dicta figura assignatas, etiam libras triginta denariorum, solvendas per presentem camerarium ad eorum stantiamentum, de denariis videlicet vinearum dicti Comunis.' See Krohn, 'The Framing of Two Tondi in San Gimignano Attributed to Filippino Lippi', for additional documents.

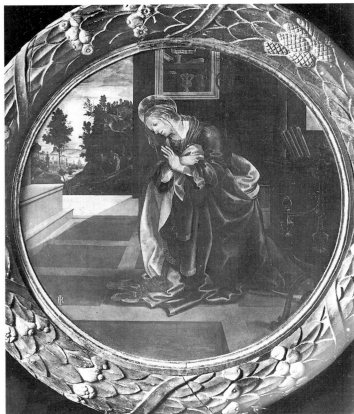

FIG. 3.2. Filippino Lippi, *Annunciation*, 1482. Museo Civico, San Gimignano

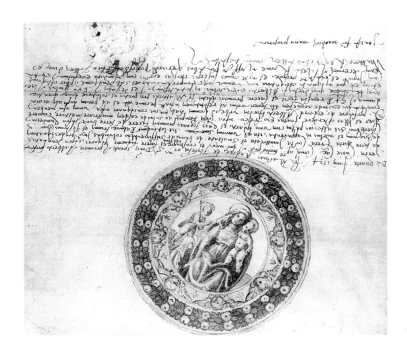

FIG. 3.3. Marco della Robbia (Fra Mattia),
Drawing and contract for a tondo, 1524.
Ashmolean Museum, Oxford

the new audience hall off the main council chamber.[50] Most interestingly, the documentation prior to the execution of the panels notes several times that the shape of the panels was undecided—they were to be either square or round, whatever seemed better (it could also refer to their framed shape).[51] The fifth document concerns two tondi commissioned in 1502 from David and Domenico di Domenico Ghirlandaio for the room of the Gonfaloniere in the Florentine Palazzo della Signoria. One depicted St Peter and St Paul, which has been identified with an ovally oriented extant panel (Fig. A113), while the other showed St Thomas and St Thomas Aquinas.[52]

The next four involve clear cases of domestic, devotional tondi. The first of these and the sixth instance consists of two payments made in 1505 by Jacopo di Piero Guicciardini to Lorenzo di Francesco for a tondo of the Nativity, which has not been identified, and to Francesco di Niccolò for its gilded frame.[53] The seventh of 1512 mentions a great tondo with the Madonna and Child, St John, the Magdalen, and two angels, also unidentified, in the estate book of Guicciardini's father-in-law, Agnolo di Bernardo de' Bardi.[54] The eighth of 1492, also not identifiable, involves payments in the account books of Zanobi di Giovangualberto Giocondi for an expensive tondo costing over 64 florins—a Madonna and Child, St John, St Zenobius, and angels—for his chamber to the painter Cilio and for a gold frame and the construction to Chimenti del Tasso.[55] The next, again unidentified, was commissioned in 1505 from Signorelli by a doctor from the Marche for seven fiorini.[56]

The tenth document is unique, for it consists of several sketches for a Madonna and Child tondo in glazed terracotta (Fig. 3.3) by Marco della Robbia, called Fra Mattia. Dated 4 June 1524, the sheet is the contract to make this lost object for the Apostolic Notary Alberto Serra.[57] It stipulates that the clay model, which is lost, was to be finished in a fortnight and the work itself in a month and a half. The tondo was designed with a typical Della Robbia double garland frame of fruit and leaves enclosing an inner circle of seraph heads. Its composition includes a female donor with her hands

[50] Between the panels and their frames are thin liners which extend only to the edge of the top surface, leaving the raw edges of the panel exposed. For the problem of the framing of these two tondi, see Olson, 'The Tondo', 40, 60 n. 88.

[51] Filippino's staging of the event inside two round forms is unusual, although there are other pairs with the Virgin Annunciate and Angel (see ibid.).

[52] Frey, 'Studien zu Michelagniolo Buonarotti und zur Kunst seiner Zeit', 128, nos. 149, 150; see also App. n. 296.

[53] The total cost was 19 florins, an amount greater than that registered for any other single object in all of his ledgers; Lydecker, 'The Domestic Setting', 137–9. It is ASF, Archivio Guicciardini, Libri di amministrazione, 12 (Libri di debitori e creditori A, di Iacopo di Piero Guicciardini, 1503–1511). Fol. 18 right: 'Lorenzo di Francesco, dipintore, de'avere adi XV di dicembre 1505 fiorini sette 1/2 larghi d'oro in oro, sono per uno tondo dipintovi una Natività, d'alteza di braccia II, auto da lui per detto pregio d'achordo secho, et mezano Michelangnolo [di Viviano] orafo; il quale tolsi per la camera mia . . . c. 16 – f. 7 s. 10 –.' Fol. 21 right: 'Francesco di Nicchiolò, dipintore, di chontro, de'avere adi 19 di febraio 1505 fiorini sei larghi d'oro in oro, per aver messo a oro et azurro fine l'ornamento del tondo della camera mia, d'achordo secho . . . c. 21 – f. 6 –.'

[54] It was replete with a blue cloth cover (ASF, Archivio Guicciardini, Bardi 30, fol. 14ʳ): 'Nella chamera grande . . . Uno tondo grande, messo a oro, in che è uno tondo di Nostra Donna chol Nostro Signore e San Giovanni e Santa Maria Madalena, chon dua Agnioli . . .'. On fol. 42ʳ: 'Uno tondo d'oro smaltato, chon fighura di Nostra Donna chol bambino in chollo e Agnioli intorno . . .'. Lydecker, 'The Domestic Setting', 143, refers to it as well.

[55] The accounts record 'uno grilanda di legnio intagliato per 1° tondo di Nostra Donna avuto da lui' and '. . . uno tondo d'albero; e fu dipinto Nostra Dona, Santo Giovanni, San Zanobi e più agnioli; in tutto, fanno l'chorta [by Cilio] . . .'. (Innocenti, series CXLIV, 409, fols. 49–53; ibid. 167–8). Lydecker, 'Il patriziato Fiorentino e la committenza artistica per la casa', 219, places the tondo in the spalliera of the camera. However, the documents do not place it there (fol. 53: 'dipintura di 4 quadri per le spaliere di chamera mia e d'una Nostra Donna chon più figure di santi e agnioli in 1° tondo').

[56] See App. n. 162; Vischer, Luca Signorelli und die italienische Renaissance, 365, 383, quotes Manni (Vita di Luca Signorelli, pittore cortonese); G. Mancini, Vita di Luca Signorelli, 145; Salmi, Luca Signorelli, 71; Kanter, 'Francesco Signorelli', 203–4.

[57] Inv. no. 669 in the Ashmolean Museum, Oxford, black chalk with indian ink wash and pen and ink measuring 405 × 292 mm. Marquand, The Brothers of Giovanni della Robbia, 23–9, no. 17, ill.; Parker, Catalogue of the Collection of Drawings in the Ashmolean Museum, ii. 360–1, ill; Gentilini, I Della Robbia: la scultura invetriata del Rinascimento, ii. 375; Olson, 'The Tondo', 60 n. 89. The verso has a sketch for a variant tondo.

clasped in prayer (one of the inscriptions identifies her as a nun of St Sixtus, thus a Franciscan). Even though this document dates from a later time, it preserves invaluable evidence.

The eleventh document of 1536 involves a payment dispute between Giovanni Antonio Bazzi, called Il Sodoma, and his patrons, the Arduini brothers, resolved on 13 October 1536, over an altarpiece of the Adoration for their family chapel and a tondo for private devotion. The ruling established that the brothers were allowed to keep the altarpiece but ordered them to return the tondo upon receiving seven scudi from the artist. On the basis of the description, Loseries has identified it as Fig. A126, which is the only surviving tondo by Sodoma of this subject. Its style, which resembles that of his *Adoration of the Magi*, supports the connection.[58]

ARTISTS' RECORDS

Earlier artists' records of tondi also exist. In fact, the first is in the rare *bottega* book of Marco del Buono and Apollonio di Giovanni, which includes for the year 1452 a tondo painted on the ceiling (*cielo*) of Giovanni di Paolo Rucellai's loggia.[59] The sparse description does not tell us what, if anything, was in the tondo. The second citation, a work commissioned in 1453, is of a 'tondo da parto', apparently a round *desco da parto*.[60] However, the third reference is both more explicit and more significant for this study. It records the order in 1455 for a costly Madonna in a tondo for Pierfrancesco de' Medici.[61] The philological form used is still transitional, 'una Nostra Donna in un tondo' (rather than 'un tondo con la Nostra Donna'). Nevertheless, this source demonstrates that the concept of the tondo existed around mid-century (once again connected with the Medici).

This conclusion is supported by other documents from 1452–3 referring to a tondo commissioned from Filippo Lippi by Lionardo Bartolini. They prove that by this date a tondo was painted with an image of the Madonna and Child, which has been identified by some scholars as Fig. 7.3.[62] If these documents indeed refer to this tondo, they represent the first known reference to

[58] Loseries, 'Sodoma's "Holy Family" in Baltimore: The "Lost" Arduini Tondo'. Archivio di Stato, Siena, Notarile antecosimiano 1118, doc. 1401 (first published by Milanesi, *Documenti per la storia dell'arte senese*, iii. 123 ff., no. 65): 'Item, condanniamo li decti Arduini a restituire al decto cavaliere un tondo di mano di decto cavaliere, dove è dentro una Nostra Donna, una santa Lisabetta, et un santo Giuseppe, tutt'hora e quando el decto cavaliere darà a li decti Arduini scudi sette: el quale tondo se intenda doversi restituire con tutto li suoi fornimenti, cioè el festone dorato, nel essere che si trova.' Previously I also had connected it with the Walters tondo (App. n. 319).

[59] Callmann, *Apollonio*, 78, no. 78; ead., 'Apollonio di Giovanni and Painting for the Early Renaissance Room', 12, 15 n. 64. It survives in a 17th-c. partial copy, Biblioteca Nazionale Centrale, Florence, MS Magl. XXXVII, 305 (Spogli di Archivi del Sen^re. Carlo di Tommaso Strozzi, 1670). Fol. 62^v reads: 'A Giovanni di Pagolo Rucellai dipingono un tondo nel cielo della loggia, 1452, f. 9'.

[60] Callmann, *Apollonio*, 79, no. 108; fol. 63^r: 'a Giovanni d'Amerigo Benci dipingono un tondo da parto con l'historia di Salamone e della Reina di Sabba, per f. 9, 1453'.

[61] Ibid. 79, no. 113; fol. 63^r: 'Pierfrancesco di Lorenzo de' Medici fa fare due forzieri e una Nostra Donna in un tondo, per molto

prezzo, 1455'.

[62] See Ch. 7 n. 32. Borsook, 'Fra Filippo and the Murals for Prato Cathedral', 79–80, no. 63, for 8 Aug. 1452 (ASP, Ceppi 211): 'Lionardo di Bartolomeo Bartolini cittadino fiorentino de' avere adì viii d'aghosto 1452 fiorini ventidue d'oro larghi, è quali gli promettiamo per frate Filippo di Tomaso da Firenze dipintore della chapella maggiore della pieve di Prato, di dargl[i]ele per di qui adì viii di dicienbre prossimo che verrà 1452 in chaso che detto frate Filippo non gli avesse finito un certo tondo del legniame ch'e è del detto Lionardo, cioè di dipignerlo di certa storia che' gli aveva chominiciato della Vergine Maria. E posto che lla chapella debbi dare a libro verde debitori e creditori segnato E, c. 17.' She also includes later documents that she believes prove Lippi either never completed the tondo for Bartolini, or the sum was paid as a penalty because he did not finish it by 8 Dec. 1452 as promised. Ruda, *Filippo Lippi Studies*, 119–20; id., *Fra Filippo Lippi*, 240–4, 453–5, dates the *Pitti Tondo* stylistically to the 1460s and, therefore, does not believe it is related to the Bartolini documents. If Filippo had missed a delivery date, it could explain why the work languished in his shop and had a long gestation (it also may suggest something about the drawing on its reverse).

an extant independent Madonna and Child tondo. It is highly likely that they do, for the work's unusually large size (135 cm. diameter) asserts its autonomy (as opposed to a roundel) and importance, while its subsidiary scenes permit its probable identification (see Ch. 7).

PLACEMENT OF TONDI OUTSIDE THE HOUSEHOLD

Little is known about the original placement of tondi outside the domestic sphere, although the following paragraphs as well as material in Chapter 4 provide clues. The documents related to Filippino's Annunciation panels, Botticelli's tondo for the Massai della Camera, and the Ghirlandaio's twin panels for the room of the Gonfaloniere reveal that tondi could be commissioned for more public secular spaces. However, these buildings had a domestic dimension, because the priors and certain civic servants lived there temporarily, making it understandable why a devotional element was inserted into the decor. Much information about the locations of other tondi is circumstantial at best, frequently originating long after the works were commissioned.

For example, Vasari notes locations of various tondi in both the 1550 and 1568 editions of the *Lives*, but the value of his citations is disputable unless backed up by payment or commission documents, since they reveal only where he saw them. An extreme but classic and much-quoted instance was not even made by the sixteenth-century historian, but by his nineteenth-century editor, Gaetano Milanesi, who in his 1878 edition first claimed, without citing a source, that Botticelli painted a tondo for the Sala dell'Udienza del Magistrato de' Massai della Camera.[63] Although Horne, like subsequent researchers, was unable to trace a document to support Milanesi's contention (conjecturing that Milanesi had taken the information from a secondary source), he identified the tondo as Botticelli's *Madonna della Melagrana* (Fig. 7.19) on the basis of the lilies carved on its original frame and located the Udienza of the Massai della Camera in the Palazzo Vecchio.[64] These fleurs-de-lis (the Florentine *gigli*) on a blue ground clinch a Florentine republican dimension and suggest a civic connection, if not the exact commission itself.[65] With the discovery of the document cited above, it is possible to conclude that Botticelli did indeed paint a tondo for the audience hall of the Magistrato de' Massai della Camera, most probably the *Madonna della Melagrana*. Although the location of this Udienza is not known, other rooms of that body were in the Palazzo del Podestà (the Bargello).[66]

At this juncture, a twofold question should be asked: what function would a tondo of the Madonna and Child have had in this semi-public room, and are there other similar placements? Perhaps it had a protective civic function. An analogous rather than exact correspondence is found in images of the Madonna in Sienese civic buildings, including the large *Maestà* frescoed by Simone

[63] Vasari (Milanesi), iii. 322, after n. 3. Milanesi appended to the description of works by Botticelli and Ghirlandaio in the Sala dell'Udienza of the Palazzo della Signoria: 'nel 1487 dipinse un tondo per la Sala dell'Udienza de'Massai della Camera', perhaps leading to a belief that the Sala dell'Udienza de' Massai della Camera was in the Palazzo Vecchio. See Olson, '1487 Payment Document', 393–6, and above, n. 47. For works cited by Vasari, see Dabell, 'The Illustrated Vasari'.

[64] Horne, *Botticelli*, 153–4. Lightbown, *Botticelli*, ii. 65–6,

believes that a date of 1487 is stylistically correct although he does not commit himself on the identification.

[65] The Magistrato de' Massai della Camera consisted of two citizens who took account of all judicial sentences and were entrusted with all published records of a certain date (Varchi, *Storia fiorentina*, XIV. x. 47–8).

[66] Uccelli, *Il Palazzo del Potestà*, 111; Rubinstein, *The Palazzo Vecchio, 1298–1532*, 66 n. 184.

Martini in the town hall, the Palazzo Pubblico, *c.*1315—which is admittedly different since the Madonna was the patron saint of Siena.[67] Similarly, the partially destroyed fresco—once in a circular configuration—depicting St Anne before the Florentine Palazzo dei Priori (Palazzo della Signoria) with the Expulsion of the Duke of Athens, recently attributed to Orcagna, had a protective, civic function.[68] Botticelli's tondo may have implied that the Madonna's heavenly realm, symbolized by the perfection of the circle, presided over the transaction of justice by the Magistrato de' Massai della Camera, which would have been adjudicated ultimately by God. Although Church and state were theoretically separate, religion permeated the workings of Florentine government. Today, tondi with the Madonna and Child hang in the Palazzo Pubblico, Siena, and in the domestic quarters of the Palazzo della Signoria, Florence. Moreover, a frescoed tondo from 1490 in the Bargello is eloquent testimony to the trend, as discussed below.

Vasari mentions three other tondi in his life of Botticelli, offering tantalizing suggestions for their original placement but no proof.[69] But he offers a further clue about their primarily domestic function with the sweeping generalization that Botticelli made tondi for homes around the city.[70]

Vasari notes other tondi in his *Vite*, some of which can be hypothetically identified. For example, he cites a marble tondo by Giovanni Rustici, probably Fig. 6.38, in the chamber of a magistrate of the Arte di Por Santa Maria, where it may have been associated with the dispensation of justice.[71] Two tondi by Luca Signorelli without early provenances have been connected with paintings Vasari describes as executed by the artist in Florence, one for a semi-public place, the other private. His *Parte Guelfa Tondo* (Fig. 7.33) has been suggested as with the one Vasari saw in the audience hall of the captains of the Parte Guelfa and is another example of a tondo perhaps linked to justice.[72] Vasari claimed that the other Signorelli painting he saw, but did not identify as a tondo, was painted for Lorenzo de' Medici.[73] On the basis of its two grisaille prophets in roundels described by the historian, the reference has been linked convincingly to Signorelli's *Medici Madonna* (Fig. 7.32).[74]

[67] It is interesting that the seal of Siena that Simone Martini painted in the border contains a round, trencher-like form and a depiction of the enthroned Madonna, the Child, and two angels with candelabra (Kosegarten, 'Einige sienesische Darstellungen der Muttergottes aus dem frühen Trecento', fig. 18).

[68] It would have had a 241 cm. diameter if complete; now transferred to the Museo Bardini, Florence; Kreytenberger, 'Bemerkungen'. It proves that there was tradition for round civic paintings in the building (see Olson, 'The Tondo', 61 n. 97).

[69] (1) Vasari saw and reported (1568 edition) one with the Adoration of the Magi in the Casa Pucci (Vasari (Bettarini and Barocchi), iii. 514). It has been connected with a tondo in the National Gallery, London (M. Davies, *The Earlier Italian Schools*, 101–2; Lightbown, *Botticelli*, ii. 25). (2) He records in 1550 another with a Madonna and angels in San Francesco al Monte, now San Salvatore al Monte (Vasari (Bettarini and Barocchi), iii. 517), identified as Botticelli's *Raczynski Tondo* (Lightbown, *Botticelli*, ii. 53–4). (3) He also notes (1568 edition) a small tondo in the chambers of the Prior of the Camaldolese monastery of Santa Maria degli Angioli, Florence (Bettarini and Barocchi), iii. 520). Horne, *Botticelli*, 255–6, has connected it with the Madonna and Child and angels in the Pinacoteca Ambrosiana, Milan (Lightbown, *Botticelli*, ii. 82–3), while Fahy has linked it to one in the Art Institute of Chicago (Fahy, 'A Tondo by Sandro Botticelli').

[70] Vasari (Bettarini and Barocchi), iii. 513: 'Per la città in diverse case fece tondi di sua mano . . .'.

[71] Vasari (Milanesi), vi. 603: 'Condusse poi in marmo, un altro tondo simile, una Nostra Donna col Figliuolo in collo e San Giovanni Battista fanciulletto, che fu messo nella prima sala del magistro de' consoli dell'arte di Por Santa Maria.' Borghini, *Il Riposo di Raffaello Borghini*, 494; Baldinucci, *Notizie dei professori del disegno*, i. 571; see below, Ch. 6 n. 97. Another association of justice and civic virtue occurs in Beccafumi's Justice in a large roundel/tondo in the Palazzo Pubblico, Siena; Jenkins, 'The Iconography of the Hall of the Consistory in the Palazzo Pubblico, Siena', ill. See below, Ch. 4 n. 11. It would be interesting to investigate these links in more depth.

[72] Vasari (Bettarini and Barocchi), iii. 63; Borghini, *Il Riposo*, 366. Zervas, *The Parte Guelfa, Brunelleschi, and Donatello*, 185–9, pl. 82, for the audience hall. The *sala grande* of the Palazzo Parte Guelfa has tondi windows—oculi or *occhi*—by Brunelleschi. For the correlation of buildings and justice, see Wittkower, 'Centrally Planned Church', 6, on Alberti, who believed that justice was a gift of God (Alberti, *L'Architettura*, VII. i. 531); below, n. 91, and Ch. 4 n. 11.

[73] Vasari (Bettarini and Barocchi), iii. 636: 'dipinse a Lorenzo de' Medici . . . et un quadro di Nostra Donna con due Profeti piccoli di terretta, il quale è oggi a Castello . . .'.

[74] Seidel, 'Signorelli um 1490'; Kanter, 'The Late Works of Luca Signorelli and his Followers, 1498–1559', intro., believes that it dates after the death of Lorenzo de' Medici in 1492.

Yet Vasari's identification of the patron is problematic, as is the work's provenance from the Medici Villa of Castello in the seventeenth century, because there is no way of ascertaining from which branch of the Medici family it came—that of Lorenzo the Magnificent (implying a date before his death in 1492) or the collateral branch of Lorenzo di Pierfrancesco de' Medici (who may have been the patron of Botticelli's *Primavera*, which Vasari also saw at Castello).[75] Finally, Vasari mentions an Adoration of the Magi by Ghirlandaio, which he saw in the house of Giovanni Tornabuoni, a location which is supported by the aforementioned Pupilli inventory of 1497.[76]

Tondi that have not been moved since their creation or removed from their original site and tondi depicted in works of art provide additional evidence regarding the locations for which tondi were commissioned. Examples of the former category include several illusionistically painted examples in the non-portable medium of fresco.[77]

These frescoed tondi were mostly commissioned for semi-public spaces, although they were intended to duplicate illusionistically the effect of actual painted panels. Executed in *buon fresco*, they would have been faster and cheaper than panels. One early sixteenth-century example in Pistoia, a Madonna and Child embracing young St John surrounded by a garland frame with fruit, was originally on the important first-floor entrance wall of the Palazzo Comunale.[78] Because all aspects of fifteenth- and sixteenth-century life still included a religious dimension, a devotional image of the Madonna and Child was part of the fabric of everyday life, and in this case of the men who governed this Tuscan town. Two detached frescoes of Madonna and Child tondi by Fra Bartolomeo, dating *c*.1514–16, have an indeterminate provenance but probably were from somewhere in the San Marco complex (Fig. 3.4).[79] Perhaps the best-known frescoed Madonna and Child tondo is by Sebastiano Mainardi (Fig. 3.5); it had both a civic and religious context in the Chapel of the Bargello, known as the Cappella del Podestà or the Chapel of St Mary Magdalene.[80] It is illusionistically set in a bejeweled round frame inside a *trompe l'œil* framing device resembling *pietra serena* and marble. A *tabula ansata* that overlaps various parts of the frame is inscribed: · *VIRGINI · EXORATAE · / PANDVLPHVS · COLLENV · / · PRAETOR · / VOTO · SVSCEPTO.* Below it is the date: *AN · SAL · MCCCCXC.* The tablet and its inscription *all'antica* result from the humanist inclinations and epigraphical interests of its patron, Pandolfo Collenuccio, *podestà* in 1490. It is balanced on the left of the altar by Mainardi's rectangular fresco of St Jerome praying in the wilderness (1490), also rendered illusionistically as an independent panel. These two paintings spoke to the devotional needs of the inhabitants of the Bargello and functioned as dedicatory votive offerings by two of the *podestà*. Perhaps they were incorporated into the earlier decoration of the

[75] Shearman, 'The Collections', 12–27; W. Smith, 'On the Original Location', 31–40; Lightbown, *Botticelli*, ii. 51–3.

[76] See above, n. 18. Vasari (Bettarini and Barocchi), iii. 479. There are two copies or derivations: one a shop reduction in the Galleria Palatina of the Palazzo Pitti (De Benedictis, 'Vicende e trasformazioni dell'Ospedale di Santa Maria di Orbatello', 31–2) and another in England (Küppers, *Die Tafelbilder des Domenico Ghirlandaio*, 30–3; Van Marle, *Development of the Italian Schools*, xiii. 263; and below, Ch. 7 n. 60).

[77] Hauptmann, *Der Tondo*, 22, only touched on the topic.

[78] With a *c*.240 cm. diameter. Mazzi, *Museo Civico di Pistoia: catalogo delle collezioni*, 35, ill. In 1916 it was transferred to cloth and placed in the museum. D'Afflito *et al.*, *L'età di Savonarola, Fra Paolino e la pittura a Pistoia nel primo '500*, 147–8, no. 17, ill., assigns it to Marco di Domenico Rossermini and dates it *c*.1520–5, together

with a tondo in oil on panel with a 75 cm. diameter in the same location (ibid. 148, no. 18, ill.).

[79] Inv. nos. 1890-8521 with a 66 cm. diameter and 1890-8523 with a 64 cm. diameter, both in fresco on terracotta in the Museo di San Marco, Florence. The records of the Soprintendenza state that they are from San Marco and cannot be traced before the Napoleonic suppression. Padovani *et al.*, *L'età di Savonarola: Fra' Bartolomeo e la Scuola di San Marco*, 203–6, nos. 61–2, ill., argues against suggestions of earlier provenances (e.g. Datini, *Musei di Prato*, 25, no. 38, ill.), stating that they have no documentary basis.

[80] Its rectangular frame measures 173 × 154 mm. See Florence, Museo Nazionale del Bargello, *Eredità del Magnifico 1492–1992*, 151, no. 127; Venturini, 'Tre tabernacoli di Sebastiano Mainardi' (also ead., 'Bastiano Mainardi', 391–2).

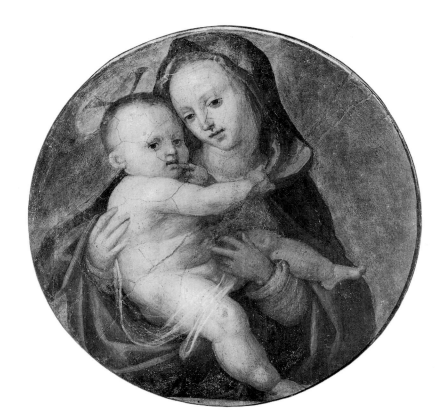

FIG. 3.4. Fra Bartolomeo, *Madonna and Child*, c.1515–16. Museo di San Marco, Florence

FIG. 3.5. Sebastiano Mainardi, *Madonna and Blessing Child*, 1490. Museo Nazionale del Bargello, Florence

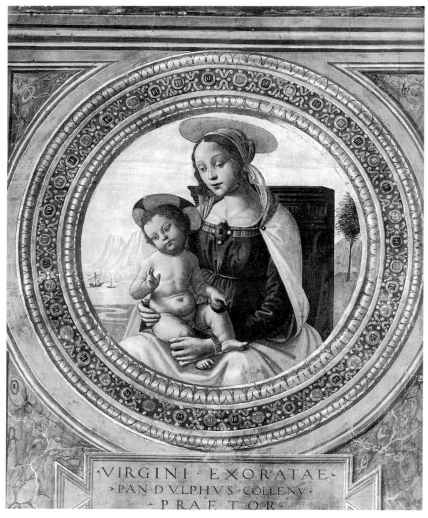

VIRGINI · EXORATAE ·
· PAN·D·VLPHVS · COLLENV ·
· PRAE·T·O·R ·

chapel to lend a more domestic dimension to this residence, while the tondo also carried ideas about divine justice for the judge as well as those judged. In addition, the tondo was a quick way of making the decoration of the chapel more *au courant*. Above all, this frescoed example provides concrete evidence that by the 1490s tondi were pervasive Florentine devotional forms. And, a frescoed tondo by Pintoricchio—over the door of the Sala dei Santi in the Vatican (Fig. 3.6)— proves that the form had spread to the centre of Christendom by the final decade of the century.[81]

Two later frescoed tondi by the eclectic painter Vincenzo di Benedetto di Chele Tamagni further illustrate the dissemination of the form in Tuscany. One, a Madonna and Child, is in its seemingly original location in a back room of the *piano nobile* of the Palazzo del Popolo of the artist's native town of San Gimignano (Fig. 3.7). In the centre of the lower portion of its wreath is an indecipherable coat of arms, which seems to include an object resembling a chalice. A partly defaced inscription outside the circumference on a banderole (*NICHOLO. DIZANOBI . . . AB MD . . . VIII[I?]*) refers to its patron, Niccolò di Zanobi Fabrini, who was *podestà* in 1526 and commissioned the work for the town hall.[82] While Tamagni was assisting Sodoma at Monteoliveto, he frescoed another tondo, this time of the Madonna and Child with St Benedict (Fig. 3.8), in a domestic ecclesiastical setting.[83] This patron saint of the Benedictine order, identified by his habit and halo, adores the Madonna and the Child from a point of view slightly behind the holy duo, thus serving as an *exemplum* during devotions for the brethren of the monastery. The tondo is framed by a *pietra serena* moulding, resembling a window into heaven, whose illusionism is increased by the Madonna's overlapping halo.

Finally, there are two sculpted tondi that also seem to have secure provenances outside the domestic sphere. One is Donatello's *Madonna del Perdono* for the Sienese Duomo (Fig. 6.5) (see Ch. 6), and the other Luca della Robbia's Madonna and Child tondo for the Arte dei Medici e Speziali on the façade of Or San Michele (see Ch. 4). In both these cases, the Madonna was the patron of the commissioning body.

EVIDENCE FOR TONDI IN WORKS OF ART

Since the Quattrocento possessed a strong naturalistic aesthetic, it is perplexing that few tondi are represented in works of art from the period. There are only eight that I can identify at this time. Several of these are not fully autonomous forms, almost all of them are sculpted examples, and two are problematic. The earliest are sculpted examples that are transitional between roundels and independent tondi. The first, which dates from the 1450s, occurs in one of the narrative scenes on Donatello's bronze altar for Sant'Antonio, Padua.[84] Its round form, enclosed in a wreath, inscribes

[81] Goffin, *Pinturicchio*, 57, ill.; Redig de Campos, *Wanderings among the Vatican Paintings*, 40. Another frescoed tondo, a Madonna and Child with four angels attributed to Ercole Banci c.1506, is in a lunette of the Bentivoglio Chapel, San Giacomo, Bologna (Stagni, 'Alcuni ampliamenti per Ercole Banci', 97, fig. 68). Its unusual religious setting may be explained by its relatively late date, its origin outside Tuscany, and the nature of the family chapel, with its domestic dimension.

[82] Inv. no. 158 in the Pinacoteca, Museo Civico, San Gimignano

(sala III), with a diameter of c.87 cm. Pecori, *Storia della terra di San Gimignano*, 572, nos. XII–XIII, 751, lists the *podestà*. Its edges suggest it has been moved.

[83] It is now detached but was once in the *vestiaria*. Cust, *Giovanni Antonio Bazzi*, 101, ill.; Minucci and Carli, *L'Abbazia di Monteoliveto*, 80, 83.

[84] The Miracle of the Speaking Babe; Kecks, *Madonna und Kind*, fig. 30.

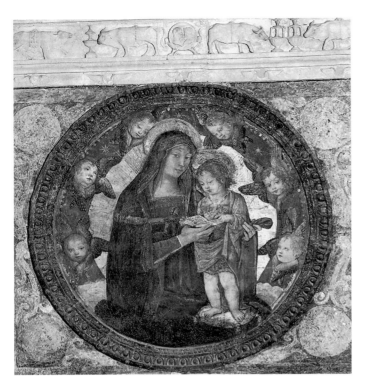

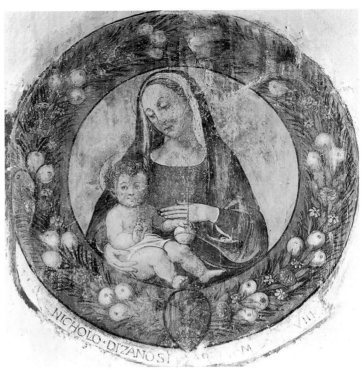

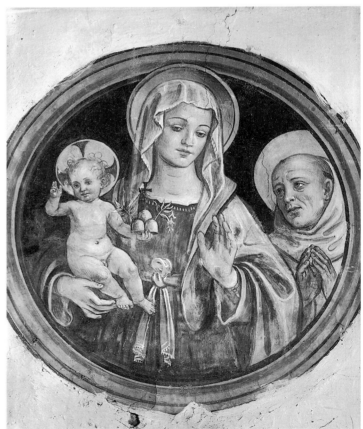

FIG. 3.6 (*above*). Bernardino Pintoricchio, *Madonna and Child with Angels*. Sala dei Santi, Borgia Apartments, Vatican

FIG. 3.7 (*above, right*). Vincenzo Tamagni, *Madonna and Blessing Child*, dated 1528? Museo Civico, San Gimignano

FIG. 3.8. Vincenzo Tamagni, *Madonna and Blessing Child with St Benedict*, sixteenth century. Abbey, Monteoliveto

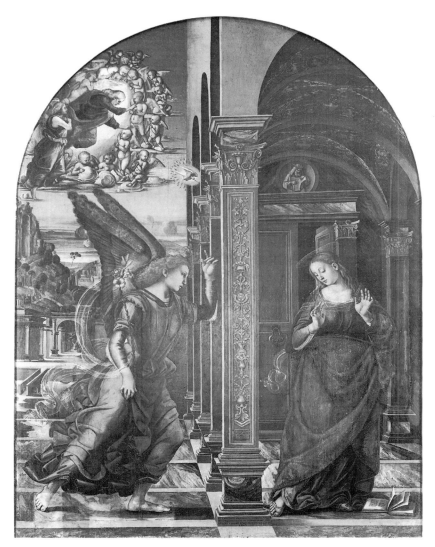

FIG. 3.9. Luca Signorelli, *Annunciation*, 1491. Galleria Comunale, Volterra

FIG. 3.10. Gherardo di Giovanni, *Sculptor in his Workshop*, from an Aesop's *Fables* in Greek, (MS 50, fol. 47ᵛ), *c*.1480. Spencer Collection, New York Public Library

FIG. 3.11. Anonymous, Woodcut illustration from Girolamo Savonarola's *Predica dell'arte del bene morire* (Florence, 1497; first edn., 1496)

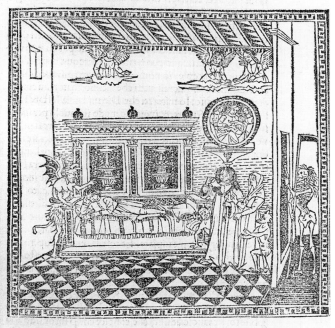

li tucti appartengono ad te che se fano: ma debbi pensare che ad ogni hora tu puoi infermarti & morire: perche questo pensiero della morte e i regula molto utile nella uita spirituale. Horsu questo basti quanto alla prima cartha dellibro che io ti ho decto che tu tifaccia dipingere. Vegnamo hora alla seconda cartha.

La secuda cartha che io ti dissi gia altra uolta e i questa che tu ti facci dipingere uno huomo cominciato ad ifirmarsi cõ

FIG. 3.12. Andrea del Sarto, *Birth of St John the Baptist*, 1526. Chiostro dello Scalzo, Florence

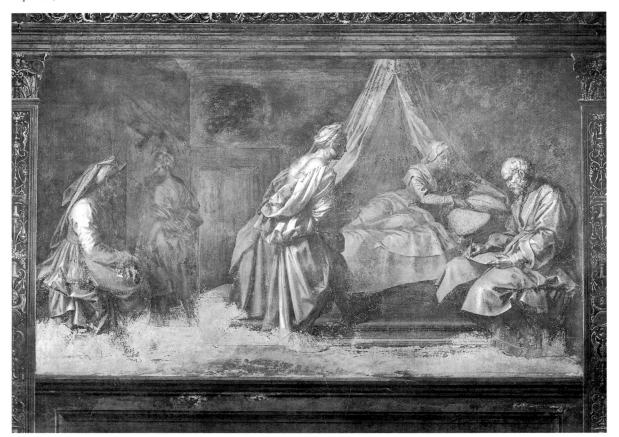

a half-length Madonna and Child in a lunette analogous to others found on contemporary Florentine tombs, such as those of Bruni and Marsuppini in Santa Croce. The second example, from the 1490s, is in Botticelli's small *St Augustine in his Study* (Galleria degli Uffizi).[85] Its half-length Madonna and Child grisaille roundel is again inscribed by a wreath and in a lunette, while in the squinches of the outside arch are grisaille profile portraits *all'antica* in smaller roundels. This juxtaposition demonstrates Botticelli's profound visual connection—between ancient and modern round forms and between secular and religious representations—to show that St Augustine was part of Roman civilization as well as the Christian tradition. Signorelli painted a third, more independent example in his *Annunciation* of 1491 (Fig. 3.9), in grisaille with a plain, flange-like edge, containing a bust of King David playing a harp, above the door to the Virgin's bedchamber.[86] Since the Annunciation took place while the Virgin was residing in Joseph's house, and because Joseph was a descendant of the House of David, by association so was the Virgin. Thereby Christ's lineage was traced from that royal house—an important issue in late quattrocento theology reflected in tondi. The fourth example is a similar sculpted tondo (depicting this time the Sacrifice of Isaac, a prefiguration of Christ's Sacrifice) painted by Fra Bartolomeo in his 1497 *Annunciation* in the same church. It is framed by elaborate sculpted dolphin (symbolic of Christ's Death and Resurrection) *grotteschi* and a crowning set of wings.[87] In this Old Testament footnote, referring to the past and future, Fra Bartolomeo paid homage to Signorelli's important motif. In both cases, the tondo form is linked with conception and birth.

The most significant representations for our purpose, because they represent autonomous tondi, are the last four. (1) On folio 47ᵛ of a fifteenth-century manuscript of Aesop's *Fables* illuminated by Gherardo di Giovanni, possibly for the Medici, a sculptor is shown in his *bottega* carving a huge marble tondo with a central seated figure in relief (Fig. 3.10).[88] (2) A woodcut illustration included in the 1496 edition of Savonarola's *Predica dell'arte del bene morire* (Fig. 3.11) contains the only fifteenth-century depiction known to this author of an independent tondo *in situ* in an domestic interior. It features a Madonna and Child with two angels and is positioned on top of a *mensola* above eye level.[89] Its high placement accords with a 1510 citation in the MPAP inventories, which seems to be the only definitive written record published to date that indicates at which height tondi were positioned.[90] Other tondi mentioned above, like the Mainardi fresco, suggest that a high placement was probable, at least in many cases. This is further supported by the fact that many late quattrocento rooms were decorated with painted *spalliere*, while bedrooms would have had beds with high headboards and probably a *lettuccio* with a high back, as in the Savonarola illustration. In addition, a number of tondi appear to have been executed with the viewer's vantage point calculated from below. (3) A drawing of a torture scene by Beccafumi shows a Madonna and Child

[85] Lightbown, *Botticelli*, ii, fig. 44.

[86] Salmi, *Signorelli*, 50, pl. 17.

[87] Knapp, *Fra Bartolommeo della Porta und die Schule von San Marco*, 29, fig. 11; J. Hall, *Dictionary*, 105–6. Creighton Gilbert (letter of 19 June 1995) pointed out that the Sacrifice of Isaac also prefigures the Nativity, because as Mary says in the 'Magnificat', Abraham then received God's promise of his seed, which Christ fulfilled. More exactly, aspects of the story of Abraham and Isaac in Genesis foreshadow events in Christ's.

[88] *Aesop's fables. English and Greek. The Medici Aesop: Spencer MS 50 from the Spencer Collection of the New York Public Library*, fol. 47ᵛ.

Until the frontispiece is discovered its owner cannot be identified, but from an inventory of 1495 we know that Piero de' Medici owned an illuminated copy of Aesop's fables with a Greek text.

[89] The illustration is the 'seconda carta' facing leaf 64ʳ in the second of four editions, 1497. The panel either leans against the wall or is attached to it. Kecks, *Madonna und Kind*, pls. I ff., reproduces rectangular devotional paintings *in situ*.

[90] 1510, MPAP 183, fol. 300ʳ: '1º Nostra Donna tonda, di sopra, dorata intorno cho'l figliuolo e Santo Giovanni.' 15th-c. Florentines had a tendency to place decorations over doors and above *spalliere* (see Thornton, *Interior*, 48).

tondo placed over a door above a judge sitting at his desk.[91] (4) The ghost of a tondo is also highly placed, painted *a secco*, above the door in Andrea del Sarto's monochrome fresco of the Birth of St John the Baptist from 1526 (Fig. 3.12). Although this area is too damaged to ascertain precisely what was once painted there, a garland of leaves and fruit can be made out on the plaster. At its centre one can discern a faint face (of the Child?), while the Madonna's may have been positioned at the upper right.[92]

SCULPTED TONDI

Sculpted tondi depicted in works of art help to pinpoint the genesis of tondi more precisely. Although Hauptmann theorized that tondi evolved under a strong impetus from Brunelleschi and subservient sculptural roundels in architectural contexts (after Antonio Rossellino's *Monument of the Cardinal of Portugal* of *c*.1461),[93] rather it seems that autonomous tondi had antecedents in smaller, sculpted devotional images. For example, Luca della Robbia's *Fortnum Madonna* (Fig. 3.13), which has an inscription on its reverse with the date of 1428 (1429 NS), suggests an even earlier genesis for the independent tondo on a small scale. Pope-Hennessy believes that the surface of this pigmented stucco squeeze with a 40 cm. diameter implies an earlier, now lost bronze original.[94] Another sculpted example is Donatello's *Chellini Madonna* (Fig. 3.14), a parcel-gilt bronze medallion-like form with a diameter of *c*.28.5 cm. and a flange with an undeciphered inscription in pseudo-Kufic, gilded letters. It has an exact negative impression/mould in reverse for casting in glass or other media.[95] This experimental work is the only Madonna relief by Donatello that can be dated securely. It must date prior to 27 August 1456, when the sculptor presented it to his esteemed physician Giovanni Chellini Sanminiati, who described it in his *Ricordanze*.[96] Not only does Chellini record a *terminus ante quem*, but he also uses the word 'tondo' and compares it in size to a *tagliere*, which it resembles and which was one of the objects in early fifteenth-century inventories that the adjective 'tondo' frequently modifies. In conclusion, these two objects suggest that prior to the 1440s and 1450s, the few independent sculptural objects that could be labelled tondi were small in scale and were generally made in malleable media—wax (later cast in bronze), stucco, and terracotta—to facilitate experiments in mass production, as further discussed in Chapter 6.[97]

[91] See Collobi Ragghianti, *Il libro de' disegni del Vasari*, i. 132, ill. For the connection of tondi with justice, see Ch. 4 n. 11.

[92] See R. Monti, *Andrea del Sarto*, fig. 217, for its preparatory drawing that is different in the left part of the composition, where a trencher or deep tray is propped up on a washstand, and nothing is depicted over the door on the rear wall. Shearman, *Andrea del Sarto*, ii. 306–7, ill.

[93] Hauptmann, *Der Tondo*, 16 ff.; Kecks, *Madonna und Kind*, 45, argues against him, noting a trecento movement towards the form in Giotto, Giovanni Pisano, and Tino da Camaino, and citing Paatz (*Die Kunst der Renaissance in Italien*, ii. 95) and his concept of the trecento monumentalization of the round format.

[94] See Ch. 6 n. 9. Pope-Hennessy, *Luca della Robbia*, 249, no. 22, ill. It is incised with two circles, around which are petal-like lappets, enclosing the inscription: 'formato adj 17 di gennaio 1428' (1429 NS). Within is a crown inscribed: 'formosi[?] nel/chasotto di Nich/olo i chossa'. The inscription is generally thought to be original.

[95] See Ch. 6 n. 16; Darr *et al.*, *Italian Renaissance Sculpture in the Time of Donatello*, 131–2, no. 28, ill.

[96] Radcliffe and Avery, 'The *Chellini Madonna* by Donatello', 377–8, quote the *Libro debitori e ricordanze* of Chellini: 'Ricordo che a di 27 d'Agosto 1456 medicando io Donato chiamato Donatello . . . egli per sua cortesia e per merito della medicatura che avevo fatta e facevo del suo male mi donò un tondo grande quant'uno tagliere nel quale era scolpita la Vergine Maria col bambino in collo e due Angeli da lato, tutto di bronzo e dal lato di fuori cavato per potervi gittare suso vetro strutto e farebbe quelle medesime figure dette dall'altro lato.' It is significant that Chellini notes it was the size of a trencher (*tagliere*), a standardized measurement in maiolica vessels. Radcliffe and Avery report five holes through the flange (four plugged with copper) and date it before 1453 (p. 384).

[97] Radcliffe and Avery have suggested that these smaller objects, also reproduced in cheap materials from a master mould and painted, made up a distinct class produced for domestic devotions (ibid. 383).

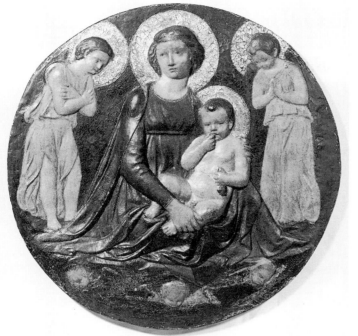

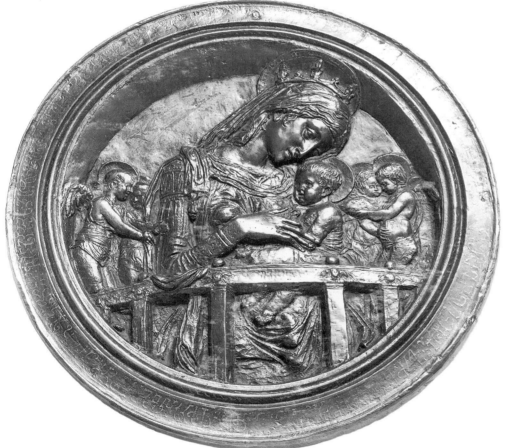

FIG. 3.13(*a*) (*above, left*). Luca della Robbia, *Fortnum Madonna*, 1428. Ashmolean Museum, Oxford

FIG. 3.13(*b*) (*above, right*). Reverse of Fig. 3.13(*a*)

FIG. 3.14. Donatello, *Chellini Madonna*, before 1456. Victoria and Albert Museum, London

Another small bronze relief of a Madonna and Child and two angels attributed to Donatello (with a 27 cm. diameter and dated to *c*.1443 on stylistic grounds) has a separate marble surround designed as a display tabernacle and offers evidence about how these small-scale tondi that resemble medallions might have been displayed (Fig. 6.4).[98] The experimental nature of this bronze is characteristic of Donatello, for it not only alludes to antique prototypes but also foreshadows, in its protruding edge, the customary framing device of subsequent tondi. The fact that its frame is in a different medium underlines its independence and raises the issue of how some of these smaller objects may have been displayed (hung or propped, as in the Savonarola illustration) with or without elaborate framing devices.[99]

DISTILLATION OF THE EVIDENCE

We can conclude the following points from the documentary evidence. Tondi were commissioned for domestic quarters both by lay persons and the clergy and for more public buildings with a domestic dimension. Tondi can be linked formally with *deschi da parto*, a conclusion reinforced by philological and documentary evidence. While the two earliest painted tondi extant both contain depictions of the Adoration of the Magi, they are neither documented nor dated precisely (assigned dates, based on internal evidence and style, range from the late 1430s to the early 1450s). Although the development of sculpted tondi is less easy to chart, these objects appear at least by *c*.1428, although it is only around mid-century that they begin to have any noticeable presence. At this same time the term 'tondo', surely an abbreviation of a longer term and connoting a distinct entity, surfaces in documents of the 1450s referring to a devotional work with a Madonna and Child. It is, therefore, no coincidence that the earliest surviving tondo painted with a Madonna and Child (Fig. 7.3) has been dated to that time. These are followed by a proliferation of the form during the tondo's apogee between 1480 and 1510, a time of growing religiosity and civic-mindedness. This conclusion is born out not only by those that survive but also by documentary evidence. Thus, there exists a close correlation between the documents and the physical evidence. One seems neatly to reinforce the other.

[98] See Ch. 6 n. 13; its marble frame has traces of gilding and measures 88 × 51 cm.; Darr *et al.*, *Italian Sculpture*, 134–6, no. 30, ill., notes copies and adaptations.

[99] Another solution is found in a tondo (inv. no. 2303 in the Staatliche Museen zu Berlin — Preußischer Kulturbesitz), a variation of the *Fortnum Madonna*, in stucco with a circular wooden frame and a 53.5 cm. diameter (Schottmüller, *Bildwerke des Kaiser-Friedrich-Museums: Die italienischen und spanischen Bildwerke der Renaissance und des Barock*, i. 30–1; Radcliffe and Avery, 'Chellini Madonna', 383, fig. 32, mistakenly think it functioned as a *desco da parto*).

4

SETTING, FAMILY, AND THE FUNCTION OF DEVOTIONAL TONDI

Enlarging on evidence presented in the previous chapter, we now turn to the setting and the function of devotional tondi, because the function of portraits, which are commemorative, is more clear-cut.

SETTING

It seems that the majority of devotional tondi were commissioned by lay individuals and placed in homes, frequently in the private *camera* of the householder, although some were commissioned by ecclesiastics, presumably for their devotional needs in private quarters. By the late Quattrocento, a few tondi are recorded in more public locations, such as town halls, but most of these are documented in sites with a domestic dimension (Fig. 3.5). Others, especially those in glazed terracotta, have occasional provenances—the majority too late to determine an original location—from religious institutions with domestic quarters.

While it would be a mistake to overemphasize the distinction between public and private works, artists seem to have been allowed greater flexibility in religious works for the home. Removed from the sacred context of the church and its liturgical needs, tondi did not have the hieratic constraints regulating altarpieces, which also under the prevailing naturalistic aesthetic and increasing secularity sometimes even included anecdotal incidents. The connection of tondi with the domestic sphere allowed artists a certain licence in their execution, as proven by Alberti's comments about the private rooms of *palazzi* (where most tondi were placed): 'we may allow ourselves more liberty in departing out of the common road, and contriving something new'.[1] Alberti also had bestowed a quasi-magical aura on the private apartment for the purpose of childbearing in a passage suggestive of one possible function of tondi.[2]

Historians of the Renaissance have demonstrated that the domestic realm had a great importance in fifteenth-century Florentine urban life, and it was in town rather than in the country where tondi tended to be situated.[3] Before the Trecento, the decorative arts had hardly penetrated

[1] Alberti, *Ten Books on Architecture*, 188. According to Lydecker, 'The Domestic Setting', 3, this more flexible environment did much to foster notions about the fine arts that are still valid today.

[2] See above, Ch. 1 n. 71.

[3] No tondi are recorded in any of the villas surveyed in the Medici inventories, although other devotional paintings are listed.

the domestic sphere, although by the Quattrocento the domestic world had come into its own, both as a physical place and as a set of values.[4] As larger, unfortified palaces were built, often by newly rich merchants, different kinds of objects were needed for their vast, novel rooms, which usually were decorated on the occasion of marriages. Much of the motivation behind the new construction lay in the desire to provide tangible evidence of the patron's and his family's status, although motives were mixed and tinged with civic consciousness as well as aesthetic pleasure.[5] This construction activity created a market demand for *deschi, cassoni*, maiolica, and the decorative arts which, it seems, by the mid-fifteenth century encompassed tondi. The secularization of art, a trend in which tondi participated, is traditionally tied to this process of domestication. A rethinking of interior spaces that accompanied these *palazzi*, many of them larger than earlier buildings, and changing tastes resulted in the alteration of interior wall treatments. The old system of painting walls to simulate tapestries gave way to one with *spalliere*, allowing for free wall space on which to hang art, including tondi, which it seems (Ch. 3) were usually displayed at a high level (Fig. 3.11).[6] These trends went hand in hand with a change in lifestyle that resulted from the relaxation of sumptuary laws.[7] All these factors encouraged a lessening of religious demands made on works of art and an increased sensitivity to artists (the individual creativity factor) to create an environment for tondi to flourish.[8]

The rise of tondi also coincided with a change in the format of altarpieces and devotional objects, a shift away, beginning in the 1430s, from intricate pinnacles and tabernacles in harmony with Gothic tastes to simpler formats around mid-century.[9] At this time, the tondo became the second option for devotional works after the rectangle. While the rectangular format was more secular and neutral, and was linked with the idea of a perspectival window, the round format immediately implied holiness, as had the tabernacle, signalling overtly a profound religious statement. Instead of immediately suggesting a church as the tabernacle did, the tondo connoted heaven and the cosmic movement of its spheres. Gradually, as the format became popular, more artists responded to its formal requirements instead of creating a rectangular composition cut by a circular, window-like frame. To compliment their setting, themes (and symbols) appropriate to the domestic sphere were introduced that were less formal than that of the early Adoration of the Magi scenes, for example, intimate portrayals of the Madonna and Child or the Holy Family, sometimes with saints who comprised the extended Holy Family. Further, unlike many rectangular devotional works, the majority of which featured only the Madonna and Child, the shape of the tondo begged for additional *dramatis personae* at the sides.[10]

The presence of a tondo in a town hall, a building where governing individuals lived temporarily, lent a domestic tenor to the seat of government. Perhaps its presence implied that the holy individuals depicted presided over civic destiny, which was under the aegis of divine grace.

[4] Callmann, *Beyond Nobility: Art for the Private Citizen in the Early Renaissance*; Goldthwaite, *The Building*, 401 ff.; Lydecker, 'The Domestic Setting'; Thornton, *Interior*; Welch, *Art and Society in Italy 1350–1500*, 277–311.

[5] Goldthwaite, *The Building*, 406 ff., discusses the motivations behind these structures (including tax shelters) and the effects they had on society and culture. Baxandall, *Painting and Experience*, 3, focuses on Giovanni Rucellai's palace and patronage.

[6] Schiaparelli, *La casa fiorentina e i suoi arredi nei secoli XIV e XV*, 141 ff.; Martinelli, *The World of Renaissance Florence*, 59 ff.;

Callmann, 'Apollonio di Giovanni', 5 ff.; Thornton, *Interior*, 32 ff.; Barriault, *Spalliera Paintings of Renaissance Tuscany*. Schiaparelli, *La casa fiorentina*, 177, notes that in the Trecento there were devotional paintings in bedrooms, and that the majority of objects were hung on the walls and some above the doors (p. 194).

[7] Goldthwaite, *The Building*, 401; Rainey, 'Sumptuary Legislation in Renaissance Florence'.

[8] Goldthwaite, *The Building*, 408 ff..

[9] Thornton, *Interior*, 264, dates it to mid-century.

[10] See Kecks, *Madonna und Kind*, for rectangular examples.

Similarly, in cases where a tondo was located in the chamber of a magistrate, its image of the Madonna and Child implied that the administration of justice meted out in that room ultimately was adjudicated by God. That idea was, in fact, inherent in the tondo format itself, as articulated in Andrea Palladio's later characterization of the circle, echoing Neoplatonic ideas: 'la Unità, la infinita Essenza, la Uniformità, e la Giustitia di DIO'.[11]

As the naturalistic impulses of the Quattrocento matured, the Virgin and Child in art and literature began to resemble mortals, and the settings in which they were depicted became more worldly to resemble quattrocento interiors or landscapes. Concomitantly, artists began to relate the space of the viewer to that of the holy personages depicted, encouraging pictorial mimesis in which holy people became the idealized models of a perfected world. It is not surprising, therefore, that as tondi became more popular, the Holy Family was an increasingly important subject. This is especially true with the painted variety, which enjoyed a broader range of subjects than their cousins in sculpture. Since tondi were frequently located within the *camera*, the family's private space, the Holy Family theme was relevant to patrons and their notion of family. It is logical, therefore, that tondi preserve reflections of the sociological and religious trends of contemporary society.

One of these trends that impacted on images in tondi was the continuing escalation of the Virgin's status during the Quattrocento, although a major controversy arose in the thirteenth century, and increased in vehemence in the fifteenth, between the Maculists and Immaculists about the question whether Mary was exempt from Original Sin. While the Immaculists argued that she was foreordained by God as free from sin, the Maculists held that she was conceived with Original Sin but that it was removed either at the Incarnation of Christ, at the Annunciation, or that she was sanctified in her mother's womb.[12] First the Benedictines and eventually the Franciscans became the proponents of the Immaculate Conception, while the Dominicans were its opponents (although St Thomas Aquinas accepted the Theory of Sanctification). In 1474 Pope Sixtus IV, a Franciscan, approved a new office for the feast of the Immaculate Conception by the Franciscan apostolic protonotary Leonardo Nogarola. This act constituted a semi-official recognition. In 1480 Sixtus accepted a second office, contained in the 'Mariale' written by Bernardino de' Busti, together with the Mass of Conception, while in two bulls of 1482 and 1483 he imposed silence on the two contending factions.

It is thus no coincidence that the popularity of the tondo accelerated after the inception of the papacy of Sixtus IV (9 August 1471). Most likely, the connotations of the tondo's form were interpreted as underlining the sinlessness of the Virgin, suggesting that depictions of the Annunciation in a round format may have been especially strong arguments for the Maculist point of view. Shifting theological ideas and lack of a fixed point of view regarding the doctrine of the Immaculate Conception resulted in artists illustrating it through images established for other

[11] Palladio, *Quattro libri dell'architettura*, IV. ii. S253, echoes Ficino, *Commentary on Plato's Symposium on Love*, 45. The association also appears in the *rota sacra romana*, the Roman Catholic tribunal for judging cases brought before the Holy See, whose name derives from the circular table used while the papacy was in Avignon (*Oxford Dictionary of the Christian Church*, 1205). The circle of the cosmos or a mappamondo was also associated with Justice in frescoes in the Sienese town hall by Taddeo di Bartolo; Kupfer, 'The Lost Wheel Map of Ambrogio Lorenzetti', figs. 3–7.

See also Ch. 3 nn. 72, 91.

[12] Prior to that time, there were three major theories: (1) the Purification Theory, that Mary's exemplary life exempted her; (2) the Sanctification Theory, that Mary was sanctified in her mother's womb and born free from Original Sin; and (3) the Immaculate Conception Theory, that she was conceived free of sin (not proclaimed dogma until 8 Dec. 1854). Levi D'Ancona, *The Iconography of the Immaculate Conception in the Middle Ages and the Early Renaissance*; *Oxford Dictionary of the Christian Church*, 692–3.

contexts and via theological ideas already accepted by the Church, for example, the Nativity, the Assumption of the Virgin, the Annunciation, King David, and images of the Virgin in heaven.[13] At the very least, the topical nature of this controversy encouraged the popularity of tondi. In addition, specific ideas related to it occasionally find reflection in tondi, such as the unusual birth of Mary from the Protoevangelium of James included by Lippi in his *Pitti Tondo* (Fig. 7.3), which argues the Immaculist view, while the Meeting of Anna and Joachim illustrates the feast of the Immaculate Conception in a neutral way.[14] By the Cinquecento, the Immaculate Conception was generally accepted, and the Council of Trent (1545–63) declared that Original Sin did not pertain to Mary. The lessening of this controversy, together with the problems of the Reformation, helps to explain the decline in tondi after the century's second decade.

THE FLORENTINE QUATTROCENTO FAMILY AND ITS RELATIONSHIP TO TONDI

Changes in the family structure and priorities both encouraged the popularity of tondi and found reflection in these domestic works. Statistics reveal a trend towards simpler configurations in Florentine families during the Quattrocento, although they developed in different typologies in urban and country environments. While the urban lower and middle classes tended to have simpler, more mononuclear families, it was the wealthy who lived in extended families with multiple households.[15] Nevertheless, the evolution of families had many variables.[16] After the devastating waves of plague in the Trecento and its decimating effects on population, the family's survival and perpetuation through procreation were important issues.[17] As we have seen, the emphasis on fertility, the woman's role in society, and the appearance of *deschi da parto* are related to this situation (Ch. 1). Further, the appearance of tondi in the first third of the Quattrocento belonged to the same fallout and can be linked to the shifting patterns in the family. Although most tondi contain images of the Madonna and Child, a cinquecento tondo with the representation of Adam and Eve (Fig. A50) shows a humanistic association between tondi and the first family from Genesis. Tondi held an important message for a domestic context and the woman of the household, whose value was measured in her fertility and ability to provide heirs (as well as her chastity).

A barometer of the emphasis on families during the post-plague era is the increase in the number of treatises concerning families and the habit of writing *ricordanze* or *ricordi*.[18] These authors sought to foster a taste and respect for, even a mystique of, family life.[19] The well-known treatise on the family by Cardinal Giovanni Dominici (d. 1419) is such a practical tract, one whose influence definitely can be seen in tondi.[20] Perhaps the most important was Leon Battista Alberti's *Della*

[13] Levi D'Ancona, *Immaculate Conception*, 15 ff.

[14] Ibid. 44 ff. Ruda, *Fra Filippo Lippi*, 243, argues that it supports a Maculist point of view.

[15] Goldthwaite, *Private Wealth*, sees the emergence of the nuclear family, an interest in domestic life, childhood, individualism in politics, large-scale domestic architecture, and family monuments as developing concurrently. See also Martines, 'The Family: The Significance of a Tradition', 152 ff.; Laslett and Wall, *Household and*

Family in Past Time; Kent, *Household and Lineage*; Herlihy and Klapisch-Zuber, *Tuscans and their Families*; Duby, *A History of Private Life*, ii. 158–309.

[16] Herlihy and Klapisch-Zuber, *Tuscans and their Families*.

[17] Ibid. 60–90.

[18] Kent, *Household and Lineage*, 113, 273.

[19] Duby, *A History*, 169 ff.

[20] Dominici, *Regola del governo di cura famigliare*.

Famiglia (*I Libri della Famiglia*), which expresses his wish for stable families in an urban society.[21] It reinforced the stress on the family ruled over by a *pater familias*, a trend that continued to build momentum in the Quattrocento, even after the population had stabilized. It was drafted in the 1430s, at nearly the same moment when we can establish the existence of tondi. Nevertheless, changes in family structure and attitudes towards it have heretofore never been related to tondi and their subjects.[22]

THE GROWING RECOGNITION OF CHILDHOOD

Concomitant with the stress on the family was the related appreciation of childhood, a trend that also impacted on tondi. In fact, the concept of childhood as a distinct stage in life first appeared during the fifteenth century.[23] Before the Trecento, children who overcame the odds of the terrible infant mortality rate were apprenticed as early as the age of 7 and lived away from their families. Then, beginning in the Trecento and in full force by the Quattrocento, school education was extended and children remained with their parents longer. Giovanni Villani, writing his chronicle in the 1330s, estimates that between 8,000 and 10,000 Florentine boys and girls between the ages of 6 and 12 were in school (one out of every two); one out of every six children (boys only) continued in secondary school to learn calculation on the abacus, which was one of the pedagogical techniques that endowed Florentine society with distinctive characteristics and an appreciation of geometry, and thus aspects of tondi. This social and financial investment in youth made Florence unique, whereas medieval society had sustained an inconsistent attitude towards children. This outlook was expressed in 1421 when the Florentine *comune* founded the Ospedale degli Innocenti, one of the first foundling hospitals, an idea related to the new visual type of nursing Charity that had appeared in early trecento Tuscany.[24]

This more sympathetic attitude towards children finds expression in tondi as well as other works of art during the Quattrocento, whereas earlier children were depicted as little adults, and there were few representations of childhood. A sympathetic portrayal of them first appeared with the cult of the infant Jesus in the Duecento, while another indication of a change in attitude was the revision of the theological stance about the salvation of babies who died without baptism. Whereas Augustine damned them, Sts Thomas, Francis, and Bernard of Clairvaux as well as Dante were milder in their pronouncements.[25] An embodiment of this profound sociological shift appears in the *Monument of Maria Pereira and Beatrice Camponeschi* by Silvestro dell'Aquila (1490s) with its poignant depiction of the deceased daughter tucked under her mother's sarcophagus, as though on

[21] Alberti, *The Family in Renaissance Florence*.
[22] Only Hayum ('*Doni Tondo*', 210 ff.) has mentioned the importance of the family when discussing Michelangelo's *Doni Tondo*.
[23] Ariès, *Centuries of Childhood*; Alexandre-Bidon and Riché, *L'Enfance au Moyen-Âge*. See also Goldthwaite, *Private Wealth*; id., 'The Florentine Palace'; Klapisch, 'L'Enfance en Toscane au début du xvᵉ siècle'; Forsyth, 'Children in Early Medieval Art'; Herlihy, 'Medieval Children'.

[24] Freyhan, 'The Evolution of the Caritas Figure in the Thirteenth and Fourteenth Centuries'. Gregorio Dati, writing in the 1420s, relates that Florence had three hospitals for foundlings ('*L'istoria di Firenze' di Gregorio Dati dal 1380 al 1404 illustrata e pubblicata secondo il codice inedito stradiniano*, 119).
[25] Herlihy, 'Medieval Children', 126. See also Ross, 'The Middle-Class Child in Urban Italy, Fourteenth to Early Sixteenth Century'; Trexler, 'Ritual in Florence: Adolescence and Salvation in the Renaissance'.

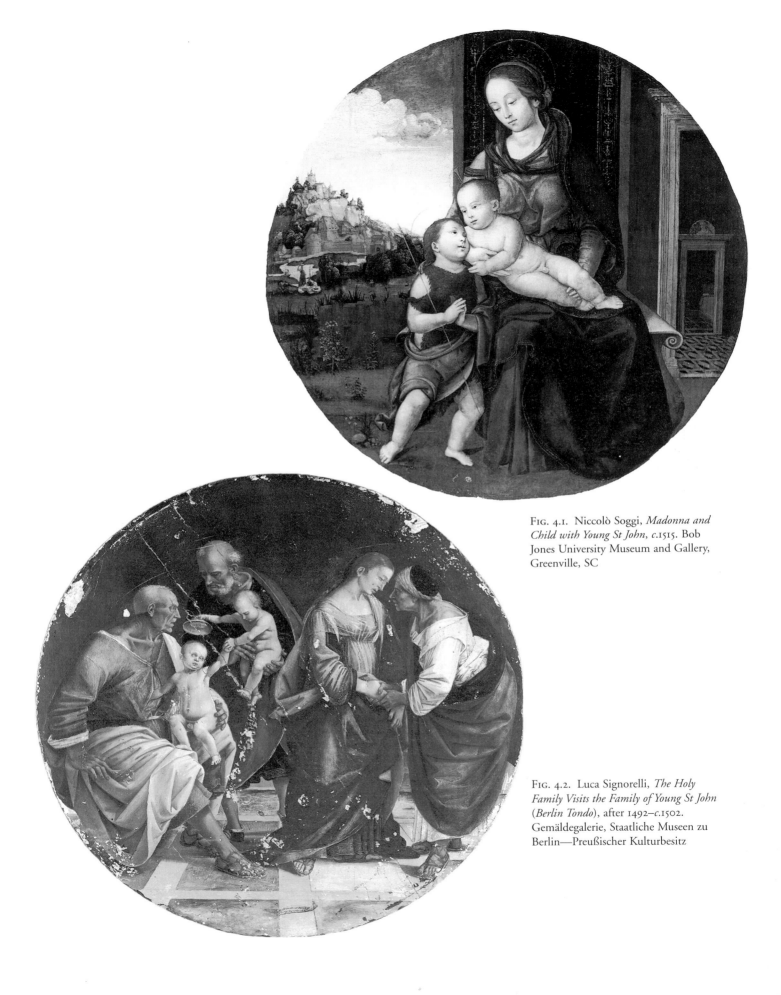

FIG. 4.1. Niccolò Soggi, *Madonna and Child with Young St John*, *c*.1515. Bob Jones University Museum and Gallery, Greenville, SC

FIG. 4.2. Luca Signorelli, *The Holy Family Visits the Family of Young St John* (*Berlin Tondo*), after 1492–*c*.1502. Gemäldegalerie, Staatliche Museen zu Berlin—Preußischer Kulturbesitz

a trundle bed.[26] It finds a subtler outlet in Florence during the last half of the Quattrocento in the sculpted busts of children, in double painted portraits with children, and in tondi (and other devotional panels) with their images of a child-like Christ.

THE FLORENTINE CULT OF YOUNG ST JOHN THE BAPTIST

This revolution in the attitude towards children also finds expression in tondi with the appearance of young St John the Baptist, the patron saint of Florence, as the nearly ubiquitous playmate of the Christ Child.[27] Before the fifteenth century, the saint was represented as an aged, ascetic hermit. His transformation was the result of Renaissance naturalism and an interest in childhood, a trend also apparent in popular literary sources, such as the Apocrypha, the *Meditationes Vitae Christi* of Pseudo-Bonaventura, and the anonymous *Vita di San Giovanni Battista*, all of which informed visual representations.[28] During the Quattrocento, the youngster was portrayed in a variety of ages ranging from a toddler to an adolescent, depending on the source utilized. His popularity in Florence is well-documented, from the poem Lucrezia Tornabuoni, the mother of Lorenzo de' Medici, wrote about him, to the altarpiece by Filippo Lippi for the private Medici Chapel in which the saint is prominently featured, to the play by Feo Belcari entitled 'La Rappresentazione quando San Giovanni fu visitato nel deserto da Cristo'. Beginning in the late 1450s, young St John came to symbolize the Sacrament of Baptism, an idea stressed in many tondi, such as the one shown in Fig. 7.24. This symbolism even spawned depictions of John and Christ enacting the rite as children, thus foreshadowing the major christological event under the guise of children's play (Figs. 4.2, A75). At the same time the belief that John was privy to foreknowledge of Christ's Passion became more pronounced. Moreover, the importance of St John in Florentine homes is supported by evidence in tondi, such as Fig. 4.1 and its domestic interior with a bust of the young saint inside a shell-shaped overdoor.[29] These humanizing tendencies were encouraged by the Archbishop of the city, Antonino Pierozzi, a member of the rigorous Observant branch of the Dominican Order, later canonized as St Antoninus, and harmonized with growing republican sentiments. The cult of young John can also be linked with the youthful confraternities that were a factor in quattrocento Florentine public life. They represented the city's ideal of lay piety, an idea taken up and embodied in Lorenzo de' Medici and exploited to the extreme by Savonarola. Just as young St John symbolized Florence, youth with its innocence became a republican ideal. Savonarola believed that they alone could carry the city to salvation and create for the millennium a New Jerusalem, a heavenly city untainted by the secular oligarchy of the Medici.[30] These ideas find expression in a variety of tondi.

[26] Olson, *Italian Renaissance Sculpture*, fig. 104. There are other quattrocento sculptures with related sentiments: an infant in swaddling clothes in the Musée du Louvre (Duby, *A History*, 22, ill.) and Martin van Heemskerck's drawing of a female effigy with a baby, which Musacchio, 'Art & Ritual', 220, connects with the dismembered tomb of Francesca Tornabuoni (*c*.1477), formerly in Santa Maria sopra Minerva, Rome (see Butterfield, *Verrocchio*, 5–6, 237–9, for the problematic tomb).

[27] See M. Lavin, 'Giovannino Battista'; ead., 'Giovannino

Battista: A Supplement'.

[28] M. Lavin, 'Giovannino Battista', 85. A youthful St John is Apocryphal and Eastern, probably Egyptian, in origin.

[29] Inv. no. P. 53.46 in the Bob Jones University Museum and Gallery, Greenville, SC, oil on panel with a 66 cm. diameter. Pepper, *Bob Jones University Collection of Religious Art. Italian Painting*, 25–6, no. 21.1, ill.

[30] See Trexler, 'Ritual', 200 ff.; id., *Public Life in Renaissance Florence*.

THE CULT OF JOSEPH

During the same period, the status of St Joseph escalated, creating an increase not only in the number of Holy Families represented in tondi, but also a change in how Joseph was portrayed. Because a representation of the Holy Family implied a reference to the sanctity of marriage and the importance of the integral family unit, the theme was appropriate for domestic tondi. At times St Joseph appears with greater prominence and a nobler demeanour than previously, as a true *pater familias*, participating in nurturing the Child (Fig. 7.33). This change stems from the Florentine emphasis on the family and from an alteration in the theological status of St Joseph.

Historically Joseph had been a problematic figure in Christianity and patristic literature,[31] although the Messianic descent of Jesus, as a son of David, was traced from Joseph through the father's line, an idea expressed in a number of tondi. Since no misunderstanding about Mary's perpetual virginity and Jesus's miraculous origin could be allowed, the Church felt uneasy about his role. Nevertheless, by 1324 the Florentine Servites had observed a feast of St Joseph on 19 March, and there is evidence that the Franciscans in Florence and Bologna also had similar observances.[32] Around 1350, after the plague, images of Joseph began to appear,[33] precipitated by the fixation on procreation and families. Already in the same century, St Bonaventura had pronounced Joseph as the perfect exemplar of devotion to the Virgin and Child,[34] a sentiment encountered in tondi.

Only in the 1400s, however, did Joseph advance to a first place among the saints, mainly through the efforts of John Gerson, Chancellor of the University of Paris, who proposed St Joseph as the exemplar and patron of all Christian families by reason of his position as head of the Holy Family. During the fifteenth century St Bernardino of Siena also became an ardent proponent of St Joseph, stimulating devotion to Joseph in Tuscany.[35] Pope Sixtus IV, who played a major role in the parallel controversy over the Immaculate Conception of Mary, officially introduced the Feast of St Joseph into the Roman Church in 1472. Thereafter, Missals and Breviaries included it as a feast to be celebrated in the Eternal City. The example of Rome led the world, and other dioceses soon followed suit. The Pope's advocacy insured that the saint appeared more prominently in miracle plays and works of art as well as in theological and devotional literature. As Joseph appeared more frequently, his status ascended to its zenith after 1490, when he appeared in tondi more conspicuously as the protector and provider of Mary and Christ (Fig. A91). In the light of this information and the placement of many tondi in the *camera* of the householder, it is significant that in past centuries it was a widespread custom for newly-weds to spend their first night of matrimony in abstinence in order to perform some devotion in honour of St Joseph, patron of families and newly-weds, that he might bless their marriage. Furthermore, it is interesting to note the European custom of baking and eating small round breads on 19 March, St Joseph's feast day, in order to honour the heavenly father (hence the round shape, which also recalls the host).[36] Certainly the

[31] His status was debated by the Church Fathers because he reportedly fathered other children (either in a previous marriage or later with the Virgin, neither of which was theologically acceptable). There is an Apocryphal book, the 'History of Joseph', of Egyptian origin (*The Apocryphal New Testament*, 84–6).

[32] Filas, *The Man Nearest to Christ: The Nature and the Historic Devotion to St Joseph*, 140.

[33] See ibid.

[34] *The New Catholic Encyclopedia*, vii. 1109–13; Filas, *St Joseph*, 477 ff. St Bonaventura writes of Joseph in his *Commentary on Luke* and *Commentary on the Sentences*, proposing Joseph as the model of the perfect life.

[35] Ibid. 500–3.

[36] Buttrick, *The Interpreter's Dictionary of the Bible*, ii. 926.

tondo form could have been associated with these breads as well as with the Eucharistic body of Christ to further embellish the sacramental symbolism depicted in many of them. Since 1215 the Real Presence of Christ's body in the Eucharist (the doctrine of Transubstantiation) had been promulgated as a Church dogma, leading to innovative ways of alluding to the Sacrament in works of art. Thus, tondi with St Joseph may have carried a talismanic dimension for couples and their family as the unit matured, together with allusions to the Sacrament and heaven.

In Florence, St Joseph enjoyed a direct sponsor in its popular Archbishop, whose continual praise of Joseph, in his influential writings and sermons delivered in the Cathedral, finds reflection in the way the saint was portrayed in tondi. Antoninus, who was concerned with providing practical assistance to meet the challenges of life and was a confessor of the Medici, wrote handy guides for the faithful.[37] In his *Summa Moralis* and *Desponsatione Mariae*, St Antoninus comments extensively on Joseph as a patron of the Church, explaining that he was the foster-father (*pater putativus*) of Jesus, endowing him with dignity, holiness, and glory. Because Joseph was a foster-father, Antoninus felt it was necessary to prove the saint's relationship to the Old Testament Joseph, a typological prefiguration of Christ.[38] Throughout his discussions, St Antoninus emphasizes family concerns to reflect the needs of his parishioners. Therefore it is not surprising that Renaissance masters frequently painted Joseph with the appearance that Antoninus gives him in his *Summa Moralis*: as 'noble of soul, nobler in birth'.[39] Antoninus' ideas find reflection in the aforementioned bronze medallion (*c*.1500) in the Victoria and Albert Museum whose frame is inscribed: *PVER NATVS. EST. NOBIS.*, wherein Mary and Joseph are depicted with equal importance.[40] St Antoninus comments that children need providers (*nutritii*), and that Joseph is correctly called the father of Christ not by virtue of geniture, but rather by reason of his care, as illustrated by Signorelli in a tondo discussed below.[41] Antoninus' pastoral stress on Joseph reached a wide audience in Tuscany because his writings circulated in numerous editions. It is significant that the inventories of Benedetto da Maiano, a sculptor of tondi, and his brother, Giuliano, who owned a large library of books, record: 'A quarto book bound in wood, Blessed [Saint] Antoninus' ('Un libro di 4° fogli legato in asse di Beato [Santo] Antoninus, *Omnis mortalium cura*').[42] This suggests that educated artists may have played a more active role than previously thought in establishing the iconography of the works of art they created, like tondi.

As a result, St Joseph begins to appear more conspicuously in works of art during the late Quattrocento (Fig. 7.25). In a tondo by Pintoricchio (Fig. A75) Joseph plays a more than active role, for he holds bread and a *fiasco* of wine, symbols of the Eucharist and a foreshadowing of Christ's Passion, at the meeting between Christ and St John after Egypt. In this guise, his nurturing is stressed and a priestly demeanour implied.[43] In his *Parte Guelfa Tondo* (Fig. 7.33), where Joseph and the Madonna are the nearly co-equal commanding figures, Signorelli painted thin gold haloes for the Madonna and Child, while he differentiated Joseph by having uneven gold rays issue from his head, distinguishing him as divinely inspired, if not exactly on par with his spouse and her child. Far from being superfluous, Joseph is the tallest figure in the composition, a concept in harmony

[37] Sparks, 'St Antoninus of Florence on St Joseph'; id., 'Cajetan on Saint Joseph'.

[38] Sparks, 'Antoninus on St Joseph', 454.

[39] Ibid. 435 ff.

[40] Ch. 1 n. 65.

[41] *Summa Moralis*, P. IV, col. 951 A B (Sparks, 'Antoninus on St

Joseph', 441 n. 41). The Latin term for foster-father is, incidentally, *nutricius* (Simpson, *Cassell's New Latin Dictionary*, 714).

[42] Cèndali, *Giuliano and Benedetto da Maiano*, 184; C. Gilbert, *Italian Art*, 44.

[43] See App. n. 203.

with the naturalistic attitude that encouraged artists to depict a mononuclear, patriarchal family unit. Further, Signorelli portrayed him as St Antoninus characterized him (pious, humble, and virtuous) by painting his feet without shoes, his hands crossed over his breast, and emphasizing his strength of character.[44]

Signorelli's *Parte Guelfa Tondo* contains a radical statement about Joseph, equalled only by Michelangelo's *Doni Tondo* (Fig. 7.37), and to a lesser extent by Andrea del Sarto's *Barbadori Holy Family* (Fig. A98). A handful of other works, not necessarily tondi, such as Raphael's *Canigiani Holy Family*, reflect similar ideas. However, Signorelli's *Parte Guelfa Tondo* enshrines the Holy Family in a uniquely integral, monumental manner that is only approached by Michelangelo's more physically united family in which Joseph plays a slightly less active role (see Ch. 7).

In the *Doni Tondo*, which was commissioned by Agnolo Doni, probably on the occasion of his marriage to the 15-year-old Maddalena Strozzi in 1503/4, Joseph crouches behind the Madonna and seems to protect her with the spread of his massive thighs, as a proper *pater familias*. The Child, who touches both parents, is caught in a dynamic equilibrium between them, while his head is nearly on the same level as Joseph's to agree with both quattrocento patriarchal lineage and his descent from David.[45] While the *Doni Tondo* embodies the existing family structure to help secure the viewer's identification with the theme,[46] other views about the relationship of the figures in it have been offered, including the proposal that Michelangelo intended its *pater familias* to be God the Father.[47] Rather, I believe that while Florentines might have read God the Father's sponsorship of St Joseph as a double entendre, Joseph's mien can be explained by Florentine theology and views on the family. The question whether the Virgin is handing the Child to St Joseph or he is lowering him to her has been explained as a play on the name Doni, from the verb 'donare', to give.[48] While it has been generally accepted that the *Doni Tondo* expresses the hope for a male heir, this does not settle the significant question: was it commissioned in conjunction with the marriage or after several years of childlessness (see Ch. 7)? What is clear, however, is that it was meant, like other tondi, as an image to instruct and preside over the family in whose home it hung. It seems that Florentines placed their conjugal life under the protection of the Holy Family and that it was most likely commissioned for the couple's marriage when the house was equipped.

St Joseph appears in another unique, naturalistic guise in Signorelli's late, highly unusual *Berlin Tondo* (Fig. 4.2).[49] In this rare narrative scene, the meeting of the families of Christ and St John, the figures are divided by sex. What is even more striking is that the fathers are nurturing their children. The infant John, seated on his father's lap, is performing a mock baptism, while he grasps the hand of the Child, accompanied by St Joseph. The poignant but affectionate meeting between the Virgin

[44] Sparks, 'Antoninus on St Joseph', 429 ff.

[45] See L. Steinberg, *The Sexuality of Christ in Renaissance Art and Modern Oblivion*, 182–3, who discusses the theology behind the censorship of the Child's genitalia.

[46] Hayum, '*Doni Tondo*', 212 ff., who delves into Doni's ambition to start a better family line.

[47] Some were presented at the 1994 conference of the College Art Association of America by: (1) T. Verdon, 'Greek Love and Jewish Marriage in Michelangelo's *Doni Tondo*'; (2) R. Goffen, 'The Virgin's Bare Arms'; and (3) L. Steinberg, 'Concerning the *Doni Tondo*: The Boys at the Back'. Steinberg's thesis (first offered in 'Michelangelo's Doni Tondo'), that Michelangelo intended the father as God the Father, is based on the unprecedented portrayal of the Virgin between a man's thighs, implying generation. See also

Verdon, '*Amor ab Abspectu*: Maria nel Tondo Doni e l'umanesimo cristiano'.

[48] Brockhaus, *Michelangelo*, 5. L. Steinberg, 'Doni Tondo', 139, sees it as embodying a wish for a child: 'the verb *donare* in its optative mood, expressing petition—*doni*, God give!' Hartt, *History of Italian Renaissance Art*, ed. Wilkins, 464, points out that 'doni' also means gifts. He claims—without support—that the first four Doni sons, all of whom died shortly after birth, were named Giovanni Battista (an idea continued in this revised edition). It is strange, therefore, that their first son who lived was named after Doni's father, Francesco, a frequent Florentine practice to propel the male line into future generations (Hayum, '*Doni Tondo*', 226 n. 27).

[49] See App. nn. 187 ff.

and Elizabeth is a reprise, not without irony, of their joyous meeting at the Visitation, when both were pregnant (Luke 1: 39–56). The manner in which they grasp hands, now with sorrow (Elizabeth bows to recognize Mary), suggests that they realize the implications of the prefiguring play: a profound foreshadowing of the beginning of the ministry of Christ and his irreversible road to the Passion. While no scriptural source has been connected with this tondo, its literary source can now be identified as the *Meditationes Vitae Christi* of Pseudo-Bonaventura, which reports a meeting between John and Christ and their families before the Flight into Egypt.[50] Further, a late trecento Tuscan codex of the *Meditationes* provides a visual precedent for some aspects of Signorelli's depiction, including all the *dramatis personae* with children of the same approximate ages.[51] Since the manuscript illustrates the Holy Family visiting Elizabeth and Zacharias before the Flight, we can conclude that this is also the subject of Signorelli's *Berlin Tondo*.[52] In fact, the methodology of the popular *Meditationes*—a set of spiritual exercises called the 'speculum'—exhorts the reader to meditate on each event in Christ's life in a personal fashion, illuminating the function of all tondi: they were the visual equivalents of *specula* tracts, meant for meditation, spiritual exercises, and didactic instruction.[53] Thus the *Meditationes* foreshadow Counter-Reformation piety, as in the *Exercises* of St Ignatius Loyola, while tondi in their naturalism anticipate, albeit in a quattrocento manner, the fusion of down-to-earth and spiritual elements in Baroque works of art.

After enjoying a brief prominence in Florentine art and thought, St Joseph once again became less important after 1515 with the onset of the Reformation. With a few exceptions, he returned to his role as the odd man out, as tondi also faded in popularity.

THE GENERAL DIDACTIC FUNCTION OF TONDI

Different types of evidence demonstrate that tondi with religious subjects functioned as devotional panels that were more relaxed than formal church altarpieces.[54] Their dominant curvilinear rhythms immediately establish a more casual, intimate tone and environment that is appropriate to a domestic setting. In addition, their shape encourages movement as opposed to the more angular ones generated by the conventional rectilinear format. This circular movement reinforces the heavenly symbolism of the round form that connotes the perfection of the figures depicted in each tondo. Moreover, some of the documentary evidence in Chapter 3 supports the argument that devotional tondi, like images in tabernacles, were transitional devotional objects that were preliminary to private family chapels. Their round shape signalled a sanctified area of the highest

[50] Olson, 'Signorelli's *Berlin Tondo*: New Information (Technical, Stylistic, and Iconographic)'. The meeting with John is usually placed after the Flight into Egypt when the Child is older (J. Hall, *Dictionary*, 125).

[51] In the Bibliothèque Nationale de France, Paris, MS Ital. 115, the earliest of fewer than twenty illustrated manuscripts of the text to survive. Pseudo-Bonaventura, *Meditations on the Life of Christ*, p. xxii ff.; Bellosi, 'Su alcune disegni italiani tra la fine del Due e la metà del Quattrocento', 11–12, believes it is Florentine.

[52] The text for the illustration (fol. 36ʳ, p. 63) in Pseudo-Bonaventura, *Meditations*, 64–5, reads: 'Then the Blessed Virgin departed from Jerusalem and went to Elizabeth, wishing to see John

before leaving that region. Go always with her wherever she goes and help to carry Jesus. When they arrived there was great festivity, especially about their children. The children made merry together; John, as though understanding, reverently approached Jesus. You also receive John with reverence, for the boy is great (in the sight) of God; perhaps he will bless you. When they had stayed a few days in that district, they left, wishing to return to Nazareth. If you desire to learn about humility and poverty, consider in the aforementioned events the donation, redemption, and the observation of the law and you can easily perceive them.'

[53] Ibid. 1 ff.

[54] Hope, 'Altarpieces and the Requirements of Patrons'.

spiritual truths worthy of contemplation. The majority seem not have had literal 'programmes', but rather contain suggestively symbolic images to which viewers were meant to bring their own religious knowledge. Because multiple biblical, patristic, and theological passages might be equally applicable, representations were meant to spark in the learned viewer a whole chain of theological connections. These polysemous or equivocal motifs were characteristic of devotional art of the period.[55] A case in point is the garden, which is among the more frequent locales portrayed in tondi. (Other settings include interiors, heaven, or the Nativity stable.) The garden can allude to the *hortus conclusus* (the enclosed garden symbolic of Mary's virginity connected with the allegorical Song of Songs to celebrate one of the virtues most prized in a wife, chastity), the earthly Garden of Paradise, or a foretaste of the eternal Paradise that comes via the Sacrifice and Grace of Christ.[56] Likewise, the meanings of the flowers—complex symbols of Christ's Passion and the Madonna's virginity— depicted in the gardens of tondi could be subject to multiple interpretations.[57] One of the most common of these is the rose, which not only could be multivalent but also could allude to the rosary which, together with books of hours and other devotional texts represented in tondi, was integrally linked with quattrocento Marian piety, specific types of devotion, and the circular rhythms in tondi (see below).

It is no wonder that it can be difficult to pin down a precise iconographical meaning for tondi unless several motifs work together towards an argument, which is sometimes the case. The tendency towards polysemy, however, facilitated multi-layered interpretations and an intensely personal type of devotional mysticism. The more learned the person(s), the more complicated the exegesis. Thus the tondo's iconography could appear to grow as the worshipper(s) developed depth in theological knowledge and ability in religious meditation, especially in the case of the more complicated examples. Similarly, the more learned the artist who created the work or the patron who made specifications for it, the more potential there was for complex iconography.

Moreover, tondi in domestic settings functioned not only as devotional pictures but also as *exempla*, inviting the owner's family to contemplate and mirror the conduct of the Holy Family. Thus, they enjoyed a function analogous to that of contemporary busts of young John the Baptist and the Child displayed in *palazzi* for male children of the household. Cardinal Dominici in his influential treatise *Regola del governo di cura famigliare* advises mothers to select appropriate pictures for their children, particularly scenes of the young Christ and John, stressing the educational value of images:

The first regulation is to have pictures of saintly children . . . And what I say of pictures applies also to statues. It is well to have the Virgin Mary with the Child in arms, with a little bird or apple in his hand etc. . . . So let the child see himself mirrored in the Holy Baptist clothed in camel's skin. . . . In this first mirror let our children be reflected as they open their eyes. . . . I advise you to have paintings made in the house for this purpose.[58]

[55] Falkenburg, *Fruit of Devotion*, 12, focuses on Flemish devotional painting but addresses theological and social developments that are apropos to tondi.

[56] Ibid. 17–25. He notes the garden's tradition—from the *locus amoenus* to the Garden of Love to the paradisiacal garden—and the loose connections between the literary texts and the images (p. 78).

[57] Levi D'Ancona, *The Garden of the Renaissance*; Falkenburg, *Fruit of Devotion*, 90.

[58] Dominici, *Regola*, 34. Welch, *Art and Society*, comments that Dominici expected youngsters not only to learn about Christian behaviour from these works of art but also to acquire some literacy and perhaps eventually use prayer books to help in their private devotions, like a book of hours. She points out that children often learned to read from them (noting that the word 'primer' for school book comes from the hour known as Prime).

Dominici's instructions apply directly to tondi and help to explain their proliferation as well as the appeal of their themes. They also illuminate the function of a tondo attributed to Cosimo Rosselli with the adolescent, 12-year-old Christ Child walking home with his parents after astounding the elders with his preaching in the temple (Fig. 4.3).[59] This unusual scene, narrated and illustrated in the *Meditationes Vitae Christi* of Pseudo-Bonaventura,[60] provided a role model for adolescent boys and enshrined the nuclear family, just as the unusual 3-year-old Child in Signorelli's *Parte Guelfa Tondo* (Fig. 7.33) would have furnished one for younger boys.

MIRRORS

Tondi can be thought of as devotional mirrors or pictorial *specula*—a term for mirrors that was frequently applied to devotional tracts.[61] Because quattrocento mirrors were usually round and convex, it is understandable why tondi and mirrors would have been equated on formal grounds alone. And the function of tondi can also be better understood through a discussion of their links with mirrors in documents and literature. Moreover, the associations would have increased as the naturalistic aesthetic matured and as subjects and settings in tondi seemed to reflect those in the world. In this way the tondo became a link between earth and heaven to help obtain the ultimate goal of all Christians, salvation.

This theory is supported by the literary traditions inherited from antiquity, which abound with pertinent comments on the didactic nature of mirrors to reveal abstract, spiritual truths. References to mirrors with archetypal images occur, for example, in the writings of Plato.[62] St Paul carried the tradition into Christian thought in two famous references.[63] The Church Fathers and medieval writers continued it. For example, St Augustine was fond of employing images like the mirrors of the soul and the mind, as was St Gregory of Nyssa, for whom a mirror reveals what we are and induces us to become what we ought to be. He was one of the most prolific writers on the mirror and believed that the mirror of the soul could be turned towards either the sensible or the spiritual world.[64] More importantly, Christian literature abounds with textual injunctions to look in a mirror in order to seek perfection.[65] Hrabanus Maurus states that mirrors are good examples, a

[59] Whereabouts unknown, panel with a 100 cm. diameter and a dark line of pigment painted around its circumference. The FKI records it as being in Munich.

[60] Pseudo-Bonaventura, *Meditationes*, 89–92, ill., for MS Ital. 115, fol 52ᵛ.

[61] 'Speculum' was liberally used in 13th-c. legal, philosophical, and satirical works, e.g. the 'Speculum humanae salvationis'. Bradley, 'Backgrounds of the Title "*Speculum*" in Medieval Literature', 107–8. The association of art and mirrors is apparent in Jan van Eyck's *Arnolfini Portrait*, whose mirror fuses two worlds: that of symbols and that of visible matter, whose existence artists and thinkers of the Renaissance were trying to reconcile. Schwarz, 'The Mirror in Art', 99, discusses it and three altarpieces by van Eyck with frames inscribed in reference to the Virgin *speculum sine macula*; see also L. Seidel, *Jan van Eyck's Arnolfini Portrait*; E. Hall, *The Arnolfini Betrothal: Medieval Marriage and the Enigma of van Eyck's Double Portrait*, 117–23.

[62] The most significant are in the *Timaeus*, 71; *Theaetetus*, 193 A;

Sophist, 239 E. In Book 10 of the *Republic*, Plato refers to the artist's work as a mirror of nature and twice removed from the truth. Brandwood, *A Word Index of Plato*, 497.

[63] 1 Cor. 13: 12: 'For now we see in a mirror dimly, but then face to face.' 2 Cor. 3: 18: 'But we all, with unveiled face beholding as in a mirror the glory of the Lord, are changed into the same image from glory to glory, even as by the spirit of the Lord.'

[64] St Gregory states that when a soul after the manner of a mirror has turned towards good, it will see in its own soul the form and shape of beauty; *De Beatitudinis Oratio*, 6 (*PG* 44, 1270 C); *De Vita Moysis* (*PG* 44, 339 A); *Commentarius in Canticum Canticorum* (*PG* 44, 867 CD).

[65] For example, St Augustine in *Enarratio in Psalmum CIII* (*PL* 32, 903, 1138); *Speculum de Scriptura Sacra* (*PL* 34, 887–1040). See *Vita Aurelii Augustini Hipponensis episcopi* by Possidius (*PL* 32, 57). In the writings of Bernard of Clairvaux, the mirror combines moral purification with good examples from holy lives (*Instructio Sacerdotis*, II. xi (*PL* 34, 788 BC)). See Bradley, '*Speculum*', 103 ff.

remark that could be applied to tondi.[66] Hildebertus of Lavadin repeats Augustine's comparison of the Holy Scriptures to a mirror, stating that knowledge of the holy pages are our mirror, a comment that seems germane to tondi.[67] The high saturation of ideas about mirrors supports the theory that while physical mirrors reflected the sensible world, tondi were considered mirrors of divine matters. Further, they provided the viewer with examples of what s/he should mirror and induced the beholder to look to her/his soul.

Other ideas about mirrors in Christian thought are also applicable to the devotional function of tondi. For example, the mirror of the mind when attuned to the Holy Scriptures was thought to reflect truth, ideal beauty, and wisdom. Further, Christ and the other members of the Trinity, together with the Virgin, were compared in theological writings to mirrors. Popular epithets of the Virgin were the *speculum immaculatum* and the *speculum sine macula* (immaculate mirror and the mirror without sin), alluding to her purity. Both derive from the seventh chapter of the Book of Wisdom ('For she is an effulgence from everlasting light and an unspotted mirror of the working of God and the image of His goodness'). They imply the perfection of Mary and suggest the miracle of Christ's Resurrection.[68] In late medieval times, the mirror became an attribute of the Virgin, although representations of the mirror as a symbol of the Virgin were infrequent until the sixteenth century. Even 'popular' literature connected Christ, the Virgin, and God with mirrors. For example, Jacobus de Voragine in his sixth sermon of the *Mariale* (*Sermones aurei de beata Maria*), written after 1255, not only addressed the Madonna as 'Mary the mirror—Christ the image', but stated 'for as all things are reflected from a mirror, so in the Blessed Virgin, as in the mirror of God, ought all to see their impurities and spots, and purify and correct them'.[69] St Bonaventura, in his *Itinerarium mentis in Deum*, commented that the soul looking inwards 'is able to discern by means of itself, as with the help of a mirror, the Blessed Trinity [the circle is a symbol of the Trinity], the Father, the Word and Love'.[70] Finally, Dante cited mirrors in thirty passages of the *Commedia*, the most important in *Paradiso* XXVI, 103–8, where Adam assures Dante that he reads the questions in his mind 'in the true mirror' of God's mind.[71]

Devotional tondi functioned as analogous 'mirrors'. The individuals portrayed served as role models whose conduct the viewer was meant to emulate, an interpretation reinforced by many tondi with representations of the Virgin and a devotional book—a Breviary,[72] Psalter,[73] book of hours,[74] or texts from one of them, like the 'Magnificat'. But it is in the words of Eusebius that one can best fathom the function of mirrors in Christian thought and their association with tondi:

[66] *Allegoriae in Universam Sacram Scripturam* (*PL* 112, 1050 D).
[67] *Sermo: De tempore in Adventu Domini* (*PL* 171, 374 BC).
[68] Schwarz, 'The Mirror in Art', 98, remarks that not only can light rays penetrate glass without violating it (the Virgin), but also glass can absorb and transfer its colours without diminishing them.
[69] Richardson, *Materials for a Life of Jacopo de Voragine*, ii. 66.
[70] Bonaventura, *The Franciscan Vision: Translation of St Bonaventure's 'Itinerarium Mentis in Deum'*, 42.
[71] Austin, 'Dante and Mirrors'.
[72] The Breviary is a liturgical book of Psalms, hymns/canticles, lessons, prayers, etc., recited in the Divine Office of the Roman Catholic Church. It was used heavily by the laity in the 13th c. *Oxford Dictionary of the Christian Church*, 199.
[73] A Psalter consists of 150 Psalms for prayer; ibid. 1140. The

Psalter was gradually replaced as the principal prayer book of the laity towards the end of the Middle Ages by the book of hours, which was based on it. J. Hall, *Dictionary*, 255.
[74] A popular prayer book for the laity in the later Middle Ages and early Renaissance. In the 13th c. the book of hours became a separate prayer book and was widely used by the 15th c. In the Western Church, the seven commonly recognized hours were: Matins and Lauds (together), Prime, Terce (Tierce), Sext, None, Vespers, and Compline (*Oxford Dictionary of the Christian Church*, 670). J. Hall, *Dictionary*, 51, lists eight canonical hours, separating Matins and Lauds. See Harthan, *Books of Hours*, 11 ff.; Wieck, *Time Sanctified: The Book of Hours and Medieval Art and Life*. Each hour had specific subjects associated with it, such as the Annunciation with Matins.

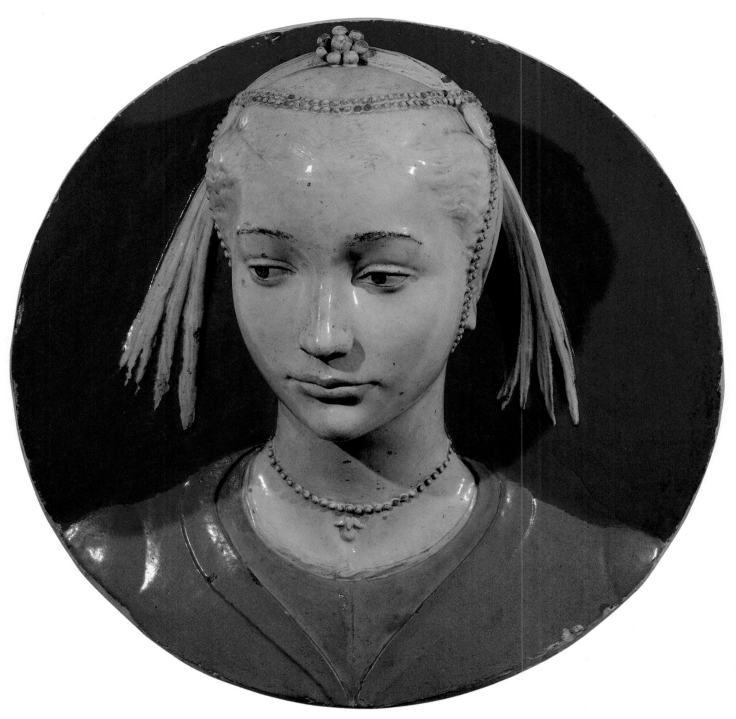

PL. I. Luca or Andrea della Robbia, *Portrait of a Lady*, *c.*1460–70. Museo Nazionale del Bargello, Florence

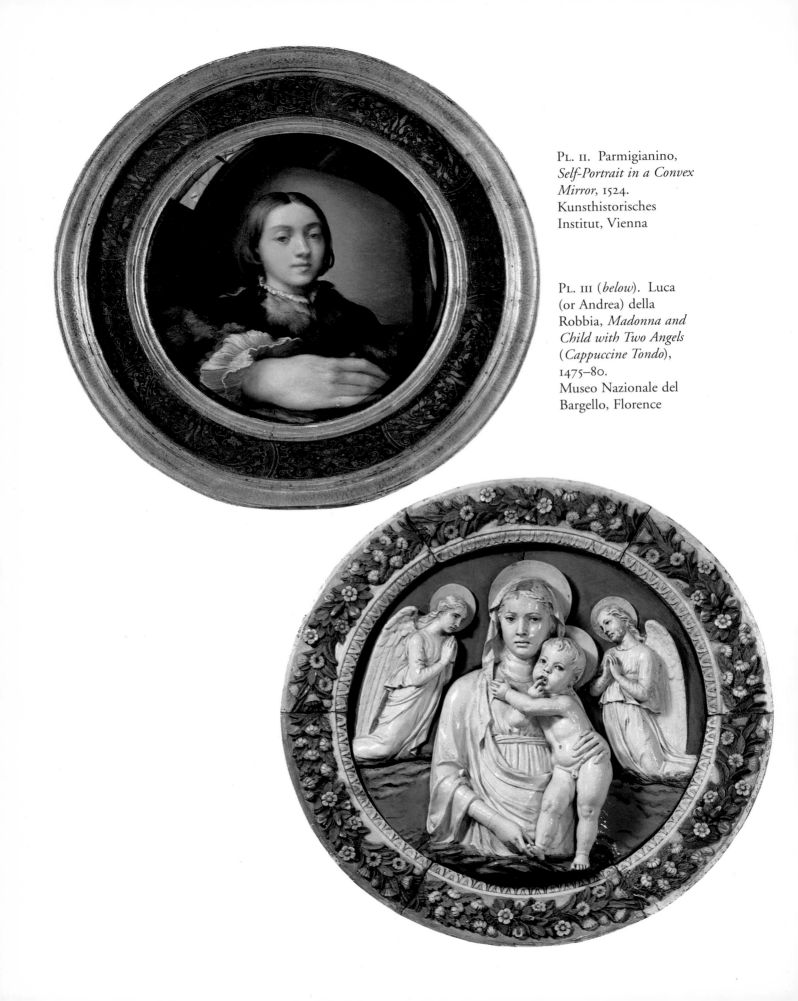

PL. II. Parmigianino, *Self-Portrait in a Convex Mirror*, 1524. Kunsthistorisches Institut, Vienna

PL. III (*below*). Luca (or Andrea) della Robbia, *Madonna and Child with Two Angels* (*Cappuccine Tondo*), 1475–80. Museo Nazionale del Bargello, Florence

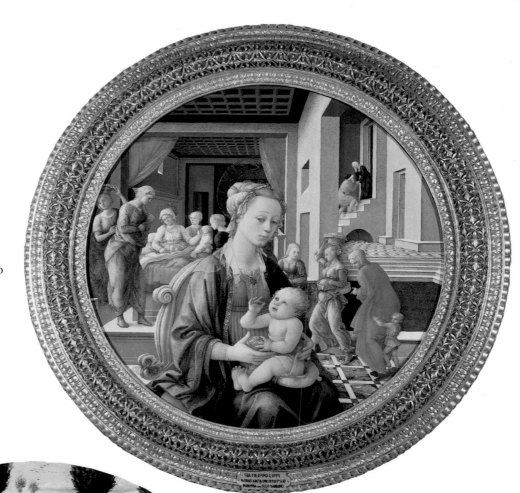

Pl. iv. Filippo Lippi,
Pitti Tondo, after 1452.
Galleria Palatina di
Palazzo Pitti, Florence

Pl. v (*below*). Francesco
Botticini, *'Hortus
Conclusus' Tondo*,
c.1480–90.
Galleria Palatina di
Palazzo Pitti, Florence

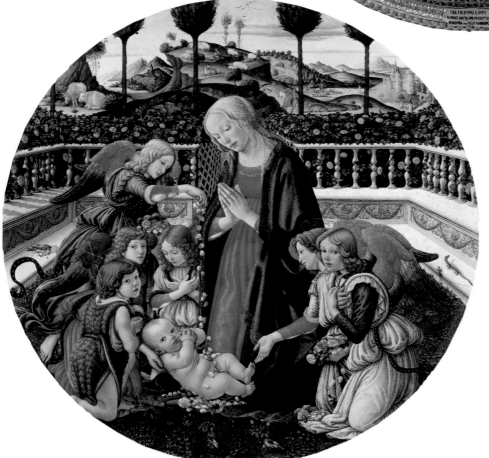

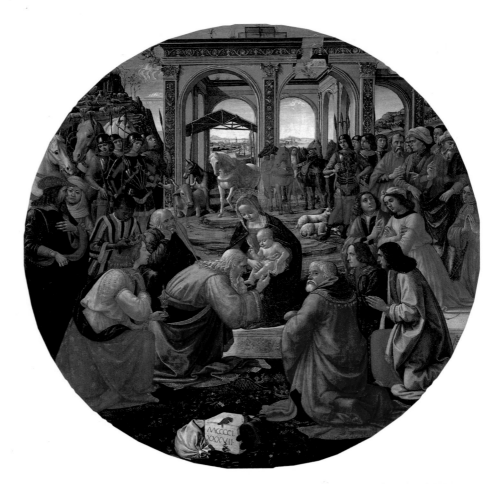

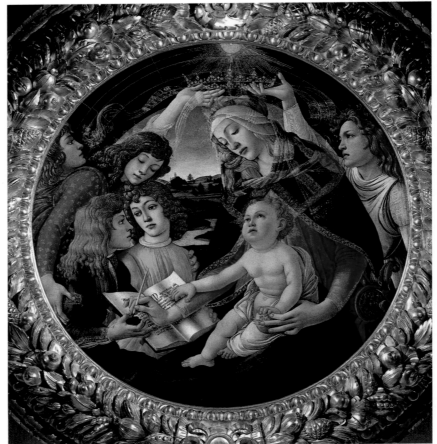

Pl. VI (*above*). Domenico Ghirlandaio, *Adoration of the Magi*, dated 1487. Galleria degli Uffizi, Florence

Pl. VII. Sandro Botticelli, *Madonna of the 'Magnificat'*, c.1481–2. Galleria degli Uffizi, Florence

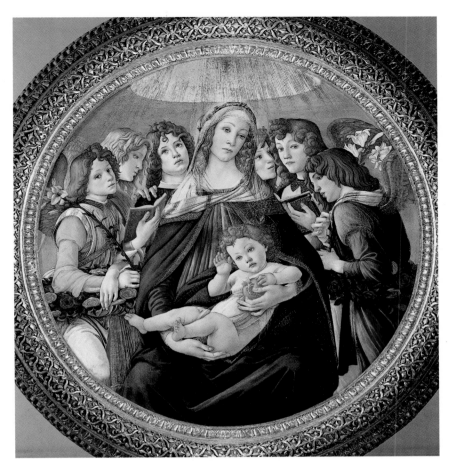

PL. VIII. Sandro
Botticelli, *Madonna
of the Pomegranate*
(*Madonna della
Melagrana*), *c.*1487.
Galleria degli Uffizi,
Florence

PL. IX (*below*). Filippino
Lippi, *Corsini Tondo*,
*c.*1481–3. Cassa di
Risparmio di Firenze,
Florence

PL. X. Luca Signorelli, *Medici Madonna, c.*1492. Galleria degli Uffizi, Florence

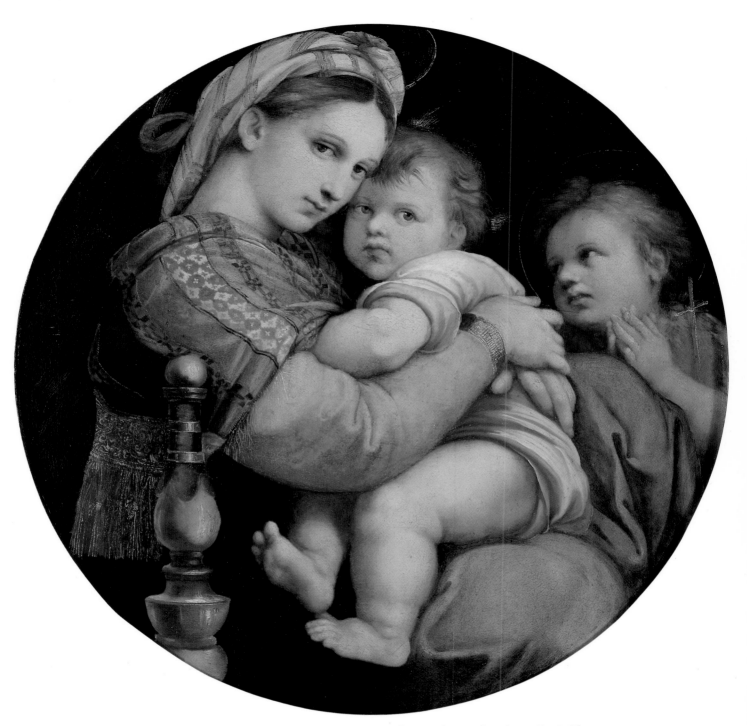

PL. XI. Raphael, *Madonna della Sedia*, 1514. Galleria Palatina di Palazzo Pitti, Florence

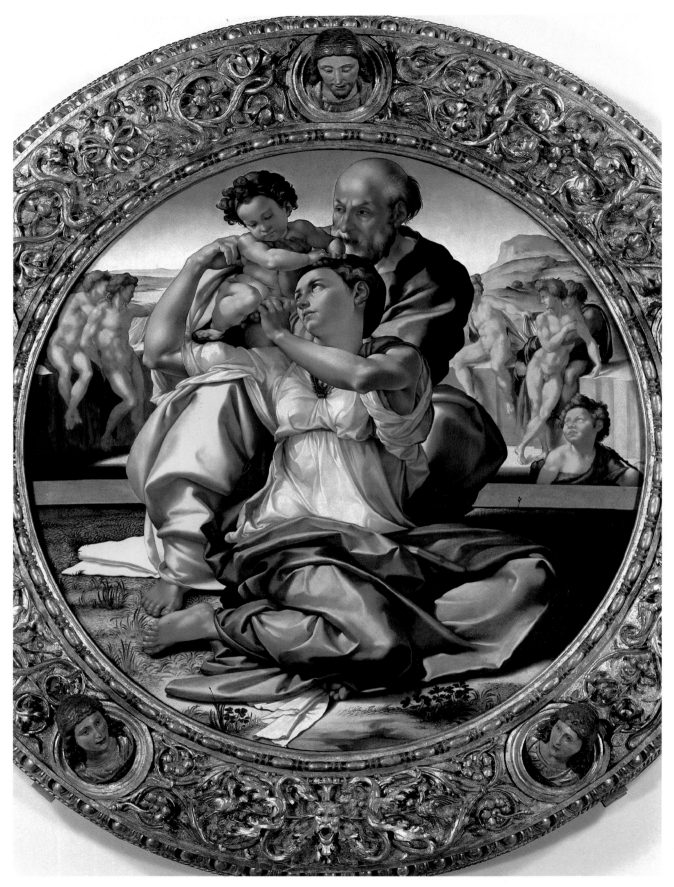

Pl. xii. Michelangelo Buonarotti, *Doni Holy Family* (*Doni Tondo*), 1504–6. Galleria degli Uffizi, Florence

As now the mirror gives an image which is clearer, cleaner, and brighter than the most noble part of our soul. If we thus look at God so he is the best mirror of our human attempts to achieve virtue of the soul, and by this manner, we are best brought to self knowledge and observation.[75]

The association of tondi with mirrors was facilitated not only by their religious symbolism but also by the increasing commonness of mirrors in the fifteenth century, when they were made of glass rather than metal. Since they were blown and covered with a metal backing—often antimony, lead/antimony, or mercury—a mirror was sometimes termed a 'spera' or 'sfera'.[76] They evolved from a novelty luxury item to a standard feature in artists' shops and homes by the late century, when numerous citations of them occur in inventories.[77] Their reflective powers were considered almost magical and they were sometimes protected by a cover. They were also an important artistic tool when naturalism was the reigning aesthetic. Judging from those that survive, mirrors frequently had elaborate frames, some more imposing than the mirrors themselves (below, Figs. 4.4–6).

While convex mirrors are represented in art, the visual excitement that the device engendered in artists is not reflected in Italian painting, although the scientific implementation of the mirror and its usefulness to the artist was important. As early as 1402 an illuminated manuscript of Boccaccio's *De claris mulieribus* contains a representation of Marcia painting a self-portrait with the aid of a round mirror.[78] The mirror was not only an indispensable aid for self-portraits, but also was involved with the study of optics and perspective, as with Brunelleschi's two famous scientific *vedute* (of the Baptistery and the Piazza della Signoria) painted c.1420, for which Manetti in his life of Brunelleschi (*Filippo di Ser Brunellesco*) states that he used a flat mirror.[79] Almost fifteen years after these experiments, Alberti in *De Pictura* wrote about the importance of the mirror as a tool, even crediting the invention of painting to the mirror image beheld by Narcissus. In a more practical vein he writes that mirrors are artistic checks on naturalistic mastery.[80] Around mid-century Filarete records a similar use of the mirror, linking it to the study of perspective.[81] Leonardo elaborates on these ideas and exclaims: 'The mirror—above all, the mirror is the teacher.'[82] Thus in Italy the mirror was both a symbol of truth and a tool for achieving an image true to nature, both of which are apropos to tondi.[83]

As painters employed mirrors more systematically, they occasionally utilized their effects for

[75] Quoted in Gibson, 'Hieronymus Bosch and the Mirror of Man', 217, who lists writers who utilized similar images.

[76] Thornton, *Interior*, 234–41.

[77] Lydecker, 'The Domestic Setting', 117, 119, 130, 132, 169. See Hartlaub, *Zauber des Spiegels: Geschichte und Bedeutung des Spiegels in der Kunst*; Gioseffi, 'Complementi di prospettiva, 2', 102–5; Schwarz, 'The Mirror of the Artist and the Mirror of the Devout', 94; Białostocki, 'Man and Mirror in Painting: Reality and Transience', 62 ff.

[78] Schwarz, 'The Mirror in Art', 110, fig. 9, from a manuscript of the Duke de Berry in the Bibliothèque Nationale de France, Paris. Białostocki, 'Man and Mirror', 66 ff., reasons that the Italian interest in idealization may have found the reflections in convex mirrors disturbing, causing them not to represent these mirrors in art, and that their involvement with perspective delegated mirrors to the painting's process.

[79] Holt, *Literary Sources of Art History*, 98–9. See also Edgerton, *The Renaissance Rediscovery of Linear Perspective*. It is interesting that

in Bruges, painters and glass makers belonged to the same guild, the Guild of St Luke (Schwarz, 'The Mirror in Art', 110), while in Florence glass and mirror makers belonged to the Arte dei Medici e Speziali, as did painters (Ciasca, *L'Arte dei Medici e Speziali nella storia e nel commercio fiorentino dal secolo XII al XV*, 371, 373).

[80] Alberti, *On Painting and On Sculpture*, 61–2, 89.

[81] Filarete, Bk. 23, 657, associating it with calculations involving the 'tondo' form. Later, Ripa (in his *Iconologia*) endows his personification of Perspective with a mirror. He positions her next to Perfection, who is depicted drawing a circle with a compass and is surrounded by the zodiacal band.

[82] Richter, *The Literary Works of Leonardo da Vinci*, i. 264. Leonardo cautions that a flat mirror should be used.

[83] The mercury backing of many mirrors may have been interpreted symbolically. Mercury was the planet and classical god associated with creativity as well as clever deception. Bonafoux, *Portraits of the Artist: The Self-Portrait in Painting*, 38–9.

painting tondi. We notice optical distortions resulting from an involvement with convex round mirrors in some tondi attributed to Raffaellino del Garbo (Figs. 7.26, A38) and Piero di Cosimo (Fig. A48). Even the postures of Joseph and Mary in Signorelli's *Parte Guelfa Tondo* (Fig. 7.33) not only echo the tondo shape but also may reflect experimentation with a circular convex mirror, a tendency more pronounced in Raphael's *Madonna della Sedia* (Fig. 7.36). Because of the optical distortions of convex mirrors, the Madonna and Child tondi modelled on them literally resemble mirrors in their physical shape, visual effects, and symbolism, completing the circle of suggestions for the viewer. The use of these mirror effects occurs more rarely in portraits (see Ch. 5).

The frames of extant fifteenth-century mirrors help to recover how people of the period regarded them and whether the physical objects were linked to tondi. From them, it is apparent that Italian mirror frames took a variety of forms, although those recorded as hanging on walls tended to be round, with rectangular ones becoming common in the Cinquecento.[84] From inventories, it seems that most hung in the private chambers of the household's head, like tondi. Frequently, their frames were elaborate, made of wood as well as of *pastiglia*, stucco, terracotta, *cartapesta*, and metal. While most were secular in ornamentation, some were highly symbolic and others had non-allegorical embellishments.[85] Because they were household items many had coats of arms with putti, motifs derived from the *imago clipeata*.[86] An early example belonging to a group of similar objects assigned to the workshop of Baldassare degli Embriachi has an amatory theme (Fig. 4.4). Its putti and crowning escutcheons reveal a connection with the *imago clipeata* whose relevance is heightened when a person beholds his/her visage reflected in the round mirror.[87] Several others whose iconographies relate specifically to the Platonic/Neoplatonic ideas have connections with marriage,[88] as well as concepts germane to devotional tondi. An important conjunction of love imagery and beauty with mirrors occurs on a *cartapesta* frame whose mirror is small and the framing element of two *amorini* holding the round mirror is a witty take-off on the *imago clipeata* (Fig. 4.5).[89] This emphasis on beauty, the result of Neoplatonism, is repeated in a Florentine example where postcoital Venus and Mars and *amorini* illustrate the erotic Neoplatonic allegory of Love Conquering Strife, a reconciliation of opposites (Fig. 4.6).[90] Its circular framing diamond ring

[84] e.g. the 1492 inventory of the Medici Palace lists two: (1) fol. 3ʳ: 'Uno specchio tondo grande di mezo rilievo f. 1'; (2) fol. 48ʳ: 'Uno specchio tondo e d'osso con 7 compassi, dentrovi 7 virtù f. 10' (Spallanzani and Bertelà, *Libro d'inventario*, 6, 93). Trecento ivory mirror cases also tend to be round and frequently feature amorous scenes of courtly love (Calkins, *Monuments*, fig. 206; Roche *et al.*, *Mirror*, pls. 35–40).

[85] e.g. a bronze convex mirror with a wooden decorated frame which has little if any symbolic content in the Museo Bardini, Florence (not in their catalogue and without an inventory number).

[86] For late quattrocento Tuscan mirrors with arms in the Robert Lehman Collection, The Metropolitan Museum of Art, see Callmann, *Beyond Nobility*, 71–2, no. 69, ill.; Newberry, Bisacca, and Kanter, *Italian Renaissance Frames*, 78–81, nos. 53–4, ill.

[87] Inv. no. 125C in the Museo Nazionale del Bargello, Florence, ivory and wood. Bertelà and Paolozzi Strozzi, *Arti del Medio Evo e del Rinascimento*, 248–9, no. 29, ill.

[88] Embodied in Venus; J. Hall, *Dictionary*, 210–11, 318 ff. The round engraving with Lorenzo de' Medici and a woman holding an armillary sphere echoes the shape of mirrors, as well as the *imago clipeata*, and concerns Neoplatonic love. Dempsey, *Portrayal*, links its armillary sphere with Lucrezia Donati's motto 'Spero', a play on

the word for hope and sphere; a mirror was also a 'spera' or 'sfera'. I believe that this sphere, jointly held by the couple, refers to the cosmic and scholarly dimensions of love and poetry championed by Lorenzo's family and intellectual coterie. The print, perhaps for a box, contains a double entendre, joining love, poetry, and the two lovers with the higher spheres while denoting the beloved as a 'mirror'. Perhaps the empty space at its centre was to be filled with a mirror-like substance. See Zucker, *Early Italian Masters*, 127–58, who on pp. 128–9 suggests that the blank may have been filled by the purchaser's arms.

[89] Inv. no. 850-1884 in the Victoria and Albert Museum, London, painted *cartapesta* measuring 46 × 41 cm. Coor, *Neroccio de' Landi, 1447–1500*, 170, no. 24, ill.; Rackham, *Guide to Italian Maiolica*, 29, pl. 11, and id., *Catalogue of Italian Maiolica*, i. 121–2, no. 351, ill., for a maiolica version. For an object possibly combining a mirror and a female bust in an allusion to the *imago clipeata* attributed to Mino da Fiesole in the Bibliothèque Nationale de France, Paris, see Foville, 'Le Mino de Fiesole de la Bibliothèque Nationale', ill.; Hartlaub, *Zauber des Spiegels*, 52, fig. 46; Zuraw, 'The Sculpture of Mino da Fiesole 1429–1484', ii. 813–16.

[90] Inv. no. 5887-1859 in the Victoria and Albert Museum, London, painted and gilt stucco with a gilt wooden frame and a 50.8

Fig. 4.4. Workshop of Baldassare degli
Embriachi, Mirror frame, *c.*1400. Museo
Nazionale del Bargello, Florence

Fig. 4.3. Cosimo Rosselli, *The Holy Family after Christ's Preaching in the Temple*, *c.*1500–4.
Whereabouts unknown

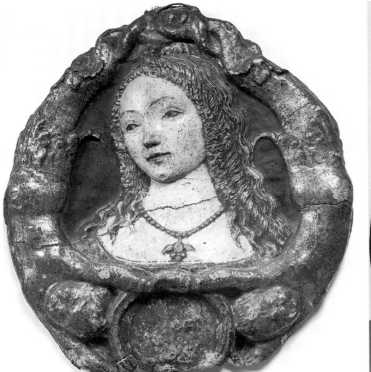

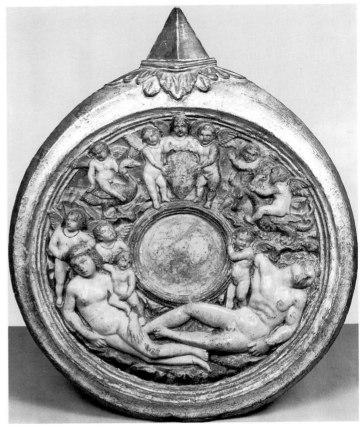

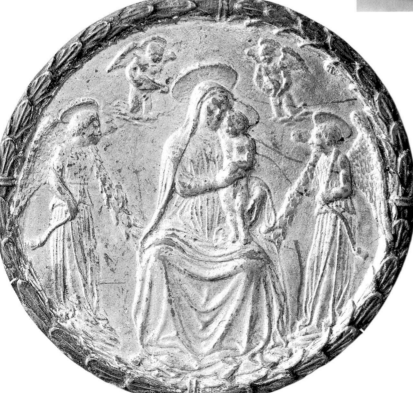

FIG. 4.5 (*above*, *left*). Workshop of Neroccio de' Landi, Mirror frame with the bust of a woman and putti, after mid-fifteenth century. Victoria and Albert Museum, London

FIG. 4.6 (*above*, *right*). Around Antonio Pollaiuolo, Mirror frame with Venus and Mars, *c*.1460–80. Victoria and Albert Museum, London

FIG. 4.7 (*left*). Attributed to the Circle of Luca della Robbia, Mirror with the Madonna and Child, two angels, and two music-playing putti, 1440–50. Victoria and Albert Museum, London

refers to eternal constancy, if not to the Medici *impresa*,[91] while its nuptial symbolism is appropriate, since most household objects were ordered in preparation for marriage.

The most significant mirror relative to a discussion about tondi and mirrors is a round, burnished metal one whose main side is decorated with a gilded relief (Fig. 4.7).[92] It features the Madonna and Child with angels and music-making putti, a subject prototypical of later tondi, surrounded by an ungilded laurel wreath that is similar to tondi frames. The object presents evidence of an actual equation of mirrors and tondi over and above the strong symbolic and functional connections mentioned earlier. Moreover, it profoundly links the duality implicit in the Renaissance Christian world: the mirror side was intended to reflect the real world, that is, a physical reflection, the relief the divine realm. With it, the owner could contemplate the spiritual reflection of heaven and the abode of archetypal ideas together with the appearances of this world.

Another tantalizing kind of mirror and one that is germane to tondi is glimpsed through an ephemeral type known in Germany as 'Heiltum'. They were not for the home, but rather were purchased along with other mementos, such as badges (some with mirrors), during pilgrimages (*Heiltumfahrten*), beginning in the fourth decade of the fifteenth century. Pilgrims carried them to sacred sites to collect invisible rays emanating from holy relics in order to transport back their reflections and magical healing powers.[93] While these ephemeral mirrors are of Germanic origin, they suggest that related ideas may have been current south of the Alps. Perhaps tondi were employed in an analogous fashion to reflect their sacred images on individuals in households or buildings where they hung.

THE ROSARY

The development of rosary devotion and its fledgling iconography can be linked to devotional tondi and their popularity.[94] This personal form of prayer developed gradually as a devotional method in medieval times in conjunction with the rise of devotion to the Virgin Mary. The origin of using beads as a device for counting prayers has been traced both to India and to medieval paternosters.[95] In the Marian rosary, the chaplet or string of beads symbolizes roses and was used with a string of prayers; hence the term 'rosary' (in German *Rosenkranz*, garland of roses, and in Italian *rosario* or *corona*), and the idea of wholeness associated with them. Although the rosary has a lengthy history, by the twelfth century it was in use in Western Europe. While St Dominic

cm. diameter. Pope-Hennessy, *Catalogue of Italian Sculpture*, i. 153–4, no. 129, ill. For Botticelli's roughly contemporary *Mars and Venus* in the National Gallery, London, see Horne, *Botticelli*, 141, and Lightbown, *Botticelli*, ii. 55–6, ill.; Cox-Rearick, *Dynasty*, 131, for astrological implications of the juxtaposition of the planets Mars and Venus, as in Ficino's *De Amore* (*Commentary on Plato's Symposium on Love*, 56).

[91] Lightbown, *Botticelli*, ii. 55, believes the frame symbolizes eternal constancy, whereas Cox-Rearick, *Dynasty*, 120, and Ventrone, *Le tems revient*, 162, no. 2.13, ill., think it signals a Medici connection. I believe a double allusion is possible. The escutcheon was probably once painted with a family's arms.

[92] See Ch. 6 n. 12.

[93] A woodcut from the Nuremberg *Heiltumbuch* of Peter Vischer of 1487 in the Bayerische Staatsbibliothek, Munich, shows them in use (Schwarz, 'The Mirror of the Artist', fig. 13).

[94] Olson, 'The Rosary and its Iconography'.

[95] See Wilkins, *Rose-Garden Game*, 30 ff. Also Oertzen, *Maria die Königin des Rosenkranzes*; Willam, *The Rosary: Its History and Meaning*; Orlandi, *Libro del Rosario della gloriosa Vergine Maria*; Cologne, Erzbischöfliches Diozesan-Museum, *500 Jahre Rosenkranz*; Speranza, 'La Madonna del Rosario'; Winston-Allen, *Stories of the Rose: The Making of the Rosary in the Middle Ages* (especially for textual material).

(1170–1221) is not linked to its inception, as claimed by the Dominicans, that Order was important in disseminating its use and popularity, including in quattrocento Florence. By at least 1481 a confraternity of the rosary was active at San Marco, having been spurred on by the interest of Antoninus and his followers.[96] Because of the relationship of Antoninus with the Medici, it is significant that the five-petalled rose, the one emblematic of the Virgin and used throughout rosary iconography, was also a Medici *impresa*. It is carved in roundels on their palace façade alternating with the *impresa* of the three feathers and diamond ring.[97] Further, Pandolfo di Cambio de' Medici, a canon of the Duomo, was an important member of the Confraternity at San Marco, suggesting that, like the Compagnia de' Magi—also located at San Marco and sponsored by the Medici—the Compagnia del Rosario may have been connected with the family. The Confraternity's statues— *Compagnia ovvero Confraternita del Psalterio ovvero Rosario della glorissima Vergine Maria. Ordinationi, capitoli, regole, privilegi et indulgentie*, an incunabulum from *c*.1485, known in two copies—graphically demonstrate the connection between the Psalter and the rosary.[98] Further, Pope Sixtus IV promoted its use, followed by Innocent VIII and Leo X.[99] The Confraternity was one of the few that allowed and encouraged the membership of lay women, cost nothing, and only encouraged prayers in the home, rendering it a viable form of lay piety for women. The development of its visual iconography from the 1470s made it accessible to the illiterate as well. While the iconography of the Madonna of the Rosary was not codified until the early decades of the Cinquecento, tondi provide evidence of a proto-iconography for use of the rosary before that time.[100] In fact, the roundness of the tondo shape and the movement it encourages connotes the rosary.

Although a rosary's beads could be arranged either as a open string or as a circlet of beads, its essential nature was circular. The roundness of the beads was paramount and connected to roses, *rotae*, rose windows, and cosmology. The physical rosary chaplet, like its circle of prayers and the *hortus conclusus*—and also like the tondo form itself—is closed. Tellingly, Wilkins writes:

> The roundness of the beads was important. It is not the simple five-petalled rose that I am thinking of, even though the number five is symbolic (in the Pythagorean tradition) of the Hieros Gamos, the sacred marriage of Heaven and Earth, and hence in general of union. I am thinking of the multifoliate rose with the deep heart. Its roundness is in depth. And roundness, whether one regards it etymologically (in the light of the Indo-European root *ri*, to go) or otherwise, is that which moves; a *rota*, wheel . . . The ring-a-ring of the rosary is a ritual going spirally upward through the Mysteries in an ascent that culminates in the mystic marriage of the soul that has borne God with the God that has borne. The circling is thus completed in depth as the *sphaera intelligibilis*.[101]

[96] Kirsch, *Handbuch des Rosenkranzes*, 115.

[97] Cardini, 'Le insegne', 63, ill.

[98] Olson, 'The Rosary'. For the altarpiece of the Compagnia in San Marco by Cosimo Rosselli, see Padoa Rizzo, 'La "Vergine del Rosario" di Cosimo Rosselli', 64–9, fig. 1.

[99] See Wilkins, *Rose-Garden Game*, 37 ff.; Meersseman, *Ordo Fraternitatis: confraternite e pietà dei laici nel Medioevo*, 1185–9; *Oxford Dictionary of the Christian Church*, 1202. Also R. M. Steinberg, 'Fra Bartolomeo, Savonarola, and a Divine Image', 326; Warner, *Alone of all her Sex: The Myth and the Cult of the Virgin Mary*. Kirsch, *Handbuch*, reproduces as a frontispiece the emblem of the confraternity of Our Lady's Chaplet, the Rosenkranz, founded by Archduke Maximilian, son of Frederick III, in 1475. It consists of three interlocking circles, the gold one with a crown of glory for the glorious rosary (Christ's descent from King David), the red with a cross for the sorrowful, and a silver or white with a comet for the joyful.

[100] For illustrated woodcuts or engravings with circular or oval frames of stylized roses and/or beads arranged in five decades, see Oudendijk Pieterse, *Dürers Rosenkranzfest en de ikonografie der Duitse rozenkransgroepen van de XVᵉ en het begin der XVIᵉ eeuw*; Winston-Allen, *Stories of the Rose*, 31–64. Frequently the frames of these designs were punctuated by five larger roses of five petals each, like paternoster bosses, to mark the decades or the fifteen scenes depicted in an abbreviated form. Moreover, the influence of Italian tondi can be seen on several (e.g. Oudendijk Pieterse, *Dürers Rosenkranzfest*, pls. 27, 54). One of the earliest images of the Madonna of the Rosary is Antonello da Messina's *San Gregorio Polyptych*, dated 1473, in the Museo Nazionale, Messina (Wilkins, *Rose-Garden Game*, 187, states it is the earliest). See Olson, 'The Rosary', for further discussion of rosary iconography.

[101] Wilkins, *Rose-Garden Game*, 99–100.

Rosaries are related to the nursery rhyme 'Ring around the Rosey' ('Ring-a-ring-a rosey' or 'Ring-a-ring o' roses'), whose origin has been linked to the plague.[102] Moreover, this children's game relates to the eternal cycle of life, death, and resurrection (the spiritual garden) rather than exclusively to the plague. The circle of youngsters playing it and the repetition is like the rosary itself, whose ultimate goal is meditative union with God.[103]

Although the rosary's symbolism is complex, it is related to traditional Marian symbolism because medieval epithets of Mary include 'rose without thorns' and 'Rosa Mystica'. She is also portrayed as the Queen of Flowers, explaining generally the floral symbolism in tondi.[104] When the *hortus conclusus* associated with her is a rose garden, a *rosarium*, as in Fig. 7.9, it not only symbolizes Mary's virginity, but also the chaplet of rosary beads and the Garden of Paradise.[105] It is a place of immortality where birds (*aves* in Latin) never die (like the goldfinch, symbolic of Christ's Death and Resurrection), and where the Virgin succeeds Eve and Christ Adam (as the Garden of Paradise replaces the Garden of Eden) to redeem souls from Original Sin. The symbolism of the rose also relates to the courtly love tradition and the poems of the *dolce stil novo*, where rose symbolism flourished. In the *Paradiso* (XXIII, 73 ff.), Dante remarks: '. . . la Rosa, in che 'l verbo divino / carne si fece . . .' ('The Rose, wherein the Divine Word made itself flesh . . .').

Until well into the sixteenth century, there was variation in the number and arrangement of rosary beads. The main beads are *ave* beads for the Hail Mary (*Ave Maria*) prayers. They are separated by fifteen paternoster beads (for 'Our Father' at the beginning and the 'Gloria Patri' at the end of each decade) with a larger, fifteenth, paternoster bead or medallion closing it. Thus, the full rosary consists of 150 Hail Maries (like the 150 Psalms), separated by paternosters, arranged in fifteen decades, which are in turn divided into three sets of five decades, recited in the smaller chaplet or *rosarium*. (Incidentally, five is the number of letters in the Virgin's name: *Maria*.) Ordinarily, only a third of the rosary, or five decades, is said on one occasion (although there were further abbreviations). This tripartite scheme corresponds to the division of the Psalter, consisting of 150 Psalms, into three. Each of the rosary triads, echoing the Trinity, symbolizes a series of Mysteries consisting of five events in the life of Christ and the Virgin on which to meditate: (1) the Joyful Mysteries (Annunciation, Visitation [or the Adoration of the Magi], Nativity, Presentation, Preaching in the Temple); (2) the Sorrowful (Agony in the Garden, Flagellation, Crowning with Thorns, Road to Calvary, Crucifixion); and (3) the Glorious (Resurrection, Ascension, Descent of the Holy Spirit, Assumption of the Virgin, Coronation of the Virgin).[106] Of these themes, the Annunciation, the Nativity, the Adoration of the Magi, after the Preaching in the Temple, the Agony in the Garden, the Crucifixion, and the Coronation of the Virgin are depicted in tondi. Various moments in the Nativity story are the most frequently represented, while the synoptic fifteenth scene of Marian devotion, the Coronation of the Virgin (Figs. 7.13, A37) implies not only the Madonna's status as Queen of Heaven but also the Immaculate Conception. The latter concept, a theological chestnut of the Quattrocento, holds that the Virgin was conceived free of sin. It is not

[102] Opie and Opie, *Oxford Dictionary of Nursery Rhymes*, 364–5. Wilkins, *Rose-Garden Game*, 81, wonders whether the English rhyme ever was recited 'ring-a-ring-a rosary' like the German 'Ringel-ringel Rosenkranz'.
[103] Ibid. 105 ff.; Levi D'Ancona, *The Garden*, 330 ff.
[104] Wilkins, *Rose-Garden Game*, 120.
[105] Ibid. 192. Also Ferguson, *Signs and Symbols*, 96, 168. See Ch.

2 n. 78, for René of Anjou's arms linking the rosary with a crown, cross, circle, and square.
[106] Wilkins, *Rose-Garden Game*, 54; Warner, *Virgin Mary*, 390 n. 20. Willam, *The Rosary*, 11–12, views the rosary as a Psalter of the laity. These scenes were in flux and constantly evolving, as Winston–Allen, *Stories of the Rose*, demonstrates.

surprising, therefore, when one of these scenes is represented in a tondo that it may be related to rosary devotion.

Similarly, when certain motifs are repeated in a numerologically significant sequence in a tondo they may also connote rosary iconography,[107] a conclusion reinforced by the associations of the tondo with the roundness of the beads and the circularity of the chaplet and its prayers. Because rosary iconography derives from Marian imagery, some of these correspondences may be purely coincidental, although it is clear that a nascent rosary iconography is present in some tondi. In the light of the five decades of the rosary and the three series of mysteries, it is understandable that the numbers five and three figure significantly in many. For example, three angels can allude not only to the Trinity but also to the three series of prayers or meditations for the rosary (Fig. 7.14). Similarly, the five trees in Botticini's tondo (Fig. 7.9), as well as the five nudes in both Filippo Lippi's and Michelangelo's tondi (Figs. 3.1, 7.37) refer not only to the five decades of the most frequently recited rosary sequence but also to the five petals of the rose associated with the Madonna and to the five wounds of Christ.[108] Each of these objects also carry their own symbolic meanings, such as the five cypresses in Botticini's tondo which allude to death and immortality.[109] In addition, the five roundels of the *Doni Tondo*'s frame function like paternoster beads, as focal points to mark the decades or alternatively the five events in the tripartite Mysteries. Even the figures in tondi frequently number three or five; sometimes the Madonna and Child are counted as one entity, other times separately. Further, rosary beads are occasionally depicted in tondi and altarpieces, as in Filippino Lippi's *Annunciation* or his *Corsini Tondo* (Figs. 3.2, 7.24), which date from *c.*1481–3, the very years of the founding of the Confraternity of Rosary at San Marco. Sometimes one encounters three five-petalled roses, as in a tondo attributed to the Master of Serumido (Fig. A51).

Wreaths of roses, which appear occasionally in paintings from the fourteenth century, decorate the frames of several tondi, although this was not the most prevalent frame decoration (see Ch. 7). Most of the relatively few tondi frames that survive are composed of garlands with fruit and/or flowers, signifying the fruits of Paradise. The few enframed by a rose garland (*Rosenkranz, corona, rosario*),[110] probably allude to the rosary.[111]

It has been said that 'prayer formed the figure of the Virgin Mary', a fact echoed in the codified rosary iconography of Lorenzo Lotto's *Madonna of the Rosary* (signed and dated 1539). In this *sacra conversazione*, the Madonna hands rosary beads to St Dominic below three groups of five roundels

[107] Olson, 'The Rosary'.

[108] Wilkins, *Rose-Garden Game*, 108. Both the rose and the flower of the apple (Christ was the second Adam), to which it is related, are five-petalled. The rose also symbolizes the beauty and perfection of the fivefold Aristotelian universe, the ever-recurring cycle, and hence eternity, like the circle (ibid. 109).

[109] Doering, *Christliche Symbole*, 67.

[110] A wreath of roses was adapted by the early Doctors of the Church to signify Christian joy, divine love, and Paradise. The red rose symbolizes charity, compassion, and the flesh conquered by the spirit as well as Christ's Passion, while the white rose signals virtue and the passions purified or the Virgin. See Joret, *La Rose dans l'antiquité et au moyen âge*, 231–2; Seward, *The Symbolic Rose*, 18–20, 36 ff., 43–6; Levi D'Ancona, *The Garden*, 330 ff.

[111] They include: (1) inv. no. 1199 with a 69.9 cm. diameter in the National Gallery, London, attributed to Pseudo Pier Francesco Fiorentino, in its original *pastiglia* frame with five mouldings, the largest with a ring of fifty roses for the *rosarium* (M. Davies, *The Earlier Italian Schools*, 186; Mitchell, 'Italian Picture Frames 1500–1825', pl. 15A); (2) inv. no. 57 with a 58 cm. diameter attributed to Pier Francesco Fiorentino in the Strossmayer Gallery, Zagreb (Zlamalik, *Strossmayerova Galerija Starih Majstora Jugoslavenske Akademije Znanosti i Umjetnosti*, 76–7, no. 26, ill.); (3 and 4) two others attributed to Pseudo Pier Francesco Fiorentino in the Collegiata, Sinnalunga, Val di Chiana, with fifty roses, and the Knable Collection, Florence, with forty-five roses (both in photographs in the FKI)—this motif appears on several tondi frames attributed to the same individual, suggesting a common carpentry shop; (5 and 6) two in glazed terracotta by Luca and Andrea della Robbia with white roses (Figs. 6.16, 6.17); (7) Benedetto da Maiano's marble one which is part of the *Monument of Filippo Strozzi* (Fig. 6.13) (see Ch. 6). In contrast to the rose frames of propagandistic Germanic examples, Florentine artists neither employed roses for tondi frames on a regular basis, nor used roses in a literal pattern punctuated every decade to simulate a chaplet.

with depictions of the five Joyful, Sorrowful, and Glorious Mysteries.[112] Their placement on a rose tree demonstrates the association between the rosary and the round format that occurs in tondi in a fledgling iconography. As the great intercessor on behalf of human beings, the Virgin bridged the gap between the human and divine worlds, just as a tondo, when used as a focal point for devotion, sometimes with the aid of the rosary, helped the worshipper transcend the boundaries between the physical and spiritual worlds.

In conclusion, it seems that devotional tondi brought contemporary ideas of religion into households and other interiors in a vivid manner. While they were no doubt intended as devotional images, merging heavenly and earthly elements, they also reflected current ideas about the family and its members.[113] Certainly, tondi also were intended as *exempla* for members of the household to mirror. And, like *deschi*, tondi may have harboured a talismanic function connected with fertility and the bearing of healthy babies.[114] The extreme popularity of tondi during their apogee, which coincides with the establishment of the Confraternity of the Rosary at San Marco, proves the power of these domestic religious images for Florentines of the Quattrocento, when they functioned as images for reflection and for the transformation of peoples' lives into something more perfect.

[112] Commissioned by the Compagnia del Rosario annexed to San Domenico, Cingoli (now San Niccolò); Dal Poggetto and P. Zampetti, *Lorenzo Lotto nelle Marche*, 338–41, no. 85, ill.

[113] Hayum, '*Doni Tondo*', 210, believes that they were not primarily devotional objects but that their Christian themes validated domestic ideals concerning the family.

[114] There were also amulets and charms to ward off the evil eye and monstrous births and to ensure a fast and safe delivery (Thorndike, *History of Magic*, 192).

5

RENAISSANCE PORTRAITS IN ROUND FORMATS

In this chapter we examine Renaissance portraits in a round format to ascertain their significance and to determine why there are so few extant on a larger scale. Based on their survival rates, portrait tondi were produced in far fewer numbers than Florentine devotional tondi. Moreover, there are fewer in paint than in sculptural media. Those in existence today seem to be experimental types that never caught on as a culturally pervasive idiom. (Renaissance medals and medallions will not be considered in this context. Although related, they constitute a study in themselves, for medals are a separate and distinct genre.)

Nevertheless, with the advent of humanism—and its revelling in ancient prototypes, its embrace of the circular form, and its interest in human beings as individuals—portraits in a round format on a relatively large scale were resurrected in fifteenth-century Italy, seemingly first in Florence. While they were related to smaller circular portraits within larger contexts, such as those in manuscript illuminations, the inspiration for fifteenth-century types came from ancient works of art and the constant reinforcement provided by the myriad examples of the *imago clipeata*. This self-conscious emulation of the antique is buttressed by much evidence, including a 1472 entry from the ledger book of the Florentine citizen Lorenzo di Matteo Morelli recording the order to paint an ancient head for a tondo in the court of his *palazzo*.[1] In general, fifteenth-century Florentine portraits in a round format first appear as commemorative examples in sculpture. Since most are within a larger sepulchral context, they could be classified as roundels or medallions, which had as their direct models the ubiquitous *imagines clipeatae*.

PROTOTYPES REVISITED

In addition to *imagines clipeatae*, other ancient prototypes for round portraits include a variety of ancient objects: Roman jewelry, cameos, and gold-glass portrait medallions prototypical of miniatures (Fig. 5.16).[2] There are also round painted portraits, such as a pensive one from Pompeii

[1] ASF, Archivio Gherardi-Piccolomini 137, fol. 71: 'dipintura d'una testa anticha per in un tondo nella chorte'. (Lydecker, 'The Domestic Setting', 119 n. 81; id., 'Il patriziato fiorentino', 216). Two other citations of tondi with visages connected with Roman traditions are in ASF, Strozziane-V, 65, fol. 20 left, in the items Alfonso Strozzi obtained from the town house of his father Filippo: 'uno tondo di marmo entrovi II teste'; 'uno tondo introvi una testa

di Nerone cholorita di marmo' (Rhoda, 'Florentine Villas in the Fifteenth Century: A Study of the Strozzi and Sassetti Country Properties', 284).

[2] See Goheen, *The Collections of the Nelson–Atkins Museum of Art*, 31, ill., for a gold pendant with a 6.7 cm. diameter and a frontal bust of a soldier, the *imago clipeata*, on its obverse, and Osiris, god of the underworld, on its reverse. Also Volbach, *Early Christian Art*, pl.

(Fig. 5.1).[3] In addition, ancient coins and rarer medallions fueled the association between the round shape and portraits. However, most of these feature the visage in an impersonal profile, which after *c.*1470 Renaissance artists abandoned in favour of a three-quarters view. The high regard in which these pieces, collected zealously by humanists, were held, coupled with the resuscitation of the art of the medal by Antonio Pisanello in the middle decades of the century (Fig. 1.23), reinforced the circle's association with portraits and its ability to confer an exalted status on the person depicted.[4] However, both coins and medals, unlike tondi, had two sides, one for the portrait and the other for the *impresa* and/or motto. Since both were small in scale, reproduced in multiples, and meant to be handled, their association with larger works to be hung was only partial at best. These ideas find concrete expression in Botticelli's *Portrait of a Man with a Medal* in the Uffizi (*c.*1475–80), whose sitter proudly holds a gold medallion of Cosimo de' Medici raised in relief.[5] Via this blatantly humanistic device, the sitter allies himself either by blood or business, or both, with the Medici. One drawback of the two-dimensional form is apparent even with the medallion in relief: its reverse cannot be viewed.

Other more contemporary objects featured visages in circular formats, for example, maiolica plates, where most frequently female profiles are represented (Fig. 5.2).[6] These *belle donne* plates, which are not really portraits, originated in the Trecento, reaching their greatest popularity at the end of the Quattrocento and the early Cinquecento. Involved with concepts of ideal beauty and love, they functioned as decorative objects displayed on the wall or on shelves. Since they were larger than medals, cameos, or coins, and were always autonomous as well as associated with the domestic environment, they rank as a parallel but different phenomenon from tondi portraits that should not be ignored.

Illuminated manuscripts furnish another context wherein fifteenth-century individuals could have seen portraits in round formats, with examples reaching from their own epoch back to Roman times. Pagan authors had been represented in bust-length *imagines clipeatae* since the first codices, and these forms were readily assimilated into the Christian vocabulary.[7] Medieval manuscript initials sometimes feature them, as in the twelfth-century inscribed self-portrait of the nun Guda in the initial Q in a book of homilies.[8] Roundels or initials also contain portraits of patrons. Because

11, for three gold-glass portraits; pl. 59, for a cameo with frontal busts.

[3] Its pendant is a male with an ivy-wreath and scroll (Ling, *Roman Painting*, 157 ff., ill.). Like the *clipeatae imagines* they were placed in or near the atrium, locations for ancestor portraits, and were usually small. See Belting, *Likeness and Presence*, 90, fig. 41, for a panel with portraits of two brothers with Hermes and Anubis.

[4] See Hill, *A Corpus of Italian Medals of the Renaissance before Cellini*; Scher, *The Currency of Fame: Portrait Medals of the Renaissance*; Cordellier and Marini, *Pisanello*. Only a few late 15th-c. medals (and cameos) feature a three-quarters view.

[5] The medallion, constructed of gilt stucco relief on a ground of carved and gilt wood, is inscribed *MAGNVS COSMVS / MEDICES PPP* (*Primus Pater Patriae*), the title conferred on Cosimo posthumously in Mar. 1465. Lightbown, *Botticelli*, ii. 33–5, ill., connects it with a similar portrait by Hans Memling (*c.*1478). A related portrait from the orbit of Botticelli of a young man before a *pietra serena* window holding a medallion of a saint, a separate panel with a 10.6 cm. diameter which, from the rectangular punch work,

was once part of a trecento altarpiece (Stapleford, 'Botticelli's Portrait of a Young Man Holding a Trecento Medallion', fig. 2). See Christiansen, 'Botticelli's Portrait of a Young Man with a Trecento Medallion', 744, who thinks the roundel, which has not been removed for examination, was inserted when the original medallion, similar to the one in the Uffizi portrait, was taken out or lost; Belting, *Likeness and Presence*, 419.

[6] Inv. no. 2593-1856 in the Victoria and Albert Museum, London, with a 45 cm. diameter. Rackham, *Catalogue of Italian Maiolica*, i. 19, no. 73, ill. For another early example, see Wilson, *Ceramic Art*, 144 ff., no. 223, ill. They often are inscribed with a woman's name and *bella* or *diva* and may have been love gifts; for one inscribed *AMORE MIO*, see Rossi, *Il Museo Horne*, 156, fig. 121.

[7] e.g. Grabar, *Christian Iconography*, 80–1, figs. 206–7, a portrait of Terence as an *imago clipeata* in a manuscript in the Biblioteca Apostolica Vaticana, and the portrait of the monk Antony in a roundel in a 10th-c. gospel in the monastery of Stavronika, Mount Athos.

[8] Bonafoux, *Portraits*, 18, ill.

imagines clipeatae, coins, cameos, and medals were of interest to Renaissance artists and their humanist patrons, they occasionally decorate later fifteenth-century Florentine manuscripts, as in a folio attributed to Francesco d'Antonio del Cherico with a medal of Cosimo de' Medici in the company of cameos portraying Roman emperors (Fig. 5.3).[9] However, these examples are small in scale.

Moreover, medallion or roundel portraits appear with increasing frequency as subsidiary motifs in decorative fresco schemes as the fifteenth century matures. Some belong to series depicting the ancestors and/or family members of the patron.[10] Others feature, either singly or in a group, Roman emperors or figures from ancient history juxtaposed with the patron. Portrait roundels—some in imitation of ancient cameos or coins, others in the style of contemporary medals, and still others more like actual portraits—enjoyed a substantial popularity. Artists such as the antiquarian Andrea Mantegna, who painted many medallions/roundels, and Jacopo Bellini, whose sketchbooks contain drawings after antique works, were fascinated by ancient numismatic and marmoreal examples.[11]

Generalized *imagines clipeatae*, clothed in Christian vestments, with generic 'portraits' appear in a variety of sacred contexts in fifteenth-century Florence. The most common contain bust-length holy individuals, types that had been continuous since Early Christian times, such as the prophets of the Duomo clock face by Paolo Uccello (Fig. 5.17). An inventive instance is Donatello's image of the Trinity (its tripartite visage surrounded by a wreath and flanked by wings) in the pediment of his Parte Guelfa niche on Or San Michele (*c*.1422–5).[12] Two others occur in: (i) the ingenious God the Father painted by Fra Angelico as a grisaille sculptural roundel in his *Cortona Annunciation*;[13] and (ii) the bust of a child by Bicci di Lorenzo simulating a carved medallion on the Madonna's throne in a panel (1433) from San Niccolò, Florence.[14] In each case, the motif encapsulates a profound theological concept to which its *imago clipeata* ancestry adds resonance.

PORTRAITS IN SCULPTURE

Portraits of Renaissance individuals in autonomous or quasi-independent circular formats appear only around mid-century, when rectangular portraits and sculpted busts become popular. The first are associated with commemorative or sepulchral contexts and are in sculptural media, hence directly indebted to the *imago clipeata*. It may be significant that their genesis dates from roughly the years assigned to the earliest devotional tondi.

Ghiberti's portraits of himself and his son Vittorio (*c*.1447) protruding three-dimensionally from

[9] MS Plut. 71.7, fol. 1, in the Biblioteca Mediceo-Laurenziana, Florence, an Aristotle manuscript dedicated to Piero de' Medici. Langedijk, *Portraits of the Medici*, i. 390–3, no. 26, 15, ill. Another example is the portrait of Cristoforo Landino by Gherardo and Monte del Fora in a roundel in his translation of Pliny (1476) in the Bodleian Library, Oxford (Chastel, *Marsile Ficin*, pl. V).

[10] These were especially popular in Lombardy, such as one (*c*.1490–1500) of twenty-three portraits (Kauffmann, *Victoria and Albert Museum. Catalogue of the Foreign Paintings*, i: *Before 1800*, 172–4, ill.; see also Terni di Gregory, *Pittura artigiana lombarda del Rinascimento*, fig. 11).

[11] e.g. fol. 48 in Bellini's sketchbook in the Musée du Louvre, Paris, after the Tomb of Metella Prima (Eisler, *The Genius of Jacopo Bellini*, pl. 84).

[12] Janson, *The Sculpture of Donatello*, i, pl. 66. The motif was later used by Michelozzo and shop in a marble basin (Lusanna and Faedo, *Il Museo Bardini a Firenze*, ii: *le sculture*, 252–3, no. 184, ill.).

[13] The device preserves the Aristotelian unities, incorporating a heavenly apparition without compromising its natural or spiritual elements. Hood, *Fra Angelico at San Marco*, 100–2, ill., dates it *c*.1432–4.

[14] Van Marle, *Italian Schools*, ix, ill. opp. 16.

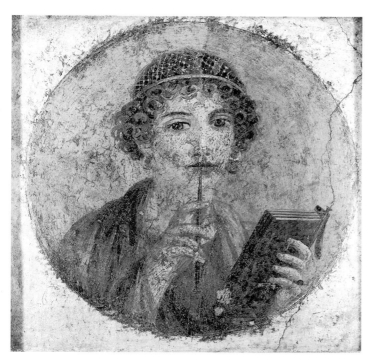

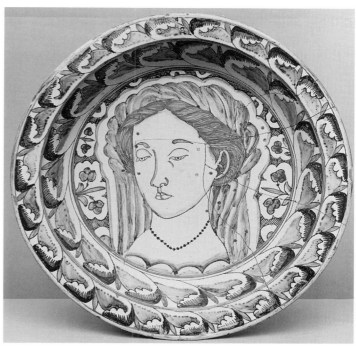

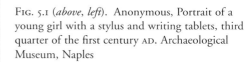

FIG. 5.1 (*above*, *left*). Anonymous, Portrait of a
young girl with a stylus and writing tablets, third
quarter of the first century AD. Archaeological
Museum, Naples

FIG. 5.2 (*above*, *right*). Anonymous, *Bella Donna*
plate, c.1450. Victoria and Albert Museum, London

FIG. 5.3 (*left*). Francesco d'Antonio del Cherico,
Detail of a page from MS Plut. 71.7, fol. 1, 1465–9.
Biblioteca Mediceo-Laurenziana, Florence

FIG. 5.4. Lorenzo Ghiberti, Detail of the *'Paradise' Doors, Self-Portrait, c.*1447. Baptistery, Florence

FIG. 5.5. Style of Desiderio da Settignano, Chimney piece, second half of the fifteenth century. Victoria and Albert Museum, London

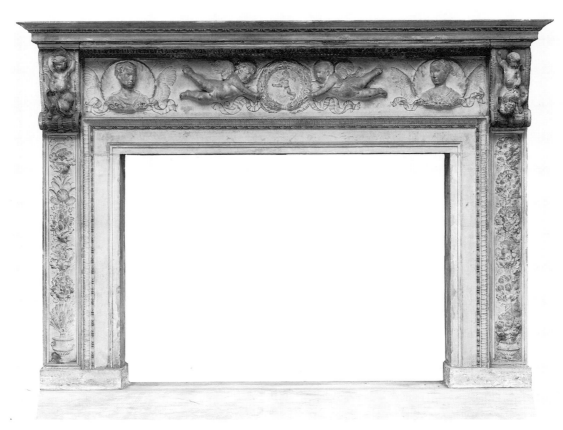

roundels on his *'Paradise' Doors* (Fig. 5.4) offer evidence that between their conception and execution frontal portraits in roundels—assuredly inspired by Roman models and based on comments about the importance of portraits in Pliny's *Natural History*, 35. 2—were deemed fashionable. They contrast with his earlier self-portrait projecting from a quatrefoil on his first set of Baptistery doors that also commemorates his work.[15] They demonstrate that Ghiberti wanted to be *au courant*, and that the circle and the *imago clipeata* had become *de rigueur* in the contemporary artistic vocabulary.

While Ghiberti's self-portrait has a feeling of autonomy, owing to the three-dimensionality of its protruding head, a pair of portraits on a *pietra serena* chimney piece, carved in relief in the style of Desiderio da Settignano, are closer to roundels (Fig. 5.5). These busts of a man and a woman in winged shells, an argument for their immortality, flank a laurel wreath, inscribing the arms of the Boni family held up by flying putti.[16] While all these motifs derive from sarcophagi with *imagines clipeatae*, the centrality of the heraldry suggests that it commemorates a marriage, underlining the connections of portraiture, heraldry, the family, and immortality. It may mark that of Giovanni Boni and Camilla di Cristofano di Gregorio Marsuppini in 1463, in which case its winged shell would be a dynastic allusion to the wife's illustrious heritage, citing the motif on Desiderio's *Marsuppini Monument* (only the detail of which is reproduced as Fig. 6.10).

Conceptually linked but more blatantly *all'antica* and autonomous is the large tondo with the relief portrait of Brunelleschi (Fig. 5.6). It forms part of the architect's two-tiered sepulchral monument in the first southern bay of the Florentine Cathedral that is separate from the tomb in the floor.[17] Hauptmann identified the work (*c.*1446–7) by Il Buggiano—Brunelleschi's foster-son, heir, and pupil—as one of the earliest Renaissance portrait tondi.[18] The architect/sculptor's visage was based on a dramatic death mask,[19] whose sunken features Buggiano enlivened. Brunelleschi is portrayed in an unusual over half-length pose adapted from a distinctive type of *imago clipeata* on sarcophagi. His head projects illusionistically over the frame, while his animated posture and expression suggest that he is greeting people entering the Duomo. His *cappuccio* rests rather awkwardly (wrongly foreshortened) on his right shoulder (on top of a mantle that some identify wrongly as a toga), exposing his head to underline his intellectual qualities. Its placement may be not only a gesture of respect but also a sepulchral convention that the individual is among the immortals, for Francesco di Giorgio positioned the deceased's *cappuccio* on his right shoulder almost identically in a drawing for a humanist tomb,[20] while Bernardo Rossellino carved Leonardo

[15] Pope-Hennessy, *The Portrait in the Renaissance*, 72, believes that after a study of the antique Ghiberti discarded the headdress of his first self-portrait to stress the intellectual qualities of the forehead. The change was inspired by *imagines clipeatae*, as revealed in one of his drawings (Brunetti, 'Ghiberti orafo', fig. 1).

[16] Inv. no. 5896-1859 in the Victoria and Albert Museum, London, *pietra serena* measuring 254 × 365.8 cm. Pope-Hennessy, *Catalogue of Italian Sculpture*, i. 135–8, no. 113, ill.; Vines, 'Desiderio da Settignano', 160–2, ill.; Pellegrini, 'La produzione di camini a Firenze nel primo Rinascimento', ill.; Coonin, 'The Sculpture of Desiderio da Settignano'. Another shell-like tondo frames the death mask of Battista Sforza in the Musée du Louvre, Paris (inv. no. R.F. 1171, now reinserted into this terracotta round mount with a laurel border; Olson, *Italian Renaissance Sculpture*, figs. 97, 99, without mount).

[17] Morozzi, *Santa Reparata*, 14–15. For the documents: Poggi, *Il*

Duomo di Firenze, ii. 130–1, nos. 2076–8; Guasti, *La cupola di Santa Maria del Fiore*, 55–7, docs. 119–21. See Schütz-Rautenberg, *Künstlergrabmäler des 15. und 16. Jahrhunderts in Italien*, 12–53; Ciardi Dupré Dal Poggetto, 'Il Buggiano scultore'; Battisti, *Brunelleschi*, 18 ff.; Collareta, 'Le "luci della fiorentina gloria"'. Later, sculpted portrait medallions, usually in profile like antique coins, enjoyed a vogue, noticeably in Lombardy; Malaguzzi-Valeri, *Gio. Antonio Amadeo*; Morsecheck, *Relief Sculpture for the Façade of the Certosa di Pavia, 1473–1499*; Lusanna and Faedo, *Museo Bardini*, 279, nos. 259–61, figs. 304–5.

[18] Hauptmann, *Der Tondo*, 31.

[19] Poggi, 'La "maschera" di Filippo Brunelleschi nel Museo dell'Opera del Duomo'; Pope-Hennessy, *Portrait*, fig. 7.

[20] Forlani Tempesti, *The Robert Lehman Collection*, v: *Italian Fifteenth-Century to Seventeenth-Century Drawings*, 202 ff.; Bellosi, *Francesco di Giorgio*, 312–13, no. 60, ill.

Bruni's *cappuccio* similarly, propping up the Chancellor's head in his effigy (Fig. 6.9). Below the tondo is a plaque inscribed *all'antica* with an epitaph by Carlo Marsuppini, alluding to Brunelleschi as a contemporary Dedalus (whom Pliny cites as the founder of architecture and construction).[21]

The monument's simple, nearly Spartan, composition consists solely of the dominant tondo portrait and tablet, both taken from Roman funeral imagery to connote the immortality of the deceased. Via such elements as the tondo's large scale, its dark, slightly concave background, and the plasticity of its mouldings, including an oak wreath (a Roman motif) bound by a ribbon, Buggiano created a novel commemorative form that is physically removed from sarcophagus and sepulchre. The monument rests on the heavily dentilated *pietra serena* string course running around the walls about sixteen feet above the pavement. If originally intended as we see it today, it was a highly appropriate tribute to a man whose ideas about the central plan and the significance of the circle harmonized with its simple yet avant-garde form *all'antica*, revised to fit Renaissance standards.

To understand just how radical this conception is, it can compared with the later *Monument of Neri Capponi* (d. 1457) (Fig. 5.7).[22] Capponi's profile visage (by Antonio Rossellino) is in a large medallion that illusionistically overlaps the borders of the sarcophagus to become quasi-autonomous. Putti-like nude angels with haloes support it in imitation of *imagines clipeatae*. These forms are echoed on the lid, where Capponi's arms are circumscribed by a laurel wreath, from which hang lateral swags of fruit, referring respectively to Capponi's eternal rewards and fame and to his family's on earth. While the portrait medallion is larger and closer to the viewer, the abstract coat of arms is hierarchically more dominant, arguing for the family's prestige based on Capponi's accomplishments. By contrast, Buggiano's *Brunelleschi Monument* was not tied to sepulchral conventions and, therefore, is bolder and more inventive.

The format set by Brunelleschi's cenotaph was followed only twice in the Duomo during the Renaissance, and with increasing variations, in monuments honouring persons with professions we today identify with the arts. These monuments have a civic dimension because the individuals honoured were associated with the Florentine Duomo and the Medici. Around 1490, at the apogee of the tondo's popularity, Benedetto da Maiano was responsible for the adjacent monument to Giotto (Fig. 5.8) and the one to Squarcialupi (Fig. 5.9). Both may have been commissioned by Lorenzo de' Medici as part of a series of illustrious men he reputedly sponsored. While they are linked in format and installation above the string course to the *Brunelleschi Monument*, only the frame of the *Giotto Monument* harmonizes with that of Brunelleschi's, while the *Squarcialupi Monument* is surrounded by a guilloche border. Both later works have humanist epitaphs, again linked to antiquity. The Medici poet Angelo Poliziano composed Giotto's in elegiac couplets,

[21]

D·S·

QVANTVM PHILIPPVS ARCHITECTVS ARTE DAE
DALEA VALVERIT CVM HVIVS CELEBERRIMI
TEMPLI MIRA TESTVDO TVM PLVRES MACHINAE
DIVINO INGENIO ABEO ADINVENTAE DOCVMEN
TO ESSE POSSVNT· QVAPROPTER OB EXIMIAS SVI
ANIMI DOTES SINGVLARES QVE VIRTVTES X·V·KL (KAL.)
MAIAS·ANNO·M·CCCC·XLVI· EIVS·B·M·CORPVS INHAC
HVMO SVPPOSITA GRATA PATRIA SEPELLIRI IVSSIT

Oy-Marra, *Florentiner Ehrengrabmäler der Frührenaissance*, 99–111, thinks that his right hand is a reference to his handi-

work (Dietl, '"In Arte Peritus": Zur Topik mittelalterlicher Künstlerinschriften in Italien bis zur Zeit Giovanni Pisanos') complementing the text's Dedalus topos.

[22] See Schulz, *The Sculpture of Bernardo Rossellino and his Workshop*, 69–74. Later tombs with portraits in round formats, all different, include: (1) the *Monument of Bernardo Giugni* (d. 1466) by Mino da Fiesole in the Badia, Florence (a related marble roundel is inv. no. A.3-1960 in the Victoria and Albert Museum, London; Pope-Hennessy, *Catalogue of Italian Sculpture*, i. 146–8, no. 122, ill.); (2) the fragmentary *Monument of Lemmo Balducci* (d. 1389) by Francesco di Simone Ferrucci (1472) on the entry wall of Sant'Egidio, Florence (Marrai, 'La sepultura di Lemmo Balducci in Firenze').

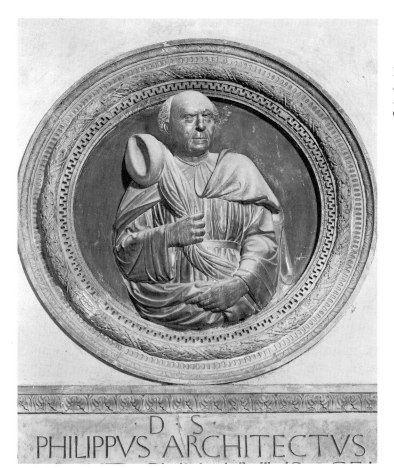

FIG. 5.6. Il Buggiano,
*Monument of Filippo
Brunelleschi*, 1446–7.
Cathedral, Florence

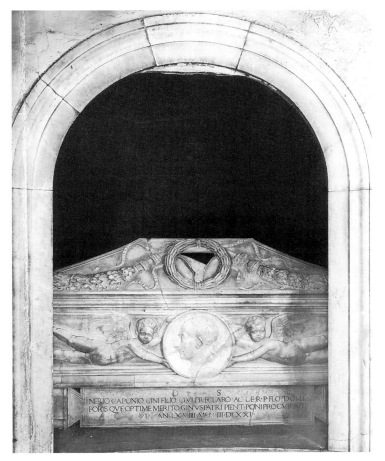

FIG. 5.7. Rossellino
Workshop, *Monument of
Neri Capponi*, after 1457.
Santo Spirito, Florence

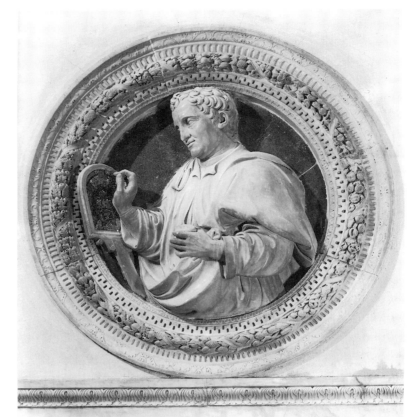

FIG. 5.8. Benedetto da Maiano, *Monument of Giotto di Bondone*, 1490. Cathedral, Florence

M PERQVEM PICTVRA EXTINCTA
I RECTA MANVS TAM FVIT ET

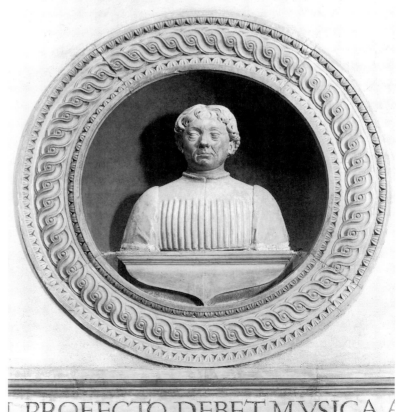

FIG. 5.9. Workshop of Benedetto da Maiano, *Monument of Antonio Squarcialupi*, *c.*1489–90. Cathedral, Florence

T PROFECTO DEBET MVSICA A

which cites him as a successor of the Greek paragon of painters, Apelles, and like that of Brunelleschi testifies to the authority of antique precedents.[23] Lorenzo is credited with Squarcialupi's more general one, in prose, whose lower left corner has been pieced together after relocation.[24]

Benedetto depicted Giotto di Bondone (d. 1336) inserting tesserae into a small mosaic of the Redeemer. Giotto's reputation as a mosaicist was due to his Navicella mosaic in Old St Peter's, while his civic association was as architect of the Campanile, although according to Giovanni Villani, he, like Brunelleschi, is buried in the Duomo. This appropriately more pictorial occupational portrait has been linked to Lorenzo's wish to resurrect the art of mosaic during the 1490s Duomo decoration and thus carries with it a civic and Medicean argument.[25]

The problematic and different *Squarcialupi Monument* consists of a three- dimensional, frontal reliquary-type bust of Antonio di Bartolomeo di Giovanni Squarcialupi (d. 1480), the musician, organ maker, and organist for the Duomo from 1432.[26] He wears a pleated doublet, whose simplicity seems earlier in date, as does the bust type, popular at mid-century, which rests on a mensola. The concave space behind is covered in stucco painted black that accelerates the three-dimensionality of the bust and differentiates it from the illusionistic, almost painterly relief of the *Giotto Monument*. It has been moved from its original location below the organ near the north sacristy, and its original format is unknown. However, if it consisted only of the elements extant, it could have been positioned on either side of the north sacristy door above the string course. Its placement away from the other two cenotaphs would help explain its differences. Like the others, however, the *Squarcialupi Monument* praised the achievements of an artist in service to the city in the Duomo.

It is curious that other than these two later echoes by Benedetto and his shop, Buggiano's quite extraordinary commemorative tondo, while visually arresting and conceptually daring, never enjoyed a following until the nineteenth century. Certainly after Benedetto's two works, the Florentine political and social upheavals of the time precluded that. There is, however, one work that definitely was influenced by the Duomo monuments: Andrea della Robbia's *Portrait of Niccolò Sernigi* (Fig. 5.10), founder of Santa Maria del Carmine, Morocco (near Tavernelle). Its unglazed,

23

ILLE EGO SVM PERQVEM PICTVRA EXTINCTA REVIXIT
CVI QVAM RECTA MANVS TAM FVIT ET FACILIS
NATVRAE DEERAT NOSTRAE QVOD DEFVIT ARTI
PLVS LICVIT NVLLI PINGERE NEC MELIVS
MIRARIS TVRREM EGREGIAM SACRO AERE SONANTEM
HAEC QVOQVE DEMODVLO CREVIT ADASTRA MEO
DENIQVE SVM IOTTVS QVID OPVS FVIT ILLA REFERRE
HOC NOMEN LONGI CARMINIS INSTAR ERAT
OB AN MCCCXXXVI CIVES POS B M MCCCCLXXXX

The XVI is recarved over other letters, resembling CON.

24

MVLTVM PROFECTO DEBET MVSICA ANTONIO
SQVARCIALVPO ORGANISTE IS ENIMITA ARTI
GRATIAM CONIVNXIT VT QVARTAM SIBI VID
ERENTVR CHARITES MVSICAM ASCIVISSE SO
RORE M FLORENTINA CIVITAS GRATI ANIMI
OFICIVM RATA EIVS MEMORIAM PROPAGARE
CVIVS MANVS SEPE MORTALES INDVLCEM AD

MIRATIONEM ADDVXERAT CIVI SVO MONV
MENTVM POSVIT

See Parigi, *Laurentiana: Lorenzo dei Medici cultore della musica*, 24, 51 ff.; Wolf, *Geschichte der Mensuralnotation von 1250–1460*, i: *Geschichtliche Darstellungen*, 228 ff.; Oy-Marra, *Ehrengrabmäler*, 105–11, figs. 44, 46.

[25] Ibid. 113. See Vasari (Bettarini and Barocci), i. 122; iii. 526; Haftmann, 'Ein Mosaik der Ghirlandaio-Werkstatt aus dem Besitz des Lorenzo Magnifico', 98–108. Also Dussler, *Benedetto da Maiano*, 51; Schütz-Rautenberg, *Künstlergrabmäler*, 54–60. For the documents, Poggi, *Il Duomo*, ii. 134, 208; Budny, 'Benedetto da Maiano', who publishes additional documentation from 7 Aug. through 24 Sept. 1490 (Archivio dell'Opera del Duomo di Firenze, VIII-1-87, Quaderno di cassa di Filippo di Bartolommeo Corsini, fols. 30, 66). Collareta, 'Le "luci"', 139–42, notes two terracotta heads of Giotto, probably studies, in the artist's inventory.

[26] Budny, 'Benedetto da Maiano', publishes the documentation from 17 Feb. 1489 through 30 June 1490 (Archivio dell'Opera del Duomo di Firenze, VIII-1-86, Quaderno di cassa di Andrea di Niccolò Giugni, fols. 39, 84).

concave tondo is separate from its glazed garland frame, and importantly its plaque is inscribed citing its source, the *imago clipeata*: *IMAGO.NICOLAI.IOHA/NNIS.SER.NISII.FVNDAT/ORIS. ECCLESIE . . .*[27]

Tellingly, it is with the Della Robbia family that the tradition for sculptural portraits in a round format continued on a smaller scale. One example is the singular but problematic tondo in glazed terracotta with an enchantingly sophisticated portrayal of a young woman (Fig. 5.11; Colour Plate I). Neither its artist nor its sitter has been established. It has been attributed to both Luca della Robbia and his nephew Andrea, and represents either a historical woman or a depiction of idealized female beauty related to that of *belle donne* plates.[28] Like other Della Robbia tondi, it lacks its frame, although it may have resembled the frame on a copy in the Louvre or the *Portrait of Niccolò Sernigi*. Its bust-length figure is highly unusual in its delicacy and sensitivity to characterization; her costume and features have a specificity and a piquant character that undermine the hypothesis that it portrays an ideal beauty. Unfortunately, the tondo format in this case does not help us decide her nature, for it could as easily supplement the concept of ideal beauty as comment on the immortality of an individual.[29] Since the lady in question is either the only surviving bust 'portrait' in a tondo possibly by Luca, or one of the earliest by Andrea, it was experimental. It helped to establish the type for Andrea who, together with his shop, executed many tondi with busts, the vast majority of which represent concepts rather than individuals. Examples include three similarly dated tondi with male busts by Andrea, such as the melancholic *Bust of a Youth* (Fig. 5.12).[30]

During the last third of the fifteenth century Andrea and his shop produced a variety of roundels with busts for known architectural contexts as well as others—of warriors, literary heroes, Roman emperors, and young boys (saints, prophets, or youths)—for unknown locations.[31] Most seem not to depict contemporary people. The family shop continued their manufacture into the Cinquecento, as in the sixty-six vivid Old and New Testament male and female busts in roundels that Giovanni designed for the Certosa del Galluzzo spandrels (1523).[32] Although Giovanni may

[27] Marquand, *Andrea della Robbia and his Atelier*, ii. 192–3, no. 347, fig. 257; Gentilini, *Della Robbia*, i. 224, ill.

[28] Inv. Robbie no. 73 in the Museo Nazionale del Bargello, Florence, glazed terracotta with a 45 cm. diameter. Pope-Hennessy, *Luca della Robbia*, 263, no. 53, ill.; Gentilini, *Della Robbia*, i. 173, 268 n. 29, ill., suggests a Medici provenance. Gentilini favours an attribution to Andrea, Pope-Hennessy to Luca *c*.1465. A copy in the Musée du Louvre, Paris, has a 56 cm. diameter with its partially restored frame (inv. no. 38; Marquand, *Luca della Robbia*, 235–6, no. 78, fig. 153).

[29] Pope-Hennessy, *Luca della Robbia*, 263, believes it a portrait. There is a similar marble woman or sibyl in a tondo holding a book inscribed *NESCIO.QUIBUS.VERBIS.QUO.* in the Staatliche Museen zu Berlin — Preußischer Kulturbesitz, attributed to the shop of Desiderio (inv. no. 2935; Schottmüller, *Bildwerke*, i. 42–4, ill.; Cardellini, *Desiderio da Settignano*, 272–4). Two related ceramic tondi with frontal busts of Clarice Orsini and Lorenzo de' Medici (*c*.100 cm. in diameter) are in the Convent of the Sisters of the Assumption of Our Lady (which served as the Medici Bank) in Bruges (Langedijk, *Portraits of the Medici*, i. 367, no. 21, 2 ill.; ii. 1153–4, no. 74, 24, ill.). They were commissioned by its manager Tommaso Portinari (1469), and although executed by a Fleming, were based on Italian models.

[30] Inv. no. 2183 in the Staatliche Museen zu Berlin — Preußischer Kulturbesitz, with a 55.5 cm. diameter. Gentilini, *Della Robbia*, i. 171, ill., 173, terms them 'teste clipeate'. There is *Giosuè* in Pesaro and

one of a *giovane* in the Metropolitan Museum of Art, New York (inv. no. 03.22 measuring 54.6 cm. with its garland frame). There are at least two other tondi of youths with garland frames: formerly in a private collection, Hamburg (with a 61.5 cm. diameter, subsequently sold at Christie's, London, on 7 July 1992, no. 61), and inv. no. 43.477 with a 55.9 cm. diameter in the Detroit Institute of Arts (ibid. 171, both ill.). Others were produced outside the Della Robbia shop (see e.g. Christie's, New York, sale cat., 11/I/94, no. 11).

[31] They include those for the Ospedale di San Paolo, Florence (Pope-Hennessy, 'The Healing Arts: The Loggia di San Paolo', with actual portraits), and the Evangelists for Santa Maria delle Carcere, Prato. See Marquand, *Della Robbias in America*; id., *Giovanni della Robbia*; id., *Andrea della Robbia*; id., *Brothers*; La Moureyre-Gavoty, *Sculpture italienne. Musée Jacquemart-André*, nos. 31–2; Bandera Viani, *Fiesole, Museo Bandini*, nos. 103, 107; Gentilini, *Della Robbia*, i; Scudieri, *Il Museo Bandini a Fiesole*, 165–70, nos. 50–2. In addition, a document of 1514 preserves Guido Magalotti's commission for a series of heads, probably executed by the *bottega* (Marquand, *Andrea della Robbia*, ii. 255–6). Other sculptors produced related series; Gentilini, *Della Robbia*, i. 216–17, 270 n. 27, ill., discusses the eighteen Aragonese heroes in tondi by Giuliano da Maiano sent to Naples in 1492 for the Sala Grande of the Villa Poggioreale, no doubt resulting from the diplomacy of Lorenzo de' Medici.

[32] Marquand, *Giovanni della Robbia*, 167 ff., no. 172, ill.; Gentilini, *Della Robbia*, ii. 317–19, 324, ill.

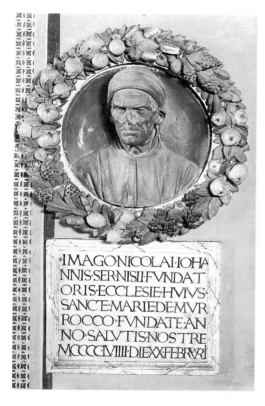

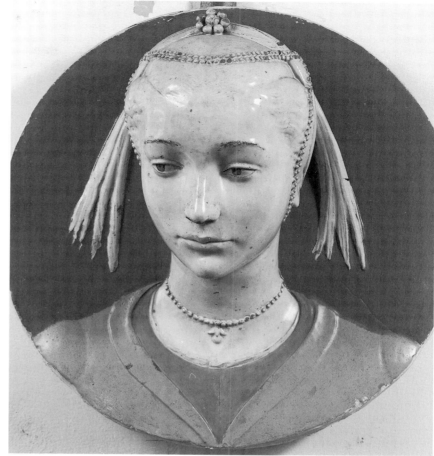

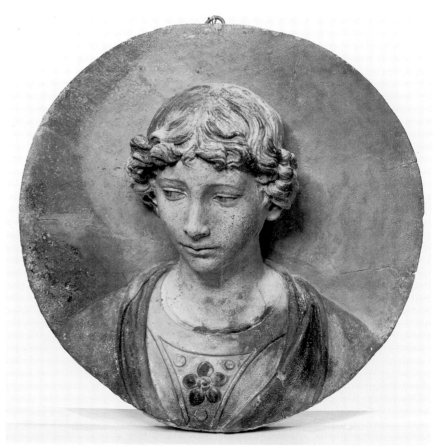

FIG. 5.10 (*above*, *left*). Andrea della Robbia
Workshop (?), *Portrait of Niccolò Sernigi*, 1490s.
Santa Maria del Carmine, Tavernelle (Val di Pesa)

FIG. 5.11 (*above*, *right*). Luca or Andrea della
Robbia, *Portrait of a Lady*, c.1460–70. Museo
Nazionale del Bargello, Florence (colour plate I)

FIG. 5.12 (*right*). Andrea della Robbia, *Bust of a
Youth*, c.1465. Staatliche Museen zu Berlin —
Preußischer Kulturbesitz

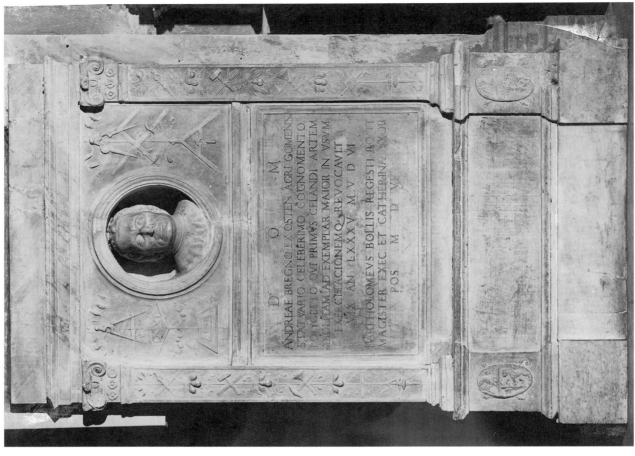

FIG. 5.14. Luigi Capponi, *Monument of Andrea Bregno*, 1506. Santa Maria sopra Minerva, Rome

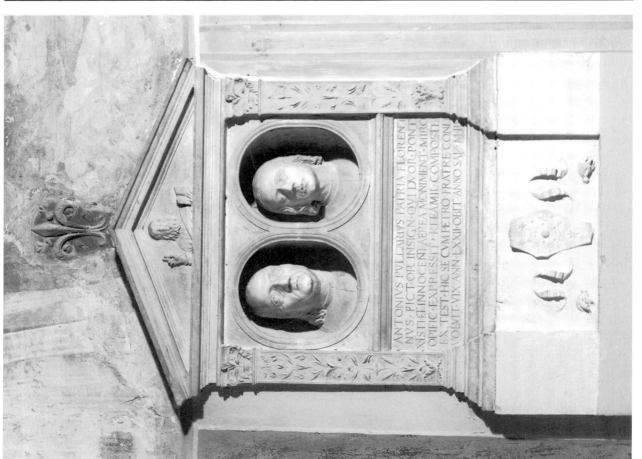

FIG. 5.13. Luigi Capponi, *Monument of Antonio and Piero Pollaiuolo*, c.1500. San Pietro in Vincoli, Rome

also have been responsible for classical busts in roundels for an unidentified programme, as well as for saints and generic figures,[33] there are no contemporary portraits by him. An interest in glazed terracotta architectural roundels continued into the mid-sixteenth century, especially in France—where after 1517 Girolamo and his older brother Luca worked, even portraying François I in a tondo[34]—and Naples—where they were influenced by Santi Buglioni. For example, in 1540 Paolo Giovio wrote about a series of famous men in profile in the Della Robbia manner made for the façade of the Neapolitan house of Tommaso Cambio. Then there is a 1542 record of ten lost 'teste di terra vetriata' ordered by Eleonora da Toledo for Naples, as well as another mid-century series of eight busts *all'antica* from the *bottega* of Santi Buglioni, of which only one survives.[35]

It is puzzling that portraits of living individuals in autonomous glazed terracotta tondi never caught on in Florence, although medallions with garland frames containing coats of arms (*stemme*) or *imprese* for insertion into a wall were very popular.[36] By way of explanation, it may be that patrons who could afford to pay the price either preferred three-dimensional bust portraits in marble or stucco, or opted, due to money or taste, for painted portraits or medals. Perhaps the funerary associations of sculpted tondi portraits served as a deterrent for the portrayal of living individuals.

However, the inclusion of circular portraits in sepulchral contexts spread to other cities and was used into the Cinquecento, always with variations. Around 1490 Lorenzo de' Medici commissioned the *Monument of Filippo Lippi*, perhaps designed by Filippino, in the Cathedral of Spoleto. It features a frontal bust of the painter/monk dressed in his habit in a roundel with a shell background symbolic of resurrection. Its format recalls the three artists' cenotaphs in the Duomo, although it is more highly embellished than its spartan Florentine counterparts. In addition to the Medici arms and an epitaph by Poliziano, it includes references to Lippi's professions, among them the cross of a cleric and the pen and brush of an artist.[37] Because Lorenzo was unsuccessful in transporting Filippo's body back to Florence, he wanted no one to forget that the painter was Florentine and so commissioned a tomb citing the city, its monuments to artists, and the Medici. This Renaissance recycling of the *imago clipeata* also enjoyed a late blossoming in Rome; for example, on the *Monument of Antonio and Piero Pollaiuolo* by Luigi Capponi (Fig. 5.13), where it relates to the Duomo cenotaphs of artists. While the epitaph of the brothers Pollaiuolo cites their Florentine origin as well as the popes they served, their highly individualized busts in ovals convey

[33] They include: the bust of a woman with a *c*.96.5 cm. diameter (Marquand, *Giovanni della Robbia*, 159–60, no. 162, fig. 98; Christie's, New York, sale cat., 11/I/94, no. 7); four busts of ancients in the Victoria and Albert Museum, London (inv. nos. 369-1864 with a 114.3 cm. diameter, 370-1864, 371-1864, and 372-1864 with 83.8 cm. diameters; Pope-Hennessy, *Catalogue of Italian Sculpture*, i. 235–7, nos. 234–7, ill.; Gentilini, *Della Robbia*, ii. 443, 449 n. 40, assigns them to the time of Benedetto and Santi Buglioni); a marble tondo of a Roman emperor with a laurel wreath after Giovanni with a 49 cm. diameter (Lusanna and Faedo, *Museo Bardini*, 284, no. 281, ill.). Marquand, *Benedetto and Santi Buglioni*, assigns them no tondo portraits, although there are other classicizing examples from the Della Robbia shop. In the second half of the century the vogue for these medallions spread to the rest of Italy.

[34] From the Château de Sansac at Loches, in the Metropolitan Museum of Art, New York (inv. no. 41.100.245, dated 1529 on its stone surround in the Musée du Louvre, Paris) by Girolamo or Luca

della Robbia (Gentilini, *Della Robbia*, ii. 366–7, ill.). For others, ibid. 368, 478–9, ill.

[35] Probably in a round format; Marquand, *Buglioni*, 195–6; Gentilini, *Della Robbia*, ii. 442–3, ill.

[36] For the early *stemma* of the Arte dei Linaiuoli on Or San Michele, see Brunetti, 'Ghiberti orafo', fig. 6. Luca first framed arms in roundels within a larger context—as in the tabernacle for the Ospedale di Santa Maria Nuova (now in Santa Maria, Peretola)—in the early 1440s. Many followed into the Cinquecento (Marquand, *Della Robbia Heraldry*; Gentilini, *Della Robbia*, i), including one for the Arte dei Medici e Speziali with the Madonna, their patron, and Child with a 180 cm. diameter that resembles a devotional tondo (Pope-Hennessy, *Luca della Robbia*, 247, ill., dates it *c*.1464–5).

[37] Ruda, *Fra Filippo Lippi*, 42, ill.; also Sordini, 'La tomba di Fra Filippo Lippi nel Duomo di Spoleto'; Schütz-Rautenberg, *Künstlergrabmäler*, 60–4; Oy-Marra, *Ehrengrabmäler*, 111.

the same meaning as those in circular formats and derive from double *imagines clipeatae* that have been compressed into Siamese twin ovals.[38] Needless to say, this quirky, unresolved pair was not repeated. To Capponi is also given the monument of the Roman sculptor Andrea Bregno (d. 1503) (Fig. 5.14). Its dominant tondo is so deeply carved behind the bust of the deceased that it appears nearly free-standing. It is flanked by reliefs depicting the tools of Bregno's trade, as a gloss on his life, and an inscription which compares him to Polycleitos, a topos similar to those of the Brunelleschi and Giotto monuments. It is also an occupational tomb, and its *imago clipeata* was especially fitting for an artist who collected antiquities.[39] The eventual outcome of Roman experiments with round portraits in a sepulchral context[40] occurs in the later sixteenth-century *Monument of Francesco Cardinal Toleto* in Santa Maria Maggiore, where the deceased's frontal bust in a recessed roundel is supported by two atlantid putti.[41] It serves both as a coda to the Renaissance interest in antiquity and naturalism and as a prelude to the Baroque transformation of them into a mystical vision. It also demonstrates that Renaissance patrons and sculptors, unlike those of antiquity with their stock *imagines clipeatae*, never settled for a formulaic use of the motif, but rather kept inventing in the true spirit of the age.

PAINTED PORTRAITS

Although most Renaissance painted portraits are rectangular, a few circular or oval examples survive that are not portrait miniatures. While there is no way of knowing how many painted tondi portraits existed in the Renaissance, it is telling that few have survived in a format larger than 14 cm. It is only within the miniature tradition that the round format for painted portraits flourished, remaining popular long after devotional tondi had become retardataire.[42] But eventually there too the oval format superseded the round.[43]

It would be logical that round, convex mirrors served as a stimulus to tondo portraits, especially self-portraits, since Italian artists were encouraged by humanist ideas. In Plato's commentary on the Delphic dictum ('know thyself'),[44] Socrates' advice to look into mirrors underlines their connection with self-portraits. Since a whole chain of later writers, theologians of the Church and secular authors like Ficino, expounded on this passage, it enjoyed a wide circulation, keeping alive the notion of the mirror as an aid in painting self-portraits.[45]

[38] Schütz-Rautenberg, *Künstlergrabmäler*, 64–5; Ettlinger, *Antonio and Piero Pollaiuolo*, pl. 133.

[39] Egger, 'Beiträge zur Andrea Bregno Forschung'; Panofsky, *Tomb Sculpture*, 69–70, ill.; Schütz-Rautenberg, *Künstlergrabmäler*, 65–8.

[40] e.g. two with flanking angels are on monuments in Santa Maria d'Aracoeli, Rome, depicting: (1) the astronomer Ludovico Grato Margani (d. 1531) by the shop of Andrea Sansovino (Anderson photograph 3636); (2) Giovanni Battista Cavalieri (d. 1507) on a socle (Anderson photograph 6398).

[41] Panofsky, *Tomb Sculpture*, figs. 432–3.

[42] There are exceptions, including the much later portrait of a man with a dog attributed to Philippe de Champagne in The New-York Historical Society (inv. no. 1867.101, oil on canvas with a 105.4 cm. diameter).

[43] Colding, *Aspects of Miniature Painting, its Origins and Development*, 31 ff., notes the connection between goldsmiths' works in *verre églomisé*, manuscript illustrations, and portrait miniatures.

[44] *Alcibiades I*, in Plato, *Plato*, viii. 194; 128 E ff. By this aphorism, Plato meant know your soul (ibid. 208–11; 132 ED–133A): 'Socrates . . . Then let us think what object there is anywhere, by looking at which we can see both it and ourselves. Alcibiades. Why clearly, Socrates, mirrors and things of that sort. Socrates. Quite right . . . And have you observed that the face of the person who looks into another's eye is shown in the optic confronting him, as in a mirror, and we call this the pupil, for in a sort it is an image of the person looking?'

[45] Ficino (*Commentary on Plato's Symposium on Love*, 160); Pseudo-Gregory of Nyssa, who wrote: 'If you wish to know God, first know yourself . . . look back into your soul as you would in a

It is not surprising, therefore, that one of the earliest extant Renaissance tondo portraits is, in fact, a self-portrait of an artist influenced by Italian Renaissance ideas: the famous miniature by Jean Fouquet (Fig. 5.15), inscribed in Latin with his name.[46] From c.1445 until c.1461 Fouquet was in Italy, where it has been proposed that he learned the technique of this three-inch portrait from the sculptor Antonio Filarete.[47] Assuredly Fouquet knew examples of Roman portrait miniatures on glass (Fig. 5.16)[48] that resemble so closely his own self-portrait, which is primarily an exploration of his features, painted with the aid of a convex mirror. When he visited Florence, he also must have seen Renaissance heads/portraits in round formats, such as those of Uccello (Fig. 5.17) and Ghiberti (Fig. 5.4). In consequence, Fouquet's frontal self-portrait blends Flemish, Florentine, and ancient elements, all of which are slightly distorted by the mirror. His work is really a miniature, and from the artist's illuminated manuscripts (with roundels, medallions, and initials with portraits), it is apparent that he was no stranger to the shape.[49] Even though its function is unknown, it may be early in a long line of portable portraits that became popular in the succeeding century. Janson assigned it the distinction of being the earliest clearly identified self-portrait of an artist that is not part of a larger context.[50]

The earliest extant autonomous painted Italian tondo portrait is by Francesco Botticini (Fig. 5.18). It dates (c.1485–90) from the decades when devotional tondi reached their apogee. Although it is smallish in size (40 cm. diameter), it is larger than Fouquet's (7.68 cm. diameter) and is not a miniature. Since the panel has an dark border around its circumference to facilitate insertion into its lost frame, it was not cut from a rectangular panel.[51] Moreover, its integrated composition complements its format. The round forms of the sitter's iridescent blue doublet—the bright robin's egg blue of the embroidered collar trim, the curves of the sleeves, and the round buttons—repeat its shape, a formal consciousness that recalls Botticelli. It may once have been displayed in a manner similar to a tondo in a later painting attributed to the Monogrammist C, *A Lady and her Daughter*, which includes a male tondo portrait (the deceased or absent husband and father) of about the same size hanging on the wall behind the sitters.[52]

Another tondo with a youth from the late Quattrocento is currently attributed to Marco d'Oggiono (Fig. 5.19). Most likely it represents the sitter in the guise of his name saint, for he holds an arrow, the attribute of St Sebastian. A photograph before the panel's restoration shows a halo, which might have been a later addition after the youth was no longer alive in order to convert it into

mirror . . . and you will be able to see that you are made to the . . . likeness of God.' (*PG* 44, 1331 B, quoted in Gibson, 'Mirror of Man', 221).

[46] Inv. no. OA56 in the Musée du Louvre, Paris, gold and enamel on copper with a c.7.68 cm. diameter. Gowing, *Paintings in the Louvre*, 79, ill.

[47] Wescher, *Jean Fouquet und seine Zeit*; Lombardi, *Jean Fouquet*, 91 ff. Filarete was working on the bronze doors of St Peter's, which have busts framed by wreaths (Pope-Hennessy, *Italian Renaissance Sculpture*, i. 64–5, 317–19, 362, fig. 115, pl. 108).

[48] In the Museo Archeologico, Arezzo, gold paint on glass with a 5 cm. diameter, dating c.250 AD. Janson, *A History of Art*, 195, ill. For another in gold foil on glass with a 10.8 cm. diameter, see Pietrangeli *et al.*, *The Vatican Collections*, 98, no. 34, ill.

[49] Independent miniature portraits are frequently thought of as 16th-c. phenomena (Foskett, *Collecting Miniatures*, 20), although examples appeared prior to that time (Campbell, *Renaissance*

Portraits, fig. 72). See Viaggini, *La miniatura fiorentina*; Foskett, *British Portrait Miniatures*, 33; D'Ancona and Aeschlimann, *Dictionnaire des miniaturistes du Moyen Âge et de la Renaissance*.

[50] Janson, *History*, 386, a conclusion which hinges on the belief that it was not part of a series surrounding the *Melun Diptych*. Another male tondo portrait, formerly in the Paul J. Sachs Collection, New York, has been given to Fouquet. Its frame appears to be an integral part of the panel and has a French inscription about love that alludes to the courtly love tradition and hints at its function. The sitter wears Italianate headgear (like a *mazzocchio—cappuccio*). Wescher, *Fouquet*, 55–61, 101, pl. 41, dates it c.1440–70.

[51] In the Nationalmuseum, Stockholm, tempera on panel with a 40 cm. diameter. Sirén, *Dessins et tableaux de la Renaissance italienne dans les collections de Suède*, 78 ff.; id., 'Das florentinischen Knabenporträt in Stockholm'; Stapleford, 'Botticini's Portrait', 433; Venturini, *Botticini*, 122, no. 62, ill.

[52] Campbell, *Renaissance Portraits*, fig. 73.

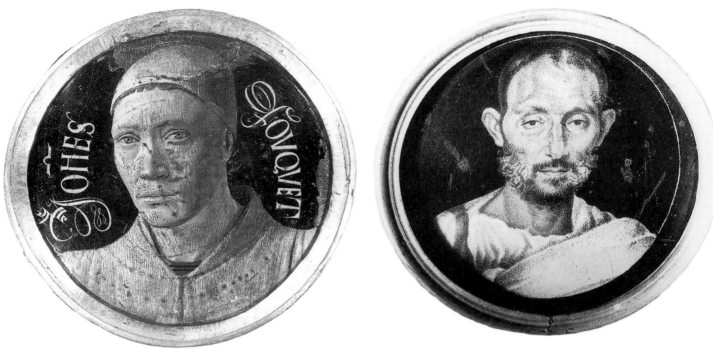

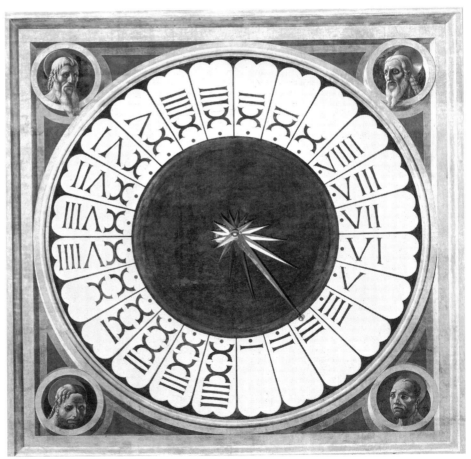

FIG. 5.15 (*above, left*). Jean Fouquet, *Self-Portrait*, *c*.1450. Musée du Louvre, Paris

FIG. 5.16 (*above, right*). Anonymous, *Portrait of a Man*, *c*.250 AD. Archaeological Museum, Arezzo

FIG. 5.17 (*right*). Paolo Uccello, *Clock with Prophet Heads*, 1443. Cathedral, Florence

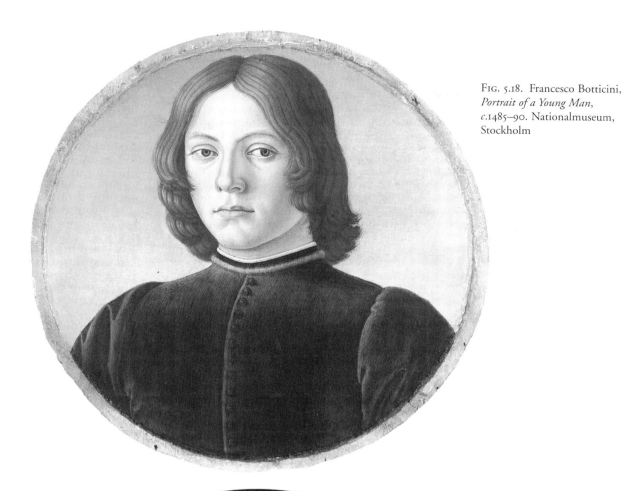

FIG. 5.18. Francesco Botticini,
Portrait of a Young Man,
*c.*1485–90. Nationalmuseum,
Stockholm

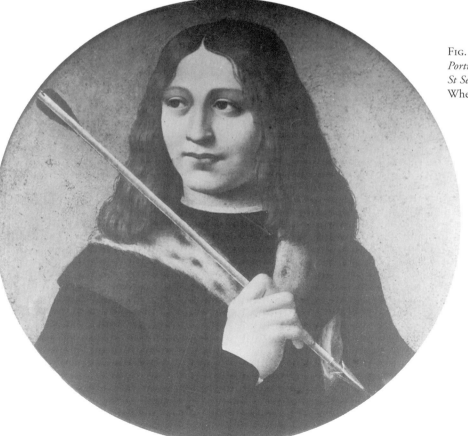

FIG. 5.19. Marco d'Oggiono,
Portrait of a Young Man as
*St Sebastian, c.*1490–1500.
Whereabouts unknown

a purely devotional image.[53] Although its whereabouts and measurements are unknown, it seems larger than a miniature.

The later, dashing *Portrait of Valerio Belli* (Fig. 5.20) is a miniature even though it was painted by the monumental painter Raphael. It measures only around 10 cm. in diameter and once belonged to the lid of a covered wooden box.[54] Belli was a famous goldsmith, gem cutter, and medalist, as well as a collector of antiquities. By portraying him in the retardataire profile pose, Raphael connected this unique portrayal with medals and coins, implying a witty conceit: a medal-like portrait of a medalist but in colour.[55]

The most famous tondo portrait is Francesco Mazzola (Il Parmigianino)'s self-portrait (Fig. 5.21; Colour Plate II).[56] Vasari relates that he painted it as a showpiece of his skills, a self-advertisement for patronage, for his Roman journey. The historian notes how he constructed the convex panel as a *mezza tonda* with the measurements of a barber's mirror, praising the distortions caused by the mirror reflected in the shape.[57] In fact, the artist over-emphasized the perverse distortions by including the leaded window and the beams of the setting. By carefully arranging his pose in a seemingly casual manner with his hand in the foreground, elongated beyond nature's standards, he accentuated the disorienting spatial sensations via a quasi-scientific basis.[58] He also exaggerated the circular elements: the artist's hand, ring, eyes, collar, hair, face (at the centre, thus the least distorted), and the once-rectilinear walls of the room. At the extreme right is the curved metallic edge of the mirror into which Parmigianino gazed to paint the panel (since the panel is supposed to be a mirror, the round object should be the picture frame, creating a sophisticated double entendre and Mannerist reversal). This witty, highly complex Mannerist manifesto on artistic creativity displays another typical Mannerist inversion, wherein nature (the mirror) causes the distortions captured, not manufactured, by the painter. Its technical brilliance and illusionism was calculated to engender astonishment and to elicit a psychological response, ranging from surprise to pleasure to a feeling of deception. The painting's exploitative effect is without precedent and successful, for Vasari was clearly titillated by it. In this precious and clever virtuoso work, realism was not used for objective truth but rather to create a *bizarria* destructive of an idealized norm.

In addition, I believe that Parmigianino's *Self-Portrait* had another facet, a highly personal, alchemical/aesthetic one involving the symbolism of mercury.[59] Vasari tells about Parmigianino's involvement with magic and the pseudo-science of alchemy, seeking to discover secrets by congealing mercury in order to become richer than heaven and nature.[60] With this, we can further interpret Parmigianino's *Self-Portrait* and its mirror *concetto* as a hermetic allusion to Hermes

[53] The FKI lists it as in the collection of Gustav Frizzoni, Milan; photographs in the Burckhardt Archive nos. 108 (before restoration), 109; Sedini, *Marco d'Oggiono*, 48, ill.

[54] Formerly in the Collection of Lord Clark, Saltwood Castle, now in a private collection, it once was inscribed *F.R.* (*Raphael fecit*). The back is inscribed twice, once in a contemporary script: *Fatto dell'anno 1517 in Ro . . . / . . . Rafael Urbinate . . .*; Fischel, *Raphael*, i. 91; Dussler, *Raphael*, 42, ill.; Gardner von Teuffel, 'Raphael's Portrait of Valerio Belli: Some New Evidence', 663–6, who believes that Raphael conceived of it as a unique *paragone*.

[55] Ibid. 664.

[56] Inv. no. 286 in the Kunsthistorisches Museum, Vienna, oil on wood with a 24.4 cm. diameter and a painted line around its circumference. Freedberg, *Parmigianino*, 201–3, ill.

[57] Vasari (Bettarini and Barocchi), iv. 534–6, in both editions. He adds that Parmigianino gave it to Pope Clement VII, who gave it to the writer Pietro Aretino, in whose house Vasari saw it; then he traces it to Valerio Belli, the medalist whom Raphael portrayed. It is interesting to note the 1552 record of a portrait by Lorenzo Lotto that had a mirror as a cover; Campbell, *Renaissance Portraits*, 67, 254 n. 126.

[58] Because of the importance of the hand in the iconography of artists, it may not be accidental that it is so prominently featured; see Dietl, '"In Arte Peritus"'.

[59] See Fagiolo dell'Arco, *Il Parmigianino: un saggio sull'ermetismo nel Cinquecento*, 31 ff.

[60] Vasari (Bettarini and Barocchi), iv. 532, in the 1568 edition. In the 1550 edition, he stated Parmigianino lost his mind and was poor.

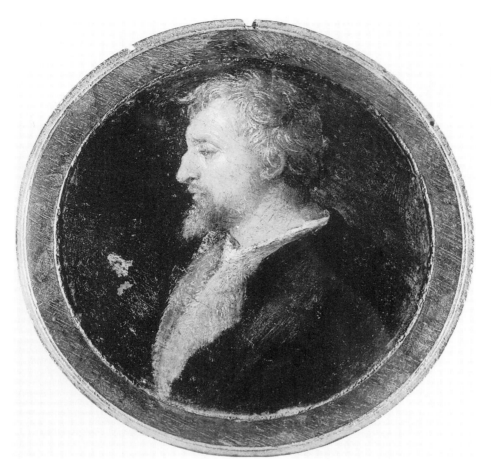

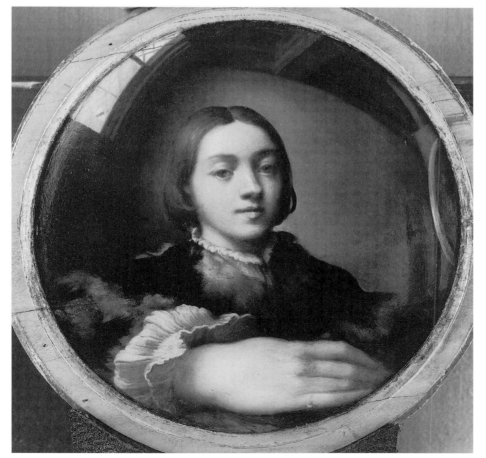

Fig. 5.21. Parmigianino, *Self-
Portrait in a Convex Mirror*, 1524.
Kunsthistorisches Museum, Vienna
(colour plate II)

FIG. 5.22. Andrea del Sarto, *Portrait of Becuccio Bicchieraio and his Wife*, 1524–8. Art Institute of Chicago

FIG. 5.23. Florentine School, *Portrait of a Young Man and an Allegory of Love and Fidelity*, c.1575. Private collection

Trismegistis and to Hermes/Mercury, the god associated with alchemy, imagination, and the ability to fool the eye, which was the goal of the artist.[61] Therefore, Parmigianino's panel is a capricious yet calculating portrayal of the melancholic artist, a true son of Mercury, as reflected in a glass mirror (perhaps backed by mercury). As such it is one of the most provocative and intellectually rigorous self-portraits ever produced, rivalled only in this format by Caravaggio's as the severed head of Medusa (an act accomplished with the help of Mercury) on a convex shield.[62]

Around the same time, Andrea del Sarto executed two small round pendant portraits (Fig. 5.22).[63] Originally, they were thought to be an independent pair representing the artist and his wife Lucrezia della Fede. Today, they are neither considered to be portraits of the Del Sartos nor autonomous, although their attribution to Andrea has never been challenged. Instead they portray Domenico da Gambassi (Becuccio Bicchieraio), Andrea's friend the glass maker, and his wife and formed part of the predella of the *Pala di Gambassi* (c.1524–8).[64] While not tondi *per se*, they were intended to appear illusionistically as somewhat autonomous, and as such are related not only to Parmigianino's *Self-Portrait* but also to the early evolution of portrait miniatures. Their framing borders are painted in a *trompe l'œil* foreshortened manner to simulate convex mirrors inserted into the panels with decorative motifs and the artist's monogram under the male portrait. Unlike the calculatingly cold and witty manipulations of Parmigianino, Andrea's portraits reaffirm reality, whereas Parmigianino's betrays it with its own evidence. Andrea may have known Parmigianino's panel, because the young artist would have passed through Florence on his way to Rome. No doubt he would have made it a point to meet with the acknowledged master of Florentine painting to show it to him (thus Parmigianino's trip could offer a *terminus post quem*).[65] It is a telling coincidence that Andrea's paintings date stylistically from that time. Further, since Becuccio was a maker of glass, he may have also been involved with mirrors, rendering these portraits even more meaningful.

Andrea's two portraits and Parmigianino's *Self-Portrait* relate to another self-portrait painted from a mirror by the miniaturist Giulio Clovio and dated 1529. While Clovio's work may also depend on Parmigianino's painting, it is indebted to miniature portraits in roundels, which derive from book illustrations.[66] Clovio's self-portrait is distinctly different from either Parmigianino's or Andrea's pair, which also may be indebted to the nascent fashion for miniatures. Clovio's is more precious, less ambitious, and clearly within the miniature tradition because of its technique and its parchment support.

[61] See Bonafoux, *Portraits*, 38–9, for a rambling account of the alchemical connections of Hermes/Mercury, mercury (Hg), the planet, and artists. Koerner, *The Moment of Self-Portraiture in German Renaissance Art*, demonstrates the complexity of some portraits of the time.

[62] Inv. no. 1351 in the Galleria degli Uffizi, Florence, oil on canvas mounted on poplar wood measuring *c.*55 cm. in diameter. Florence, *Gli Uffizi: catalogo generale*, 204, ill.

[63] Inv. nos. 1964.1097a and 1964.1097b in the Art Institute of Chicago, oil on panel; the image of the male measures 11 cm. in diameter (the panel 22.4 × 15.9), the image of the female 11.2 cm. (the panel 22.5 × 15.2). Freedberg, 'Andrea and Lucrezia: Two New Documents in Paint for their Biography'; Lloyd, *Italian Paintings before 1600 in the Art Institute of Chicago*, 215–19, ill.

[64] Vasari (Bettarini and Barocchi), iv. 377; Conti, 'Andrea del Sarto e Becuccio Bicchieraio', 161–5; Natali and Cecchi, *Andrea del Sarto*, 112–13, 123.

[65] Freedberg, 'Andrea and Lucrezia', 22 ff. The pair has analogies to miniatures of Martin Luther and his wife, Katherine von Bora, on occasion of their marriage (with 10 cm. diameters) by Lucas Cranach (c.1525); Friedlander and Rosenberg, *The Paintings of Lucas Cranach*, 107, nos. 177, 177a, ill. Cranach also painted mythological works in this format (Koepplin and Falk, *Lukas Cranach*, 275 ff., ill.) in the early Cinquecento when the round format was popular in Germany.

[66] In the Kunsthistorisches Museum, Vienna, gouache on paper or vellum with a 7 cm. diameter; inscribed: *Julius Clouius Croatus sui ipsius effigiator A.° aetat: 30 salut: 1528*. Vasari (Bettarini and Barocchi), vi. 213–19; Freedberg, 'Andrea and Lucrezia', 26; Giononi-Visani, *Giorgio Giulio Clovio: Miniaturist of the Renaissance*, ill.

While the miniature portrait tradition received a tremendous impetus in England during the sixteenth century, it was also alive and well in Italy, as witness the copper miniature of a young man before a view of the Piazza del Duomo (Fig. 5.23). Its reverse, in a medallic format, features an allegory of Love and Fidelity, which has led to the theory that it was a gift from the young sitter to his fiancée.[67]

The art of miniatures continued to be practised in Italy and throughout Europe in different media through the end of the Cinquecento. Miniatures, like the one on slate in the manner of Agnolo Bronzino[68] and those attributed to Francesco Salviati,[69] were the precious expression of Mannerist courtly ideas as well as appropriately intimate objects for personal images. Later examples include ones painted by women artists, such as Sofonisba Anguissola's double portrait (Fig. 5.24), whose prototype was assuredly a Roman double glass portrait.[70] The mirror remained an important tool for self-portraits, as in one by Sofonisba Anguissola in an oval format, which was at the time fast eclipsing the round format. The medallion she holds with her monogram is inscribed: *SOPHONISBA ANGUISSOLA VIR[GO] IPSIVS MANV EX SPECVLO DEPICTAM CREMONAE* ('The maiden Sofonisba Anguissola painted this from a mirror by her own hand').[71]

While portraits in subsidiary roundels appeared through the sixteenth century, ovals soon eclipsed them as well. Late round examples include the portraits on slate of Cosimo I and Eleonora da Toledo in the Studiolo of Francesco I by the Bronzino shop (Fig. 5.25) that can also be read as illusionistic tondi.[72] These portraits, *c*.112 cm. in diameter, in their high intensity and finish have the qualities of enlarged miniatures, which in itself ranks as a Mannerist conceit. Their connection with *imagines clipeatae* is underlined by the pair of putti flanking each and the signs of the zodiac on their frames which derive from season sarcophagi (Fig. 1.5) and imply the cosmic immortality of the distinguished pair (Ch. 1). They eloquently testify to the enduring influence of the *imago clipeata* that inspired portraits in a round format, in this case even a painted example.

There are other incidental portraits in round formats from the Cinquecento that are larger than miniatures. A case in point is one by an artist of the Venetian school depicting a geometer, who holds a compass in his right hand with which he points to the date 1555.[73] Dürer's *Portrait of Johannes Kleberger* (1526), partially motivated by the artist's recollections of his Italian sojourns, is a more complex example. Dürer's illusionistic conceit is unique, as is his brilliant manipulation of the traditional associations of medals, sculptural roundels, and St John the Baptist's head on a charger as a play on the sitter's name.[74] An even more bizarre and illusionistically manipulative portrait

[67] In a private collection, oil on copper with a 10.6 cm. diameter. New York, Haboldt & Co., *Tableaux anciens des écoles du nord, françaises et italiennes*, 52–3, ill., attributes it to Alessandro Allori.

[68] Inv. no. 5787 in the Galleria degli Uffizi, Florence, oil on slate with an 18 cm. diameter. Florence, *Gli Uffizi*, 192, ill. Medallions or roundel portraits of the Medici also feature in the 16th-c. decoration of the Palazzo Vecchio; see Langedijk, *Portraits of the Medici*.

[69] Mortari, *Francesco Salviati*, 141, no. 95; 145, no. 111; 153, no. 136; 157, no. 160, all ill.

[70] Inv. no. 61.84 in the Allen Memorial Art Museum, Oberlin College, Oberlin, Ohio, formerly in the Samuel H. Kress Collection (K1213), oil on panel with a 40 cm. diameter. Shapley, *Paintings*, iii. 31; Caroli, *Sofonisba Anguissola e le sue sorelle*, 188–9, no. A6, ill. See also Pierlingieri, *Sofonisba Anguissola*, 156, figs. 93–4, 108–10, ill.; Gregori *et al.*, *Sofonisba Anguissola e le sue sorelle*, 25, pl. 1.

[71] In the Museum of Fine Arts, Boston, oil on copper measuring 8.2 × 6.3 cm. Caroli, *Sofonisba*, 196–7, no. 3, ill.; Gregori *et al.*, *Sofonisba*, 196–7, no. 6, ill.

[72] Baccheschi, *L'opera completa del Bronzino*, 95–6, ill.

[73] Inv. no. 970 in the Galleria degli Uffizi, Florence, oil on a slate with a 102 cm. diameter. Florence, *Gli Uffizi*, 511, ill.

[74] Inv. no. 850 in the Kunsthistorisches Museum, Vienna, oil on wood measuring 36.7 × 36.6 cm. Panofsky, *Albrecht Dürer*, i. 241; Strieder, *Albrecht Dürer*, 15, ill. The nude throat is cut beneath the pit and projects from a plain roundel (a medallic format), which appears like a slab of gray marble, although the bust is paradoxically painted in flesh colours. Round formats were also used in the century in anamorphosis designs, as in the portrait of Edward VI by Guillaume Scrots, 1546, in the National Portrait Gallery, London (Campbell, *Renaissance Portraits*, 205, fig. 221).

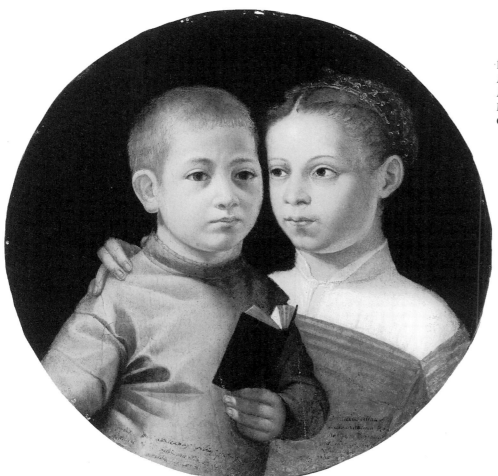

FIG. 5.24. Sofonisba Anguissola, *Double Portrait of Two Children of the Attavanti Family*, after 1550. Allen Memorial Art Museum, Oberlin College, Oberlin, Ohio

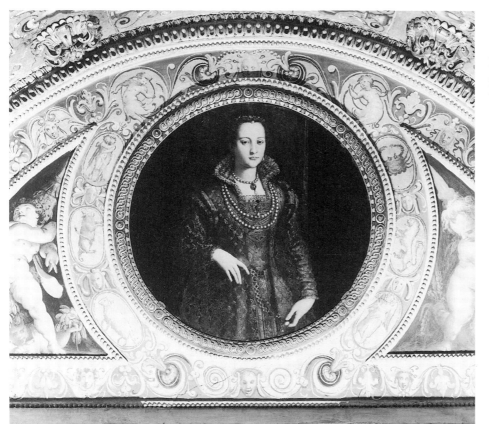

FIG. 5.25. Agnolo Bronzino, *Portrait of Eleonora da Toledo*, 1570. Studiolo of Francesco I, Palazzo Vecchio, Florence

coming out of this tradition is the aforementioned convex round shield by Caravaggio with his self-portrait as the screaming, severed head of Medusa.

In the end, it is puzzling but telling that painted portraits in round formats larger than miniatures, as well as sculpted examples, never enjoyed the vogue that propelled painted religious tondi into the foreground of domestic commissions in late quattrocento Florence.[75] One explanation may lie in the fact that the round form was too closely associated with sepulchral images and heavenly symbolism to be used successfully in portraying the living on a large scale. Further, a formal similarity with medals may have inhibited its development as a distinctive form, for medals had the advantage of two sides, the obverse for the portrait and the reverse for the *impresa*. In miniatures, the two-sided approach could be retained, whereas painted larger-scale tondi could not compete with that double-sided advantage. (Although theoretically they could have been painted on both sides, none that survive shows evidence of a painted version, as one occasionally finds on rectangular portraits, such as Leonardo's *Ginevra de' Benci*.) Therefore, individuals seem either to have commissioned medals for their specific functions and connotations or rectangular painted portraits with their implications of illusionistic rectangular windows into space. In addition, sixteenth-century patrons may not have been attracted to the round format because it did not easily accommodate the display of the symbolic accoutrements that became part of the formula of larger Mannerist portraiture, especially in the environment of the Medici court. Thus, the round format for portraiture remained in limbo, caught between the precious qualities of miniatures and medals and the more monumental possibilities of rectangular portraits.

[75] There are also problematic works—those cut into round formats and those in round formats which may not be portraits—e.g. the roundel with a female head and a 25.4 cm. diameter attributed to Sebastiano del Piombo (*c*.1530) in the Kimbell Art Museum, Fort Worth (Loud and Jordan, *In Pursuit of Quality: The Kimbell Art Museum*, 174, ill.). Its rounded edges indicate that it was not cut; Hirst, *Sebastiano del Piombo*, 139, no. 183, pl. 183.

6

SCULPTED DEVOTIONAL TONDI

WHEREAS it was established in Chapter 3 that experimental sculpted tondi existed by 1429, in this chapter the evolution of sculpted tondi is charted, making correlations with painted examples.[1] Sculptors' contributions to the tondo format and iconography are considered in an attempt to distill trends in a roughly chronological fashion. By way of introduction, one generalization can be offered: tondi in sculptural media, save for a few exceptions, tend to have fewer *dramatis personae*, accommodate fewer narrative and symbolic dimensions, and have less spatial elaboration than their painted counterparts. Some of these distinctions result from the nature of the media themselves. It is for that reason that they are being considered separately.

EXPERIMENTAL TONDI

Three marble Madonna and Child reliefs constitute part of the trecento preparation for the tondo and parallel the painted roundels at Assisi and Padua (Figs. 1.12–13). One of these has been attributed to Giovanni Pisano (Fig. 6.1),[2] and the other to the shop of Tino da Camaino (Fig. 6.2).[3] A third, less refined, roundel with three-dimensional figures, stylistically near Tino, surfaced in Florence without a provenance but with pointed lower corners, like the ends of molars, and an unfinished back to indicate that once it was inserted into larger context.[4] Unique illusionistic features in each of the three create depth and add to their quasi-autonomy: in the Raleigh relief, it is the position of the figures and the drapery overlapping the dentilated frame, while in the Empoli relief it is the contrapposto and the plasticity of the figures projecting outside the frame's heavy moulding. Yet all three were once part of a larger context.

As discussed earlier, roundels had enjoyed a certain popularity since antiquity, especially in

[1] Hauptmann, *Der Tondo*, 11 ff., conjectured that the 'moveable tondo' occurred in mid-century sepulchral monuments, culminating in those of the Cardinal of Portugal and Filippo Strozzi, contradicting his statement that the anomalous *Certosa Madonna and Child* (*c*.1350–60) was the first self-sufficient tondo (ibid. 117).

[2] Inv. Carocci no. 1 in the Museo della Collegiata di Sant'Andrea, Empoli, marble with a 45 cm. diameter and a thickness of *c*.7 cm. It was immured in the wall above a lavabo in the Collegiata Sacristy, but its original location is uncertain. Since the Madonna looks to her left, it was meant to be seen from that angle. Paolucci, *Il Museo della Collegiata di S. Andrea in Empoli,* 33, ill. Its unfinished edges

prove that it was framed or set in a context. See Middeldorf-Kosegarten, 'Pisano', 37; Carli, *Giovanni Pisano*, 64.

[3] Inv. no. GL.60.17.4 in the North Carolina Museum of Art, Raleigh, formerly in the Samuel H. Kress Collection (K1022), marble measuring 45.7 × 49.5 × 10.2 cm. It is embedded in a rectangle and was part of the chasse of St Octavianus with a *terminus post quem* of 14 Jan. 1312; Middeldorf, *Sculptures from the Samuel H. Kress Collection: European Schools XIV–XIX Century*, 6–7, ill.

[4] Whereabouts unknown, marble measuring *c*.74 cm. in width, with traces of polychromy. In Jan. 1994 the unpublished relief was at Alberto Bruschi Antichità, Florence, on loan from a Milanese dealer.

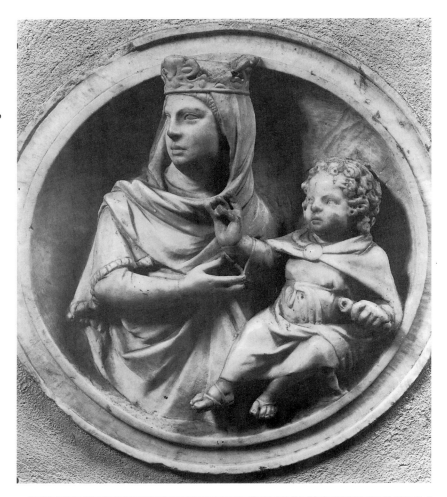

Fig. 6.1. Attributed to Giovanni Pisano or Workshop, *Madonna and Child*, *c*.1268. Museo della Collegiata di Sant'Andrea, Empoli

Fig. 6.2. Workshop of Tino da Camaino, *Madonna and Child* (fragment), *c*.1312. North Carolina Museum of Art, Raleigh

Rome, but by the end of the Trecento they began appearing with greater frequency in Florence to pave the way for tondi. A case in point is the small roundel with the blessing Christ holding a book in the Gothic pediment of the *Monument of Bishop Neri Corsini* (d. 1377) in Santo Spirito, where it replaces the trefoil or quatrefoil. Its shape fights with the pediment's angularity but is pinned behind the dominant triangular frame.[5] By the 1420s, during the efflorescence of humanism, sculpted roundels had achieved more prominence in Florence than in previous centuries. For example, Donatello carved two subsidiary ones on his Parte Guelfa tabernacle,[6] and Brunelleschi designed eight *pietra serena* roundel frames eventually filled by Donatello's stucco reliefs in the Old Sacristy. Contemporaneously, Michelozzo and Donatello were involved in the Neapolitan *Monument of Cardinal Brancacci* with its three-dimensional roundel of Christ blessing—replete with a wreath *all'antica*, shorthand for the heavenly spheres and victory through Christ.[7]

Ghiberti's two sets of bronze Baptistery doors help gauge the evolution of circular forms. They provide firmly dated examples by the same artist that function as a barometer of taste. Ghiberti ornamented the interior of his first set (completed 1425) with lions' heads inside flat concentric circles, whereas the panels of his East Doors (completed *c.*1450) feature on the interior two more three-dimensional blank circles. Moreover, Ghiberti placed his prophet heads and his self-portrait on the first doors in quatrefoils (following Andrea Pisano's earlier model), whereas he put them inside roundels on the second (Fig. 5.4).[8] Not coincidentally, independent tondi began to appear between the dates of these doors.

From inscriptions and documents, one can date the inception of autonomous sculpted tondi between 1425 and 1456. Although there is a good possibility that the first independent sculpted tondo does not survive, we can identify the pivotal individuals engaged in the early stages of its evolution: Ghiberti, Luca della Robbia, and Donatello, all of whom, incidentally, worked on Ghiberti's doors. Tellingly, all three were intimately involved with modelled methods of sculpture—wax, bronze, stucco, and terracotta—whose ease of execution allowed for experimentation. Further, these malleable, pictorial media lent themselves to the production of smaller, domestic devotional tondi because, with the exception of bronze, they were less expensive than stone. It is difficult to pinpoint the first independent tondo extant because the dates of all but two potential candidates are based on internal stylistic evidence and lack the certainty of documents. However, if we believe the inscription on the back of the *Fortnum Madonna* (Fig. 3.13), an early example of the form survives, and its master mould or original bronze is thought to be the work of Luca della Robbia.[9] The Ghibertesque quality of the drapery supports an early date.[10]

Luca della Robbia was a decidedly seminal figure in the early production of small devotional Madonna and Child tondi. He followed his *Fortnum Madonna* with a more complicated terracotta,

[5] A Roman example is the painted roundel, given to Pietro Cavallini, with Christ blessing and holding a book in the *Monument of Cardinal Matteo Acquasparta* (d. 1302) by Giovanni da Cosima in Santa Maria d'Aracoeli (Schulz, *The Sculpture of Bernardo Rossellino*, pl. 163).

[6] Bennett and Wilkins, *Donatello*, 84, 176, ill.

[7] Lightbown, *Donatello and Michelozzo*, i. 83–127, ill.

[8] Krautheimer, *Ghiberti*, ii, pls. 68, 136.

[9] See Ch. 3 n. 94. Inv. no. 10 in the Ashmolean Museum, Oxford, polychromed stucco with a 40 cm. diameter. See Pope-Hennessy, *Luca della Robbia*, 249, ill., who believes that it was moulded from a

low relief in bronze and lists variants, as does Marquand, *Luca della Robbia*, 257–62, nos. 105–10; Gentilini, *Della Robbia*, i. 22, 147 n. 21, posits an earlier wax model.

[10] Pope-Hennessy, *Luca della Robbia*, 249. Although Ghiberti is not credited with any tondi, a Madonna and Child terracotta with a 65 cm. diameter, painted with a blue background and stars, was formerly in the Kaiser Friedrich Museum, Berlin, and attributed to his shop (inv. no. 7164; Schottmüller, *Bildwerke*, i. 2, ill., dates it *c.*1439–46). It relates to the 'Corsini type' by Luca (Marquand, *Luca della Robbia*, 239–43, nos. 85–94, ill.); n. 43 below.

the *Detroit Tondo* (Fig. 6.3). Judging from the number of replications, this relief, in which Luca tried to achieve the atmospheric *rilievo schiacciato* of Donatello, was most likely distributed commercially.[11] However, one of the most important objects for this study is the pivotal small bronze tondo, whose reverse functions as a mirror (Fig. 4.7).[12] Several factors—its nude putti-like angels, foreshortened haloes, and greater compositional harmony with the tondo format—indicate that it postdates the *Fortnum Madonna*. Its utilitarian and profoundly symbolic status as a mirror yields symbolic implications applicable to other tondi (see Ch. 4).

Related to the two previous works is a bronze tondo attributed to Donatello, the second influential sculptor of tondi and the most innovative in iconography and techniques (Fig. 6.4).[13] It is slightly concave and has a pronounced rim surrounding the seated Madonna of Humility. In its ambiguous setting two putti tie laurel swags to its illusionistic, rounded sides, which could be read as a tent-like structure, alluding to the canopy of heaven (see Ch. 3). It is installed in an unusual, elaborate Renaissance marble surround, whose decorative style suggests a date after 1450 and preserves an idea of how some small sculpted tondi may have been displayed. The surround showcases the tondo, while its lateral candelabra create the effect of a small altarpiece. Its contrasting colour emphasizes the independence of the bronze tondo, while its iconography—consisting of two angels holding a crown and a banderole (formerly inscribed in gilt letters . . . *AVE MARIA* . . .)—cites the Immaculate Conception to join the two pieces conceptually.

As noted in Chapter 3, Donatello created his *Chellini Madonna* (Fig. 3.14) before 27 August 1456, when the physician described it in his *Libro debitori reditori e ricordanze*, distinguishing it as the only firmly documented Madonna relief by Donatello. It is also unique because its reverse has a negative impression to use as a mould for reproduction in glass and other materials.[14] Moreover, it demonstrates an important change from the settings of most earlier tondi. While Donatello may have intended it to represent a celestial locale (reinforced by the fact it is depicted *dal sotto in sù*), it is not as conclusively set in heaven, although four standing angels are present.[15] Its convex balustrade—decorated with seraph heads and crowned with spherical finials that repeat its shape—could either demarcate a sacred terrestrial location, with a slightly liturgical tenor, or enclose a heavenly space. Alternatively, it could designate the *hortus conclusus*. Perhaps Donatello intended this ambiguity to connect the earthly and heavenly realms and to stress the dual nature of Christ, part human and part divine. Its half-length figures, involved in an intimate embrace, project towards the viewer like the railing that repeats the curvature of the tondo, providing a tangible link between the two worlds.

Around the time that Donatello made his gift to Chellini, he designed and began his half-length

[11] Inv. no. 49.533 in the Detroit Institute of Arts, terracotta with a 33.3 cm. diameter. Pope-Hennessy, *Luca della Robbia*, 257, ill., dates it to the 1440s and lists nine versions in terracotta and stucco, one of which is rectangular with a circular indentation. See also Marquand, *Luca della Robbia*, 220–31, nos. 67–73; Darr *et al.*, *Italian Renaissance Sculpture*, 151–2, no. 41, ill.; Gentilini, *Della Robbia*, i. 22–3, 147 n. 26.

[12] Inv. no. 7694A-1861 in the Victoria and Albert Museum, London, bronze (with a high proportion of tin establishing it as a speculum metal) partially gilt with a 16.5 cm. diameter. Darr *et al.*, *Italian Renaissance Sculpture*, 152–4, no. 42a, ill., notes two stucco versions, neither of which is a mirror.

[13] Inv. no. Pl.7462 in the Kunsthistorisches Museum, Vienna, gilt bronze with a 27 cm. diameter. Ibid. 134–6, no. 30, ill., mentions

other versions including one in stucco on wood with a 26.5 cm. diameter which was in the Kaiser Friedrich Museum, Berlin (inv. no. M.7; Schottmüller, *Bildwerke*, i. 102, ill.).

[14] Inv. no A.1-1976 in the Victoria and Albert Museum, London, bronze parcel gilt with a diameter of *c*.28.5 cm. Darr *et al.*, *Italian Renaissance Sculpture*, 131–2, no. 28, ill. See Radcliffe and Avery, 'Chellini Madonna'; Dale, 'Donatello's *Chellini Madonna*: "Speculum sine macula"', figs. 4–7, who offers a reconstruction to explain the distortion of the balustrade from its reflection in a mirror (but not the figures).

[15] Four signifies the earthly elements, the Evangelists, the corners of the world, the Rivers of Paradise, and the temperaments, and suggests completion (J. Hall, *Dictionary*, 128 ff.).

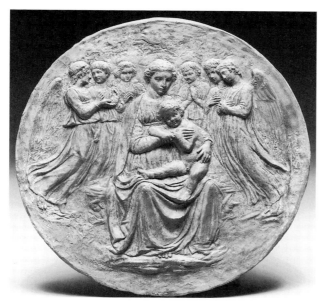

FIG. 6.3. Luca della Robbia, *Detroit Tondo*, c.1428/30–40. Detroit Institute of Arts

FIG. 6.4. Attributed to Donatello, *Madonna and Child*, c.1443. Kunsthistorisches Museum, Vienna

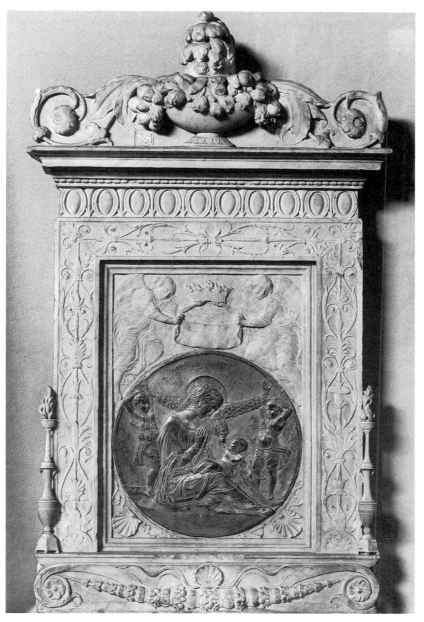

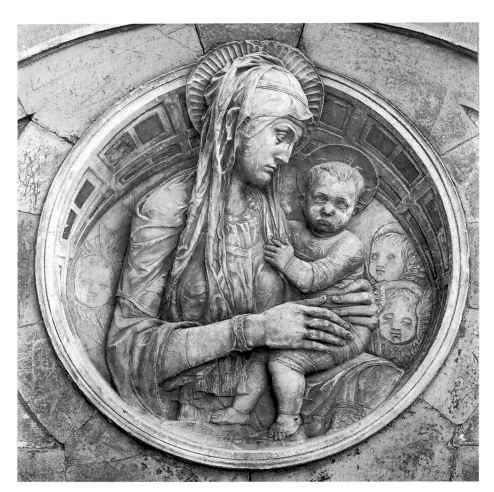

FIG. 6.5. Donatello,
Madonna del Perdono,
*c.*1457–8. Museo dell'Opera
del Duomo, Siena

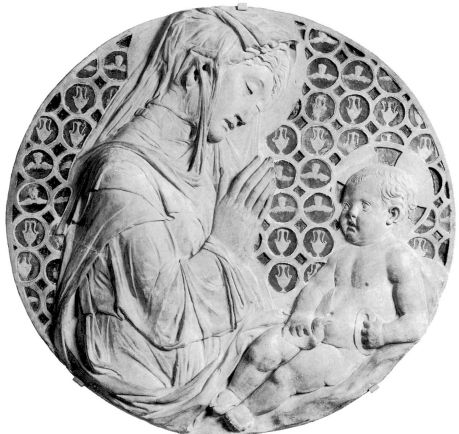

FIG. 6.6. Attributed to
Donatello, *Piot Madonna*,
*c.*1460. Musée du Louvre,
Paris

Madonna del Perdono (Fig. 6.5), probably commissioned for a chapel in the Sienese Duomo but later moved to the exterior tympanum above the right transept door (the Porta del Perdono).[16] Although it embellished an architectural setting, the low relief could never be interpreted as a subsidiary motif within a larger architectural programme like Donatello's Old Sacristy roundels. Its powerful, floating quality argues that it should be regarded as a tondo placed in a pre-existing structure, a conclusion underlined by the physicality of the Madonna's halo and head projecting over the frame of the oculus. Yet its skied placement, blue glass inserts in its coffers, and four cherub faces suggest a vision of the celestial realm and make it seem like a porthole to Paradise.

A fourth highly experimental tondo attributed to Donatello, the *Piot Madonna* (Fig. 6.6), dates from approximately the same time, when the sculptor was interested in glass techniques.[17] In this low relief, Donatello was literally seeing circles. Its half-length adoring Madonna and reclining Child are positioned before a screen of glass circles that circumscribe amphorae and winged seraphim heads modelled in white wax on a red wax background. The circles are punctuated with smaller diamond-shaped glass panels over blue wax. This background, which may represent a textile, signals a more earthly setting than is present in some of these early tondi, albeit a symbolic one. The seraphim, the highest order of angels, symbolize the heavenly nature of the pair (echoed in the symbolic ring which the Child holds), while the amphorae underline his sacrificial destiny, recalling their funerary associations on the *Season Sarcophagus* (Fig. 1.5). This theme is reiterated by the bird, symbolic of the soul as well as the Sacrifice of Christ, which the Child, wearing a cross nimbus of Sacrifice, holds.

Although the previous four tondi are the only surviving ones among the Madonna and Child panels that are seriously considered to be autograph, other Donatellesque examples, mostly in stucco and terracotta, testify to his involvement with the form.[18] A related oval relief in marble, the *Hildburgh Madonna*, has been attributed to Donatello although it is not generally accepted.[19] In addition, his partner, Michelozzo Michelozzi, is credited with a marble Madonna and Child tondo framed by a laurel wreath bound with a ribbon.[20] Since its style reflects that of the disassembled *Aragazzi Monument* by Donatello and Michelozzo, it may have been in the studio during the long gestation of that work (*c.*1430–7) and used to make stucco squeezes, a number of which are extant (Fig. 6.7).

[16] In the Museo dell'Opera del Duomo, Siena, marble with coloured blue glass inlay measuring 90 × 88 × 9 cm. Carli, *Donatello a Siena*, 34–6; Bennett and Wilkins, *Donatello*, 62–3, 155, 230 n. 59; Bellosi, *Francesco di Giorgio*, 176–81, no. 20, ill.; Pope-Hennessy, *Donatello Sculptor*, 267, 348 n. 27. It may have been completed by another hand when Donatello departed Siena in 1457. Dale, 'Chellini Madonna', fig. 10, reconstructs its two rows of coffers as a flat wooden ceiling, seen from below as in a convex mirror. While the mirror iconography is tempting, the figures are not distorted and the coffers more closely resemble a foreshortened arch seen *dal sotto in sù*.

[17] Inv. no. R.F. 3967 in the Musée du Louvre, Paris, terracotta with traces of gilding, inlaid glass (restored in plexiglass), and wax measuring 74 × 75 × 7 cm. Darr *et al.*, *Italian Renaissance Sculpture*, 112–13, no. 16, ill. Variant stucco versions include one with a 76 cm. diameter in the Acton Collection, Florence (Avery, 'Donatello's

Madonnas Revisited', 231, fig. 26).

[18] A number of Nativity tondi have been attributed to him, including two within rectangles—e.g. a stucco in the Victoria and Albert Museum, London (inv. no. 4-1890; Pope-Hennessy, *Catalogue of Italian Sculpture*, i. 260–1, no. 278, ill., lists three versions and stucco and *cartapesta* replications with prophets at the corners that he attributes to Urbano da Cortona *c.*1460).

[19] In the Victoria and Albert Museum, London; Pope-Hennessy, *Catalogue*, 91–3, no. 73, ill., lists casts; Avery, 'Donatello's Madonnas', 225–6; Wohl, Review of *Donatello-Studien*, 315–16.

[20] Whereabouts unknown, formerly in the Mendelssohn Collection, Berlin, marble. For the *Aragazzi Monument*, see Lightbown, *Donatello and Michelangelo*, i. 167–229; Caplow, *Michelozzo*, i. 348, 417–19, suggests it was in the monument's lunette.

DECORATIVE PROGRAMMES

Not only the small sculptural tondi produced during the middle decades of the Quattrocento, but also the profusion of roundels in important, innovative contexts during these decades fed the frenzy for the round shape. Not coincidentally, they appear in three centrally planned edifices as well as in the courtyard and rooms of Palazzo Medici. One of the first locations decorated with roundels of any notable presence is Brunelleschi's Old Sacristy (Fig. 2.9), wherein Donatello's eight painted stucco reliefs, dated after 1434, assume a prominent position.[21] It is not only their larger size (*c*.215 cm. in diameter), but also their pictorially ambitious qualities that set them apart from many roundels to endow them with a transitional status. No wonder that Brunelleschi disliked these complex additions to his simple wall planes![22] Another significant decorative program with roundels—that of the Pazzi Chapel in Santa Croce by Brunelleschi—was probably begun *c*.1430–3.[23] Its twelve roundels of seated Apostles (begun *c*.1442) are given to Luca della Robbia, perhaps with the assistance of Andrea,[24] while the four Evangelists in the pendentives date from a later time (*c*.1442–61) and have been attributed to various sculptors.[25] Both the Pazzi Chapel and the Old Sacristy also have friezes of smaller roundels with motifs that thematically echo the sacrificial and heavenly themes.

The third centrally planned structure where impressive roundels were visible in mid-century Florence was the Chapel of the Cardinal of Portugal.[26] The leitmotif of its decorative scheme is the circle, beginning with the five glazed terracotta ceiling roundels with celestial frames, four with the Cardinal Virtues around a central one with the dove of the Holy Spirit framed by seven candlesticks. As mentioned in Chapter 2, each wall has an oculus, whose *pietra serena* mouldings suggest the rings of heaven. Those that function as windows reveal a glimpse of the physical sky, while the one around the Madonna and Child with its heavenly blue background makes it a *fenestra coeli*, as in the Virgin's title, Window of Heaven.[27] Finally, the inlaid cosmati floor, with its five larger roundels echoing those on the ceiling, completes the swirling cosmic harmony intended by the Chapel's designer, the mathematician Manetti.

Another very significant and influential location for prominent roundels in architectural contexts was the Medici Palace, where roundels with secular subjects embellished not only its courtyard (Fig. 1.3) but also one of its interior rooms. Twelve slightly concave glazed terracotta roundels by Luca della Robbia depicting the Labours of the Months (Fig. 6.8) most likely once decorated the vault of Piero de' Medici's study on the *piano nobile* (*c*.1456).[28] Their technique represents the only example of a full painting in glaze by Luca, while their two-tone blue borders echo the heavenly connections implicit in their round forms. Although their iconography depends on northern illuminated manuscripts, details testify to the use of Columella's *De Re Rustica* (at least

[21] Elam, 'Brunelleschi and Donatello', 9–10.

[22] Manetti, *Vita di Filippo Brunelleschi*, 109–10.

[23] Pope-Hennessy, *Luca della Robbia*, 236–8, ill.; Gentilini, *Della Robbia*, i. 48, 139 nn. 66–7. No documents relating to the sculptures of this building, begun as a chapter house by Andrea de' Pazzi and completed in 1473, have been published.

[24] With 134 cm. diameters, like the roundel over the entrance; Pope-Hennessy, *Luca della Robbia*, 237–8, ill.

[25] With 170 cm. diameters; ibid. 236–8.

[26] Hartt, Corti, and Kennedy, *Chapel*; Pope-Hennessy, *Luca della Robbia*, 48–9, 244–5, ill. For other roundels, probably from series, by Andrea, see ibid. 270–1, figs. 50–3.

[27] Shearman, *Only Connect*, 77, refers to the concept.

[28] Inv. nos. 7632-1861–7643-1861 in the Victoria and Albert Museum, London, glazed terracotta with *c*.60 cm. diameters. Pope-Hennessy, *Luca della Robbia*, 43–5, 240–2, pls. X–XII, figs. 63–71; Ames-Lewis, *The Library*, 13–16; Gentilini, *Della Robbia*, i. 110–12.

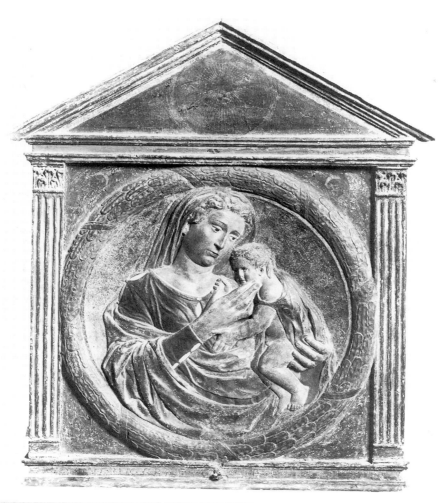

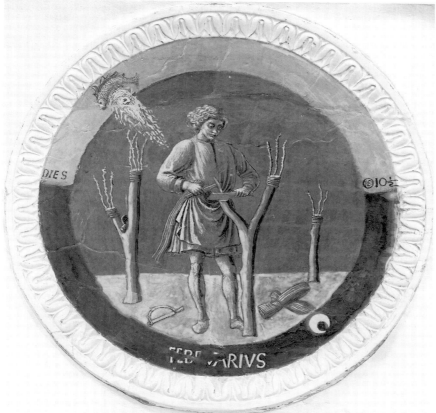

Fig. 6.9 (*left*). Bernardo Rossellino, *Monument of Leonardo Bruni*, 1444. Santa Croce, Florence

Fig. 6.10 (*above*). Desiderio da Settignano, Detail of the *Monument of Cardinal Marsuppini*, after 1453 (before the frescoed canopy on the wall was discovered in 1997). Santa Croce, Florence

one copy, discovered by Poggio Bracciolini in 1417, was made for Piero de' Medici, who kept it in this very room).[29] From traces of glazes on the circumferences, they were once set into fields simulating red and green porphyry.[30] Thus, with their white frames they belonged to an iconographical programme with the same tripartite heraldic Medici colour scheme as in the Old Sacristy and Medici tombs, all set against celestial blue, and all reinforcing the importance of the circle.

SEPULCHRAL MONUMENTS

While these decorative programmes fed the circle's popularity, it was the appearance of monumental Madonna and Child roundels in the lunettes of mid-century sepulchral monuments that most likely furnished the impetus for Madonna and Child devotional tondi to double or triple in size. (They assumed the position of the sacral plate in Donatello's *Cavalcanti Annunciation*.) These roundels display a chronological evolution towards quasi-autonomy wherein they can be read either as tondi representing the heavenly realm that have been grafted onto larger complexes or as prominent roundels.

There is no doubt that the first—a half-length Madonna and Child roundel flanked by two praying angels on Bernardo Rossellino's *Monument of Leonardo Bruni* (Fig. 6.9)—is part and parcel of the architectural unit, because both its upper and lower edges are anchored behind the lunette's border, rendering it for ever a roundel. It represents the blessed realm into which Bruni's soul is received and is the only overtly religious element in an otherwise secular, humanist civic tomb, whose real theme is the immortality of Bruni's fame. Moreover, its subsidiary status is emphasized by the crowning *clipeus* with Bruni's coat of arms, which is framed by a wreath and held by putti, recalling its ancient prototype.[31]

The roundel of Desiderio's *Monument of Cardinal Marsuppini* of 1453 (Fig. 6.10), Bruni's successor as Chancellor of Florence and composer of his epitaph, is directly across the nave in Santa Croce.[32] While still fairly attached to the architectural unit, it begins to free itself at the upper edge and is not overshadowed by a crowning element of the same shape. Moreover, its figures are more involved with the viewer, while their haloes overlap the frame and the Madonna's cloak cascades into the viewer's space.

Yet it is only in the innovative *Monument of the Cardinal of Portugal* (1460–6) by Antonio Rossellino that the Madonna and Child roundel illusionistically disengages itself from the complex (Fig. 6.11).[33] In contrast to the earlier monuments, where angels passively adore the Madonna and Child roundel, Rossellino's form is physically supported by two angels as it wafts down from

[29] Pope-Hennessy, *Luca della Robbia*, 242, mentions two copies in the Biblioteca Mediceo-Laurenziana, Florence (MS Plut. 53, 27 and MS Plut. 63, 32, inscribed with Piero's name). Ames-Lewis, *The Library*, 16, 277, records the latter as Biblioteca Laurenziana 53, 32, a copy made especially for Piero in the mid-1450s, which might help to date the cycle.

[30] Gentilini, *Della Robbia*, i. 110, believes their blue and white scheme derives from Islamic tiles.

[31] Schulz, *Bernardo Rossellino*, 32–51, 99–104, ill.; Pope-

Hennessy, *Italian Renaissance Sculpture*, ii. 278–9, 353–4, ill., argues that the tomb's design was influenced by Alberti.

[32] Ibid. 286–7, ill.; Olson, *Italian Renaissance Sculpture*, 100–2; Schulz, 'Glosses on the Career of Desiderio da Settignano'.

[33] Pope-Hennessy, *Italian Renaissance Sculpture*, ii. 288–9, ill.; Olson, *Italian Renaissance Sculpture*, 102–3, ill. The *Monument of Lorenzo Roverella* by the shop in San Giorgio, Ferrara, has a similar roundel flanked by two angels (Planiscig, *Bernardo and Antonio Rossellino*, pls. 86–7).

heaven. As such it is the first mystical depiction of the Madonna and Child actively claiming the soul of the deceased for all eternity. Further, Rossellino's heaven is more specific than in the two earlier examples, where it is designated only by the round form. He carved six seraphim heads separated by stars and clouds on the inner moulding of its frame, enlivening it with gilding and the relief's blue background with gilded stars. A garland *all'antica*, signifying victory, bound with ribbons and decorated with the fruits of Paradise, comprises the outer moulding of the almost proto-Baroque form, to make its iconography even more explicit.

Following closely on its heels is the *Monument of Count Hugo of Tuscany* (1469–81) by Mino da Fiesole, who approached its Madonna and Child roundel much more conservatively.[34] It remains stoically frozen in its context, imprisoned in the lunette behind a moulding by only a matter of an inch.[35] Its isolation results from the stark, dark background of the lunette and the absence of angels (they hold the epitaph on the sarcophagus). In fact, it represents a step backwards in the progression.

It was Benedetto da Maiano, heir to Antonio Rossellino, who finally liberated in stages the Madonna and Child sepulchral roundel from its architectural pinions to float freely unsupported. He explored the potential of this motif in three works: (i) the *Monument of Maria of Aragon* (from the 1480s, begun by Antonio Rossellino) in Sant'Anna dei Lombardi (Fig. 6.12); (ii) the radical *Monument of Filippo Strozzi* (*c*.1491) in Santa Maria Novella (Fig. 6.13); and (iii) the more conservative *Altar of San Bartolo* (1493–5) in Sant'Agostino, San Gimignano.[36] In all three, the sculptor employed Rossellino's device wherein a seraph abuts the top and bottom of the roundel, although it is only in the *Strozzi Monument*, with its simple dark background that enhances the roundel's floating quality, that Benedetto's vision soars and the roundel becomes an illusionistically autonomous tondo. Here, the four flying angels are all detached, both from the ground and the round form, with their hands folded in prayer rather than touching or overlapping its frame.[37] This liberation coincides with the zenith of painted tondi, which may also have influenced its outer frame of leaves and roses, symbolic of the Virgin and the rosary, whereas its celestial quality is derived from its autonomy.[38]

LATER SCULPTURAL TONDI AND THE DELLA ROBBIA FAMILY

To judge from surviving examples, a substantial number of Madonna and Child devotional tondi in sculptural media were produced in Florence after mid-century, most of which were not in stone.

[34] Sciolla, *Mino da Fiesole*, 64–70, ill.; Pope-Hennessy, *Italian Renaissance Sculpture*, ii. 288–9, ill.

[35] Mino's *Monument of Cardinal Cristoforo della Rovere* (d. 1477) in Santa Maria del Popolo, Rome, has a Madonna and Child inside an oval (Venturi, *Storia*, vi, fig. 440).

[36] Lein, *Benedetto da Maiano*, 69–72, 110–19, ill. See also Tessari, 'Benedetto da Maiano tra il 1490 e il 1497'; Ciardi Dupré Dal Poggetto *et al.*, *La bottega di Giuliano e Benedetto da Maiano nel Rinascimento fiorentino*; Lamberini, Lotti, and Lunardi, *Giuliano e la bottega dei da Maiano*, 55–63, 92–103. The shop *Monument of Antonio degli Agli* (d. 1477) in Santa Maria all'Impruneta also features a roundel with a Madonna and Child with two seraphim in

rilievo schiacciato whose wreath is supported by an external seraphim (it is echoed below the sarcophagus with the epitaph in an inlaid *clipeus* with another inscription bordered by dark stone); Proto Pisani, 'L'arredo sepolcrale del Vescovo Antonio degli Agli', 58, ill.

[37] Other versions include a painted stucco squeeze with a 76 cm. diameter; see Valentiner, *Catalogue of an Exhibition of Italian Gothic and Early Renaissance Sculpture*, n.p., no. 48; nn. 82–3 below.

[38] Later sepulchral roundels include one on the unexecuted tomb that Benvenuto Cellini designed for himself in Santa Maria Novella; see I. Lavin, 'The Sculptor's "Last Will and Testament"', 24.

FIG. 6.12 (*left*). Benedetto da Maiano, *Monument of Maria of Aragon*, 1488–90. Sant'Anna dei Lombardi, Naples

FIG. 6.13 (*below*). Benedetto da Maiano, Detail of the *Monument of Filippo Strozzi*, 1490–3. Santa Maria Novella, Florence

FIG. 6.11. Antonio Rossellino, *Monument of the Cardinal of Portugal*, 1460–6. San Miniato al Monte, Florence

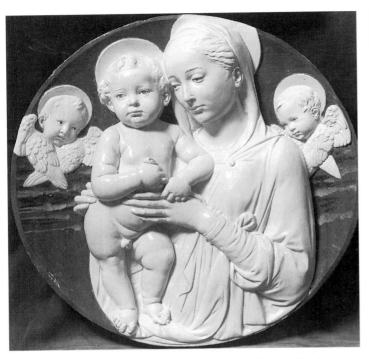

FIG. 6.14(a). Andrea della Robbia, *Madonna and Child with Two Seraph Heads*, c.1480–5. The Andrew W. Mellon Collection, National Gallery of Art, Washington, DC

FIG. 6.14(b). Reverse of Fig. 6.14(a)

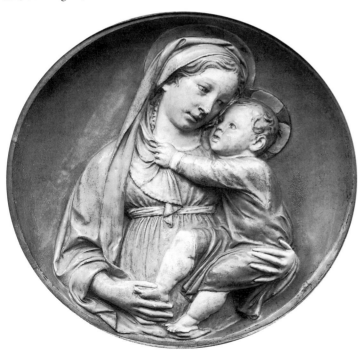

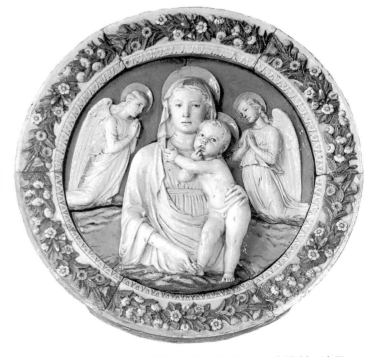

FIG. 6.15. Luca della Robbia, *'Corsini' Madonna*, 1440s (the original). Corsini Collection, Florence

FIG. 6.16. Luca (or Andrea) della Robbia, *Madonna and Child with Two Angels (Cappuccine Tondo)*, 1475–80. Museo Nazionale del Bargello, Florence (colour plate III)

Today, these works are scattered in public and private collections worldwide. One problem in dealing with them is a lack of knowledge regarding their commissions, provenances, and original installations. Another involves the many casts and squeezes in existence, a good number of which have not been thoroughly studied or traced.

Since the largest collective body of sculpted tondi belongs to the Della Robbia family and their respective shops and circles, most were produced in the famous glazed terracotta medium whose superb glazes remained a prized family secret. The medium allowed for many variations, including unique originals modelled by the sculptor, squeezes, and multiples from the same mould, as well as modifications to works from the same mould that could be made before drying and firing. This versatility carried over less frequently to circular adaptations of compositions originally conceived for rectangular or arcuated formats and vice versa. It also encompassed shop adaptations and pastiches and resulted in variations and reductions from different moulds by the successive Della Robbia *botteghe* and other individuals down to the present day.[39]

Although the backs of Della Robbia tondi really have not been studied, they are revealing and have an immediacy similar to drawings and sculptural maquettes. Even when there are several versions from the same mould, each reverse is unique because the parts in higher relief on the front were hollowed out freely from the back to facilitate proper firing. Take, for example, Fig. 6.14: its reverse has a two-pronged hollow behind the Madonna and Child and at the lower left a person dragged four fingers across the surface and at the right made a random groove with a sharp instrument. The *versi* of others from the same mould have different hollows and furrows. An extreme variation occurs in one in the Metropolitan Museum of Art. Its reverse has an architectonic configuration of around eight hollow pockets, rather like deep irregular honeycombs with thick walls, implying that a different person produced it.

An analogous process was followed for the frames, which were frequently modelled or moulded separately and in sections (as sometimes were the reliefs) and assembled when the ensemble was mounted into a wall. Thus, Della Robbia tondi and their frames were well suited to Italian interior construction techniques. While they could be inserted into masonry, as on the façade of Or San Michele, they were most easily immured in the plaster walls of quattrocento interiors as well as hung. A passage in the 1492 Medici inventory offers a related installation for a glazed terracotta Madonna and Child on top of a dripstone sunk into the wall ('Una Nostra Donna di mezzo rilievo invetriata in sun una ghocciola fitta nel muro (L. 3).').[40]

We have already acknowledged that lyrical Luca was a seminal figure in the tondo's evolution; in addition to creating the earliest surviving Madonna and Child tondo and frontal Florentine bust-length sculpted portrait, he produced a myriad of tondi with arms and devices (*stemme* and *imprese*), whose ceramic surface ensured lasting colour without the expense of less brightly coloured inlaid stone.[41] Most often they were encircled by festive garland frames, symbolizing the flourishing and/or fecundity of the institution or family.[42] They too have a development and, like devotional tondi, reveal an increasing influence from painting.

[39] See the books by Marquand; Gentilini, *Della Robbia*.

[40] Müntz, *Les Collections*, 82; Spallanzani and Bertelà, *Libro d'inventario*, 57.

[41] Marquand, *Robbia Heraldry*; Pope-Hennessy, *Luca della Robbia*; Gentilini, *Della Robbia*, i. 135–7. His largest is the *impresa* of René of Anjou with a 335.3 cm. diameter in the Victoria and Albert

Museum, London (Pope-Hennessy, *Luca della Robbia*, 248–9, ill.). See also Ch. 5 n. 36.

[42] He and his shop also produced a Madonna and Child in a mandorla in the Musée Jacquemart-André, Paris (La Moureyre-Gavoty, *Sculpture italienne*, no. 27, ill.; Pope-Hennessy, *Luca della Robbia*, 254–5, ill.).

Moreover, Luca's intimate, simple 'Corsini type' marks the commencement of his multiple production of devotional tondi (Fig. 6.15). The brightly coloured example in the Corsini Collection is considered by some scholars to be the original of an early group, comprised of replicas in several media related to a Ghibertesque terracotta tondo. Others believe it is after a lost original by Luca.[43] Its simplicity and pronounced rim and concave surface, derivative from a certain type of *imago clipeata*, continued to be a feature in many sculptured tondi.[44]

Not surprisingly the later tondi of Luca and his nephew Andrea reveal a greater connection with paintings, since the role of the polychromed terracotta medium was to strike a compromise between the media, marrying the three-dimensionality of sculpture with the vivacity and clarity of colour (and the strength not found in polychromed wood). A case in point is the *Madonna and Child with Two Angels* (1475–80) from Sant'Onofrio delle Cappuccine (Fig. 6.16; Colour Plate III), which has a greater elaboration indicative of the later century in its additional *dramatis personae* and extended palette.[45] The intense yellow haloes, echoed in the flowers on its frame, add a decorative effect that, like the free brushwork of the blue glazes in the sky, reveal the influence of painting. Similarly, the innovative *Adoration of the Shepherds* (Fig. 6.17),[46] which dates from around this time but slightly earlier, includes many naturalistic details and a stronger narrative dimension than earlier sculpted tondi. It is a departure from Luca's earlier tondi in the specific inscription on the angel's scroll, its full-length figures, and its ambitious landscape setting, which reflect contemporary paintings. Except for a few elements that echo its shape, it could have fitted into a rectangular format. A closely related convex tondo with a rim and a garland frame is the so-called '*Foulc Adoration*' (Fig. 6.18).[47] Its implied reference to the Incarnation gives it a more overtly devotional focus, which Luca explored in other formats. This theme was especially sacred to the Franciscans and their cult of the *presepio*, but it ultimately depended on the fourteenth-century 'Revelations' of St Bridget of Sweden, which flourished after mid-century.[48] Its angelic quartet, one member of which holds a scroll inscribed *Gloria inexcelsis De[o]*, sings the anthem of the angels after the Annunciation to the Shepherds (Luke 2: 14). Typical of the second half of the century, the work is gilded, decorative, and includes even more worldly elements than Luca's earlier tondi. Its blessing Child reclines in a posture directly relating to the viewer as well as one more conciliatory towards the format. Further, the glazing technique and modelling are more fluid, in a stylistic response to painting techniques and to the influence of Andrea, who began to work separately *c*.1455–60, in turn influencing his uncle with whom he occasionally collaborated.[49]

Without Luca, Andrea della Robbia was responsible for a number of roundels in glazed

[43] In glazed terracotta with a 33 cm. diameter. See above, n. 10. Gentilini, *Della Robbia*, i. 98–9, ill., 158 n. 12. Marquand, *Luca della Robbia*, 239–43, nos. 85–93, ill., lists variations in stucco, terracotta, stone, and *cartapesta*, with diameters between 28 and 39 cm. Pope-Hennessy, *Luca della Robbia*, 251, believes it is later and after a lost original by Luca (*c*.1440). For the version in the Philbrook Museum of Art, Tulsa (formerly in the Samuel H. Kress Collection, K42), with a 32 cm. diameter, see Middeldorf, *Sculptures from the Kress Collection*, 34–5, fig. 62.

[44] See e.g. Giuliano, *Museo Nazionale Romano: le sculture*, i/2, 90–1, ill.

[45] Inv. Robbie no. 27 in the Museo Nazionale del Bargello, Florence, glazed terracotta with a diameter of 100 cm. Marquand, *Luca della Robbia*, 71–2, no. 17; Pope-Hennessy, *Luca della Robbia*, 267–8, ill.; Gentilini, *Della Robbia*, i. 127, ill., 138, 167 nn. 67–8.

[46] Inv. no. 7752-1862 in the Victoria and Albert Museum, London, glazed terracotta with a diameter of 139.7 cm. Its floral garland frame (in ten sections) is moulded. Pope-Hennessy, *Luca della Robbia*, 262–3, ill.; Gentilini, *Della Robbia*, i. 138–9, ill.

[47] Inv. no. W1930-1-64a, b (frame) in the Philadelphia Museum of Art, glazed terracotta with traces of gilded decoration and a *c*.104 cm. diameter, 167 cm. with a shop frame (not original). Marquand, *Luca della Robbia*, 170–1, no. 51; Pope-Hennessy, *Luca della Robbia*, 263, ill.; Gentilini, *Della Robbia*, i. 134, 177, ill.

[48] Cornell, *The Iconography of the Nativity of Christ*, 10.

[49] Andrea and his *bottega* produced other works on the La Verna Adoration theme of *c*.1479; see Marquand, *Andrea della Robbia*, ii. 119–41, nos. 122–42; Gentilini, *Museo Nazionale del Bargello: Andrea della Robbia*, i: *Madonne*, 8, ill.

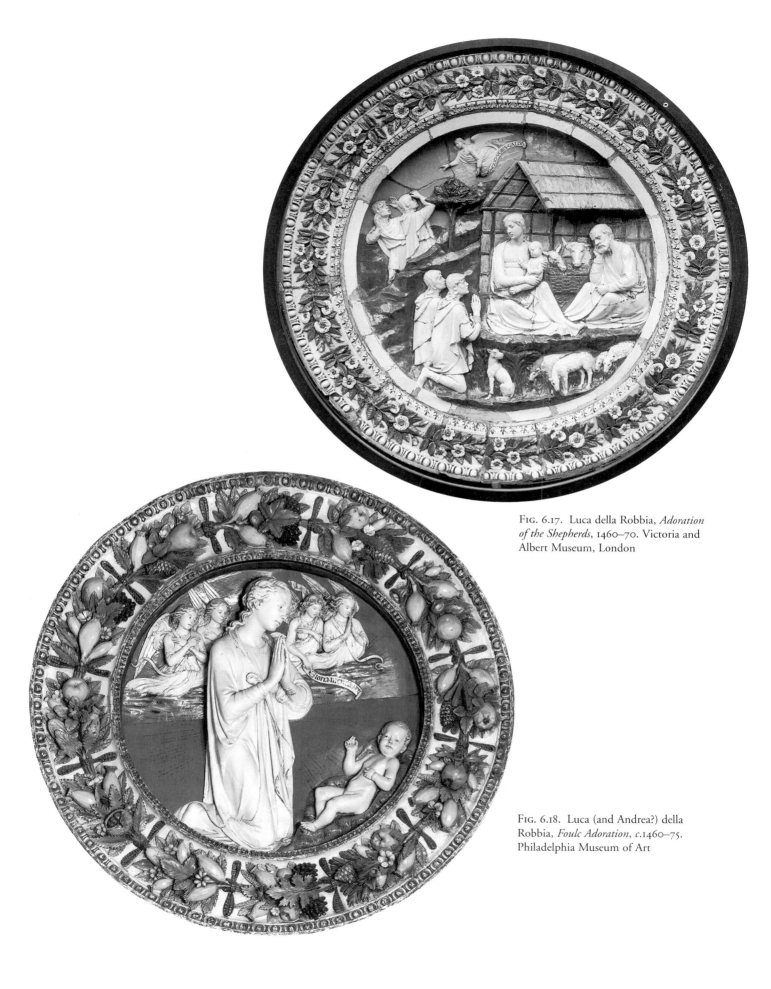

Fig. 6.17. Luca della Robbia, *Adoration of the Shepherds*, 1460–70. Victoria and Albert Museum, London

Fig. 6.18. Luca (and Andrea?) della Robbia, *Foulc Adoration*, c.1460–75. Philadelphia Museum of Art

FIG. 6.19. Andrea and Giovanni della Robbia, *Madonna and Young St John Adoring the Child*, 1500. Museo Nazionale del Bargello, Florence

FIG. 6.20. Andrea and Giovanni della Robbia, *Madonna Adoring the Child with a Coronation of the Virgin by Two Angels*, 1460–5 and reworked 1520. Museo Nazionale del Bargello, Florence

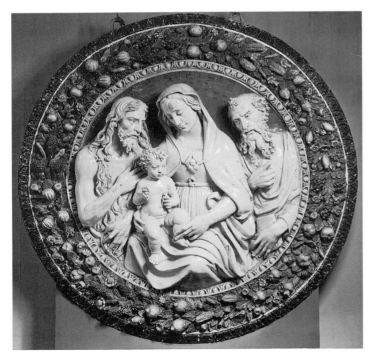

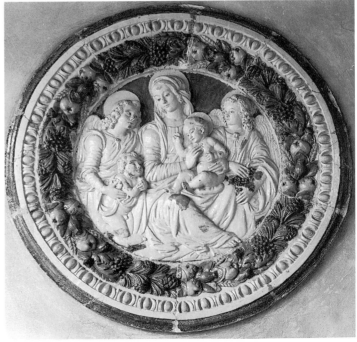

FIG. 6.21. Marco della Robbia (Fra Mattia), *Madonna and Child with St John the Baptist and St Jerome*, c.1520. Staatliche Museen zu Berlin — Preußischer Kulturbesitz

FIG. 6.22. Santi Buglioni, *Madonna and Child with Young St John and Two Angels*, c.1510–20. Museo della Collegiata di Sant'Andrea, Empoli

terracotta and involved with several decisive decorative programs with roundels.[50] His most famous series are those of babes wrapped in swaddling-clothes on the façade of the Ospedale degli Innocenti (c.1487).[51] He and his shop also produced coats of arms.

It was during the productive decade of the 1480s, at the zenith of tondi production, that Andrea and his shop created many devotional works in multiple versions, some adapted to the circular form and others conceived for it. Consequently moulds were used, as in his most popular composition conceived in the circular format, the *Madonna and Child with Two Seraph Heads* (Fig. 6.14), also referred to as the 'Madonna Foulc' from the provenance of perhaps the earliest version.[52] Two of the finest, both without original frames—one in the Victoria and Albert Museum[53] and the other in the National Gallery of Art[54]—feature clouds whose glazes have been applied in a similar painterly technique and palette. The angelic forms are probably seraphim, the highest order. A number of the later ones, such as the Bargello tondo,[55] still have their original frames (some with two borders, a ring of seraphs and a garland). All versions and sizes have a rim and a concave surface deriving from the *imago clipeata* and increasing the three-dimensionality of their figures.[56]

Andrea further adapted and popularized Luca's treatment of the Adoration of the Child theme (Fig. 6.18) in an evolutionary series. Two of these Andrea modelled in one unique version each. The earliest (c.1485–90) retains the Virgin facing towards the right, while alterations include the pairing of the four angels that look inward towards the Virgin instead of turned in unison towards the right.[57] In the second (c.1490–5), Andrea radically transformed the original by orienting the Virgin towards the left and replacing the four angels with two.[58] In the next step of the evolution, known in shop examples, seraph heads replace the two angels, while young St John along with the ox, ass, a bird (the Holy Ghost), and two trees add enrichment (Fig. 6.19).[59]

Andrea's art flourished in Laurentian Florence, especially during the late decades of the Quattrocento under the sway of Savonarola and the Dominicans. In fact, Andrea had strong connections with the Dominicans. Two of his sons, Marco (after 1496 Fra Mattia) and Francesco

[50] They include: the Evangelists for Santa Maria delle Carcere, Prato, c.1491; the saints for the Ospedale di San Paolo, Florence, c.1495; the Evangelists for the chapel of Paolo Tolosa in Sant'Anna dei Lombardi, Naples, c.1495; a standing Christ as a pilgrim (c.1475) now in Santa Maria Novella (Gentilini, *Della Robbia*, i. 175, ill.); *God the Father Blessing*, c.1480 with a 140 cm. diameter, in the Museo della Collegiata, Empoli (inv. Carocci no. 55; Paolucci, *Collegiata*, 143–4; Gentilini, *Della Robbia*, i. 196, ill., 209, 269 n. 13). See also Marquand, *Andrea della Robbia*; Gentilini, *Della Robbia*, i. 169 ff.

[51] With diameters of 100 cm. Marquand, *Andrea della Robbia*, i. 10–18, no. 6, ill.; Pope-Hennessy, *Luca della Robbia*, 177–8, ill.; Gentilini, *Andrea della Robbia*, 3.

[52] Gentilini, *Della Robbia*, i. 221, lists versions, some with variations, whose inception he dates c.1480–5. Marquand, *Andrea della Robbia*, i. 71–4, nos. 50–2; ii. 52–6, nos. 149–56, lists eleven with varying dimensions and reproduces several. Gentilini, *Andrea della Robbia*, 24–5, no. 7, ill., believes the Nîmes example (Musée des Beaux-Arts, Foulc Collection) is earlier (c.1480) than those dating from the 1490s where the Child has a cross nimbus and the Madonna's veil is changed (the frame with its seraphs he believes also dates from that decade). He adds others in Santa Lucia a Casa Romana presso Dicomano, whose location is now Proprietà Pieve di Santa Maria a Dicomano, and at auction (Sotheby's, London, sale cat., 16/V/68, no. 64).

[53] Inv. no. 5633-1859 in the Victoria and Albert Museum,

London, glazed terracotta with a 53.3 cm. diameter. Pope-Hennessy, *Catalogue of Italian Sculpture*, i. 214–15, no. 204, ill.

[54] Inv. no. 1937.1.122 (A-11) in the National Gallery of Art, Washington, DC, formerly in the Andrew W. Mellon Collection, glazed terracotta with a 54.7 cm. diameter.

[55] Inv. Robbie no. 30 in the Museo Nazionale del Bargello, Florence, glazed terracotta with a 58 cm. diameter (87 cm. including its frame). Gentilini, *Andrea della Robbia*, 24–5, no. 7, ill.

[56] Andrea's shop also produced tondi slightly removed from the type, such as ones in the Museo Civico, San Sepolcro (c.1503), and the Pinacoteca Comunale, Città di Castello (c.1490–1500). Gentilini, *Della Robbia*, i. 232, both ill. See Marquand, *Andrea della Robbia*, ii. 178–81, nos. 223–4, 322–8, 338, for other variants.

[57] Inv. no. 2792 in the Musée Cluny, Paris, glazed terracotta with a 185 cm. diameter. Marquand, *Andrea della Robbia*, i. 65–6, no. 441, fig. 48; Gentilini, *Della Robbia*, i. 222, ill.

[58] In the Museo Bandini, Fiesole, glazed terracotta with a c.120 cm. diameter. Marquand, *Andrea della Robbia*, ii. 31–3, no. 135, 1–7; Bandera Viani, *Museo Bandini*, 37–8, no. 106, ill.; Scudieri, *Museo Bandini*, 163–4, no. 49, ill.

[59] Inv. Robbie no. 12 in the Museo Nazionale del Bargello, Florence, formerly in Santissima Annunziata delle Murate. Gentilini, *Andrea della Robbia*, 7, ill.; id., *Della Robbia*, ii. 289, ill. There are numerous versions with variations.

(after 1495 Fra Ambrogio), assumed the habit at San Marco, while two of his daughters became nuns.[60] No wonder many moulded replicas and reworkings, as well as *bottega* reductions, survive from the period, when the regeneration of popular religious sentiments created a demand for devotional works and tondi flourished.[61]

From the last decade of the Quattrocento until the end of his prolific career, there was an increasing amount of studio collaboration in Andrea's *bottega*, which continued to produce tondi. Ones with *stemme* and *imprese* were the bread-and-butter products of an enterprise that spread throughout Tuscany and beyond the Italic boot. Giovanni—who was neither as accomplished an artist nor as distinctive a personality as his father—contributed along with his brothers (Marco, Luca, Francesco, and Girolamo) to the spread of the Della Robbia genre and collaborated with his father on a tondo mentioned previously (Fig. 6.19). Then, *c.*1520, he adapted a rectangular Madonna adoring the Child, created by Luca and Andrea (*c.*1460–5), into a tondo (Fig. 6.20), transforming it into a Coronation of the Virgin that is indicative of the later Della Robbia production.[62]

The later Della Robbia phenomenon is very interesting sociologically. In the last quarter of the Quattrocento, numerous scenes of the Madonna Adoring the Child were produced by the Della Robbia *bottega* to feed the desires of reformers hungry for images to stimulate the religious education of children and didactic devotion.[63] Giovanni's works catering for this need contain an even greater blending of traditions from painting and sculpture than the works of Andrea, and can create a somewhat overworked and garish effect whose expressive colours, however, like those in contemporary painting, capture the mood of Florence between the fall of the Medici in 1494 (or the death of Lorenzo in 1492) and their reinstatement to absolute power in 1537.[64]

The eclectic, third-generation Della Robbia continued to expand established types, although the number of devotional tondi decreased. Under the influence of painted examples (see Ch. 7 and App.), they occasionally introduced saints into compositions with the Madonna and Child, as in one by Fra Mattia (Fig. 6.21).[65] Girolamo, who had gone to France at the end of 1517, and Luca (Il Giovane), who joined him in 1529, continued the tradition for the French court that desired to create its own italianate Renaissance.[66]

The major competitors of the Della Robbia in Florence were Benedetto Buglioni and Santi di Michele called 'Buglioni', his nephew once removed and ward, who, together with other shops, manufactured a similar type of glazed terracotta ware from the 1490s through the 1560s, including an occasional devotional tondo.[67] During the Cinquecento, however, devotional tondi were neither among the products most in demand nor the most interesting works in the medium. In fact, many tondi by the two Buglioni are pastiches of those by the Della Robbia and others.[68] However,

[60] Caterina in 1496 and Margherita in 1502.

[61] For an exploration of Savonarola's impact, see Weinstein, 'The Myth of Florence'; id., *Savonarola and Florence*; R. M. Steinberg, *Fra Girolamo Savonarola, Florentine Art, and Renaissance Historiography*; M. B. Hall, 'Savonarola's Preaching and the Patronage of Art'.

[62] Inv. Robbie no. 48 in the Museo Nazionale del Bargello, Florence, formerly in Sant'Onofrio delle Cappuccine. Marquand, *Giovanni della Robbia*, 161–2, no. 105, ill.; Gentilini, *Della Robbia*, ii. 320, ill.

[63] Gentilini, *Andrea della Robbia*, 3–8.

[64] See Olson, 'Studies', for a consideration of the links between the palette and expressionistic style of Botticelli and the late quattrocento

religious/political climate.

[65] Inv. no. 161 in the Staatliche Museen zu Berlin — Preußischer Kulturbesitz, glazed terracotta with a 144 cm. diameter. Marquand, *Giovanni della Robbia*, 140–2, no. 145; Schottmüller, *Bildwerke*, i. 141, ill.; Gentilini, *Della Robbia*, ii. 375–6, ill.

[66] For Giovanni, ibid. 279 ff. For his brothers, Marquand, *Brothers*; Gentilini, *Della Robbia*, ii. 329 ff.

[67] Ibid. 390 ff. See also Marquand, *Buglioni*; Gurrieri and Amendola, *Il fregio robbiano dell'Ospedale del Ceppo a Pistoia*.

[68] e.g. Benedetto Buglioni produced ones after Benedetto da Maiano's Scarperia tondo (Fig. 6.31) and adapted elements in others (Gentilini, *Della Robbia*, ii. 433, 454, 464, ill.).

Santi infused a more sophisticated complexity into the *bottega* and seems to have introduced two new tondo compositions, known in versions from *c*.1510–20: (i) the Madonna adoring the Child supported by an angel and (ii) the Madonna and Child with St John the Baptist and two angels (Fig. 6.22), both influenced by the paintings of Lorenzo di Credi (Figs. A56–7).[69] There are also endless variations of indifferent quality and uncertain age.[70] To complicate the situation, these and Della Robbia copies are still manufactured today. As is the case with Hellenistic terracottas, *caveat emptor*, with thermoluminescence tests mandatory.

DIVERSE TONDI OF THE LATER QUATTROCENTO

A group of singular devotional tondi by diverse sculptors, such as Desiderio da Settignano, reveal additional aspects about the functions and the development of tondi and testify to the fact that sculptural tondi never flourished to the same extent as their painted cousins. While it would seem natural for Desiderio, an accomplished sculptor of devotional Madonnas, to have produced Madonna and Child tondi, he curiously appears not to have been involved with them. His unique contribution to the format, the *Arconati–Visconti Tondo* (Fig. 6.23), however, is distinctive, perhaps because it dates from mid-century before devotional tondi subjects were established.[71] It represents a less than half-length Child and St John after the Flight into Egypt, the earlier of only two tondi known, both in stone, where the theme is envisioned as an isolated incident between the two boys. This simple, focused portrayal was appropriate for marble, because without polychromy more complex depictions would be difficult to read. In this refined relief, it is the younger Child, identified by his cross-nimbus, who is in command and more prominent. With an omniscient air, he embraces the startled John. Once again, this theme may have been inspired by the advice of Cardinal Dominici in his treatise, wherein he urges mothers to choose scenes of the young Christ and John and notes: 'It will not be amiss if he should see Jesus and the Baptist pictured together.'[72]

 Despite media limitations, Antonio Rossellino and his shop, influenced by Luca della Robbia's glazed terracottas and paintings, tried to introduce narrative and genre elements into other monochromatic sculpted tondi, as in two with Nativity scenes (Figs. 6.24–5). Fig. 6.24, a variation on Luca's *Adoration of the Shepherds* (Fig. 6.17), has many details, including an Annunciation to the Shepherds with five rustic figures that may have served to mark the decades of the rosary, which are difficult to read due to the monochromatic medium. To remedy the situation and clarify the elements Rossellino placed his two-thirds-length Virgin and Child close to the viewer and applied gilding.[73] The tondo's frame of stars and clouds alternating with seraphs underlines its celestial

[69] Ibid. 414, both ill. The first is in the Museo di Palazzo Taglieschi, Anghiari; the second, with a 110 cm. diameter, is in the Museo della Collegiata di Sant'Andrea, Empoli (inv. Carocci no. 55; Paolucci, *Collegiata*, 145, ill.). Marquand, *Buglioni*, 75–7, nos. 80–3, lists versions.

[70] e.g. two formerly in the Samuel H. Kress Collection (K92 and K109 with 29.2 and 51.9 cm. diameters); Middeldorf, *Sculptures from the Kress Collection*, 37, 40, figs. 65, 73.

[71] Inv. no. R.F. 1626 in the Musée du Louvre, Paris, marble with a 51 cm. diameter. Darr *et al.*, *Italian Renaissance Sculpture*, 181–2, no. 57, ill.; Coonin, 'Desiderio'. Vasari (Milanesi), iii. 110, describes a similar [if not the same] tondo in the *guardaroba* of Duke Cosimo

de' Medici (not mentioned in the 1492 Medici inventory).

[72] Dominici, *Regola*, 34. Derivations include one with a 41 cm. diameter in the Museo Horne, Florence, with a profile head of young St John (inv. no. 122; Rossi, *Il Museo Horne*, 150, ill.; Victor Coonin believes it is a 19th-c. copy of a rectangular one in the Bargello (letter of 25 Aug. 1993)) and a 19th-c. terracotta squeeze in the Victoria and Alberti Museum, London (inv. no. A.8-1916; Pope-Hennessy, *Catalogue of Italian Sculpture*, i. 141–2, no. 116, ill.).

[73] Inv. no. 90 S in the Museo Nazionale del Bargello, Florence, marble with a 100 cm. diameter. Rossi, *Il Museo del Bargello*, opp. pl. 24.

import and the idea that through the Incarnation, the believer can enter Paradise to enjoy eternal life. Further, this porthole-like aperture serves as a ledge on which the infant lies, spilling out illusionistically into the viewer's space to connect the celestial sphere and the elemental world of the viewer. This device underlines Christ's dual nature, which theologically bridges the two realms, to argue that only through his Sacrifice can the viewer enter the Kingdom of Heaven. To continue this argument, the tondo may have also had a garland and fruit frame like its terracotta variant (Fig. 6.25).[74] While both tondi are related to the sculptor's rectangular Nativity in Sant'Anna dei Lombardi, Naples (1470–5), no context or date is known for either devotional work. After these works, the Adoration theme, which was not readily adapted into the sculptural canon, especially its background landscape and narrative details, appeared only in polychromed tondi.

Around the same time, Mino da Fiesole produced at least one important Madonna and Child tondo, which in its simplicity contrasts with the Adoration tondi and in its plasticity seems quintessentially sculptural (Fig. 6.26).[75] Vasari first described it as over the entry of the Badia,[76] although it is not known whether it was commissioned for this location. However, Mino is documented as working for the Benedictine Badia on other commissions and the work was carved to be seen from below.[77] Its placement in an existing architectural context was similar to Donatello's *Madonna del Perdono* (Fig. 6.5), while its frame's fairly elaborate egg and dart and strigulated mouldings argue in their strength for the object's autonomy, unlike that of a simpler marble Madonna and Child tondo attributed to Mino (Fig. 6.27), which may have formed part of a funeral monument.[78] By contrast, the half-length seraphim base of the *Badia Tondo* not only reinforces its celestial nature but also argues that it was not part of a sepulchral complex. In fact, the seraph with its wings spread is analogous to a *mensola* and seems to support the tondo. It clutches a small cross and wears a necklace of thorns, alluding to Christ's Sacrifice and marking the entrance of a church, where the Mass was celebrated and the miracle of Transubstantiation took place via a round wafer of bread and wine from a circular chalice. Mino's tondo was thus intended as an advertisement for this divine gift that all believers receive.

Several eclectic sculptors of the next generation also produced tondi, some of which are innovative and which were influenced by painting. For example, some time after 1477 Francesco di Simone Ferrucci carved a full-length marble Madonna and Child with a cross-nimbus (Fig. 6.28).[79]

[74] Inv. no. 81 in the Staatliche Museen zu Berlin — Preußischer Kulturbesitz, terracotta with a 94 cm. diameter. Schottmüller, *Beschreibung der Bildwerke der christlichen Epochen*, v: *Die italianischen und spanischen Bildwerke der Renaissance und des Barock*, 61, ill. Hauptmann, *Der Tondo*, 139, believes it was a model for the marble. W. Bode, according to Michael Knuth, expressed some doubts about it (letter of 30 Dec. 1997).

[75] Inv. no. 74 in the Museo Nazionale del Bargello, Florence, marble with a *c.*90 cm. diameter. Sciolla, *Mino da Fiesole*, 74–5, ill.

[76] Vasari (Milanesi), iii. 120.

[77] Paatz and Paatz, *Die Kirchen*, i. 289, dated it *c.*1480 and located it over the door of the north aisle; Zuraw, 'Mino da Fiesole', ii. 706–12.

[78] Formerly inv. no. 98 in the Kaiser Friedrich Museum, Berlin (destroyed), Carrara marble with a 64.5 cm. diameter, damaged during removal. Schottmüller, *Bildwerke*, i. 58, ill.; Sciolla, *Mino da Fiesole*, 108–9; Zuraw, 'Mino da Fiesole', ii. 731–4, ill. Variants are in the Metropolitan Museum of Art, New York (inv. no. 30.95.105; Sciolla, *Mino da Fiesole*, 135) and Santa Brigida, Rome (a later copy).

[79] Inv. no. GL.60.17.25 in the North Carolina Museum of Art, Raleigh, formerly in the Samuel H. Kress Collection (K5F5B), marble with a 62.2 cm. diameter and a concave ground. Middeldorf, *Sculptures from the Kress Collection*, 30–1, ill., lists five polychromed stucco replicas but not a similar one in the Metropolitan Museum of Art, New York, with a 65.1 cm. diameter (inv. no. 1986.319.2). Valentiner, *The Samuel H. Kress Collection: North Carolina Museum of Art*, 60 ff., suggests the Kress tondo was part of the tomb of Francesca Tornabuoni by Verrocchio; Covi points out that a full-length Madonna is not usually found on tombs ('A Florentine Relief'), although the *Tartagni Monument* has a three-quarters length Madonna roundel with a 90 cm. diameter. Further, Middeldorf believes the Kress marble was not meant for insertion because it is smooth on the back and too thinly carved (11 cm.). Schrader, 'Francesco di Simone Ferrucci, 1437–1493', 183–7, lists casts including inv. no. A.12-1958 in the Victoria and Albert Museum, London; inv. no. 1879 in the Musée Jacquemart-André, Paris (La Moureyre-Gavoty, *Sculpture italienne*, 53, ill.).

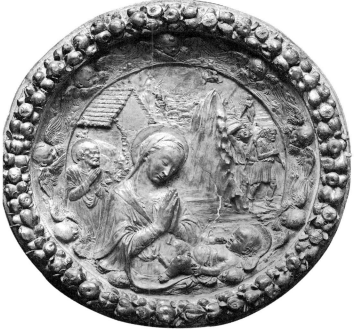

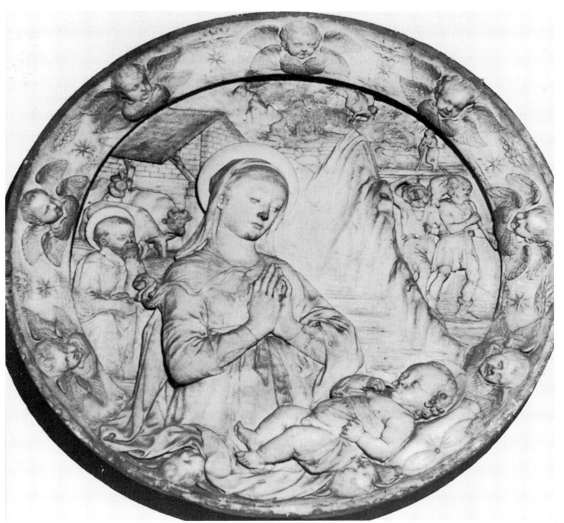

Fig. 6.23 (*above, left*). Desiderio da Settignano, *Meeting of Young St John and the Christ Child (Arconati-Visconti Tondo)*, 1453–5. Musée du Louvre, Paris

Fig. 6.24 (*left*). Antonio Rossellino, *Adoration of the Child with St Joseph and the Annunciation to the Shepherds*, after 1475. Museo Nazionale del Bargello, Florence

Fig. 6.25 (*above, right*). Antonio Rossellino (?), *Adoration of the Child with St Joseph and the Annunciation to the Shepherds*, after 1475. Staatliche Museen zu Berlin — Preußischer Kulturbesitz

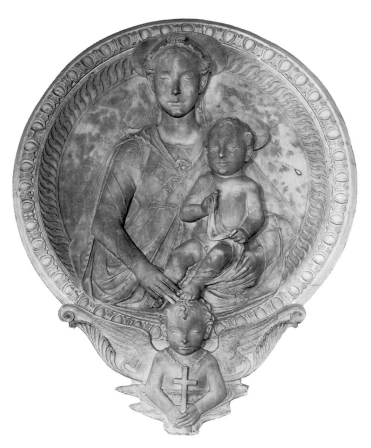

Fig. 6.26. Mino da Fiesole, *Badia Tondo*, c.1470. Museo Nazionale del Bargello, Florence

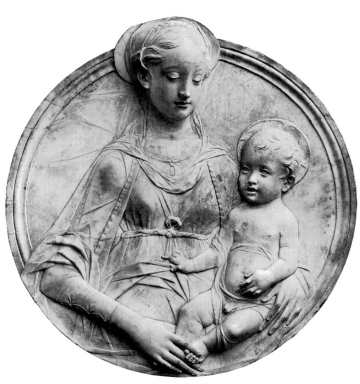

Fig. 6.27. Mino da Fiesole, *Madonna and Child*, c.1480. Formerly Kaiser Friedrich Museum, Berlin (destroyed)

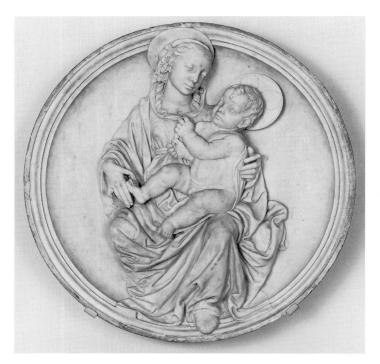

Fig. 6.28. Francesco di Simone Ferrucci, *Madonna and Child*, after 1477. North Carolina Museum of Art, Raleigh

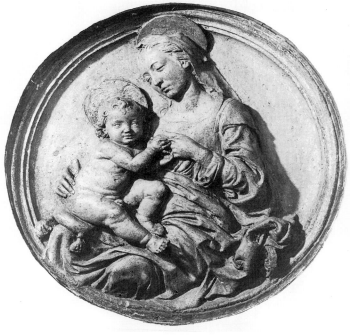

Fig. 6.29. Francesco di Simone Ferrucci, *Madonna and Child* from the *Monument of Alessandro Tartagni*, after 1477. Whereabouts unknown

It is one of the first marble tondi with a full-length Madonna, a type more characteristic of painted panels, and shows the influence of Leonardo and Verrocchio. Its smaller size suggests that it may have been an independent object and not part of a larger complex. Nevertheless, its simple forms and the small moulding on which Madonna's foot rests imply a further framing device, if not an architectural context. In type it is close to Francesco's *Tartagni Monument* (*c.*1477), whose roundel was replicated in stucco versions (Fig. 6.29).[80] Another Madonna and Child tondo (the missing Child was a separate piece of wood), in a technique used by artists to pose models for drapery studies (Fig. 6.30), demonstrates the strong influence of painting on sculpted tondi at the time, especially in the background.[81] Moreover, its combination of media was more characteristic of Siena.

During the final decades of the century, Benedetto da Maiano and his family *bottega* joined the Della Robbia and others in the mass production of tondi but in several media in addition to marble. These replications in terracotta, stucco, and *cartapesta* fed the Florentine market for private, inexpensive devotional works. Moreover, the inventories of the sculptor's possessions at his death list tondi, demonstrating his involvement with their production (see Ch. 3). His shop also catered for the demand for a more expensive marble tondo as shown in Fig. 6.31, a variation of his Strozzi monument roundel (Fig. 6.13), which was reproduced in glazed terracottas by Benedetto Buglioni.[82] Its frame has a ring of ten seraphs (seven totally visible) without the stars of the Strozzi roundel, although Benedetto's telling contribution to the tondo—the casual naturalism of the pudgy Child—is maintained in this and in another *bottega* version featuring stars in its frame alternating with seraphs (Fig. 6.32).[83] Shop versions and variations exist for of all Benedetto's Madonna and Child tondi and roundels, save the Kress example.[84] Some are original works of art, while others are replications. An example of the former is a large polychromed terracotta (Fig. 6.33), whose condition is problematic, while its construction is interesting.[85] Its figures demonstrate that it was meant to be hung relatively high, an appropriate placement for its dark blue background and its lighter blue inner gesso frame with gold stars simulating a celestial vision. Another less ambitious shop tondo is a polychromed stucco replica (Fig. 6.34).[86] The type, perhaps after a lost marble, enjoyed a tremendous popularity for it survives in many replications of varying qualities and dates produced for the cheaper mass market.[87] Another composition, related to the sculptor's rectangular *Blumenthal Madonna*, also was mass produced in stucco and *cartapesta* by the shop. Some are

[80] Formerly in the Marcello Guidi Collection, Florence, with an 88 cm. diameter according to the FKI. See Schrader, 'Francesco di Simone', 164–9, for the tomb; 173–4, for two other polychromed stucco casts (formerly inv. no. 7165 in the Kaiser Friedrich Museum, Berlin; Palazzo Bardini, Florence) and the mention of others.

[81] Piero Corsini Gallery, New York, wood, gilding, moulded gesso-soaked cloth, tempera on wood with a 74 cm. diameter. Wollesen-Wisch, *Italian Renaissance Art: Selections from the Piero Corsini Gallery*, 62–3, ill. Its painted landscape—on comparison with a similar Madonna and Child in a tabernacle (Bellosi, *Francesco di Giorgio*, 410–13, no. 87, ill., attributed to Francesco di Giorgio and Giacomo Cozzarelli)—however, is original.

[82] In the Prepositura di Santi Jacopo e Filippo, Scarperia, marble with traces of gilding and a 100 cm. diameter, probably in its original frame. Poggi, 'Un tondo di Benedetto da Maiano'; Comuni di Barberino di Mugello, *Echi e presenze donatelliane in Mugello*, 36–7, ill.; Lein, *Benedetto da Maiano*, 136–9. Benedetto Buglioni's terracottas include inv. no. 66.41.2 with a 57.2 cm. diameter in the

Metropolitan Museum of Art, New York (Marquand, *Robbias in America*, 159, no. 67, fig. 66).

[83] Inv. no. 61.4.12 in the Elvehjem Art Center, Madison, Wis., formerly in the Samuel H. Kress Collection (K1310), in marble with a 67.7 cm. diameter. Middeldorf, *Sculptures from the Kress Collection*, 32–3, ill.; Lein, *Benedetto da Maiano*, 139. Another is placed in the problematically reconstructed *Monument of Antonio di Bellincioni degli Agli* (d. 1477) in Santa Maria dell'Impruneta; Middeldorf, 'A Forgotten Florentine Tomb of the Quattrocento', ill.

[84] Middeldorf, *Sculptures from the Kress Collection*, 32.

[85] Inv. no. S27e14 in the Isabella Stewart Gardner Museum, Boston, polychromed and gilt terracotta with stucco and a 104 cm. diameter, including its frame. Vermeule, Cahn, and Hadley, *Sculpture in the Isabella Stewart Gardner Museum*, 115–16, ill.

[86] Inv. no. S27W9 in the Isabella Stewart Gardner Museum, Boston, polychromed stucco with a 57 cm. diameter. Ibid. 117, ill.

[87] Kecks, *Madonna und Kind*, 144ff., figs. 102a, b.

FIG. 6.30 (*right*). Sienese, *Madonna and Child* [Child missing] *with Painted Landscape*, 1490–1500. Piero Corsini Gallery, New York

FIG. 6.31 (*below, left*). Workshop of Benedetto da Maiano, *Madonna and Child*, 1490–5. Prepositura di Santi Jacopo e Filippo, Scarperia

FIG. 6.32 (*below, right*). Workshop of Benedetto da Maiano, *Madonna and Child*, 1490s. Elvehjem Art Center, Madison, Wis.

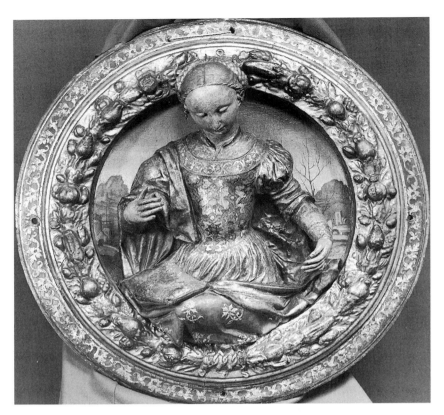

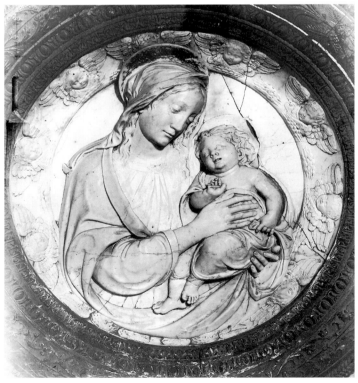

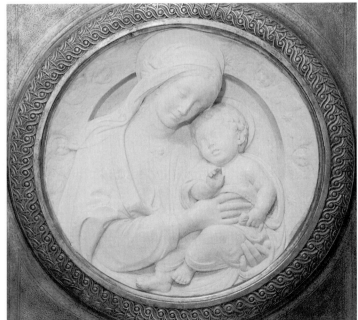

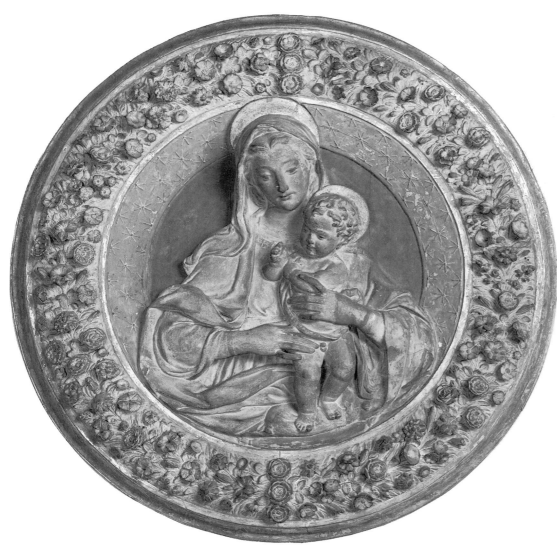

FIG. 6.33 (*left*). Benedetto da Maiano, *Madonna and Child*, *c.*1490. Isabella Stewart Gardner Museum, Boston

FIG. 6.34 (*below, left*). After Benedetto da Maiano, *Madonna and Blessing Child with Seraphs*, after 1485–95. Isabella Stewart Gardner Museum, Boston

FIG. 6.35 (*below, right*). After Benedetto da Maiano, *Madonna and Child*, *c.*1490. Museo Nazionale del Palazzo Venezia, Rome

replete with shields for painting with coats of arms and other features such as inscriptions to customize them (Fig. 6.35).[88] It was for this mass market that the majority of sculpted tondi were made.

DISSEMINATION OUTSIDE FLORENCE

Renaissance sculpture was itinerant by nature. As Florentine and Tuscan sculptors travelled, they disseminated abroad native types and motifs. One of the most common was the Madonna and Child roundel in a sepulchral context, where it continued to be placed in the lunette, as in Ferrucci's *Tartagni Monument* in San Domenico, Bologna. Late quattrocento sculptors like Mino exported it to Rome, where Andrea Sansovino continued the tradition on: (i) the *Monument of Cardinal Ascanio Sforza* (after 1505) and (ii) the *Monument of Cardinal Basso della Rovere* (after 1507), both in Santa Maria del Popolo, and (iii) the *Monument of Cardinal da Vicenza (Pietro Manzi, Bishop of Cesena)* (d. 1504) in Santa Maria d'Aracoeli. In Santa Maria d'Aracoeli it carried a special meaning, for the church covered the location where the miraculous image of the Virgin and Child appeared to Augustus (see Ch. 2).[89] In Venice, roundels achieved a certain popularity, but the Madonna and Child tondo and sepulchral roundel never, save for a few exceptions, caught on.[90] Antonio Rizzo rendered an unusual one in *rilievo schiacciato* (Fig. 6.36) that may have been part of a sepulchral monument, although it has been singled out as the only half-length Madonna and Child tondo in fifteenth-century Venetian art.[91] It was meant to be viewed *dal sotto in sù*, as a window into heaven from which the Child, standing on a ledge, is introduced to the spectator by the Madonna's gesturing hand overlapping the frame. The *Monument of Doge Andrea Vendramin* in Santi Giovanni e Paolo (c.1489–93) by Tullio Lombardo demonstrates the regional differences quite aptly.[92] Its Child, standing as though he were synonymous with the circle or Communion wafer, is supported by whimsical Venetian winged mermaids with front legs, testifying to Tullio's classicism and the *imago clipeata* source to which he gave an imaginative, maritime Venetian twist. However, it took the Florentine sculptor and architect Jacopo Sansovino to place a Virgin and Child roundel in a lunette on the *Monument of Archbishop Livio Podocataro* in San Sebastiano (1555), a High Renaissance, full-length celestial Madonna.[93] Lombardy, whose sculptural tradition was linked to that of Venice, was a region whose artists never truly became involved with Madonna and Child tondi, although patrons did commission roundels with portraits and religious scenes. Nonetheless, Agostino Busti, Il Bambaia, included a Madonna and Child roundel in the lunette of his *Monument*

[88] In the Museo Nazionale del Palazzo Venezia, Rome, with a 53 cm. diameter according to the FKI. The marble in the Metropolitan Museum of Art, New York, formerly in the Blumenthal Collection was replicated in tondi (ibid., figs. 98b–d). One in *cartapesta* with a 63 cm. (45 cm. without frame) diameter in the Musée Jacquemart-André, Paris, is inscribed *AVE MARIA GRATIA PLENA DOMINVS* on its frame with a coat of arms (inv. no. 2025; La Moureyre-Gavoty, *Sculpture italienne*, 63, ill.); another version in the same museum has a 71 cm. diameter without its frame (ibid. 62, ill.).

[89] Huntley, *Andrea Sansovino: Sculptor and Architect of the Italian Renaissance*, figs. 37, 42, 45.

[90] One exception is in the Vittorio Cini Collection, Venice (inv. no. VC 6718), a small (c.67 cm. diameter) unpublished Madonna and Child marble tondo, encased in a black stone garland and fruit frame encircled by a iron ring, attributed to Tommaso Fiamberti or Flamberti (a Lombard active from c.1498 in Venice).

[91] Whereabouts unknown, no dimensions available, by Schulz, *Antonio Rizzo: Sculptor and Architect*, 139, ill., who reported it in a private collection in Amsterdam in 1930 with two copies in Venetian houses.

[92] Luchs, *Tullio Lombardo and Ideal Portrait Sculpture in Renaissance Venice, 1490–1530*, 41–50, ill.

[93] Boucher, *The Sculpture of Jacopo Sansovino*, ii. 340–1, ill.

FIG. 6.36. Antonio Rizzo,
*Madonna and Child, c.*1470?
Whereabouts unknown

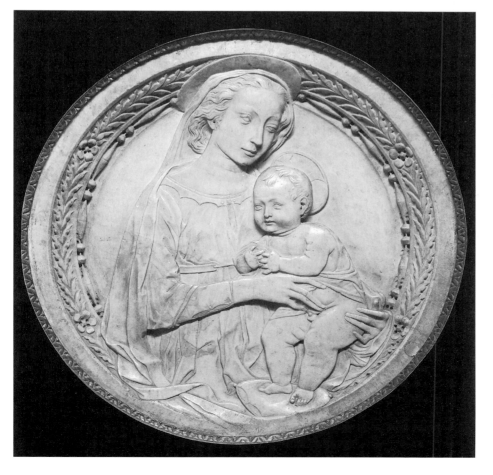

FIG. 6.37. Attributed to
Francesco di Simone Ferrucci,
*Madonna and Child, c.*1470.
Nelson–Atkins Museum of Art,
Kansas City, Mo.

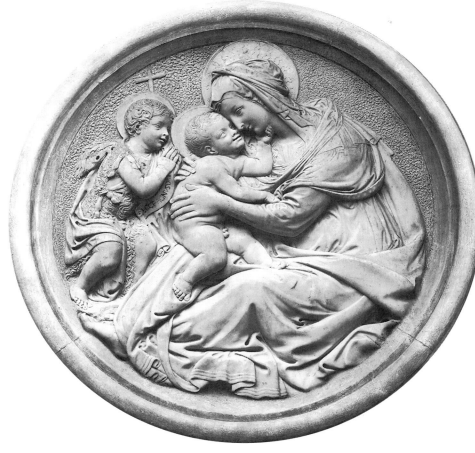

FIG. 6.38. Giovanni Francesco
Rustici, *Madonna, Child, and
Young St John*, after 1506. Museo
Nazionale del Bargello, Florence

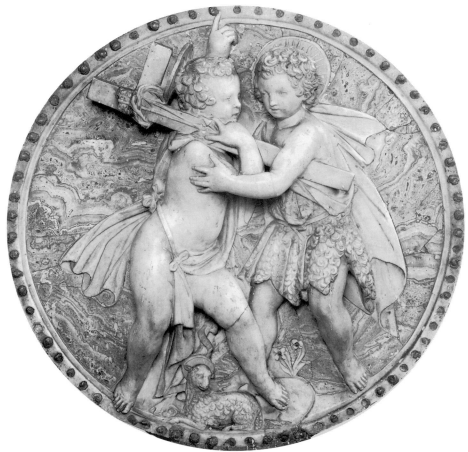

FIG. 6.39. Giovanni Francesco
Rustici, *Meeting of Young St John
and Christ*, c.1505. Musée du
Louvre, Paris

of Marino Caracciolo (after 1538) in the Milanese Duomo to mark his return to a central Italian classicism and to celebrate a patron who had spent much time in Rome.[94]

A group of miscellaneous tondi are more problematic, such as one marble in Kansas City given to Francesco di Simone Ferrucci (Fig. 6.37).[95] Its style seems closer to that of Desiderio or Antonio Rossellino, so that it could only be an early work, although the dry treatment of its framing mouldings, especially the bead and reel, raise questions about its origin, as evidenced in a number of nineteenth-century approximations of the Renaissance style.[96]

CINQUECENTO MARBLE TONDI

Of the few marble tondi carved during the fifteenth century, there is extant only one large-scale example with a full-length Virgin, that of Francesco di Simone (Fig. 6.28). Like so many works from the circle of Verrocchio and Leonardo, it heralds High Renaissance ideas. Therefore, it comes as no surprise that the four known marble tondi carved in Florence in the early Cinquecento all contain full-length forms.

The first to be considered is by Giovanni Francesco Rustici, a pupil of Verrocchio and friend of Leonardo, who, Vasari relates, carved a marble tondo for the silk merchant's guild (see Ch. 3). This passage has been linked with Fig. 6.38, a work that reflects Michelangelo's two tondi from the first decade of the century (below, Figs. 6.40–1).[97] Its thin polished rim suggests that the sculptor considered it finished and that the unusual nubbly background was a self-conscious affectation of Michelangelo's *non-finito* technique. Rustici's tondo seems to belong to the latter half of the first decade, when both Raphael and Michelangelo were involved with tondi. However, there is no certainty that Rustici or his patron responded this quickly to ideas, although the artist assuredly sculpted it before his departure for France in 1528. Like the two marble tondi by Michelangelo, it has three figures, including a full-length, barefoot Madonna of Humility. Although the holy trio are in positions similar to those in the *Taddei Tondo*, their proportions seem more quattrocentesque, and they wear haloes, unlike Michelangelo's supra-human figures. John holds his scroll with the carved letters *ECCE AGNVS DEI* (John 1: 29: 'Behold the Lamb of God [who taketh away the sin of the world].'), which were once polychromed or gilded (but are now black), as probably was the Virgin's halo decorated with flames.

Rustici was concerned with relating his figures to the circular format more than many quattrocento sculptors not only because of Michelangelo's and Raphael's activity but also because

[94] Fiorio, *Bambaia*, 122–4, ill. Litta, *Famiglie celebri italiane*, iii. n.p., for the patron.

[95] Inv. no. 33-111 in the Nelson–Atkins Museum of Art, Kansas City, Mo., marble with a diameter of 66 cm. Kansas City, *The William Rockhill Nelson Collection and Mary Atkins Museum of Fine Arts*, 115, ill.; Schrader, 'Francesco di Simone', 137–9. It was once in a larger tabernacle, whereabouts unknown, which resembles a 19th-c. pastiche (Alinari 17935). Venturi, 'Francesco di Simone Fiesolano', pl. XVIII; Malaguzzi-Valeri, 'Sculture del Rinascimento a Bologna', 361, ill.; Planiscig, 'Pietro Lombardo ed alcuni bassirilievi veneziani del '400', 480–1, ill.; Pope-Hennessy, *Catalogue of Italian Sculpture*, i. 170–1, no. 143.

[96] Pope-Hennessy, *The Study and Criticism of Italian Sculpture*, 223–70. Some of these were legitimate approximations not meant to deceive.

[97] Inv. no. 133 in the Museo Nazionale del Bargello, Florence, marble with a *c*.90 cm. diameter. See De Nicola, 'Notes on the Museo Nazionale of Florence—I', 177–8; Lightbown, 'Michelangelo's Great Tondo: Its Origins and Setting', 29; C. Davies, 'I bassorilievi fiorentini di Giovan Francesco Rustici: esercizi di letteri', 111–12; fig. 32, for a stucco replica with a 110.5 cm. diameter, formerly New York, Volpi sale, 1927, whose wreath may preserve the marble's original.

of his own sensitivity to the form, perhaps partially due to the fact that he was also a painter, according to Vasari (although no paintings by him are known). Moreover, Vasari cites at least three (perhaps five) tondi by him. The second is a lost bronze relief of the Annunciation, which he states was similar to that of the silk merchants and with a beautiful perspective aided by Raffaello Bello and Niccolò Soggi.[98] Vasari also reports that Rustici created a related sculpture and painting which, from this context and his descriptions, were most likely tondi. He terms the sculpture—made for Piero Martelli and depicting the Madonna and Child on clouds filled with cherubim, a typical tondo subject—a 'tondo rilievo', a round relief. The other, a large oil with a garland of cherubim forming a diadem around the head of the Virgin, is also appropriate for a tondo.[99] In addition, Vasari relates that Rustici made a marble Madonna tondo for the chapel of Jacopo Salviati's *palazzo*, which is an illusionistically independent tondo in a lunette that is still *in situ*.[100]

Before turning to Michelangelo's marble tondi, a unusual tondo attributed to Rustici should be mentioned, a relief of the young St John and Christ (Fig. 6.39).[101] While its prototype by Desiderio had slightly longer than bust-length figures (Fig. 6.23), Rustici's features full-length High Renaissance ones. Further, St John points up to heaven with his finger overlapping the frame in a reference to Leonardo's *St John* (a painting in the Musée du Louvre). Nevertheless, the tondo's frame, decorated with metallic studs (iron because of the patina) or paste to simulate jewels, seems archaizing.

During the first decade of the Cinquecento Michelangelo Buonarotti carved his two tondi in Florence—the so-called '*Taddei Tondo*' (Fig. 6.40)[102] and the *Pitti Tondo* (Fig. 6.41)[103]—as well as painted his *Doni Tondo* (Fig. 7.37). All three have sombre moods which contrast with the nearly giddy domestic scene of Rustici's large tondo. Although no commission documents are associated with these three, their style, coupled with later evidence, points to a date in the first decade of the century. Both sculptures are usually dated sometime before the artist's 1505 departure for Rome to work on the *Julius Tomb*, but Michelangelo could have worked on them sporadically after his return until he was summoned to Rome in 1508 to work on the Sistine Ceiling. Michelangelo's three conceptions are inextricably bound together and were influenced by Leonardo—who returned to Florence in 1500 to exhibit his cartoon of the Virgin, St Anne, and the Child.[104] In them Michelangelo grappled with the challenge presented not only by Leonardo's unified compositions but also by the tondo format. Further, it was during the probable gestation of these tondi that Raphael arrived in Florence (1504), where he stayed until 1508.[105]

Vasari relates that Michelangelo began two tondi, one for Raphael's friend Taddeo Taddei and

[98] Vasari (Milanesi), vi. 602–3, states that it was sent to the King of Spain. Although Milanesi on p. 602 n. 3, remarks that no painter named Raffaello Bello is known, it is tempting to link this person with Raphael Sanzio.

[99] Ibid. 601–2.

[100] Ibid. 606. Ciardi Dupré (Dal Poggetto), 'Giovan Francesco Rustici', 37–8; C. Davies, 'Rustici', pl. 21.

[101] Inv. no. R.F. 1622 in the Musée du Louvre, Paris, marble and onyx alabaster with metal and a *c*.80 cm. diameter. De Nicola, 'Notes', 177 n. 22.

[102] In the Royal Academy, London, marble with a 109 cm. diameter. Tolnay, *Youth*, 162–3, ill., lists drawings associated with it; Lightbown, 'Michelangelo's Great Tondo'; Redig de Campos, 'La Madonna e il Bambino nella scultura di Michelangelo'; Murray,

Michelangelo, 23–4, 44, ill.; Pope-Hennessy, *Italian Renaissance Sculpture*, iii. 303, ill.

[103] Inv. no. 93 S in the Museo Nazionale del Bargello, Florence, marble with an irregular diameter of *c*.82 cm. at its greatest width and 85.5 at its greatest height. Tolnay, *Youth*, 160–1, ill.; Pope-Hennessy, *Italian Renaissance Sculpture*, iii. 303, ill.

[104] See Tolnay, *Youth*, 189–90, pl. 123, for a drawing (in the Département des Arts Graphiques, Musée du Louvre, Paris) related to Leonardo's Madonna and Child with St Anne cartoon and the *Taddei Tondo*. For Michelangelo's drawings, Hirst, *Michelangelo and his Drawings*; id., *Michelangelo, Draftsman*.

[105] See Lightbown, 'Michelangelo's Great Tondo', 23–4, fig. 3, for a drawing by Raphael in the Département des Arts Graphiques, Musée du Louvre, Paris, after the *Taddei Tondo*.

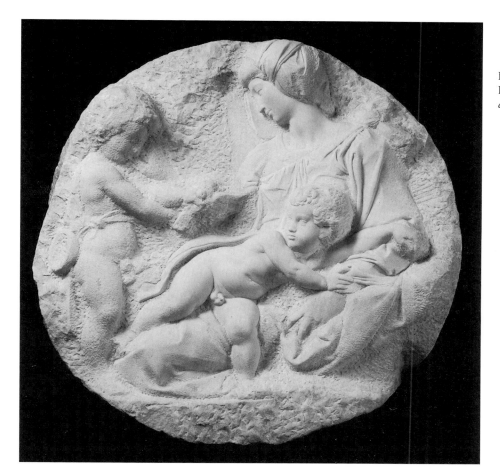

FIG. 6.40. Michelangelo Buonarotti, *Taddei Tondo*, c.1504. Royal Academy, London

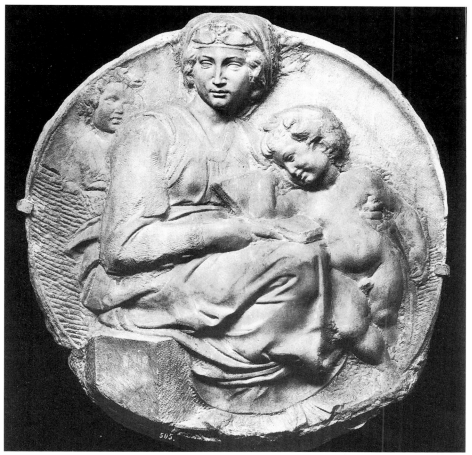

FIG. 6.41. Michelangelo Buonarotti, *Pitti Tondo*, c.1503–6. Museo Nazionale del Bargello, Florence

the other for Bartolomeo Pitti.[106] Because they are *non-finito* but were nevertheless purchased, their acceptance was a pivotal step towards a new aesthetic embracing the *concetto* and the artistic process as the most important aspects of a work of art. The possible intervention of assistants renders the *Taddei Tondo* doubly difficult to date, fuelling the disagreement about which should be dated earlier, although Vasari does mention the *Taddei Tondo* first.

The profile figures of the *Taddei Tondo* seem more retardataire than the frontal ones of the *Pitti Tondo*, although both have High Renaissance figures that need no haloes to set them apart. The Child is the most polished figure, while the other *dramatis personae* remain in various stages of completion. The tondo's strange young St John, who seems a leftover from the quattrocento vocabulary, introduces the viewer into the composition by mischievously offering to the Child a goldfinch, symbolic of the Passion because it eats thistle thorns.[107] The Child, who is modelled on a putto from an ancient Medea sarcophagus,[108] flees in terror across the Madonna's lap in a profound moment, indicative of the relief's great psychological expression and foreshadowings, as in the cup on John's back intimating Christ's Baptism and the start of his ministry. It appears that Michelangelo intended the relief to be slightly concave, a feature of early sculpted tondi. The hint of a raised upper framing border roughed in with his claw chisel behind the Madonna suggests that the sculptor may have intended to carve a ring of heaven over which the figures would have projected, as in other sculpted tondi. In this early effort Michelangelo tried out ideas from other sculptures. But, as with all great minds, when he grappled with the tondo tradition, he broke new ground to provide sculpted tondi with unprecedented insights.

A number of scholars believe that the smaller *Pitti Tondo* is a less mature work,[109] while only a few think that this smaller tondo is later.[110] The issue is clouded by the fact that Michelangelo probably worked on both simultaneously. It is further obscured because the *Taddei Tondo*, whose design seems earlier, may have been finished by assistants over time (Michelangelo may have abandoned it because of its substantial damage). The *Pitti Tondo* has an even more pronounced concave background than the *Taddei Tondo*, a feature encountered in some *imagines clipeatae*. Like the *Taddei Tondo*, it has a pronounced lip but is more deeply carved. Further, its design is more integrated. Its frontal, full-length sibylline Madonna is nearly three-dimensional, and in type, pose, and proportions resembles the *Bruges Madonna*. On her headdress is a seraphim (frequently in the form of a broach on her robe), indicative of her humility, her celestial status, and her power of prophecy.[111] She sits on a sculptor's block, Michelangelo's personal hallmark, whose corner projects towards the viewer, and looks out omnisciently, holding a book and meditating on the tragic destiny of her son that she cannot prevent. His pose, while taken from a funeral genius on a Phaedra sarcophagus in the Pisan Camposanto,[112] is that of a classical Greek 'thinker', rhetorically connoting deep melancholy at the realization of his arduous destiny. Squeezed in at the left is St John, carved in *rilievo schiacciato* and placed near a roughly executed area that almost has the appearance of a wattled fence, separating the *sub gratia* figures from John, the last prophet of the Old Testament, the world *sub lege*. He serves as yet another reminder of Christ's mission, and his

[106] Vasari (Milanesi), vii. 157.

[107] Friedmann, *The Symbolic Goldfinch, its History and Significance in European Devotional Art.*

[108] Tolnay, *Youth*, 162–3, ill.

[109] e.g. Tolnay (ibid.), who argues because of its larger size and dramatic composition that the *Taddei Tondo* is later.

[110] e.g. Pope-Hennessy, *Italian Renaissance Sculpture*, iii. 303.

[111] Tolnay, *Youth*, 160, supports the prophetic interpretation, citing Dionysius the Areopagite's *Concerning the Celestial Harmony* (*Hier. Coel.*, vii. 1).

[112] Wilde, 'Eine Studie Michelangelos nach der Antike', 55 ff., fig. 15.

expression, like that of the Child, is full of pathos. With its framing rim and iconography, this tondo is closer in many ways to the earlier *Madonna of the Stairs* than is the *Taddei Tondo*, although its more resolved composition argues that it is the more mature work.

After Michelangelo's two tondi, few marble examples were produced by Florentine artists, as though Michelangelo had fulfilled the potential inherent in the format. More likely, this circumstance indicates a clear preference for painted or glazed terracotta tondi. The few examples in stone or bronze that were created, like those of Rustici, were clearly influenced by paintings and Michelangelo's efforts. A ruinous marble Madonna and Child tondo with an glazed terracotta frame offers an insight into the problematic fate of the sculpted tondo in the sixteenth century.[113] This work is a pastiche, a reprise, lacking the vitality of earlier sculpted tondi. Moreover, all the sixteenth century tondi discussed, as well as a circular relief of the Holy Family by an unknown sculptor in the Sacristy of the Florentine church of Sant'Agata,[114] survive with no surround other than rims like those of Michelangelo. His two powerful marble tondi thus mark the end of a type which never surfaced again as a vital sculptural form. In fact, after the first decade of the sixteenth century very few sculptural tondi were produced except for glazed terracottas and stucco squeezes that perpetuated variations of earlier works. In addition, during this politically, economically, and religiously troubled period in Florence, few tombs were erected, so that sculptors were not involved with Madonna and Child roundels.[115] With the sporadic return of the Medici until their restatement to absolute power in 1537, and the subsequent growing sense of prosperity and stability, a new type of tomb developed, ultimately influenced by Michelangelo's New Sacristy tombs in San Lorenzo. (Incidentally, Michelangelo included roundels for reliefs in their planning stages.[116]) Moreover, by the end of the 1520s the oval began to usurp the circle in a restless Mannerist search for variety, although painted tondi continued to be produced sporadically through the 1530s and beyond.

Thus, tondi in sculptural media, which tend to have fewer *dramatis personae*, accommodate fewer narrative and symbolic dimensions, and have less spatial elaboration than their painted counterparts, never were produced in the seeming numbers and with the great variety of their painted cousins. In part, the explanation of their restricted development lies in the limitations of their media and their cost (appliable to marble and bronze), a conclusion reinforced by the large numbers of colourful and relatively inexpensive tondi in glazed terracotta and painted stucco. Furthermore, because they were more generalized and could not include the kind of detailed symbolic elaboration that was an important aspect of devotional art, sculpted tondi did not have the same appeal for the domestic market as painted tondi, which could accommodate intricate, profound, and multivalent iconographic enrichment.

[113] In the Museu Nacional de Arte Antiga, Lisbon, with an 80 cm. diameter (with its glazed terracotta frame, 138 cm.). Wohl, 'Two Cinquecento Puzzles', ill.; Barocchi, *Il giardino di San Marco: maestri e compagni del giovane Michelangelo*, 90–2, no. 18, ill.; Höfler, 'New Light on Andrea Sansovino's Journey to Portugal'.

[114] For this marble with a 52 cm. diameter, see Von Holst, 'Ein Marmor Relief von Pontormo', ill. A variant stucco with a 52 cm.

diameter was formerly in the Kaiser Friedrich Museum, Berlin (inv. no. 2638; Schottmüller, *Bildwerke*, i. 172–3, ill.).

[115] M. B. Hall, 'Savonarola's Preaching', 511.

[116] See Tolnay, *The Medici Chapel*, pls. 82, 85–6, 89–90, 92, 95, 99–101, for drawings. As architect of St Peter's, he returned to the central plan; Ackerman, *The Architecture of Michelangelo*, 193 ff.

7

PAINTED DEVOTIONAL TONDI: THEIR CONSTRUCTION, BEGINNINGS, AND SUCCESS

SINCE the largest number of Renaissance tondi belong to the painted devotional variety, in this chapter we shall investigate their beginnings and assess the reasons for their overwhelming, albeit temporary, success. To explore and characterize their evolution, we shall first discuss the construction of round panels and their frames. Next, we shall consider the five earliest painted autonomous tondi and a few others of an uncertain date, followed by a discussion of the early *botteghe* that executed them. Then we shall examine a selection of the most accomplished painted devotional tondi—which developed during the middle decades of the Quattrocento to become a pervasive form only in the 1480s—to determine why they were the most popular variety. To understand more fully the patterns of production of painted tondi, the reader should consult the Appendix, which also can be used as a reference tool. This roughly chronological consideration characterizes the tondi produced by many artists and explicates the iconographies of additional panels, providing a broader, supplementary context for the discussion of the individual success stories in this chapter. Both sections amplify ideas presented in the first four chapters.

CONSTRUCTION OF PAINTED TONDI AND FRAMES

It is difficult to generalize about the construction of tondi panels for several reasons, including the fact that it is impossible to remove many from their installations and/or frames for inspection. Furthermore, a goodly number, especially in the United States, have been cradled and/or trimmed. When examining only the painted surface, it is often difficult to determine how many boards comprise each panel, since cracking and splitting can seemingly multiply the number of planks. From a survey, however, a few generalizations can be offered. The most common dimension for a devotional tondo is between 80 and 87 cm., although they range from the 33.4 cm. diameter of Botticelli's *Ryerson Tondo* (Fig. 7.20) to the 192 cm. diameter of the Botticelli shop *Madonna dei Candelabri* (Fig. 7.22). The scale of the work may relate not only to the panel's original placement but also (although not necessarily) to its cost. Tondi are usually composed of several planks, four to six being the most common. Like the one by the Ghirlandaio shop at Hampton Court, however, they can also be a single plank, or, as with Raphael's *Alba Madonna* (Fig. 7.34), which has been

transferred to canvas, they may have been executed on one plank that split.[1] There are instances where the seams between the planks are smoothed not only by gesso but also first by canvas applied over the joints, as with a Botticelli shop tondo (Fig. A18) or the *Doni Tondo* (Fig. 7.37).[2]

The images of some tondi appear to have been painted up to the edge of the gessoed panel (there is always the chance that the panel could have been trimmed), while frequently the painter applied a thin ring of red or blackish pigment around the circumference. This plain area would not have been seen when the panel was inserted into its frame, but it helped the artist gauge the composition so that part of the image was not obscured. This procedure could hold true not only for devotional tondi but also for the few portraits in a round format. Examples with painted outer bands include Botticini's portrait, Botticelli's tiny tondo,[3] and the *Doni Tondo* (Figs. 5.18, 7.20, 7.37). Even Andrea del Sarto's Gambassi portraits (Fig. 5.22), illusionistically rendered on rectangular boards, were outlined in reddish pigment, which is related to their being linked to 'miniatures', from *minium* the Latin word for the red lead pigment used for illuminating letters in manuscripts. Occasionally, both the painted image and the gesso terminate within several centimetres of the panel's edge, leaving a ring of raw wood to facilitate insertion into the frame, such as in Figs. 7.2, A3, A4. These traits occasionally are revealed by ill-fitting frames.

Quite frequently the construction of tondi must have been coordinated with the design for the painted image because only seldom does the joint of two boards run through the visage of the Madonna or Child or the main individuals in the composition. One exception is Botticelli's *Madonna della Melagrana* (Fig. 7.19), comprised of six wooden planks, where from the reverse a seam is visible bisecting the Madonna's countenance.[4] (From my examination of Botticelli's tondi, the construction of many panels is superficially similar, suggesting the same carpenter shop for some.) Another possible exception is a Ghirlandaio shop/Mainardi tondo, which appears to be constructed of boards on a diagonal from the lower left to the upper right, one seam of which cuts through the Madonna's face, although it may actually be a split.[5]

The planks of tondi are usually aligned diagonally in an attempt not only to avoid the faces of the main figures but also to balance stresses and minimize warping. The most common orientation is on a diagonal from the lower left to the upper right. On occasion, as with a tondo by Fungai, the planks run vertically.[6] In this case, the widest was reserved for the Madonna and Child, ensuring that no seams would interrupt the perfection of their visages. This brief excursus demonstrates that the construction of tondi is interesting and deserves a scientific investigation and coordination of evidence.

It is difficult to generalize about tondi frames because so many panels are separated from their original frames, and existing ones have rarely been examined in their own right. Frames are frequently built up in sections, whose joints one sees in profile. In most of these and in frames from

[1] For the Ghirlandaio shop tondo (inv. no. 1566 in the Collection of H. M. Queen Elizabeth II, Hampton Court, poplar panel with an 82 cm. diameter and a 3.5 thickness), see Shearman, *The Early Italian Pictures in the Collection of Her Majesty the Queen*, 154, ill.; the Raphael, n. 191 below.

[2] For the Botticelli, see App. n. 53. It is constructed of three planks of poplar wood with the grain running vertically (measuring *c.*7 × 43.1 × 8.8 cm. in width). There are two inserts: the one on top measures 44 cm., the one on the bottom 40.8 cm. For the Michelangelo, n. 201 below.

[3] N. 90 below. The image inside measures *c.*32.5 cm. in diameter.

The circumference line was painted first because the architectural features overlap it at the left.

[4] N. 84 below.

[5] Inv. no. SN 20 in the John and Mable Ringling Museum, Sarasota, oil on panel with a 95.5 cm. diameter. Tomory, *The John and Mable Ringling Museum of Art. Catalogue of Italian Paintings Before 1800*, 29–30, no. 22, ill.; Venturini, 'Mainardi', 973–4, ill.

[6] Inv. no. 1331 in the National Gallery, London, on panel measuring 119 × 118 cm. (irregular). M. Davies, *The Earlier Italian Schools*, 206–7.

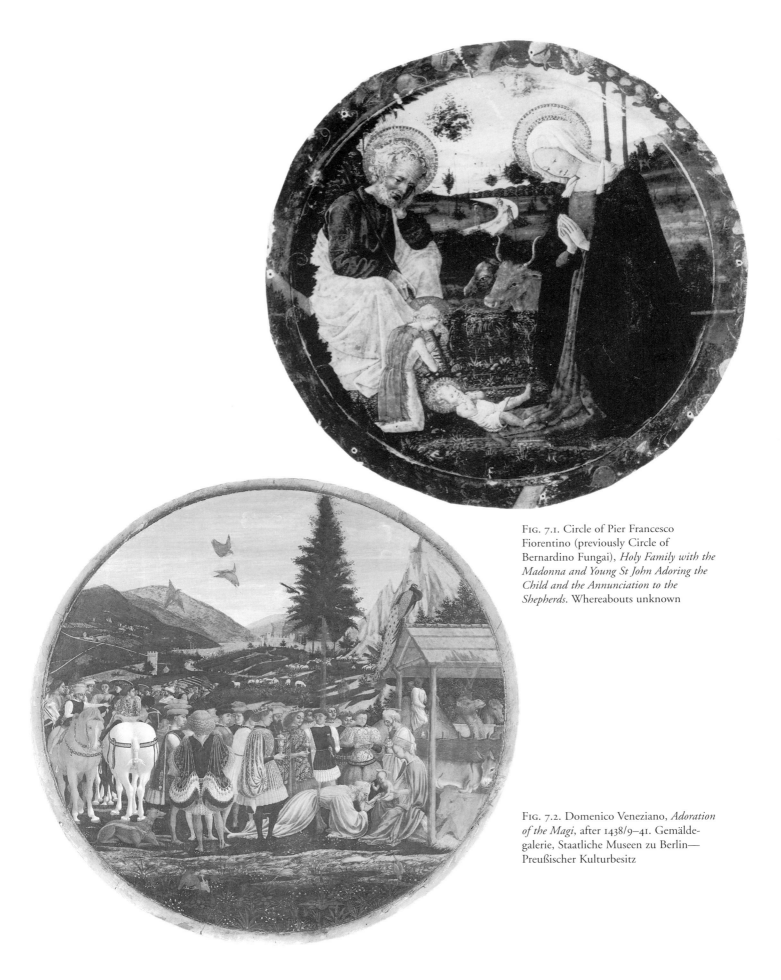

FIG. 7.1. Circle of Pier Francesco Fiorentino (previously Circle of Bernardino Fungai), *Holy Family with the Madonna and Young St John Adoring the Child and the Annunciation to the Shepherds*. Whereabouts unknown

FIG. 7.2. Domenico Veneziano, *Adoration of the Magi*, after 1438/9–41. Gemälde-galerie, Staatliche Museen zu Berlin—Preußischer Kulturbesitz

a single piece of wood, there is a narrow empty area adjacent to the opening on the back, the rabbett, which is covered on the front of the frame by a projecting lip. Into this area the panel was inserted. The frames of most devotional tondi that survive are in the form of wreaths or garlands whose surface has been gilded. Some are simple garlands of leaves, while most include fruit to signify the fruits of Paradise available to the devout via the Madonna and Child. Others consist of pine needles and cones or leaves and flowers. Less frequently they are composed of architectural mouldings, and only occasionally decorated with symbolic roses connoting the rosary (Ch. 4) or rings of seraphim or stars to signify heaven. Thus they frequently are symbolically wedded to the tondo, implying a triumph over death and the enjoyment of the fruits of Paradise through belief in the Madonna and Child or, in the case of roses, via the rosary. With portraits, garland frames imply the glory and the immortality of the individual portrayed.[7] Needless to say, all garland frames for tondi continue ideas from the *imago clipeata*.

There are also more singular framing solutions, for example, that of Michelangelo's *Doni Tondo*, which represents a rare instance where the frame is integrally related to its panel's iconography and its patron's heraldry, and whose intricately carved mouldings were appliquéed to its unusually thick support.[8] Signorelli's *Medici Madonna* (Fig. 7.32) features another custom-tailored frame but a rectangular one painted in grisaille,[9] while a tondo close to Pier Francesco Fiorentino offers an individual and inexpensive alternative, an illusionistically painted garland frame bound with red ribbons (Fig. 7.1).[10] These, however, are exceptions to the general rule.

EARLY PAINTED TONDI

It is significant that the subject of the two seemingly earliest painted tondi to survive—by Domenico Veneziano and Filippo Lippi (Figs. 7.2, 3.1)—is the Adoration of the Magi. As previously noted, the Adoration theme has chivalric overtones and links to early *deschi*, making it a transitional subject. Since these panels are dated between 1438 and 1460 on the basis of internal evidence and circumstantial documentary records, their inception has been assigned to the late 1430s during the period following Cosimo de' Medici's 1434 return from exile. At that time, his family's power gradually began to solidify into a 'disguised aristocracy' that eventually became entrenched in republican Florence. Moreover, there is evidence to suggest that both were owned, if not commissioned, by the Medici, who were a driving force behind the Florentine lay confraternity of the Compagnia de' Magi. Further, I believe that the round shape—an emblematic play on Cosimo's name (cosmos)—appealed to the Medici intellectually, religiously, and dynastically (Ch. 3). In addition, tondi, which are the shape of the macrocosm, complement the role of the kings as representatives of the faithful and the Universal Church (a goal of the Council of Florence sponsored by the Medici).[11]

[7] Eisler, 'The Athlete of Virtue: The Iconography of Asceticism', 97. See also Cecchi, 'Les Cadres ronds de la Renaissance florentine', 21–4; Newberry, Bisacca, and Kanter, *Frames*, 78–85; Baldi *et al.*, *La cornice fiorentina e senese*, 42–6; Sabatelli, *La cornice italiana dal Rinascimento al neoclassicismo*.

[8] Schleicher, 'Relazione sul restauro della cornice del Tondo Doni', 71–6; n. 210 below.

[9] N. 146 below.

[10] Whereabouts unknown, oil on panel with a 56.5 cm. diameter. Sotheby's, London, sale cat., 31/X/90, no. 99. Nail holes and surface damage reveal that at one time another frame was attached over it and its dimensions reduced.

[11] Ruda, *Fra Filippo Lippi*, 210.

Veneziano's tondo is usually considered the earlier of the two and its inception dated to *c.*1439–41, based on the Greek headgear worn by its background figures, which appeared in Florence only after the Church Council in 1439.[12] The panel has convincingly been correlated with an Adoration listed in the Medici Inventory of 1492.[13] Moreover, it has inscriptions in both Latin and French related to ideas about time and abundant nature that are consistent with Medici family heraldry and thematic, dynastic interests.[14] Further, the family's interest in the Magi went far beyond mere membership in the Compagnia de' Magi, because they were the personal patrons of the confraternity, which had its headquarters at San Marco, whose rebuilding the family also sponsored. Beginning in 1428, the confraternity staged annual *feste* dedicated to the Magi that gave vent to the desire of the Florentine aristocracy to preserve the courtly pageantry and chivalric codes they could not maintain as citizens. These inclinations are reflected in the splendour of the costumes Veneziano painted and are a direct expression of Medici ideas, especially since the three kings became emblematic of the Medici *c.*1440 in Florence.[15] Other paintings of the subject were commissioned by the family and their associates; for example, the frescoes by Benozzo Gozzoli in the Medici Palace Chapel (1459) and Botticelli's *Lama Adoration*, not to mention the fresco in Cosimo's cell at San Marco, all of which contain Medici portraits.[16] Even Filippino's later Adoration for San Donato a Scopeto features portraits of the collateral branch of the family.[17] Further, Veneziano's tondo contains Medici portraits that set precedents for these later Adorations. Most important of the portraits is that of Piero, to the right of the youthful king, who looks at the viewer and holds a falcon, one of Piero's emblems symbolizing that he is the custodian of the faithful.[18] It is significant, therefore, that the procession of the Magi in this tondo may not only represent the re-enactment of the confraternity's festival, but also cite the Council of Florence and its attendees.[19]

The inception of Lippi's larger Adoration tondo has been traditionally dated, like the Veneziano tondo, from the 1430s to the 1450s.[20] Its provenance as well has been traced to the Medici household via a description in the 1492 inventory.[21] Its design and execution, which are not coherent in authorship, have been attributed to both Fra Angelico and Lippi, who were, according to the famous letter sent by Veneziano to Piero de' Medici (1 April 1438), the two most popular painters in Florence at the time. It probably experienced several campaigns in Lippi's shop, where it was worked on sporadically, thus accounting for anomalies in style. Most recently the Angelicesque collaborator has been identified as none other than Benozzo Gozzoli, the artist of the Medici Chapel Adoration frescoes.[22] This very tondo could be the painting mentioned but not described in a letter of 1439 from Fra Filippo to Piero de' Medici.[23]

Lippi's panel is innovative, not only in its shape but also in its iconography and treatment of the theme, because the scene is more centralized in contrast to the horizontal organization in

[12] Inv. no. 95A in the Staatliche Museen zu Berlin — Preußischer Kulturbesitz, Gemäldegalerie, tempera on poplar panel, cracked down the centre, with an 84 cm. diameter and raw wood around its circumference. Hatfield, 'The Three Kings', i, no. 27; Wohl, *Veneziano*, 120–3, ill.

[13] Ch. 3 nn. 42–3.

[14] See Cox-Rearick, *Dynasty*.

[15] Hatfield, 'The Compagnia de' Magi'.

[16] Ibid. 135–41; id., *Botticelli's Uffizi 'Adoration'*; Brock, 'Sguardo pubblico, privato e intimo sulle immagini religiose del Quattrocento fiorentino'.

[17] Neilsen, *Filippino Lippi*, 112, ill.; Hatfield, 'Adoration', 90 n. 78.

[18] Wohl, *Veneziano*, 71–2, pls. 44, 46–7.

[19] Ibid. 72.

[20] Inv. no. 1952.2.2 (1085/PA) in the National Gallery of Art, Washington, DC, formerly in the Samuel H. Kress Collection (K1425), tempera on panel with a 137.2 cm. diameter. Shapley, *Paintings*, i. 95–7, ill.; Ruda, *Filippo Lippi Studies*, 40–76, ill.; id., *Fra Filippo Lippi*, 210–15, 316–25, 437–41, ill.; Boskovits, 'Attorno al Tondo Cook: precisazioni sul Beato Angelico e su Filippo Lippi e altri'.

[21] Ch. 3 n. 41.

[22] Ahl, *Gozzoli*, 264–6, no. 85.

[23] Ruda, *Fra Filippo Lippi*, 324, 520, doc. 6.

Veneziano's tondo, painted as though it were a rectangular work cut by an ocular opening.[24] This sensitivity to the form signals the wave of the future for the second half of the century. Moreover, its five nudes wearing loincloths, symbolizing pagan antiquity and pre-Christian civilization, provide prototypes for Signorelli's *Medici Tondo* and Michelangelo's *Doni Tondo*.[25]

Lippi's tondo is an exceptionally rich illustration of Epiphany themes and is more complicated than Veneziano's panel. However, like Veneziano's, Lippi's tondo reveals a connection with *deschi da parto*, a latent International Gothic taste, and a subtle variety of religious symbolism amplified in such features as the *porta salvationis* and the animals (e.g. the peacock).[26] In the left background, which heretofore has not been examined, a figure plows with oxen or horses, while nearby a man looks up at the sky. At least two adjacent figures do likewise and/or gesticulate in amazement. Their actions imply that Lippi envisioned the Star of Bethlehem just outside the perimeter of the tondo. In the far right middle ground he depicted boisterous youngsters, as if didactically to underline the exemplary behaviour of the Child, an idea he expanded in his next tondo (Fig. 7.3; Colour Plate IV), reinforcing the function of tondi in the domestic environment. Overall, the tondo's symbolic imagery depends on a blend of well-known sacred texts and commentaries in an original exegesis rather than on any programmatic argument.[27] This polysematic approach is especially valid for more complicated works. Lippi's tondo also embodies ideas about the Incarnation, because the Feast of Epiphany on 6 January commemorates not only the Adoration but also the Baptism of Christ and the Wedding at Cana, an antetype of the Eucharist.[28] These associations insured that while the Adoration did not continue to be the most popular theme for tondi, it would never totally be dropped. In fact, patrons purchased tondi of the Adoration through the form's decline in the Cinquecento.

The shape of Lippi's tondo increased the panel's meaning. Since the circle is the ancient emblem of the macrocosm, like most Adorations Lippi's painting is an allegory both of the Church and the continuity of life. This conclusion finds support in the pomegranate—a symbol of the Church as well as of Resurrection—held by the Child. The semi-nude figures in the middle ground, about to be converted to Christianity, represent death and rebirth through Baptism, the first Sacrament of the Church. The ruins on which they stand have been linked to those of the palace of David, which Christ was to rebuild, as well as to the prophecy of Simeon alluding to the Death and Resurrection of Christ.[29] This motif illuminates the polysematic potential of devotional art wherein symbols were meant to trigger a chain of associations and erudition on the viewer's part, referring to biblical, apocryphal, patristic, and popular theology. Certainly in the case of Lippi, a Carmelite monk, one

[24] Wohl, *Veneziano*, 72, suggests that Veneziano utilized the format like an oculus, as the window Alberti described in *De pictura* through which the subject is seen.

[25] Hatfield, 'Adoration', 33–67, rejects Eisler's interpretation ('Athlete of Virtue', 87–8), adding that in quattrocento painting nude figures signify persons who lived before the Mosaic law (without Grace) or neophytes awaiting Baptism. The left two have crossed over the ruin to join in the procession and perhaps are closer to being converted (the same ratio as in the *Doni Tondo*).

[26] After St Augustine wrote that the peacock's flesh did not decay, it symbolized immortality and resurrection (J. Hall, *Dictionary*, 238). The ox and ass, sacrificial animals, symbolize the humblest creatures who recognized Christ as the son of God as well as the Old and New Testaments (Réau, *Iconographie de l'art chrétien*, ii/2, 228–9, gives Pseudo-Matthew of the Apocrypha as the source;

Ferguson, *Signs and Symbols*, 22–3). The pair of pheasants are an avian symbol of redemption (Ruda, *Fra Filippo Lippi*, 213).

[27] See Hope, 'Altarpieces', 535–71.

[28] Ruda, *Fra Filippo Lippi*, 210. See also Nilgen, 'The Epiphany and the Eucharist: On the Interpretation of Eucharistic Motifs in Medieval Epiphany Scenes', 311 n. 5; Hatfield, 'Adoration', 55, 64–5.

[29] Ruda, *Fra Filippo Lippi*, 213–15. Hatfield, 'Adoration', 56–9, discusses the sources for the ruin, among which is the prophecy of Simeon in Luke 2: 34: 'Behold this child is set for the fall [*ruinam*] and rising again [*resurrectionem*] of many in Israel.' Also, Amos 9: 11: 'In that day I will raise up the tabernacle of David . . . I will rebuild it . . . because my name is invoked upon them.' The ruins could also signify the Temple of Solomon (which Christ would restore) or the Templum Pacis that collapsed on the night of his birth (upon whose ruins the Church would be built).

would expect a depth of religious interpretation, just as one would with his intellectually oriented pupil, Botticelli.

After the inception of these two Adoration tondi, there seems to be a gap in painted tondi until the early 1450s. Nevertheless, during the interim several small round panels of indeterminate origin may have been produced. They indicate future trends for devotional tondi because they contain more focused images of the Madonna and less narrative. Two of these are panels that have been placed in the orbit of Fra Angelico. The first represents a Madonna before the wall of the enclosed garden holding a pet bird (probably a goldfinch) while supporting the standing toddler, who reaches for it (Fig. 7.4). While its retardataire gold background indicates a heavenly setting, the wall creates an earthly dimension for this charming but odd representation that has been connected with another panel noted in the 1492 Medici inventory.[30] The punch work around its circumference suggests that it was originally round and has not been cut, while its small size inconclusively implies that it may have been a roundel in a larger context, although this subject matter is unusual for that location. At the very least, the panel's subject and shape either herald tondi or suggest that it was painted around mid-century within a conservative tradition. Another small round panel, an Annunciation, has been attributed to a follower of Angelico as well as to Gozzoli.[31] Again, we do not know definitively whether it was intended for a larger context or was created as an independent work.

We do know, however, that Filippo Lippi painted a watershed tondo (Fig. 7.3) after his Adoration that is either foreshadowed or reflected in Fig. 7.4.[32] It is the first extant large-scale Madonna and Child painted on a round panel that we know was intended to stand on its own as an independent work of art. Further, it has been linked to the documents (from 1452–3) recording a tondo commissioned by Lionardo di Bartolomeo Bartolini.[33] It is significant that Bartolini's tondo is described with a narrative dimension—'certa storia . . . della Vergine'—thus relating it to both early Adoration tondi and *deschi*, but more importantly this vague phrase seems to describe the two lateral scenes in Lippi's *Pitti Tondo*. The inclusion of such ambitious subsidiary narratives is quite unusual, and when present in later tondi they tend to be devotional scenes of saints, not the Virgin. Thus, there is a good chance that Lippi's *Pitti Tondo* is the panel commissioned by Bartolini. However, we have no way of ascertaining whether the artist finished it for Bartolini or completed it at a later date for another client.[34] The arms drawn on its reverse, not those of Bartolini that have a lion rather than a griffin rampant, do not help resolve the question.[35] Lippi's figures, space, and the

[30] Inv. no. 1966.267 in the Cincinnati Art Museum, tempera on panel with a 22.6 cm. diameter (with its frame *c*.24.1 cm., the gessoed and painted surface 19.3 cm.). Adams, 'Fra Angelico's Virgin and Child', ill., connects it with the 1492 inventory: 'Uno tondo chon una Nostra Donna piccholo, di mano di fra Giovanni, f. 5' (Müntz, *Les Collections*, 64; Spallanzani and Bertelà, *Libro d'inventario*, 33); 'Accessions by Purchase 1963–6', 43, ill.; Spike, *Italian Paintings in the Cincinnati Art Museum*, 4–5, no. 2, ill.

[31] In the Maison d'Arte Antiquaria, Lugano (in 1995), tempera on panel with a 24.1 cm. diameter. San Diego, Fine Arts Society, *A Catalogue of European Paintings, 1300–1870*, 20, ill. (deaccessioned); Ahl, *Gozzoli*, 233–4, no. 44, ill.

[32] Inv. no. 343 in the Galleria Palatina di Palazzo Pitti, Florence, tempera on panel with a 135 cm. diameter, lacking its original frame. Florence, *Gli Uffizi*, 335, ill., dates it *c*.1453; Ruda, *Fra Filippo Lippi*, 240–4, 453–5, ill. Hauptmann, *Der Tondo*, 187 ff., identified it as the first Madonna and Child tondo, discounting the Certosa panel he

had championed earlier.

[33] Ch. 3 n. 62.

[34] Ruda, *Fra Filippo Lippi*, 242, doubts that the documents are connected with the *Pitti Tondo*. His primary objection is stylistic, believing that it dates from the 1460s; however, Pope-Hennessy, *Study and Criticism*, 150, dates it to *c*.1452.

[35] Ruda, *Fra Filippo Lippi*, 240 ff., suggests these arms may belong to the Martelli family (Spreti *et al.*, *Enciclopedia storico-nobiliare italiana*, iv. 418–20; for Bartolini arms, 525). The drawing is in charcoal with watercolour wash on a prepared surface. There is another explanation for the design, painted on a diagonal orientation from the obverse. It may have been intended for an earlier, abandoned commission, and Lippi recycled the panel. Reinforcing this conclusion are the two cropped upper corners of the escutcheon (from photographs, the panel is installed so that its reverse cannot be examined), while the lower two are too close to the edge to accommodate insertion into a frame.

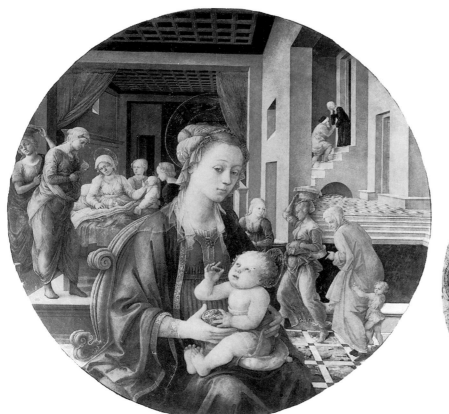

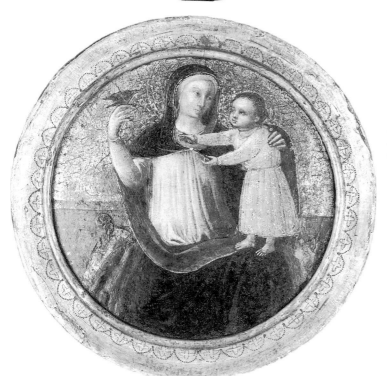

Fɪɢ. 7.3(*a*) (*above, left*). Filippo Lippi,
Pitti Tondo, after 1452. Galleria Palatina di
Palazzo Pitti, Florence (colour plate IV)

Fɪɢ. 7.3(*b*) (*above, right*). Reverse of Fig.
7.3(*a*)

Fɪɢ. 7.4 (*left*). Florentine School near Fra
Angelico, *Madonna and Child*, after 1450.
Cincinnati Art Museum

extravagant volutes of the Virgin's chair have analogies to the artist's paintings from the 1440s to the 1460s, as in a *sacra conversazione* commissioned by the Medici before 1450.[36] Therefore, it seems appropriate to assign a date to the years following 1452, the same time as Lippi's Prato frescoes (1452–67), supporting the link with the document.[37] The document's demand for a delivery by the Feast of the Immaculate Conception may be connected with the Meeting of Joachim and Anna depicted in its right background (not in any other tondo). In fact, as mentioned previously, at the time Lippi painted the *Pitti Tondo*, the Feast of the Conception was not yet official but was celebrated locally and illustrated by both the Meeting of Joachim and Anna and the Nativity of the Virgin, the very background scenes that Lippi depicted. He may have given the birth scene more prominence because it was easier to relate to the central figures and because birth scenes were commonly associated with the format from *deschi*.[38]

In this tondo, Lippi emphasized the domestic environment, portraying the Madonna with her ornate hair bound in tissue veils and her forehead shaved in the height of fashion, foreshadowing his even more elegant *Poggio Imperiale Madonna*.[39] Behind the holy pair at the right a child clings to the legs of one of the three entering women. This shy, naughty child contrasts with Christ's model behaviour, suggesting that he was intended as an *exemplum* for children, adding to the tondo's domestic tenor. When Filippo painted this panel, he was a sophisticated storyteller, employing different scales and perspectives to distinguish between the times and places of the continuous narrative. He therefore set the Meeting of Anna and Joachim, which usually takes place at the Golden Gate, in an interior setting to preserve the illusion of a unified ambiance. Lippi also utilized round forms as a leitmotif to counter the rectilinearity of the perspective—for example, haloes, jewels, pillow, pomegranate, curves of the chair, bowl, basket, and the tomb-like arch below the stairway at the right. The holy duo together hold the pomegranate, a symbol of the Church and of Christ's Death and Resurrection, in a naturalistic manner, while the Child holds one seed, as though contemplating whether to accept his destiny, as he casts his eyes up to explain its significance to his mother and to seek her approval.[40]

In his pivotal *Pitti Tondo*, Lippi pioneered a new type of Renaissance domestic painting. As is characteristic of later tondi, it unifies the terrestrial and celestial worlds in an equilibrium typical of quattrocento ideals. Lippi's tondo praises the Madonna and Child as well as exalts maternity, children, and the domestic sphere. Thus Lippi should be viewed as a progenitor of painted tondi featuring the Madonna and Child, the most popular type that flourished in the last quarter of the century, during which time it was explored and its standard iconographies refined by many painters who embroidered on diverse sub-themes.

[36] Ruda, *Fra Filippo Lippi*, 414–16, ill.

[37] 1452 is the very year when documents about definite tondi begin to surface (Ch. 3).

[38] Ruda, *Fra Filippo Lippi*, 243, believes that the Birth may have been included in the panel in a more prominent representation than the Meeting to emphasize the Maculist argument.

[39] A related drawing of a Madonna's head is in the Gabinetto Disegni e Stampe degli Uffizi, Florence (ibid. 334–6, 500–1, ill.). A derivation of the related *Poggio Imperiale Madonna* in an oval format

is in the Metropolitan Museum of Art, New York (Baetjer, *European Paintings in the Metropolitan Museum of Art*, i. 108, ill.). A tondo version attributed to the shop of Pier Francesco Fiorentino is listed in the Cook Collection, Richmond, Surrey.

[40] Ruda, *Fra Filippo Lippi*, 240, believes that because the Child holds up the seed to his mother, the fruit refers to a passage in the Song of Solomon (4: 3: '. . . thy temples are like a piece of pomegranate within thy locks . . .'; cf. 6: 7).

EARLY TONDI AFTER FRA FILIPPO LIPPI

Following Lippi's seminal work and before the format became pervasive in the 1480s, only a few artists painted a handful of tondi that are difficult to date but are nonetheless important. One of them, attributed to a follower of Francesco Pesellino, has a fascinating iconography revelatory of all tondi (Fig. 7.5).[41] Like Donatello's *Madonna del Perdono* (Fig. 6.5), it is seen *dal sotto in sù* and functioned as a foreshortened oculus into heaven, alluding to the Madonna as the *fenestra coeli*. Its Child holds a section of a pomegranate, while Mary prepares to nurse, reinforcing its inscription *MATER ON[M]NIVM* and the message of the Incarnation. A group of conservative tondi of indeterminate dates have been assigned to Pier Francesco Fiorentino, a follower of Gozzoli, and to an artist identified as Pseudo Pier Francesco Fiorentino, to whom he has been linked in a *bottega* practice.[42] This shop catered for clients preferring blonde-haired, fragile figures indebted to Pesellino and Lippi, frequently depicted in heavenly golden splendour, sometimes embellished with three-dimensional gilded gesso dots. It specialized in formulaic tondi with half-length figures of the Bridgettine Madonna adoring the Child, usually with St John and angels, as in a tondo with a more progressive landscape setting (Fig. 7.6).[43] Most of the tondi in this group, which depend on a common cartoon adapted and enlivened with novel elements in each case, resemble another in which St John adores the Child against a gold background, whose squares of gold leaf are inscribed with rays of light to convey the celestial radiance of the holy pair (Fig. 7.7).[44] John's presence reflects his role as the last prophet of the Old Testament, for he was to 'bear witness of the Light, that all men through him might believe' (John 1: 7). At the right is another child with a halo, either a wingless angel or a child saint who has no attributes but is present in other tondi from this shop.[45] Many of these retardataire works may be stylistically deceptive, even postdating the 1481 founding of the Confraternity of the Rosary, as suggested by the rosette motifs of their frames.[46]

Following Lippi, one of the earliest *tondai* with a group of tondi to his credit is the lyrical Francesco Botticini (see Ch. 4 and App.).[47] His tondo with a panoramic landscape of the Arno valley (Fig. 7.8) can be dated, by its view of Florence seen from the north with Fiesole at the left, near in time to the bird's-eye-view landscapes of Alesso Baldovinetti and Antonio Pollaiuolo in the 1470s.[48] A more generic landscape appears in other related tondi by his shop, such as one where instead of a Florentine *veduta* the painter introduced a more northern cityscape.[49] In another, the

[41] Whereabouts unknown, published without location or measurements. Berenson, 'Quadri senza casa. Il Quattrocento fiorentino, I and II', 684, ill.; later as in the Worcester Art Museum in id., *Homeless Paintings*, 174, fig. 312. That museum, however, has no record of its being accessioned or lent. Fiorella Gioffredi Superbi informed me that on the back of the photograph is written: 'Raymond Henniker-Heaton', and in Berenson's handwriting: 'Worcester Mass. since then at Miethkes', Vienna'.

[42] Berenson, *Florentine School*, i. 169–70 for Pier Francesco Fiorentino; 171–4 for Pseudo Pier Francesco Fiorentino. M. Davies, *The Earlier Italian Schools*, 420, mentions the two signed works of Pier Francesco Fiorentino, a priest active for the most part in San Gimignano. He believes that Pseudo Pier Francesco Fiorentino is a collection of different hands.

[43] Inv. no. P.51.8 in the Bob Jones University Museum and Gallery, Greenville, SC, tempera on panel with a 79.4 cm. diameter. Pepper, *Bob Jones Collection*, 24, no. 19.1, ill.

[44] In the Galleria Luzzetti, Florence, tempera on panel with a 71.1 cm. diameter. Sotheby's, New York, sale cat., 11/I/90, no. 25.

[45] e.g. one panel with a 77.5 cm. diameter; Sotheby's, London, sale cat., 8/XII/76, no. 66.

[46] Ch. 4 n. 111.

[47] Berenson, *Florentine School*, i. 39–41, lists eight tondi to his credit (wrongly the *Ryerson Tondo*); Venturini, *Botticini*, seven.

[48] In the Credito Bergamasco Collection, Bergamo, tempera on panel with a 105 cm. diameter. Milan, Gilberto Algranti, *Antologia di dipinti di cinque secoli*, n.p., ill.; Venturini, *Botticini*, 113, no. 36, ill.

[49] In the Cassa di Risparmio Collection, Florence, tempera on panel with a 90 cm. diameter. Zamarchi Grassi, Chiarini, and Spalletti, *Opere d'arte della Cassa di Risparmio di Firenze*, 46–7, ill.; Gregori, Paolucci, and Acidini Luchinat, *Maestri e botteghe*, 244–5, no. 9.8, ill.; Venturini, *Botticini*, 125, no. 69, ill.

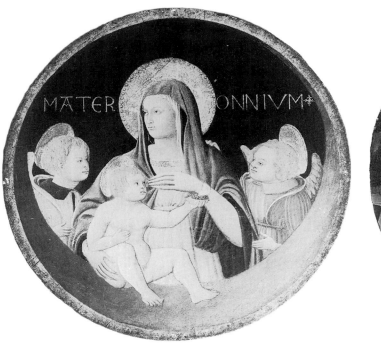

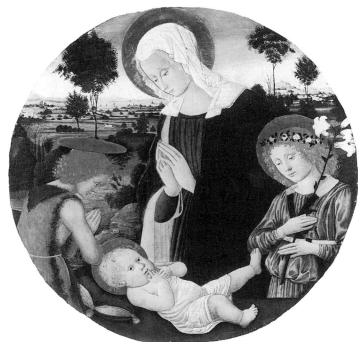

Fig. 7.5 (*above, left*). Follower of Francesco Pesellino, *Madonna and Child with Angels*, *c*.1450. Whereabouts unknown

Fig. 7.6 (*above, right*). Pier Francesco Fiorentino, *Madonna, Young St John, and an Angel Adoring the Child*, after 1460. Bob Jones University Museum and Gallery, Greenville, SC

Fig. 7.7 (*right*). Pier Francesco Fiorentino (Pseudo?), *Madonna, Young St John, and an Angel (?) Adoring the Child*. Galleria Luzzetti, Florence

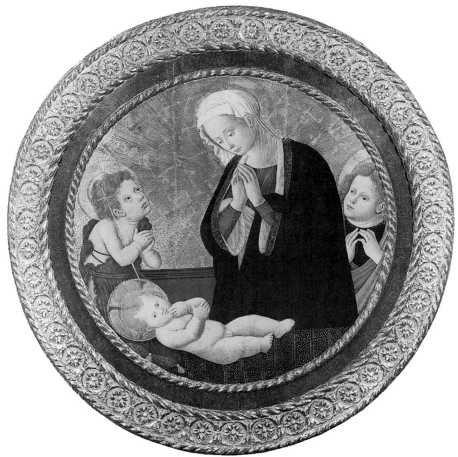

Virgin and Child have been adapted from the same composition but are joined by the adoring young St John and two angels derived from Leonardo's and Verrocchio's *Baptism*, providing a *terminus post quem* from the early 1470s.[50] The fourth in this group has further modifications,[51] as do two others,[52] providing a concrete idea of the way painting shops functioned and worked after cartoons or drawings kept in the *bottega*. Botticini's *Madonna and Child with a Breviary*, while related, is a completely new design with a simpler but more monumental composition, suggesting a later date (*c.*1490).[53] We know from its open devotional book that the Madonna, like all new mothers, had been busy with her devotions until her child awakened. Thus, this tondo becomes a perfect didactic tool for a domestic interior, providing a visual *exemplum* of piety for a new mother. None of these tondi is as iconographically complex, however, as Botticini's *'Hortus Conclusus' Tondo* (Fig. 7.9; Colour Plate V), discussed below, whose Madonna and Child are based on the same shop design as this group, suggesting that its patron was intimately involved with its iconography.

This discussion of early painted tondi ends with Cosimo Rosselli, who was not a prolific painter of them but served as a linking figure: he was the teacher of Piero di Cosimo, one of the most creative *tondai*, and like Botticini studied with Neri di Bicci, whose shop was involved in the tondo's germination in roundels. Seven tondi have been assigned to Rosselli's understudied oeuvre, although many of these are collaborative works (see App.). A case in point is Fig. 7.10, previously ascribed to Piero di Cosimo and Fra Bartolomeo among others, which is dated to the late 1480s when Rosselli was influenced by young artists in his shop who later would use this panel as a point of departure.[54] Its Child reclines on a bundle of wheat, symbolic of the bread of the Eucharist and foreshadowing his Sacrifice, adored by the Madonna to underline the Incarnation. This theme occurs in many tondi whenever shafts of wheat, the manger/sarcophagus/altar, or balustrade/altar are present, stressing patristic and liturgical connections with the Eucharist.[55] Herein Joseph assumes a more prominent position, a result of his rising status and his sponsorship by St Antoninus, while his role in the escape from Herod's treachery is foreshadowed in the wine cask and travelling sack for the Flight into Egypt.

In conclusion, in contrast to sculpted tondi, painted examples had a later, faltering start. Nevertheless, both in painting and sculpture, the form did not really flourish until the 1480s, owing to factors previously noted, including: economic growth; burgeoning lay piety, for example, the existence of the Confraternity of the Rosary in Florence after *c.*1481; and a growing stress on the domestic sphere and the family.

[50] Inv. no. R.F. 2083 in the Musée du Louvre, Paris, on panel with an 82.5 cm. diameter, formerly in the Arconati–Visconti Collection. Brejon de Lavergnée and Thiébaut, *Catalogue sommaire*, 157, ill.; Venturini, *Botticini*, 125, no. 68, ill.

[51] Whereabouts unknown, formerly in the Ashburnham Collection, Sussex. Sotheby's, London, 24/VI/53, no. 17; Berenson, *Florentine School*, ii, fig. 1067; Gregori, Paolucci, and Acidini Luchinat, *Maestri e botteghe*, 156, 244–5, ill.; Venturini, *Botticini*, 125–6, no. 70, ill.

[52] The two panels are recorded with: (1) an 85 cm. diameter in the Marquess of Northampton Collection, Castle Ashby, Northampton; (2) a 90 cm. diameter, whereabouts unknown, formerly in the Quincy Shaw Collection, Boston. Venturini, *Botticini*, 126, nos. 71, 72, ill.

[53] Inv. no. 1948.201 in the Cincinnati Art Museum, tempera on canvas transferred from panel with a 107.3 cm. diameter. Groschwitz, 'Botticini', ill.; Spike, *Italian Paintings in the Cincinnati Art Museum*, 18–19, no. 6, ill.; Venturini, *Botticini*, 127–8, no. 80, ill.

[54] Inv. no. 354 in the Galleria Palatina del Palazzo Pitti, Florence, on panel with a 116 cm. diameter. Fahy, 'The Earliest Works of Fra Bartolommeo', fig. 2, as Rosselli; Gregori, Paolucci, and Acidini Luchinat, *Maestri e botteghe*, 77, no. 2.10, ill., as by the shop.

[55] Ferguson, *Signs and Symbols*, 40; Nilgen, 'The Epiphany and the Eucharist'. The motif was popular after Hugo van der Goes's *Portinari Altarpiece* arrived in Florence (where the wheat is separate from the Child); Stens, 'L'arrivo del trittico Portinari a Firenze'.

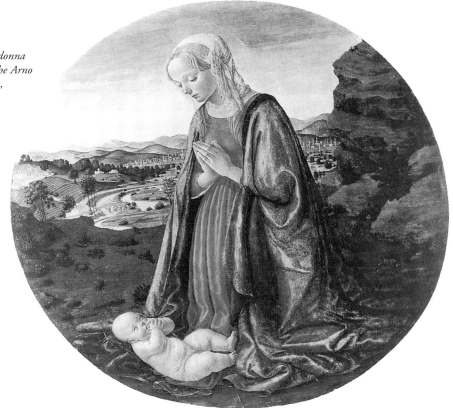

FIG. 7.8. Francesco Botticini, *Madonna Adoring the Child with a View of the Arno Valley*, c.1475. Credito Bergamasco, Bergamo

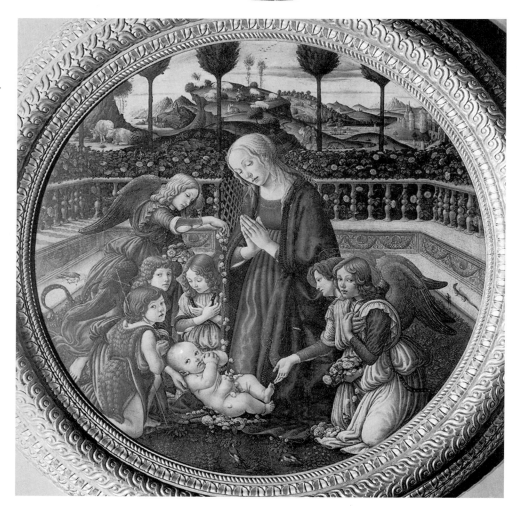

FIG. 7.9. Francesco Botticini, *'Hortus Conclusus' Tondo*, c.1480–90. Galleria Palatina di Palazzo Pitti, Florence (colour plate V)

SUCCESSFUL PAINTED TONDI

The height of the vogue for painted tondi fell into the decades of the 1480s and 1490s, during which time thousands were produced. Many of these are extant today, in fact, too many even to mention in the Appendix. Because of their large number it is instructive to consider the most successful examples and to ask why they were a success. Yet success can be defined in several ways. One measure is whether the work was replicated or copied. However, the most intricate and expensive commissions tended not to be duplicated in their entirety, revealing that multiples indicate only one kind of success. Although each and every one of these tondi is successful to some degree, we shall discuss in depth selectively only those that succeed in the unity or power of their iconographies, the cohesiveness of their compositions, the quality of execution, and the influence they may have had on other artists and other works. Moreover, because of the personal, lyrical nature of these devotional works, few are without charm, making the following choices, arranged in a roughly chronological order, very difficult.

Francesco Botticini

As previously mentioned, Botticini, one of the first painters responsible for a substantial number of tondi, painted his justifiably most celebrated example (Fig. 7.9) during the apogee of the form.[56] This large, expensive work featuring rosary iconography (Ch. 4) and an enclosed garden, symbolic of Mary's purity, must have been a commissioned work. The *hortus conclusus* from the Song of Songs 4: 12 ('A garden enclosed is my sister, my spouse'), which functioned as a symbol of the Immaculate Conception of Mary,[57] is such a prominent feature in this panel that the title *'Hortus Conclusus' Tondo* seems appropriate. Botticini positioned his figures in a triangular formation inside this sacred architectural enclosure (resembling a palatial playpen), which forms a square with four corners, symbolic of the earth, circumscribed in the circular panel, emblematic of heaven. Strangely for the *hortus conclusus*, the enclosure has an open wattle gate. The base of its classicizing balustrade consists of a step decorated with shells and swags *all'antica* (symbolic of Christian triumph over death). Enveloping this structure and framing the Child's entourage are rose bushes (with white, pink, and red flowers), symbolic of Mary's virginity and Christ's Passion. Its five angels, offering pink and white roses and throwing rose petals (a sacramental act),[58] are arranged in two groups: three around Christ at the left, symbolizing the Trinity, and two at the right, embodying the dual nature of Christ. This same division occurs with the nudes in Lippi's *Adoration* and the *Doni Tondo*. In aggregate they could be used to mark the five decades of the rosary during devotion, as could the row of five funereal cypresses. While cypresses generally symbolize death or immortality, here the number five, as with the angels, facilitated use of the rosary and signalled the five wounds of Christ as well as the name Maria. Moreover, the naturalistic but symbolic roses filling the tondo provide an overwhelming reference to the rosary. Its foreground is packed with other symbols for devotional

[56] Inv. no. 347 in the Galleria Palatina di Palazzo Pitti, Florence, oil on panel with a 123 cm. diameter. Chiarini, *Pitti Palace*, 56–7; Venturini, *Botticini*, 125, no. 67, ill.; Olson, 'The Rosary'. The Ufficio per Documentazione of the Uffizi records that it came from the collection of Cardinal Leopoldo de' Medici as by Botticelli.

[57] Levi D'Ancona, *Immaculate Conception*; ead., *The Garden*, 330 ff.; J. Hall, *Dictionary*, 326–7.
[58] L. Steinberg, *Sexuality of Christ*, 12, believes the dropping of rose petals on Christ's genitals stresses the doctrine of his Incarnation and is connected with the Dionysiac phallus.

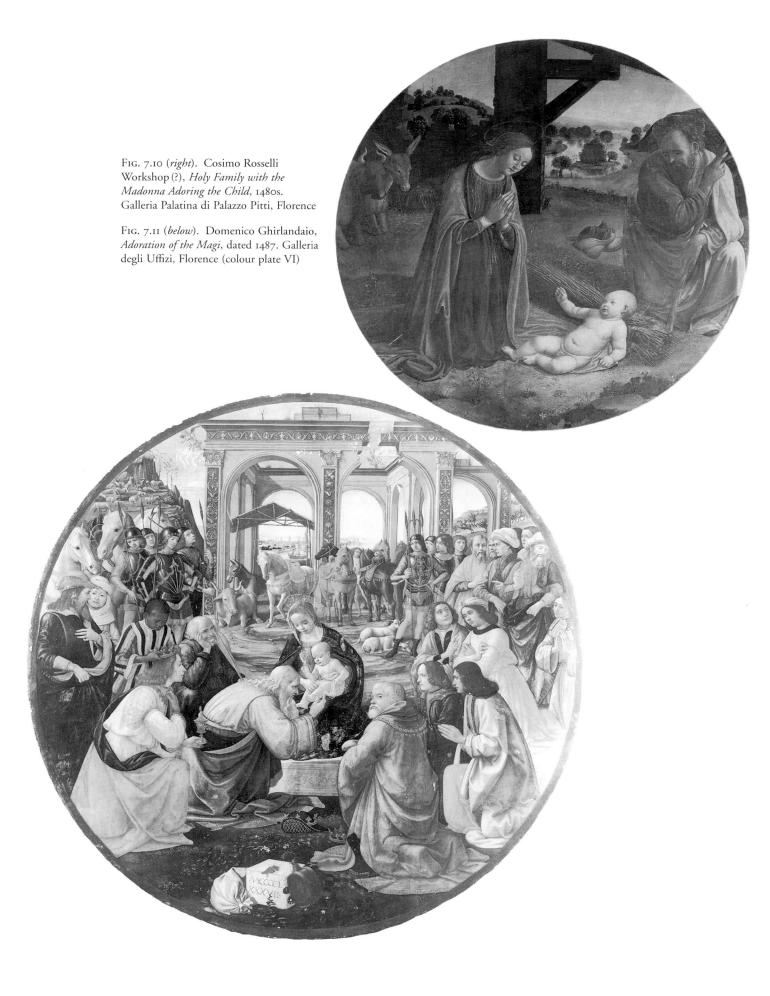

FIG. 7.10 (*right*). Cosimo Rosselli
Workshop (?), *Holy Family with the
Madonna Adoring the Child*, 1480s.
Galleria Palatina di Palazzo Pitti, Florence

FIG. 7.11 (*below*). Domenico Ghirlandaio,
Adoration of the Magi, dated 1487. Galleria
degli Uffizi, Florence (colour plate VI)

focus, such as two goldfinches that foreshadow the Passion and Resurrection of Christ. Another bird at the left is involved with an unidentified object (a seed or insect); it may symbolize the soul. It perches directly opposite two lizards of the type one finds in any Italian garden (to the left of the Madonna and Child, the side traditionally associated with evil) and like them casts shadows. Because lizards or salamanders are associated ambiguously with fire, they can either represent the realm of evil or the ability to extinguish such fires.[59] While it is tempting to dismiss them as merely demonstrating the artist's enthusiasm for nature, they probably were symbolic and may have been requested by the patron. The gentle but melancholy mood of this work is partially created by the cast shadows from the consoles of the balustrade whose four sides symbolize the earth, herein dominated by the round tondo. They add another naturalistic symbol, foreshadowing the death of Christ, to this tondo, which ranks as one of the most lyrical and influential of the century. However, because of the complex and personal nature of its symbolism, its influence largely lay in its general mood and its rose symbolism, which can be connected generally with the rosary and the newly established Confraternity of the Rosary. Its success resides in the clarity of its themes, keyed in instantaneously by its round shape connoting the sacred, celestial realm as well as the circularity of the rosary, thereby linking the terrestrial and celestial worlds, the rectilinear and circular elements.

Domenico Ghirlandaio and Associates

Domenico Ghirlandaio's shop, which produced numerous tondi (see App.), many of them collaborative efforts, enjoyed a different kind of success, a great commercial one, although Domenico's only autograph tondo may be his large *Adoration of the Magi* (Fig. 7.11; Colour Plate VI).[60] It is known in two other versions, attesting to its success on one level, which certainly was the result of its subject and its patron, who may have been a member of the *Compagnia de' Magi*.[61] Most likely it is the same tondo Vasari reported in the house of Giovanni di Francesco Tornabuoni, a Medici associate, which also was recorded in the 1497 Pupilli inventory of his household in the room of his son Lorenzo.[62] Domenico deemed the tondo important because he dated it on a marble fragment *all'antica* in the foreground *MCCCCLXXXVII*.[63] While there are semicircular configurations in its composition, the scene would have succeeded equally well in a rectangular format, although it would not have had the profound symbolic allusions it now carries to the macrocosm and heaven. According to Leo Steinberg, Ghirlandaio has shown the old Magus genuflecting not so much to pay homage to the Child, but to inspect his genitalia in order to ascertain whether he was the Incarnate Word, the humanation of God.[64] The two kneeling younger men to the right of the Madonna may indeed portray the donors or the donor's sons (if the adjacent bearded older man is the donor and not simply one of the Magi) and/or members of the

[59] Cirlot, *A Dictionary of Symbols*, 277; J. Hall, *Dictionary*, 270–1. Their positive meaning—that they vanquished the fires of Hell—could be interpreted as an analogy to Christ, especially since there are two, possibly alluding to his dual natures.

[60] Inv. no. 1619 in the Galleria degli Uffizi, Florence, tempera on panel with a 172 cm. diameter and a red painted rim around its circumference, in a later frame. Florence, *Gli Uffizi*, 289; Kecks, *Ghirlandaio*, 150, ill., believes it was only designed by Domenico.

[61] A shop derivation with a 99.5 cm. diameter is in the Galleria

Palatina di Palazzo Pitti, Florence (inv. no. 358, tempera on panel with embossed gold crowns; Florence, *Gli Uffizi*, 289, ill.). Milanesi (Vasari (Milanesi), iii. 258 n. 5) confuses the original with a copy in an English private collection, formerly in the Pandolfini Collection.

[62] Ch. 3 n. 18.

[63] Covi, *Inscription*, 671, mistakenly believes the Roman numeral V was deleted.

[64] See L. Steinberg, *Sexuality of Christ*, 1 ff., for the *ostentatio genitalium*.

Compagnia de' Magi.[65] In the shop adaptation, the earlier composition has been cropped to the panel's reduced dimensions, and the stable altered. In addition, one of the presumed portrait figures, the kneeling man between the bearded man and the youth with the white cloak and pageboy coiffure, has been eliminated no doubt to tailor this tondo to its patron. Although the subject of these two tondi harks back to the earliest painted tondi known, they represent more 'modern' interpretations of the event. Since Ghirlandio's art marks the fulfilment of Renaissance naturalism and the narrative tradition, it is fitting that he filled his Adoration tondo with studies from nature and anecdotes, among the most interesting of which is the carefully studied foreground still life—influenced by the one in his rectangular *Adoration of the Shepherds* (d. 1485) in the Sassetti Chapel. It consists of a marble fragment together with a travelling sack and a canteen for water or wine that alludes to the Holy Family's journey to Bethlehem to be taxed and to their imminent departure for Egypt. On top of the stone fragment lies a small case for spectacles (Ghirlandaio was familiar with spectacles for he painted a pair on the *leggio* in his St Jerome fresco in the Ognissanti *c.*1480). These objects successfully fill the awkward exergue inherent in the shape that is so difficult to resolve and add to the success and appeal of this composition.

An ingenious tondo by Gherardo di Giovanni, an artist who has been associated with Ghirlandaio (see App.), is successful for a different reason: the manner in which its composition is integrated with its form (Fig. 7.12). Many elements echo its shape, including the orb of the world crowned by a cross that is held by the Child and the heavenly choir of seven angels (symbolic of the Seven Sacraments and the seven Joys and Sorrows of the Virgin) crowning its composition.[66] The *concetto* for this celestial choir came from the *sacra rappresentazione* in San Felice in Piazza that employed Brunelleschi's apparatus (*ingegni*) for suspending a choir of real boys dressed as angels, which was resurrected at least twice between 1471 and 1494.[67] In its left background Gherardo painted Tobias and the Angel and on the right an adolescent St John as devotional footnotes to appeal to youngsters in the household—to encourage devotions via didactic role models. In sum, the tondo succeeds because of its composition tailored to the circular form and the lyrical, devotional mood that accompanies it.

Although the associates of Ghirlandaio's sprawling shop painted numerous tondi, most of them paid little heed to the round form with the exception that the figures may echo the shape of the panel (see Figs. 7.12–16, A1–15). While the iconographies of some of these are fascinating and varied, they tend to be fairly standard and sometimes prosaic. Nevertheless, there are exceptions, such as the panel attributed to the Master of Santo Spirito, Giovanni Graffione (Fig. 7.13), who painted at least eight tondi (App.). Its highly eclectic yet original composition reveals the influence of Filippino Lippi,

[65] Hatfield, 'The Three Kings'; id., 'The Compagnia de' Magi'; id., 'Adoration', where on p. 90 n. 78 he states that the white-bearded Magus looking over his shoulder is identical with one of the onlookers in the 'Calling of the First Apostles' in the Sistine Chapel. Steinmann, *Die Sixtinische Kapelle*, i. 385 ff., identifies him as John Argyropoulos. Simons, 'Portraiture and Patronage in Quattrocento Florence, with Special Reference to the Tornaquinci and their Chapel in S. Maria Novella', ii. 110 n. 144, does not accept this identification. She adds (p. 139 n. 81) that the young donor on the right in white may be Lorenzo di Giovanni Tornabuoni and the tondo commissioned to celebrate the birth of his son Giovanni on 11 Oct. 1487. Everett Fahy (pers. comm. 1994) supports her conclusions. Kecks, *Ghirlandaio*, 150, believes the figures cannot be identified.

[66] Inv. no. 53.86 in the Seattle Art Museum, oil on panel with a 90.2 cm. diameter; Fahy, *Some Followers of Domenico Ghirlandaio*, 123–4, fig. 19. For the symbolism of seven, J. Hall, *Dictionary*, 279, 325. Gherardo's choir is surrounded by a circle of light whose upper half implicitly continues, cut by the circumference of the tondo. It demonstrates that while the Madonna and angel of this panel were used with variations in a rectangular panel (Fahy, 'Some Early Italian Pictures in the Gambier–Parry Collection', fig. 24), Gherardo sensitively harmonized its composition with the tondo shape in other features.

[67] Olson, 'Brunelleschi's Machines of Paradise and Botticelli's *Mystic Nativity*'.

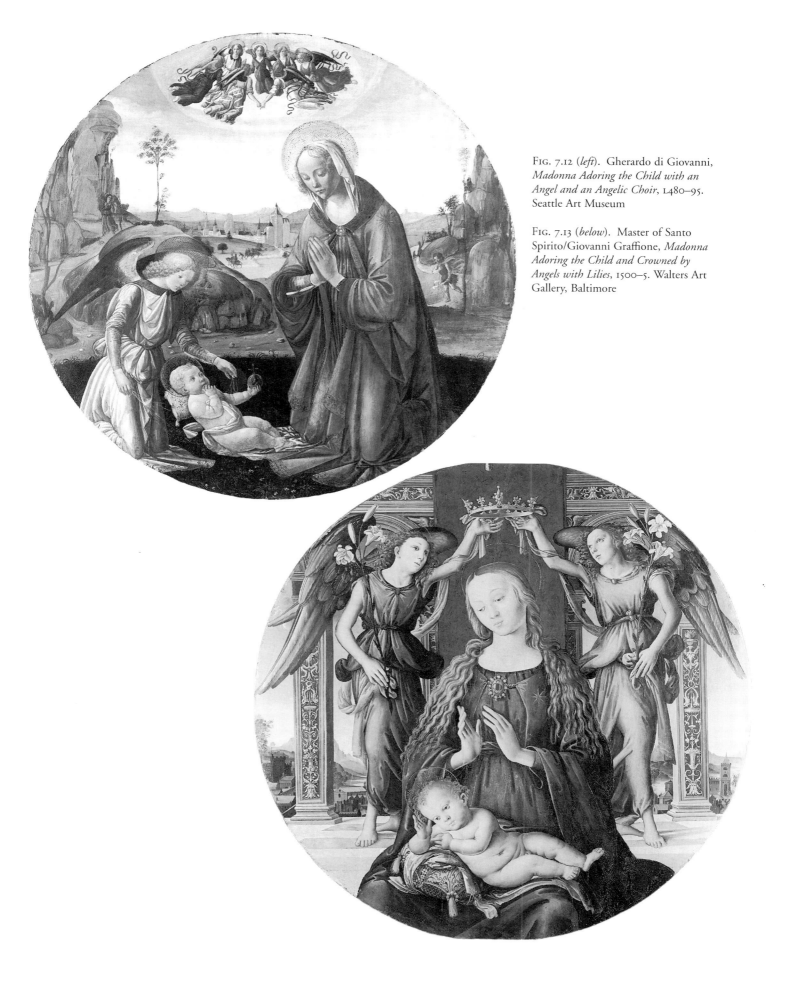

Fig. 7.12 (*left*). Gherardo di Giovanni, *Madonna Adoring the Child with an Angel and an Angelic Choir*, 1480–95. Seattle Art Museum

Fig. 7.13 (*below*). Master of Santo Spirito/Giovanni Graffione, *Madonna Adoring the Child and Crowned by Angels with Lilies*, 1500–5. Walters Art Gallery, Baltimore

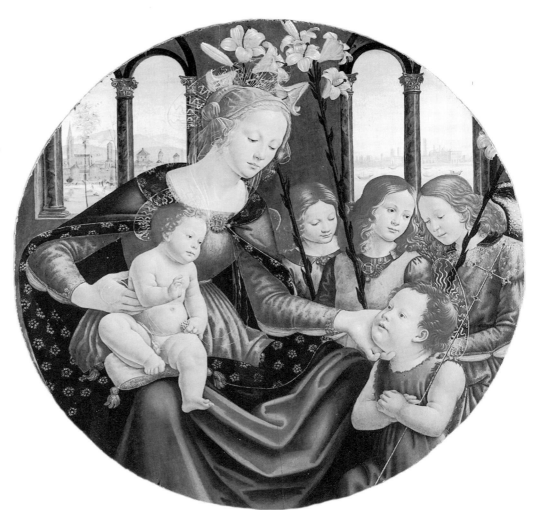

FIG. 7.14 (*right*). Domenico Ghirlandaio, Workshop, and Sebastiano Mainardi, *Madonna and Child with Young St John and Three Angels with Lilies*, *c.* 1485–1500. Musée du Louvre, Paris

FIG. 7.15 (*below, left*). Domenico Ghirlandaio Workshop and Sebastiano Mainardi, *Madonna and Child with Young St John*. Lady Merton Collection, Stubbing House, Maidenhead

FIG. 7.16 (*below, right*). Sebastiano Mainardi, *Madonna and Child with Adoring Young St John and an Angel*, *c.*1500. Museo Civico, San Gimignano

Lorenzo di Credi, and northern painters (especially in the background and the Madonna's coiffure), and it is by far the most iconographically interesting tondo attributed to the artist.[68] Its Madonna, seated before a cloth of honour, brings her hands together in reverence to adore the Child reclining, as in a *pietà*, on an elaborately brocaded pillow in her lap. The viewer's attention is didactically drawn to the Babe by the vanishing point of the perspectival floor (located above his head) and his gaze, which would have engaged the viewer in a high placement of the panel as he gives a benediction. Its quasi-liturgical feeling is reinforced by the cloth with which the angels hold the crown above the Madonna's head. In general, its iconography relates to the Immaculate Conception, with the Virgin crowned as Queen of Heaven (*Regina Coeli*).[69] It also exemplifies *aureola* iconography signalled by the regal diadem, an award for an exceptional victory and reserved for virgins, martyrs, and doctors of the Church, singling the Madonna out as a virgin, a theological concept quintessential to Marian piety.[70] This identification, which need not be exclusive of the *Regina Coeli* allusion, harmonizes with the lilies, attributes arguing that Mary was a virgin despite being a mother, in an attempt to reconcile the *virgo et mater* dichotomy. Adding to the clarity of its themes, its painter sensitively employed enough curvilinear motifs to counter its rectilinear architecture and to insure its visual success, in such motifs as the loggia arches, the round arms of the angels that function like bookends echoing the tondo shape, the foreshortened crown, the Virgin's brooch, and the haloes of the holy duo.

As noted, one mark of success is repetition, and the most extreme case of serial repetition involving one composition occurs with a group of tondi from the shop of Ghirlandaio, easily identified by its mullioned windows, usually in pairs flanking its figures (Figs. 7.14–15). There are more than sixteen versions of this composition extant, including one in the Louvre thought to be the original, and a much more distant derivation in San Gimignano (Fig. 7.16), suggesting that many more may have been produced—that is if one estimates conservatively that around 10 per cent of all fifteenth-century works of art have survived.[71] These tondi are of varying quality and many were probably prepared in advance to be altered slightly upon purchase. Their windows feature classical colonnettes like those in paintings by Verrocchio (e.g. his *Madonna and Child with a Pink*), Lorenzo di Credi, and Leonardo from the 1480s. Most have a view of Venice—featuring the Palazzo Ducale, the Campanile, and San Marco—with gondolas through the right window derived either from a woodcut or a drawing made *in situ* and preserved in the studio.[72] Through the left window there is usually a generic cityscape, which in many cases includes an octagonal building that may allude generally to the city of Jerusalem[73] or Florence. Within this group there are many variations.[74]

[68] Inv. no. 37.432 in the Walters Art Gallery, Baltimore, panel of two planks measuring 109.7 × 107.7 with a 1.6 cm. thickness, trimmed and reduced. Zeri, *Italian Paintings*, i. 108–9, no. 71, ill.

[69] Levi D'Ancona, *Immaculate Conception*, 28 ff.

[70] E. Hall and Uhr, '*Aureola super Auream*: Crowns and Related Symbols of Special Distinction for Saints in Late Gothic and Renaissance Iconography', 575; also eid., '*Aureola* and *Fructus*: Distinctions of Beatitude in Scholastic Thought and the Meaning of Some Crowns in Early Flemish Painting'.

[71] Venturini, 'Modelli fortunati e produzione di serie', 151, 162–3, thinks most are heterogeneous studio works in which Mainardi was a collaborator, with Domenico contributing occasionally; see also ead., 'Bastiano Mainardi', 432.

[72] Tomory, *Ringling Catalogue*, 29–30, no. 22, ill., opts for the print hypothesis but makes no suggestions. Breydenbach's

Peregrinatio in Terram Sanctam, published in Mainz in 1486 and 1490, is a possibility, although there are no exact correspondences. No other incunabulum with Venetian views has the same vantage point from the Giudecca, implying that a drawing may have been the source. It is important that Ghirlandaio's shop, known for its topographical expertise, employed this exotic but distinctive cityscape.

[73] Ibid. 30.

[74] M. Davies, *The Earlier Italian Schools*, 326; Shapley, *Paintings*, i. 127; Tomory, *Ringling Catalogue*, 29–30; Venturini, 'Modelli', 151. Venturini, 'Bastiano Mainardi', 432–3, cites related works in Ajaccio (rectangular); East [formerly] Berlin, Birmingham, Boughton House, Cherbourg, Denver [formerly; see Christie's, New York, sale cat., 3/II/97, no. 129], Florence, Hamburg, Maidenhead, formerly Milan, Naples, Paris, Perugia, San Gimignano, Sarasota, Vaduz, and

One of the finest and most lavish versions, albeit discoloured by varnish (Fig. 7.14) is probably the prototype in which Domenico painted the face of its Madonna.[75] Its Madonna affectionately cups the chin of young St John who holds his cross-staff as the Child blesses him.[76] Her gesture and the linkage of her right and left arms joins John of the Old Testament with Christ of the New. The Child holds a fruit—perhaps a section of a pomegranate, symbolic of his Death and Resurrection—while its three angels (the Trinity or the three mysteries of the rosary) hold lilies (purity) on long stems (the two behind the Madonna's head create a second halo reinforcing her purity). As a group, the tondo's figures no doubt facilitated counting the five decades of the rosary to suggest a reason, over and above its charming details, for its market demand and success.

Other versions contain variations in motifs, dimensions, and quality. An extreme example is a panel of high quality in Maidenhead (Fig. 7.15), where the composition has been streamlined and uniquely altered by its creator. Here, the angels have been eliminated to allow for a more developed Venetian *veduta* that includes a fascinating scene of urban terrestrial traffic.[77] Further, a balustrade has been added in the exergue to form a bridge with the viewer's space. On top of it rests an open book with a clasp to stress the devotional activity of the Madonna and to underline the function of tondi in stimulating like activities in the viewer. In a few cases these alterations may have been stipulated by patrons. The furthest removed from the original is a tondo with one angel (Fig. 7.16), where the scene uniquely takes place outdoors. This is one of only two panels in the group that is assigned fully to Mainardi, executed after he had returned to San Gimignano in 1500.[78] Its right background includes a view of the Arno with a bridge and a tower building, perhaps a memory of Florence, although it also resembles the banks of the river near Pisa, where Mainardi is documented during 1493–4.

Sandro Botticelli

Nothing, however, prepares us for the type of success enjoyed by Sandro Botticelli and his workshop, which can be measured both quantitatively and qualitatively. Botticelli was one of the most prolific and inventive *tondai*, and his shop issued scores of variations, pastiches, and legitimate inventions on his compositions. A survey of them demonstrates why Botticelli was in such demand as a *tondaio*: he was excited by the challenges of the format, and his experience illustrating Dante predisposed him to profound explorations of it. He was one of the few artists who truly understood

Washington [formerly]. Fahy, *Followers*, 215–19, includes others in previous locations, and in his unpublished list of Jan. 1975 in the Frick Art Reference Library he added two others in: (1) the John Levy Gallery, New York [actually the panel formerly in Denver]; (2) private collection, Providence.

[75] Inv. no. M.I. 1547 in the Musée du Louvre, Paris, warped panel with a 92 cm. diameter. Brejon de Lavergnée and Thiébaut, *Catalogue sommaire*, 200, ill.; Venturini, 'Bastiano Mainardi', 912–18, ill. A drawing of two boys in the Gabinetto Disegni e Stampe degli Uffizi, Florence, was preparatory for its two angels (Gregori, Paolucci, and Acidini Luchinat, *Maestri e botteghe*, 87–8, no. 2.22, ill.). A nearly identical but smaller version with an 85.1 cm. diameter from the same cartoon is inv. no. 61.97 in the Birmingham Museum of Art, formerly in the Samuel H. Kress Collection (K267); Shapley, *Paintings*, i. 127, ill.; Venturini, 'Bastiano

Mainardi', 722–4, ill.; ead., 'Modelli', 150–1. Its third angel does not hold a lily stalk because of the smaller composition.

[76] L. Steinberg, *Sexuality of Christ*, 110 ff., connects the gesture with marriage when between the Madonna and Child. In this context it would have had a human rather than a theological dimension, an affectionate naturalistic detail.

[77] In the Lady Merton Collection, Stubbing House, Maidenhead, panel with a 76.2 cm. diameter and a ring of pigment around its circumference. Venturini, 'Bastiano Mainardi', 851–2, ill.; ead., 'Modelli', 150–1, ill.

[78] Inv. no. 36 in the Museo Civico, San Gimignano, tempera on panel with an 87 cm. diameter. Venturini, 'Bastiano Mainardi', 430–4, ill.; ead., 'Modelli', 150–1, ill. Its provenance from Mainardi's home town supports this idea. The other is inv. no. 15 in the Musée Henry, Cherbourg (Venturini in a letter of 23 Sept. 1996).

the constraints of the form and used them advantageously, not simply for their symbolic potential but for compositional harmony and profundity. Further, his autograph tondi exhibit a compositional progression, implying that he invested much thought in them over and above his patron's requirements (see App.). It is in his mature works that his true brilliance surfaces.

A case in point is his famous *Madonna of the 'Magnificat'* c.1480–1 (Fig. 7.17; Colour Plate VII), which visually enlarges upon a quotation from the 'Magnificat', a theme that was a speciality of his shop (see App.). This composition was so popular that at least five variations were painted, although none of them is as complicated as this tondo, proving that it was indeed special.[79] The tondo's detailed inscriptions and the quantity of gold adorning its surface indicate that the unknown patron was both learned (as well as pious) and wealthy, and that it was a special commission. The 'Magnificat' (Luke 1: 46–55) is a canticle of praise expressing Mary's joy when she meets her cousin Elizabeth, who greeted her as mother of the Lord. It has been sung at Vespers (evening) as one of the Seven Hours of the Divine Office since the time of St Benedict.

Botticelli's tondo features a unique representation of a literary Madonna, engaged in writing in a book with ornate clasps and gilded and tooled edges, assisted by her divine son. No other image quoting the 'Magnificat' places her in the authoritative guise of an author of holy words. The left page of the codex she is inscribing contains a passage (Luke 1: 72–9) in black ink with red initials excerpted from the 'Song of Zacharias' or the Benedictus (Luke 1: 68–79), which was sung at Lauds in the morning. It refers to the exceptional birth of Christ's predecessor, St John. In verse 69 there is a reference to Christ's lineage from the House of David, establishing that the left page of the Madonna's book concerns the Old Testament. The right, on which the Madonna is writing with her son's aid, contains the first lines (Luke 1: 46–9) of the 'Magnificat'. Since the entire 'Magnificat', the Virgin's song of praise to the Lord, was used daily as the canticle for Vespers in the Breviary, lay books of hours, the Little Office of the Virgin, and other votive offices, people were familiar with the words that reminded them of the Incarnation. Because Botticelli painted the Madonna pausing to dip her quill in the inkwell after 'Quia', meaning 'because', he invites the viewer to continue the passage and actively participate in its reading ('Because he that is mighty hath done great things to me.'). Text and *aureola* (crown) are linked in Botticelli's *Madonna of the 'Magnificat'* to celebrate the *virgo et mater* theme and the divine plan that is engendered by the dove of the Holy Spirit inside the raised, gilded disk of heaven at the top of the tondo.[80] By embodying this paradoxical theme, the Madonna defends her purity (her right to bear Christ) and her motherhood. Because her crown is composed of stars, Botticelli also intended to portray her as a celestial being, as Queen of Heaven (*Regina Coeli*), as she is characterized by Dante and known through the 'Regina coeli laetare', one of the four great Marian antiphons, sung after Compline from Easter to the Friday after Pentecost.

[79] Inv. no. 1609 in the Galleria degli Uffizi, Florence, tempera on panel with a 118 cm. diameter. Lightbown, *Botticelli*, ii. 42–4, ill.; Florence, *Gli Uffizi*, 178, ill. The versions, all with variations, include ones in: (1) the Musée du Louvre, Paris (inv. no. 1295 with a 114 cm. diameter); (2) the Pierpont Morgan Library, New York (with a 94 cm. diameter); (3) the Barbara Piasecka Johnson Collection, Princeton (with a 62 cm. diameter, formerly in the Mount Trust; Grabski, *Opus Sacrum*, 88–93, ill.); (4) the Kunstmuseum, Berne, now in two ovals (inv. no. 74); (5) the Hahn Collection sale, Frankfurt, 1934. Added to it are: (6) another with three angels (possibly the one in the Hahn sale?) with a 65 cm. diameter (Christie's, New York, sale cat., 5/VI/80, no. 232); (7) a copy with

five angels and a 109.2 cm. diameter (Christie's, New York, sale cat., 16/X/87, no. 171).

[80] E. Hall and Uhr, '*Aureola* and *Fructus*'. Buren, 'The Canonical Office in Renaissance Painting: Raphael's *Madonna at Nones*', 44, credits the popularity of the book motif to Botticelli (1470s), noting St Antoninus' influence and his comparison of the Virgin to a book, the *pergamen virginium*, inscribed with the words of God (nn. 95, 222 below). For the text, *Nova Vulgata Bibliorum Sacrorum*, 1859–60; Sparrow, *Visible Words: A Study of Inscriptions in and as Books and Works of Art*, 55–7, who observes that the Child's hand pauses on the word *humilitatem*; Covi, *Inscription*, 524–5.

This joyful text is an appropriate complement to the 'Magnificat'.[81] The panel's round *pietra serena* arch/window at its upper extremity reinforces this interpretation, for it can be interpreted as the *fenestra coeli*, the window of heaven, as the Virgin Immaculate was called, heightening the other allusions to the Immaculate Conception. It also helps physically to bridge the space of the holy scene and that of the viewer.[82] Five young boys, presumably wingless angels, in harmony with the Florentine cult of youth, surround the holy pair in the *Madonna of the 'Magnificat'*. (In shop variations some have wings.) Here, as well as in several other tondi, their wingless nature must reflect contemporary theological speculation that Botticelli has embodied. They also harbour numerical meanings related to the rosary (the five wounds of Christ, the letters in Maria), serving as a devotional aid for the recitation of the prayers in five decades. Finally, the forward placement of the Madonna and Child before the window and near the viewer reinforces the conclusion that tondi linked heavenly and earthly elements to resolve basic theological paradoxes.

The success of Botticelli's *Madonna of the 'Magnificat'* resides not only in its finely tuned, albeit polysemous iconography, but also in its masterful composition, which has a symphony of round and curvilinear forms harmoniously echoing the tondo's shape. They are found in: the Virgin's veils, her crown, the arcs of the arms and drapery, the window arch, the gold disk, the finial of the chair, the pomegranate held by the Child, and even the foreshortened inkwell. They create a gentle repetition to complement the linear lyricality of Botticelli's image, marrying form and content, the secret of his success.

This tondo was followed by his more formally balanced *Raczynski Tondo* (Fig. 7.18) that has been linked to Vasari's 1550 description of a tondo with life-size angels in San Francesco.[83] Botticelli certainly designed this charming and critically neglected panel, whose iconography grows out of the *Madonna of the 'Magnificat'* and foreshadows that of the *Madonna of the Pomegranate*. Its eight (the number of the Resurrection) wingless angels hold lilies emblematic of the Madonna's purity, and those on the right read (sing) from a book with five gold bosses on each side (one cannot see enough of the book on the left to determine if it has similar bosses). The intertwined chorus is symmetrically arranged in a semicircle to echo formally the panel's shape, also repeated in the abbreviated, kinetic foreshortened circle of heaven over mother and Child. A painterly gold cloud rings this circle, enlivened by red pigment to endow it with a feeling of activated divinity. (The effect is similar to one created by Domenico Veneziano in the halo, which hovers like a neon UFO, above St John in the predella of his *St Lucy Altarpiece*.) Inside the celestial ring, two hands (those of God the Father) hold the bejewelled crown of the *aureola* over the Madonna. Since the crown's finials do not terminate in stars, its themes are, therefore, simply *virgo et mater* and the Incarnation. The Virgin's purity is reinforced by the lilies, while the buxom babe symbolizes her human

[81] E. Hall and Uhr, '*Aureola* and *Fructus*', 577, explain the stars on her crown as a reference to the Virgin as a teacher because Doctors of the Church sometimes had an *aureola* of stars. Ettlinger and Ettlinger, *Botticelli*, 84, suggest that she is portrayed as the Woman of the Apocalypse from Rev. 12: 1, which refers to a crown of twelve stars. The crown of Botticelli's Madonna contains more, determining that it is instead an allusion to her celestial nature.

[82] The Ettlingers argue that the *pietra serena* arch is a rainbow related to Apocalyptic imagery (ibid.).

[83] Inv. no. 102A in the Staatliche Museen zu Berlin — Preußischer Kulturbesitz, Gemäldegalerie, poplar wood with a 135 cm. diameter and a dark area painted around its circumference.

Vasari (Bettarini and Barocchi), iii. 517–18; Horne, *Botticelli*, 120–1; Lightbown, *Botticelli*, ii. 53–5, ill., concluded that Vasari does not cite the tondo's original location because tondi were secular paintings, not altarpieces; see above, Ch. 3 n. 69. It is the same tondo with singing angels which Bocchi (*Le bellezze della città di Fiorenza*, 126–7) noticed in a chapel on the right of the same church, then known as San Salvatore. Botticelli's only other tondo with singing angels extant is the *Madonna of the Pomegranate* (although several shop tondi have angels that could be interpreted as singing, whose provenance proves it was not seen by Bocchi and Vasari. The head of the angel to the Madonna's left has been connected with a drawing (Rennes, Musée des Beaux-Arts de Rennes, *Disegno: actes du colloque*

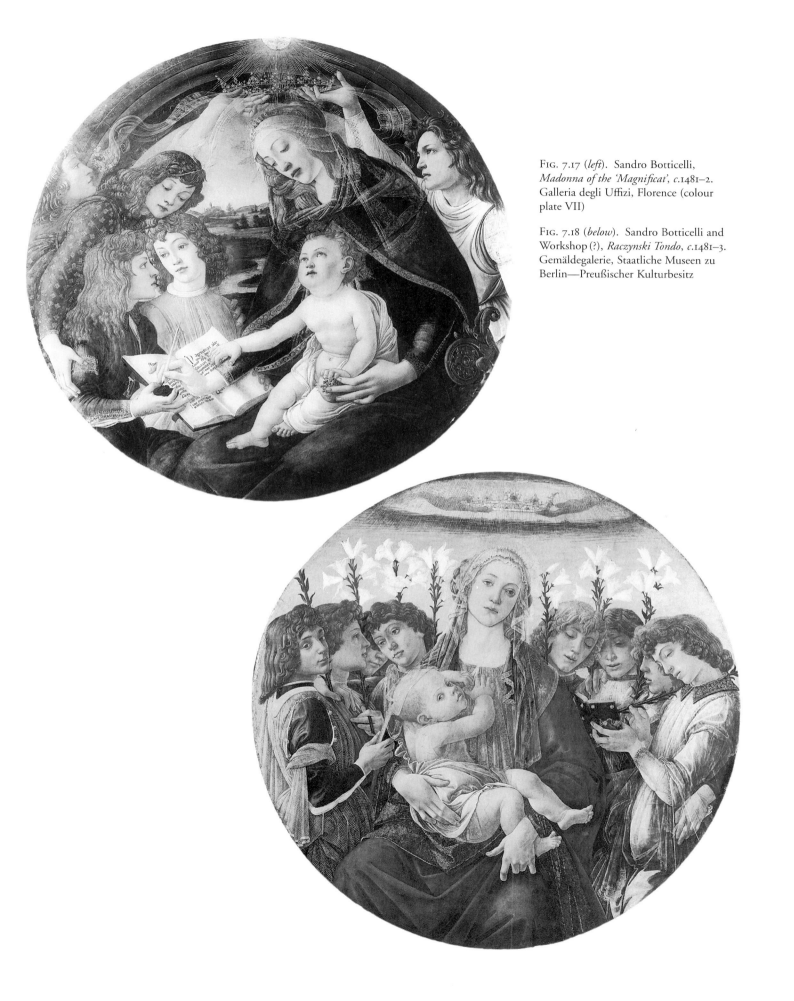

FIG. 7.17 (*left*). Sandro Botticelli, *Madonna of the 'Magnificat'*, c.1481–2. Galleria degli Uffizi, Florence (colour plate VII)

FIG. 7.18 (*below*). Sandro Botticelli and Workshop (?), *Raczynski Tondo*, c.1481–3. Gemäldegalerie, Staatliche Museen zu Berlin—Preußischer Kulturbesitz

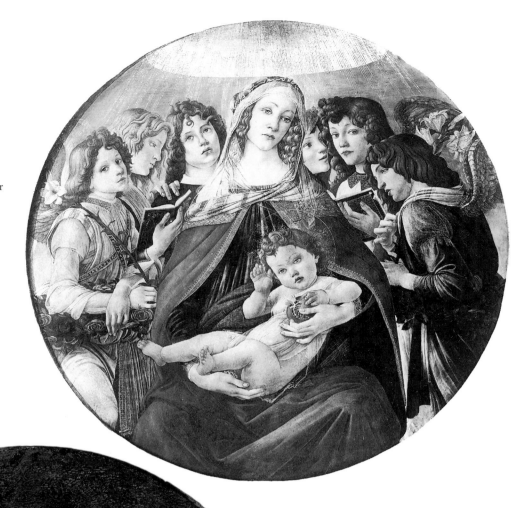

FIG. 7.19 (*right*). Sandro Botticelli, *Madonna of the Pomegranate (Madonna della Melagrana), c.*1487. Galleria degli Uffizi, Florence (colour plate VIII)

FIG. 7.20 (*below*). Sandro Botticelli, *Ryerson Tondo*, 1490–1500. Art Institute of Chicago

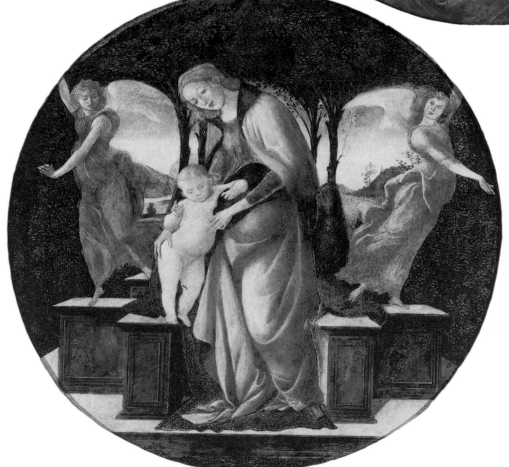

motherhood (reinforced by his reaching to nurse). In addition, the Madonna, who looks at the viewer with a profound sense of melancholy, symbolizes the Church and its charity, linking the spheres of heaven and the viewer on earth.

Botticelli refined these thematic and compositional ideas in his more monumental *Madonna della Melagrana* (Fig. 7.19; Colour Plate VIII), whose simplified, stylized forms date from a later time and critique his *Raczynski Tondo*.[84] Its six angels hold two devotional or song books and two lilies. As in the *Raczynski Tondo*, they form a semicircle around the triangular Madonna. With an intensified gaze of melancholy, the Madonna and Child engage the viewer. Although they are in the sky, the holy pair relates to the viewer's space because a garland of red and pink roses—symbolizing the Passion and love of Christ and the Madonna, 'the rose without thorns', as well as the rosary— separates them from the heavenly choir.[85] The panel's upper section, the dome of heaven, is more successfully integrated into its composition than in the previous two tondi. This area consists of a large, simple segment of a gold circle incised with parallel rays descending onto the individuals below to indicate divine approval. It echoes Dantesque concepts and, according to Horne, was influenced by Paradiso XXXIII. 53–4 ('Lo raggio dell'alta luce, che da sè è vera.').[86] *Pentimenti* under this gilded surface suggest that the artist struggled with the area and in the end resolved the problems inherent in his earlier works by radical simplification. The Madonna's halo overlaps this curved area, which her head just touches, linking her with the highest heaven in a circular manner. The Child places one hand on the pomegranate, the round fruit symbolizing his Resurrection and the Church, while waving (a casual blessing?). It should be noted that when the Child holds a pomegranate, the Italian word 'melagrana' contains an implied reference to apple, *mela*. It is as though the fruit were an antidote used by the second Adam, Christ, to redeem the sins of the first in order to gain everlasting life. The theme of the Madonna's importance and her Immaculate Conception is further emphasized by other elements. For example, the inscription on the bodice sash of the leftmost angel, *AVE GRAZIA [GRATIA] PLENA* . . ., cites Gabriel's salutation to the Virgin (Luke 1: 28). These words could be interpreted either as Maculist or Immaculist. Other typical Marian symbols are applicable to this bittersweet but harmonious composition, which is iconographically the most direct of the artist's tondi.

The *Madonna della Melagrana* is in its original frame, whose widest moulding consists of a carved frieze of fleurs-de-lis on a bluish background. Horne connected it with a tondo that Milanesi described (as painted in 1487 for the Magistrato de' Massai della Camera) but was unable to trace the document that would account for Milanesi's deduction, conjecturing that his information came from a secondary source.[87] The commission document has now been located.[88] While its discovery proves that Botticelli did indeed paint a tondo with the Madonna for the Magistrato de' Massai della Camera, it does not definitively connect that work with his *Madonna della Melagrana*.

du Musée des Beaux-Arts de Rennes, 24, ill.). A shop version, reduced to a lunette, is in the Lindenau-Museum, Altenburg (Oertel, *Frühe italienische Malerei in Altenburg*, 155, ill.).

[84] Inv. no. 1607 in the Galleria degli Uffizi, Florence, tempera on panel with a 143.5 cm. diameter. Its back, which was partially visible in its installation during the 1980s, consists of six panels placed on a support; it is about 8.9 cm. thick. It was cited with its frame as a work of Botticelli in the 1675 inventory of the collection of Cardinal Leopoldo de' Medici (ASF, Guardaroba, 826, fol. 77ᵛ). Again, there

are copies. Horne, *Botticelli*, 154–6; Mandel, *The Complete Paintings of Botticelli*, 99, no. 89, ill.; Lightbown, *Botticelli*, ii. 65–6, ill.; Florence, *Gli Uffizi*, 178, ill.; Covi, *Inscription*, 375, 380.

[85] Sill, *A Handbook of Symbols in Christian Art*, 52.
[86] Horne, *Botticelli*, 121.
[87] Ibid. 153–5. Lightbown, *Botticelli*, ii. 65–6, likewise concluded that he had taken it from a secondary source but one with a copying error.
[88] Olson, 'An Old Mystery Solved'; Ch. 3 nn. 47, 63–6.

Yet the lilies on its frame allude not only to the purity of the Virgin but also to Florence, for they were a civic symbol, thus arguing that Botticelli may indeed have painted this tondo for that city office.[89] In that case, the theme of grace and salvation in the *Madonna della Melagrana* would have been coupled with that of civic justice to imply that the administration of justice meted out in the room in which it was hung was ultimately adjudicated by God. Since the Madonna, as Queen of Heaven, was expected to embody the virtues of mercy, wisdom, charity, and justice, the subject fitted with the judicial function of this room.

Botticelli's smallest tondo is the refined *Ryerson Tondo* (Fig. 7.20),[90] where he grapples with the inconsistencies inherent in painting rectangular architecture in a circular composition by employing two angels to pull back curtains of a baldacchino against its sides to reveal the royal mother and child. A date in the late 1490s agrees with its elongated figure types and its somewhat grainy surface, perhaps partly painted in oil.[91] Its standing Virgin (characteristic of that decade) supports her standing son beneath gold-striated curtains of heaven, which add to its private, devotional aura. They hang above the low architectural structure, whose reliefs are decorated with candelabra delicately articulated in gold pigment. The lateral pedestals on which the angels perch contain roundel reliefs of the Annunciate Angel and Virgin, arguing for Mary's worthiness. Behind the Madonna are four trees, whose symbolism is not clear, although they occupy a position similar to those in the artist's *Mystic Nativity* (dated 1501). They could be interpreted as part of the *hortus conclusus* to harmonize with the Annunciation roundels. More likely, they transform the tondo into an inventive representation combining the Madonna del Baldacchino and Madonna degli Alberetti iconographies,[92] where they signify the four regions of the earth, countering the heavenly circle, underlined by the triple arches created by the trees that imply a nave flanked by two aisles. Even on this diminutive scale, the *Ryerson Tondo* fuses heavenly and earthly elements, demonstrating Botticelli's ability to innovate within established iconographic types.

The *Ryerson Tondo* is iconographically related to Botticelli's *Madonna del Padiglione* (Fig. 7.21), in which the artist also employs the baldacchino as a symbol of heaven and royalty but uses it in such a manner that it more blatantly echoes the tondo's shape.[93] Both works have been identified as the tondo mentioned by Vasari in his 1568 edition as being in the chamber of the Prior of the Camaldolese monastery of Santa Maria degli Angeli [Angioli] (Ch. 3). The latter has the frenzied actions, freely painted surface, delicate gold highlighting, and odd figural proportions, such as the disproportionately large head of the Virgin, characteristic of Botticelli's late style. As in the *Ryerson Tondo*, Botticelli combines syncretistically, in a fashion analogous to literary humanists, stock themes to create an unorthodox iconography. He mixes four visual traditions: the *Madonna del Latte* (or *Maria Lactans* with the Virgin squirting her breast towards the Child to stress his humanation); the Madonna of the Pavilion (the royal and celestial lineage of the pair); the

[89] Olson, 'Studies', 283 ff., discusses civic imagery in the art of Botticelli; see also Bulst, 'Die *Sala grande* des Palazzo Medici in Florenz: Rekonstruktion und Bedeutung', 109–11. Cecchi, 'Les Cadres', 22; id., *La cornice*, 14, and Ciardi Dupré Dal Poggetto *et al.*, *La bottega*, 88–7, relate the frame to Giuliano da Maiano (it resembles the ceilings of the Sala dell'Udienza and the Sala dei Gigli in the Palazzo Vecchio).

[90] Inv. no. 1954. 282 in the Art Institute of Chicago, tempera on panel thinned and mounted on pressed board with a 34.4 cm. diameter (painted surface 32.5 cm.). Lloyd, *Earlier Italian Paintings*,

38–40, ill.; Ch. 3 n. 69 (3).

[91] Ibid. 38. He states it is in tempera, while Lightbown, *Botticelli*, ii. 83, notes oil. It dates from the time when Botticelli used mixed media (tempera *grassa*) or painted in a manner which resembled its use.

[92] Molmenti and Ludwig, 'Arte retrospettiva: La Madonna degli Alberetti', note it usually includes two trees, symbolizing the wood of the True Cross or the purity of the Virgin; J. Hall, *Dictionary*, 187.

[93] Inv. no. 1 in the Pinacoteca Ambrosiana, Milan, tempera on panel with a 65 cm. diameter. Olson, 'Studies', 310 ff.; Lightbown, *Botticelli*, ii. 82–3, ill.

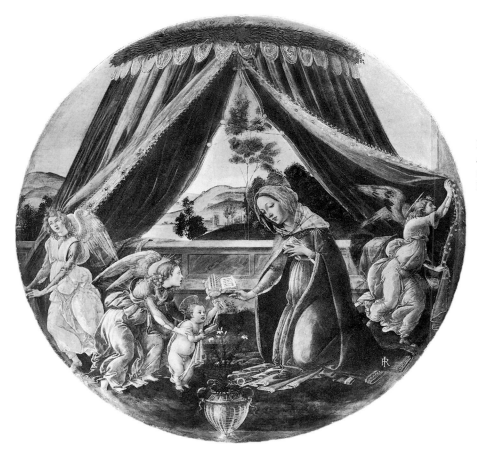

FIG. 7.21. Sandro Botticelli,
*Madonna of the Baldacchino
(Madonna del Padiglione)*, c.1492–4.
Pinacoteca Ambrosiana, Milan

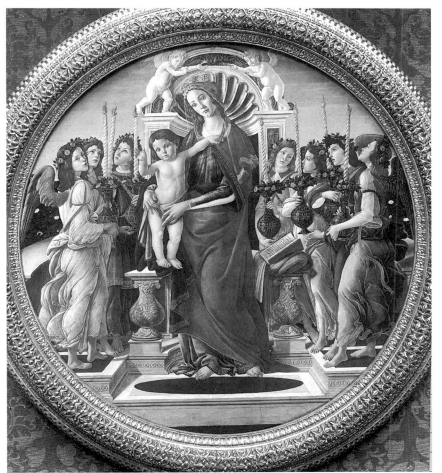

FIG. 7.22. Sandro Botticelli and
Workshop, *Madonna and Child
with Seven Angels (Madonna dei
Candelabri)*, 1487–90. Formerly
Kaiser Friedrich Museum, Berlin
(destroyed)

Annunciation (the composition); and the Madonna adoring the Child (Bridgettine Nativity). Continuing the celestial linkage, the Madonna wears the *Stella Maris* on her shoulder, as described in the *Golden Legend*.[94] Two angels theatrically pull back the red canopy with intricately decorated borders to reveal the vision, which transpires before a marble wall and thus inside the *hortus conclusus* or the Garden of Paradise of the second Adam. Botticelli painted an open book with an illegible inscription, whose pages are being ruffled by the wind resting on the prie-dieu-like ledge to demonstrate that the Virgin was dutifully engaged in her devotions. Her hand, which gestures towards the Child, is directly aligned with this book, underscoring its significance for the function of the tondo and the need for devotional exercises on the part of the viewer. Moreover, an open book symbolizes the Madonna's wisdom (*Madonna della Sapienza*) and could refer as well to St Antoninus' metaphor of the Madonna as a book on whose parchment God has written.[95] The Child—wearing a cross nimbus to foreshadow his Sacrifice—is tended by three angels (the Trinity or the three mysteries of the rosary). Once again these five figures serve to mark the decades of the rosary. Just outside the wall on the central axis grows a single tree, alluding to the Tree of Jesse and the exalted lineage of Christ and the Virgin as well as to Christ's fate to be crucified on the cross. It joins the book and the pavilion as central symbols arguing for the special status of Mary. The tree is emphasized by two strings connecting the back of the baldachin that intersect it with an X, subtly stressing its importance and the linkage of heavenly and earthly elements (its four branches are inscribed in the circle). In the exergue is a gold vase, deftly painted *alla prima*,[96] which, like the pavilion and its foreshortened wreath, echoes the rotundity of the tondo. It rests on a *pietra serena* ledge which mollifies its awkward placement in the tondo's curvature but indicates the artist's desire to resolve illusionistically this problematical area. From it protrude three lily stalks (the Trinity or the three mysteries of the rosary), arguing for the Virgin's purity via the *virgo et mater* theme, as well as citing another of the prototypes Botticelli employed in this eclectic but innovative composition: the Annunciation. Here, the Child assumes the gesture of the angel, visually reinforcing the purity of the Madonna.

Moreover, lilies were multivalent civic symbols in quattrocento Florence—as in Rogier van der Weyden's *Madonna and Saints* in Frankfurt, which was at that time in the Medici collection, as well as in Hugo van der Goes's *Portinari Altarpiece*, where lilies were placed in an analogous position.[97] Furthermore, in writings and in the sermons of Savonarola during the republican unrest of late century, lilies became a flagrant metaphor of civic sentiments. Thus the lilies in Botticelli's *Madonna of the Baldacchino* do not simply represent a double entendre. They are the key to its meaning and are linked to the millennial myth of the city and its rebirth, a myth exploited equally by Savonarola and the Medici for their own ends.[98] Further, the three lilies would have been

[94] Voragine, *The Golden Legend or Lives of the Saints*, ii. 124: 'Thus Balum the prophet compared our Lady to a star for three causes. First for she is adorned and giveth beauty to all human creatures like as a star doth on the firmament, for she hath opened to us the gate of paradise . . . The gate of paradise, which by Eve was closed from all men, is now opened by the blessed Virgin Mary. Secondly, like as the star enlumineth the night by its clearness, in like wise the glorious lady enlumineth by her life all holy church . . .'.

[95] Levi D'Ancona, 'The *Doni Madonna* by Michelangelo', 50 n. 68. St Antoninus remarked that the parchment of the book is scraped of impurities and bleached, like the Virgin, while the writing is likened to the Incarnated word of God.

[96] Lightbown, *Botticelli*, i. 118, identifies it as the *vas electionis*.

[97] Koch, 'Flower Symbolism in the Portinari Altarpiece'; Olson, 'Studies', 311–12. The Madonna may be related to the Florentine myth of rebirth, reflecting the twelfth chapter of the Apocalypse, and thus the ferment of the 1490s.

[98] Weinstein, 'Myth of Florence'; id., *Savonarola*. Olson, 'Studies', 316–19, suggests that the artist's brother with whom he lived, Mariano, a known *piagnone*, was the Savonarola sympathizer. Botticelli, who is not documented as a *piagnone*, seems to have been more apolitical but linked to the general republican cause. Nevertheless, he did not escape the influence of Savonarola and responded to the religious tenor of the times.

appropriate for a commission from Lorenzo the Magnificent in the light of the escalating republican sentiment in which he cloaked his 'disguised aristocracy'. In fact, the reverse of Lorenzo's own medal (*c*.1490) by Niccolò Spinelli contains the personification of Florence holding similar lilies.[99] This iconography would equally have suited Lorenzo's republican-sympathizing cousins Lorenzo and Giovanni di Pierfrancesco (who assumed the surname Popolano).[100] Lilies were not only a sign of the Virgin's purity but also a blatant metaphor for Florentine republicanism, whether under the guise of the Medici aristocracy or in its purer form.

The stylistic date of the tondo agrees with the republicanism rampant in Florence after 1490, especially after the death of Lorenzo in 1492, while its finely gilded surface and chivalric overtones imply that it was a costly private commission. Arguing in favour of a Medici commission are the red spheres (probably fruit), which look like *palle*, embedded in the gesso-embossed garland at the top of the baldacchino. A conspicuous central group of four is directly over the crossed ties, although even on inspection *in situ* their exact identity cannot be ascertained. They are too small to be pomegranates and too large to be cherries, so that they may have been meant as apples, symbolic of Christ as the new Adam (with the Madonna as the new Eve).[101] Although the central cluster of four is not the appropriate number of later Medici heraldry,[102] nevertheless it is tempting to conclude that the red orbs refer to the Medici since they probably are embedded in the foreshortened laurel wreath (*lauro* was emblematic of Lorenzo and an allusion to victory in general) that echoes the panel's shape. However, four was also the number of trees in the *Ryerson Tondo* and it could be interpreted as the earthly four in contrast to the heavenly, circular tent.[103] Botticelli painted fourteen other red orbs embedded in the wreath, seven on each side (the number of completion and perfection in early Christian writings, the days of the week, the Sacraments, the gifts of the Holy Spirit, and the Joys and Sorrows of the Virgin),[104] a numerological stress intended to stimulate devotional associations. The baldacchino, which is a secular reference to royalty as well as to the tent of heaven, was used in *sacre rappresentazioni* and in the chivalric festivals staged in Florence under Lorenzo.[105] It was also employed in the decorations for the triumphal entry of Charles VIII into Florence in 1494,[106] while the gilded lappets at the top of Botticelli's baldachin contain indecipherable designs lettered in gold that recall the coats of arms on the 1494 canopies.[107] Although it is tempting to interpret this tondo as reflecting the ceremonies for entry of Charles, at this point we can only conclude that it is Botticelli's version of Florentine taste in the 1490s, and its baldachin finds reflection in other works by Botticelli's shop (see App.).

The largest tondo to issue from Botticelli's *bottega* and the largest to survive from the

[99] Hill, *Corpus*, i. 247, no. 926, ill.

[100] Shearman, 'The Collections', 177, published a 1503 inventory of their villa at Fiesole that cites bed covers with lilies owned by them. They also possessed a tondo with the arms of the king of France (the fleur-de-lis): '1º tondo d'asse grande del re'. This may have been only a heraldic device, perhaps the one seen by Marin Sanudo over the door of their house for the entry of Charles VIII in 1494 (Borsook, 'Decor in Florence for the Entry of Charles VIII of France', 116: 'Et il simel in caxa de Piero Francesco pur de Medici, con uno tondo in su lo usso [uscio], messo a oro con le arme dil Re, et con festoni pendenti da lati . . .').

[101] Ferguson, *Signs and Symbols*, 187 ff. The leaves are probably laurel, although they could be olive, symbolic of peace at the

Nativity and the Immaculate Conception of the Virgin.

[102] Before Lorenzo the definitive number of *palle* (balls) had not been established; he began setting the number at six; Cardini, 'Le insegne', 55–74.

[103] In addition they could allude to the Four Last Things stressed in Apocalyptic theology.

[104] J. Hall, *Dictionary*, 187.

[105] Wackernagel, *The Florentine Renaissance Artist*, 200.

[106] Borsook, 'Decor', 107, 118, documents 3, 7, n. 19 (citing the diary of Sanudo).

[107] Mandel, *Botticelli*, 105, no. 128, believes they contain an *S.*, *M.*, and *F.*, signifying Sandro Mariano fecit. Lightbown, *Botticelli*, i. 118; ii. 82–3, located an *M* and interpreted it as standing for Maria.

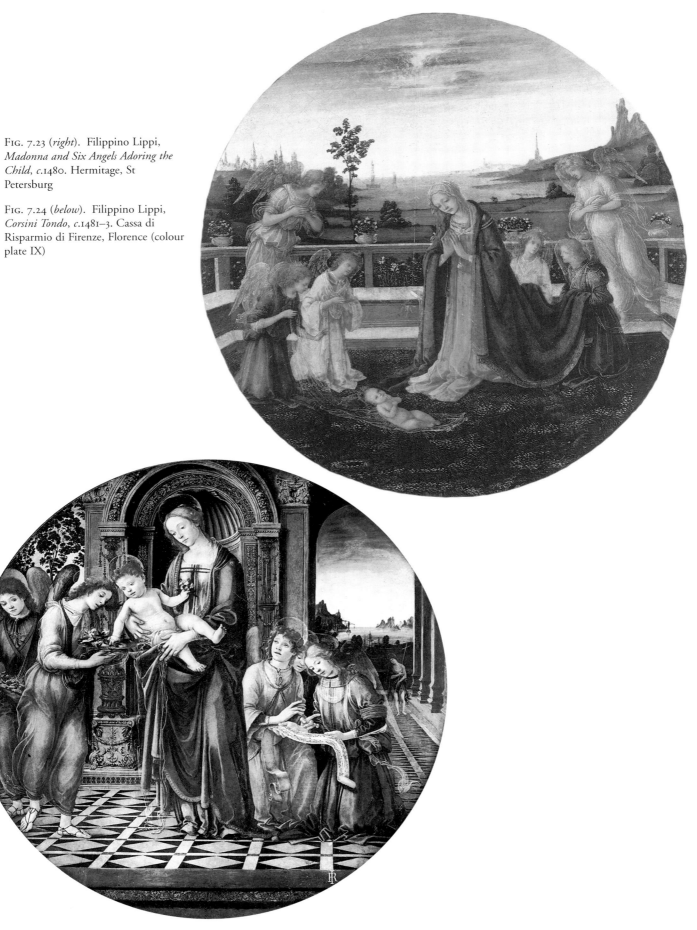

FIG. 7.23 (*right*). Filippino Lippi, *Madonna and Six Angels Adoring the Child*, *c*.1480. Hermitage, St Petersburg

FIG. 7.24 (*below*). Filippino Lippi, *Corsini Tondo*, *c*.1481–3. Cassa di Risparmio di Firenze, Florence (colour plate IX)

Quattrocento until it was destroyed by fire in 1945 was the *Madonna dei Candelabri* (Fig. 7.22).[108] Botticelli himself probably played a role in its symbolically and spatially complex design, which dates *c.*1487–90. Its Madonna and Child were surrounded by a semicircle of winged angels carrying vases of roses that also held twisted paschal candles used liturgically for Easter and special feast days. The metal vases that doubled as candelabra derived from the seven candlesticks mentioned in the Apocalyptic Book of Revelation and illustrated by Botticelli in his Dante drawings for *Purgatorio* XXIX (and XXX), while the number of angels symbolized the seven gifts of the Holy Spirit among other things (also the Sacraments in the Catholic Church, the days of the week, the Joys and Sorrows of the Virgin, as well as the number of completion and perfection).[109] The roses alluded to epithets of the Virgin, with the white, red, and pink varieties having their own meanings. The angels all wore circular garlands of roses, referring to the rosary, as they interrupted the Madonna at her devotions (her book, with its pseudo-Hebrew text, revealed that the artist had access to a Hebrew inscription but copied the characters randomly). Very sophisticated perspectival calculations lay behind its composition.[110] Moreover, the Madonna stood on a foreshortened circle of inlaid marble, symbolizing, among other things, her perfection and heaven. She was being crowned with an *aureola* by two putti, who stand on the semicircular aedicula of the throne and flank its shell niche, emblematic of both the Resurrection and the Madonna. Further, the scene took place before a semicircular parapet, demarcating the *hortus conclusus* or the Garden of Paradise, backed by a similarly shaped rose hedge. Thus its exceptionally intellectual, elegant iconography was matched by a formal symphony of elements that echoed its shape: the inlaid floor; the garlands of roses; the arch and apse; the hemicycle of the balustrade; the hedge of rosebushes; and the foreshortened *aureola*. The powerful rhythms of this rose-filled composition invited the viewer into a hypnotic recitation of the circular rosary, a meditation aided by a tangible focus both on the tondo and the round beads, marking a high point in the conception of tondi.

Filippino Lippi

Since Filippino Lippi was a pupil of not only Botticelli but also his father, two distinguished *tondai*, it is not surprising that even his first solo effort, whose fragile types and delicate but painterly execution date it to his early career, was successful (Fig. 7.23).[111] Its setting, like the thematically and compositionally related Fig. 7.9, is in the *hortus conclusus*, but here the structure's simplicity makes it seem even more like an outdoor playpen where the Bridgettine Madonna has paused in her devotions to adore her wondrous son. The square enclosure, emblematic of earthly things, is set inside the circular panel, symbolic of heaven. Its railing is decorated with four (earthly) pots planted with pink roses and white lilies, symbolic of the Virgin as free from Original Sin, the rose without thorns. Although its iconography is less complicated than that of Botticini's panel, it has intriguingly unique features. For example, two of the six (perfection) angels hold up the Madonna's robes, as though she were a queen. The red book on top of the transparent sacramental cloth, which

[108] Formerly inv. no. I.104 in the Kaiser Friedrich Museum, Berlin (destroyed), poplar wood with a 192 cm. diameter. Lightbown, *Botticelli*, ii. 131–2, ill. Its frame was a variant of that on the *Madonna della Melagrana*.
[109] Ferguson, *Signs and Symbols*, 154, 162.
[110] Kern, 'Eine perspektivische Kreiskonstruktion bei Sandro

Botticelli', 137–44.
[111] Inv. no. 287 in the Hermitage, St Petersburg, tempera on copper transferred to panel with a 53 cm. diameter. Kustodieva, *The Hermitage Catalogue of Western European Painting. Italian Painting*, 231–2, no. 122, ill.

may refer to the Child fulfilling the prophecy of the Old Testament or to St Antoninus' characterization of Mary as a book in which God wrote, highlights the panel's devotional function. The port depicted in its mid-ground forms a natural halo around the Madonna's head, indicating literally that she is the Port of our Salvation, while rays of light descend from a dramatic opening in the sky to designate the Child as the miraculous Saviour. Curiously, few elements, except the delicate crown of roses on the ground at the left, a reference to the rosary, echo the shape. Because this tondo dates from around the same time as Botticini's '*Hortus Conclusus*' *Tondo*, it is tempting to conclude that they were stimulated by a common source, perhaps a *tableau vivant*, a theological treatise, or a sermon.

Although Filippino's *Corsini Tondo* (Fig. 7.24; Colour Plate IX) has only a seventeenth-century provenance from the Medici Villa of Careggi,[112] internal and external evidence suggests a Medici commission, perhaps one from Lorenzo himself.[113] This sizable panel, with a 173 cm. diameter, is one the largest surviving tondi from the Quattrocento, a distinction formerly held by Fig. 7.22.[114] And, a recent technical examination has revealed that it was painted in Filippino's characteristic tempera *grassa* medium.[115]

Its distinctive iconography is different from that of any other tondo. Its standing Madonna holds the Child in front of a shell niche, symbolic of the Virgin as well as of the Resurrection and Baptism, which forms a second halo around her head and creates a quasi-ecclesiastical setting. Its inlaid floor with an intricate perspective display of squares introduces the theme of the square inside the circle, the earthly four circumscribed by the heavenly circle. Filippino portrayed the Child selecting a nosegay of pink five-petalled roses from a bowl offered by an angel. The sacramental nature of this gesture, symbolizing Christ's acceptance of his Passion, is heightened by the transparent cloth with which the angel holds the bowl, like an acolyte with the host. Moreover, a liturgical tenor is created by the other angels: one on the left has its drapery filled with roses, while the three grouped at the right sing from a musical scroll.[116] Polyphonic music was an increasingly popular element in fifteenth-century Church liturgy, and contemporary writers on music fully agreed with St Augustine's remarks in his *Confessions* that 'I feel that when the sacred words are chanted well, our souls are moved and are more religiously and with a warmer devotion kindled to piety than if they are not so sung . . . the custom of singing in Church is to be approved, so that through the delights of the ear the weaker mind may rise up towards the devotion of worship.'[117] The importance of

[112] In the Cassa di Risparmio Collection, Florence, oil and tempera on panel with a 173 cm. diameter, formerly in the Corsini Collection. Natali and Del Serra, *Capolavori e restaurazione*, 373–4; Zamarchi Grassi, Chiarini, and Spalletti, *Opere*, 50–3, ill.; Gregori, Paolucci, and Acidini Luchinat, *Maestri e botteghe*, 240–1, no. 9.3, ill.

[113] Neilsen, *Filippino*, 36 n. 40, cites Crowe and Cavalcaselle, *A History of Painting in Italy*, iv. 289 n. 3. From 1482 Filippino was involved with Lorenzo on various projects. Only a document will prove, however, that Lorenzo commissioned this tondo.

[114] Hartt, *History*, 350 (also ed. revised by Wilkins, 340), states it is the largest. (Gregori, Paolucci, and Acidini Luchinat, *Maestri e botteghe*, 240, no. 9.3, ill.) A tondo in Würzburg, sometimes ascribed to Ridolfo Ghirlandaio, has the same diameter (App. n. 279).

[115] Del Serra, 'A Conversation on Painting Techniques', 15–16.

[116] Although in Gregori, Paolucci, and Acidini Luchinat, *Maestri*

e botteghe, 240, no. 9.3, Jonathan Nelson notes that the wordless music is a motet in the late style of Guillaume Dufay, quoting an oral communication of H. C. Slim, in a letter of 18 Jan. 1998, Slim now believes that no such identification is possible. Thanks to Bonnie Blackburn for her help in clarifying this. For a transcription of the music see V. Scherliess, *Musikalische Noten auf Kunstwerken der italienischen Renaissance bis zum Anfang des 17. Jahrhunderts* (Hamburg, 1972), 104–5. See also Covi, *Inscription*, 693.

[117] *Confessions*, X. xxxiii. 49–50, trans. Chadwick, 207–8 (repeated by St Thomas Aquinas in his *Summa theologica* 2:1590–1 (II–II.92.2)). On this passage and its relevance to 15th-c. music see Page, 'Reading and Reminiscence: Tinctoris on the Beauty of Music', esp. pp. 12–13. Thanks to Bonnie Blackburn for pointing this out. See also Winternitz, *Musical Instruments and their Symbolism in Western Art*, 137–49.

music at the time is seen in the burgeoning number of compositions written for devotional offices. The music of the angels is a vast topos; Jacobus de Voragine reflected the common view when he wrote in the *Golden Legend* that 'angels' voices accompanied divine events'.[118] By the late fifteenth century angels were frequently depicted as singing polyphonic music, as various tondi from Filippino's shop demonstrate. Further, the five angels in the *Corsini Tondo* aided rosary recitation, a conclusion reinforced by not only the five-petalled roses but also by strings of beads which hang from the two candelabra carved on the pilasters of the architecture, divided into three parts like the three Mysteries. Coincidentally, the Confraternity of the Rosary was active at San Marco in Florence by 1481–3, exactly the time when this tondo was painted (Ch. 4). The connection between rosary beads and roses is crucial for the iconography of this tondo, which includes both. Since it was intended as a visual tool, like the rosary, to transport the worshipper to a higher consciousness in conjunction with the beads, and it is no longer in the Corsini Collection, the tondo could be thought of as Filippino's 'Rosary Tondo'.

The angels are disposed left to right in a two to three ratio, the same one used for the nudes in Lippi's *Adoration* and Michelangelo's *Doni Tondo*. At the right is a loggia, where a thinly painted adolescent St John stands before a Leonardesque seascape. *Pentimenti* reveal that he was added after the setting. He does not relate proportionately to the Madonna, who dominates the composition and wears a golden star with points like a compass, indicating that she is the 'Star of the Sea' (*Stella Maris*, from the hymn 'Ave Maris Stella Dei Mater alma').[119] To quattrocento minds, bent on connections with older texts, the Old Testament significance of Mary's Hebrew name, Miriam, was important. Mariam (Miriam), sister of Moses, was a prophetess who led the Hebrews in a song of victory known as the 'Canticle of Mariam' or the 'Song of Moses, Mariam, and the Sea' (Exod. 15: 20), to celebrate Yahweh's victory over Pharaoh at the Red Sea. It is no coincidence, then, that in this tondo Filippino depicted angels singing music, connecting the Old Testament with the New, one of the goals of Florentine humanism. Appropriately, there is a body of water in the background connoting a port, which could refer to Mary as the Port of our Salvation as well as Miriam's association with water. On another level, it may allude to a burning contemporary political issue important to its patron.

In 1406 Florence had acquired the crucial port city of Pisa on the Arno in one of the city's biggest territorial gains. Although Pisa itself had silted up and the actual port was at Porto Pisano at the river's mouth, Pisa remained a critical location for all goods imported to and exported from Tuscany. It was an access to the sea that the city had been coveting for centuries.[120] The Medici were involved in this territorial acquisition and began purchasing land around Pisa. The 1492 Medici inventory reveals that the family owned a large quantity of land in Pisa, more than other wealthy Florentine families. Further, Lorenzo showed a great interest, participating in all aspects of Pisan life.[121] Records of the Archivio Mediceo Avanti il Principato demonstrate that between 1474 and 1478, just prior to Filippino's tondo, Lorenzo spent a sizable amount of time there, and later visited the city annually.[122] This information can be correlated with the *Corsini Tondo*, in which the sea is prominently depicted behind St John; he stands under an arch, signifying triumph (an allusion to

[118] Jacopo da Voragine, *Legenda Aurea*, ed. T. Graesse (Bratislava, 1890), 520, quoted by Geiger, *Filippino Lippi's Carafa Chapel*, 152.

[119] *The New Catholic Encyclopedia*, ix. 207–8; Hirn, *Sacred Shrine*, 465; J. Hall, *Dictionary*, 330.

[120] Hale, *The Thames and Hudson Encyclopedia of the Italian Renaissance*, 252–3.

[121] Rubinstein, *Florentine Studies: Politics and Society in Renaissance Florence*, 409.

[122] Ibid. 434–5.

the Florentine triumph over Pisa or to the Sacrament of Baptism, or a multi-level reference to both). The Pisan interpretation hints at a Medici connection, although the panel could have been executed for any Florentine family in the trade and banking business with interests there. Only a document can substantiate what is now a working hypothesis.

The more traditional interpretation of this detail pivots around St John and the Sacrament of Baptism. Filippino's inclusion of the patron saint of Florence amalgamated political ideals with the traditional baptismal theme to reflect not only civic but also religious triumph. Not accidentally there are eight figures in the tondo, a number frequently found in octagonal baptismal fonts to symbolize the Resurrection, eight days after Christ entered Jerusalem.[123] The lilies in the angel's trencher and the nosegay of pinkish white roses—references to Christ's Passion and Mary as the mystical rose and the rose without thorns—which the Child hands his mother echo the idea of purity.[124] Further, the trencher refers to a sacral plate and thus to the Christian Sacrifice, an idea repeated in the sacrificial altar *all'antica* that forms part of the throne/altar, which is related to the one painted by Leonardo in his *Annunciation* (*c.*1470). Thus, all the elements in the *Corsini Tondo* merge civic and Christian associations in a humanist vision. Grouped together, they imply that the Florentines rose to power through their faith in Christ and their righteousness, connecting their victory over Pisa with the Sacrament of Baptism and the promise of life everlasting through Christ's Sacrifice and Mary's intercession. This complicated yet unified iconography is one indication of the panel's success.

Filippino's *Cleveland Tondo* (Fig. 7.25) dates from a later time, as evidenced by its darker palette and more mature types.[125] The four tondi related to it testify to its popularity and argue that its cartoon or a drawing of its composition remained in the shop for consultation. This very sophisticated tondo with five figures has a composition that pivots around two intersecting triangles: the pyramidal body of the Madonna and the inverted pyramid formed by the Virgin's lap and the heads of Sts Joseph and Margaret. The work, which dates from the early 1490s after Filippino's return from Rome, also reveals the impact of Flemish painting, specifically via the *Portinari Altarpiece*, which stimulated in him novel approaches to symbolism and objects. Its exergue is painted to resemble a *trompe l'œil* green serpentine parapet, creating a transition to the viewer and supporting a still life of objects that footnote ideas in the main composition. At the right is a wooden box, a type depicted in Flemish and Florentine paintings of domestic interiors; its cover is slightly askew, with the reed cross of St John casting a shadow on top of it (foreshadowing Christ's fate). In a quotidian setting, it would contain cheese or small objects, but in this context, it evokes a coffin and the death of Christ (who in the tondo wears a cross nimbus). Its open lid, therefore, symbolizes the Resurrection, a theory supported by the position of John's cross. Furthermore, these

[123] Ferguson, *Signs and Symbols*, 154; J. Hall, *Dictionary*, 39.

[124] Levi D'Ancona, *The Garden*, 33 ff.; J. Hall, *Dictionary*, 268.

[125] Inv. no. 1932.227 in the Cleveland Museum of Art, tempera and oil on panel (oak?) with a 153 cm. diameter and a provenance from the Carafa family. L. Berti and Baldini, *Filippino Lippi*, 206; Cleveland, The Cleveland Museum of Art, *European Paintings before 1500*, 76–9, ill. There are really two versions and two derivations. One copy is in the Strossmayer Gallery, Zagreb (inv. no. 54, tempera on panel with an 81 cm. diameter; Zlamalik, *Strossmayerova*, 96–7, no. 37, ill.), the other, in the collection of Lord Crawford of Balcarres, is listed in the FKI with a 99 cm. diameter. A third without St Joseph is in the Galleria della Accademia, Florence

(inv. no. 9202 with a 68.5 cm. diameter; Bonsanti, *Accademia*, 42). A fourth, with two angels replacing St Joseph and St Margaret, in the Art Gallery and Museum, Glasgow (Fig. A31), has a different theme though it is related in style and composition (inv. no. 368, tempera on wood with a 119.4 cm. diameter according to the FKI; Neilsen, *Filippino*, 195–6, fig. 95). The verso of a drawing in the Istituto per la Grafica, Rome, contains a bust-length female figure that has been connected with the female saint in this tondo as well as the Madonna in Filippino's *Adoration of the Magi* (Goldner and Bambach, *The Drawings of Filippino Lippi and his Circle*, 264–6, no. 78, ill.).

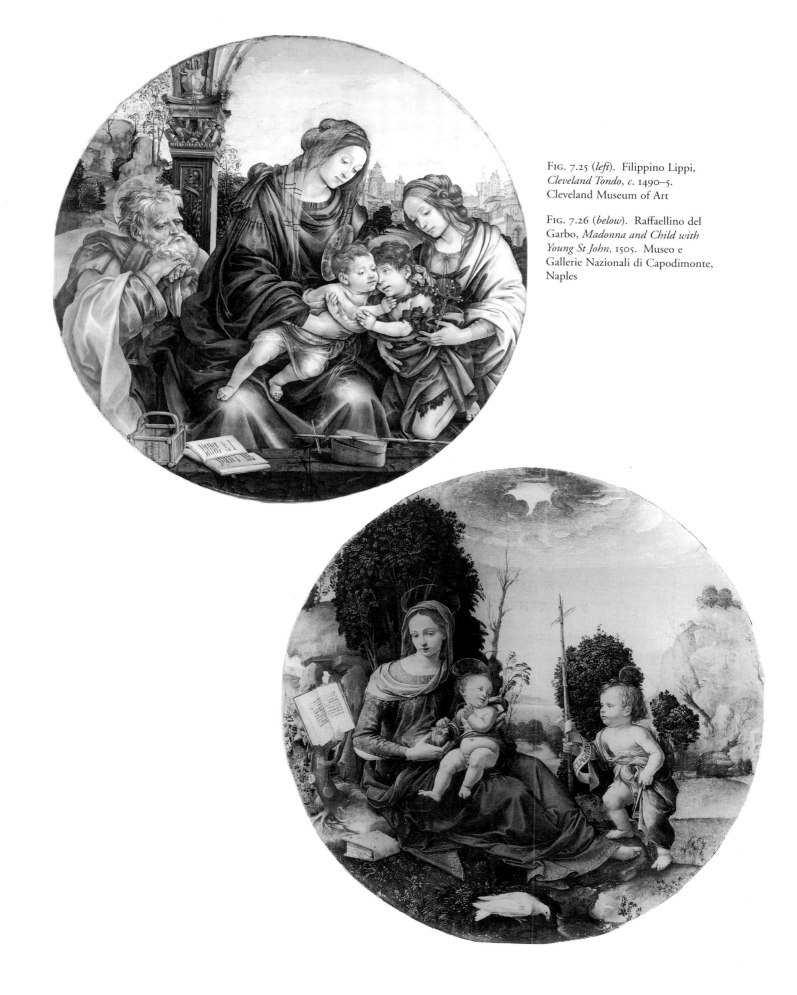

FIG. 7.25 (*left*). Filippino Lippi, *Cleveland Tondo*, *c.* 1490–5. Cleveland Museum of Art

FIG. 7.26 (*below*). Raffaellino del Garbo, *Madonna and Child with Young St John*, 1505. Museo e Gallerie Nazionali di Capodimonte, Naples

objects are placed directly below Christ as he embraces St John, indicating the acceptance of his destiny as the Lamb of God. This box is not accidental but instead ranks as a 'disguised symbol'.[126] Further, the arch formed by the two children above the box suggests the idea of victory over death. Like the box, the open book rests on the parapet and its diagonal placement adds to its immediacy. It faces the Madonna to indicate that she is a *Madonna della Sapienza*, while reinforcing the devotional function of the panel. Its pages do not record a specific passage, although Filippino created the illusion of a legible text with illuminated initials. The right page begins *Lumimo* . . . and its only legible word is so largely inscribed that it cannot be missed: *VESPERI*, indicating the devotional office of Vespers at which the 'Magnificat' was recited. By emphasizing *VESPERI*, Filippino implied that the *exemplum inter exempla*, the Blessed Virgin, was interrupted in her devotions by the children. It is also significant that the traditional illustration for Vespers was the Flight into Egypt.[127] Near Joseph is a basket, an object he sometimes carries, usually holding two doves for sacrifice. Because the basket is empty, we know the moment depicted is after the Circumcision and before the Flight.[128] In addition, Filippino represented Joseph as nearly sleeping to foreshadow his dream in which the angel urges him to take flight from Herod.

Further symbols in the decorative motifs of the architectural pier reflect Filippino's Roman sojourn to work on the Carafa Chapel in Santa Maria sopra Minerva (1489–92) and his intense study of antiquity.[129] Afterwards Filippino creatively employed his knowledge, as in the capital of this pier where barbarian captives (from Roman triumphal arches) are rendered as four atlantid figures. They signify the four corners of the earth and thus again allude to the heaven and earth synthesis.[130] Symbolically the pier, signifying that the New Order is built on the Old, can be read as part of a triumphal arch, denoting that Christ has triumphed over pagan antiquity and death.

St Margaret, who is identified in the *Cleveland Tondo* by an inscription on the ribbons crisscrossing her bodice: *S. MARGHA/RITA. VIR* (Virgin and virtue), is a significant addition to its iconography. Although we can only speculate about why she was included, there are two explanations that seem most likely: she was the patron saint either of the patron's wife or of the convent that commissioned the tondo. Filippino depicted her holding the cross with which she destroyed Satan when he appeared to her as a dragon. Significant for the talismanic function of tondi within the household, St Margaret was the patron saint of childbirth. Her popularity derived from her patronage of those in childbirth, and it is in the late Quattrocento that she makes her appearance with greater frequency in Florentine painting.[131] Her inclusion suggests that this tondo may have been a lay commission. It is also telling that herein she holds St John before her womb like the Madonna does Christ. She is one more element that enriches this tondo to help explain the composition's popularity and success.

[126] A painting of 1521 by Lotto in the National Gallery, London, includes a small coffin on which the Child sits, a grisly prefiguration (Caroli, *Lorenzo Lotto*, 260, ill.).

[127] J. Hall, *Dictionary*, 51.

[128] L. Steinberg, *Sexuality of Christ*, 49 ff., 157 ff., on the Circumcision. On p. 52 he notes that Christ's was assigned to the eighth day, and that his Resurrection was eight days after his entry into Jerusalem. Thus 1 January became the beginning of the calendar year, symbolizing new life, and foreshadowing the sacrifice and the second letting of his blood.

[129] See Shoemaker, 'Drawings after the Antique by Filippino Lippi'; Geiger, *Carafa Chapel*.

[130] Atlas, on whom atlantids were based, in Greek mythology supported the heavens and was thought to have had a vital role in the construction of the cosmos; J. Hall, *Dictionary*, 35. In this tondo, the atlantids support the area from where the arch springs, an allusion to the heavens.

[131] Ibid. 198. Fineschi, *Notizie storiche sopra la stamperia di Ripoli*, 43, notes prints of St Margaret produced by the publishing house of the Domenican monastery San Jacopo di Ripoli, which printed images for the Confraternity of the Rosary at San Marco.

Raffaellino del Garbo

An associate of Filippino, Raffaellino del Garbo, was also a successful *tondaio* both in Filippino's shop and on his own. His three most interesting tondi (Figs. 7.26, A38–9.) employ a celestial vision similar to the one in Filippino's earliest tondo (Fig. 7.23), and the most resolved of this trio has one formed by clouds whose swirling shapes echo the tondo but escape stylization (Fig. 7.26).[132] Here, Raffaellino has shed earlier formulae to express divine sanction via a purely naturalistic phenomenon. The work was most likely painted when the artist was experimenting with mirrors and optical effects, because it has an illusionistically convex shape that is accentuated by the roundness of the trees and countered by the clouds that lead into depth. This trait also appears in contemporary tondi by Piero di Cosimo and Raphael, whose influence appears in other aspects of this panel. Its Madonna pauses in reading her devotional book, propped up on a natural lectern, whose pruned branches foreshadow Christ's death. The text with abbreviations and deletions from the 'Magnificat' (Luke 1: 46 ff.) is displayed didactically.[133] Below in the exergue is a white dove, perhaps signifying the presence of the Holy Spirit (a device popularized by Piero di Cosimo). Because the bird drinks from a pool of water, the image may instead refer to the Sacrament of Baptism initiated by the entering St John, in which case the bird would symbolize the soul (or it may have been an equivocal symbol). The Madonna's pose is related to Signorelli's *Parte Guelfa Tondo* (Fig. 7.33), although it is closer to that of the ancient statue of Ariadne (reversed) in the papal collection that influenced Raphael.[134] While we could continue to analyze this tondo, suffice it to say that it marks the height of Raffaellino's creativity within the format.

Piero di Cosimo

In contrast, Piero di Cosimo's most successful tondi are those that charm the beholder by their pure power of observation and by the profundity of their inventive symbols. The earliest extant tondo by Piero is one of his most fascinating (Fig. 7.27).[135] It features the Madonna adoring the Child in a country setting based on St Bridget's *Revelations*, which notes that Joseph withdrew, as in this tondo where he sleeps under a rustic shelter. Piero depicted his Madonna in the process of bringing her hands together in an animated gesture which has been connected with the *Portinari Altarpiece* of van der Goes, in Florence by 1483.[136] Because of her prayerbook, we realize that she has paused during devotions to recognize the divinity of her son. The book is inscribed from Heb. 1: 10–11 (referring to Ps. 101: 26–7 of the Vulgate): 'Et tu in principio . . . terram fundasti: et opera manuum tuarum sunt caeli. Ipsi peribunt, tu autem permanebis, et omnes ut vestimentum veterascent.' ('Thou, Lord, found the earth in the beginning, and the heavens are the work of thy hands; they

[132] Inv. no. Q 43 in the Museo e Gallerie Nazionali di Capodimonte, Naples, on panel with an 85.5 cm. diameter. Spinosa, *Museo e Gallerie Nazionali di Capodimonte*, 30, ill.

[133] Covi, *Inscription*, 529, transcribes the lettering in upper-case letters, whereas it is by and large in lower case.

[134] See Thompson, *Raphael*, 112, 124, ill.

[135] Inv. no. 37.1 in the Toledo Art Museum, oil on panel with a 160 cm. diameter. Toledo, *The Toledo Museum of Art. European Paintings*, 126–7, ill., repeats the allegation of Crowe and Cavalcaselle, *A History of Painting in Italy*, v. 88 n. 3, that Lorenzo de' Medici presented it to a lady of the Guiducci family. Douglas, *Piero di Cosimo*, 118–19; M. Bacci, *Piero di Cosimo*, 72, ill.; ead., *L'opera completa di Piero di Cosimo*, 88, no. 14, ill.; Fermor, *Piero di Cosimo*, 150, ill; Forlani Tempesti and Capretti, *Piero di Cosimo*, 108–9, no. 16, ill.

[136] Knapp, *Piero di Cosimo*, 40–3.

Fig. 7.27 (*right*). Piero di Cosimo, *Toledo Tondo*, c.1488–90. Toledo Museum of Art

Fig. 7.28 (*below*). Piero di Cosimo, *Holy Family with Young St John and Two Angels Reading*, late 1490s. Gemäldegalerie, Dresden

will perish, but thou remainest; they will all grow old like a garment.')[137] Thus, Christ is presented as the fulfilment of the Old Testament, a meaning reinforced by the presence of the ox and ass, pinpointing the scene to Bethlehem. The somnabulant Joseph is receiving the angel's instructions for the Holy Family to depart, a conclusion echoed in the Child who sleeps, foreshadowing his tragic destiny, against a travelling sack.[138] To reinforce Christ's fate, Piero placed him on a strange rock that resembles an altar and refers to the Church (Matt. 16: 8–19). From this dead rock springs a stream of water, alluding to the Sacrament of Baptism. Nearby perches a bird—identified as a coal-tit as well as a goldfinch—about to take a drink. The goldfinch—symbolic of the Crucifixion, Passion, and Resurrection of Christ, among other things—was popular in devotional art after the decimating waves of the Black Death and enjoyed a resurgence in the tension-fraught years of the 1490s.[139] Directly above the recumbent Child is an ominous rock formation that resembles a dolmen to imply Christ's tomb and to echo the intimations of death found elsewhere. Then, to the right grows a severed tree sprouting new branches, again alluding to his Death and Resurrection. The foreground, littered with plants and flowers, like the dandelion indicative of Christ's Passion, testifies to Piero's keen interest in nature symbolism.[140] In the right meadow sheep graze, possibly an allusion to Christ as the good shepherd (Luke 15: 3–7; John 10: 1–18; Ps. 23) since no Annunciation to the Shepherds is depicted. Through these bucolic images, Piero created a visual sermon on the life of Christ and his gift to mankind. Allusions to his Birth, Baptism, Crucifixion, and Resurrection create, so to speak, a full circle in the cycle of birth and regeneration. How appropriate that they are related through naturalistic symbols which participate in the cycle in nature!

The innovative iconography of Piero's slightly later Holy Family with St John, two angels, and the Child on an altar-like rock is complemented by a greater sophistication of forms echoing its format (Fig. 7.28).[141] This scene is set before the departure to Egypt, when the Apocrypha records a meeting between John and Christ, a conclusion supported by the wicker *fiasco* and the grazing ass for the impending journey.[142] A large triangular rock repeats the geometric configuration of the Holy Family and is one of many interlocking triangles in a composition also integrated by circular rhythms. It forms a canopy over the *dramatis personae* and functions as a double entendre, foreshadowing Christ's tomb in harmony with the dead trees populating the background. St Joseph gestures to the Child to introduce him and to indicate that he is the Saviour from the House of David, the fulfilment of Old Testament prophecy. John touches his head with one hand and with the other holds the reed cross indicating that he is the Incarnation. Mary's hand on the Child's thigh

[137] See Covi, *Inscription*, 458–9, for the painted inscription. Douglas, *Piero di Cosimo*, 43–4, observes that the word 'Domine' in verse 10 in the Epistle to the Hebrews of St Paul (1: 10–11) has been omitted.

[138] Douglas (ibid. 44 n. 9) claims it to be the first sleeping Child in Florentine art.

[139] Friedman, *Symbolic Goldfinch*, pl. 11, xviii, identifies it as a coal-tit, symbolic of fertility and Christ's Sacrifice and Resurrection (ibid. 29–30) and, pp. 7 ff., discusses the goldfinch's symbolism (the soul, the Passion, Resurrection, and Death of Christ) and its miraculous curing powers. Birds would have delighted children who may have become involved with a such a representation, thus making it an astute didactic tool. On p. 150 he lists four paintings by Piero with goldfinches. Fermor, *Piero di Cosimo*, 150, 216 n. 43, states that the bird's identity is debated because it lacks the red spot on the head for the goldfinch. It is possible that artist intended it as an

allusion to the human soul.

[140] Levi D'Ancona, *The Garden*, 126–8 (dandelion); also 199–200 (lady's bedstraw, which lined the bed in which Mary lay to give birth to Christ).

[141] Inv. no. 20 in the Gemäldegalerie, Dresden, oil on panel with a 165 cm. diameter. M. Bacci, *Piero di Cosimo*, 73–4, ill.; ead., *L'opera completa*, 87–8, no. 16, ill.; Fermor, *Piero di Cosimo*, 150–2, fig. 73; Forlani Tempesti and Capretti, *Piero di Cosimo*, 118–19, no. 28, ill.

[142] Fermor, 150–1, believes that it depicts the Rest on the Flight into Egypt. She also identifies in the foreground pairs of cherries, conventional fruits of heaven as well as fruit which miraculously fed Christ during the journey to Egypt. According to the Gospel of Pseudo-Matthew, a palm tree with dates bent down during the Flight to feed the Child; it could be replaced by cherries (Levi D'Ancona, *The Garden*, 90).

could be interpreted as highlighting his genitals to prove the humanation of God, the Incarnation. Finally, it is significant that in this compositionally integrated tondo one of the two angels reading or singing from a book looks down, while the other looks up, symbolizing the dual nature of Christ and the linkage of heaven and earth in tondi.

Piero's most geometrically integrated tondo features an intimate half-length Madonna and Child with young St John kneeling to recognize Christ as the Saviour, while his staff with its banderole lies prone on the sarcophagus/altar-like parapet on which the boys stand (Fig. 7.29).[143] The two saints in the middle ground were meant as devotional *exempla*: Jerome, guarded by his ferocious lion, mortifies his flesh before a crucifix, while St Bernard of Clairvaux reads at a lectern in ruins before a Cistercian monastery and behind a chained demon symbolic of his conquest of heresy. Piero depicted both in religious ecstasy, as though they were experiencing with the viewer the vision of the holy trio. This conclusion is reinforced by geometry: the triangular forms of the Madonna and children are locked in place by an inverted triangle, whose base runs between the saints. Further, Piero and his shop continued this wonderfully inventive and charming symbolism in other tondi, such as Fig. A45, which, nevertheless, is not as successful compositionally (see App.).

Lorenzo di Credi

By contrast, the success of Lorenzo di Credi's tondi can be measured in terms of sheer quantity if not always in inventiveness (see App.). Along with Botticelli, he shares the distinction of heading a shop which influenced the largest number of tondi extant, including a large *bottega* production. One of Credi's important tondi (Fig. 7.30)[144] has a pen-and-ink compositional study (Fig. 7.31).[145] It is easy to see—with its limpid landscape and symbolic still life—that it is one of Credi's *capolavori*. No wonder that it has been connected with a work Vasari discussed as by Leonardo! Its bouquet and clear vase of water, symbolic of Mary's purity, betray not only the influence of Leonardo but also a study of Flemish techniques. Its devotional book is didactically inscribed for the viewer's benefit: *ECCE .VIRGO / CONCIPIET.ET / PARIET FILIVM / ET. VOCABITV/R.NOMEN EI/VS.EMANVEL / ISAIAS.VII.C/APITVLO.* (Isa. 7: 15: 'Behold, a young woman shall conceive and bear a son, and shall call his name Immanuel.'). This passage is prefaced by a reference to the House of David and Isaiah's prophecy, presenting Christ as the fulfilment of the Old Testament. Further, near the lower borders of its trimmed study Credi drew two or more concentric circles revealing that he debated about how closely to crop his composition, eventually allocating more space to the lower half. While this design could have been used for a rectangular work, it would have been lifeless in that format. It is the animated interaction between the circle and the Greek cross—the symbols of heaven and the earth (as well as the Crucifixion), hence Christ's dual nature—that activates the tondo, yet keeps it stable, and made it popular and influential.

[143] Inv. no. 433 in the Musée des Beaux-Arts, Strasbourg, oil on panel with a 94 cm. diameter. Strasbourg, *Musée des Beaux-Arts de la Ville de Strasbourg. Catalogue des peintures anciennes*, 130–1, no. 224; M. Bacci, *Piero di Cosimo*, 80–1, ill.; ead., *L'opera completa*, 91–2, no. 30, ill.; Fermor, *Piero di Cosimo*, 153–4, fig. 76; Forlani Tempesti and Capretti, *Piero di Cosimo*, 113–14, no. 20, ill. A drawing in the Metropolitan Museum of Art, New York, has been linked to the head of the Virgin; see Goldner and Bambach, *Filippino and his Circle*, 358–9, no. 119, ill.

[144] Inv. no. 433 in the Galleria Borghese, Rome, tempera on panel

with an 88 cm. diameter. Della Pergola, *Galleria Borghese: dipinti*, ii. 31–2, no. 39, ill.; Dalli Regoli, *Lorenzo di Credi*, 136–7, no. 75, ill., notes that it was identified with a work Vasari (Milanesi, iv. 25) describes in 1568 as by Leonardo for Pope Clement VII.

[145] Inv. no. AE 1297, formerly no. 57, in the Hessisches Landesmuseum, Darmstadt, silverpoint, pen and brown ink with white heightening on paper tinted pink, measuring 100 × 95 mm. Dalli Regoli, *Lorenzo di Credi*, 135, no. 70, ill., does not agree that the drawing is a study for the tondo.

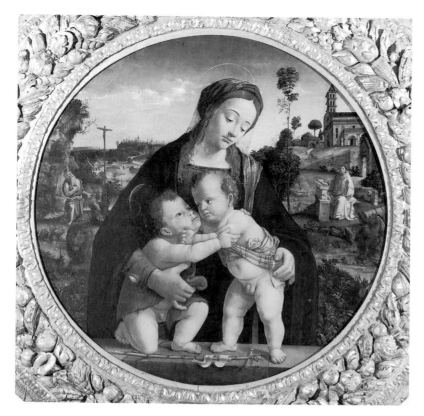

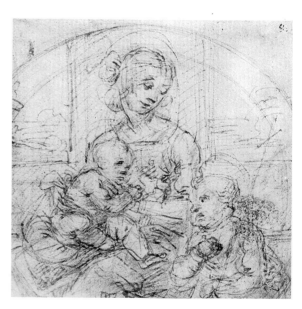

FIG. 7.29 (*left*). Piero di Cosimo, *Madonna and Child Embracing Young St John with St Jerome and St Bernard of Clairveaux*, *c*.1495–1500. Musée des Beaux-Arts, Strasburg

FIG. 7.31 (*below, right*). Lorenzo di Credi(?), *Drawing of the Madonna and Child Blessing Young St John*, *c*.1490. Hessisches Landesmuseum, Darmstadt

FIG. 7.30 (*left*). Lorenzo di Credi, *Madonna and Child Blessing Young St John*, *c*.1488–95. Galleria Borghese, Rome

Luca Signorelli

Although not a Florentine citizen, Signorelli may have painted at least two tondi in Florence, one of which is his most symbolically intricate tondo, his *Medici Madonna* (Fig. 7.32; Colour Plate X).[146] It consists of a tondo inserted into a rectangular frame with grisaille roundels painted in emulation of stone sculpture. The work is a conscious compromise between the tondo, for its symbolism, and the rectangular shape. Although more elements in the *Medici Tondo* echo its shape than in its thematic and stylistic predecessor (Fig. A66), its composition would have worked equally well in a rectangular format, although its symbolism would not have been as pointed. Its casual Madonna of Humility (*humus* = earth), rather than merely adoring her offspring, is maternally helping her son (whose gold halo has worn off) to take his first fledgling steps, thus allying it thematically with the domestic sphere. Her head, which has traces of a faint halo, resembles that of the Virgin in Signorelli's *Annunciation* (dated 1491, Fig. 3.9) and other works from the time (a flipped version of the Bichi Chapel Tiburtine Sibyl) to date the work to the early 1490s, supporting Vasari's information (with a *terminus ante quem* of 1492 if it was for Lorenzo il Magnifico and not his cousin). Its foreground has a profusion of flowers, contributing to its Arcadian mood, which approaches that of the *Pan*, painted, according to Vasari, for the same patron. The *Medici Madonna* thus reflects a favourite Medici theme, the revival of the Virgilian Golden Age and spring brought about not only by the Child but also by Medici rule in the city of the flower, Fiorenza. In fact, Lorenzo's motto was *le tems revient*, a cyclical theme connoting hope in Christian Resurrection and the renewal of Spring.[147]

There are strong reasons to believe that the *Medici Madonna*, like Fig. A66 and the *Doni Tondo* (Fig. 7.37), is concerned explicitly with Baptism in a syncretistic manner characteristic of late quattrocento humanism.[148] Its grisaille bust of a wizened St John in a scallop shell crowning the central axis confirms the theme. His juxtaposition with the tondo alludes to Baptism and rebirth, as well as to the *imago clipeata*. Below his shell, wings refer to either the Holy Spirit, which descended on Christ at his Baptism, or to the Byzantine tradition wherein John had angel's wings.[149] Directly beneath is a *tabula ansata* inscribed with John's salutation: ·*ECCE AGNVS* / ·*DEI*· (John 1: 29). The bust of St John is flanked by two roundels with prophets, like those in Signorelli's *Circumcision*. Although they are generic and without attributes, they have been identified as Isaiah and Ezekiel who foretold of the Incarnation of Christ and the Virgin Birth.[150] Like John, they belong to the Mosaic law, the world *sub lege*, while John links them with the Madonna and Christ. In the squinches two seraphim, intercessors between man and God and the highest order of angels, are in perpetual adoration of the Madonna and Child.[151] They are echoed in the small reclining

[146] Inv. no. 502 in the Galleria degli Uffizi, Florence, oil on panel (it seems to betray the presence of tempera) measuring 170 × 117.5 cm. in its frame with a dark ring outlining the tondo for insertion into its frame. Its roughly horizontal planks have a 114 cm. diameter. The Documentazione of the Uffizi records that the reverse is inscribed: '16 luglio 17 . . . Dalla Guardaroba della Villa di Castello Luca Signorelli . . .', where it was first recorded in an inventory of 1689. Moriondo, *Mostra di Luca Signorelli*, 14–15, no. 7, ill.; Salmi, *Luca Signorelli*, 49–50, ill.; Scarpellini, *Luca Signorelli*, 121–2, ill.; Florence, *Gli Uffizi*, 517, ill. See also App. n. 162.

[147] Cox-Rearick, *Dynasty*, 77–8, 83 ff., 329.

[148] Levi D'Ancona, 'The Medici Madonna by Signorelli'.

[149] J. Hall, *Dictionary*, 16, 172.

[150] Levi D'Ancona, 'Medici Madonna', 327 ff.; ead., *The Garden*, 28. Isa. 7: 14; Ezek. 44: 2.

[151] J. Hall, *Dictionary*, 16–17. Levi D'Ancona, 'Medici Madonna', 327–8, thinks that they symbolize the two testaments and are connected with the Blessed Amedeus of Lausanne's beliefs (*Homiliae octo in B. Mariam Virginem. Homilia I—PL* 188, 1308A), among other ideas.

angels holding cherub heads of the frieze, a sophisticated play on the *imago clipeata*. In sum, the tondo's frame creates an ocular window into the idealized world bridging terrestrial and celestial realities.

However, the main focus of this compound work is the tondo. In its foreground, the area of the Christian world *sub gratia*, the barefoot Madonna of Humility is seated diagonally on a patch of grass, which Levi D'Ancona believes is not parched because she was exempt from Original Sin, reflecting an Immaculist point of view.[152] Since Signorelli also painted this mottled ground in his contemporary *Portrait of a Man*, she may be over-interpreting this motif. The veritable flower garden surrounding the Madonna, however, has many other plants which are carefully delineated and arranged roughly in two rows. At the left of Christ near his raised leg grows the most prominent flower, the chrysanthemum, symbolic of chastity.[153] Wormwood, symbolic of bitter remembrance and death as well as of St John the Baptist, sprouts under Christ's feet.[154] Other plants include: (1) aconite, near Christ's foot, for death;[155] (2) veronica, for his Passion and Salvation;[156] (3) parsley, under the Virgin's mantle, which sprouts in May and signifies the Virgin Mary;[157] (4) nettle, above the Virgin's feet, for death or repentance;[158] (5) another chrysanthemum at the far right, for her virginity; and (6) blunt-sorrel, under the chrysanthemum, for martyrdom.[159] In the front row, from the left are: (1) mallow, for salvation;[160] (2) plantain, with its pointed leaves like the spear which pierced Christ's side, for humility;[161] (3) cyclamen, dedicated to the Virgin (red spots in the heart symbolize the bleeding sorrow of the Virgin at the Crucifixion of Christ);[162] (4) toothwort; (5) agrimony; (6) violet, for humility;[163] (7) poppy, because of the cross at its centre symbolic of the Passion of Christ and the Eucharist;[164] (8) wormwood again; (9) wallflower, symbolic of love, both earthly and divine;[165] (10) adonis, symbolic of death and resurrection;[166] and another nettle but fully dead.[167] There are other repetitions, while the grass can be interpreted as symbolic of Salvation, Paradise, and the Church.[168] In sum, these plants celebrate the Virgin, presenting her as the *Virgo Mediatrix*, and the Child who, by his Incarnation and Passion, brought Salvation and hope to mankind. The Child's raised foot not only shows that he is learning to walk but also foreshadows his Resurrection and Ascension.[169]

The water Signorelli painted flowing in parallel areas behind his Madonna and Child alludes to

[152] Ibid. 323; ead., *The Garden*, 25–30. Although there is no *hortus conclusus per se*, she maintains that Signorelli alluded to one via the plants as described in Song of Songs 4: 12, interpreted by St Jerome as signifying Mary's purity (*PL* 23, 254; 22, 510).

[153] Levi D'Ancona (*The Garden*, 96–7) notes it also symbolizes death.

[154] Ibid. 413–14, according to St Bernardino of Siena, 'De Beata Vergine', *Opera Omnia*, vi, art. III, c. 1. According to Bartolomeo Ambrosini, it was called 'St John's herb' because on the night before the birth of the Baptist, people lit a fire under this plant's roots and, out of the tiny fragments of coal, they gathered amulets.

[155] Ibid. 35.

[156] Ibid. 392.

[157] Ibid. 292.

[158] Ibid. 244–5. For Hrabanus Maurus, *De Universo* (*PL* III, 522), it symbolized lust (hence death), but for Dante (*Purgatorio*, XXXI. 85), repentance.

[159] Ibid. 29. On p. 362 she defines the plain sorrel, and she terms (pp. 412–13) the wood sorrel the 'herb alleluia', symbolizing heavenly joy because it blooms around Easter. Signorelli may have confused his botanical cousins.

[160] Ibid. 224.

[161] Ibid. 30, 308–10. Levi D'Ancona identifies three of these.

[162] Ibid. 118–19.

[163] Ibid. 398–401.

[164] Ibid. 321–3.

[165] Ibid. 402. Virgil describes it in *Eclogues* II. 18; the tondo is suffused with a mood equivalent to the *Eclogues*.

[166] Ibid. 30, 37.

[167] Ibid. 244–5.

[168] Ibid. 27, 166–8. In Gen. 1: 11 (and in other biblical passages) it was interpreted by Godfredius, Abbot of Admont (*Homilia 65 in Festum Assumptionis*—*PL* 174, 968A), as the salvation brought to earth by the Baptism of Christ. For Albertus Magnus, it signified the ever verdant faith of the Virgin, who believed in Christ when he was dying (*De B. Virgine Maria Sermones*, in F. de Alva y Astorga, *Bibliotheca Virginalis* (Madrid, 1648), i. 601). For Hrabanus Maurus (*De Universo*—*PL* II, 529) it symbolized Paradise or the Church full of the flowers of virtue.

[169] Levi D'Ancona, *The Garden*, 28.

the Sacrament of Baptism and receives an unusual emphasis. The first area, directly behind the holy pair, separates them from the middle ground.[170] The second flows behind the four nearly nude youths, indicating that they are on an island. The one at the left is in an analogous position to the seated woman at the left of Signorelli's *Pan*, whose composition is also permeated by the same shadows as the *Medici Madonna*,[171] while two blow long pipes like those in the *Pan*.[172] On analogy with descriptions in literature, these figures are Arcadian shepherds from the pagan world, manifestations of the world *ante legem*, a symbol used by Michelangelo in his *Doni Tondo*.[173] A precedent for their presence occurs in Lippi's Adoration tondo (Fig. 3.1), which belonged to the Medici. In Signorelli's *Medici Tondo* the separation of the four youths from the Madonna and Child and their lack of awareness of the holy pair, together with their dreamy and poetic nature, is explained by their pagan status. They were meant to contrast with the initiated, baptized viewer, who beheld the vision of the Madonna and Child. It is significant that there are four, the number of the earth and the material world from which Christians require cleansing. Moreover, to the right grazes a white horse, which evokes a pastoral setting, but symbolizes baser qualities, like pride or lust, of the world *ante legem*.[174] Thus, the *Medici Madonna* contains a tripartite, hierarchical system of the world, typical of the late fifteenth-century mentality, nurtured on syncretistic Neoplatonic philosophy linking heaven and earth.

Both the *Medici Madonna* and the *Pan* have a decidedly Virgilian mood (Vasari notes that both were painted for Lorenzo de' Medici, who fostered pastoral, poetic concepts in his escapist but brilliant circle). And it was Virgil who described in his messianic fourth *Eclogue* the prophecy of the Tiburtine Sibyl foretelling the birth of a baby who would bring the return of the Golden Age.[175] Two of the earliest publications of Virgil's pastoral works occurred in Florence, translated into Italian by Bernardo Pulci in 1481 and 1494, with poems by poets of the Medici circle. In addition, Lorenzo was rhetorically credited (on the Virgilian mode) as having brought about the return of the Golden Age. Virgil's *Eclogues*, set in Arcadia, frequently contain references to Pan, whom Signorelli depicted enthroned like a pagan Christ. Perhaps the following phrase in the fourth *Eclogue* could refer to the content of the two paintings for Lorenzo: 'Even Pan, were he to contend with Arcady for judge would own himself defeated.'[176]

[170] Levi D'Ancona (ibid.) believes that the water is a spring and thus a metaphor of Mary (and that it also represents the fountain of the Canticles).

[171] For the *Pan*, see Freedman, 'Once more Luca Signorelli's Pan Deus Arcadiae', who cites Plutarch's 'the great Pan is dead' from *De defectus oraculorum* (36, 429 D). When Eusebius retold this legend in *Praeparationis evangelicae libri* (V. 17. 6), he explained that the death of Pan meant the victory of Christ. This strengthened the theoretical connection between Pan and Christ, which Ficino reiterated in his *De religione christiana fidei et pietate liber* (ch. 22). Lorenzo himself celebrated Pan in *Altercazione*, IV. 3–6.

[172] The act of blowing on rustic pipes represents a form of communication, whose exact significance we can no longer penetrate.

[173] Eisler, 'Athlete of Virtue', 82–97, interprets them as 'athletes of virtue'.

[174] Ferguson, *Signs and Symbols*, 20. J. Hall, *Dictionary*, 253, adds that the horse symbolizes pride, which is countered by humility (the Virgin). It also relates to the image of the soul from Plato's *Phaedrus*, 246 ff. (which ends with a prayer to Pan)—celebrated by Ficino and

the Medici circle. Wittkower, 'A Symbol of Platonic Love in a Portrait Bust by Donatello'; Janson, *Donatello*, ii. 141–3, no. 323, ill.; Allenen, *Marsilio Ficino and the Phaedran Charioteer*. The image is also illustrated in the background of Signorelli's *Pan*.

[175] See above, Ch. 2. Francesco Sassetti, general manager of the Medici bank, commissioned Ghirlandaio to paint the vision of Augustus with the emblem of St Bernardino of Siena and the Tiburtine Sibyl over the entry of his family chapel in Santa Trinita, Florence. The chapel's iconography interweaves family and civic legends with history and the patron's goals, interconnections that provide us with a view into a mentality which is close to that in the *Medici Madonna*. Borsook and Offerhaus, *Francesco Sassetti*, 29 ff. Müntz, *Les Collections*, 45, notes a copy of Virgil in the 1464 Medici inventory: 'Virgilius cum omnibus operibus . . .'.

[176] Freedman, 'Once more', 138, romantically believes that viewed together—although not meant as a pair—the *Medici Madonna* and the *Pan* projected the basic beliefs of Lorenzo and his circle. For the Golden Age see Gombrich, 'The Renaissance and the Golden Age'; Cox-Rearick, *Dynasty*.

Another area of water in Signorelli's *Medici Madonna* separates the nude youths from the next sliver of land with its ruined triumphal arch, symbolizing the pagan past,[177] and a natural rock arch, the triumph of Christianity.[178] Saplings, identified as aspens, sprout from both.[179] Through the natural arch beyond yet another sliver of water one glimpses a round building, the perfect theoretical form. Its three storeys symbolize the Trinity, while it alludes to round churches, which were frequently dedicated to the Virgin—like round temples of antiquity served for female deities—and to martyria, in this case to Christ's own tomb as a foreshadowing of his Sacrifice. In fact, Signorelli's building bears a resemblance to the Anastasis, built around the Holy Sepulchre in Jerusalem.[180] It could also represent a baptistery, which often took a centralized shape in Italy. In Christianity, it was Christ's death which made eternal life possible, linking the concepts of Death, Baptism, and Resurrection, in a circular fashion harmonious with the tondo shape and linking it to the octagonal Baptistery of Florence, which has a similar revetment of coloured marble and whose eight sides symbolize the eighth day and the Resurrection.[181] Its slightly undulating dome resembles that of the Dome of the Rock in Jerusalem, which Signorelli could have known via prints, especially Breydenbach's woodcut, where it is identified by an inscription as the Temple of Solomon.[182] This allusion would imply that Florence was the New Jerusalem, a popular millenarian theme at the end of the century.[183]

The equivocal nature of this tholos may have been meant to be pondered by the viewers of the syncretistic 1490s, although in the context of this tondo, with its grisaille bust of St John, it was surely meant to connote a baptistery. It is framed by the natural arch, which, unlike the man-made one on the left that is being split apart by plants, supports sprouting growth, and implies the triumph of Christianity via Baptism. While John the Baptist is not present in the actual tondo, his prominence on the central axis of its frame, together with the abundance of water, argues that the ensemble's iconography pivots around Baptism. By being baptized, Christians attain eternal life, as foretold by the prophets and realized through Christ's Death. In essence, this tholos rounds out the extremely rich symbolism of one of the most complicated iconographies depicted in a tondo, implying that a specific adviser informed some of the artist's decisions.

Signorelli's very different, simple iconography in his seemingly later *Parte Guelfa Tondo* (Fig.

[177] Levi D'Ancona, 'Medici Madonna', 330, citing Hrabanus Maurus, interprets the ruin as the crumbled kingdom of the Jews, and the branches as Christ (Isa. 11: 1: 'And there shall come forth a rod out of the stem of Jesse, and a branch shall grow out of its root.').
[178] Levi D'Ancona, *The Garden*, 27, believes that the natural arch refers to Mary as 'The Gate of Heaven', citing St Bonaventura as well as St Peter Damian's epithet 'Magnificent door of life'.
[179] Ibid. 27–8, 57. Aspen is a symbol of lament and the Passion of Christ, while saplings are the virtues of the Virgin—Charity, Chastity, and Piety—as well as the Redemption realized by the cross of Christ.
[180] E. B. Smith, *The Dome*, pls. 1–6. See Krautheimer, 'Iconography', 1–33; Lehmann, 'Dome', 1–27; Ch. 2. Signorelli's structure bears a startling resemblance to a design in the Département des Arts Graphiques, Musée du Louvre, Paris for a mausoleum sketched by Leonardo; Pedretti, *Leonardo architetto*, 122 ff., figs. 29–30, who dates it stylistically to 1507, the very year when an Etruscan tumulus was found on 23 Jan. near Castellina.
[181] L. Steinberg, *Sexuality of Christ*, 156–7. The numerological significance of the octagon is linked with eschatological time and the Resurrection of Christ eight days after he entered Jerusalem.

Mausolea, sacristies, and baptisteries were connected in thought, and some centrally planned baptisteries copied the Anastasis in Jerusalem where Christ had risen. Signorelli's building has the three elements of the Anastasis: ambulatory, gallery, and clerestory, mentioned in Krautheimer, 'Iconography'.
[182] Both the Dome of the Rock and the Holy Sepulchre are represented in Breydenbach's *Peregrinatio in Terram Sanctam*. The structure also appears in Ghirlandaio's *Nativity* in the Sassetti Chapel, where Ghirlandaio painted portraits of Lorenzo de' Medici and his family, advisers, and Augustus' vision (Borsook and Offenhaus, *Francesco Sassetti*, pls. 24–5a & b).
[183] The theme of Florence as the 'New Jerusalem', occurs in the Old Sacristy (Ch. 2); see Schevill, *History of Florence from the Founding of the City through the Renaissance*, 350; Peters, *Jerusalem*. In the 1490s the Florentine republican tradition and apocalyptic Christian millenarianism coalesced in the belief that Florence was a living creature with a destiny shaped by Divine Providence. F. Gilbert, 'Florentine Political Assumptions in the Period of Savonarola and Soderini', 209 ff.; Weinstein, *Savonarola*, 34 ff.

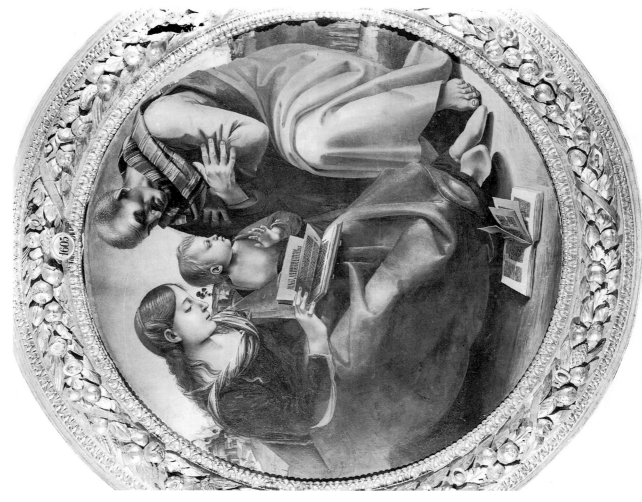

FIG. 7.33. Luca Signorelli, *Parte Guelfa Tondo*, 1490–1500. Galleria degli Uffizi, Florence

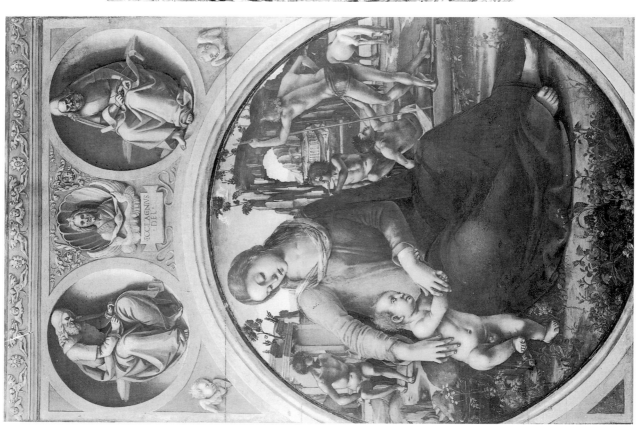

FIG. 7.32. Luca Signorelli, *Medici Madonna*, c.1492? Galleria degli Uffizi, Florence (colour plate X)

7.33) is nevertheless related to the *Medici Madonna* and successful.[184] Vasari saw it in the Udienza of the Captains of the Parte Guelfa, where later Borghini also places it.[185] Although Signorelli may have been in contact with the Parte Guelfa via his Cortona connections, because the exact nature of that association is unknown, only circumstantial evidence points to the tondo's commission by the Parte Guelfa.[186] Nevertheless, the gold highlights throughout the painting, especially in the Virgin's hair and red cloak, testify to the richness of its commission.

The iconography of the *Parte Guelfa Tondo* is innovative, while its breadth and simplicity demonstrate that Signorelli was on the brink of a High Renaissance style, making it easy to understand why it may have been influential on Michelangelo. Its composition has been reduced to three large protagonists close to the picture plane. At the left introducing the viewer into its space is a very girlish Virgin, portrayed as the *Madonna della Sapienza* reading or pondering ideas from a book, whose illegible text has the enlarged red initials and black letters of illuminated manuscripts and printed books.[187] The book at her feet, whose pages blow in the wind, fills in the exergue, underlining that Christ is the fulfilment of the Word as well as reminding viewers about their devotional responsibilities. The Child, who is the unusual age of three or four years, holds his left hand up as he comments on the Madonna's text, while Joseph kneels in adoration with his hands crossed over his chest in recognition of his divine foster-son. There is no biblical or apocryphal source for this singular depiction of the Holy Family. A gap exists in the visual tradition of the christological narrative between the Flight into Egypt and the moment when Christ reaches 12 and preaches in the temple (Luke 2: 41). The Infancy Gospels of the Apocrypha, especially the Gospel of St Thomas and the Gospel of Pseudo-Matthew, fill this void in Jesus's earthly existence. They portray the Child as precocious in wisdom and miracle-working and Joseph as nurturing, although neither contains a scene like the one Signorelli painted. In the canonical Bible, it is the Gospel of Luke, especially, and Matthew which stress Jesus' association with the House of David and his earthly lineage through his paternal line (Luke 1: 27). Signorelli's scene takes place in Nazareth, where the Holy Family settled after returning from Egypt. It derives, I believe, from the Gospel of Luke in the verse immediately preceding Christ's teaching in the Temple of Jerusalem (Luke 1: 39–40): 'And when they had fulfilled all things prescribed in the Law of the Lord, they returned to Galilee, into their own town of Nazareth. And the child grew and became strong. He was full of wisdom and the Grace of God was upon Him.' Because Signorelli's scene lacks a visual tradition, it allowed the artist freedom to be more inventive. Moreover, the *Parte Guelfa Tondo* is significant sociologically because by depicting this later stage in Christ's childhood, it reflects the profound change in attitudes towards children and the family (Ch. 4) and thus was ideally conceived for a domestic setting. Reflecting this environment, both Mary and Joseph bend over to conform to the panel's shape as they recognize the special status of their son. Further, their postures may partially result from Signorelli's exposure to circular, convex mirrors and his desire to transfer their symbolism to this tondo (Ch. 4). One notices that the knees of the Virgin and Joseph, along with the central area of the painting, appear to bow out slightly. No wonder that Vasari considered it a masterpiece, calling it *bellissimo*.[188]

[184] Inv. no. 1605 in the Galleria degli Uffizi, Florence, oil on panel with a 124 cm. diameter, which seems to have a ring of raw wood around its circumference. Florence, *Gli Uffizi*, 517, ill. Its surface seems to have tempera-like qualities.
[185] Borghini, *Il Riposo*, 366.
[186] See G. Mancini, *Signorelli*, 169–70.
[187] J. Hall, *Dictionary*, 329; the Book of Wisdom makes her the *Mater Sapientiae*.
[188] Vasari (Milanesi), iii. 637.

It is Signorelli's figure of Joseph, distinguished as divinely inspired, if not exactly on a par with his earthly spouse and her child, that is unprecedented. This type with a closely shaved head resembles the Joseph figure in two other works by the artist, implying the use of the same model or type for all three.[189] Joseph's prominence in the *Parte Guelfa Tondo* can be partially explained by his role as Christ's surrogate father, an idea stressed in late quattrocento Florentine theology (Ch. 4). In fact, he is the tallest figure in the composition, a distinction that prepares us for the *Doni Tondo*. His position is explained only in part by the naturalism of the late Quattrocento that allowed artists to depict a more secular family unit, which would have been patriarchal. The more pastoral, down-to-earth attitude of St Antoninus had emphasized Joseph's role as a Christian teacher, to which Signorelli alludes in this tondo dealing with the education of Christ. Piety and humility were part of Antoninus' characterization of Joseph, traits that Signorelli gave him in the *Parte Guelfa Tondo* in his bare feet and hands crossed over his breast. Antoninus' belief in the ecclesiastical symbolism of the marriage of Joseph and Mary (as well as the virginity of Joseph) also find expression here.[190] With its unusual emphasis on Joseph, the *Parte Guelfa Tondo* was a radical statement, to be followed only by a few others, that was appropriate for a domestic environment.

Raffaello Sanzio

While he produced fewer tondi than either Signorelli or Botticelli and their workshops, Raphael ranks alongside Botticelli as one of the few artists to exploit fully the compositional possibilities of the round shape (see App.). He seized on this early in his career, as seen in Fig. A83, one of his drawings in which he viscerally grapples with some of the problems inherent in the round format.

To characterize his success with the form, we turn to Raphael's *Alba Madonna* (Fig. 7.34), which is usually dated to his early Roman period on convincing stylistic grounds. It has always been popular, and is known in numerous copies.[191] It combines traits gleaned from his study of Michelangelo's tondi and Leonardo—an evolution documented in the artist's drawings—with heroic Roman ideas. Its most revelatory preparatory drawing is a two-sided sheet (Fig. 7.35),[192] whose verso contains a study of a male assistant in the pose of the Madonna and a half-length

[189] In the rectangular Holy Family in the National Gallery, London (M. Davies, *The Earlier Italian Schools*, 484–5) and the *Berlin Tondo* (Fig. 4.2).

[190] Sparks, 'Antoninus on Joseph', 429 ff. In his *Chronicles* (based on the Infancy Gospels), he also wrote extensively on Joseph, following St Thomas Aquinas (*Summa*, III, q. 29, art. 2). Sparks (ibid. 439 n. 34) cites J. J. Davis, 'A Thomistic Josephology', *Cahiers de Joséphologie*, 8/2 (1960) (continued in 14/2, 1966). Antoninus wrote in his *Summa Moralis* (P. IV, col. 950): 'Since Mary could be espoused only to a man who would be of the tribe of Juda and the family of David, from the genealogy of the spouse, that is, of Joseph, is taken her genealogy and that of Christ her Son.'

[191] Inv. no. 1937.1.24(24)/PA in the National Gallery of Art, Washington, DC, formerly in the Andrew W. Mellon Collection, oil on panel transferred to canvas with a 94.5 cm. diameter. The museum file notes that the original vertical wood grain of the panel indicates that there were possibly two vertical joints, one at the centre of the painting and the other four inches from the right edge, although in some ways they are more characteristic of splits in the panel. Dussler, *Raphael*, 35–6, ill., cites copies. The earliest reference to the tondo, which came from the church of the Olivetani (Santa

Maria del Monte) in Nocera dei Pagani, near Naples, in 1623, led Dussler to suggest that it was commissioned and donated by Paolo Giovio, who became Bishop of Nocera in 1528. Giovio, however, did not come to Rome until 1514 (Ettlinger and Ettlinger, *Raphael*, 118), although it is possible that he obtained the work from another source. Friedman, 'The Plant Symbolism of Raphael's *Alba Madonna* in the National Gallery of Art, Washington', 216, criticizes the theory that Julius II may have been the patron (based on the association of the Della Rovere oak with the tree stump) on the grounds that this tree is not identifiable. Wasserman, 'The Genesis of Raphael's *Alba Madonna*', 35–7, resurrects this untenable theory and suggests without proof that Bernardino Orsini, Bishop of Nocera, might have been the patron.

[192] Inv. no. 456/7 in the Musée des Beaux-Arts, Lille, red chalk and pen and brown ink, measuring 421 × 271 mm. (Knab *et al.*, *Raphael: Die Zeichnungen*, 592, nos. 384–5, ill., lists it as inv. nos. 456ʳ, 456ᵛ). Joannides, *The Drawings of Raphael*, 202, nos. 278ʳ, 278ᵛ, ill., dates it 1509–10 and reproduces a drawing for St John in the Boymans–van Beuningen Museum, Rotterdam, as well as a sheet (also related to the *Madonna della Sedia*) in the Fitzwilliam Museum, Cambridge (ibid. 203, nos. 279, 280).

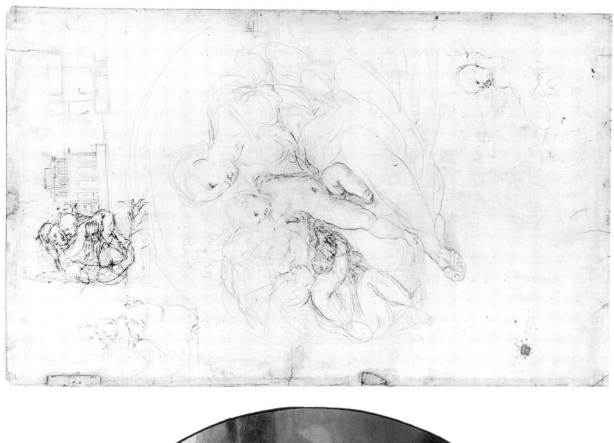

FIG. 7.35. Raphael, *Drawing with Studies for the 'Alba Madonna' and the 'Madonna della Sedia'*, c.1508–9. Musée des Beaux-Arts, Lille

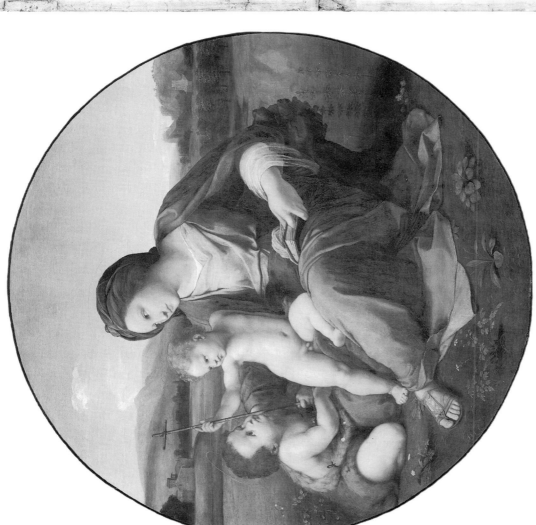

FIG. 7.34. Raphael, *Alba Madonna*, c.1508–9. Andrew W. Mellon Collection, National Gallery of Art, Washington, DC

embracing Madonna and Child which fits into a round format. The recto has at the upper left two smaller sketches of the Madonna, Child, and young St John in a rectangular format, flanked by an elevation of a round 'temple' and a plan of a square palazzo with a courtyard, the perfect forms of the Renaissance. As a group, they resemble stream-of-consciousness notations that reflect Raphael's indecision over the panel's composition, weighing a circular against a rectangular format, heavenly implications versus earthly ones. At the centre of the recto is a group of three figures circumscribed by quickly drawn elliptical lines. They enclose an elongated Madonna of Humility and a standing Child who leans against his mother, while St John holds a lamb up to him, as in Leonardo's *Madonna, Child, and St Anne* (1506). At the upper right is a faintly indicated round structure, almost like a recollection of the building in Signorelli's *Medici Madonna* (Fig. 7.32). Other drawings also record the artist's struggles with this composition. It is only in the final painting where the ideas from the studies converge to create the profound and eloquent meaning of this image.

The *Alba Madonna* reflects the impact of the Roman environment on Raphael at the time of the Stanza della Segnatura. Its figures are arranged obliquely on a diagonal, integrated compositionally and psychologically by the cross, which both children grasp, and by the gazes of its figures. For the first time in Raphael's oeuvre, the contours of the seated Madonna and the other figures harmonize with the circular form. In fact, the entire composition is orchestrated with curves in mind. The weighty Madonna, whose classicizing drapery gives her the appearance of an ancient goddess, is warm, tender, and accessible; she has a grandeur that does not require the thin halo over her head. It is, however, her sandaled foot (which resembles that of the *Apollo Belvedere* in the papal collection, a sculpture Raphael would employ with more exactitude in his *Madonna of Francis I*), where we sense the beginning of the artist's more archaeological approach to antiquity. The tondo's foreground features botanical symbolism, including the dead tree against which the Madonna leans, alluding to the impending Passion.[193] The plant held by St John is the anemone, known as the 'Easter Flower' or 'Flower of Resurrection', because of its ancient association with immortality (it also symbolizes sorrow and death), while other plants in the work refer to the Virgin.[194] With this plant symbolism, simplified from that in quattrocento paintings, Raphael infused the work with a deeper meaning while embellishing its problematic exergue, partially disguised by the Madonna's drapery.

Yet it is really in the undocumented *Madonna della Sedia* (Fig. 7.36; Colour Plate XI) where Raphael, still struggling with the tondo format, pushes the shape to its ultimate balanced potential,[195] causing Jacob Burckhardt to remark of it: 'The Madonna della Sedia sums up, as it were, the entire philosophy of the tondo.'[196] In its early stages, however, it was envisaged as a rectangular painting close to the *Madonna della Tenda* (Alte Pinakothek, Munich). Moreover, it is close to several sketches on the Lille sheet (Fig. 7.35) related to the *Alba Madonna*, to which it is inextricably linked.

The *Madonna della Sedia* is the consummate Renaissance tondo.[197] Its intimate, half-length scale

[193] Friedman, 'Plant Symbolism', 216 ff.
[194] Ibid. 216–17; Levi D'Ancona, *The Garden*, 44–5.
[195] Inv. no. 151 in the Galleria Palatina di Palazzo Pitti, Florence, oil on panel with a 71 cm. diameter. Nagler, *Neues allgemeines Künstler Lexikon*, xvi. 403–4, lists copies; Dussler, *Raphael*, 36, ill.; Gombrich, 'Raphael's *Madonna della Sedia*'. A related drawing in the Cleveland Museum of Art has a Madonna and Child with St

John inscribed in circular as well as square lines (inv. no. CMA 78.37; Joannides, *Raphael*, 201, no. 273, ill.).
[196] Burckhardt, *Vorträge*, 322.
[197] Gombrich, '*Madonna della Sedia*', 65, recounts a diverting tale of how the tondo was invented from the bottom of a wine barrel, as related in a book by Ernest von Houwald (1820) and illustrated in a lithograph (1839) by August Hopfgarten.

is especially appropriate to a domestic, devotional panel. The seated Madonna, who at first glance does not appear to be the Virgin Mary because she is so casually presented, looks boldly at the viewer. She wears a scarf wrapped around her head like a turban (an exotic motif Raphael had used for Charity (Fig. A85), whose composition is related to this tondo). It has the effect of a secular halo although both St John and the Madonna have thin gold haloes, while there are gilt rays, remnants of a cross nimbus, around the Child's head. The Madonna's luxurious patterned shawl curves around her shoulders, adding to the sumptuosity of the environment and increasing the feeling that the tondo was a costume piece in which models were used.

The painting's incredibly subtle composition pivots around the formal theme of the circle, marking the *Madonna della Sedia* as a masterpiece in the form. Every element is a variation on the curve, yet all parts are subservient to the whole. This underlying gestalt explains why the resulting harmony is no mystery. On one level, the panel is a formalistic tour de force, as though its theme really were the circle and its curves, as rendered in the haloes, the Madonna's turban, the liquid orbs of the eyes, the faces, the contours of the figures, the arcs of the arms, the curving cloth back of the *sedia* (chair) that gives with the weight of the Virgin, etc. The most obvious circular element is the spherical bronze finial on the opulent chair, made from material indicative of a wealthy household. It is a perfect sphere which echoes the format and implies both eternity and the cycle of birth–death–rebirth in the Christian doctrine made possible by Christ's Sacrifice. This finial is the prototype for one on the papal chair Raphael rendered in his *Portrait of Leo X (Giovanni de' Medici) and his Nephews* (1517–19), a dynastic portrait containing heraldic emblems.[198] Just as the orb in the papal portrait refers to the Medici *palle* of the Pope's coat of arms, and the acorn finials on the papal chair in Raphael's *Portrait of Julius II* cite his family symbol, the Della Rovere oak, the finials in the *Madonna della Sedia* may be an allusion to the work's unidentified patron. While it is impossible to prove that it was painted for Leo X, it is tempting to speculate that this might have been the case, especially since its provenance is traced to the Medici in the sixteenth century, and Leo was one of Raphael's major patrons.[199] It has been noted that its composition reflects the illusionistic effects of a convex mirror, alluding by its shape and painted forms to this symbol of the Virgin's purity.[200] This surface effect is especially noticeable in the dramatically foreshortened elbow of the Child, which juts out three-dimensionally to seemingly bow out the space. The effect is more pronounced and accomplished than in Fig. A84 and also is appropriate for the close-up format that more nearly approximates a reflection in a mirror.

In sum, the panel represents the culmination of Raphael's tondi and an optimum solution to the devotional image of the Virgin and Child. Its accessible *dramatis personae* are both earthly (earthy) and heavenly, because they are inscribed in the perfect form symbolic of divinity and eternity. Therefore, it encapsulates the ephemeral equilibrium of the High Renaissance, between the natural and the ideal, the earthly and the spiritual.

[198] Jones and Penny, *Raphael*, 165–6, 168, ill., point out that in the portrait the Hamilton Bible in the Pope's own collection is open to the first page of the Gospel of St John. Not coincidentally, Leo's name was Giovanni.

[199] It was recorded in 1589 in the collection of the Grand Dukes of Tuscany and displayed in the Tribuna of the Uffizi.
[200] Schwarz, 'The Mirror in Art', 98.

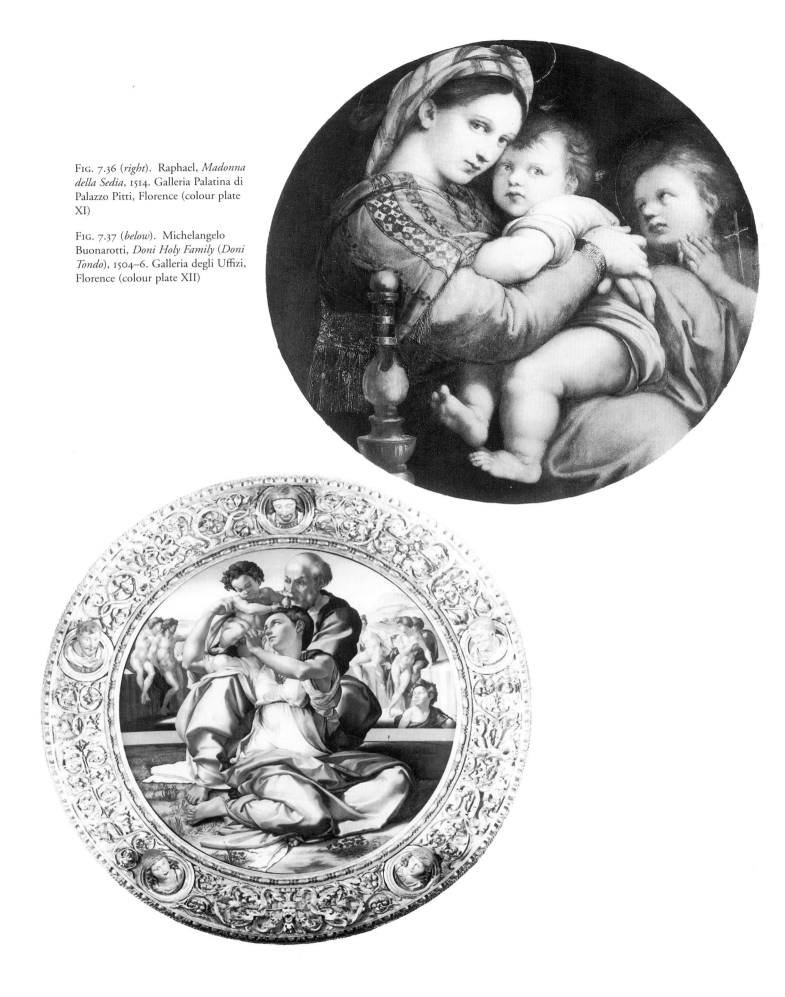

FIG. 7.36 (*right*). Raphael, *Madonna della Sedia*, 1514. Galleria Palatina di Palazzo Pitti, Florence (colour plate XI)

FIG. 7.37 (*below*). Michelangelo Buonarotti, *Doni Holy Family* (*Doni Tondo*), 1504–6. Galleria degli Uffizi, Florence (colour plate XII)

…elo Buonarotti's *Doni Tondo*

Similarly, Mich… …*Don. …ndo* (Fig. 7.37; Colour Plate XII), which is the only documented, finished easel pai… …ely executed by him, presents the apogee of tondi containing the Holy Family theme. Re…ed …o sculpted tondi (Figs. 6.40–1), it was made for Agnolo di Francesco Doni and remaine… …ion of the Doni family at least until 1564, although its commission date is unknown.[201] …it mention of the work occurs in a letter of 1549, written by the expatriate Anton Francesco Doni from Venice to a friend relating what he should see while visiting Florence.[202] Then, Vasari mentions the painting in both editions, and Condivi also discusses it.[203]

Agnolo Doni, a friend of Michelangelo from a prosperous Florentine family of clothiers and dyers, settled in the quarter for that trade near Santa Croce. In 1503–4 he constructed a palace on the Corso dei Tintori and ennobled his status through marriage to Maddalena Strozzi.[204] According to Vasari, a rift developed between Michelangelo and Doni when the patron refused to pay the agreed 70 ducats for the tondo. After much disagreement, Michelangelo was victorious and Agnolo paid double the original price.[205]

However, the important question remains: when was the tondo commissioned? The answer is intimately associated with the panel's iconography. The tondo has been dated to 1503/4, the year of their marriage, and interpreted as a commemoration of it and a celebration of the virtues of the Christian conjugal bond under the protection of the Holy Family.[206] It has also been dated to 1506, on the basis of its stylistic similarities with the Sistine Ceiling (1508–12) and the thesis that its iconography is linked with the Doni dynasty and the hope for an imminent child.[207] Another scholar, who dates the tondo to 1506, believes that it was commissioned after thirty months of a childless marriage and that its meaning is linked to the word *donare* in its optative mood expressing petition—*doni*, God give—in this case, children (Ch. 4). Yet another scholar arrived at a 1506 *terminus post quem* arguing that one of the five nude figures in the background depends on the *Laocoön*, which was only excavated in 1506 in the presence of Michelangelo, and that these figures could reflect a programme by Bramante for displaying antique sculptures in an exedra of the Belvedere.[208] It is also possible that the tondo was commissioned for the marriage and, knowing Michelangelo's habits of procrastination, just took until 1506–8 to complete. The Doni's first

[201] Inv. no. 1456 in the Galleria degli Uffizi, Florence, tempera *grassa* on a warped convex poplar panel, divided into five vertical planks, the largest in the centre, with a 120 cm. diameter measuring with the original frame 172 cm. See L. Berti *et al.*, *Il Tondo Doni*, ill., who on p. 38 mention two copies, one of *c*.1530 by Bacchiacca (App. n. 300), and the anonymous Flemish one in the Fogg Art Museum, Cambridge, Mass. (in a rectangular format on loan from the Museum of Fine Arts, Boston). Florence, *Gli Uffizi*, 383, ill., notes that it was first mentioned in the Anonimo Magliabechiano (1537–42). Hirst, *Michelangelo, Draftsman*, 30, no. 10, reproduces a preparatory drawing after a male model for the Madonna's head in the Casa Buonarotti, Florence.

[202] Doni, *Disegno del Doni*, 47 ff. (also quoted in Hayum, '*Doni Tondo*', 224 n. 3), after the supposed date for the Anonimo Magliabechiano.

[203] See Tolnay, *Youth*, 163 ff., for a historiography and for his

theory that it embodies God's tripartite plan for the salvation of humanity: *ante legem*, *sub lege*, and *sub gratia*.

[204] Hayum, '*Doni Tondo*', 225 n. 20, cites the pertinent document. Cecchi, 'Agnolo e Maddalena Doni committenti di Raffaello', dates it 1506, gives the marriage date as 31 Jan. 1504, and attributes the frame to Marco and Francesco del Tasso.

[205] Vasari (Milanesi), vii. 158 ff.

[206] Hartt, *History*, ed. Wilkins, 463–4.

[207] Hayum, '*Doni Tondo*', 212–20. She cites (p. 226 n. 31) as evidence that Agnolo had plans for a family dynasty, the Poligrafo Gargani, D775a, Biblioteca Nazionale Centrale, Florence, which records that he began a family sepulchre in the Badia in 1526.

[208] Natali, 'L'Antico, le scritture, e l'occasione: ipotesi sul Tondo Doni', cites (p. 36 n. 1) G. Poggi, *Kunstchronik*, NF 18 (1907), 229–300, who discovered the frame. (The English version is 'Dating the Doni Tondo through Antique Sculpture and Ancient Texts'.)

surviving child was a girl, born in September of 1507 and named Maria. A little over a year later, a second child, a boy, was born and named Francesco after Agnolo's father, as was the custom.[209]

The panel's original frame, an integral part of the work, is assumed to have been designed by Michelangelo. Suggestions for its execution range from Michelangelo himself to the brothers Del Tasso and Baccio da Montelupo.[210] It is different from more customary tondo frames of garlands with fruit and/or flowers, featuring instead five heads protruding from roundels derived from Ghiberti's *Porta del Paradiso*, a name which, according to Vasari, Michelangelo bestowed on it.[211] Taking the associations further, these heads allude to the location where all newborn Florentines were baptized, stressed in the *Doni Tondo* by the presence of young St John. The two lower heads are usually identified as pagan sibyls (although the Annunciate Virgin and Angel or two angels have been suggested),[212] while two Old Testament prophets are positioned on either side of Christ at the apex. This hierarchy is the *ante legem, sub lege, sub gratia* one found less diagrammatically on the Sistine Ceiling and in Signorelli's *Medici Madonna*. The number five, the number of the roundels of the frame and the number of youths in the background, is a leitmotif unifying the painting and its frame. It recalls the number of the wounds of Christ and the letters in the Madonna's name (MARIA—the name of the first surviving Doni child), as well as the decades in the rosary. In addition, the frame has not only the Strozzi crescent moons at the upper left, Angelo's homage to his esteemed wife, but also lions' heads in the surrounding vegetal grotesque ornament, referring to Doni's coat of arms (a gold rampant lion and three crescent moons with points towards the right on a diagonal), alluding to the marriage itself.[213] The moons are bound together with ribbons that interlock with the lions, perhaps a further reference to the marriage bond. If these motifs were heraldic they functioned as pictographic devices, a cryptic homage to the marriage, but did not constitute a coat of arms *per se*.

The *Doni Tondo* is based on a melange of sources which Michelangelo had digested to forge his inimitable style, whose seeming simplicity belies its complexity. Among these are: Leonardo's highly integrated figures, Raphael's essays on the Madonna, Signorelli's *Medici Madonna*, and a group of ancient sculptures. For the Madonna's pose, the suggested sources include an ancient torso of a crouching figure.[214] The position of the Child on the Madonna's shoulders derives from an antique cameo in the Medici collection echoed in the medallion in the Medici Palace courtyard with the infant Dionysos (the dying and resurrecting god associated with grapes and flesh and a parallel of Christ) (Figs. 1.2–3).[215] The *pietra serena* line bisecting the tondo derives from the exergue of ancient coins, although its symbolism, demarcating holy ground, will soon be apparent.

Michelangelo's composition is divided into three spatial and figural areas: the foreground with the Holy Family; the middle with St John; and the background on whose perimeter perch five nude youths (ambiguously they inhabit both John's space and the background). These constitute the tripartite divisions of the world.

[209] Hayum, '*Doni Tondo*', 226 nn. 26–7.

[210] Ragghianti, *Arte, fare e vedere—dall'arte al museo*, 45–52, proposes Michelangelo as its sculptor on comparison with the wood crucifix in the Casa Buonarroti; Caneva, 'La cornice del Tondo Doni: nota storico-critica', 49–52; Schleicher, 'Cornice del Tondo Doni'; Cecchi, 'Agnolo e Maddalena', 429–39; id., 'Les Cadres', 23–4, attributes it to the Del Tasso shop and notes that it is made of several pieces of pear wood mounted on poplar; Sabatelli, *La cornice italiana*, 43–4.

[211] Vasari (Milanesi), ii. 242.

[212] Natali, 'L'Antico', 34.

[213] Ibid. 29 ff. Hayum, '*Doni Tondo*', 225 n. 16.

[214] Natali, 'L'Antico', 21 ff. Further, he thinks that the Virgin's head is taken from an antique sculpture of the dying Alexander in the Uffizi (see figs. 2–7, 21–3).

[215] G. Smith, 'A Medici Source for Michelangelo's Doni Tondo', figs. 2, 3.

The Holy Family is clustered into a seemingly inseparable unit, wherein Christ's and Joseph's heads appear to be on nearly the same level, referring to the patriarchal chain, to the fact that Christ traced his lineage from the House of David through Joseph, an argument celebrated in tondi. The Child's action has been hotly debated: is he stepping up to his mother or is she about to release him to his foster-father? While the pose of the Child has been connected with figures carrying vases in ancient art,[216] the manner in which the Child stands partly on the Madonna and partly on Joseph makes it a wonderfully ambiguous posture in which it is nearly impossible to determine the direction in which he is going.[217] We should note that the Child steps on the purple cloth of Joseph's robe or the yellow/orange of his cloak. This is the only area where all three of the main figures touch, although there is an intricate chain of touch within the trio. Michelangelo intentionally chose complimentary yellow and purple for Joseph's drapery (also the colours he wears in the Botticelli shop tondo in the Gardner; see App.). Purple is a colour associated with royalty and a sign of imperial power, thus further allying the Child with the House of David as well as with God the Father, through Joseph's line. In Christian doctrine, purple is the colour of sorrow and penitence, thus also foreshadowing Christ's sacrifice. It is used in the Church's calendar for Good Friday, and with yellow, symbolic of divinity and revealed truth, for Easter.[218]

Michelangelo's reasons for placing the Child and his earthly family in an actively ambiguous composition most likely derive from his desire to stress its dynamic unity.[219] The equilibrium of the Child's posture and the interlocked figures seem to extol the values of a unified family with the parents caught in a reciprocal action of giving the Child. As discussed, St Antoninus was a champion of Joseph as well as of the family and no doubt his ideas found reflection in Michelangelo's arrangement. But he also saw in the marriage of Mary and Joseph a higher meaning, an ecclesial symbolism (noted by St Bonaventura as the most perfect of unions), and remarked that the Law of the Gospel is that the Spirit himself is The Gift.[220] Because Christ is physically on top of the Madonna, he assumes the time-honoured ancient position of the victor over the vanquished, embodying the principle of the New Order triumphant over the Old. Mary, who was born under the Old Testament, is superseded by the New, an idea echoed in the tripartite hierarchy of the frame roundels (sibyls, prophets, Christ). By suggesting that Christ is about to step on Mary's arm, Michelangelo conveys that Christ derived his nature from her but at the same time is superior to her, an expression of the Incarnation.[221] The Madonna of Humility with bare feet is the central focus. Her sanctification is referred to not only by the Child's gesture of laying his hands on her head, but also by the closed devotional book in her lap (symbolic of the *Madonna della Sapienza*). The book is customarily represented as open, leading to the conclusion that the image originated in a sermon by St Antoninus with an explanation of three reasons why the closed book symbolizes Mary.[222] The book also implies that the Madonna was in the middle of her devotions.

[216] Tolnay, *Youth*, 165.
[217] Hartt, *History*, 467, posits that the poses in the *Doni Tondo* may refer to the prophecy of the Virgin Birth in Lam. 1: 15: 'the Lord hath trodden the virgin the daughter of Judah, as in a winepress'. It is dropped in the edition edited by Wilkins. Levi D'Ancona, '*Doni Madonna*', 50 n. 68, claims that the position of the Child is based on Job 31: 36: 'That I may carry him upon my shoulder . . .'.
[218] Ferguson, *Signs and Symbols*, 153.
[219] Liebert, *Michelangelo: A Psychoanalytic Study of his Life and Images*, argues that it is due to his tragic relationship with his mother. L. Steinberg, 'Doni Tondo', 139, states that 'no woman takes a baby in her arms with furled fingers' and believes that the action is slanted towards the Madonna releasing him to Joseph; in his 1994 talk, 'Concerning', he posited that the male figure was handing the Child to the Madonna. See also Spitz, *Art and Psyche: A Study in Psychoanalysis and Aesthetics*, 65–7.
[220] Sparks, 'Antoninus on St Joseph', 453.
[221] Levi D'Ancona, '*Doni Madonna*', 44.
[222] Levi D'Ancona (ibid. 50 n. 68) cites the sermon *De nativitate sanctae Mariae sermo* 5.1, in Alva y Astorga, *Bibliotheca Virginalis*, ii. 472. See n. 80 above. Because the book is closed and sealed, it is like Mary's Virginity.

In his 1994 talk, Leo Steinberg addressed other features of the *Doni Tondo*. He reviewed his theory that the patriarchal figure is not Joseph but God the Father to explain why the Virgin is placed between his thighs in an obvious generational allusion. He believes that this juxtaposition would have been impossible if the figure were Joseph and supports his argument by stating that Michelangelo used the same bald type for God the Father. (I believe that Michelangelo represented him too humbly for God the Father, although a double reading could have been intended with Joseph the protector stepping in for God the Father). Mary symbolizes the Church, while the hovering posture of the Child prefigures the raising of the host. Steinberg argues that the five background figures are not there to be baptized, because John turns his back to them. Further, he is strongly against the idea that these nudes are Platonic homosexual figures, 'banishing forever the spectre of sodomy'. (I agree with the conclusion that Michelangelo did not intend them as homosexuals, but believe that his sublimated sexuality expressed itself subconsciously.) Steinberg offers instead the idea that they are wingless angels. What he does not address is the fact that in late quattrocento Florence there already existed a tradition of wingless angels. Take, for example, tondi by Botticelli; however, none of Botticelli's are nude. Nudity to Michelangelo at this stage in his life was a symbol of purity as well as an idealistic celebration of human dignity. Steinberg interprets the cloth the figures hold as a prefiguration of the shroud in which they are trying to wrap themselves (as in his *Madonna of the Stairs*); this is the ultimate offering of love (that they are immortal and are willing to take on death), however, he admits that angels cannot die, cancelling his argument. Steinberg also connects the cloth with Doni's occupation as a weaver and posits that these beings sit on a semicircular rock signifying the foundation of the apse of the Church, as well as the shape of the Strozzi crescent, thus tying panel to frame.[223]

Hayum interprets the panel as stressing lineage (patrilineal), and thus for Doni the establishment of an important family. She adds another level by associating it with the flood subjects from Ovid's *Metamorphoses* depicted on the versi of Raphael's portraits of Agnolo and Maddalena Doni. She identifies the *Doni Tondo* background nudes as the five sons of Noah with the two righteous sons (Shem and Japheth) on the left (Christ's right) and comments on the importance of Noah, the father of fathers, and his relevance to Tuscany and Florence.[224] Although Hayum does not fully explain the flood imagery, the versi of Raphael's portraits contain a similar stress on propagation, an idea not foreign to works of art of the period.[225] However, she neither grapples with the isolation of the youths, nor explains why, if the good sons are ashamed of their father's nudity, they themselves are nude.

Hartt also offers some iconographical observations that are pertinent. He prefaces his discussion by stating that the tondo's difficult meaning has provoked some farfetched explanations. (This is

[223] Ch. 4 n. 47. Like Steinberg, Verdon, 'Greek Love', argues against Levi D'Ancona's interpretation of the youths as homo-sexuals, while acknowledging a homoerotic content. He believes that the work's harmony derives from Ficino's *Convivium*, a mystical Christian commentary on Plato's dialogue of the same name. Michelangelo was exposed to these ideas while in residence in the Medici Palace, although many of them permeated the Christian tradition. Certainly Michelangelo's poetry, as well as his art, reveal a familiarity with Neoplatonic concepts, such as the threefold form of love that finds expression in the *Doni Tondo*, beginning with the possible carnal variety of the nude youths.

[224] Hayum, '*Doni Tondo*', 211 ff. Her discussion of circular T-O maps showing the world after the flood is interesting. One of the interpretations of the Sistine Ceiling also puts a generational slant on its programme which is connected with the *Liber Concordiae* of Joachim of Fiore (a work with many circular *rotae*; Bull, 'The Iconography of the Sistine Chapel Ceiling').

[225] As in a triptych with the Madonna and Child by Hugo van der Goes in the Städelsches Kunstinstitut, Frankfurt. Its wings contain portraits of a young couple, while its frame has coats of arms and the inscription *En Esperance* (Hayum, '*Doni Tondo*', 220, 232 n. 87).

partially owing, I believe, to Michelangelo thinking in levels and to the personal nature of both his art and thought.) Hartt also cites the word 'doni', pointing out that a prayer for the Octave of Epiphany asks God to look down in mercy on the gifts of his Church, 'by which we offer "that which is signified, immolated, and received by these gifts; Jesus Christ"; *doni* is the Italian for "gifts", *dona*, the Latin'. Hartt adds that the Epistle for the fifth Sunday after Epiphany (note the number five) is drawn from Col. 3: 12–17. In the preceding chapter (2: 17) St Paul characterizes the new moon as a 'shadow of things to come, but the body is of Christ'. Furthermore, this Epistle deals with Baptism, a concept which is central to this tondo because of the significance afforded to St John (the first four Doni sons, all of whom died shortly after birth, were named Giovanni Battista, according to Hartt; see below). The Epistle urges the faithful to strip themselves of their old person and to put on new clothing. It later lists two groups of five vices (five nude youths and medallions on the frame) to be removed and replaced by five virtues (mercy, kindness, humility, modesty, and patience). Hartt observes that the nudes have stripped and are playing with white drapery, signifying their new purity. The two at the left, he believes, seem to be trying to calm the disputing ones. Finally, Hartt theorizes that the position of the Virgin, lower than that of her husband despite her status as Queen of Heaven, derives from the Epistle to the Colossians (3: 18): 'Wives, submit yourselves unto your own husbands.'[226]

Many of the theories regarding the *Doni Tondo* contain valid points about its composition and about Michelangelo's art. The theological ideas are applicable to the devotional function of tondi, which were meant to encourage polysemic exegesis. Because the artist's ideas manifest an endemically personal dimension and are extremely complex, even in his earliest work and poetry they appear more enigmatic than usual.

Yet it is only within the context of the tondo tradition that Michelangelo's *Doni Tondo* can be understood. It is significant how it participates in this tradition and how it departs from it. Let us now reread it in this context. Michelangelo depicted a supra-human Holy Family, whose figures are so physically powerful that he dispensed with artificial haloes in an unorthodox but humanistic manner. He portrayed Joseph as the patriarch, reflecting contemporary ideas about the family. Joseph's head is just right of centre and, by virtue of its height, dominates the composition. It is balanced by Christ's smaller head, whose more forward position compensates for its smaller size. Mary occupies the centre, stressing her pivotal theological importance. This arrangement emphasizes that Christ has superseded the Old Order of his foster-father, from whom he and his mother trace their royal lineage. As Joseph supports Christ's body, his thighs seem to circle the form of Mary, suggesting his role as a protective *pater familias*, as in Alberti's *Della Famiglia*.[227] Natali believes that the action of handing the Child to Mary pictorially demonstrates the patriarchal descent from the House of David, not, as Steinberg theorizes, because Joseph is really God the Father.[228] While the Virgin's pose in relation to Joseph is formally indicative of a generative relationship, it is less so than in Michelangelo's *Bruges Madonna*. Rather, it is a formal device that he used to indicate several kinds of linkages, because he also employed it for the genius between the legs of Daniel on the Sistine Ceiling, where the genius is the inspiration for the prophecy and not the product of generation. In fact, the Madonna is actually seated in front of Joseph's legs (which

[226] Hartt, *History*, ed. Wilkins, 464.
[227] Hayum, '*Doni Tondo*', 231, suggests that the hierarchy of the Holy Family is an accommodation to the existing family structure to

secure the viewer's identification.
[228] Natali, 'L'Antico', 29.

echo the tondo shape and the semi-circular wall). Only her right upper arm touches one of his knees to aid in the support of the Child, whom they are rearing on earth. Moreover, this central cluster of figures is a sculptural solution to the problem of portraying a group, where the nurturing status of Joseph was stressed (an idea in Signorelli's *Parte Guelfa Tondo*, where a painter's solution was employed). These integrated forms stem in part from Michelangelo thinking like a sculptor and wanting to fuse the family group into a compact, solid unit, as he would in marble. In addition, a slight bowing out of the central part of the tondo, compensated for by the curve of the *pietra serena* wall, suggests that Michelangelo too was familiar with convex mirrors and their symbolism associated with the Virgin.[229]

Michelangelo painted only a few symbolic plants in his tondo—as did Raphael in his roughly contemporary *Alba Madonna*—such as two in the foreground with tripartite leaves echoing the trio of figures. At the left is the clover (the Trinity), while at the right is the anemone (immortality and the Passion of Christ).[230] The only other plant is conspicuously silhouetted against the gray *pietra serena* strip: the hyssop, symbolic of Baptism. Significantly, it grows within the sacred area of the Holy Family, the world *sub gratia*. In his *Allegoriae in sacram scripturam* (*PL* 112, 1088), Hrabanus Maurus writes: 'From the Cedar of Lebanon to the hyssop which grows on a stony wall we have an explanation of the Divinity which Christ has in his Father [a passage that forms a neater correlation if one could read Joseph equivocally] and of his humanity that he derives from the Virgin Mary.'[231] The hyssop grows in a solitary place and symbolizes penitence, humility, and a new innocence, hence its association with Baptism (Ps. 51: 7). In the Vulgate, it is Ps. 50: 9: 'Asperges me hyssopo, et mundabor; lavabis me, et super nivem dealbabor.' This is the text of the antiphon for the aspersion of holy water on Sunday Mass outside Eastertime. It also recalls Isaiah's prophecy of the Virgin birth 'for he shall grow up before him as a tender plant, as a root out of a dry ground'.[232]

Just behind the *pietra serena* divider, there is a deep drop into space, which can in no way be read as a continuation of the white crescent rock. At the right, partially hidden by the *pietra serena* strip, is St John, separated by level, space, size, and position from the Holy Family, but presumably approaching them. These differences underscore the superiority of the Holy Family as part of the New Order. It has been suggested that the Baptist looks up at the Child, but from the angle of his eyes it is more likely that he gazes up to heaven to await inspiration, while his cross-staff is on line with the Child to designate him as the Saviour. John's position echoes his transitional place, as both the last prophet of the Old Testament and the first of the New. He stands strategically between the Holy Family and the background figures and is isolated except for the adjacent hyssop. His juxtaposition with the lone plant must be crucial to the meaning of the tondo. At this point it must be noted again that Hartt has claimed that the first four Doni children—all sons who died—were named Giovanni Battista.[233] Doni's third child (second son) who lived beyond infancy was named

[229] Godoli, 'Il Tondo Doni fra impianto compositivo, ambientazione originaria e museografia', 52, notes a 10 mm. difference in the convex shape of this wall, adding to the illusion of the panel's convexity.

[230] Ferguson, *Signs and Symbols*, 32; Levi D'Ancona, *The Garden*, 99–101 (clover), 44–6 (anemone, also symbolizing the Trinity and sorrow and death).

[231] Levi D'Ancona, '*Doni Madonna*', 46–7.

[232] Hartt, *History*, ed. Wilkins, 464. A Signorelli shop tondo (Fig. A71) also features a prominent hyssop; see App. n. 197.

[233] Ibid. He cites no source. Hayum, '*Doni Tondo*', 226 nn. 26–7,

notes baptismal records for two Doni children (Maria and Francesco) in the Archivio dell'Opera del Duomo, Florence, without folio numbers. My own transcriptions of the birth records of the two earliest children differ slightly. They are: (1) Archivio dell'Opera del Duomo, Registro dei battezzati femmine, 1501–1512, fol. 94ᵛ, for Friday, 10 Sept. 1507: 'Maria nanna e romola d'g d. francᵒ don p.d. Sᵒ Jacᵒ fra fossi N adi 8 hore 21 3/4' ('Maria Nanna et Romola d'Agnolo di Francesco Doni, popolo di S. Jacopo fra' Fossi, nata adi 8, hore 21 3/4'); (2) Archivio dell'Opera del Duomo, Registro dei battesimi maschi, 1501–12, fol. 116ᵛ (118ᵛ), for Tuesday, 21 Nov. 1508: 'Francᵒ giovanmaria e romolo d'agᵒlo di francᵒ doni

Giovanni Battista, a name popular with the Donis, as with many Florentine families. In the Registro of 1517 his second name is given as 'Joseph' (not Giuseppe or Gioseffo, and thus related to the Latin Josephus), an indication that the name was important to and held in high regard by the Doni, which adds to our understanding of St Joseph's prominence in the *Doni Tondo*.[234]

The rough-hewn wall on which the nudes sit divides the pit-like space from the third level with its generalized landscape of water and mountains. Above it at the right, directly above the hyssop plant, grows a solitary tree, which may be the Cedar of Lebanon, noted by Hrabanus Maurus. Levi D'Ancona identifies it as a citron (Italian *cedro*), explaining that it was used to depict the Cedar of Lebanon (Michelangelo, unlike Leonardo, was not interested in botany, and the tree is generic, which does not affect its importance).[235] Its placement in an otherwise spartan background, and in a position analogous to the round temple in Signorelli's *Medici Madonna*, is not accidental. Its alignment with the hyssop connects it with the meaning in the quotation from Hrabanus Maurus. The material of the crescent resembles the rock in the artist's *Cascina Cartoon* and in his beloved marble quarries at Carrara (a personal allusion), although it may well refer to the half-moon of the Strozzi arms, for it was customary for family emblems to be pictographically represented—like the *sassetti* (pebbles) in Ghirlandaio's Sassetti Chapel and the Medici *palle*.[236] This dry swimming pool-like pit could be interpreted, among other things, as a reference to a baptismal font, while on a formal level it echoes the tondo's shape and must harbour a meaning integral to it. The five nude youths lounging there are not only slighter prototypes of the *ignudi* on the Sistine Ceiling, but also sum up the problems and types explored in the artist's earlier works, such as the *Madonna of the Stairs*, the *Crucifix*, and the *Battle Relief*. In their numerical division and iconography, they are similar to the five nudes in Lippi's *Adoration* (Fig. 3.1).[237] On a basic symbolic level, as on the Sistine Ceiling, they represent the world *ante legem*. They may be non-Christians or Jews waiting to join the Christian camp via Baptism, a theory supported by the writings of Joachim of Fiore, wherein five is the number of Jews before Christ.[238] Further, Natali quotes St Paul's letter to the Ephesians 2: 11–22, which refers to those about to be welcomed into Christ's fold.[239] Michelangelo's youths resemble those in Signorelli's *Medici Madonna* and *Munich Tondo* (Figs. 7.32, A66) who carry allusions to Baptism. A baptismal interpretation would harmonize with the presence of John and the prominence of the hyssop plant in the *Doni Tondo*. In this scheme, the tondo would represent

p.[opolo] di S° Jac° fra fossi N adi 21 hore 6 1/2' ('Francesco Giovanmaria et Romolo d'Agnolo di Francesco Doni, popolo di S. Jacopo fra' Fossi, nato adi 21 hore 6 1/2'). A search of the Registro from 1503 revealed that no earlier children were recorded as having been born to Agnolo Doni and baptized, indicating that if they were born they indeed died immediately after birth or prematurely when no baptism could be arranged. The grandfather's name was frequently used only after he died; in the case of Francesco Doni, Agnolo's father, who died in 1497 before the marriage, the second surviving Doni child, the first surviving male, was named after him.

[234] For Giovanni Battista Doni, see Cecchi, 'Il Tondo Doni agli Uffizi', 46 n. 12; Registro Battesimi Maschi (Libro dei battezzati maschi) 1512–22, fol. 104ʳ, for Thursday, 17 Sept. 1517: 'Giovannbᵃ Joseph e rto d'agᵒlo di francᵒ doni P di S° Jacᵒ fra fossi N adj 16 [17] hore 24' ('Giovan Battista Joseph et Romolo d'Agnolo di Francesco Doni, popolo di S. Jacopo fra' Fossi, nato adi 16 (17) hore 24').

[235] Levi D'Ancona, 'Doni Madonna', 47.

[236] Hartt, *History*, ed. Wilkins, 464.

[237] Hayum, '*Doni Tondo*', 210, 224 n. 6, reviews their various identifications, ranging from ephebian youths, to athletes, homosexuals, lovers, Christian martyrs, catechumens, neophytes, wingless angels, and the sons of Noah. See Cecchi, 'Tondo Doni', 43 ff.

[238] Bull, 'Iconography', 602 n. 55.

[239] Natali, 'L'Antico', 37 n. 26. It is also possible that the number five refers to the five letters of the name MARIA, as in Michelangelo's *Madonna of the Stairs*, whose iconography has been linked to Girolamo Benivieni (a poet in the Medici circle, whom Michelangelo knew) and his poem *Scala della vita spirituale sopra il nome di Maria*. The letters are symbolized in the five steps depicted in Michelangelo's relief (as quoted and noted in Olson, *Italian Renaissance Sculpture*, 159). Benivieni also wrote two other poems in which he spelled out the name MARIA in upper-case letters; Benivieni, *Opere*, fols. 149ᵛ–150ᵛ. No doubt this is related to the idea that the Madonna was the *scala coeli* of the Old Testament Jacob's dream, the heavenly ladder down which God descended to men; Hirn, *Sacred Shrine*, 464.

the rebirth of humanity with the advent of Christianity via Baptism and the Incarnation of Christ.[240] The youths hold pieces of cloth, which foreshadow those held by the Sistine Ceiling *ignudi* as well as Christ's shroud (in the *Madonna of the Stairs*), suggesting that they harboured a personal meaning for the artist. Because the painting was executed when Michelangelo's interest in Neoplatonism was high, the nude body was for him a symbol of the divine. Perhaps then, these androgynous youths embody the part of human beings that can be purified by Baptism, the soul (which has five parts according to Ficino and is frequently depicted nude).[241] Because they are oblivious to the miracle of the Holy Family, they are not, as Steinberg has suggested, angels because angels in tondi are always attentive to the Child and solicitous of the Madonna. Therefore, unaware of the holy personages and involved with each other, the nudes must belong to the world *ante legem* like the *ignudi* of the Sistine.

In conclusion, the *Doni Tondo* sums up and surpasses trends in fifteenth-century Holy Family tondi. No matter when it was commissioned, it must have been associated with the Doni's hoped-for descendants, because the purpose of marriage in the Renaissance was propagation of the family. Most likely, it was meant to preside over their bedroom with religious and talismanic dimensions validating certain secular and domestic ideas of the family within a Christian framework while assisting in devotional exercises. Its supra-human beings without haloes represent a 'veritable apotheosis of the family'.[242] Since they are placed within a cosmic context, the tondo, they are raised by association to heaven. The painting thus reiterates the importance of the family and the power of this social unit. Moreover, its stress on St John and the hyssop reflects the republican sympathies of both its creator and patron at the time of its execution.[243] Joseph, who is cast in shadow, functions as the foundation of the group and the link to the Old Testament. The Madonna is more highly lit and is more connected to the New Testament, which her triumphant son, striding as onto the tomb in the Resurrection, embodies. Finally, despite the lengthy list of views on whether the Madonna is handing the Child to Joseph or whether he is lowering Christ to her, it is the ambiguity of the action which lends a dynamism, resulting from a seemingly reciprocal motion, which is, after all, the essence of any good marriage. When the Doni employed this tondo in their devotions they could use the five nudes and heads of the frame to mark each decade of the three mysteries of the rosary, represented by the three members of the Holy Family. Unlike the nudes and even St John, they saw the Holy Family and through prayer and meditation could begin to understand them and the Christian miracle.

Raphael's and Michelangelo's pivotal tondi are followed by a group of panels painted by Florentine artists that represented the rather swift denouement of the form; for these see the Appendix. They embroider devotional variations on the Madonna and Child and Holy Family themes that are sometimes amazingly inventive and many times charmingly composed. Nevertheless, for a variety of reasons discussed in the subsequent chapter, the vogue for devotional tondi soon died out.

[240] Salvini, *The Complete Works of Michelangelo*, 169–70.

[241] Levi D'Ancona, 'Doni Madonna', 48–9, notes the contemporary controversy raging over the immortality of the soul, believing that their division, two to three, matches that of Ficino's Neoplatonic philosophy (citing in n. 59 *Platonica theologica*, in *Opera omnia*, 374, 381); the two on the left, the higher soul (divided into soul and intellect) and the three on the right the lower soul (the

forces of imagination, sensation, and nourishing faculty). She then interprets them as signifying the two natures of Christ and the trio the Trinity.

[242] Hayum, 'Doni Tondo', 213.

[243] Michelangelo's republican allegiance is well known. Agnolo Doni's is noted by Cecchi, 'Tondo Doni', 46 n. 12; id., 'Agnolo e Maddalena', 437–8.

8

THE FATE OF THE TONDO

THE singularity of the Florentine tondo phenomenon depended on specific cultural associations and complex layers of refined, symbolic arguments associated with the circle that were alive in Florence. Elsewhere, even in cities in touch with Florentine Renaissance ideas, tondi did not enjoy the same vogue they experienced in Florence. While the tondo's lineage dates back to antiquity and its inception from the early stages of fifteenth-century humanism, we have seen that it blossomed in the last two decades of the Quattrocento, when it began to spread into the rest of Tuscany and beyond. Its apogee occurred in Florence between 1480 and 1515, a time of growing religiosity and civic-mindedness, a trend born out not only in the tondi that survive but also in parallel documentary evidence. There were multiple reasons for the ascendancy of the tondo, including the active involvement of the laity in religion, for example, the Compagnia del Rosario and other confraternities, and the growing piety of which the Savonarolan movement was only the tip of the iceberg. Savonarola, who wanted to baptize secular sources in the service of his theocratic vision, was not an iconoclast and was in favour of images to spur on devotion. However, his attitude towards art was ambivalent and full of contradictions. He wanted the viewer to admire God, who created the beauties of the world, and not the artist who created them in works of art.[1] While this complicated period in the history of Florence has been studied by a number of scholars, they have not addressed the tondo phenomenon *per se*.[2] Tondi, intended for the private or semi-public sphere and having a spiritual content that descends from the traditional icon, may have avoided Savonarola's charges about the lack of spirituality in art. Although they were not hung in churches, their round shape declared their sanctity. Since tondi were basically private commissions, they, like rectangular devotional works, could continue to be produced if the patron had the financial resources and the inclination during the troubled period from the expulsion of the Medici in 1494 to the strengthened resolve of the Republic in the early years of the Cinquecento—a period that stunted or curtailed public commissions.[3] This would help explain their continuity into the sixteenth century.

In fact, the tondo was such a pervasive form in Florence between *c*.1480 and *c*.1515 that when certain foreign artists visited the Italian peninsula and specifically Florence they either adopted it or accepted commissions to paint Madonna and Child tondi. Examples include works by Johannes Hispanus and Alonso Berruguete (Fig. A119) both of whom produced tondi that can be related in their compositions and symbolism to Florentine examples.[4]

[1] Belting, *Likeness and Presence*, 472.

[2] e.g. Weinstein, *Savonarola*; R. M. Steinberg, *Savonarola*; M. B. Hall, 'Savonarola's Preaching', 491–522, who outlines the drop in patronage of large-scale commissions in Florence 1494–1504.

[3] Stephens, *The Fall of the Florentine Republic 1512–1530*.

[4] e.g. Hispanus painted a panel with a 73 cm. diameter and a Madonna and Child holding an apple with two angels, whereabouts unknown. Christie's, New York, sale cat., 10/I/90, no. 26, which cites F. Zeri, '"Me Pinxit", 6, "Ioanes Ipsanus"', *Proporzioni*, 2 (1948), 174, no. 206a, ill. For Berruguete, see App. n. 307.

Judging from the number of late quattrocento and early cinquecento tondi extant, painted ones were more popular than sculpted tondi, which were made in marble but more frequently in glazed terracotta, as well as in bronze, stucco, *cartapesta*, and other materials. While devotional tondi sometimes contain representations of the Adoration and other subjects, the majority feature the Madonna and Child, frequently with saints. The tondo was thus one of several types of art on the theme of the mother and child, embodying the culture's obsession with women and children and the education of children (the 'merchant pedagogy').[5] It was one of the forms which flooded the Florentine market as part of the idealization of home life and celebration of family relationships, further reflecting the humanism of the Quattrocento as well as its adulation of the circular form and the sanctity and holiness communicated by the heavenly circle.

THE LATER FATE OF THE TONDO

The form flourished from the mid-fifteenth century until *c.*1515–20, when for a variety of complex reasons, including the religious unrest of the Reformation and the onset of Mannerism, it lost its vital cultural meanings and its popularity waned precipitously. Moreover, although no studies have addressed the subject thoroughly, the number of private devotional images, which more often than not assumed a rectangular shape after 1520, seems to have declined due to economic as well as religious factors. In other works of art in the wake of massive religious, political, and social changes, the oval, rather than the circle, seemed to reflect better the ambivalence and the instability of the times. The culture no longer could aspire to the simple perfection and harmony expressed by the circle, ideals that motivated much of the religious and secular patronage of the Quattrocento and early Cinquecento. Although a trickle of later devotional tondi continued through the twentieth century, they are all but devoid of the unique cultural connotations and aspirations that the form held for Florentines of the Renaissance. Nevertheless, the roundel remained a popular option in decorative schemes for centuries, although there too the oval asserted itself emphatically. Despite these changes, the round form continued to be a popular way to represent heaven on a larger scale and hence was employed in the illusionistic decorative schemes of ceilings and domes.

Tondi were popular until *c.*1515 when they began to languish in an extended decline. The building momentum of the Reformation and Counter-Reformation, with its revision of the cult of the image, impacted on their production. Their popularity may also have been influenced by the shift in power, patronage, and artistic centres from Florence to Rome, where three powerful popes—Julius II (1503–13), Leo X (1513–1521), and Clement VII (1523–34), the last two Medici—brought the Golden Age to the Eternal City until the Sack of Rome in 1527. Because the devotional tondo was a Florentine type that catered to a specific set of ideas, it never caught on as a pervasive form elsewhere (only incidentally in Rome), except tardily in Siena (see App.), remaining in essence a Florentine phenomenon. Other than incidental anomalous examples, the tondo tradition we have surveyed seems to have disintegrated by the mid-Cinquecento. Thus, while the geometry remained constant, the meaning of the word 'tondo' has never been quite the same as in Florence of the Renaissance.

[5] Goldthwaite, 'The Florentine Palace', 1009 ff.

The overwhelming reasons for the demise of the Madonna and Child devotional tondo, no doubt, relate not only to sixteenth-century religious upheavals but also to new artistic and cultural ideals that were part and parcel of Mannerism. Simply stated, we can say that the centre could not hold and that the circle no longer expressed the ideas of a restless culture whirling in a tempestuous sea of change that thrived on experimentation. Rather, the ambiguity of the extended circle, the oval or ellipse, better expressed the dynamism and unrest of the age. In this period obsessed with artifice and forms beyond nature, a naturalistic depiction of religious figures no longer held the appeal that it had at an earlier date, when artists and patrons alike were intoxicated with the power to represent the world they observed with their eyes. So many good ideas have been explored in the ink spilled on the topic of Mannerism that this author would prefer to let those writers speak to the subject themselves. It is telling that at around the same time when sculpted and painted tondi decreased in number, architects and patrons began to abandon the centrally planned church as the ideal form, not only for practical liturgical reasons, but also because of the loss of compelling connections with the philosophical associations of the circle.

The shift in the cultural and religious focuses that contributed to the decline of the tondo as a devotional form was supplemented by a technical change: the widespread adoption of the oil technique. Its popularity may have accelerated the passing of the tondo as a vital option for devotional commissions. With the use of oil pigments came the employment of canvas for a support. Panel paintings went slowly out of fashion even though tempera continued in use for fresco. Although some tondi were painted on canvas, it was a difficult form to achieve in that material on a circular stretcher (various older panel paintings have subsequently been transferred to canvas).[6] A hint of the problems involved with stretching a canvas on a round support can be seen in a photograph taken of one of Monet's *Nymphéas* without its frame (see Fig. 8.4 below).

By 1520–5 Madonna and Child tondi were rarely produced in Florence. While the tondo's former status led some patrons to commission a few, one feels that these are rarely artistically compelling works. For example, the Holy Family attributed to Perino del Vaga (Pierino Buonacorsi) (Fig. 8.1) no longer has an experimental edge.[7] This is also the case with the much later, eclectic Madonna and Child tondo by Costantini de' Servi (Fig. 8.2)—the artist's only known painting, signed on the marble fragment: *OP'S ·DE / COSTA/NTINI / DESE/RVIS* and derived from Andrea del Sarto's Madonna del Sacco fresco as well as Michelangelo's figures.[8] Servi's strange Child—nearly four or five years of age and athletic, reflecting in pose and musculature Michelangelo's Sistine *ignudi* and the Torso Belvedere—jumps astride the Madonna's lap (she also resembles heroic Sistine types).[9]

[6] The *Rest on the Flight into Egypt* by the Guercino workshop in the Walters Art Gallery, Baltimore (inv. no. 37.1893 with its painted surface measuring 40.9 × 38.7 cm.) is an example of an oil on canvas tondo. Zeri, *Italian Paintings*, ii. 480–1, no. 361, ill. The work copies a larger canvas in the Cleveland Museum (inv. no. 1967.123 with a 68.5 cm. diameter).

[7] Inv. no. 24 in the Collections of the Prince of Liechtenstein, Vaduz Castle, oil on panel with an 84 cm. diameter. Stix and Strohmer, *Die Fürstlich Liechtensteinische Gemäldegalerie in Wien*, 92, ill.; Armani, *Perin del Vaga*, 317, no. B. XIV, ill.; Hunter, 'The Drawings and Draughtsmanship of Girolamo Siciolante da Sermoneta', fig. 3. For the artist, Siena, Comune di Siena, *Domenico Beccafumi e il suo tempo*, 406–9.

[8] Inv. no. 1971.278 in the Cleveland Museum of Art, oil on panel with an 87.5 cm. diameter. Cleveland, The Cleveland Museum of Art, *Catalogue of European Paintings of the 16th, 17th, and 18th*

Centuries, 414–15, no. 181, ill. An x-radiograph reveals that it was painted over an earlier composition with a Bridgettine Madonna and Child and young St John, turned 45 degrees.

[9] Other late examples exist as well. One suspects that a detached fresco in a round format with a depiction of the Madonna seated on the clouds embracing her standing Child, attributed to the Circle of Vasari, was once part of a larger work. It is currently to the right of the staircase in the Refectory of San Michele in Bosco, Bologna (photograph in the FKI). Florian Härb (pers. comm. 15 Jan. 1996) dates it before 1550. See Corti, *Vasari. Catalogo completo dei dipinti*, 24–7, no. 11, for the Refectory. It is interesting to note that *c*.1565 Vasari painted an oil on silk banner for the Confraternity of Santa Maria with an image of the Madonna della Misericordia in a round format with a 192 cm. diameter (in the Museo Diocesano, Arezzo; ibid. 120, no. 96, ill.).

In the early sixteenth century the tondo form spread beyond Florence and even Tuscany, although its only real blossoming occurred in Siena, where patronage encouraged its growth. Domenico Beccafumi, the gifted Sienese painter, encouraged by his contacts with Florence, was a prolific producer of tondi (Figs. A120–3) with a uniquely Sienese flavour (see App.). As the form took hold, Beccafumi and other Sienese artists, such as Bartolomeo Neroni and Sodoma (Figs. A124–8), developed unique approaches and civic iconographies, for example the inclusion of St Catherine of Siena.

In the later decades of the sixteenth century there was only a trickle of devotional tondi, now not exclusively Florentine, with the Madonna and Child, such as the more traditional Madonna and Child tondo that has been assigned to Sofonisba Anguissola.[10] Sometimes in these later tondi one encounters a unique twist on the traditional devotional subjects associated with the format. A case in point occurs in a seventeenth-century painting given to Francesco Solimena, where, in keeping with the taste of the Seicento, St Joseph is depicted in an intimate manner adoring the wondrous Child without the Madonna even being present.[11] Another later painting in a round format with a Madonna and Child theme is the fascinating example by the Italian-influenced Paulus Moreelse; it features an elaborate, illusionistic cartouche frame with four seraphim painted at its corners as though holding up the dome of heaven (Fig. 8.3).[12] Herein, the idea of the tondo is retained illusionistically, even though the support for the oil medium is a rectangular canvas. The positions of the Madonna and Child, who appear to lean outside the painted frame in keeping with a seventeenth-century aesthetic, play with the illusion between the spectators' space and the pictorial plane, engaging the viewer energetically.[13]

In succeeding centuries, the round form survived to enframe a myriad of subjects—animals, plants, fruit, rustic landscapes, biblical scenes, still lifes, allegories, or genre scenes, the latter of which frequently pivot around themes involving women, love, or charity, and even scenes of witchcraft. In a few cases, there is a distant echo of an earlier meaning that the form held for Florentines of the Renaissance, sometimes via a rare representation of a mother and child or a Holy Family.[14] But in the majority, such as Ingres's *Turkish Bathers* in the Musée du Louvre, few traces of original tondo *concetti* remain, even in works painted by Italian artists. However, some of the ideas survived underground to be revived occasionally in a variant fashion with a novel twist, as in Frederic Leighton's round *Garden of the Hesperides* (1892). Herein, the classical, mythological Garden of Paradise and its golden apples has been substituted for the Christian Garden of Paradise

[10] In the Galleria Regionale della Sicilia, Palermo, oil on panel with a 37 cm. diameter. Caroli, *Sofonisba*, 202, no. A14, ill.

[11] Inv. no. AP.733.1 in the Cummer Art Gallery, Jacksonville, Fla., oil on canvas with a 60 cm. diameter. Reproduced in *Burlington Magazine*, 109 (1967), p. xix, when it was for sale at the Newhouse Galleries, New York.

[12] Whereabouts unknown, oil on canvas measuring 69.5 × 58.5 cm. Sotheby's, New York, sale cat., 17/I/92, no. 110.

[13] Other late examples include a large Holy Family painted *c*.1610 and attributed to the Cavaliere d'Arpino in the Museo del Duomo, Ferrara, and a detached fresco from the Villa Zianigo by Giandomenico Tiepolo, *c*.1754–9, today in the Ca' Rezzonico, Venice, where the Holy Family in a tondo is worshipped by San Gerolamo Miani, all surrounded by an illusionistic rectangular frame. One could identify the Moreelse and the Tiepolo images as intermediary between tondi and Rubens's use of an archaic image of

the Madonna of Mercy concealed but incorporated into his 1608 painting in the Chiesa Nuova, Rome, wherein the holy image is transformed into a memory of olden times as discussed by Belting, *Likeness and Presence*, 488–90, pl. IX, fig. 294.

[14] For example, an unknown Macchiaiolo painted a pyramidal pile of peaches poised on a foreshortened round compote on a round surface. Its abstract purity and formal concentration echo principles in harmony with a quattrocento aesthetic; Del Bravo, 'Una natura morte Macchiaiola', ill. The small work looks to be painted on panel and is in a private collection. Its circumference is delineated with a thin line of plain pigment, like quattrocento tondi, to facilitate insertion into its frame. This consciousness of earlier practices seems fitting, because Macchiaioli painters studied their quattrocento artistic ancestors assiduously with both a nationalistic and aesthetic zeal.

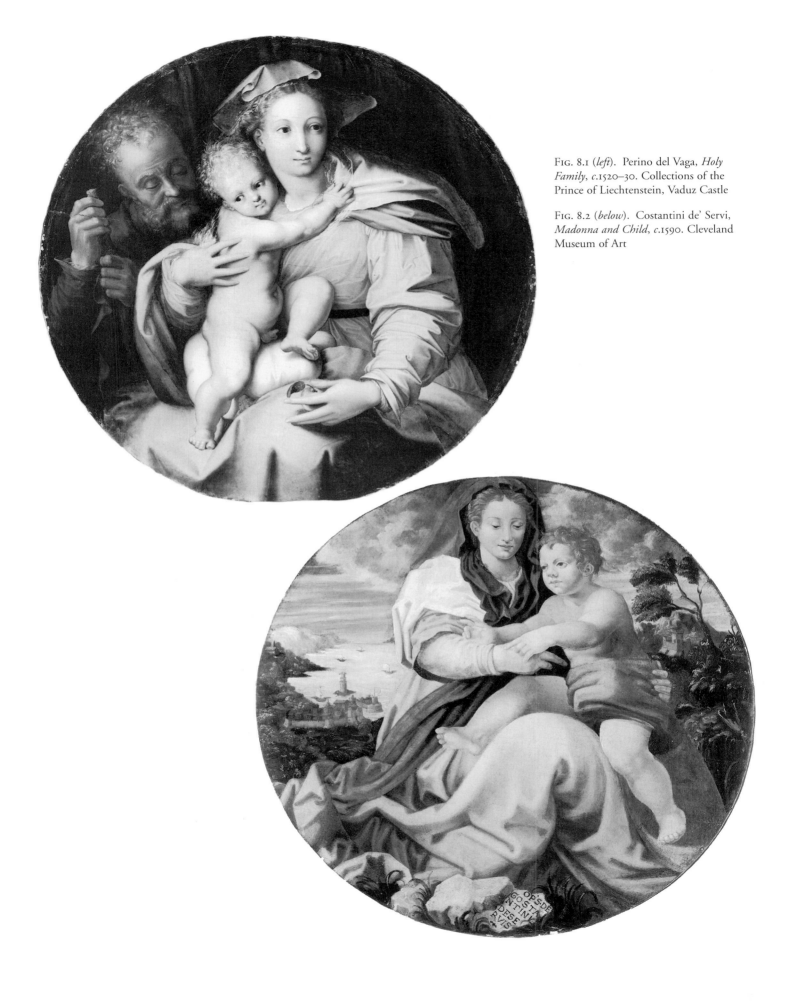

Fig. 8.1 (*left*). Perino del Vaga, *Holy Family*, c.1520–30. Collections of the Prince of Liechtenstein, Vaduz Castle

Fig. 8.2 (*below*). Costantini de' Servi, *Madonna and Child*, c.1590. Cleveland Museum of Art

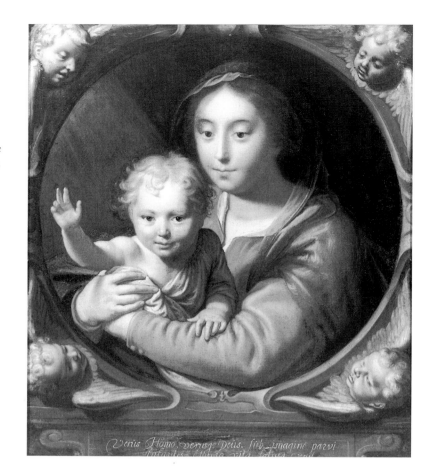

FIG. 8.3. Paulus Moreelse, *Madonna and Child Enframed by Four Seraphs*, after 1600. Whereabouts unknown

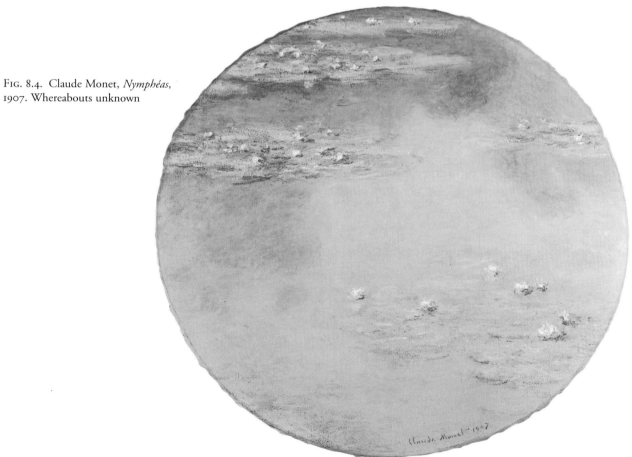

FIG. 8.4. Claude Monet, *Nymphéas*, 1907. Whereabouts unknown

that had been integrally linked with Renaissance tondi and the cosmic circle of eternity and divinity.[15] Certainly, the English Pre-Raphaelite artists, who intently studied Italian Renaissance culture, knew about and used the format—as in Ford Maddox Brown's *The Last of England* (1852–5) in the City Museum and Art Gallery, Birmingham, where the intimate familial theme is tailored to contemporary issues, and as in Byam Shaw's two later Annunciation tondi designs for the decoration of the chapel of St Mark's College, Chelsea. Likewise, these artists were acquainted with the Garden of Paradise theme, as demonstrated by the poem 'The Earthly Paradise' by their colleague William Morris.

A distant echo of the garden symbolism and its link with eternity may be found in the four tondi of water lilies painted by Claude Monet (Fig. 8.4), an artist not usually known for his symbolism, who all his life denied any deeper meaning to his art.[16] (Monet's four tondi belong to his water lily series of forty-eight canvases, forty-four with rectangular shapes, which was exhibited at Durand-Ruel in Paris in May 1909.) It is important, therefore, to realize that the only teacher Monet tolerated,[17] Charles Gleyre, painted a tondo entitled *The Earthly Paradise* (*c.*1870, in the Musée Cantonal des Beaux-Arts, Lausanne). Further, Monet's tondi are linked to the use of roundels in traditional decorative schemes and more specifically to mirrors. The latter connection seems convincing since Monet himself was directly concerned in the series with reflections. According to a letter from Monet to Paul Durand-Ruel on 28 January 1909, he first entitled the series 'Reflections', later calling them 'Water-lilies, series of waterscapes'.[18] Moreover, the artist's good friend George Clemenceau—who hinted that the water lily paintings held for Monet more profound, universal meanings similar to those that have always been linked with the circle—associated them with mirrors.[19] Monet's *Grands Décorations*, the oval water lily series in the Jeu de Paume, the Orangerie, Paris, begun as early as 1900, have been characterized as an expression of the artist's intense desire for wholeness.[20] This same longing permeates his four tondi.

The question remains how conscious Monet was of Renaissance tondi and whether he saw an example either in the Louvre or in a private collection that influenced him to paint his round

[15] In the National Museums and Galleries on Merseyside, Lady Lever Art Gallery, Port Sunlight, oil on canvas with a 169 cm. diameter. Ormond and Ormand, *Lord Leighton*, 171, no. 364, ill.; Newall, *The Art of Lord Leighton*, 128–9, ill. Leighton also executed a number of other works in round formats.

[16] Spate, *Claude Monet: Life and Work*, 307, claims that Monet rejected any metaphysical interpretation of his work, insisting that he sought only to be true to his sensations of nature. The four oil on canvas tondi, the only ones Monet painted in his career, were executed during a period of great artistic frustration. They are in: The Dallas Museum of Art (inv. no. 1981-123 with an 81.3 cm. diameter); the Musée Municipal Alfonse Georges Poulain, Vernon (inv. no. 46 with a 90 cm. diameter); the Musée Municipal d'Art et d'Industrie, Saint-Etienne (with an 80 cm. diameter); and formerly the Alice Tully Collection, New York (with a 79.5 cm. diameter; Christie's, New York, sale cat., 9/XI/94, no. 21).

[17] According to Kendall, *Monet by Himself: Paintings, Drawings, Pastels, Letters*, 242.

[18] While it is clear that the artist used the round format as a formal deviation—to help him in this late search for a new tack—he may have consciously adopted it for four paintings in the series because of the associations linked with that numeral. Four is a number of balance but it also permeates Western cultural thought

with associations that could be linked to the water lily canvases—e.g. the Four Elements, the Four Parts of the World, the Four Seasons, the Four Rivers of Paradise, all appropriate to the garden symbolism to which he so obviously, but perhaps subconsciously, alluded in the water lily series. He may have been unaware of the symbolism of the Four Last Things.

[19] Clemenceau remarked: 'In the mirror of his pond . . . rightly speaking, therein resides the miracle of the *Nymphéas* which shows us the order of things. . . . Forever changing aspects of a universe unknown, yet one which expresses itself in our sensations. Does admitting emotions hitherto unknown mean obtaining new states of assimilation from the mute infinity? Isn't it penetrating further into the world itself—into the impenetrable?' Clemenceau continued using the word 'cosmic' to describe Monet's ideas (Paris, Centre culturel du Marais, *Claude Monet at the Time of Giverny*, n.p.).

[20] Spate, *Monet*, 311. She adds (p. 314) that Monet had a desire to be buried at sea, to return to the water. The four tondi date close in time to the elliptical water lilies in the Jeu de Paume. The shapes of Monet's tondi on a purely formal level could have suggested to the artist ideas about the eternal cycle of life that he articulated through his pigment but denied in his words.

compositions. Or could he have seen another type of round painting or a mirror in a round frame that triggered an idea and inspired his adoption of the format? How familiar was he with the associations connected with Renaissance tondi? It is relatively safe to assume that Monet must have been cognizant of the garden symbolism associated with tondi as well as the basic cosmic symbolism of the eternal circle. After all, the tondo was an old form that also was used to new ends by other nineteenth-century and early twentieth-century artists such as the Orphist Robert Delaunay and Piet Mondrian.

Before closing, we should note, not without amusement, that Madonna and Child tondi were produced into the twentieth century, as witness an enthroned Madonna and Child adored by two angels which came up in auction in 1982. This panel has a 92.4 cm. diameter and its composition copies the central part of a rectangular *sacra conversazione* by Domenico Ghirlandaio in the Galleria degli Uffizi.[21] Furthermore, Zimmer's article on later twentieth-century tondi after Jasper Johns's *Target* testifies to the fact that the word and form itself, which is highly suitable for non-representational art, is still alive.[22]

But in the end, these later examples all serve as foils to demonstrate the unique, idealistic goals that motivated Florentine Renaissance patrons to purchase and artists to create their animated round paintings and sculptures. These largely devotional works of art—inspired by ideas from antiquity and its heritage, current philosophical and cosmological concerns, as well as specific historical developments in fifteenth-century theology, religion, and family life—united in a unique way the secular and religious venues of contemporary life. While devotional tondi were intended as images to transform the lives of those who beheld them into something more perfect (as the portraits in a round format were meant to immortalize the sitter) and to provide a tantalizingly harmonious foretaste of heaven in domestic and residential quarters of Renaissance Florence, they also preserve for us in a tangible visual form many of the ideas found in contemporary writings that were deemed important by quattrocento Florentines. Moreover, in their very form tondi embody the basic Christian, cosmic cycle of birth, death, and resurrection.

[21] Christie's, New York, sale cat., 16/I/92, no. 20, where it is listed as Italian school 20th c. For the Ghirlandaio altarpiece, see Florence, *Gli Uffizi*, 288, ill.
[22] Zimmer, 'The Tondo'.

APPENDIX
Painters of Tondi

The Appendix is meant to be consulted in conjunction with Chapter 7 in order to characterize briefly the productions of various artistic workshops and to establish the larger context for the works discussed in that chapter. (The tondi discussed here are by no means a definitive listing.) It is arranged by artists and their shops in a roughly chronological order, and its most detailed sections address the tondi of inventive *tondai* and iconographically unusual tondi. As a whole, this supplement reveals the diversity of approaches taken to the format and highlights the most common themes and ideas that artists explored in tondi. In consulting this section, it is important to keep in mind two points. The first is that it is not my intention in this study to make any stylistic attributions, while the second, related, concept concerns what we know about fifteenth-century artistic practice.[1] When a painting was designed by an artist, any number of hands in his shop may have participated in its execution. These collaborators could range in experience and age from independent artists to shop assistants and *garzoni*. Many, if not most, paintings produced during the Renaissance were collaborative efforts from the traditional *bottega* system of training in which the fledgling artist was taught to work in the style of his master. As tondi became popular, shops produced variations or pastiches under various degrees of the master's supervision from drawings or models kept in the shop. Therefore, it is frequently difficult to establish air-tight attributions, and the process of distinguishing minor, anonymous masters has no point in a typological study of this nature, which is better organized by shops and their associates.

The earliest painted tondi and their artists are discussed within the context of Chapter 7 but are listed here for a sense of chronology and the convenience of the reader.

DOMENICO VENEZIANO. See Chapter 7.

FRA FILIPPO LIPPI. See Chapter 7.

WORKSHOP OF FRA ANGELICO. See Chapter 7.

FOLLOWER OF FRANCESCO PESELLINO. See Chapter 7.

PIER FRANCESCO FIORENTINO. See Chapter 7.

FRANCESCO BOTTICINI. See Chapter 7.

COSIMO ROSSELLI

Berenson attributed three tondi to Rosselli, while Fahy assigned seven to him.[2] For a discussion of his workshop as an important place for the development of ideas about tondi and for Fig. 7.10, see Chapter 7.

[1] See Gregori, Paolucci, and Acidini Luchinat, *Maestri e botteghe*.

[2] Berenson, *Florentine School*, i. 189–92; Fahy, 'An Altarpiece by Cosimo Rosselli', 55–7. For Rosselli, see Vasari (Milanesi), iii. 183–91; Van Marle, *Italian Schools*, xi. 386–418; Venturini, 'I Rosselli'. A panel with a 79 cm. diameter in the Musée des Tissus, Lyon, is attributed to him; its Child reclines on the exergue as on a sarcophagus (Lyon, Musée des Tissus, 1890–1990, 67, no. 14, ill.).

Several other tondi have also been given to Rosselli, including the unusual one with an adolescent Christ (Fig. 4.3), but some of these attributions are difficult to sustain under the circumstances of the artist's understudied oeuvre. They reside more comfortably in limbo under the designations Rosselli shop or late Quattrocento Florentine School.

DOMENICO GHIRLANDAIO AND ASSOCIATES

While we have acknowledged that many tondi are shop productions, it hardly prepares us for the extended shop practice of Domenico Bigordi, called 'del Ghirlandaio'.[3] Even though he may have rendered only one tondo (Fig. 7.11) himself (Ch. 7)—focusing his prose style instead on portraits, fresco cycles, and altarpieces—he delegated the painting of devotional tondi to associates in his *bottega*. Many times these were collaborative ventures involving more than one hand. Owing to the strong control he exercised over this shop dynasty—including members of his own family—the products have a relatively homogeneous quality that sometimes makes attributions difficult.

A large number of tondi have been assigned to members in Ghirlandaio's sprawling circle (historical individuals as well as anonymous masters). An interesting Annunciation tondo attributed to a modest talent associated with Ghirlandaio, the Master of Apollo and Daphne, reveals the influence of other contemporary artists as well (Fig. A1).[4] While its composition exhibits no sensitivity to the round format, it responds to the tradition wherein the Annunciation, like the Adoration, was one of the few narrative scenes represented in a tondo format to allude symbolically to the Immaculate Conception.

Other artists that have been associated with Ghirlandaio include the sons of Nanni di Miniato del Fora, Bartolomeo di Giovanni and his younger brother Gherardo—a musician, miniaturist, mosaicist, and painter (Fig. 3.10).[5] They and a younger brother Monte were involved in a workshop—rented from the Badia of Florence until the end of May 1465 and from December of that year in the Canto del Garbo—until 1476 when Bartolomeo, now identified as strictly a *cartolaio* and not a painter, left to work separately. Gherardo, who was praised by Leonardo and was a friend of Poliziano and Lorenzo de' Medici, designed the ingenious tondo (Fig. 7.12) discussed in Chapter 7.

The painter Bartolomeo di Giovanni, who was formerly linked with the *cartolaio* Bartolomeo di Giovanni, is now identified by documents as 'Bartolomeo di Giovanni di Domenico dipintore' who had a shop 'al Canto de' Pazzi'.[6] Although his oeuvre has become a catch-all for difficult attributions, this artist was involved with a number of tondi. Most of them are not highly innovative. The best-known is his *Adoration of the Magi* (Fig. A2) with a blending of the types and motifs from Ghirlandaio and Botticelli to suggest that it is one of his earliest.[7] Nevertheless, he designed it with a sophisticated X-shaped composition. Filling the exergue in emulation of Ghirlandaio's *Adoration* are a walking staff, baggage, and a saddle, whose curve repeats the arch of the stable ruin and the upper contour of the panel while countering the lower rim.

[3] Steinmann, *Ghirlandaio*; Berenson, *Florentine School*, i. 74–7; Venturini, 'I Ghirlandaio'; Fahy, 'Domenico Ghirlandaio', forthcoming.

[4] Whereabouts unknown, panel measuring 86.4 × 81.3 cm., deaccessioned by the Metropolitan Museum of Art, New York (Sotheby Parke-Bernet, New York, sale cat., 15/II/73, no. 17). Fahy, *Followers*, fig. 14; for the artist pp. 11–20bis, 103–12. Its frame (*c*.1480–1500), perhaps the original, is in the Metropolitan Museum of Art (inv. no. 53.228). It has an exterior diameter of 120.7 cm. (interior 80.6 cm.) and a repeated inscription *MIHI SATIS* ('It suffices me'), which may have been the owner's motto, on the continuous ribbon binding the palm fronds (Newberry, Bisacca, and Kanter, *Frames*, 78, no. 52, ill.).

[5] Berenson, *Florentine School*, i. 24–7; Fahy, *Followers*, 21–45, 126–66; Pons, 'Precisazioni su tre Bartolomeo di Giovanni: il cartolaio, il sargiaio, e il dipintore'; ead., 'Bartolomeo, Gherardo, e Monte di Giovanni'.

[6] Vasari (Milanese), iii. 240–1; Berenson, *Florentine School*, i. 24–7; n. 5 above.

[7] Inv. no. 61.44.13 in the M. H. De Young Memorial Museum, San Francisco, formerly in the Samuel H. Kress Collection (K363), panel with a 95.2 cm. diameter. Shapley, *Paintings*, i. 129, ill.; Fahy, *Followers*, 156. Another tondo of the same subject attributed to him with an 88 cm. diameter but with figures derived from Botticelli's *Lama Adoration* is reproduced in *Antichità viva*, 18:1 (1957), 57, ill.

Another tondo by Bartolomeo betrays the influence of Lorenzo di Credi and contains a clever symbolic device (Fig. A3).[8] The motif—a column engaged to a pier—refers to the relationship between the Old and New Testaments. This conclusion is reinforced by the fact that the pier relates physically to St John, the last prophet of the Old Testament, while the column is spatially associated with Christ. Other, less inspired, tondi assigned to Bartolomeo's problematic oeuvre feature male saints who imply the specific theological orientations of their patrons and increase their devotional significance.

Biagio d'Antonio—whose career parallels that of Ghirlandaio, beginning with the Sistine Chapel frescoes where the two were affiliated—specialized in the staple themes and compositions from the Ghirlandaio atelier.[9] A later work by him with an intriguing, elegant background loggia arcade demonstrates how the usually rustic stable could be domesticated in the late Quattrocento to approximate the environment where the tondo was hung (Fig. A4).[10] Its sculpted roundel in the arcade's squinch contains the bust of a bearded man, probably of David, referring to Christ's royal lineage, which is linked directly to the babe, reclining on a bundle of wheat near the column and beneath the roundel. This identification is reinforced by the Child's gesture, indicating surprise that he is the chosen one, and the apple he holds that symbolizes he is the second Adam come to fulfil the Old Testament prophecy. The open roundel in the back loggia arcade may refer to the macrocosm of the universe, in which case both circular devices function as profound footnotes that visually echo the panel's shape.

Piero del Donzello, another identifiable artist linked with the Ghirlandaio *bottega*, is known to have worked with his artist brother Polito. To this little-known master, Fahy assigns four or five tondi (depending on whether a homeless tondo duplicates another).[11]

A collection of anonymous masters also have been associated with Ghirlandaio's extended shop. Among them are Maestro Allegro,[12] the Master of Tavernelle,[13] the Master of the St Louis Madonna,[14] the Master of the Manchester Madonna, whose connection seems tenuous, and the Master of Santo Spirito, who painted in a more lyrical tone than many in the shop and is credited with at least eight tondi, some of which are iconographically distinctive.[15] The latter artist, now identified as Giovanni Graffione, specialized in the Incarnation theme, as in a Holy Family (Fig. A5), where the Madonna and Child are placed near three angels, symbolic of the Trinity and the three mysteries of the rosary.[16] For one of his most successful tondi (Fig. 7.13) see Chapter 7.

Another anonymous associate is the so-called 'Master of Marradi'. Tondi attributed to him, while

[8] Inv. no. 507 in the Museo Horne, Florence, tempera on panel with a 100 cm. diameter and an unprimed border of *c.* two inches for insertion into its frame, in ruinous condition. Rossi, *Il Museo Horne*, 142; Fahy, *Followers*, 139; Florence, *Gli Uffizi*, 146, ill.

[9] His work has been confused with that of Giovanni Battista Utili; Fahy, *Followers*, 204–11, gives eleven tondi to Biagio, some homeless and with simple compositions. Berenson, *Florentine School*, i. 209–12, lists five. There are others as well, many with disputed attributions, e.g. a panel with an 88 cm. diameter in the Chigi Saracini Collection, Siena (Gregori, Paolucci, and Acidini Luchinat, *Maestri e botteghe*, 73–4, no. 2.5, ill., also cite a version with an 83 cm. diameter in the Snite Museum, Notre Dame, Ind. (inv. no. 61.64.1; Parke-Bernet, New York, sale cat., 12/V/60, no. 103) and a drawing for the Madonna's head in the Gabinetto Disegni e Stampe degli Uffizi in Florence (ibid. 86–7, no. 2.21, ill.)). Interestingly, Lydecker, 'The Domestic Setting', 118, 288, records a partnership between Biagio and Jacopo del Sellaio in 1472.

[10] Whereabouts unknown, panel with a 58.4 cm. diameter. See *Burlington Magazine*, 109:6 (1967), pl. V, with its raw wood border (listed as property of the Arcade Gallery, 28 Old Bond Street, London W1), as well as Christie's, London, sale cats., 27/XI/59, no. 64, 1/VII/66, no. 94.

[11] Fahy, *Followers*, 220–1; Pons, 'Piero e Polito del Donzello'. There are other identifiable artists operative in the same sphere; see ead., 'Il pittore Filippo d'Antonio e la sua attività tra Valdesa e Val di Pesa (II parte)'.

[12] Zeri, 'Eccentrici fiorentini—II', 314–16.

[13] Fahy, *Followers*, 200–2, believes that he may be Niccolò Cartoni, an assistant of Filippino Lippi.

[14] Fahy, 'Early Italian Pictures', 134–7.

[15] Fahy, *Followers*, 192–6, and Zeri, *Italian Paintings*, i. 108, suggest he is Giovanni di Michele da Larciano, called Graffione.

[16] Inv. no. 2492 in the National Gallery, London, panel with a 126 cm. diameter. M. Davies, *The Earlier Italian Schools*, 187, who assigns it to the Florentine School connected with Ghirlandaio; Fahy, *Followers*, 193, to the Master of Santo Spirito. The same cartoon was used in reverse for another tondo (Sotheby's, Florence, sale cat., 9/XI/71, no. 12). To demonstrate what murky waters of attribution we are in with the extended circle of Ghirlandaio, suffice it to note that in the past the panel has been given to Sellaio and to Raffaellino del Garbo.

conservative, are not without charm, and can again betray the work of several hands.[17] Most frequently they depict the Madonna and Child with angels and are intimate in mood, while only three have the more ambitious Holy Family theme. Several include young St John, and some have retardataire gold backgrounds indicative of the archaizing trend popular in late quattrocento Florentine art.[18] A tondo in Avignon includes a cloth of honour fastened at the top of the tondo in such a manner that it functions as a baldacchino as well and sets up a formal dynamic with the circular format (Fig. A6).[19] In addition, a rare *Madonna del Latte* in the format has been attributed to him (Fig. A7).[20] Its cruciform design, implied by the intersection of the cloth of honour and the exergue balustrade, was a device adhered to by less inventive *tondai* during the late Quattrocento. The allusion to lactation stresses Mary's nurturing nature and the humanation of Christ, as well as her association with Charity and the Church.[21] The most complicated tondo ascribed to the Master of Marradi also contains symbols that argue for the purity and unique status of the Virgin (Fig. A8). Herein an angel wearing a rose garland on its head holds another garland of roses (alluding to the Virgin as the rose without thorns as well as the rosary) and a stalk of lilies (purity) behind a wall, symbolic of the *hortus conclusus* and the Virgin's unblemished nature.[22] To stress further the sacredness of the scene and the devotional purpose of the tondo, this Madonna of Humility rests her finger on a book inscribed with a gloss on the action portrayed (Luke 1: 28, the Annunciation). The omniscient Child, contained within her pyramidal body, seems to be expounding on this text in praise of his exalted mother, while an adolescent John kneels before the holy pair, holding his cross-staff with its banderole inscribed from John 1: 29: *ECCE AGNUS DEI*. Because the palm tree positioned behind John may foreshadow the Child's impending martyrdom, the nearby rocks may allude to the tomb. Among the other tondi with slightly more monumental forms that exemplify the Master of Marradi's later style is a Holy Family with two angels, whose Madonna adores her child reclining on a parapet that functions as a symbolic altar strewn with implements of the Passion (Fig. A9).[23] This panel affects the pietistic tone and simplified treatment characteristic of Florentine art, especially that of Botticelli, in the decades around 1500.[24]

The Master of the Borghese Tondo worked in late quattrocento Florence with both Ghirlandaio and Rosselli, painting variations on Ghirlandaio shop tondi.[25] His paintings are grouped around his namesake panel with its Holy Family and two shepherds, whose rustic types reveal the influence of Flemish painting via the *Portinari Altarpiece* of van der Goes and Ghirlandaio's *Sassetti Altarpiece*.[26] One of his finest features

[17] Ibid. 181–5. Fahy records six, including ones formerly in Lyon, now in Avignon (see below, n. 19), and in the Musée Fesch, Ajaccio (inv. no. 852-1-731 with a 75.5 cm. diameter; Thiébaut, *Ajaccio, Musée Fesch: les primitifs italiens*, 101, no. 19, ill.).

[18] See Bernacchioni, 'Tradizione e arcaismi'.

[19] Inv. no. 20157 in the Musée du Petit Palais, Avignon, panel with a 45 cm. diameter. Laclotte and Mognetti, *Avignon, Musée du Petit Palais: peinture italienne*, 149–50, no. 145, ill. Another tondo in the same museum (inv. no. 21098 with a 68 cm. diameter) features young St John adoring the Child and two angels with lilies to underline the Madonna's purity (ibid. 148–9, no. 142, ill.).

[20] Whereabouts unknown, listed in the FKI as in the possession of a Florentine art dealer, without dimensions.

[21] L. Steinberg, *Sexuality of Christ*, 127–30. The need for food and sexuality were essential to the human condition, which in Christ's case had to be proven.

[22] Inv. no. A520d in the Ashmolean Museum, Oxford, panel with an 88 cm. diameter. Lloyd, *Earlier Italian Paintings*, 109, ill.

[23] Whereabouts unknown, listed in the FKI as in a private collection, Lugano, in 1928, without dimensions. Fahy, *Followers*, 184 (as formerly in Lucerne).

[24] A curious and fascinating tondo with a gold background and a 59.7 cm. diameter, whose unknown whereabouts prevents a specific determination of its nature, has been attributed to the Master of

Marradi. Its Madonna and Child are a truncated copy of a panel given to Lorenzo Monaco in the Metropolitan Museum of Art. See Fahy, 'Early Italian Pictures', 134 n. 30; id., *Followers*, 184; Gregori, Paolucci, and Acidini Luchinat, *Maestri e botteghe*, 207–11, ill., who attribute the two angels to the Master of Marradi and propose they were added to a work by Monaco, noting that they demonstrate that the Master of Marradi was one of the quattrocento artists involved in restoring earlier art. Eisenberg, *Lorenzo Monaco*, 150–1, believes that the Madonna and Child are modern additions after the Monaco shop panel (ibid., fig. 141). He thinks that either the centre of the tondo had been left incomplete or had suffered sufficient damage to necessitate its replacement with this anachronistic copy (letter of 22 Mar. 1994). It is not clear whether the panel was even meant to be a tondo.

[25] Venturini, 'Un altro pittore fiorentino nell'Appartamento Borgia: il Maestro del Tondo Borghese', assigns to him a homeless tondo from the second decade of the Cinquecento with an archaistic iconography, the Madonna della Misericordia, as well as a pigmented border around its circumference (ibid. 284, 286 n. 16, 288, ill.). Fahy, *Followers*, 167–8, attributes seven tondi to him and believes he may be Jacopo del Tedesco.

[26] Inv. no. 352 in the Galleria Borghese, Rome, tempera on panel with a 78 cm. diameter. Della Pergola, *Galleria Borghese*, i. 30–1, no. 35, ill.

a related theme with St John supporting the Child's head as the babe grasps the cross-staff to accept his destiny (Fig. A10).[27] Flanking the rays of the Star of Bethlehem, two flying angels hold a scroll inscribed with musical notes (an accurate chant notation of the intonation of the Gloria melody commonly called Gloria IV) and the words of their song: *G lo ria inexcelsis de'o* [*Gloria in excelsis deo*].

Yet another eclectic personality connected with Ghirlandaio, about whom nothing is known, is named after a tondo from the Holden Collection.[28] A tondo in London has been assigned to him (Fig. A11) which contains a standing Virgin (a relatively rare type that appears late in the fifteenth century).[29] The poses of its figures, including the Child selecting flowers offered by a Verrocchesque angel and the two kneeling angels reading music from a scroll, derive from Filippino's *Corsini Tondo* (Fig. 7.24). The London tondo is especially noteworthy for a pagan motif on the base of its throne, a satyr, symbolic of the culture that Christianity superseded and one of the few pagan motifs that intrude into the devotional sanctity of tondi.

The Master of the Lathrop Tondo, who has been identified as Michelangelo di Pietro Mencherini, has been mentioned earlier in conjunction with his namesake tondo in Los Angeles (Fig. 1.20).[30] Similar types find repetition in a *Holy Family with St Catherine of Alexandria* (Fig. A12), where the saint dominates nearly half of the composition.[31] No doubt her presence was due not only to the fact that she had a special relationship with the Child and, therefore, served as a good *exemplum* for women of the household or convent that commissioned the tondo, but also she may have been the patron saint of one of its women. The learned and aristocratically dressed saint is transcribing words dictated by the Child in a lavish illuminated manuscript, an unconventional iconography that may have been requested by the patron.

RAFFAELLO BOTTICINI

Raffaello Botticini, the son of Francesco, is also associated with the late Ghirlandaio shop.[32] His oeuvre has not been adequately examined, although his earliest works display connections with his father, while his later style shows chameleon-like fluctuation. Although the *Adoration of the Magi* from the Ryerson Collection was formerly given to Francesco, it is now attributed to Raffaello (Fig. A13).[33] Botticini's *Adoration*, while it is indebted to Botticelli's (Fig. A16), features the most emphatic, centralizing architecture of any circular treatment of the theme that in its size, vaulting, and use of arabesque *grotteschi* recalls the grandeur of Rome. Since its stable, symbolic of the New Order, is constructed within the ruins of a pagan temple containing a nude statue, the panel has a more pointed reference to secular ruins *all'antica* than any other. Most likely the ruins, therefore, were meant to represent the Templum Pacis in Rome, which according to Jacobus de Voragine contained a statue of Romulus and collapsed the night of Christ's birth.[34] In order to counter the architecture's rectilinearity, the artist introduced forms in harmony with the tondo—roundels, arches, and circular forms in the floor. He has also enriched it with symbols, such as the ship, an unusual reference to the return of the Magi to the East via a route avoiding Jerusalem and Herod.[35]

[27] Whereabouts unknown, oil and tempera on panel with a 116 cm. diameter, whose circumference is outlined in black pigment. Sotheby's, Milan, sale cat., 15/XII/92, no. 281.

[28] Inv. no. 1916.791 in the Cleveland Museum of Art, poplar panel measuring 89.8 × 85.4 cm. Cleveland, *Catalogue of European Paintings of the 16th, 17th, and 18th Centuries*, 454–5, ill. Fahy, *Followers*, 171, attributes eight other tondi to him.

[29] Inv. no. 3B1 in the Courtauld Gallery, London, tempera on panel with an 84 cm. diameter and a painted line around its circumference, formerly in the Lee Collection. Troutman, *The Painting Collections of the Courtauld Institute of Art*, 49, attributes it to a master after Filippino. The attribution to the Master of the Holden Tondo was taken from Fahy, *Followers*, 171.

[30] Ragghianti, 'Il pittore dei Guinigi', fig. 161; Fahy, 'A Lucchese Follower'; id., *Followers*, 176, lists an Adoration as his only other

tondo; see Ch. 1 n. 75.

[31] Whereabouts unknown, formerly inv. no. 36.6.1 in the Gibbes Museum of Art, Charleston, SC, the Samuel H. Kress Collection (K270), panel with a 68.6 cm. diameter. Shapley, *Paintings*, ii. 121, ill.

[32] Fahy, *Followers*, 212–13, assigns six tondi to him (Zeri, 'Raffaello Botticini', reproduces three: figs. 9, 10, 12); Venturini, 'I Botticini'.

[33] Inv. no. 1937.997 in the Art Institute of Chicago, tempera on a poplar panel of four boards aligned at a slight angle with a 104.2 cm. diameter. Waterhouse, 'Earlier Paintings in the Earlier Years of the Art Institute: The Role of the Private Collectors', 86, 91 n. 10; Lloyd, *Italian Paintings*, 49–53, ill., as 'Attributed to Raffaello Botticini'.

[34] *The Golden Legend*, i. 48. The Templum Pacis was equated with the Basilica of Maxentius.

[35] Lloyd, *Italian Paintings*, 52.

Among the other tondi with a variety of subjects and an eclectic mixture of styles assigned to Raffaello Botticini is a homeless tondo in ruinous condition (Fig. A14). It seems to date later and has traits reminiscent of Bugiardini, especially its snub-nosed children.[36] Here, the Madonna is seated on a low wall with the Child reaching out to cup tenderly the head of an older St John as the two children embrace. At the left one angel holding a musical scroll kneels before the wall, while the other at the right kneels behind the wall and leans on a similar scroll. Perhaps these angels allude to the New and Old Testaments, the one in the presence of Christ and the other connected but not able to cross into his world. The exergue is filled with symbolic plants, offering additional devotional foci for the worshipper of this five-figure panel for rosary devotion. A more unusual tondo depicting the Lamentation of the Dead Christ with St John, the Madonna, and Mary Magdalene (Fig. A15) has been accepted as by Raffaello.[37] In its background are Sts James and Roch, represented as pilgrims to leave no doubt about its devotional function, a purpose intensified by the instruments of the Passion and symbolic flowers strewn in its foreground.

BENEDETTO AND DAVID GHIRLANDAIO

The oeuvres of other Ghirlandaio family members are in flux, and their works are frequently confused with other individuals. This is an indication of the success of the Ghirlandaio shop and the *bottega* system. Take, for example, Benedetto Ghirlandaio, Domenico's younger brother who, before his eyes weakened, was by vocation a trader in manuscripts. David (Davide), another brother and collaborator of Domenico who seems to have been the administrator of their large workshop, worked as a mosaicist and educated his nephew Ridolfo (see below) after Domenico's death.[38] For many of the works attributed to them it would be prudent to assign them simply to the Ghirlandaio shop.[39]

SEBASTIANO (BASTIANO) MAINARDI AND THE GHIRLANDAIO SHOP

In the past, a vast array of tondi have been attributed to Sebastiano or Bastiano di Bartolo Mainardi (second husband of Domenico's sister Alessandra), many of them far too freely.[40] Together with other members of Ghirlandaio's shop and circle, he may have been involved in scores of collaborative tondi whose attributions may never be sorted out, although Venturini has made much progress in defining his oeuvre. Mainardi's broadly frescoed ex-voto tondo in the Bargello Chapel (Fig. 3.5), which is unquestionable, demonstrates that he was a competent but not an overly inspired *tondaio*. More importantly, it provides a dated work around which to group others, together with dated versions of the Holy Family given to Mainardi and/or the Ghirlandaio shop (one 1492 and the other 1493).[41]

It is with tondi associated with the Ghirlandaio shop and Mainardi that we see a repetitious use of drawings or cartoons without major variations in an unprecedented manner. This factory-like production is

[36] Whereabouts unknown, FKI. The panel, which appears to have been cut, once had a wider painted line around its circumference and betrays the work of several hands.

[37] In the Christ Church Picture Gallery, Oxford, panel with a 97.8 cm. diameter. Shaw, *Paintings by Old Masters at Christ Church, Oxford*, 55, no. 49, ill. A rectangular version is in the Uffizi.

[38] Van Marle, *Italian Schools*, xiii. 134–65; Francovich, 'David Ghirlandaio—I'; Berenson, *Florentine School*, i. 72–3, no tondi. For the workshop, see Venturini, 'I Ghirlandaio'.

[39] e.g. inv. no. 1937.1005 in the Art Institute of Chicago, panel with a 97.5 cm. diameter on a secondary wood support and cradled. Lloyd, *Italian Paintings*, 100–2, ill.

[40] For the artist, see Vasari (Milanese), iii. 272 ff., in his life of

Ghirlandaio; Berenson, *Florentine School*, i. 125–8, who assigned twenty-one tondi to him; Fahy, *Followers*, 215–19; Venturini, 'Mainardi'; ead., 'Modelli', 150–1; ead., 'Tre tabernacoli', 43, 47 n. 12; ead., 'Il Maestro del 1506: la tarda attività di Bastiano Mainardi'.

[41] The first is inv. no. 485 in the Museum der bildende Künste, Leipzig, tempera on panel with a 121.5 cm. diameter. Leipzig, Museum der bildenden Künste Leipzig, *Katalog der Gemälde*, 131, ill.; Covi, *Inscription*, 672; Venturini, 'Mainardi', 826–7, ill. The second, whereabouts unknown, FKI as in the Ridolfi Collection, Florence, but without dimensions; Berenson, *Florentine School*, ii, fig. 981; Venturini, 'Mainardi', 805, ill. Like some other painters, Mainardi at times used the same cartoon or drawing for rectangular compositions.

opposed to the one employed in the shops of Botticelli and Lorenzo di Credi, the two other most prolific *botteghe* for tondi, where, especially in that of Botticelli, frequently more invention on the prototype was encouraged. Many Ghirlandaio shop tondi were most likely painted serially for commercial sale without specific patrons, informing us about contemporary painting practice and the late quattrocento Florentine art market. Mainardi and his collaborators in the Ghirlandaio workshop produced tondi with two main themes. The first is a devotional variation on the historical Nativity, a Holy Family with the Madonna adoring the Child (sometimes with young St John and/or shepherds).[42] The second is the Madonna and Child with young St John and/or angels. One of the latter types, with angels but not St John, includes a damaged tondo with a depiction of the Madonna adoring the Child before a cloth of honour.[43] Despite extensive losses and repaint, it is a pleasing, albeit simple, composition, whose attribution rests more comfortably within the Ghirlandaio shop, unlike a variation of the subject in Mainardi's native town that is a late autograph work.[44] For the most extreme case of serial repetition, see Chapter 7 (Figs. 7.14–16).

With these and other miscellaneous tondi that gravitate to the orbit of Ghirlandaio's extended shop, we can begin to judge the great demand for tondi during the 1480s and 1490s. But nothing can prepare us for Botticelli, whose associates and assistants worked roughly contemporaneously to Ghirlandaio's workshop.

SANDRO BOTTICELLI

Perhaps the most difficult *tondaio* to characterize is Alessandro di Mariano di Vanni Filipepi, called Botticelli, who endowed his figures with expressive emotions via his line and the distortion of their postures and facial expressions.[45] He was one of the most prolific and inventive *tondai*, and his shop produced scores of variations, pastiches, and legitimate inventions on his tondi compositions. Sometimes it is nearly impossible to ascertain the extent of Botticelli's participation in each. Lightbown attributes eight tondi to him and reproduces twenty-four by the shop (discounting copies), while another study, claiming to be 'complete', reproduces thirty-two by Botticelli and shop,[46] although others continue to surface. A survey of them demonstrates why Botticelli was in such demand as a *tondaio*. He was excited by the challenges the format presented, and his experience illustrating Dante predisposed him to profound explorations of it. Further, his autograph tondi exhibit a compositional progression that proves he wrestled with the problems inherent in the form to find ever more pleasing solutions.

Botticelli is mentioned in commission/payment documents for three tondi. Unfortunately, they are too vague to be linked definitively with paintings, although several have been connected with specific tondi (Figs. 7.19–21).[47] In addition, Vasari mentions four tondi by Botticelli, two of which have been tentatively associated with extant panels—an Adoration of the Magi in Casa Pucci and a Madonna and Child and singing angels in San Francesco (Figs. A16, 7.18).[48] Significantly, Vasari also remarks that Botticelli painted many tondi in houses throughout Florence.[49]

[42] See Venturini, 'Mainardi'; ead., 'Il Maestro del 1506'.

[43] Inv. no. 14.40.635 in the Metropolitan Museum of Art, New York, tempera transferred to canvas from wood with a 98.4 cm. diameter. Venturini, 'Mainardi', 883–5, ill. A smaller version (31 cm. diameter) of finer quality with a dark line around its circumference is in the Vittorio Cini Collection, Venice (inv. no. 4027 in tempera on panel); Zeri, Natale, and Mottola Molfino, *Dipinti toscani e oggetti d'arte dalla collezione Vittorio Cini*, 29–30, no. 16, ill.; Venturini, 'Mainardi', 988–9, ill.; Gregori, Paolucci, and Acidini Luchinat, *Maestri e botteghe*, 250, no. 9.12, ill.

[44] Inv. no. 34 in the Museo Civico, San Gimignano, tempera on panel with a 77 cm. diameter. Venturini, 'Mainardi', 471–3, ill.; Gregori, Paolucci, and Acidini Luchinat, *Maestri e botteghe*, 162, no. 5.5, ill.

[45] Horne, *Botticelli*; Olson, 'Studies'; Lightbown, *Botticelli*; id., *Sandro Botticelli: Life and Work*.

[46] Mandel, *Botticelli*.

[47] See Ch. 3 nn. 46–7, 64–5.

[48] Ch. 3 n. 69.

[49] Vasari (Milanese), iii. 312: 'Per la città, in diverse case fece tondi di sua mano...'. Perhaps the large tondo valued highly in the 1498/9 inventory of Lorenzo and Giovanni di Pierfrancesco de' Medici's house (in the room with Botticelli's *Pallas and the Centaur* and possibly the *Primavera*) was by Botticelli ('Uno tondo di lignamo con adornamenti d'oro d'intorno, dipintovi la Vergine Maria col Nostro Signore in collo'); Shearman, 'The Collections', 25 (ASF, MAP CXXIX, fol. 515ʳ).

Botticelli's earliest surviving tondo (*c*.1470–5) is his *Adoration* (Fig. A16), which is no doubt the one seen by Vasari.[50] Its subject is the same as the two earliest tondi panels, one by his master, while its relatively large size indicates that it was an expensive, important commission. In it Botticelli applied his remarkable compositional abilities and for the first time centralized the scene completely. While Lippi had turned the course of the Magi's retinue to work with the shape (Fig. 3.1), he did not compensate for the incongruity between the rectangular layout and the format. Botticelli's innovative solution demonstrated insight into the compositional problems of tondi early in his career. By placing the Madonna and Child, as well as the vanishing point of the perspective, near the centre of the tondo, and breaking up the orthogonals so that they are not too dominant, he created an equilibrium between the narrative and iconic elements. This unity is only slightly disturbed by the background architecture.

Botticelli's second tondo, the one that may have been executed for the Salutati bank, presents a unique staging of a favourite devotional theme, the Madonna and St John adoring the Child (Fig. A17).[51] The artist depicted the holy trio in a narrow area connoting a rose garden. At the bottom he painted an illusionistic wall to indicate a sacred enclosure (the *hortus conclusus*, and to suggest the Garden of Paradise to which the new Adam and Eve will return, and an altar). This area creates an exergue that serves as a transitional barrier, while its tentative quality reveals Botticelli's relative inexperience with the format. Its inscription from the 'Magnificat' is now fragmentary and rubbed; it once read: *QVIA. RESPESIT. HVMILITATE./ ANCILE. SVE.* ('quia respexit humilitatem ancillae suae', Luke 1: 48).[52] If we suppose a relatively high hanging, the inscription was close to the viewer's eye level for legibility.

Three of his most successful tondi (Figs. 7.17–19) present a conscious, ever more sophisticated development of the 'Magnificat' theme. They are discussed in Chapter 7.

A tondo attributed to Botticelli from the Kress Collection is more problematic (Fig. A18).[53] The figures appear to predate the *Madonna of the Pomegranate* and are close to those of the artist's *Washington Adoration* and the *Madonna of the Book*, while the background seems later. In addition, more than one hand participated in its execution, which may be the result of a twofold campaign (the Virgin's face is close in type to those of Sellaio). The arch in its exergue functions formally as a filler device and strikes a threatening note to anyone from the post-Freudian era. It has been identified as a cave or abyss symbolizing death, hell, or sin, over which Christ triumphs,[54] and a prefiguration of the tomb (as in the artist's *Agony in the Garden*).[55] It also resembles the Roman *cloaca maxima* to remind us of Rembrandt's similarly evocative structure in the later states of his *Ecce Homo*. In this tondo, the form signals the old pagan order, which is related to the arch beneath the Joachim and Anna scene of Lippi's *Pitti Tondo* (Fig. 7.3), while simultaneously echoing the tondo shape.

In two other tondi (Figs. 7.20–1) Botticelli employed another device to harmonize with the tondo shape, that of the baldacchino, which also harbours celestial and Marian symbolism. They are discussed in Chapter 7.

Considered together, Botticelli's tondi, in which the master was responsible for the conception as well as a goodly portion of the execution, seem to present themes centered on the Immaculate Conception of Mary

[50] Inv. no. 1033 in the National Gallery, London, tempera on panel of five or six planks running from the upper left to the lower right with a 131.5 cm. diameter and a ring of exposed wood around its circumference. M. Davies, *The Earlier Italian Schools*, 101–2; Lightbown, *Botticelli*, ii. 25–6, ill. Antonio Pucci, the suggested patron, later commissioned four paintings from Botticelli.

[51] In the Museo Civico, Piacenza, tempera on panel with a 96 cm. diameter. Ibid. ii. 40–1, ill.; Sabatelli, *La cornice italiana*, 102–3, ill., for its frame.

[52] Covi, 'Botticelli', 270–2; Lightbown, *Botticelli*, ii. 41.

[53] Inv. no. 1952.2.4 (1087)/PA in the National Gallery of Art,

Washington, DC, formerly in the Samuel H. Kress Collection (K1432), tempera on panel of three members with a 59.6 cm. diameter. X-radiography has uncovered two inserts at the top and bottom as well as joints covered with canvas and gessoed. There is also a central split without canvas and gesso. Shapley, *Painting*, i. 122–3, ill. See also Friedman, 'Two Paintings by Botticelli in the Kress Collection', 120–3; Lightbown, *Botticelli*, ii. 79, ill., who notes that E. Fahy attributed it to Sellaio in 1970.

[54] Tolnay, 'Remarques sur la sainte Anne du Léonard'.

[55] Lightbown, *Botticelli*, ii. 79.

and the Incarnation of Christ. They are enlivened with echoes of Dantesque imagery and innovative iconographies. It was Botticelli's literary character (he was sickly as a child and in school longer than many) that equipped him for, and perhaps predisposed him to, these highly imaginative and harmonious explorations. His *bottega* produced tondi in a similar spirit.

BOTTICELLI WORKSHOP

The tondi produced by Botticelli's shop—like the rectangular paintings—are, as one would expect, variations on themes explored by the master (sometimes in collaboration). They include works with various degrees of his intervention: from those designed and partially painted by him to panels produced under his aegis, to tondi that were created by individuals either influenced or trained by him. Most of these have variants. Sometimes they are derived from or related to rectangular panels, but more frequently they relate solely to other tondi, reinforcing the fact that Botticelli and his associates conceived them specifically for a round design. The majority date from the late 1480s and 1490s, at the height of the form's popularity, and they can be divided by subject categories and typologies.

The first category consists of simple images of the Madonna and Child, of which none by Botticelli himself survives. Since a shop tondo once in the Kress Collection was probably cut from a rectangular panel, there are even fewer.[56] A tondo, whose Madonna and Child derive from the design used for the shop tondo in the Galleria Borghese, together with a few others, fits into this category.[57]

The largest number of Botticelli shop tondi include young St John portrayed at various ages. In fact, his shop specialized in tondi with the adolescent John, a phenomenon connected with the youthful lay confraternities which sprang up in Florence during the second half of the Quattrocento as an expression of lay piety (coinciding with the popularity of republicanism and also of tondi).[58] In most, St John is positioned at the left and was intended as the person with whom the viewer could identify, especially adolescents, introducing them into the picture. On occasion John is smaller in scale than the Madonna and Child to emphasize his lesser status and to underline his association with the viewer. Examples include Fig. A19[59] and Fig. A20, the latter of which may be the product of several campaigns, based on the following evidence.[60] Freely drawn faces flanking the central figures were discovered when this painting was transferred to a new panel, revealing that angels were originally planned and that John may have been a tardy addition.[61] Moreover, the right side is unresolved. It appears that its artist first intended to represent a ledge with a book but then painted a red cloth (a sacramental allusion) over it. This red colour, symbolic of Christ's Passion, is echoed in John's drapery, because he had foreknowledge of Christ's destiny. On top of the cloth are five unidentifiable round objects, perhaps jewels, which may relate to the five decorative studs on book covers in other Botticelli tondi. Since this area is muddled, the lightly painted book may have been part of a campaign

[56] Inv. no. 1961-6/11 in the El Paso Museum, Texas, formerly in the Samuel H. Kress Collection (K1240), panel with an 84.5 cm. diameter. Shapley, *Paintings*, i. 124, ill.; Lightbown, *Botticelli*, ii. 154, ill.

[57] Whereabouts unknown, formerly in the Mestchersky Collection, Moscow, panel with a 170 cm. diameter. Mandel, *Botticelli*, 99, no. 93, ill.; Lightbown, *Botticelli*, ii. 130–1. Others where the Madonna holds the Child before a balustrade and windows forming a cross are in: the Palazzo Vecchio, Florence (inv. no. 3444, panel with an 87 cm. diameter and its original garland frame; Mandel, *Botticelli*, 100, ill.); the Gallerie Fiorentine (inv. no. 1890, n. 5452, panel with an 89 cm. diameter, on deposit in San Giovanni Fuorcivitas, Pistoia); the Jacquemart-André Collection, Chaalis (Van Marle, *Italian Schools*, xii. 226, ill.).

[58] Trexler, 'Ritual', 201 ff.; id., *Public Life*.

[59] Inv. no. 1970.160 in the Cleveland Museum of Art, tempera on

panel with a 68 cm. diameter and a ring of pigment around its circumference. Mandel, *Botticelli*, 100–1, no. 99, ill., as formerly in the Lazzaroni Collection, Rome, lists variants, mostly in a tondo fomat; Cleveland, *European Paintings*, 50–3, ill.; Lightbown, *Botticelli*, ii. 124–5, ill.

[60] Inv. no. 930 in the Sterling and Francine Clark Art Institute, Williamstown, Mass., tempera and oil on a cradled panel with an 84 cm. diameter and a ring of pigment around its circumference. Ibid. ii. 125–6, ill. Thanks to Sam Edgerton for sharing two student papers on this tondo by Stuart Lingo and Sandra Ludig.

[61] Photographs when it was transferred from its poplar support in 1952 preserve traces of *pentimenti* of three heads on the back of the paint film. They provide an unusual opportunity to examine an artist's working method and suggest a spontaneous evolution in which motifs were manipulated and new elements added.

which was never brought to completion. Again, the appearance of the number five is tantalizing because it occurs repeatedly in tondi associated with the use of the rosary (its five decades) and also refers to the five wounds of Christ, both of which harmonize with the symbolism of the colour red.

The most popular Botticelli shop Madonna and Child tondi depict the two in the company of St John and adolescent angels that reflect contemporary youthful confraternities. One of the simplest features a standing Madonna as well as two angels (Fig. A21).[62] The left angel, who looks at the viewer and holds a spear, is Michael, while the right one, who leans on the balustrade and genuflects in deep reverence holding a lily, is Gabriel. The scene takes place in a room corner, whose rectilinear architectural elements create an upside-down Y-form, reminiscent of a cross, that works dynamically and symbolically with the round shape. Its arms open onto a ledge in the exergue, where a book is displayed on a *leggio* at an angle, as though the Madonna had been interrupted in her devotions. One of the largest tondi in this category (Fig. A22)[63] dates from c.1488–90 and has six angels (the number of creation and perfection, symbolizing divine power, majesty, wisdom, love, mercy, and justice).[64] Its Madonna and Child are seated in an area that looks ecclesiastical and connotes an altar enclosure, underlining the sanctity and purity of the pair as well as the sacramental nature of the Child, who holds a pomegranate and waves to the kneeling John. The older child, who formally leads the viewer into the composition on a diagonal, appears to adore the larger figures, implying that they are a vision he is experiencing, a conclusion supported by the fact that his hands are open in an expression of awe. The wingless angels are arranged in an arc behind the balustrade, which functions like a choir screen, singing or reading from two books (the covers of the right one are decorated with five bosses). Some angels hold lilies, while others wear or hold crowns of flowers. The second from the left wears a rose garland, an allusion to the rosary, while the angel directly to the right of the Madonna wears one composed of jasmine, which blooms in May, the month of the Madonna. Jasmine, when combined with roses as here, also symbolizes faith.[65] Three elegant metal vases, symbolic of the Trinity and the mysteries of the rosary, are filled with white and pink roses to reinforce this symbolism.[66] Another tondo in this group is a frontal *Madonna del Latte* with a suckling Child adored by an adolescent St John and an angel clasping a sacramental cloth to its chest.[67] The inscription *M (?) Giuljano da san Ghallo* on its reverse has led some scholars to attribute it to that artist, although most now interpret it as indicating that Botticelli's shop was sending it to Giuliano in the capacity of patron or framer.[68] This conclusion is feasible since Giuliano made the frame for Botticelli's *Bardi Altarpiece* (1484–5), and the two artists had a working relationship and similar aesthetic ideas.[69] A pair of tondi in this category—both from the same cartoon and with nearly identical measurements—have images of the Madonna being crowned with an *aureola* by two angels and adored by John. The panel closest to the master is Fig. A23,[70] whose five figures are poised before the *hortus conclusus* wall, beyond which white roses echo the *aureola*, rosary, and the *virgo et mater* themes.

Another large and popular category of Botticelli shop tondi involves the Madonna and Child only in the

[62] Inv. no. 348 in the Galleria Palatina di Palazzo Pitti, Florence, tempera on panel with a 115 cm. diameter. Mandel, *Botticelli*, 103, no. III, ill.; Lightbown, *Botticelli*, ii. 128, ill.

[63] Inv. no. 348 in the Galleria Borghese, Rome, tempera on a panel with two vertical planks and a 170 cm. diameter. Della Pergola, *Galleria Borghese*, ii. 18, no. 15, ill.; Lightbown, *Botticelli*, ii. 130–1, ill.

[64] Ferguson, *Signs and Symbols*, 154.

[65] Levi D'Ancona, *The Garden*, 193 ff.

[66] A derivative composition is known in several versions. One in a private collection, Chicago, panel with an 86.5 cm. diameter, has vases of flowers, including three white five-petalled roses for counting the rosary, its five decades and three mysteries. Fiocco, 'A Newly Discovered Tondo by Botticelli', pl. II; Mandel, *Botticelli*, 99, no. 90, ill. (listed as in the Edwards Collection, Cincinnati); Lightbown, *Botticelli*, ii. 132–3, ill., lists at least four versions, gives

the correct provenance for the tondo version in Chicago, but reproduces the wrong panel, the one formerly in the Akron Art Institute with an 88 cm. diameter (Christie's, New York, sale cat., 19/I/82, no. 116). There are other versions as well.

[67] Inv. no. 275 in the National Gallery, London, tempera on panel with an 84.5 cm. diameter consisting of three or four planks running on a diagonal from the lower left to the upper right. M. Davies, *The Earlier Italian Schools*, 110–11; Mandel, *Botticelli*, 98–9, no. 83, ill.; Lightbown, *Botticelli*, ii. 132, ill.

[68] Ibid. 132.

[69] Olson, 'Studies', 91–111.

[70] Inv. no. 69 in the Galleria Pallavicini, Rome, tempera on panel with a 111 cm. diameter. The other is inv. no. 226 in the National Gallery, London, measuring 114.5 × 113 cm. M. Davies, *The Earlier Italian Schools*, 110; Lightbown, *Botticelli*, ii. 133–4, ill.

company of angels, whose numbers range from one to a small chorus. The simplest is the Madonna and Child with a wingless angel holding a book with a lengthy inscription from the 'Magnificat' (Fig. A24).[71] Its lettering is not as elegant as that of the *Madonna of the 'Magnificat'*, although the devotional emphasis of this more spartan tondo is similar. The narrative implication is that the Child, wound up in his mother's pink veil (foreshadowing the shroud and his martyr's death), has distracted her from devotions. Another shop tondo—a Madonna and Child with five wingless angels (the decades of the rosary), three of which (the number of the mysteries of the rosary) hold red roses emblematic of Christ's Passion—contains an innovative motif (Fig. A25).[72] Its Child grasps a rose stem, injuring himself on a thorn in a prefiguration of the Passion, although the angel to the left of the Madonna tries in vain to prevent the injury. This tondo demonstrates the extraordinary inventiveness sustained by Botticelli and his shop.

A subcategory, the Madonna adoring the Child in the company of wingless angels and a backdrop of roses, which is referred to as the *Madonna delle Rose*, enshrines rosary iconography. There are two shop versions, both of which may reflect a lost original. The smaller, more tightly composed, version features four angels and red roses, symbolic of the Passion of Christ,[73] while the larger has pink roses and five angels arranged in a modified arc (Fig. A26).[74] In addition to the roses (referring to the Virgin as the 'Rosa Mystica' and the five decades of the rosary), the angels in the latter tondo hold olive branches (divine peace at the Nativity and the Immaculate Conception).[75] (In the version with four angels, the Madonna and Child would be the fifth decade.)

The large *Corsini Tondo* (Fig. A27) contains six (perfection and creation) winged angels. They accompany the Madonna embracing a standing Child beneath a richly decorated baldacchino (inscribed with letters transcribed as *AVE MA[RIA]/PL[ENA] DO...NVS T*).[76] The Virgin is being crowned by angels who draw back the honorific/celestial curtains. The bejewelled *aureola* they place on the Madonna is decorated with symbolic flowers: lilies (purity), marguerite (innocence of the Child), olive (divine peace), palm (victory), and wheat (bread of the Eucharist).[77] The four foreground angels, symbolic of the earth, hold instruments of Christ's Passion (the sponge and rod, lance, nails, and crown of thorns), communicating a pietistic tone characteristic of the 1490s, while the rhythms of the angels' limbs, wings, and cocked heads, together with the sinuous curves of the draperies, the baldacchino, and crown hypnotically create a meditative state.

For the largest tondo from Botticelli's shop, which was also the largest to survive from the Quattrocento until it was destroyed in the Second World War, a Madonna and Child with six angels (Fig. 7.22), see Chapter 7.

It seems that Botticelli's shop produced fewer tondi with representations of the Holy Family than did Ghirlandaio's associates. The surviving examples tend to date after 1490, coinciding with the zenith of Joseph's popularity, and usually feature the saint sleeping in the presence of a Bridgettine Madonna. These tondi are not among the shop's most successfully resolved compositions. One example from the Kress

[71] Inv. no. P.52.23 in the Bob Jones University Museum and Gallery, Greenville, SC, tempera on panel with a 96.5 cm. diameter. Pepper, *Bob Jones Collection*, 7–8, no. 4.1, ill. See also Lightbown, *Botticelli*, ii. 142, ill.; Covi, *Inscription*, 527. None of the 'Magnificat' inscriptions in Botticelli's shop tondi is identical.

[72] Inv. no. 10 in the Gemäldegalerie, Dresden, tempera formerly on apple wood, transferred to a new panel and restored to *c*.92 cm. in diameter. Lightbown, *Botticelli*, ii. 129, ill.

[73] Inv. no. 580 in the Galleria Palatina di Palazzo Pitti, Florence, tempera on panel with a 110 cm. diameter. Lightbown, *Botticelli*, ii. 152, ill.

[74] Inv. no. 1938.226 in the Baltimore Museum of Art, tempera on panel with touches of oil and a 132.7 cm. diameter. Mandel, *Botticelli*, 99, no. 92, ill.; Lightbown, *Botticelli*, ii. 153; Rosenthal, *Italian Paintings, XIV–XVIII Centuries, from the Collection of the*

Baltimore Museum of Art, 54–65, ill. Carroll, 'Floral Symbolism in an Early Florentine Painting', identifies five symbolic plants: the plantain (the well-trodden path of righteousness); the bluet (the Madonna's cloak); the violet (humility and mourning); the strawberry (virtuous works); and the scarlet pimpernel or shepherd's weatherglass (alluding to the Passion).

[75] Levi D'Ancona, *The Garden*, 261–3.

[76] Inv. no. 167 in the Galleria Corsini, Florence, panel with a 147 cm. diameter which appears to be composed of four planks running from the lower left to the upper right. The gold letters of the inscription on the right of the canopy, difficult to discern, appear to be *DOMIN[VS?]*. Lightbown, *Botticelli*, ii. 126, ill.; Covi, *Inscription*, 380.

[77] Levi D'Ancona, *The Garden*, 211, 124, 263, 282–3.

Collection, which lacks circular elements to echo its format, reveals that its artist tried unsuccessfully to adapt a rectangular format to the demands of a tondo.[78] Another with the Madonna and two shepherds adoring the Child in the Gardner Museum has a more active St Joseph but may reflect at least two painting campaigns.[79] Although the panel has many elements representative of Botticelli's style *c*.1481–7, the diverse proportions of its figures and the three or four styles in which the panel was executed indicate that several hands participated in its execution. Possibly Botticelli himself was responsible for the Madonna. Certainly a separate artist painted the gigantic figure of Joseph, who tenderly bends over the Child, embodying one of the earliest depictions of the Child's foster-father involved with his actual care.

In a consideration of Botticelli shop tondi one must mention the unfinished drawing, redrawn in ink, by Giuliano da Sangallo, discussed in Chapter 2 (Fig. 2.12).[80] Although parts of the sheet are difficult to read, it seems that the artist drew six angels, two of whom are seated in the foreground, creating for the first time a truly circular composition involving angels that wrap around the base of the tondo. A cherub head sketched in ink directly below the standing Madonna ingeniously joins the two sides of the problematic exergue. Because the posture of the Child is nearly identical with that in many later tondi from Botticelli's shop, it may preserve a lost tondo or a preparatory design for one that was never realized.[81] However, the sheet also exhibits affinities with the paintings of Ghirlandaio and Filippino.

JACOPO DEL SELLAIO

Jacopo del Sellaio (di Arcangelo), who was influenced by Botticelli (after their collaboration in Filippo Lippi's shop) and Ghirlandaio, painted lyrical, private devotional tondi during the late Quattrocento.[82] His iconographic specialities were the Bridgettine Madonna and the Madonna of Humility seated on a decorative cushion. But, like some individuals in Ghirlandaio's shop—such as one of Sellaio's own collaborators, Biagio d'Antonio—his name has become a convenient place to deposit problematic attributions. A reliably autograph tondo contains a Bridgettine Madonna and young John adoring the Child with St Jerome (praying before a crucifix) and two shepherds (Fig. A28).[83] A closely related tondo includes a subsidiary scene of Tobias and the Archangel Raphael either as a saintly *exemplum* or because the patron had a special association with Tobias.[84] To appreciate the charm of Sellaio's art one has only to look at a tondo in Avignon (Fig. A29).[85] Its Madonna of Humility is seated on a elaborate pillow inside the *hortus conclusus*, whose architectural projections have illusionistic bas-reliefs of putti with escutcheons (the shield below John is emblazoned with a civic design resembling that of the *capitano del popolo*). On top are: on the left two birds, perhaps goldfinches, foreshadowing Christ's Passion or generally symbolizing souls; on the right three cherries (the Trinity), a compote, and other fruits of Paradise.

[78] Inv. no. GL.60.17.26 in the North Carolina Museum of Art, Raleigh, formerly in the Samuel H. Kress Collection (K215), tempera on panel with a 125.7 cm. diameter. Shapley, *Paintings*, i. 122–3, ill.; Mandel, *Botticelli*, 104–5, no. 126, ill.; Lightbown, *Botticelli*, ii. 134–5, ill.

[79] Inv. no. P27e1 in the Isabella Stewart Gardner Museum, Boston, tempera (?) on light hardwood, measuring 79.2 × 78.8 cm. Hendy, *European and American Paintings in the Isabella Stewart Gardner Museum*, 41–3, ill.; Lightbown, *Botticelli*, ii. 135–6, ill. Von Holst, 'Michelangelo in der Werkstatt Botticellis?', 329–35, attributes the figure of Joseph to the young Michelangelo.

[80] MS Barb. lat. 4424, fol. 4ᵛ (2ᵛ), in the Biblioteca Apostolica Vaticana, Rome, silverpoint with redrawing in pen and brown ink on parchment measuring 445 × 390 mm. Hülsen, *Giuliano da Sangallo*, pl. 4ᵛ; Morello, *Raffaello*, 46, ill. For the artists' relationship, Olson, 'Studies', 91 ff.

[81] Fabriczy, 'Giulianos da Sangallo', 197–204.

[82] Berenson, *Florentine School*, i. 195–9, lists eleven tondi by Sellaio. See also Van Marle, *Italian Schools*, xii. 374–415. Lydecker, 'The Domestic Setting', 118, 288, records a partnership between Sellaio and Biagio d'Antonio in 1472; Pons, 'La pala del Sellaio per il Carmine', 9–10, has additional bibliography on the artist.

[83] Inv. no. 364 in the Galleria Palatina di Palazzo Pitti, Florence, tempera on panel with a *c*.98 cm. diameter. Chiarini, *Pitti Palace*, 55, ill.

[84] In the Galleria Giorgio Franchetti, Ca' d'Oro, Venice, panel with an 85 cm. diameter. Venice, Ca d'Oro, *La R. Galleria Giorgio Franchetti alla Ca' d'Oro*, 102–3. J. Hall, *Dictionary*, 304–5, for Tobias.

[85] Inv. no. 20647 in the Musée du Petit Palais, Avignon, panel with a diameter of 84 cm. Laclotte and Mognetti, *Peinture italienne*, 196–7, no. 217, ill.

In one of the his most unusual tondi (Fig. A30)—with the Madonna and Child flanked by two angels, St Peter Martyr with his knife, and Tobit with a box—Sellaio employed the round format to create the sensation that the figures are actually inside a royal, celestial tent, while the entire object resembles a mirror.[86] Two garlands of white flowers may serve as reminders of the rosary, whose five decades could be marked not only by the tangible beads but also by the tondo's five figures (the Madonna and Child as one entity). Because of the presence of Tobit and Peter Martyr, patrons of the Confraternity of the Misericordia, its patron more than likely was associated with that confraternity, from which this panel traces its provenance.

FILIPPINO LIPPI

Berenson assigned eight tondi to Filippino Lippi, although several others have been attributed to him and artists in his orbit.[87] It is logical that Filippino excelled in painting tondi because he was a pupil not only of his father, who was in the vanguard of their development, but also of Botticelli, one of the most prolific *tondai*. Moreover, his career flourished during the heyday of the form. The 1504 inventory of his shop lists four tondi, offering a tantalizing hint of his activity.[88] Filippino produced at least three significant tondi (Figs. 7.23–5; see Ch. 7), plus the Annunciation pair in San Gimignano; he was involved with many shop works as well.

As previously noted, Filippino's tondi depicting the Annunciation (Fig. 3.2) were commissioned in 1482 by the town of San Gimignano (under Florentine control since 1354) for the Palazzo del Comunale.[89] Because the lily was a civic symbol of Florence, the subject may have been subtle propaganda asserting the supremacy of Florence over San Gimignano in the guise of a religious theme. Filippino painted his figures in two interiors which harmonize but are not contiguous, indicating that they may have been hung with a gulf of space between them. Since the orthogonal lines of the terracotta-coloured floor run at different angles, as does the light, and because Gabriel is larger than the Virgin, it seems likely that the two panels were executed in sequence rather than simultaneously.

Both contain still lifes, although the cupboard behind the Virgin is filled with objects that represent a learned commentary on her role in God's plan for human salvation. At the top hangs a piece of paper with an inscription on her status as the chosen one in God's plan: *BENEdictas dom* . . . (Luke 1: 68, from the 'Song of Zacharias' praising God for the saviour from the house of David). Next to the paper are a carafe (the fountain of life or the Virgin's purity), a maiolica *albarello*, a knife (martyrdom), an apple (Original Sin from which Christ, the second Adam, would redeem the world, with the Virgin as the second Eve), a covered oval wooden box, and a rosary. Prior to the execution of Filippino's tondi, Ghirlandaio painted similar objects, including the *scrinium deitatis* in the scholarly study of his St Jerome fresco (1480).[90] This box—together with its nearby apple, carafe, and paper—also appears in other northern works. It refers to the fifteenth-century Annunciation hymn 'Nobile triclinium, / in forma virginalis / deitatis scrinium / et flos imperialis.'[91] This passage is an appropriate reference to have included in these Annunciation tondi, where the box lid is

[86] Inv. no. 18 in the Museo del Bigallo, Florence, tempera on panel with an 81 cm. diameter and its original frame. Kiel, *Museo del Bigallo*, 123, no. 18, ill.

[87] Berenson, *Florentine School*, i. 108–11. See also Hauptmann, *Der Tondo*, 224 ff.; Neilsen, *Filippino*, 127–9; Scharf, *Filippino Lippi*; Berti and Baldini, *Filippino*; Nelson, 'Aggiunti alla cronologia di Filippino Lippi'. Goldner and Bambach, *Filippino Lippi and his Circle*, 307, no. 95, ill., believe that the circular sheet in The Pierpont Morgan Library, New York (inv. no. IV 3), depicting Job visited by three friends, was preparatory for a painting in a round format, although neither its composition nor an earlier study in a rectangular format necessarily implies that the composition was round.

[88] Ch. 3 n. 45. It also includes a list of volumes by Dante, Ovid, and Poggio. Like Benedetto da Maiano and Botticelli, Filippino was learned and had literary tastes that would have informed his paintings.

[89] Inv. no. 43.DP in the Museo Civico, San Gimignano, tempera with oil on panels with 126 cm. diameters. Ch. 3 nn. 49–51.

[90] It was influenced by the Jan van Eyck shop panel of St Jerome in his study that may be the work noted in the 1492 Medici inventory (for the panel, see Ainsworth and Martens, *Petrus Christus*, 68–71, no. 1, ill.).

[91] Bergström, 'Disguised Symbolism in "Madonna" Pictures and Still Life II', 346 n. 44.

closed, emblematic of Mary's virginity. *Scrinium* is the Latin word for a case, chest, or box for keeping books, paper, or letters. Since the oval closed box in Filippino's *Annunciation* is different from the round one in van Eyck's painting but is similar to the box in his *Cleveland Tondo*, it may have been a prop in the artist's studio. Beads, indicative of the rosary and the devoutness of the Virgin, hang from the top shelf, stressing the tondo's devotional nature. Below are maiolica vases that provide further evidence of Filippino's prowess with still life, stimulated by an exposure to Flemish painting. One resembles a Hispano-Moresque, double-handled storage jar with the Medici *palle* that exists today, while the other is an *albarello*.[92] Filippino also depicted a mechanical clock in the Virgin's chamber similar to the one in Botticelli's St Augustine fresco (*c*.1480) opposite Ghirlandaio's *St Jerome* in the Ognissanti, Florence. The newly developed device, whose technology became widespread in the late Quattrocento, symbolizes the passage of time,[93] while its rotundity reflects cosmic and geometric harmony as well as the shape of the tondo. Furthermore, by 1482 clocks were important for the Church as a means of recording festivals and in noting the hours for prayers, and as such appropriate for tondi.[94]

 A group of diverse tondi were produced by Filippino and his shop. One features the Madonna seated on a *pietra serena* parapet decorated with a generic coat of arms and an inscription with Gabriel's salutation to the Virgin: *AVE. GRA.PLEN* (Fig. 1.21).[95] This sarcophagus-like parapet and the somnambulant Child foreshadow Christ's death.[96] In another of the most iconographically interesting ones young St John kneels on a balustrade before a tripartite window, symbolic of the Trinity, with curtains that create a canopy alluding to the holy scene's celestial nature (Fig. A31). Christ stands with his right foot on top of a book in a victor-over-vanquished pose, as the fulfilment of the Old Testament, while the placement of his left foot on a transparent cloth stresses the sacramental implications of his fate. An angel at the left didactically holds open a music book, eliciting the viewer's participation.[97] Another angel supporting John wears a rose garland to reinforce the function of the five figures for reciting the rosary. Filippino's shop also produced several tondi with the Holy Family. Some were based on a shop drawing modified in each instance, while in one Joseph physically introduces the Child to young St John.[98] Finally, a shop tondo (Fig. A32), also influenced by other artists, features an older John as well as St Joseph in a physically equal mirror image of the Virgin adoring the Child. This panel is stylistically indicative of a group of eclectic tondi produced in late quattrocento Florence.[99]

[92] Wilson, *Ceramic Art*, 28, pl. 16, reproduces a similar vase (*c*.1465) with wing handles and the arms of Piero or Lorenzo de' Medici.
[93] Kemp, 'The Taking and Use of Evidence, with a Botticellian Case Study', 211, 215 n. 12, suggests that the clock in the Botticelli fresco, which points between the twenty-fourth and the first hour, marks the end of the twenty-four hour cycle (which corresponds in the Italian system to the setting of the sun). More recently (Kemp, *Behind the Picture: Art and Evidence in the Italian Renaissance*, 184) he suggests that the time is 8 o'clock in the evening. Stapleford, 'Intellect and Intuition in Botticelli's *St Augustine*', believes that it refers to the beginning of eternity and the limitations of human mortality.
[94] See Reti, *Leonardo*, 240 ff., for clocks.
[95] Ch. 1 n. 79. It has also been assigned to Raffaellino del Garbo.
[96] Firestone, 'The Sleeping Christ-Child in Italian Renaissance Representations of the Madonna', 52 ff.
[97] Inv. no. 368 in the Glasgow Museums: Art Gallery and Museum, Kelvingrove, tempera on wood with a 119.4 cm. diameter, according to the FKI. Neilsen, *Filippino*, 195–6, fig. 95; Covi,

Inscription, 693–5, for its repainted musical score. Bonnie Blackburn (pers. comm. 1998) observes that the music looks readable, but the notes do not fit together. She suggests that the same person painted them who executed the music in Filippino's *Corsini Tondo*. The tondo's composition and theme, as well as those of several other tondi given to Filippino and Raffaellino del Garbo, are close to a cut drawing with the Virgin and Child with Angels in the Metropolitan Museum of Art, New York (inv. no. 1968.68.204), suggesting that the drawing may have been preparatory to a tondo or another devotional work (Goldner and Bambach, *Filippino Lippi and his Circle*, 280–1, no. 85, ill.).
[98] Inv. no. 20262 in the Musée du Petit Palais, Avignon, tempera on panel with a 130 cm. diameter. Laclotte and Mognetti, *Peinture italienne*, 124–5, no. 112, ill. A fragment of the Madonna in the Metropolitan Museum of Art, New York (inv. no. 1982.73) has been identified by Christiansen ('European Paintings', 38, ill.) as part of its model.
[99] Whereabouts unknown, tempera on panel with a 111 cm. diameter. Christie's, London, sale cat., 24/III/61, no. 37.

Raffaellino del Garbo

Although Vasari characterizes Raffaellino del Garbo, a pupil of Filippino, as a precocious artist who never lived up to his promise, a shooting star, whose work was barely distinguishable from that of his master, the artist's contribution is being re-evaluated.[100] Raffaellino participated in the execution of many tondi, both in Filippino's shop and on his own, and created one which is a masterwork in the form (Fig. 7.26; see Ch. 7). Since his style came under various other influences, and there are few firmly documented works to define his oeuvre, some of the several score tondi attributed to him should preferably be designated 'Workshop of Filippino' or identified as a collaboration involving Raffaellino. All these had an important message for a domestic context and the woman of the household, whose value was measured in her fertility and ability to provide heirs (as well as fidelity to her husband and chastity).

His most popular subject was the Madonna and Child with angels, with the Bridgettine Madonna adoring the Child running a close second. One unusual, lyrical tondo features a standing Madonna holding the sleeping Child, who rests a foot on a book, signifying that he is the fulfilment of the Old Testament prophecies. They are flanked by two angels playing a lyre guitar and syrinx pipes before the low wall of the *hortus conclusus* (Fig. A33).[101] In a copy, the angels also produce celestial music of the spheres, a theme appropriate for a tondo with the holy babe, sleeping to prefigure his death.[102] Another iconographically innovative tondo has been connected with both Raffaellino and Filippino (Fig. A34).[103] It features a standing Virgin, who is tenderly setting her child, whom she holds with a transparent cloth as though touching the host, onto an ornate pillow on the altar-like architecture. Two adoring angels hold up the Madonna's garments like acolytes during Mass, carrying the liturgical implications further. To the right lies an open book with an illegible approximation of a text, alluding to the Child as the fulfilment of prophecy, while simultaneously underlining the importance of devotions. Under the influence of works like Leonardo's *Benois Madonna*, the painter crowned this domestic setting with a rectangular window that does not work with the round shape.

Raffaellino is responsible for three compositions featuring the Madonna and Child between saints Catherine and Mary Magdalene. One is a drawing (Fig. A35).[104] Because its circumference is scored for transfer, it was most likely preparatory for a tondo, but probably not for either one of two extant tondi with the same female saints (reversed), unless it represents an earlier idea for one of them. The Oxford sheet seems closer to the *Pucci Tondo* (Fig. A36) because in both the Child is blessing Mary Magdalene.[105] Instead of the circle of angels in the upper zone, the panel has a throne with a cloth of honour and a square canopy from

[100] Vasari (Milanesi), iv. 233–41, who states that he died at the age of 58, although a recently discovered document establishes that he was still alive in Apr. 1527; Hauptmann, *Der Tondo*, 219–23; M. Davies, *The Earlier Italian Schools*, 454–6; Berenson, *Florentine School*, i. 185–9, who assigns eighteen tondi to him; Carpaneto, 'Raffaellino del Garbo: I. Parte', and ead., 'Raffaellino del Garbo: II. Parte', who comments on various tondi; Goldner and Bambach, *Filippino Lippi and his Circle*, 39–43, 338–51.

[101] Inv. no. 90 in the Staatliche Museen zu Berlin — Preußischer Kulturbesitz, Gemäldegalerie, tempera on panel with an 84 cm. diameter and a ring of dark pigment around its circumference. Bock *et al.*, *The Complete Catalogue of the Gemäldegalerie Berlin*, 33, ill. Several centimeters around the circumference were either unpainted or painted in a dark colour that has partially worn off for insertion into the frame. For the instruments, Winternitz, *Musical Instruments*, pl. 14.

[102] Inv. no. 4902 in the National Gallery, London, canvas transferred from panel with an 84.5 cm. diameter. M. Davies, *The*

Earlier Italian Schools, 457.

[103] Formerly inv. no. S.1 in the Kaiser Friedrich Museum, Berlin (destroyed), panel with a 105 cm. diameter. Berlin, Königliche Museen zu Berlin, *Die Gemäldegalerie des Kaiser-Friedrich-Museums*, i. 54, ill.; Berlin, *Beschreibendes Verzeichnis der Gemälde im Kaiser-Friedrich-Museum*, 167; Neilsen, *Filippino*, fig. 61.

[104] Inv. no. 0051 in the Christ Church Picture Gallery, Oxford, pen and brown ink heightened with white gouache on brown-pink tinted paper, with a 278 mm. diameter (section replaced at the top). Shaw, *Drawings by Old Masters at Christ Church, Oxford*, i. 47, ill.; Goldner and Bambach, *Filippino Lippi and his Circle*, 346–7, no. 115, ill.

[105] Inv. no. 4903 in the National Gallery, London, canvas transferred from panel with a 128 cm. diameter and a painted line around its circumference (formerly in the Casa Pucci, Florence). M. Davies, *The Earlier Italian Schools*, 457; Berenson, *Florentine School*, ii, fig. 1169. There is also a drawing in the British Museum linked to the hands of the Madonna.

which hang lappets and four strings of beads with crosses (alluding to the rosary as well as the four elements of the earth). The other, quite different, tondo features full-length figures and a specific narrative of the Mystical Marriage of St Catherine, in which the saint kneels on her wheel, whose shape echoes the tondo's own (Fig. A37).[106] Like Catherine, the Madonna is crowned. While her crown may be an *aureola*, it assuredly also indicates that she is Queen of Heaven, because the canopy is inscribed: *REGINA.CELI.LETARE. ALLELVIA.QA.Q.MERVI⁵*, a quotation from the antiphon prescribed by the Roman Breviary from Compline of Holy Saturday to None of Saturday after Pentecost.[107] Its presence confirms the tondo's iconography, stressing Christ's Sacrifice and Mary's role in Salvation. In both panels the baldachins allude to the royal, celestial nature of the pair, an element missing in the drawing, which may have been preparatory for yet a third tondo.

The last three tondi of Raffaellino to be discussed are among his finest and emphasize divine revelation through a celestial meteorological display, a motif in Filippino's early tondo (Fig. 7.23). The first contains a Holy Family positioned before a balustrade with a huge crack, perhaps foreshadowing Christ's tragedy (Fig. A38).[108] A stylized star with three rays (the Trinity) blesses the Child as a gloriously dramatic sky indicates in a naturalistic manner divine approval of the miraculous Child. Earlier Raffaellino had employed a related, less naturalistic approach to the heavens, whose abbreviated Ptolemaic system of concentric circles repeats the tondo's shape (Fig. A39).[109] Here, two cherubs lower a crown with ribbons onto the Madonna's head, indicating that she is the Queen of Heaven and a virgin despite the fact that she is seated on the ground as a Madonna of Humility (*virgo et mater*). She and the blessing Child jointly hold a pomegranate, the antidote to the sins of the first Adam and another round repetition, while an angel holds a book containing the 'Magnificat' for their devotions, which are interrupted by the arrival of the young St John. For the tondo with the most refined celestial display (Fig. 7.26), see Chapter 7.

Many other tondi have been associated with Raffaellino. One of these, attributed to the Master of the Naumberg Madonna, features reliefs with confrontations between a centaur and a man—allegories of the bestial versus the higher aspects of human intellect under Christianity—which are among the rare secular *all'antica* motifs in tondi (Fig. A40).[110] A few others should be reassigned near the Master of San Filippo, an anonymous artist working near Lucca *c*.1490–1500.[111] Two very individualistic panels can be linked to the shop of either this master or Filippino. The first has a rare portrait of its kneeling patron, with his *cappuccio* slung over his shoulder in a show of respect, perpetually adoring the Madonna and Child, who blesses him for this devotion (Fig. A41).[112] In the view through the window the artist also depicted the Magi journeying past the Porta di S. Niccolò in Florence. The specificity of these elements demonstrates that the patron played a role in the tondo's creation. The second features a Madonna with the Child seated before a balustrade with a pomegranate; the pair are adored by St Jerome clutching a rock to mortify his flesh (Fig. A42).[113]

[106] Inv. no. 1976.46 in the Fogg Art Museum, Harvard University, Cambridge, Mass., tempera on panel transferred to canvas with a 137.2 cm. diameter. Bowron, *European Paintings before 1900 in the Fogg Art Museum*, 126, ill.

[107] Covi, *Inscription*, 593–4, transcribes it not citing this tondo: 'Regina caeli, laetare, alleluja; Quia quem meruisti [portare, alleluja: Resurrexit, sicut dixit, alleluja: Ora pro nobis Deum, alleluja.]' ('Queen of heaven, rejoice, alleluia; For He whom you deserved to bear, alleluia, Has risen, as He said, alleluia; Pray God for us, alleluia.')

[108] Inv. no. 1154 in the Museum of Fine Arts, Budapest, panel with a 102 cm. diameter and a ring of dark pigment around its circumference. Carpaneto, 'II. Parte', 15, dates it to *c*.1511; Tátrai, *Museum of Fine Arts Budapest: Old Masters Gallery*, 100, ill. It is unpainted around the circumference for insertion into its frame.

[109] Whereabouts unknown, formerly collection of Marion Davies, Beverly Hills, panel with a 91.4 cm. diameter. Berenson,

Florentine School, ii, fig. 1169; Parke-Bernet sale cat., 24/V/44, no. 77. The book is inscribed on the left page: *Agnus/car an/imū mea do/minū. [E]t/exultator/spirirusui/eus soco*; on the right: *Sahn rari me⁵/Quia resp/exit humi/litatem a /neille suc/ecce enim/erbochea* (a garbled quotation from the 'Magnificat': [left:] 'Magnificat anima mea Dominum. Et exsultavit spiritus meus in Deo [right:] salutari meo; quia respexit humilitatem ancillae suae, ecce enim ex hoc bea[tam me dicent]').

[110] Whereabouts unknown, panel with a 74.5 cm. diameter and a ring of dark pigment outlining its circumference. Sotheby's, New York, sale cats., 13/X/89, no. 58, 5/IV/90, no. 99. Fahy, *Followers*, 186, for the artist.

[111] For the artist, Natale, 'Note sulla pittura lucchese alla fine del Quattrocento'.

[112] Whereabouts unknown, panel with a 76 cm. diameter, according to the FKI.

[113] Inv. no. 1149, Wawel Castle, Cracow, oil on panel with a 76 cm.

PIERO DI COSIMO

Piero di Cosimo, one of the most bizarre, creative artists of the late Quattrocento, painted tondi with natural phenomena that harbour iconographic symbols of great insight.[114] Moreover, he is one of the few artists whose oeuvre includes a number of drawings related to tondi, such as a sheet cut in an irregular circle (Fig. A43).[115] Although there is no way of ascertaining whether this drawing was preparatory for a tondo, the circular discs in the spandrels and oculus of its ruin tend to support that conjecture from a formal point of view. Since Piero was a pupil of Cosimo Rosselli, from whom he took his name, it is understandable that among his earliest tondi are shop paintings that have been attributed to both artists, some of whose attributions may remain for ever in limbo. See Chapter 7 for a selection of Piero's most successful tondi (Figs. 7.27–9).

One of the most unusual tondi attributed to him contains a quickly painted image of St Jerome in the wilderness (Fig. A44).[116] It has an integral, thin wreath frame and the slightly convex quality of a mirror. Its ascetic saint, who translated the Vulgate, kneels near a rustic *leggio* or altar meditating from a book propped up against a human skull. Noticeably absent from the scene is Jerome's lion, which one would expect Piero, a great *animalier*, to have rendered with relish (although an area to the right of the saint's shoulder is damaged and might have once had that image). The right background contains a view of the sea with a boat, perhaps referring to the Church, and snowcapped mountains. As one would expect, the artist's fresh approach is intense and personal. This devotional *exemplum* is unusual for a tondo, but was a popular late quattrocento subject for rectangular panels, an idea reinforced by two drawings of the saint by the artist.[117]

Piero depicted a standing Madonna and Child with St John in a tondo with bizarre motifs (Fig. A45) that continue the artist's special brand of naturalistic symbols.[118] Its Madonna is familiarly chucking the chin of John, who carries the reed cross and a sprig of broom (symbolic of divinity and the Incarnation of Christ, as well as the virtuous soul and humility).[119] She balances the blessing Child on a rustic lectern made from a severed but sprouting fig tree, foreshadowing his Death and Resurrection and celebrating his status as the second Adam. The Child has his hand on a book, signifying that he is the Word Incarnate. Various flowers and mushrooms ('God's sons because they seemed to be born without seed') grow in the foreground, including a dandelion gone to seed that refers to the Passion.[120] The angel plucks a narcissus, symbolic of the triumph of divine love, sacrifice, and eternal life over sin and death.[121] Piero painted a curious motif on top of the rock at the left: a black bird looking at an elongated object, which appears to be a chrysalis, symbolic of resurrection.[122] The bird most likely symbolizes the soul confronting the meaning of death and the

diameter. Białostocki and Walicki, *Malarstwo Europejskie w Zbiorach Polskich, 1300–1800*, 460, no. 25, ill., attribute it to Raffaellino [?]; Cracow, Muzeum Narodowe w Krakowie, *Malarstwo Włoskie XIV I XV Wieku*, 70, no. 56, ill.

[114] Vasari (Milanesi), iv. 131–44; Douglas, *Piero di Cosimo*; M. Bacci, *Piero di Cosimo*; ead., *L'opera completa*. Fermor, *Piero di Cosimo*, 149, believes that Piero's tondi 'comprise the most distinguished and sophisticated part of his religious output'.

[115] Inv. no. 78 in the Graphische Sammlung Albertina, Vienna, pen and brown ink with brown wash over black chalk (with retouchings) on white paper, measuring 154 × 164 mm., trimmed and laid down. Berenson, *The Drawings of the Florentine Painters*, ii. 260, no. 1863, ill.; Griswold, 'The Drawings of Piero di Cosimo', 280–2, ill. Another is inv. no. 343 E in the Gabinetto Disegni e Stampe degli Uffizi, Florence, in pen and brown ink, measuring c.138 × 132 mm.; Goldner and Bambach, *Filippino Lippi and his Circle*, 356–7, no. 118, ill. There is a faint indication of another figure in the right middleground (Joseph?).

[116] Inv. no. 31 in the Museo Horne, Florence, panel with a 74 cm. diameter. M. Bacci, *Piero di Cosimo*, 72–3, ill.; Rossi, *Il Museo Horne*, 142–3, ill; M. Bacci, *L'opera completa*, 87–8, no. 15, ill.; Fermor, *Piero di Cosimo*, 202–3, fig. 99; Forlani Tempesti and Capretti, *Piero di Cosimo*, 114, no. 21, ill. The Documentazione of the Uffizi notes the frame is carved from the same panel.

[117] See Griswold, 'The Drawings', 228–35, ill. Two other tondi of the subject include one given to Granacci (Fig. A65) and the other to a follower of Fra Bartolomeo.

[118] In the Museu de Arte, São Paulo, panel with a 129 cm. diameter and discoloured glazes. Douglas, *Piero di Cosimo*, 46–7, 119; M. Bacci, *Piero di Cosimo*, 94, ill.; ead., *L'opera completa*, 93–4, no. 40, ill.; Forlani Tempesti and Capretti, *Piero di Cosimo*, 129, no. 37, ill.

[119] Levi D'Ancona, *The Garden*, 71.

[120] Ibid. 135–42 (fig), 234 (mushroom), 126 (dandelion).

[121] Ibid. 243; Ferguson, *Signs and Symbols*, 34.

[122] J. Hall, *Dictionary*, 291, notes that a caterpillar, chrysalis, and butterfly together signify not merely the insect life-cycle but the stages of man's earthly life, death, and resurrection.

potential for resurrection in the Incarnate Christ,[123] because the slightly baffled bird confronting the chrysalis is directly on line with the positive narcissus flowers and does not appear malevolent. This kind of earthy visual image seems akin to those used by contemporary preachers. But only an artist with a profound appreciation of nature, like Piero, would have been able to tell the Christian message in such a convincingly prosaic yet profoundly symbolic manner.

Piero included other intriguing iconographical details in a tondo with the Madonna, St John, and an angel adoring the Child (Fig. A46),[124] who reclines on a cloth over a bundle of wheat signifying the bread of the Eucharist and alluding to Bethlehem (meaning House of Bread, according to St Gregory the Great).[125] A red rose at his feet, like an offering, symbolizes his Passion. At the right is a dove or pigeon, which may be an allusion to the presence of the Holy Spirit, or alternatively—because the dove is bicoloured—may be a commentary on Christ's dual nature (this idea is repeated with a variation in one of two shop versions, the one in the Hermitage (Fig. A49)). Directly above in the stable's loft, Joseph descends the stairs towards a saddle. He has just experienced his dream wherein the angel (standing in the loft surrounded by a glorious light) warned him to flee Herod's wrath. Two other angels in the sky indicate that the Annunciation to the Shepherds is taking place out of the viewer's vision. Grazing in the left middle ground are the ox and ass, symbolic of the Gentiles and the Jews, while a group of riders, perhaps the Magi, approaches. At the extreme left are two small nearly indistinguishable figures with haloes; the seated one holds a cross-staff to identify the scene as the meeting of Christ and John before the Baptism.[126] Thus, this tondo presents a personal interpretation of events surrounding Christ's Nativity and his mission that constitute a visual challenge to unravel during devotion.

Another late tondo by Piero with shop collaboration is painted in a different technique that betrays the influence of Andrea del Sarto and Leonardo but nonetheless contains a highly individual iconography. In its right background is one of the most beautiful Florentine cityscapes of the early sixteenth century, before which is a vignette of St Martin dividing his cloak with a beggar (Fig. A47).[127] (St Martin may have been the patron's onomastic saint, while St Margaret may have been the patron saint of his wife.) Margaret, the saint of childbirth, who is separated from the Madonna and Child by the diagonal rock on which her crucifix rests, pauses in her devotional reading to engage the viewers' attention, inviting them to contemplate this profound event. The freely painted work, suffused with a variation of Leonardo's *sfumato*, has an iconography linked to Leonardo's *Madonna and Child with St Anne* (*c.*1506). The Child embraces the Mystic Lamb offered by John, thereby accepting his destiny (his Incarnation is stressed by the proximity of the Lamb's hoof to his genitals).[128] In addition, there are other references to Christ's Passion and triumph, demonstrating Piero's gift for presenting symbolic ideas in the guise of quotidian phenomena.

Both Bacci and Fermor assign to Piero a tondo with an opaque black background (Fig. A48). Since the panel went through two or three campaigns in Piero's *bottega*, separated by as much as ten years, it is difficult to date.[129] In this shallow composition, related to a rectangular panel in the Cini Collection, a Madonna of

[123] If the bird was meant as a blackbird, or less likely a member of the crow family, the meaning could change because both birds could be interpreted as symbols of the devil and evil. If this is the case, the motif would represent the triumph of Christ over Satan and of eternal life over death and sin. Friedman, *Symbolic Goldfinch*, 24; Ferguson, *Signs and Symbols*, 24–6; Petersen, *A Field Guide to the Birds of Britain and Europe*, 269, 301–11.

[124] Inv. no. 1939.1.371 (464)/PA in the National Gallery of Art, Washington, DC, formerly in the Samuel H. Kress Collection (K1096), oil on canvas transferred from a panel with a 145.7 cm. diameter. M. Bacci, *Piero di Cosimo*, 95, ill.; Shapley, *Paintings*, ii. 119, ill.; Fermor, *Piero di Cosimo*, 152, fig. 74; Forlani Tempesti and Capretti, *Piero di Cosimo*, 119–20, no. 30, ill.

[125] *Homilia VIII in die Natalis Domini* (*PL* 76, 1104).

[126] Shapley, *Paintings*, ii. 119, ill.; Fermor, *Piero di Cosimo*, 152,

who notes that in the *Golden Legend* of Jacobus de Voragine, Christ came to John to be baptized on the same day as the Epiphany.

[127] Inv. no. 1963.17 in the Philbrook Museum of Art, Tulsa, formerly in the Samuel H. Kress Collection (K169), panel with a 137.8 cm. diameter. M. Bacci, *Piero di Cosimo*, 101, ill.; Shapley, *Paintings*, ii. 120, ill.; Fermor, *Piero di Cosimo*, 152, fig. 75, believes it is Piero's latest surviving tondo; Forlani Tempesti and Capretti, *Piero di Cosimo*, 141–2, no. 49, ill.

[128] It refers to Christ's circumcision. L. Steinberg, *Sexuality of Christ*, 49; Bynum, 'The Body of Christ in the Middle Ages: A Reply to Leo Steinberg'.

[129] In a private collection, panel with a 75.01 cm. diameter and a thickness of 7.01 cm., comprised of two planks with many knots and a seam running horizontally. M. Bacci, *Piero di Cosimo*, 90, ill.; ead., *L'opera completa*, 100–1, no. 70, ill.; Fermor, *Piero di Cosimo*, 140, 216

Humility holds the Child towards St John.[130] The work's illusionistically convex space, which counters the concave circle of the figures, suggests that the artist had been examining mirrors and their visual effects. In another unique action worthy of Piero, the Child eats a piece of fruit, most likely an apple (referring to Christ as the second Adam) or a plum (the Passion, because of its colour), given to him by John. This act signifies an acceptance of his destiny, an idea repeated in the red rose on the ground. Once again, the five entities in the tondo could have functioned as focal points for the rosary.

Several other tondi produced under the aegis of Piero and dating from the latter half of the artist's career provide amplifications of earlier designs. As previously noted, two nearly identical shop tondi (Fig. A49) relate to the Washington tondo (Fig. A46) and present an interesting problem.[131] Since the diameters of all three are nearly identical, one can deduce that at least the later two were executed from the same cartoon, although minor differences in techniques, styles, and motifs abound. Neither is in optimum condition, and both were probably worked on by more than one hand. At the right stand two languid angels, who hold long pipes similar to those in the *Medici Tondo* of Signorelli and participate in a ritualistic recognition of the Incarnation. Joseph puts the ox and ass of the Old and New Testaments out to pasture in a poetic landscape, which is especially beautiful in the Borghese panel. Above, in the rafters of the Hermitage tondo, perch two doves or pigeons, the black one over St John and the white over Christ. They may relate to the bicoloured bird in Piero's Washington tondo and like it symbolize the dual nature of Christ or the two Testaments. These birds certainly were not essential, since in the Borghese version there is only one white dove, which may symbolize the presence of the Holy Spirit.

Other tondi hover around Piero's orbit, some of which are even further removed from the master. A panel (Fig. A50) with an unusual representation of Genesis scenes involving Adam and Eve, the forefathers, an Old Testament variation on the Holy Family that would have communicated related values and ideals of the family, was formerly attributed to an artist working with Piero after 1505 who was familiar with *spalliera* paintings of the 1490s. After restoration in 1997, it has been assigned to Piero himself.[132] Another tondo, formerly given to Piero and now assigned to the Master of Serumido, contains some iconographically interesting details and a beautiful cinquecento landscape (Fig. A51).[133] Its Madonna and Child with young St John are flanked by two columns and positioned on a plateau, below which spreads a bucolic countryside reminiscent of the idyllic landscapes by Fra Bartolomeo. On the balustrade in its exergue are three white sweet-brier roses with five petals each (alluding to the five wounds of Christ) for the recitation of the three mysteries of the rosary in five decades. Nearby are another flower, perhaps a daisy symbolic of the Incarnation of Christ—an idea illustrated in the tondo—and a devotional book, emblematic of the panel's function.[134] They demonstrate the high level of creativity that Piero inspired in other artists working in his *bottega* or influenced by him.

nn. 26–7, fig. 69; Forlani Tempesti and Capretti, *Piero di Cosimo*, 119, no. 29, ill. In 1992 Ann Milstein Guité, of Richard L. Feigen and Co., informed me that Bacci had seen the painting and attributed it to Piero. It has been X-radiographed, revealing that the Madonna and Child were painted first and subsequently altered, while the background was originally a rocky grotto inspired by Leonardo's *Madonna of the Rocks*.

[130] Zeri, Natale, and Mottola Molfino, *Dipinti toscani*, 31–2, no. 17, ill.; Fermor, *Piero di Cosimo*, 140, fig. 67.

[131] Inv. no. 54 in the Hermitage, St Petersburg, canvas transferred from panel with a 144 cm. diameter. M. Bacci, *Piero di Cosimo*, 98–9, ill., who assigns it to Piero c.1510 but repainted; Kustodieva, *Hermitage Catalogue*, 343–4, no. 184, ill. For inv. no. 343 in the Galleria Borghese, Rome, tempera on panel with a 140 cm. diameter, see M. Bacci, *Piero di Cosimo*, 99, ill.; ead., *L'opera completa*, 94–5, nos. 45–6, ill.; Forlani Tempesti and Capretti, *Piero di Cosimo*, 138, no. 45, ill.

[132] In the Galleria Luigi Bellini, Florence, panel with a 71 cm.

diameter. Parke-Bernet, New York, sale cat., 10/XII/58, no. 10; Sotheby's, New York, sale cat., 6/VI/85, no. 38; Venturini and Scarpelli, *Studio del Tondo di Piero di Cosimo 'I Progenitori'*. Close to Piero is another tondo, inv. no. 7940 in Wawel Castle, Cracow, panel with an 85 cm. diameter, formerly in the Lanckoronski Collection, Vienna; see Miziolek, 'The Lanckoronski Collection in Poland', 36, fig. 19.

[133] Whereabouts unknown, panel with an 89 cm. diameter. Sotheby's, London, sale cat., 9/VII/75, no. 5. The FKI attributes it to the Master of Serumido. Forlani Tempesti and Capretti, *Piero di Cosimo*, 137, no. 44, ill., list it in a private collection in Italy and attribute it to Piero.

[134] Levi D'Ancona, *The Garden*, 368 ff., citing St Bernard of Clairvaux (*PL* 184, 715) for the sweet-brier rose; 124–6, for the daisy. Forlani Tempesti and Capretti, *Piero di Cosimo*, 129–30, no. 38; 142–5, nos. 50, A2, A4, A6, A11–13, A15, reproduce other tondi given to Piero and his shop, as well as one, pp. 107–8, no. 15, ill., which has recently been assigned to Piero himself.

Lorenzo di Credi

Vasari's life of Lorenzo di Credi (Lorenzo di Antonio d'Oderigo), who trained as a goldsmith and attached himself to Verrocchio, in whose *bottega* Leonardo was a colleague, is brief but important. Vasari informs us that one of his first paintings was a Madonna tondo that was sent to the King of Spain (whose design he copied from Verrocchio).[135] After this auspicious beginning, one would expect Credi to be a master *tondaio* and, indeed, he and his shop were in terms of sheer quantity if not in inventiveness. Later in this biography Vasari mentions another tondo of a Madonna that he saw in the house of Ottaviano de' Medici, adding that Lorenzo painted many works with the Madonna in Florentine houses.[136]

Together with his shop, Lorenzo painted so many tondi that Berenson's attribution of ten seems conservative.[137] Along with Botticelli and Ghirlandaio, he shares the distinction of heading a shop which influenced the largest number of tondi extant. While Credi's oeuvre is better studied than those of some contemporaries, it lacks a secure chronology. Moreover, many of the attributions to anonymous masters operating in his galaxy are in flux. However, the Madonna and Child tondi for which his shop was so famous can be divided into thematic types. Before turning to them, however, we must note a singular tondo representing a young male saint (St Louis of Toulouse?) ascending to heaven, flanked by two angels (Fig. A52), where the format was selected for its celestial implications.[138] It is likely that its adolescent saint was identified with the patron or his son and that the panel served a devotional function, although the nature of its installation is unknown. From the hands of the angels, positioned as though they were supporting an *imago clipeata* (or the young saint's body), and the saint's toga-like drapery, the artist must have looked to antique art for inspiration.

The simplest composition that the Credi shop specialized in is the Bridgettine Madonna adoring the Child, exemplified by Fig. A53.[139] Here Lorenzo's ability to convey intimacy is accented by the anecdotal detail of the Child placing his finger in his mouth while reclining on a bundle of wheat. This conservative but charming composition survived in a drawing within the shop to be employed endlessly by assistants.

About a score of tondi with a closely related theme, the Bridgettine Madonna with St John adoring the Child, are given to Credi and his *bottega*. One of the finest is also connected with the previous tondo (Fig. A54).[140] Even the Child's posture is identical, suggesting use of the same drawing with the addition of John from another source. The Credi shop utilized cartoons or pattern drawings repeatedly, sometimes for both rectangular paintings and tondi, adding figures from different compositions and many times reversing them.

For Credi's important tondo with the Madonna and Child blessing young John and its preparatory drawing (Figs. 7.30–1) see Chapter 7. It goes without saying that there are copies and derivations from this influential work.

A tondo in the Uffizi with the Madonna adoring the Child has an unusual action: in place of the customary St John, a kneeling angel crowns the Child with a leafy garland foreshadowing his Passion (Fig. A55).[141] It is directly related to, among others, a tondo in which an angel supports St John as he adores the Christ, creating the effect of stills from a movie camera and making the viewer want to genuflect with

[135] Vasari (Milanesi), iv. 563–71. See also Hauptmann, *Der Tondo*, 210–16; Dalli Regoli, *Lorenzo di Credi*; Brewer, *A Study of Lorenzo di Credi*.

[136] Vasari (Milanesi), iv. 568.

[137] Berenson, *Florentine School*, i. 115–17.

[138] Inv. no. 26.88 in the Huntington Art Gallery, San Marino, CA, panel with a 58 cm. diameter and a painted area around its circumference. Dalli Regoli, *Lorenzo di Credi*, 121–2, no. 41, ill.

[139] Inv. no. 89 in the Staatliche Museen zu Berlin — Preußischer Kulturbesitz, Gemäldegalerie, panel with a 73 cm. diameter. Ibid. 124, no. 49, ill.

[140] In the Galleria della Fondazione Quirini Stampalia, Venice, panel with an 85 cm. diameter. Ibid. 134–5, no. 68, ill.

[141] Inv. no. 883 in the Galleria degli Uffizi, Florence, tempera on panel with an 87 cm. diameter, perhaps in its original frame regilded. Ibid. 182–3, no. 181, ill.; Florence, *Gli Uffizi*, 344, ill.

them.[142] The cartoon was reused in other works, for example, Fig. A56, to which a sleeping St Joseph and two smaller vignettes, an Annunciation to the Shepherds and a beautiful landscape with a bridge, have been added.[143] The latter area contains an anecdote that may refer to Christian Charity: on the bridge a lame man begs from a soldier flanked by a barking dog. Another shop tondo without this incident contains the same five foreground figures but reversed.[144]

Scores of other tondi from the Credi circle, many executed by two or more individuals, illustrate various devotional themes. For example, a popular type after 1500 features a seated Madonna holding a blessing Child between two kneeling angels, sometimes in the presence of St John (Fig. A57).[145] The holy pair is usually positioned in front of either a tree, forming a natural halo, a throne, a landscape, or a cloth of honour. It is interesting that few tondi from Credi's circle include ancillary saints other than St John. Those few that do, with the possible exception of the one in Nîmes with a Mystical Marriage of St Catherine, seem further removed from the artist and his shop.[146] An artist identified as 'Tommaso', who seems to have specialized in tondi, has been associated with Credi (at least twenty-five tondi have been given to him, although this list needs refining).[147] An especially engaging example has a Madonna and Child enthroned and adored by St John, while two angels accompany them on a lute and a vielle or lira da braccio (Fig. A58).[148] In addition, a fascinating drawing assigned to an anonymous follower of Credi, 'The Master of the London Madonna Studies', contains sketches for tondi (Fig. A59) that reveal a fascinating artistic personality who was probably one of the individuals working in Credi's shop.[149]

FRANCESCO GRANACCI

Many of the tondi previously given to Francesco Granacci, who is better known for his festival designs and assisting Michelangelo on the Sistine Ceiling, are problematic. His currently reconstructed oeuvre demonstrates what a good weeding out of old attributions might accomplish in the case of other artists. Although Vasari implies he painted many tondi, Von Holst in a reductionist manner assigns only two tondi to him.[150] One may be the Trinity that Vasari described as painted for the house of Pierfrancesco Borgherini, for whom the artist also painted Joseph serving Pharaoh; its format was no doubt selected for its celestial associations (Fig. A60).[151] The latter was associated with a cycle of fourteen paintings (by Pontormo, Andrea del Sarto, and Bacchiacca) illustrating the Story of Joseph.[152] It reflects the pietistic sentiments of its time and

[142] Inv. no. 09.197 in the Metropolitan Museum of Art, New York, panel with a 91.5 cm. diameter. Dalli Regoli, *Lorenzo di Credi*, 159–60, no. 127, ill.

[143] Inv. no. 1599 in the Galleria degli Uffizi, Florence, on deposit in the Museo Horne, tempera *grassa* on panel with a 115 cm. diameter. Florence, *Gli Uffizi*, 343, ill.

[144] Inv. no. WAF 191 in the Alte Pinakothek, Munich, poplar panel with a 98.5 cm. diameter. Dalli Regoli, *Lorenzo di Credi*, 161, no. 131, ill.; Fahy, *Followers*, 50 ff., fig. 37, who attributes it to Fra Bartolomeo; Munich, *Alte Pinakothek Munich*, 160, ill.

[145] Inv. no. 1942.6 in the Joslyn Art Museum, Omaha, Nebr., panel with an 89.5 cm. diameter. Dalli Regoli, *Lorenzo di Credi*, 194, no. 267, ill.; Day and Sturges, *Joslyn Art Museum: Paintings and Sculpture from the European and American Collections*, 25, ill.

[146] For the tondo in the Musée des Beaux Arts, Nîmes, panel with an 85 cm. diameter, see Dalli Regoli, *Lorenzo di Credi*, 177, no. 169, ill.

[147] Berenson, *Florentine School*, i. 207–8, distinguishes him from Tommaso di Stefano Lunetti, a pupil of Credi. Dalli Regoli, *Lorenzo di Credi*, 175 ff.; Goldner and Bambach, *Filippino Lippi and his Circle*, 370–2, for a recent synopsis of Tommaso.

[148] Inv. no. 50 in the Hermitage, St Petersburg, oil on canvas transferred from panel with a 127 cm. diameter. Kustodieva, *Hermitage Catalogue*, 246–7, no. 131, ill., ascribes it to the workshop of Lorenzo di Credi. For the instruments, Winternitz, *Musical Instruments*, 118; Ventrone, *Le tems revient*, 247–8, nos. 7.9–10.

[149] Inv. no. Pp. 1-30 in the British Museum, London, pen and brown ink on ochre-tinted paper, cropped and measuring 244 × 182 mm. Berenson, *Drawings*, ii. 258, no. 1859B, ill.; Popham and Pouncey, *Italian Drawings in the Department of Prints and Drawings of the British Museum: XIV and XV Centuries*, i. 127–8; Collobi Ragghianti, *Il libro*, i. 109, ill.; Griswold, 'The Drawings', 306–7, ill. A sheet by the same hand (inv. no. 1968.364r in the Rijksprentenkabinett, Amsterdam) has a partial study for a tondo held up by an angel like an *imago clipeata*.

[150] Vasari (Milanesi), v. 339–45; Von Holst, *Francesco Granacci*.

[151] Inv. no. 229 in the Staatliche Museen zu Berlin — Preußischer Kulturbesitz, Gemäldegalerie, panel with a 103 cm. diameter and a ring of dark pigment around its circumference. Ibid. 145–6, no. 26, ill.

[152] Vasari (Milanesi), v. 343; Braham, 'The Bed of Pierfrancesco Borgherini', 757 n. 9, cites G. Rosini, *Storia della pittura italiana*, v (1845), 63, who stated without a source that the Trinity surmounted the bed as a 'Capoletto'.

its visionary quality strikes a chord similar to Fig. A52. In the last sentences of Granacci's life, Vasari adds that he painted many other 'tondi' and 'quadri' both large and small.[153] One of these may have been Fig. A61, a panel revelatory of Granacci's quattrocentesque orientation.[154]

A group of tondi, some with implied cruciform shapes, have been assigned to Granacci's circle, although it may be more prudent to relegate them to the category 'Florentine School'. In ones with cruciform shapes, the vertical and horizontal elements create a sophisticated interplay of a Greek cross (four squares) with a circle, the perfect geometrical and implicitly Christian forms. One, whose vertical element, flanked by windows partially glazed with round leaded panes echoing the panel's format, could be read as a cloth of honour (Fig. A62).[155] A later asymmetrical composition juxtaposing a landscape with an interior occurs in a more cinquecentesque tondo in which the Madonna marks her place in a devotional book (Fig. A63).[156] Another tondo with an unusual subject, the Evangelist John on the island of Patmos (identified by his eagle and the inscription in his book), had been attributed to Granacci, although more recently it has been associated with the atelier of Ghirlandaio (Fig. A64).[157] In the tradition of author portraits, the saint writes and further assumes a pose close to the Madonna in Signorelli's *Medici Madonna* (Fig. 7.32). This panel's function, however, remains unknown. Was it meant as part of a series of the Evangelists, or a representation of an individual's patron saint? Did it—like the tondi with celestial images (Figs. A52, A60)—have a devotional function different from tondi with the Madonna and Child?

One of the aforementioned tondi with St Jerome in penitence has been attributed to the young Granacci (Fig. A65).[158] There are two others, one by Piero di Cosimo (Fig. A44) and a Venetian-looking panel in the Cini Collection.[159] The date of the tondo at Longleat is assuredly *c*.1490, because its figure and setting betray the influence of Filippino Lippi, as in his *Virgin Appearing to St Bernard* in the Uffizi (*c*.1485–90), *St Jerome in Penitence* in the Galleria della Accademia, Florence, and the St Jerome in his *Madonna and Child with St Jerome and St Dominic* in the National Gallery, London. Its chapel-like grotto, as well as its botanical details, were influenced by Leonardo's activity and interests, as in his *Madonna of the Rocks*. The rocks and some of the details, however, are characteristic of Filippino, as is the saint's intensely ecstatic expression.

LUCA SIGNORELLI

In the past Luca Signorelli's innovative tondi have been overshadowed by his large-scale frescoes, although two of them may have been influential on Michelangelo.[160] At least seventeen tondi have been assigned to Signorelli, five of which are autograph or minimally assisted (there is the possibility of a sixth which is now in another format). At least five others involve the collaboration of Luca (to varying degrees) and some may

[153] Vasari (Milanesi), v. 344. Berenson, *Florentine School*, i. 98–100, lists twelve tondi.

[154] Inv. no. 2987.1 in the Honolulu Academy of Art, formerly in the Samuel H. Kress Collection (K532), panel with an 87.6 cm. diameter. Shapley, *Paintings*, ii. 124, ill.; Von Holst, *Granacci*, 132, no. 6, ill.

[155] Whereabouts unknown, formerly on panel with an 85.1 cm. diameter transferred to canvas. Venturini, 'Mainardi', 891–2, ill., lists it in the collection of Evelyn B. Metzger as of 1976 after the Borchard Collection, New York, and attributes it to the Maestro della Storia di Giuseppe Spiridon. See also Berenson, *Florentine School*, ii, fig. 1267; Von Holst, *Granacci*, 200, no. 183.

[156] Inv. no. 67 in the Museum of Fine Arts, Budapest, panel with vertical planks and an 85 cm. diameter. Ibid. 183, no. 131, ill.; Tátrai, *Museum Budapest*, 39, ill.

[157] Inv. no. 1208 in the Museum of Fine Arts, Budapest, tempera on panel with a 75.5 cm. diameter. Von Holst, *Granacci*, 183–4, no.

132, ill.; Tátrai, *Museum Budapest*, 47, ill., to the circle of Ghirlandaio. Covi, *Inscription*, 366–7, transcribes the inscription in the saint's book: *APOCALI [PS]/ YHS·X[V]*. The scroll he holds is inscribed with the beginning of the Gospel of John: *IN PRINCIPIO ERAT VER[BVM]*.

[158] In the collection of the Marquess of Bath, Longleat, Wiltshire, panel with a 57.8 cm. diameter and a painted area outlining its circumference. By E. Fahy in Barocchi, *Il giardino*, 49–51, no. 11, ill.

[159] Fischer, *Disegni di Fra Bartolommeo e della sua scuola*, 34–5; Barocchi, *Il giardino*, 51, fig. 17.

[160] Berenson, *Italian Pictures of the Renaissance: Central Italian and North Italian Schools*, i. 394–401, lists nine tondi. Monographs include: Vischer, *Signorelli*; Cruttwell, *Signorelli*; G. Mancini, *Signorelli*; Venturi, *Luca Signorelli*; Dussler, *Signorelli: Des Meisters Gemälde*; Moriondo, *Signorelli*; Salmi, *Signorelli*; Scarpellini, *Signorelli*; Kury, *The Early Work of Luca Signorelli: 1465–1490*; Paolucci, *Signorelli*.

involve Luca's nephew Francesco.[161] Only one relatively late and very general document (1505) concerning Luca's tondi is known and no work has been definitively linked to it.[162] In addition, only one late tondo by the artist in Berlin is signed (Fig. 4.2).[163]

Based on Vasari's testimony, Luca Signorelli is thought to have made at least one trip to Florence in the late 1480s and early 1490s after working in Siena, and from his contacts and patrons should be considered in this study.[164] Vasari mentions three works from this trip, two of which were supposedly painted for Lorenzo de' Medici.[165] However, from the evidence in Signorelli's oeuvre and his peripatetic nature, he must have made more than one trip to Florence.[166] He was exposed to Florentine ideas early, for already in 1481–2 he was at work in the Sistine Chapel, assisting Pietro Perugino, whom he reportedly met in Florence. Moreover, his *Vagnucci Altarpiece* (dated 1484) demonstrates knowledge of Florentine art, while he is documented in the environs of Florence at Castiglion Fiorentino in 1484.[167] A gap in documents in his southern Tuscan town of Cortona and a listing in Florence implies that he was again there between 1490 and 1491.[168] Further, it is possible that Signorelli could have travelled between Florence and Siena as well as Cortona and Volterra, where he had other commissions prior to the San Brizio Chapel (1499). In fact, a line drawn from Florence to the Tuscan cities of Arezzo, Cortona, Siena, and Volterra forms an oval, demonstrating the feasibility of his working in these centres on a regular basis.

Signorelli flirted with the circle in other commissions, as in his *Annunciation* in Volterra (Fig. 3.9) with a bona fide sculptural tondo over the door of the Virgin's bedchamber. Its relief of King David with his harp footnotes Christ's lineage from the House of David.[169] Among the other examples are two large grisaille roundels with sibyls in the Bichi Chapel of Sant'Agostino, Siena, featuring foreshortened coffers similar to those of Donatello's *Madonna del Perdono* in that city.[170]

Signorelli produced three general categories of tondi in which he invented novel iconographies: the Madonna and Child; the Holy Family; and the Holy Family with saints. From style and partial provenances it seems that he executed his first tondi in Florence during the late 1480s or early 1490s. Without documents, this conclusion remains a hypothesis, although it can be supported by an impressive body of circumstantial evidence. Vasari tells us that Signorelli's *Medici Madonna* was painted for a Florentine patron and that he saw the *Parte Guelfa Tondo* in the city. Both his *Corsini Tondo* and *Munich Tondo* have early Florentine

[161] For Francesco, see Kanter, 'The Late Works', 290 ff.; F. F. Mancini, 'Signorelli, Francesco', 838; Kanter, 'Francesco Signorelli'.

[162] The document of 3 Sept. contains a mention of a tondo with the Madonna and other figures for Giovannantonio di Luca di Matelica (ASF, Notarile Antecosimiano 11413—formerly Rog. L. 49, as cited by G. Mancini, *Signorelli*, 145—Girolamo Laparelli, 1505–7, fols. 28ᵛ–30ᵛ): 'Et quendam rotundum ligniaminis cum imagine gloriosissime virginis marie, et aliis figuris, prout visum fuerit dicto magistro Luce'. Kanter and Franklin, 'Some Passion Scenes by Luca Signorelli after 1500', 190, no. 4, link (pp. 181–2) this general description to a tondo formerly in the Korda Collection, London (sold Christie's, London, 10/VII/87, as lot no. 100). They follow Salmi, *Signorelli*, 62, 71. The male saints in the Korda tondo, identified by Kanter and Franklin as St Antony of Padua and an attributeless elder St John the Evangelist, could have been added, they conclude, as patron saints of Giovannantonio, the potential owner. Creighton Gilbert (letter of 19 June 1995) writes that this document may refer to a tondo formerly in the Baduel Collection, Florence, which repeats a composition Signorelli had previously painted in the tondo in the Corsini Collection; further (letter of 7 July 1995) that the figure Kanter and Franklin identify as St John the Evangelist may be St Joseph, as stated by earlier writers. In fact, the description in the document could be applied to several late tondi from Signorelli's shop. In a letter of 2 Aug. 1997, Gilbert points out that it is highly unlikely, given the freedom to paint 'other figures',

as specified in the document, that Signorelli would have chosen the patron's saints (he thinks small figures, such as those in the *Medici Madonna*, would be more likely).

[163] Olson, 'Signorelli's *Berlin Tondo*'; see Ch. 4 n. 49 and below.

[164] Ingendary, 'Rekonstruktionsversuch der "Pala Bichi" in San Agostino Siena'; M. Seidel, 'Die Fresken des Francesco di Giorgio in S. Agostino Siena'; Kanter, 'The Late Works'; Bellosi, *Francesco di Giorgio*, 420–3, 440–7.

[165] Vasari (Bettarini and Barocchi), iii. 636–7, a 'Nostra Donna' with two small prophets, the *Pan*, and a tondo of 'Nostra Donna' for the Udienza de' Capitani di Parte Guelfa that he terms 'bellissimo'.

[166] Raphael's father Giovanni Santi wrote a poem in *terza rima* honouring quattrocento painters, characterizing Signorelli as inventive with a wandering spirit; Bek, 'Giovanni Santi's "Disputa de la pictura"—A Polemic Treatise'.

[167] Mancini, *Signorelli*, 55.

[168] Cruttwell, *Signorelli*, 121–3. Around 5 Jan. 1491 he was one of the artists invited to judge the competition for the façade of Santa Maria del Fiore, although he did not participate. By 23 Aug. 1491 he was back in Cortona and elected to the Consiglio Generale; Mancini, *Signorelli*, 79; M. Seidel, 'Signorelli um 1490'.

[169] Two Gospels discuss the lineage of Joseph from King David's house: Luke (1: 27) and Matthew, who begins his account with the lineage of Joseph. See Ch. 3 n. 87 for Christ's genealogy.

[170] M. Seidel, 'Die Fresken', ill.; id., 'Signorelli um 1490', ill.

provenances. Unfortunately, Signorelli's one signed tondo (Fig. 4.2) has an incomplete provenance. Of the remaining tondi close to the artist, three are from Florentine collections and one from nearby Prato. These statistics, nevertheless, insinuate the importance of Florence in his tondi.

Signorelli's tondo in Munich (Fig. A66) dates fairly early in his career.[171] It seems thinly painted (or overcleaned since there are no traces of haloes, traditional in Signorelli's works) and, while it was painted on the master's design, may have been assisted. Its original garland frame of fruits and flowers surrounds the image of a casual Madonna whose hands are folded in prayer at the recognition of her child's divinity. Nearby is a stream of water that is conceptually linked to the Child. Opposite him is a seated nude youth with one bare foot who is in the act either of taking off or putting on a sandal. This motif is not just a genre detail, but has a significance central to the tondo's theme. His pose is based on the famous ancient bronze *Spinario* (thornpuller) that Signorelli would have seen in Rome.[172] From similar figures in Signorelli's oeuvre, and on analogy with neophytes about to be baptized in other paintings,[173] this *spinario* is related to baptismal iconography alluding to sinful (pagan) nature.[174] Although John the Baptist is not depicted in the *Munich Tondo*, his forthcoming mission is alluded to by the presence of water and this neophyte. Formal analysis strengthens the baptismal argument: the hands of the Child and the Madonna's drapery link the areas of water to the neophyte, while the buildings in the left background of the *Munich Tondo* resemble Roman tombs. Their placement on the side of the river opposite the Madonna, Child, and neophyte sets up the death-versus-life choice offered by the Sacrament. Moreover, this youth has analogies with the nudes and theme of the *Medici Madonna* (Fig. 7.32), which are indubitably associated with Baptism.

Baptism was a significant theological issue in quattrocento Florence, and in his highly influential *Summa*, St Antoninus devoted pages to discussing it.[175] While Christ's Baptism, marking the beginning of his ministry, did not occur until he was an adult, Florentines of this epoch included allusions to it in works of art where he is a Child to foreshadow an event in which their civic saint played an important role.

While Signorelli was iconographically inventive in the *Munich Tondo*, he did not grapple with the requirements of the panel's shape. Because the composition could have been painted within a rectangular format, it gives the effect of an ocular window through which the viewer looks. The artist's early insensitivity to these special requirements, however, gave way to an appreciation of the shape as his response became increasingly sophisticated. Even though we know virtually nothing of either his patrons or their contracts, we can establish a rough chronology for Signorelli's tondi by analyzing his solutions. Therefore, the next tondo in his treatment thematically and stylistically is his *Medici Madonna* (Fig. 7.32), followed by his *Parte Guelfa Tondo* (Fig. 7.33), both discussed in Chapter 7.

Like the *Parte Guelfa Tondo*, the massive lateral figures of Signorelli's closely related *Corsini Tondo* (Fig. A67), and a copy with identical dimensions, conform to its shape, representing a further refinement and a greater approximation of a convex mirror.[176] The blonde Virgin's head, which is almost a mirror image of the

[171] Inv. no. 7931 in the Alte Pinakothek, Munich, limewood panel with an 87 cm. diameter. Munich, *Alte Pinakothek*, 504–5, ill. Mancini, *Signorelli*, 173; Dussler, *Signorelli*, 202; Salmi, *Signorelli*, 55, ill.; Scarpellini, *Signorelli*, 131, ill.; Seidel, 'Signorelli um 1490', fig. 77, reproduces its X-radiograph in which the head of the Madonna has two *pentimenti* profiles where the cartoon was moved, suggesting that the artist was working experimentally, as opposed to later in the Bichi Chapel, where the cartoon was reused. He dates it shortly before 1490.

[172] Bober and Rubinstein, *Artists and Antique*, 235–6, no. 203, ill., state that the Renaissance interpretation of the figure as a shepherd (pastor) began in 1513. Oertel, *Italienische Malerei zum Ausgang der Renaissance—Meisterwerke der Alten Pinakothek*, 28–9, believes that it alludes to the material way of life prior to Christ.

[173] Signorelli and shop reused the motif for a youth in one of the

two small panels in the Toledo Museum of Art (once part of the *Bichi Altarpiece*; Salmi, *Signorelli*, pl. 37), in which, like the *Spinario*, the left leg is raised as though the assistant used his master's drawing after the ancient work, while the youth in the *Munich Tondo* is freely adapted with the opposite leg off the ground. Another figure based on it but reversed from that in this tondo is in the *Baptism of Christ* (documented 1508) in San Medardo, Arcevia (Moriondo, *Signorelli*, 90–1, no. 46, ill.).

[174] Camille, *The Gothic Idol*, 83–7, believes it was a guilt-ridden image of pagan excess and vice.

[175] In vol. iii of the Venetian edition of 1582 discussed by Hartt, Corti, and Kennedy, *Chapel*, 122.

[176] In the Galleria Corsini, Florence, oil on panel of planks running from the upper left to the lower right with a 115 cm. diameter. Dal Prà, *Bernardo di Chiaravalle nell'arte italiana dal XIV*

figure in the *Medici Madonna*, is more closely linked to that of the Tiburtine Sibyl in the Bichi Chapel.[177] In fact, Signorelli used the same cartoon for both, although the *pentimenti* in the Virgin's hair in the *Corsini Tondo* suggests that it dates before the Tiburtine Sibyl. In this tondo Signorelli depicted St Jerome holding the rock with which he has been mortifying his flesh and St Bernard of Clairvaux, the writer of the *Meditations* renowned for his learning, as an author wearing the Cistercian habit. Bernard enjoyed great popularity in late quattrocento Florence owing to his connection with the cult of the Virgin, and here Signorelli stressed his devotion to her to remind worshippers of his writings about her.[178]

Signorelli's tondo with the Holy Family and a female saint writing (his *Pitti Tondo*) embodies a departure, because it is the first time that either he or his shop depicted half-length figures in a tondo (Fig. A68).[179] It contains some awkward passages, for example, the bodice of St Catherine and the facial structure of Joseph. Its Madonna and its female saint are related to figures in his *Annunciation*, helping to date the work *c*.1490–2, although it is difficult to place it more precisely because of old restoration. The composition is equally keyed to a rectangular format, a fact reinforced by its parapet, which is covered by a green cloth (resurrection and life) with three folds (the Trinity).[180] The Child sits on a reddish cushion, referring to his royalty and Passion, while the wheat alludes to the bread of the Eucharist and Christ's Sacrifice, and a cherry symbolizes the fruits of Paradise.[181] Although the female saint lacks attributes other than her pen and book, she can be tentatively identified as Catherine of Alexandria; since she wears no ring, the scene takes place before her Mystical Marriage. When St Catherine is depicted holding a book, it refers to her knowledge, for she was a patron of education and learning and of young girls.[182] Here, she has been blessed by the apparition of the Holy Family; her arrested gesture reveals surprise, as though her concentration has been interrupted by their arrival, either in the flesh or in a vision. Because of its function, this panel served as an *exemplum* in a home or a convent, encouraging learning and devotional prayer.

An assisted oval painting, which was once in a tondo format, is closely related (Fig. A69).[183] If its cut sides were extended to form a complete circle, there would be enough space to inscribe comfortably lateral figures and to insert a hint of landscape. The painting is Florentine in its iconography and style, while the face and upper torso of the Virgin, except for her right hand holding the Child, are from the artist's cartoon used for his *Annunciation* (Fig. 3.9). At the right is a male figure who has been identified as Joseph. However, he has no halo like the other holy figures, and his shabby clothes are not characteristic of the Child's foster-father. Rather his humble gesture, subservient position, and peasant costume identify him as a shepherd.[184] Moreover, he is slightly out of scale with the other figures, although viewers could identify with him as a bridge into the painting.

Another tondo with a composition and theme analogous to that of the *Pitti Tondo* is even more a product of assistantship (Fig. A70).[185] Its Holy Family and the Franciscan St Antony of Padua, holding his attribute,

al XVIII secolo, 144–5, no. 23, ill.; Bellosi, *Francesco di Giorgio*, 438–9, no. 94, ill. Dussler, *Signorelli*, 50–1, ill., also reproduces it together with a shop copy in the Baduel Collection.

[177] M. Seidel, 'Signorelli um 1490', 214 ff.

[178] Ferguson, *Signs and Symbols*, 108–9; J. Hall, *Dictionary*, 46.

[179] Inv. no. 355 in the Galleria Palatina di Palazzo Pitti, Florence, panel with a 99 cm. diameter. Moriondo, *Signorelli*, 26–7, no. 14, ill.; Chiarini, *Pitti Palace*, 56, ill.; Paolucci, *Signorelli*, 33, ill. Cecchi, 'Les Cadres', 23, discusses its frame.

[180] Ferguson, *Signs and Symbols*, 151, notes green as the Church's liturgical colour for Epiphany.

[181] Ibid. 40 (wheat), 29 (cherries); J. Hall, *Dictionary*, 66, 330.

[182] Ferguson, *Signs and Symbols*, 193–5; J. Hall, *Dictionary*, 58–9. In the *Golden Legend*, St Catherine was celebrated for her erudition as well as her royal status. She was removed from the Catholic

Church Calendar in 1969 because of her uncertain historicity.

[183] Inv. no. I 1821 in the Musée Jacquemart-André, Paris, measuring 102 × 87 cm. A letter from the museum (12 Dec. 1989) in answer to my query confirms that it was once probably a tondo.

[184] There are shepherds with similar torn sleeves in a late shop Nativity for the Chiesa del Gesù, Cortona, in the Museo Diocesano (Moriondo, *Signorelli*, 124–5, no. 65, ill.) and an *Adoration of the Shepherds* in the Johnson Collection, Philadelphia Museum of Art (Dussler, *Signorelli*, 181, ill.). He may have been one of a rustic pair.

[185] Whereabouts unknown, formerly in the Korda Collection, London, oil on panel with an 86 cm. diameter (Christie's, London, sale cat., 10/VII/87, no. 100). Salmi, *Signorelli*, 62, pl. 66b; Dal Prà, *Bernardo*, 150, no. 26, ill., lists it in the possession of Antichità Moretti, Prato. Creighton Gilbert sent me notice of another version in oil on canvas with a 73.66 cm. diameter, on the cover of *Pharos*, 6:4 (1968), as in the collection of Mrs Mac B. Rojtman.

a heart, appear as a vision to St Bernard, who is seemingly in the act of writing his *Meditations*. The pose of Antony formally echoes that of the Child, underlining the fact that he like St Francis, the founder of his order, was considered an *alter Christus*.[186]

Signorelli's only signed tondo is inscribed *LUCHAS +SIGNORELLVS /+ DE CORTONA+* on the *cartellino* resembling a discarded paper in its exergue. It contains an innovative scene with full figures (Fig. 4.2).[187] While most scholars consider it an autograph work, there is no agreement about its date, although its dark tonalities argue for a date after 1500.[188] The *pentimenti* of a servant woman carrying a bowl or basket on her head that have been illuminated by infrared reflectography and X-radiography suggest that originally Signorelli planned a different solution, but decided that the figure spoilt the clarity of the foreground. Its dark background was added subsequently by the artist or by another individual in his shop to cover this area.[189]

At first glance, this tondo appears to represent a purely genre scene, except that the figures, whose postures bend over to echo the panel's curves, all wear haloes. Actually it is an iconographically innovative religious scene.[190] Its textual source in the *Meditations on the Life of Christ* (*Meditationes vitae Christi*), attributed to Pseudo-Bonaventura, relates how little St John showed respect for Christ despite the fact that both were youngsters.[191] In an unusual manner, Signorelli has depicted Zacharias, as in the illustrations of the *Meditationes*,[192] striding in from the back holding St John. John turns over a dish—that looks like a sacral plate and a halo—above the Child, who perches on the lap of weary Joseph. Except for the dish and the action of the boys, it would be impossible to discern which father and son was meant to represent Joseph and the Child because the ages of the two children are not differentiated, perhaps the result of Signorelli being forced to invent when no strong visual tradition was available. Further confusing the identification is the fact that Signorelli had used both types of men in earlier works to represent St Joseph.

Finally, a late Signorelli shop *Sacra Conversazione* (*Prato Tondo*) (Fig. A71), which is pastiche, is not without some fascinating features.[193] The poses of its Madonna and Child were taken from the same drawing as the two figures in a tondo in Cracow.[194] In both, the Madonna points to the Child's right foot, a gesture seen in other late paintings celebrating the Virgin by Signorelli and shop. In the *Prato Tondo*, as in other later

[186] Salmi, 'Signorelliana', 114, connects the work with the documented tondo *c.*1505 (above, n. 162). Kanter and Franklin, 'Passion Scenes', 181, state that Signorelli provided his patron with a picture from stock and believe that of all tondi surviving by Signorelli only this one satisfies all the minimum circumstantial requirements. They identify the saint as Bernard (a Cistercian) or Benedict (an Olivetan), the right saint as Antony of Padua, and the left as John the Evangelist. They believe that the lateral saints are additions, the patron's saints, accounting for the disparity of scale.

[187] Inv. no. 79B in the Staatliche Museen zu Berlin — Preußischer Kulturbesitz, Gemäldegalerie, poplar panel with a diagonal grain and a 70 cm. diameter and a ring of pigment around its circumference. The panel consists of two boards; one large plank practically covers the width with a small piece at the upper right on a diagonal. It has been thinned, probably before cradling, and is only 11 mm. thick, whereas originally it was probably 2.5 to 3 cm. The reverse has twenty-five linden braces, like sutures, to reinforce the split areas, as well as coatings of wax to stabilize it to climatic changes. See Berlin, *Catalogue*, 410–11, ill.; Olson, 'Signorelli's *Berlin Tondo*'. See also above, pp. 92–3. Mancini, *Signorelli*, 172, cites and illustrates a tondo with an 88 cm. diameter formerly in the Mancini Collection, a later variant perhaps by Francesco Signorelli. It and two other tondi of the same subject, whereabouts unknown, differ from the Berlin panel in many aspects. The second, formerly in the Bruce Museum, Greenwich, Conn., measures 76.5 × 77.5 cm.; Christie's, New York, sale cats., 10/VI/83, no. 76, 8/XI/84, no. 88,

mistakenly identify it as the Mancini picture dated 1530–40. The third is recorded as with Paolini in Rome in 1937 on a photograph in the Berenson Collection, Villa I Tatti, Florence. Kanter, 'The Late Works', 206, ill., attributes all three to Francesco. (In a letter of 7 Feb. 1997, however, he now believes that the Paolini tondo is not by Francesco or a member of Luca's shop.)

[188] Dussler, *Signorelli*, 81, ill., 203, dates it 1498; Salmi, *Signorelli*, 61, ill., *c.*1505; Scarpellini, *Signorelli*, 140, to the first decade of the Cinquecento; Kanter, 'The Late Works', 224–5, *c.*1513. In the lower part of the decoration of the San Brizio Chapel (1499–1504), Signorelli painted roundels with black backgrounds and narratives in grisaille with multiple figures illustrating scenes from Dante's *Commedia* that seem related.

[189] See Olson, 'Signorelli's *Berlin Tondo*'.

[190] Ch. 4 nn. 50–3.

[191] Olson, 'Signorelli's *Berlin Tondo*', 102.

[192] Ibid., fig. 5. Andrea del Sarto's *Barbadori Tondo* (Fig. A98) has a black background, does not have Zacharias, but includes the other five figures.

[193] In the Museo Civico, Prato, tempera on panel with a 73 cm. diameter in its original frame. Datini, *Musei di Prato*, 27, ill., implies that the Madonna was painted by Luca and dates it *c.*1520.

[194] Inv. no. 7944 Wawel Castle, Cracow, measuring 75.5 × 74.3 cm., formerly in the Lanckoronski Collection, Vienna. Dussler, *Signorelli*, 186, ill., 211, dates it *c.*1510; Miziolek, 'Lanckoronski', 36, fig. 20.

works, the Madonna balances on the clouds and heads of cherubs, denoting the Immaculate Conception, without conveying any levitation. The tondo must have had a Franciscan patron because of the presence of St Francis and St Clare, his female Franciscan counterpart who balances him formally and conceptually.[195] A mixture of iconographical elements in its exergue include five species of plants: the blue columbine (shown twice), for Mary's innocence; the lily, for Mary's purity; the poppy, symbolic of sleep and death, prefiguring the Child's Passion; the dandelion, alluding to the bitter Passion of Christ; and in front of a foreshortened wooden disc, the hyssop, symbolic of Baptism and purification and the Passion of Christ.[196] The placement of the hyssop in a manner analogous to its location near the wall in the *Doni Tondo* (1503–6) suggests a *terminus post quem* for the *Prato Tondo*.[197] Nearby a banderole with twisted loops that seems intended for an inscription floats above the wooden disc, which formally echoes the tondo and may represent a rosary table, a German invention consisting of a circular, flat piece of wood like a cheeseboard, often painted with stylized roses. If it were intended as a rosary table, it would symbolize the microcosm, the *Imago mundi*.[198] Its placement near the viewer argues that it could have been associated with this function. (The panel contains five adult figures to facilitate recitation of the rosary, while similar inscribed banderoles were part of rosary iconography.) The other option is that it was meant as a *desco* and associated with childbirth. This interpretation could imply that the banderole may have been a stylized representation of the Virgin's miraculous girdle, the holiest relic of Prato, kept in the Cappella della Cintola in the Duomo.[199] This local cult relic was considered an aid for birthing mothers and was depicted in paintings for the town.

From Signorelli's art, it is clear that by the late Quattrocento the devotional tondo had spread from Florence into Tuscany, to cities in south-eastern Tuscany near Umbria, as well as to Siena. Therefore, the following three painters, who were producers of tondi, will be considered.

PINTORICCHIO

Bernardino di Betto, Pintoricchio, a pupil of Perugino and friend of Signorelli who was in great demand as a decorator not only in papal Rome but also in Siena and other urban centres, painted diverse tondi panels in addition to his frescoed example in the Vatican (Fig. 3.6). Because of his peripatetic nature, Pintoricchio's art is broadly based and, like that of Signorelli, retains influences of the locations where he worked. An early simple tondo based on the formulaic cross within the circle composition reveals the painter's decorative orientation (Fig. A72).[200] Its blessing Child wears a coral necklace to ward off evil and ornate pseudo-Roman sandals, while the Madonna holds a cloth up to the Child like the priest to the host. A tondo with shop participation (Fig. A73), which is really a devotional *sacra conversazione*,[201] has a tightly delineated drawing related to it (Fig. A74).[202] Pintoricchio's most skilfully designed tondo (Fig. A75) has background scenes

[195] St Clare (Santa Chiara), a disciple of Francis born in Assisi, established the order of the Poor Clares, who were dedicated to the education of poor girls. Ferguson, *Signs and Symbols*, 114; J. Hall, *Dictionary*, 69. She is frequently depicted with St Francis and St Catherine of Alexandria, as here, suggesting that the tondo may have been destined for a family with Franciscan ties or for a Franciscan institution.

[196] Levi D'Ancona, *The Garden*, 105–8 (columbine); 210–20 (lily); 321–3 (poppy); 126–8 (dandelion); 181–3 (hyssop).

[197] Ibid. 181–3; Hayum, 'Doni Tondo'. Levi D'Ancona, 'Doni Madonna', 44–6, states the hyssop's significance was derived from Hrabanus Maurus (*De Universo*, PL 111, 5281; *Allegorie in sacrum scripturam*, PL 92, 1088). It is also based on Num. 19: 6, concerning sacrifice, and especially on Ps. 50: 9 (Vulgate): 'Purge me with hyssop, and I shall be clean, wash me and I shall be whiter than snow.' Levi D'Ancona, *The Garden*, 181–3, notes that according to John 19: 29, its flower was an emblem of the Passion of Christ and administered with the vinegar to Christ on the cross.

[198] See Wilkins, *Rose-Garden Game*, 192, for rosary tables.

[199] Datini, *Musei di Prato*, 69, no. 181, reproduces the relic's gold casket (1446). Its lid is inscribed with a winged round wreath, intertwined by a banderole much like the one in Signorelli's tondo. The left side is inscribed *MATER DEI* . . . (the right is illegible in reproduction).

[200] Inv. no. 3496 in the Museo Poldi Pezzoli, Milan, tempera on panel measuring 79 × 80.6 cm. Milan, *Museo Poldi Pezzoli*, i: *Dipinti*, 155, ill. Carli, *Il Pintoricchio*, 57, ill.

[201] In the Davis Museum, Wellesley College, Wellesley, Mass., oil on panel with a 61.9 cm. diameter. Christie's, London, sale cat., 4/XII/62, no. 78; Christie's, New York, sale cats., 18/V/94, no. 55, 11/I/95, no. 16.

[202] Inv. no. 4382 in the Département des Arts Graphiques, Musée du Louvre, Paris, silverpoint on yellow paper, measuring 350 × 290 mm., cropped, with a circular contour. Collobi Ragghianti, *Il libro*, i. 88, ill., discusses it with works by Perugino, to whom the Louvre attributes it.

featuring St Antony of Padua and St Jerome, no doubt requested by its patron.[203] Joseph holds a cask of wine and a loaf of bread with two lobes to cite the journey from Egypt but more profoundly to foreshadow the Eucharist. To his left St John and the Child are depicted at the unusual age of three or four years. The blonde Child is dressed in heavenly white raiment decorated with gold stars. He carries a book, symbolic of wisdom, and wears a cross nimbus. John, with his cross-staff and a maiolica pitcher alluding to Baptism, is linked to the Child by their intertwined arms and their poses that connect them to the fountain at the right (an ancient sarcophagus with a tap from which water trickles). Finally, one of only several quattrocento tondi with the theme of the Mystical Marriage of St Catherine of Alexandria has been assigned to Pintoricchio's circle.[204] Here, the triumphal arch behind the saint's martyrdom alludes to the triumph of the Christian life. The diversity of these tondi by Pintoricchio and his *bottega* suggest that his patrons stipulated specific iconographic requests.

PERUGINO

Pietro Vannucci, known as Perugino, was the teacher of both Pintoricchio and Raphael. He is being considered between the two because his serene art forms more of a bridge to the ideals of the early Cinquecento than the quattrocento art of Pintoricchio. He painted at least one autograph tondo, his *Madonna and Child Enthroned between Two Female Saints and Two Angels* (Fig. A76).[205] Its saints, both barefoot because they are on sacred ground and humble, are identified as Rosa and Catherine of Alexandria (holding a clear covered glass vessel and roses, and a book and a martyr's palm, respectively). The work may have been executed for a Florentine patron, although nothing is known about its genesis. Its five figures— with the Madonna and the Child as one entity—aided in a recitation of the rosary, a conclusion supported by the presence of Santa Rosa. The implied square of the *hortus conclusus* and the base of the throne are surrounded by the circumference of the tondo—the earthly four elements or corners of the world enclosed by the heavenly circle, a theme echoed in the decorative pattern on the base of the throne. Moreover, the patterns of the square floor tiles repeat the quadripartite arrangement of the two angels and two saints, endowing it with an extreme formalistic harmony. Because there are a number of derivations, we know that it was considered successful. Another tondo, which may have been designed by Perugino, is the *Madonna del Sacco* (Fig. A77).[206] Its influence is seen in two shop versions and more distantly derived compositions. Several other tondi, including those by the Master of the Greenville Tondo, can be assigned to artists working within Perugino's galaxy.[207]

BERNARDINO FUNGAI

Although Sienese artists executed tondi in the fifteenth century, it is really only in the Cinquecento that they

[203] Inv. no. 495 in the Pinacoteca Nazionale, Siena, panel with an 85 cm. diameter, a dark line around its circumference, and its original *cartapesta* frame (123 cm.). Torriti, *La Pinacoteca Nazionale di Siena: i dipinti*, 323–4, ill. A copy (32.5 × 19 cm.) is recorded in the FKI as in the H. Oelze Collection, Amsterdam, and assigned to Fungai.

[204] Inv. no. 44.51 in the Allen Memorial Art Museum, Oberlin, Ohio, poplar wood with a 62.2 cm. diameter. Stechow, *Catalogue of the European and American Paintings and Sculpture in the Allen Memorial Art Museum*, 121, ill., dates it *c.*1504–8.

[205] Inv. no. 719 in the Musée du Louvre, Paris, tempera on panel with a 151 cm. diameter whose circumference was probably once outlined in a ring of dark pigment. Becherer *et al.*, *Pietro Perugino*, 58–60, cite J. M. Wood, 'The Early Paintings of Perugino' (Ph.D. diss., University of Virginia, 1985), 185, who identified the left saint

as Mary Magdalene, who was traditionally paired with St Catherine to embody Penitence and Wisdom, instead of Rose of Viterbo. Camesasca, *L'opera completa del Perugino*, 92–3, no. 28, ill.; Scarpellini, *Perugino*, 80–1, no. 39, ill. Berenson, *North and Central*, i. 325–33, gives five tondi to Perugino, one of which is a copy.

[206] Inv. no. G 20 in the Collections of the Prince of Liechtenstein, Vaduz Castle, with a 97 cm. diameter and a false signature: *PETRVS / PERRVSINVS P.* Camesasca, *Perugino*, 123, no. 278, ill.; Scarpellini, *Signorelli*, 312.

[207] For a tondo assigned to the Master of the Greenville Tondo (inv. no. P.59.192 in the Bob Jones University Museum and Gallery, Greenville, SC, oil on panel with a 103.5 cm. diameter), see Pepper, *Bob Jones Collection*, 20, no. 14.1, ill., who lists in the appendix (pp. 317–18) four tondi attributed to this artist.

adopted the form; one of them, who straddles the two centuries and produced several tondi under the influence of Florentine and Tuscan–Umbrian artists, is Bernardino Fungai.[208] A characteristic early panel contains the Madonna and blessing Child surrounded by six half-length flying angels in a triangle reminiscent of a mandorla, an anachronistic heavenly device, and background narrative scenes.[209] Fungai's most unusual tondo with assorted anecdotal details for spiritual meditation dates from c.1505–15 (Fig. A78).[210] It has a captivating image of Christ, wearing a talismanic coral necklace with a cross and a cross nimbus, carried on a rose-bedecked litter by two angels. An ascetic female saint—either Mary of Egypt or Mary Magdalene—kneels at the right. She contemplates the Child and serves as the viewer's role model or intermediary. Behind the parapet are two other ascetic desert saints, a mature St John and St Jerome (?), jointly reading a book, perhaps Jerome's *Vulgate* to underline that Christ is the fulfilment of the Old Testament.[211] Two seated Franciscan monks pray in the right background, while St Francis receives the stigmata at La Verna, accompanied by two brethren. To the right of the Virgin's head is St Christopher, ferrying the Child across the river on his shoulders. The tondo thus invites the viewer to imitate St Mary in adoring Christ and provides other figures in devotional attitudes and vignettes to leave no doubt about its devotional function. Although other tondi have been attributed to Fungai as well as to Sienese artists and shops operative in the years surrounding the millennium, it is now time to consider tondi produced in the Cinquecento.

THE CINQUECENTO

While a number of quattrocento artists lived beyond the turn of the sixteenth century and continued to produce tondi, such as Piero di Cosimo and Botticelli, a new group of painters reached maturity during the first decade to compete with and eventually to outlive them. By this time, while the tondo had spread beyond Florentine territory, the lion's share of tondi, except for a late blossoming of the form in Siena, were still of Florentine origin. Even though artists like Raphael—who had a seminal Florentine residence—Fra Bartolomeo, Albertinelli, and Bugiardini each painted tondi, their output does not compare with the heavy production by painters between 1480 and 1505.

LEONARDO DA VINCI AND HIS ASSOCIATES

While there are no surviving tondi by Leonardo, 'the universal man' was obsessed with circular forms in his wide-ranging inquiries into the underlying mysteries of life that fill his notebooks and drawings (Fig. 2.11), including those of centralized architecture.[212] Leonardo painted or designed a number of lost Madonnas, one of which may have been a tondo, preserved in a Leonardesque panel by Marco d'Oggiono (Fig. A79),[213] known as the 'Madonna of the Lake'.[214] In Leonardo's wake, Giovanni Antonio Boltraffio, a Milanese

[208] Vasari (Milanesi), vi. 416, in the commentary; Van Marle, *Italian Schools*, xvi. 465–85; P. Bacci, *Bernardino Fungai*; Berenson, *North and Central*, i. 149–52.

[209] Inv. no. 1331 in the National Gallery, London, measuring 119 × 118 cm. (irregular). M. Davies, *Earlier Italian Schools*, 206–7.

[210] Inv. no. 61.013.000 in the Lowe Art Museum, Coral Gables, Fla., formerly in the Samuel H. Kress Collection (K1341), tempera on panel measuring 123.1 × 125.1 cm. (irregular). Shapley, *Paintings*, ii. 110, ill.; Coral Gables, Fla., Lowe Art Museum, *The Renaissance and Baroque Collection*, 5, ill.

[211] Shapley, *Italian Paintings*, ii. 110, ill., identifies the saint as Jerome. Another unlikely possibility is that he is Joseph. Shapley believes the female saint is Mary of Egypt, partly based on the fact that all three saints experienced ascetic life in the desert.

[212] Pedretti, *Leonardo: A Study in Chronology and Style*; Reti, *Leonardo*; Pedretti, *Leonardo architetto*; Clark, *Leonardo da Vinci*.

[213] Wasserman, '*Alba Madonna*', 47–8.

[214] Inv. no. P.56.92 in the Bob Jones University Museum and Gallery, Greenville, SC, oil on panel with a 26 cm. diameter. Marcora, *Marco d'Oggiono*, 122–3, ill.; Budny, 'The Sequence of Leonardo's Sketches for the Virgin and Child with Saint Anne and Saint John the Baptist', 48, 50 n. 73; Pepper, *Bob Jones Collection*, 16–17, no. 19.1, ill.; Sedini, *Marco d'Oggiono*, 120–1, ill., suggests it may have been a roundel of a predella. Martin Kemp in written correspondence (1993) believes that this painting has only the 'most tenuous connections with Leonardo'. Pedretti, *Leonardo*, 105, believes the original must have been a small tondo probably derived from a painting by Raphael. Wasserman, '*Alba Madonna*', 47–8,

follower, produced an unusual half-length *Madonna del Latte* (Fig. A80), whose archaistic simplicity is moving.[215] The Madonna's starkly bared breast, the only round form in the composition, is near bull's-eye centre. It graphically emphasizes the theme and formally echoes the panel's shape, while other curvilinear elements add to its rhythmic unity. In addition, the flowers in the still life symbolically enrich this minimal but affecting scene, wherein the mystery of the Incarnation, alluding to Christ's need for food and his physical humanity, is presented before the dark void of eternity.

RAFFAELLO SANZIO

Raphael, who like Botticelli utilized the circle as a basic unifying device in many of his compositions, painted several significant tondi. They demonstrate that he, the consummate designer, continually invented unique and increasingly subtle solutions to its challenges. While he produced fewer tondi than Botticelli, he ranks alongside him as one of the few artists to exploit profoundly the compositional possibilities of the round shape.

His first tondo is the *Conestabile Madonna* (Fig. A81), which dates stylistically to 1503–4, while he was working with Perugino in Perugia or just after his arrival in Florence (1504). Its square frame with decorative borders is thought to be part of the original conception and is joined to its panel.[216] Despite its small size and the tentative nature of its round form embedded within a square, the work shows Raphael breaking out of formulas acquired from Perugino. Its underdrawing, uncovered when the work was transferred to canvas, reveals that originally the Madonna and Child held not a book but a round fruit, most probably a pomegranate or an apple to designate him as the second Adam.[217] This substitution makes the melancholic Virgin a *Madonna della Sapienza* and stresses the erudition of the precocious Child who, while reading the book, simultaneously points to himself as the fulfilment of the Word. Moreover, the devotional book further underscores the panel's function.[218]

Definitely dating from Raphael's Florentine period is the more monumental *Madonna Terranuova* (Fig. A82), once owned by the Duke of Terranuova from whom it takes its name.[219] A preparatory drawing, which has been cut, suggests that at one time he may have planned it in an arcuated format.[220] The tondo includes a wall behind the Madonna, referring to the *hortus conclusus*, and at the extreme right a third child, designated by his halo as an infant saint and tentatively identified as St James the Less.[221] He seems an afterthought, added for balance, although his presence reinforces the tondo's function in the domestic

dates it *c*.1519 and thinks the influence went the other way—that Leonardo's oblique composition influenced Raphael (Fig. 7.34). Further, it seems related to a Leonardesque sheet in the collection of H. M. Queen Elizabeth II, Royal Library, Windsor Castle, attributed to Filippino Lippi; Goldner and Bambach, *Filippino Lippi and his Circle*, 276–7, no. 83, ill.

[215] Inv. no. 727 in the Accademia Carrara, Bergamo, oil on panel with a 54 cm. diameter. Rossi, *Accademia Carrara, Bergamo: catalogo dei dipinti*, 97, ill.

[216] Inv. no. 252 in the Hermitage, St Petersburg, tempera on canvas transferred from panel, measuring 17.5 × 18 cm., with moulded grotesque ornament. Fischel, *Raphael*, i. 45, ill.; De Vecchi, *The Complete Paintings of Raphael*, 91, no. 32, ill.; Pope-Hennessy, *Raphael*, 181–3, ill.; Dussler, *Raphael*, 7, ill.; Kustodieva, *Hermitage Catalogue*, 368–9, no. 202, ill.

[217] The drawing (Pope-Hennessy, *Raphael*, fig. 166), seen from the back, shows how Raphael modified its design after the cartoon was drawn. A drawing in the Graphische Sammlung Albertina, Vienna, contains a related Madonna who, with the Child, holds a pomegranate in one hand and a book in the other (Joannides,

Raphael, 149, no. 68, ill.).

[218] Another, slightly later, tondo in the Sir Brian Mountain Collection, London (oil on wood with a 79 cm. diameter; Dussler, *Raphael*, 7, ill.) has also been attributed to Raphael, although it does not rest as securely in his oeuvre. While it may have been designed by him, not everyone agrees that he painted it. Nevertheless, it reflects ideas current in Florence about St Joseph and the Holy Family.

[219] Inv. no. 247A in the Staatliche Museen zu Berlin — Preußischer Kulturbesitz, Gemäldegalerie, oil on wood with an 86 cm. diameter. De Vecchi, *Raphael*, 91, no. 36, ill.

[220] Inv. no. 431 in the Musée des Beaux-Arts, Lille (Oppé, *Raphael*, pl. 45; Joannides, *Raphael*, 149, no. 69, ill.; Knab *et al.*, *Raphael*, 565, no. 98, ill.). There are ideas that relate both to the *Madonna Terranuova* and the *Madonna of the Palm* on another sheet in the same museum (Joannides, *Raphael*, 201, 274, ill.), as well as a study for the head of the Madonna in the *Madonna Terranuova* in the Kupferstichkabinett, Berlin (Knab *et al.*, *Raphael*, 565, no. 99, ill.). Dussler, *Raphael*, 16–17, notes several other sheets that can be associated with it; in fact, all his Madonna and Child compositions from *c*.1504–14 are interrelated.

[221] Berlin, *Catalogue*, 342.

environment. Because the word *AGNIVS* is prominently displayed on John's scroll, which Christ also grasps, his sacrificial role as the Lamb of God is stressed.

It is in a preparatory drawing (Fig. A83),[222] reflecting the artist's first ideas for the rectangular *Madonna del Granduca*,[223] where Raphael directly grapples with pivotal problems inherent in the round format. Its several lightly sketched rectangular framing lines are fainter than the circular and oval ones, demonstrating that at one stage Raphael envisaged the composition as a tondo. Its more curvilinear shapes and the orientation of the Madonna's body harmonize with a round circumference, whereas the forms seem more angular in the painting. According to the drawing, Raphael originally planned a landscape instead of a stark black background. Areas of repainting also signal background changes, and the panel may have been cut, since the Madonna's halo has been severed. Its evolutionary nature has been confirmed by technical investigation. X-radiography reveals that the Madonna and Child were originally placed in an interior room or loggia. Further, reflectograms show an underdrawing that was transferred from a cartoon onto the primed surface by the traditional *spolvere* method, leading to the conclusion that the background was applied later, when this area had suffered paint losses.[224] This evidence suggests that the panel might have been larger and raises the possibility that it may have been in a tondo.

Certainly, the *Holy Family of the Palm* (Fig. A84) dates from the later part of Raphael's Florentine period.[225] Its prominent palm tree either foreshadows the Flight or sets the scene in Egypt or on the journey, while the symbolic foreground plants reveal the influence of Leonardo's studies. In response to his environment, Raphael portrayed a tender relationship between the Child and St Joseph, embodying the contemporary Florentine interest in Joseph as a nurturer (Ch. 4). In addition, this painting, like other tondi, seems to reflect illusionistically the curved surface of a convex mirror, a symbolic reference to the Virgin's purity.

These effects are further explored by Raphael in the predella for his *Baglioni Altarpiece* (signed and dated 1507) with its grisaille medallions of the three theological virtues Faith, Hope, and Charity (Fig. A85).[226] Only in the central, highly integrated group of the four babies with Charity—wearing a turban and enclosed in a roundel—does Raphael grapple with the round form to reveal his Florentine experiences and point the way towards his two mature tondi. The interplay of its figures arranged in a pyramidal shape harmonizes

[222] Inv. no 505 E in the Gabinetto Disegni e Stampe degli Uffizi, Florence, black chalk over a stylus impression, measuring 213 × 184 mm. Dussler, *Raphael*, 18; Joannides, *Raphael*, 158, no. 105, ill. Joannides reproduces (ibid. 158, nos. 106–7) two other related sheets in the Städelsches Kunstinstitut, Frankfurt, and Kunsthalle, Hamburg.

[223] Inv. no. 178 in the Galleria Palatina di Palazzo Pitti, Florence, oil on panel measuring 84 × 55 cm. Dussler, *Raphael*, 18–19, ill., questions whether the dark background is original. He also notes a copy in France with a landscape, but Pope-Hennessy (*Raphael*, 185) doubts whether its background is original and identifies areas of overpainting and believes the copy too far removed to be valuable. The work has been examined technically and X-radiographed; Chiarini, 'Paintings by Raphael in the Palazzo Pitti, Florence'.

[224] Ibid. 80–3.

[225] In the Duke of Sutherland Collection, on loan (since 1945) to the National Gallery of Scotland, Edinburgh, oil on panel transferred to canvas with a diameter of 101.4 cm. Clifford *et al.*, *Raphael: The Pursuit of Perfection*, 36–40, no. 5, ill., suggest that it does not represent Egypt or the Flight because the palm tree depicted is indigenous to Europe. However, this only demonstrates that Raphael used a tree that was available to him as a model. (Levi D'Ancona, *The Garden*, 35, cites the textual source for the palm as the Apocryphal Gospel of Pseudo-Matthew.) The catalogue notes the sarcophagus-like structure on which the Virgin sits, which may

be a prefiguration of Christ's destiny, or a symbol of the Old Order, or may be the manger, in which case the palm tree would function as a foreshadowing of the Flight. An old photograph suggests that the composition was once outlined in dark pigment to facilitate insertion into its frame. Several scholars have connected it without proof to one of Raphael's early paintings for his friend Taddeo Taddei, mentioned but not described by Vasari (Milanesi, iv. 321 n. 2). Two drawings by Raphael in which he studied the *Taddei Tondo* of Michelangelo support this contention; Joannides, *Raphael*, 155, no. 93ᵛ, ill. (inv. no. 3856 in the Département des Arts Graphiques, Musée du Louvre, Paris), and 159, no. 111, ill. (inv. no. 783 in the Collection of the Duke of Devonshire, Chatsworth). Joannides (ibid. 171, nos. 155, 156ʳ–157ʳ) reproduces studies for the *Madonna of the Palm*, including one in the Musée du Louvre and three sides of two sheets in the Biblioteca Apostolica Vaticana (especially Vat. Lat. 13391, on whose recto two circles are drawn around the composition); Knab *et al.*, *Raphael*, 570–1, nos. 157–9, 164, ill. For a copy with an 89 cm. diameter, see Sotheby's, Monaco, sale cat., 5/XII/92, no. 270.

[226] Inv. no. 331 in the Pinacoteca Vaticana, tempera on panel measuring 18 × 44 cm. A preparatory study is in the Graphische Sammlung, Albertina, Vienna (inv. no. Bd. IV, 245; Knab *et al.*, *Raphael*, 576, no. 218, ill., gives the inv. no. as 245, R.51, S.R. 301). Joannides, *Raphael*, 168, no. 142ʳ, ill., notices that the round format is indicated lightly at the lower left.

with the curvilinear format to create a dense tension resulting from his digestion of Michelangelo's tondi and Leonardo's integrated Madonnas.

When Raphael arrived in Rome, probably in late 1508, he began work on the ceiling of the Stanza della Segnatura, decorated with medallions—a format established by Sodoma—whose circles are echoed in the swirling patterns of its inlaid floors.[227] Therein, Raphael transferred his Florentine infatuation with the circle to the 'School of Athens', where the figures traditionally identified as Ptolemy and Zoroaster hold terrestrial and celestial globes, and the whole lunette-shaped composition is knitted together by circular forms. For example, the arch if extended would form a perfect circle at the fresco's centre. The two grisaille medallions in the pendentives of the Bramantesque dome inscribe at the left a figure holding a book or harp (?) and at the right a figure holding a globe, while above, in the illusionistic keystone of the arch framing the scene, a winged putto holds a globe. These round elements contribute to the circular symphony, which counterpoints the linear or artificial perspective grounding the scene and finds mature expression in Raphael's *Alba Madonna* and *Madonna della Sedia* (Figs. 7.34–5) discussed in Chapter 7.

When Raphael painted his *Madonna of Foligno c.*1512 (Fig. 2.3) as an ex-voto for Sigismondo de' Conti, a papal secretary of Julius II and a humanist historian, he utilized the tondo form with which he had been experimenting.[228] Although he ultimately opted for the symbolism carried by the circle in order to visualize an incident associated with the painting's intended location on the high altar of Santa Maria d'Aracoeli, the seat of the Franciscan order in Rome, a drawing reveals that he originally planned a mandorla.[229] The gold disc is a direct allusion to the church's site on the Capitoline, in ancient times the location of the Altar of the Sky, where Augustus witnessed his vision of a divine child. According to a medieval legend, the emperor Augustus had sought advice from the Tiburtine Sibyl after learning that the Roman Senate wanted to deify him. She said 'Haec est ara filii Dei' and predicted that he would remain a god until a greater god arrived. Then she showed him a vision of the Virgin and Child surrounded by a golden aura. (See Ch. 2 for the vision recorded in Virgil's fourth Eclogue and Jacobus de Voragine's *Golden Legend*.) It is telling that in his *Madonna of Foligno* Raphael adapted two features of Augustus' vision, the golden disc and the rainbow, to the specific needs of his patron.[230]

In his depiction, Raphael alluded not only to the literary description of the vision but also to its visual tradition in Santa Maria d'Aracoeli, including the mosaic over its lateral entrance (Fig. 1.10). As one enters the church via this door, the tomb of Pietro da Vicenza (d. 1504) by Andrea Sansovino on the right contains a roundel relief of the Madonna and Child in the clouds. In the left transept, below the pavement of the *tempietto* dedicated to St Helen, is a cosmatesque altar with a depiction of this same apparition to Augustus; it was placed on the legendary site of the sibyl's prophecy after the middle of the Trecento. A similar representation is found at the centre of the church's cinquecento painted wooden ceiling. Because Raphael's *Madonna of Foligno* reflects the local image associated with the Aracoeli, it is not possible to understand it

[227] Jones and Penny, *Raphael*, 49–57. Also Redig de Campos, *Raffaello nelle Stanze*, 20 ff.; Shearman, 'The Vatican Stanze: Functions and Decoration'; Kelber, *Raphael von Urbino*, 461–7; Winner, *Raffaello a Roma*, 29 ff.

[228] Inv. no. 329 in the Pinacoteca Vaticana, oil on canvas transferred from panel, measuring 301 × 198 cm. Dussler, *Raphael*, 31–2, ill. It should be acknowledged that the solid gold disc also occurs in works by others, although never as simply as here.

[229] Joannides, *Raphael*, 203, no. 281, ill., reproduces the study in the British Museum, London, squared for transfer. A related sheet in the Städelsches Kunstinstitut, Frankfurt (ibid. 203, no. 282ʳ, ill.), contains a sketch of the Virgin and Child in a rectangle with a circular glory behind the Madonna. Another sheet in the Collection of the Duke of Devonshire, Chatsworth, has several ovoid/circular

forms behind the Virgin that have been pricked for transfer (Knab *et al.*, *Raphael*, 601, no. 461, ill.).

[230] The identification and analysis of the background rainbow and meteor (fireball) in the *Madonna del Foligno* is flawed in Ettlinger and Ettlinger, *Raphael*, 123–4. Rather, both are portents of Conti's exalted status, death, and eventual salvation, and are appropriate to a historian in a period when natural phenomena were interpreted as prescient signs (Olson, *Fire and Ice: A History of Comets in Art*, 46). Conti probably died before the painting was completed, because Raphael portrayed him as cadaverous, and the central *tabula ansata* is blank. See also Conti da Foligno, *Le storie de' suoi tempi dal 1475 al 1510*; Redig de Campos, 'La "Madonna di Foligno" di Raffaello'; Einem, 'Bemerkungen zu Raffaels "Madonna di Foligno"'; Humfrey and Lucco, 'Dosso Dossi in 1513', 27.

without knowledge of this tradition. Moreover, it is significant that Conti was buried in its choir, and that Raphael, in the true spirit of humanism, revived Augustus' vision on which Conti so conspicuously pinned his hopes for salvation by employing a quasi-independent tondo.

Raphael's most accomplished visual essay in the tondo format is his *Madonna della Sedia* (Fig. 7.36). It is examined in Chapter 7.

The later *Madonna of the Candelabra* (Fig. A86) is usually attributed to Raphael's shop, although at least the Madonna and Child may have been designed by the master.[231] The panel has been reduced and may once have included young St John at the lower right, where the Madonna's gaze is directed.[232] It is also possible that the cut panel once included attributes that would identify the right haloed figure as St John. Its lateral figures, their heads ambiguously placed to add a Mannerist note, derive from Roman prototypes of the early Trecento featuring angels carrying torches, for example, the mosaic above the lateral door of Santa Maria d'Aracoeli (Fig. 1.10). Its composition is also linked to the half-length image of the Saviour flanked by flaming torches popular at the end of the fifteenth century, which was based on a sixth-century icon of Christ, the 'Lateran Saviour'. Both prototypes can be traced to images of the emperor flanked by torches used in ceremonies of public homage.[233] (The motif of flanking candles appears later in Rosso's *Dead Christ*.) In addition, the candlelight of the tondo reflects Raphael's contemporary interest in nocturnal scenes and light effects as displayed in the Stanza d'Eliodoro (1512–14).

In Raphael's late oeuvre his involvement with the circle manifests itself in all aspects of his artistic production, including architecture, where he was concerned with the central plan.[234] Two prints by Marcantonio Raimondi after Raphael from the period of his intensive study of antiquity—*The Judgment of Paris* (1514–18) and *Quos Ego* (*c*.1518)—contain the zodiacal circle in imitation of the *imago clipeata* on sarcophagi.[235] Furthermore, Raphael used circles extensively in an unfinished chapel for Agostino Chigi with a cosmic theme in Santa Maria del Popolo (1512–20) and in the unfinished Chigi Chapel in Santa Maria della Pace.[236]

Two other tondi are among the few associated with the circle of Raphael. One is a Holy Family inscribed and dated: *IOH. FRANC PENNI / MDXXII* on the stone fragment on which the Child is being placed by his mother as the literal sacrificial fulfilment of the Old Order that Christianity replaced (Fig. A87).[237] Raphael's influence is apparent, as is that of Giulio Romano, especially in the modelling and the chiaroscuro, while Joseph's face and earnestly clenched hands reveal that he was most likely based on a life study.[238] Sebastiano del Piombo, who was influenced by Michelangelo and Raphael after his arrival in Rome, painted another (Fig. A88). Its idiosyncratic mixture of Venetian and Roman elements reveals Sebastiano's reactions

[231] Inv. no. 37.484 in the Walters Art Gallery, Baltimore, oil on panel of two members with a vertical grain measuring 65.7 cm. vertically and 64 cm. horizontally. It has been reduced and cradled; Zeri, *Italian Paintings*, ii. 348–54, no. 232, ill. Dussler, *Raphael*, 56–7, ill., believes that it is by Francesco Penni derived from Raphael. Another version, whereabouts unknown, has been recorded.

[232] Zeri, *Italian Paintings*, ii. 353, explains that the 1693 inventory of the Borghese Gallery described this figure, lost when the panel was cut. Other evidence, such as the chipped paint around the circumference and the Madonna's severed halo, support the reduction.

[233] Ibid. 350. Zeri cites an official portrait of a Roman emperor in a Carolingian copy in the Bibliothèque Nationale de France, Paris (MS lat. 9661, fol. 53; Grabar, *Christian Iconography*, fig. 198).

[234] At Bramante's death in 1514, Raphael inherited the task of centrally designed St Peter's and later planned centralized Sant'Eligio degli Orefici (Heydenreich and Lotz, *Architecture*, 181, 277, 368 n. 14).

[235] Jones and Penny, *Raphael*, 174, ill., 182, ill.; see also Oberhuber, *The Works of Marcantonio Raimondi and his School*.

[236] Dussler, *Raphael*, 93 ff.; Jones and Penny, *Raphael*, 104 ff.; Weil-Garris Brandt, 'Cosmological Patterns in Raphael's Chigi Chapel in S. M. del Popolo'.

[237] Whereabouts unknown, formerly inv. no. 387 in the Staatsgalerie, Stuttgart, oil on panel with an 89 cm. diameter. In 1923 it was deaccessioned to the Munich dealer A. S. Drey. Lange-Tübingen, *Verzeichnis der Gemäldesammlung im Kgl. Museum der bildenden Künste zu Stuttgart*, 176, refers to an attribution to Giovanni Antonio Sogliani; Berenson, *Italian Pictures of the Renaissance*, 119, attributes it to Bugiardini. Both give its inv. no. as 466. Although its authenticity has been questioned, Konrad Oberhuber stated (letter 1961) that the date of 1522 fits the style of the figures but not the background. I agree; the latter seems to date earlier and/or was painted by a different hand. My thanks to Veronica Mertens for this information.

[238] Other tondi linked to Raphael include a panel with a 122 cm. diameter in the Museum of Fine Arts, Budapest. Tátrai, *Museum Budapest*, 100, ill., believes it is after a lost original by Raphael.

to central Italian traditions and exemplifies the nature of his Romanization.[239] The panel's half-length Madonna attempts to support her son seated on a parapet (his precariousness and the suggestion of a sarcophagus foreshadow his Death). The Child, derived from a putto/angel behind God the Father in Michelangelo's 'Creation of Adam' on the Sistine Ceiling,[240] twists in contrapposto to hide a goldfinch, as though to shield his mother from the painful knowledge of his destiny. Yet Sebastiano does not grapple with the geometry inherent in the form that Florentine painters were apt to exploit, although he certainly was attempting to fit into the artistic mode in Rome, controlled since 1513 by Florentine popes.

It is surprising that the artists of Raphael's extensive Roman *bottega* produced so few tondi. Nevertheless, this information reinforces the fact that outside Florence, with a few exceptions, the form did not thrive. In addition, by Raphael's death in 1520 artists were interested in other problems, and the divine equilibrium so eloquently communicated by the tondo format no longer expressed the religious goals and needs of artists and patrons alike.

MICHELANGELO BUONAROTTI

His *Doni Tondo* (Fig. 7.37) is discussed in Chapter 7.

MARIOTTO ALBERTINELLI

Mariotto di Biagio Albertinelli, a sometime partner of Fra Bartolomeo, produced, together with his associates, a fair number of tondi, all dated on the basis of style, before the decline of the form.[241] His earliest is, except for its foreground figures, very quattrocentesque with a piecemeal feeling, but nonetheless charming (Fig. A89). The work could have been painted in a rectangular format because other than the postures of the Madonna and angel, none of the elements conforms in any significant manner to its shape.[242] The Child, still bound in swaddling clothes, clutches a goldfinch (symbolic of his fate and Passion), while another goldfinch perches in the foreground. He also grasps the cross of his destiny (intertwined with a plant, perhaps the olive of peace) and a crown of thorns, handed to him by an angel with changeant-coloured wings. A triadic angelic chorus in the sky presides over the scene, praising God and holding a musical scroll (now without notes) inscribed in red letters: *gloria ineccelsis deo*. The tree above the Child's head is a multivalent symbol, alluding to Christ as the second Adam, to his Death/Resurrection via the Tree of Life, and to the Tree of the Knowledge of Good and Evil, from which the cross was thought to have been made.[243]

In Albertinelli's later tondi, the artist became more sensitive to the requirements of the format and responded to the High Renaissance style in circulation at the time. A case in point is his simplified and more monumental *Holy Family with the Adoration of the Child* (Fig. A90).[244] Despite damage, its experimental

[239] In the Pouncey Collection, London, panel with a 66 cm. diameter. Zeri, *Pittura e controriforma*, 15, dates it *c.*1520; Hirst, *Sebastiano del Piombo*, 38–9, ill.

[240] Ibid. 39.

[241] Berenson, *Florentine School*, i. 1–2, lists four tondi by him, all discussed below. Vasari (Milanesi), iv. 223, records a tondo with a Medici coat of arms and the three theological virtues which the artist painted for Leo X: '. . . dipinse a olio un tondo della sua arme, con la Fede, la Speranza e la Carità, il quale sopra la porta del palazzo loro stette gran tempo'. Borgo, *The Works of Mariotto Albertinelli*, fig. 4, sees Albertinelli's hand in the Annunciation in the Volterra Cathedral with a depiction of the Sacrifice of Isaac; Padovani *et al.*, pp. 57–60, no. 6, ill., assign it to Bartolomeo exclusively.

[242] Inv. no. 365 in the Galleria Palatina di Palazzo Pitti, Florence, oil on panel with an 86 cm. diameter. See ibid. 283–5, ill., and fig. 129,

a drawing in the Gabinetto Disegni e Stampe degli Uffizi, Florence (related to it with a similar inscription [*Gloria.Inecelsis.Deo.*] under the chant melody of Gloria IV, which Bonnie Blackburn pointed out, noting that the last section has been written in measured note values, reflecting contemporary performance); Padovani *et al.*, *L'età di Savonarola*, 52–3, no. 2, ill. Borgo, *Albertinelli*, 249 ff., argues that its inscription (corrected above and to the right, as *ineccelsis*) does not correlate with Albertinelli's tondo and is a copy after another work by either Fra Bartolomeo or Albertinelli.

[243] Ferguson, *Signs and Symbols*, 39; Sill, *Handbook*, 104–7.

[244] In the Altomani Collection, Pesaro, oil on wood with an 85.73 cm. diameter, formerly in the Detroit Institute of Arts. Borgo, *Albertinelli*, 303–4, fig. 19, notes that the figures appear with variations in a rectangular painting in the Courtauld Institute, London; Padovani *et al.*, *L'età di Savonarola*, 39, ill. The figures in both derive from a pen and ink drawing by Fra Bartolomeo in the

colours—for example, the vivid violet cloth in which the Child is wrapped—and the freely painted landscape are apparent. It is set in the wilderness on the way to Egypt, for there are no stable buildings and the centrally situated Child reclines on a travelling sack. In this tondo the artist placed a premium on the nearly equal status of Joseph and Mary and the importance of the Holy Family as a unit.

A more complex Holy Family with St John and darker lighting (Fig. A91) shows the impact of Fra Bartolomeo and the influence of Savonarola's ideas about the divine role of pictorial imagery. It is inscribed in a personal, devotional manner characteristic of Bartolomeo near the goldfinch above a tiny gold cross within a circle: *ORATE P[RO] PICTORE* ('intercede for the painter', if he is addressing the Holy Family, or 'pray for the painter' if viewers of the painting are addressed), although it has been judged a collaboration between Fra Bartolomeo and Albertinelli, weighed more heavily to the latter because of its darker tonalities.[245] Some elements, like the pose of the Child, derive from Albertinelli's earlier tondo in the Pitti, although the Ringling tondo is rendered in a more unified High Renaissance style. Its goldfinch perches on a rock near a body of water, introducing the theme of Baptism, as well as testifying to the influence of Leonardo's compositions.[246] St John is supported by Joseph, who, excercising his parental duties, points to Christ as though introducing the two. In this calm but intensely religious composition, an active Joseph and the more passive Madonna are equals in size and station.

Several other tondi in addition to the Ringling tondo have been placed within the 'San Marco Workshop' and have been attributed, although less successfully, by some to Albertinelli. They also have certain affinities to Fra Bartolomeo and many betray the work of several hands.[247]

FRA BARTOLOMEO

Baccio della Porta, known as Fra Bartolomeo, ranks as one of the major Florentine High Renaissance painters.[248] For a time in partnership with Albertinelli, Fra Bartolomeo and his associates are responsible for several tondi. They include the two intimate frescoed Madonna and Child tondi mentioned previously (Fig. 3.4). The others contain depictions of the Holy Family, a logical theme for Bartolomeo in the light of his connection with the Dominicans, the order of St Antoninus, the advocate of the family and St Joseph.

Perhaps the most intriguing tondo by Bartolomeo is his autograph Holy Family, in which both parents,

Gabinetto Disegni e Stampe degli Uffizi, Florence (ibid. 297, ill.). Another related tondo in tempera and oil on canvas transferred from panel with a 100 cm. diameter is in the Hermitage, St Petersburg (inv. no. 2067; Kustodieva, *Hermitage Catalogue*, 29, no. 1, ill.).

[245] Inv. no. SN26 in the John and Mable Ringling Museum of Art, Sarasota, Fla., oil on panel measuring 115.7 × 114.6 cm. Tomory, *Ringling*, 9, no. 2, ill., lists two copies and a rectangular variant (he believes another in the Jean Zanchi Collection, Lausanne, is the prototype), as well as shop copies formerly in the Mauritzhuis, The Hague, and a reversed composition in a private collection, Wuppertal-Barmen. Tomory notes that this tondo is identical with that listed in the 1516 inventory of Fra Bartolomeo's works, which is not sufficient proof that it is by Bartolomeo rather than Albertinelli. For the inventory of 3 Dec. 1516 (in the Biblioteca Medicee-Laurenziana, San Marco 920, Ricordanze B, 127–9), see Borgo, *Albertinelli*, 556 ff. Borgo (p. 374) supports a joint authorship weighted towards Albertinelli, believing it is the same tondo listed in the document of Jan. 1513 (Biblioteca Medicee-Laurenziana, San Marco 920, Miscellanea No. 2, insert 8—'tondo d'una Natività di braccia dua. 12'.), recording the division of the paintings between Bartolomeo and Albertinelli when they split up their partnership (ibid. 548–9). (A second tondo is listed as going to Albertinelli: 'Uno tondo di braccia dua dipinto . . . fior 17'.) Borgo, 559, believes this same painting is listed in the 1516 inventory of Bartolomeo: 'Item un Tondo di dua br. nel quale era una Natività, venduto a Giovanni Bernardini lucchese . . .'.

[246] Similarly, in a tondo less securely attributed to Albertinelli, a goldfinch drinks from St John's baptismal bowl (inv. no. 54-401/11 in the Columbia Museum of Art, Columbia, SC, formerly in the Samuel H. Kress Collection (K148), oil on lindenwood with a 116.9 cm. diameter). Shapley, *Paintings*, iii. 126, ill., attributes it to Fra Bartolomeo; Borgo, *Albertinelli*, 305–9, ill.

[247] For one example, see below, n. 292. It has been attributed to both Ridolfo Ghirlandaio and Albertinelli; Von Holst, 'Fra Bartolomeo und Albertinelli', 309, fig. 42.

[248] Vasari (Milanesi), iv. 175–215; Knapp, *Fra Bartolommeo*; Gabelentz, *Fra Bartolommeo und die florentiner Renaissance*; Berenson, *Florentine School*, i. 22–4, assigns three tondi to him, all discussed below. For Bartolomeo's relationship to Savonarola, see R. M. Steinberg, 'Fra Bartolomeo', 319–28, who notes that Savonarola stated that a painting is like love—both have the capability of delighting men—and that a painting is similar to love for if it is a good painting man can, in his contemplation of it, become ecstatic and lose his corporeal limitations (*Fra Girolamo Savonarola, Prediche eccelentissime . . . sopra il Salmo 'Quam Bonus Israel Deus'* (1539), 164 ff.).

each in his own fashion, adore the Child (Fig. A92).[249] A rare cartoon with an almost identical diameter (Fig. A93) provides a unique opportunity to compare a complete cartoon with an existing tondo.[250] The contours of its delicate figures—without haloes in the drawing but with them in the painting—are scored with a stylus. Despite this cinquecento method of transfer, the painting does not precisely conform to the drawing, revealing that Bartolomeo moved his composition 50 mm. to the right on the panel to achieve a better balance.[251] The artist introduced other modifications into the painting, which may be among the first works that he executed after his cessation of painting under the influence of Savonarola.[252] In both, the poignancy of Fra Bartolomeo's deep religious sentiment is successfully communicated.

Among the early tondi attributed to Bartolomeo is one in Munich, which is also given to Lorenzo di Credi and has been discussed above.[253] Its affinities to Credi are stronger than those to Fra Bartolomeo, although there are some similarities to a rectangular Madonna and Child with St John in the Metropolitan Museum of Art, considered an early work by Bartolomeo.[254] It probably is a collaboration involving a third personality who worked with both individuals.

A slightly later tondo by Bartolomeo—less linear in execution—is a work of c.1495 executed in a creatively eclectic manner similar to that of Albertinelli (Fig. A94).[255] A poetic light flickers over its soft surfaces, while a divine disturbance, similar to those in tondi by Raffaellino (Figs. 7.26, A38–9), illuminates the sky. A variant in the Ashmolean was based on the same cartoon.[256]

An unusually simple tondo with a narrative scene of the Nativity has been attributed to the circle of Bartolomeo (Fig. A95).[257] It betrays Albertinelli's influence, except in the background mill, which is close to one in the early panel by Bartolomeo (based on a work by Hans Memling in Florence) and executed in a spirit similar to Bartolomeo's landscape drawings. It is strange that its artist made no concessions to the round format despite its harmonious composition, except for the round, symbolic pomegranate.

Three other drawings in round formats have been associated with Fra Bartolomeo's oeuvre. The sheet with the Madonna and Child and five kneeling angels, one of whom supports St John at the left, is autograph (Fig. A96).[258] It is noteworthy that, as in other works with five elements for reciting the rosary, the division of the angels is the same: two on the left and three on the right. Although no surviving painting has been related to it, Bartolomeo indicated the circumference by a quick line, perhaps drawn with a compass.

[249] Inv. no. 3491 in the Museo Poldi Pezzoli, Milan, oil on panel measuring 89.4 × 90.7 cm. It has a black line around its circumference to facilitate insertion into its frame. Milan, *Museo Poldi Pezzoli*, 158, ill., traces its provenance to Florence; Padovani *et al.*, *L'età di Savonarola*, 75–6, no. 13, ill., list preparatory drawings.

[250] Inv. no. 1779 E in the Gabinetto Disegni e Stampe degli Uffizi, Florence, black chalk on prepared grey-brown paper of six folios scored and squared with black chalk, with an 88.2 cm. diameter. Fischer, *Disegni di Fra Bartolommeo*, 66–8, no. 27, ill.; Fischer, *Fra Bartolommeo, Master Draughtsman of the High Renaissance*; Padovani *et al.*, *L'età di Savonarola*, 76–7, no. 13a, ill.

[251] Fischer, *Disegni*, 67, ill. The painting is 25 mm. wider and 12 mm. higher than the cartoon.

[252] Fischer (ibid. 67–8) cites additional drawings related to this composition.

[253] Inv. no. WAF 191 in the Alte Pinakothek, Munich. Borgo, *Albertinelli*, 33–4, 47–8, to Bartolomeo with affinities to Credi, citing Dalli Regoli; see also above, n. 144.

[254] Fahy, 'Fra Bartolommeo', 145, fig. 14.

[255] Inv. no. 439 in the Galleria Borghese, Rome, tempera on panel with four vertical planks and an 89 cm. diameter. Della Pergola, *Galleria Borghese*, ii. 16–17, no. 13; Borgo, *Albertinelli*, 32–3; Gregori, Paolucci, and Acidini Luchinat, *Maestri e botteghe*, 78–9, no. 2.11, ill.; Padovani *et al.*, *L'età di Savonarola*, 49–52, no. 1, ill.

[—] Fahy, 'Fra Bartolommeo', 143 n. 7, lists two copies; for one see n. 256; the whereabouts of the other—which passed from the Wilson Collection, Florence, to the Carmichael Collection, Livorno—is unknown.

[256] Inv. no. A104 in the Ashmolean Museum, Oxford, panel with an 86.3 cm. diameter. Lloyd, *Earlier Italian Paintings*, 22–3, ill.

[257] In a private collection, according to the FKI. Pagnotta, *Giuliano Bugiardini*, 234, no. 114, ill., relates it to two other paintings in the orbit of Albertinelli: in the collection of the Principe Pio di Savoia, Mombello (fig. 107); Sotheby's, London, sale cat., 26/VII/33, no. 41.

[258] Inv. no. P & W 113ᵛ; RL 12782ᵛ in the Collection of H. M. Queen Elizabeth II, pen and brown ink heightened with white measuring 164 × 244 mm. Roberts, *Italian Master Drawings: Leonardo to Canaletto: From the British Royal Collection*, 28, no. 4, ill. A similar one is listed by Berenson as an old copy by the school of Bartolomeo (inv. no. 344 F in the Gabinetto Disegni e Stampe degli Uffizi; Berenson, *Drawings*, ii. 47, no. 529, ill.). A drawing of the Coronation of the Virgin in a roundel in the Fogg Museum of Art, Cambridge, Mass., is given to a follower (Mongan and Sachs, *Drawings in the Fogg Museum of Art*, i. 51, no. 62, ill., connect it with Suor Platilla Nelli, a Dominican nun of the cloister of St Catherine of Siena and a pupil of Fra Bartolomeo and Fra Paolino).

ANDREA DEL SARTO

While Vasari is filled with praises for Andrea del Sarto's paintings of 'Nostra Donna', he never identifies any as tondi *per se*.[259] In addition to a small group of tondi that can be assigned to the artist, in 1591 Bocchi referred to a 'tondo' painted by Andrea.[260] One of the earliest tondi by Andrea may be preserved in a preparatory drawing (Fig. A97) influenced by Leonardo, the *Doni Tondo*, and Raphael.[261] While it is not absolutely certain that the drawing, now on a circular sheet, was meant as a tondo, a good case can be made for this theory. Its focal point, the apple or pomegranate, which the Madonna and Child jointly hold, coupled with the rhythm of limbs, echo its contours. Moreover, its subject and composition fit into the tondo's evolution as we have seen it develop. In addition, many of its elements, including its oblique organization, resemble the lost Leonardo *Madonna of the Lake* and Raphael's *Alba Madonna* (Figs. A79, 7.34), while it is reminiscent of Andrea's *Madonna del Sacco* lunette, especially in its low point of view.

The only tondo definitely by Andrea is his signed *Holy Family with St John and St Elizabeth* (Fig. A98), also known as the *Barbadori Tondo*. It was originally painted in a round format, although when transferred to canvas it was transformed into an oval, and now has been restored to its original dimensions.[262] It is inscribed and signed at the upper left: *ANDREA .DEL / SARTO .FLORE./NTINO .FACIEB/AT* (followed by his monogram) and was probably the work described by Vasari (both editions) as in the house of Baccio Barbadori.[263] Although Vasari does not state that this painting was a tondo, Shearman believes Vasari refers to this work, a valid conclusion because no other composition by Andrea with the same figures is known.[264] Its setting is ambiguous and dark, similar to the backgrounds of other paintings by Andrea c.1516–17 influenced by Leonardo.[265] Although several works find reflection in this tondo, Andrea's prototype was Raphael's rectangular *Canigiani Holy Family* (c.1507), which has the same *dramatis personae*.[266] Both feature a distinctive dialogue between the two elders, Elizabeth and Joseph, in the second tier of action. This naturalistic detail lends resonance and focuses attention on the massive Madonna of Humility and Child. Further, its curvilinear figures echo the shape of the panel, and the resulting distortions are not unlike those found in a convex mirror. Drawn from the Franciscan *Meditations*, Joseph's presence underlines this saint's popularity in the wake of his veneration by Sixtus IV. The family-centred grouping, all without haloes in High Renaissance fashion, was assuredly meant as a model for the family in whose house it hung. Its composition contains circular elements to complement its format, while the figures are compressed by the confines of the circumference to a further degree than ever before. The three adults fill the extremities, rendering them more monumental and the scene more intimate, an effect, however, which verges on a Mannerist claustrophobia. Like Raphael's *Madonna della Sedia*, it has casually seated figures with an earthy dimension that almost overshadows the religious import carried by its shape. By using his wife Lucrezia as the model for the Madonna, as was his custom, Andrea has heightened its personal dimension. Yet with the bizarre, Mannerist grimace of St John, one senses the impending tragedy that will break up this family unit.

[259] Vasari (Milanesi), v. 5–81. Freedberg, *Andrea del Sarto*, i; Shearman, *Andrea del Sarto*.

[260] Bocchi, *Le bellezze*, 182–3, a tondo by Andrea with the Birth of John the Baptist, which sounds more like a *desco* and the *tafferie* of Pontormo (Figs. A115–16).

[261] Inv. no. 638 E in the Gabinetto Disegni e Stampe degli Uffizi, Florence, black chalk on gray paper with a 250 mm. diameter. R. Monti, *Andrea del Sarto*, 26, 135, ill., dates it to the time of Raphael's *Alba Madonna*; Florence, Palazzo Pitti, *Andrea del Sarto 1486–1530, dipinti e disegni a Firenze*, 194–5, ill.

[262] Inv. no. 714 in the Musée du Louvre, Paris, on canvas transferred from panel with a c.86 cm. diameter. Emile-Male, 'La Restauration de la Sainte Famille d'Andrea del Sarto . . .', and Beguin, 'A Propos de la Sainte Famille en tondo d'Andrea del Sarto', 861–70; Cordellier, *Hommage à Andrea del Sarto*, 35–6; Natali and Cecchi, *Andrea del Sarto*, 70, ill.

[263] Vasari (Milanesi), v. 14.

[264] Shearman, *Andrea del Sarto*, ii. 239–40.

[265] Freedberg, *Andrea del Sarto*, ii. 83, ill., feels that it is a reprise of the rectangular Holy Family in the Musée du Louvre, Paris (fig. 66); Shearman, *Andrea del Sarto*, i, fig. 38a; ii. 222–5, no. 36.

[266] Jones and Penny, *Raphael*, fig. 48.

The work enjoyed a great popularity; not only was it engraved in reverse by Jacques Callot in 1613 but also there are copies, a demand which testifies to a continuing vogue for tondi.[267]

Another tondo from Andrea's sphere of influence, the so-called *Benson Madonna*, has a simpler composition with three-quarters length figures arranged in a pyramidal composition.[268] Its Madonna and Child derive from Andrea's destroyed *Sarzana Altarpiece* (dated 1528) with the same cartoon or studio drawing utilized for both. The only element in harmony with its round format is the glowing aureole of warm, yellow light around the holy pair that creates a naturalistic phenomenon to indicate holiness.

GIULIANO BUGIARDINI

Giuliano Bugiardini, who reputedly began his artistic studies in the Medici Garden at San Marco with Michelangelo, executed tondi during the years when Raphael, Andrea del Sarto, Albertinelli, and Bartolomeo were active in Florence.[269] His artistic personality is not completely defined and the task may prove difficult since, like Piero di Cosimo in his late years, Bugiardini was a stylistic chameleon. He specialized in tondi with simple representations of the Madonna and Child with young St John, catering for the market during the days of the republic, when Florence's patron saint enjoyed great popularity. Sometimes Joseph is also included but usually as an afterthought. There are at least a score of tondi attributed to him, like Fig. A99, which betrays the influence of Piero and Franciabigio.[270] Bugiardini's tondo in Turin—a Madonna and Child, with a cross nimbus, adored by St John with Joseph leading a donkey in right middle ground—is representative of this group.[271] Among the finest by Bugiardini is one with the stable and a vignette of Tobias and the Archangel Raphael in its background (Fig. A100).[272] An interesting cut panel in Copenhagen may once have been a tondo (Fig. A101). It features an unusual reclining Madonna in a pose influenced by Michelangelo's Adam in the Creation scene on the Sistine Ceiling (in reverse) who is interrupted while reading a devotional book.[273] Its Christ in a playful gesture lunges at the cross held by St John to indicate that he accepts his adult mission.

Four other unusual tondi are assigned to Bugiardini. The first is a three-quarters-length standing Madonna and blessing Child with St John (Fig. A102).[274] Another—a Madonna of Humility supporting the Child who holds a book with Joseph approaching—has an unorthodox iconographical detail: a sleeping young John (Fig. A103).[275] This image may indicate that the last prophet of the Old Testament belongs to the passing order or that he is dreaming this vision of the Holy Family. Another tondo in Bologna features a complex theological linkage communicated through a chain of gestures (Fig. A104).[276] Its Madonna marks

[267] Freedberg, *Andrea del Sarto*, i, fig. 86. For a copy with a 110 cm. diameter in St Patrick's Cathedral, New York, see Shearman, *Andrea del Sarto*, i. 68d, ill. Shearman (ii. 239–40, no. 49) considers the Louvre rectangular version to be a copy and lists others in round and rectangular formats. Munich, *Alte Pinakothek*, 491–2, ill., notes that there are thirteen rectangular copies.
[268] Inv. no. 61.17 in the Lowe Art Museum, University of Miami, Coral Gables, Fla., formerly in the Samuel H. Kress Foundation (K1081), oil on panel transferred to canvas with a 67 cm. diameter. Freedberg, *Andrea del Sarto*, ii. 174; Shearman, *Andrea del Sarto*, ii. 292, ill., notes two copies (one as untraced in Budapest—actually inv. no. 51.770 with a 66 cm. diameter in the Museum of Fine Arts, Budapest; Tátrai, *Museum Budapest*, 108, ill.—and the other rectangular in the Galleria Borghese, Rome); Shapley, *Paintings*, ii. 129, ill.
[269] Vasari (Milanesi), vi. 201–9; Berenson, *Florentine School*, i. 44–6, assigns four tondi to Bugiardini; Pagnotta, *Bugiardini*.
[270] Inv. no. 79.1133 in the Indianapolis Museum of Art, oil on panel with an 87 cm. diameter. Pagnotta, *Bugardini*, 209–10, no. 41, ill.

[271] Inv. no. 114 in the Galleria Sabauda, Turin, tempera *grassa* on panel with a 97 cm. diameter. Gabrielli, *Galleria Sabauda: maestri italiani*, 84, ill.; Pagnotta, *Bugiardini*, 195–6, no. 10, ill., dates it *c.*1506–7 and states that its original frame is by Giovanni Barili.
[272] Inv. no. 68-10 in the Nelson–Atkins Museum of Art, Kansas City, Mo., oil with traces of tempera transferred to masonite with a 125.7 cm. diameter. Ibid. 196, no. 13, ill.; Rowlands, *Italian Paintings, 1300–1800*, 138–52, no. 18, ill.
[273] In the Nivaagaard Picture Gallery, Denmark, oil on panel measuring 60 × 80 cm. Ibid. 196–7, no. 14, ill.
[274] In a private collection, Florence, formerly in the Blakiston-Wilkins Collection, Florence, oil on panel, according to the FKI. Ibid. 197, no. 15, ill.
[275] Inv. no. 66 in the Hermitage, St Petersburg, oil on panel transferred to canvas with an 89 cm. diameter. Ibid. 221, no. 68, ill.
[276] Inv. no. 526 in the Pinacoteca Nazionale, Bologna, oil on panel with a 98 cm. diameter. Ibid. 212, no. 46, ill.; Bernardini *et al.*, *Pinacoteca Nazionale di Bologna*, 94.

her place in a book while simultaneously pointing to it and looking at John, to whom her omniscient son points; her gesture indicates the significance of her sacred book, whose prophetic texts name John as the precursor of Christ. A damaged work attributed to Raffaello Botticini (Fig. A14) should be associated with Bugiardini on the basis of a comparison with the two previous tondi.[277]

There are a number of problematic tondi assigned to Bugiardini. For example, the *Rothermere Tondo* (Fig. A105), which was attributed to Ridolfo Ghirlandaio by Pagnotta, has been reattributed to Bugiardini by Fahy.[278] Among them is a large, ornate tondo in Würzburg (photographed before its 1982 restoration removed the later ring of stars around the Madonna's head) (Fig. A106).[279] It has a standing, crowned Madonna (*aureola*—the *virgo et mater* theme) holding the Child, who grabs the reed-cross given to him by an older St John. At the Virgin's feet are two white doves, a motif found in the tondi of Piero di Cosimo, but here included without the pointed symbolism of Piero. Joseph is seated in the shadows at the right, absorbed in reading a book, while three female virgin martyrs, two with *aureola* crowns and one wearing a wimple and a crown of roses, kneel in adoration at the left. The central female is St Catherine of Alexandria, identified by her book and the wheel on which she kneels. To her right is most likely St Ursula holding a banner with a white cross and an arrow.[280] The third saint is probably either Dorothea or Euphemia, identified by her rose crown; she also appears to hold a small object or animal.[281] These two rather esoteric saints imply a commission tailored to the patron's request. Thus this tondo may have been painted for a convent or a devout family with a number of female members and aristocratic interests. Certainly its large size, 173 cm. in diameter, indicates that it was a significant commission hung in a grand space.

FRANCESCO FRANCIABIGIO

It would seem natural that Franciabigio, a student of Albertinelli who for a time shared a shop with Andrea del Sarto, painted tondi.[282] Yet less than a dozen have been assigned to this master, who needs study. Around seven surviving examples from his orbit involve the Madonna, Child, and St John, while several contain additional *dramatis personae*. Franciabigio's earliest tondo (Fig. A107) is a hybrid work. It was once attributed to Raffaellino and shows a strong connection with Piero (especially the Madonna's face).[283] A less quattrocentesque treatment of the theme occurs in a more mature tondo (Fig. A108).[284] Its architectonic, High Renaissance composition is underlined by the simple Tuscan order and horizontal parapet on which the Madonna sits. The broken column at the left, against which leans the reed-cross of young John, alludes to the Old Order which is passing away with the advent of Christ, a theme echoed in the placement of the Virgin's foot on the architectural fragments in the victor-over-vanquished pose. Its cartoon was reused and cropped in a half-length shop tondo, in which John hands Christ not only a rose but also a little crown of thorns.[285] One of the artist's most successful extant tondi (Fig. A109) was influenced by Raphael's *Bella*

[277] Whereabouts unknown, according the FKI—see above, n. 36.

[278] In the University Catholic Chaplaincy, Oxford, panel measuring 89 × 89.7 cm. Fahy, Review of Laura Pagnotta, *Bugiardini*, ill.

[279] Inv. no. Z420 (K90) in the Martin von Wagner-Museum der Universität and Mainfränkisches Museum, Würzburg, oil on panel with a 173 cm. diameter. Hoffmann, *Martin von Wagner Museum der Universität Würzburg: Gemäldekatalog*, 77, no. 179, ill. Tilman Kossatz (letter of 17 July 1991) related that the attribution to Bugiardini was made by A. Jan Fraser of the Indianapolis Museum of Art in 1982. The museum attributes it to a Florentine artist *c*.1500.

[280] J. Hall, *Dictionary*, 317–18. Her banner should be a red cross on a white ground, the Christian banner of victory. Ferguson, *Signs and Symbols*, 170.

[281] Ibid. 108–9; Hoffman, *Martin von Wagner*, 77, identifies them as Euphemia (?), Catherine, and Ursula.

[282] Vasari (Milanesi), v. 189–200; Berenson, *Florentine School*, i. 64–6, lists eight tondi by him; McKillop, *Franciabigio*.

[283] Inv. no. 2178 in the Galleria della Accademia, Florence, oil on panel measuring 92 × 86 cm. McKillop, *Franciabigio*, 125–6, no. 3, ill., dates it *c*.1506 and gives its measurements as '58 diameter'; Florence, *Gli Uffizi*, 270, ill.

[284] In the Roberto Ranieri di Sorbello Collection, Perugia, oil on panel with an 86 cm. diameter. Bodmer, 'Ein unbekanntes Werk des Franciabigio'; McKillop, *Franciabigio*, 126–7, no. 4, ill.

[285] Inv. no. 517 in the Galleria degli Uffizi, Florence, oil on panel with a 58 cm. diameter. Ibid. 127, 193–4; Florence, *Gli Uffizi*, 270, ill.

Giardiniera (1507).[286] Its High Renaissance figures have no haloes, and John sleeps as in a tondo attributed to Bugiardini (Fig. A103); in both the youth may be experiencing a vision of the Holy Family to which the viewer is also privy. Yet another tondo attributed to Franciabigio contains a Madonna whose face is quite different than the type usually painted by the artist and a St John in a Michelangesque pose derived from the Torso Belvedere.[287] Additional tondi have been assigned less convincingly and may be shop collaborations, including one with the Mystical Marriage of St Catherine.[288]

GIOVANNI SOGLIANI

Giovanni Sogliani, a pupil and assistant of Lorenzo di Credi, who had his own workshop by 1515, painted in Florence and Pisa (after 1528) but retained a style tied to the previous century. Some of his tondi are based on Credi's designs, while his later works testify to the impact of Bartolomeo, Albertinelli, and Andrea del Sarto.[289] A later panel features in the right background an anachronistic representation of Raphael and Tobias from the Book of Tobit, a popular fifteenth-century theme, which no doubt had a specific meaning for its patron (Fig. A110).[290]

RIDOLFO GHIRLANDAIO

The oeuvre of Domenico Ghirlandaio's son Ridolfo, who made the transition to a High Renaissance style, is finally being studied.[291] A pupil of David Ghirlandaio and Fra Bartolomeo, Ridolfo's eclectic works are difficult to identify. Take, for example, a problematic tondo with a standing Madonna and Child and St Dominic, assuredly commissioned by a patron with Dominican connections (Fig. A111).[292] As mentioned, some scholars have given this panel to Albertinelli, whose dated painting of 1506 in the Musée des Augustins, Toulouse, provided the model for some of its figures.[293] A tondo in Manchester (Fig. A112)[294] is close to several others, especially the strange posture of its reclining Child, proving a studio drawing must have preserved this composition, with variations in each version by several hands.[295]

A highly unusual tondo with a decidedly warped and oval inclination has been assigned to both Ridolfo and his teacher David, from whom it was commissioned. Instead of the customary Madonna and Child

[286] Inv. no. 888 in the Galleria della Accademia, Florence, oil on panel, measuring 97 × 94 cm. McKillop, *Franciabigio*, 127, no. 5, ill.; Florence, *Gli Uffizi*, 270, ill.

[287] Inv. no. 458 in the Galleria Borghese, Rome, oil on panel with two vertical planks and an 87 cm. diameter. McKillop, *Franciabigio*, 39, 171–2, no. 39, ill., dates it *c*.1519–23.

[288] In the Guicciardini Collection, Florence, with no published technical information. McKillop assigns it to Bugiardini with a date in the early second decade (ibid. 196–7); Pagnotta, *Bugiardini*, 230, no. 96, ill., dates it to the first decade.

[289] Vasari (Milanesi), v. 123–32; S. J. Freedberg, *Painting of the High Renaissance in Rome and Florence*, i. 495 ff.; Berenson, *Florentine School*, i. 200–2, lists two tondi by him.

[290] Inv. no. 37.524 in the Walters Art Gallery, Baltimore, panel of three planks with a vertical grain measuring 96.3 × 95.3 with a thickness of 3.1 cm. Zeri, *Italian Paintings*, ii. 318–19, no. 205, ill. Two rectangular works based on the same drawing for the two central figures are known: in the Musée des Beaux-Arts, Brussels, and the Galleria Sabauda, Turin. Freedberg, *Painting*, i. 495, believes that the Walters tondo predates the other two, while Zeri thinks that it is the last.

[291] Berenson, *Florentine School*, i. 77–9; Griswold, 'Early Drawings by Ridolfo Ghirlandaio'; David Franklin is currently

studying Ridolfo.

[292] Inv. no. 43.1 in the Mint Museum of Art, Charlotte, NC, formerly in the Samuel H. Kress Collection (K1181), transferred from panel to canvas with an 88.9 cm. diameter. Shapley, *Paintings*, iii. 18–19, ill.; n. 247 above.

[293] Ibid. iii. 19. In 1974 it was published by Von Holst ('Fra Bartolomeo und Albertinelli', 309, ill.) as part of the San Marco Workshop. For the work in Toulouse, influenced by Piero di Cosimo, Berenson, *Florentine School*, ii. fig. 1316.

[294] Inv. no. 1947.188 in the Manchester City Art Galleries, Manchester, oil on panel with a 114 cm. diameter. Manchester, City Art Galleries, *A Century of Collecting, 1882–1982: A Guide to Manchester City Art Galleries*, 49, no. 30, ill. Zeri, 'The Second Volume of the Kress Catalogue', 456, believes that it is by Ridolfo and the prototype is his fig. 52, another version of unknown whereabouts (panel with a 97 cm. diameter; Sotheby's, London, sale cat., 25/XI/70, no. 97); Venturini, 'Il Maestro del 1506', fig. 44, reproduces a version by Mainardi, whereabouts unknown.

[295] Another is inv. no. 37.6785.269 in the Witte Memorial Museum, San Antonio, Texas, formerly in the Samuel H. Kress Collection (K1063), panel with a 97.2 cm. diameter. Shapley, *Paintings*, ii. 122–3, ill.; Venturini, 'Il Maestro del 1506', 141 n. 125, gives it to the shop of Ridolfo.

theme, it has two standing saints, Peter and Paul, the pillars of the Christian Church (Fig. A113). Its indefinite provenance from the Convent of the Murate in Florence affords no idea of its function, although the information that it may be the work commissioned for the room of the Gonfaloniere in the Palazzo della Signoria is tantalizing.[296] Although its large size confirms its autonomous status, the panel remains an anomaly. Needless to say, it must be connected with the Early Christian tradition in which these same two saints were frequently paired in small gold and glass medallions.[297] Here, the two are separated by a opened, propped-up book and St Paul's sword. They gaze at the circular vision at the top of the panel. The only obvious concession to its format is the shape of this luministic phenomenon, which is repeated in the arcs formed by the arms of the saints. One can speculate that the half-visible vision represents God, or Christ and the Madonna, providing a unique twist on representations in other tondi. The viewer, together with Peter and Paul, those *exempla* of the ardour of the Christian faith, understands the vision and its message. It is significant that the composition has been stretched into an oval to accommodate the standing figures, a fact symptomatic that the tondo form was beginning to loose its integrity.

FLORENTINE TONDI AFTER 1510

From the evidence provided by surviving works of art, it seems that after *c*.1510–15 the number of tondi produced in Florence began to dwindle quite rapidly. Younger artists tended to produce only one or a few tondi, although the form still remained an option for devotional works. Like earlier cinquecento tondi, these works tended to be simple compositions and their iconography was not as complex as late quattrocento examples, despite the onset of Mannerism. At this time, however, tondi caught on in Siena where, after a cultural lag, they enjoyed a last-gasp vogue. And it is Beccafumi, at once both retardataire and thrillingly abstract and progressive, who became the major Sienese *tondaio*. Before considering his tondi, we shall discuss other painters of tondi in this later Florentine ambiance.

IL BACCHIACCA

Based on extant evidence, Francesco d'Ubertini Verdi, called 'Il Bacchiacca', should not be known as a painter of Madonna and Child tondi.[298] Yet he was associated with artists who painted them and rendered works in round formats, among them an Agony in the Garden, a popular devotional scene during the late fifteenth and early sixteenth centuries (Fig. A114).[299] Tellingly, the one Madonna and Child tondo attributed to him is a copy of the *Doni Tondo*, where instead of Michelangelo's spartan background, he rendered a bucolic rural landscape with two figures.[300] His best-known painting in a round format illustrates the story

[296] Inv. 1890, no. 6063 in the Galleria Palatina di Palazzo Pitti, Florence, panel with a 105.5 cm. diameter; the reverse has an old piece of paper with an inscription that it was removed from the convent of the Murate. Florence, Palazzo Pitti, *Mostra di dipinti restaurati delle gallerie*, 5–6, ill. Milanesi (Vasari, vi. 533 n. 2) in the life of David remarks: 'Nel 1503 dipinge un tondo con san Pietro e san Paolo per la camera del Gonfaloniere nel Palazzo Priori . . .'. Francovich, 'David Ghirlandaio—I', 86–7 n. 10, correlated that notice with the painting. Rubinstein, *Palazzo Vecchio*, 45, 76–7 n. 286, fig. 50, notes the commission document of 31 May 1503 from David Ghirlandaio and that of its pendant of Thomas the Apostle and Thomas Aquinas from Domenico di Domenico of 8 June for the apartment of the Gonfalonier of Justice, Piero Soderini (ASF, Operai del Palazzo, 10, fol. 53ᵗ); Ch. 3 n. 52. The 1969 Pitti catalogue notes that in 1574, at the death of Cosimo I, his widow Cammilla Martelli was suddenly closed up in the convent of the Murate by Francesco and took her possessions with her, speculating that the

panel may have originally been in one of the *stanze* that Piero Soderini had redecorated in 1503, at his entrance as Gonfaloniere, of which there is no trace. It cites M. Chiarini, *Dizionario biografico degli italiani*, x, *ad vocem*, who assigned it to Ridolfo.

[297] See Grabar, *Christian Iconography*, 68–9, figs. 163–7, for ancient gilded glass portraits and bronze medals pairing the two saints.

[298] Vasari (Milanesi), vi. 454–6; Nikolenko, *Francesco Ubertini called 'Il Bacchiacca'*.

[299] Inv. no. 775 in the York City Art Gallery, panel with a 97.1 cm. diameter and a ring of dark pigment outlining its circumference. York, York City Art Gallery, *Catalogue of Paintings. Foreign Schools 1350–1800*, 3–4, ill.; Nikolenko, *Bacchiacca*, 55, ill., observes connections with prints by Lucas van Leyden and Dürer.

[300] In a private collection, Florence, panel with a 101.6 cm. diameter. Ibid. 154, ill. It was formerly listed as in Volterra.

of Ghismonda with the heart of Guiscardo from Fiametta's story in Boccaccio's *Decameron* (Fig. 1.17).[301] Its shape and size have always suggested that it is a *desco da parto*, a conclusion supported by the conjoined coats of arms on its reverse. This theme (that the matrix of a good marriage and dynasty is the constancy of love) bolsters other evidence that *deschi* could have been ordered near the time of the marriage. Both it and the two Pontormo shop *tafferie da parto* discussed below (Figs. A115–16) reveal a lingering taste for (or a revival of) these objects in the Cinquecento.

Pontormo

Jacopo Carrucci da Pontormo, an exact contemporary of Bacchiacca,[302] probably produced a *tafferia da parto*, with the Birth and Naming of St John the Baptist, resembling a thick wooden bowl whose edge has been gilded to serve as a frame (Fig. A115).[303] In profile, it has a slight foot with incised lines that echo the four circumscribing the body of its reverse, whose surface is gessoed. The image on the concave interior resembles those on *scodelle* and parturition sets of maiolica (Fig. 1.18), which began to usurp the place of *deschi da parto* in the early sixteenth century. Thus Pontormo's work attempts to reconcile the two forms: one retardataire and the other the height of fashion. In addition, it resembles Andrea del Sarto's rendition of the theme in the Scalzo Cloisters (1526) (Fig. 3.12), which betrays *pentimenti* of a tondo. Further, Pontormo nominally attempted to tailor his composition to the requirements of the tondo, echoing its shape in the fan and haloes. A slightly smaller, damaged version (Fig. A116) nearly repeats the scene.[304] To realize how stylized these panels are, they can be compared with a more detailed, later representation of the subject (Fig. A117). Unlike the two from Pontormo's sphere, this panel is flat and does not resemble a *scodella*. It also has marvellous interior details, like the charcoal brazier and the maiolica pitcher, as well as a wonderful genre portrayal of a cat warming itself that belong to the Sienese tradition, herein melded with the Florentine tradition of *deschi da parto*.[305]

Pontormo also executed a simplified, almost abstract half-length Madonna and Child tondo (Fig. A118). It has been connected with a work that Vasari stated was painted for the *camera* of one of Pontormo's major patrons, Lodovico Capponi, demonstrating its continuity with earlier traditions.[306] The panel has the

[301] Inv. no. 61.13 in the Lowe Art Museum, University of Miami, Coral Gables, Fla., formerly in the Samuel H. Kress Collection (K308), oil on panel with a 66.7 cm. diameter. Shapley, *Paintings*, iii. 7, ill.; Nikolenko, *Bacchiacca*, 40, ill., dates it stylistically to *c*.1520–1; De Carli, *I deschi da parto*, 184–5, no. 42, ill. The exact date probably hinges on the Carducci–Guidetti marriage, the families of the coats of arms on the reverse.

[302] Vasari (Milanesi), vi. 45–95; L. Berti, *Pontormo*; id., *L'opera completa del Pontormo*; Costamagna, *Pontormo*.

[303] Inv. no. 1532 in the Galleria degli Uffizi, Florence, oil on panel with a *c*.59 cm. diameter. Florence, *Gli Uffizi*, 431, ill. It appears to have a provenance from the Della Casa–Tornaquinci family (their coat of arms is painted on its reverse) and may refer to the birth in 1526 (1527) of Aldighieri (first-born son of Girolamo Della Casa and Lisabetta di Giovanni Tornaquinci; Ferrazza and Bruschi, *Pontormo*, n.p.; De Carli, *I deschi da parto*, 186–7, no. 53, ill.). Costamagna, *Pontormo*, 281–2, no. A30, ill., points out that there is an inscription on the paper on which Zachariah writes, *iohannes*, his son's name.

[304] In a private collection, London, panel with a 52 cm. diameter. It was formerly in the collection of Elio Volpi in the Palazzo Davanzati, Florence (Ferrazza, *Palazzo Davanzati e le collezioni di Elia Volpi*, 117). Its reverse has the arms of the Ughi and Antinori families. (The Ughi and the Della Casa were relatives, so that it is understandable that the two *tafferie* are related.) It probably was painted in 1526 to celebrate the birth of the first male heir to Mariano di Giorgio Ughi and Oretta di Amerigo Antinori, married

in 1523. Ferrazza and Bruschi, *Pontormo*, n.p., ill.; Costamagna, *Pontormo*, 283, no. A30a, ill.; De Carli, *I deschi da parto*, 188–9, no. 54, ill. While its design is identical with that of the other in the Uffizi, its colour scheme is different. An examination of the two—e.g. their shapes and incised lines—seems to indicate a common origin. Both may be shop productions, based on a drawing by the master.

[305] In a private collection, Pordenone, panel with a 70 cm. diameter and an area of bare wood around its circumference to facilitate insertion into its frame. De Carli, *I deschi da parto*, 226–7, no. 73, ill., dates it 1570–80 and assigns it to an unknown Sienese artist.

[306] In the Palazzo Capponi delle Rovinate, Florence, oil on panel originally a tondo with a 77 cm. diameter, incised around its circumference, inside a *trompe l'œil* frame with another incised circle before the painted decoration begins. The height of the original panel with frame was *c*.88 cm.; it was converted into an oval (*c*.106 × 80 cm.) in the 18th c. It may be the very tondo recorded in 1534 in the Archivio Capponi delle Rovinate, Registro III, Acquisti di beni di Ludovico e figli Capponi, Ricordo dell'inventario delle cose mobili dopo la morte di Ludovico Capponi, fol. 19ʳ: 'Un quadro di nostra donna grande tondo', which is found 'Nella camera grande sul verone'. My thanks to Niccolò Capponi for the citation. Vasari (Milanesi), vi. 272; Berti, *L'opera completa*, 101–2, no. 99, ill.; Costamagna, *Pontormo*, 193–4, no. 54, ill.

remnants of a decorative design in grisaille, revealing that Pontormo painted it in one piece with its frame. Its yellow background simulates the gold of heaven, while its broadly painted style is close to that of Pontormo's Capponi Chapel in Santa Felicità (1525–8).

ALONSO BERRUGUETE

A fascinating interlude in our discussion of Florentine tondi is provided by the Spanish painter Alonso Berruguete. His residency in Italy (c.1504–17) resulted in at least one tondo that reveals the impact of Florentine ideas and artists' styles, foremost those of Pontormo and Michelangelo (Fig. A119).[307] Berruguete's intimate composition also betrays the influence of High Renaissance iconography, while the profile pose of the Madonna and the intensely psychological and physical relationship between her and the Child results from his study of reliefs by Donatello and Michelangelo; the curtain at the left is a device which Raphael used at almost the same time in his *Madonna della Tenda*. The panel supports the theory that in the first two decades of the Cinquecento, the tondo was still a pervasive and viable form. It also demonstrates that as a foreigner Berruguete adapted to his new environment and the expectations of its patrons. However, the figures in Berruguete's panel are more expressive than those in tondi by most Florentines and in that are incipiently Mannerist, resembling the exaggerated forms of Rosso and Beccafumi, whose paintings Berruguete may have seen. They do not sit comfortably in the ideal form, intimating that it would not remain significant through the sixteenth century.

DOMENICO BECCAFUMI AND SIENESE TONDI

Domenico Beccafumi, the gifted Sienese painter, was a prolific producer of tondi that were encouraged by his contacts with Florence but have a uniquely Sienese flavour.[308] His successful employment of the tondo for his patrons helped to encourage a late blossoming of the form in Siena. He also utilized the circular format in works other than tondi in inventive ways that usually carry celestial implications. For example, in his mystical altarpiece depicting St Paul enthroned (c.1516 in the Museo dell'Opera del Duomo, Siena), he included a tondo/roundel in its stone spandrel. This tondo encloses an image of the Holy Family with a male saint and functioned either as a painting within the painting or as a mystical window into heaven, revealing the artist's familiarity with the concept.[309] This evidence testifies to his exposure to Florentine ideas in the Roman environment during his 1510–12 vist and to the possibility of a stop in Florence.

It is no coincidence that all Beccafumi's tondi date stylistically after his return from this sojourn. Domenico brought to the format his Sienese brand of religious mysticism as well as a decidedly Sienese iconography and distinctive palette. Over fifteen tondi have been assigned to Beccafumi, and there are others relegated to his sphere. A great portion feature the Holy Family wherein Joseph does not play a leading role; others depict the Madonna and Child and various saints. At least six include St Catherine of Siena, one of Siena's civic patron saints, indicating the distinctly Sienese orientation of some of his tondi. Several of these depict Catherine's mystical marriage to the Child (Fig. A120).[310] This more complicated theme is

[307] In the Loeser Collection, Palazzo Vecchio, Florence, oil on panel with an 85 cm. diameter. Siena, *Domenico Beccafumi*, 404–5, no. 83, ill., notes that its frame of fruits and flowers may be by Berruguete, who also practised as a sculptor in Florence. Freedberg, *Painting*, i. 252–5, 536–9; Siena, *Domenico Beccafumi*, 402–3.

[308] Vasari (Milanesi), v. 633–58; Hauptmann, *Der Tondo*, 273–4; Baccheschi, *L'opera completa di Beccafumi*; Siena, *Domenico Beccafumi*. See Gabriele, *Le incisioni alchemico-metallurgiche di Domenico Beccafumi*, for his interest in alchemy.

[309] Siena, *Domenico Beccafumi*, 116–19, no. 10, ill. A drawing in the Gabinetto Disegni e Stampe degli Uffizi, Florence (inv. no. 1257

F; ibid. 431, no. 90, ill.), proves that it was definitely conceived as a tondo with a Holy Family and male saint.

[310] Whereabouts unknown, panel with a 79.5 cm. diameter. Sotheby's, New York, sale cat., 8/1/81, no. 54. It is related to another in the Doria Pamphili Gallery, Rome, with a 92 cm. diameter (Baccheschi, *L'opera completa*, 102, no. 113, ill.). There are two other tondi of the subject in the Museo Civico, Siena: one in oil on panel with a 34 cm. diameter and another in tempera on panel with an 80 cm. diameter (Bisogni and Ciampolini, *Guida al Museo Civico di Siena*, 40–1, no. 137, ill.; 42, no. 147, ill.).

characteristic of the artist after 1525, suggesting that both he and his patrons evolved individual iconographies as the novelty of the imported form wore off and Sienese tastes began to assert themselves.

A panel formerly attributed to the eclectic Girolamo del Pacchia has been assigned to Beccafumi as an early work (Fig. A121).[311] The pose of its chubby Child recalls the Adam in Michelangelo's Creation scene on the Sistine Ceiling. Moreover, it reveals a knowledge of both Michelangelo and Raphael in a spirit akin to that of Berruguete's tondo, proving Beccafumi's Florentine/Roman inspiration.

All but one of Beccafumi's earliest tondi are organized in an intimate half- or two-thirds-length format and most have dark backgrounds, an effect popular in the first decade of the Cinquecento with the widespread impact of Leonardo. The darkness accentuates Beccafumi's bizarre, hallucinatory colours and facilitates his penchant for eerie light effects. The exception to this rule is his large *Holy Family with St John in a Landscape* (Fig. A122).[312] This panel has a decidedly Florentine composition and stylistically dates *c.*1515. Its Leonardesque *sfumato* argues that Beccafumi may have travelled to Rome via Florence. As in no other tondo by his hand, the full-length Madonna and Joseph echo its shape in good Florentine fashion (with the front of one juxtaposed to the back of the other). Moreover, the image has been affected by a study of the effects of a convex mirror, a trait accentuated by the round, rhythmic patterns in the leaves on its trees. As in Leonardo's *Madonna and Child with St Anne*, the Child hugs the lamb, symbolic of his Sacrifice. To reinforce this theme, John's foreshortened hand holding the scroll inscribed *ECCE AGNUS DEI* points to the Child, while his other holds his cross-staff with one finger pointing to Joseph's hand. This dynamic gesture, again reminiscent of Michelangelo's Creation of Adam scene, recalls Christ's royal lineage from the House of David through his foster-father and reflects the current theological importance of Joseph (echoed in the fact that Christ looks at Joseph).

Other Beccafumi tondi more frequently feature half-length figures. For example, the Holy Family where a donor, or possibly another male saint, is included at the right (Fig. A123).[313] Its Child leafs through pages of a devotional book that the donor holds up to him while gazing directly into his eyes. Beccafumi cast an ecstatic St John as a prominent personage in this discordant mystical moment set in an ambiguous space. His five-figure arrangement suggests that the donor and the unusual blonde-haired Baptist were jointly experiencing a vision, and that these figures provide focal points for the rosary. Yet its carved frame has only four protruding prophets' heads that were nevertheless influenced by Florentine elements, the *Doni Tondo* frame and Ghiberti's *'Paradise' Doors*.

A consideration of Beccafumi's tondi closes with a mention of his *Charity* with its seated woman surrounded by children playing with dogs and hobby-horses. Although described as a 'tondo', this charming work is technically not a tondo because the round image is painted on a square panel.[314] Its small size suggests that it was once part of a larger context, perhaps from a series of virtues that decorated a piece of furniture or a room. Charity's pose, however, depends on the *Madonna del Latte* type, and her nurturing role on images in Madonna and Child tondi.

[311] Inv. no. 35 in the Pinacoteca Nazionale, Siena, oil on panel with a 68 cm. diameter and in its original frame (98 cm.) with outer and inner bands of gilded leaves and an inner garland of pine cones and fruit painted black. Siena, *Domenico Beccafumi*, 104–5, no. 6, ill.; Torriti, *Pinacoteca*, 376–7, ill. It was formerly in the Samuel H. Kress Collection (K1008). Shapley, *Paintings*, ii. 112, ill.

[312] Inv. no. 1073 in the Alte Pinakothek, Munich, chestnut panel with a 113 cm. diameter and a Sienese provenance. Munich, *Alte Pinakothek*, 64, ill.; Siena, *Domenico Beccafumi*, 65, ill.

[313] Inv. no. 6532 in the Museo Horne, Florence, oil on panel with an 80 cm. diameter. In its original frame (149 cm.) thought to have been carved by Giovanni Barili, although Antonio had been the traditional choice; Sabatelli, *La cornice italiana*, 108–9; Cecchi, 'Les Cadres', 23–4, suggests that it may have been executed by Lorenzo Donati. The panel has a Genoese provenance, and since Vasari (Milanesi), v. 649, records that late in his career Beccafumi worked for the Doria family in Genoa, it is tempting to hypothesize that it was painted during his Ligurian sojourn. Siena, *Domenico Beccafumi*, 174–5, no. 27, ill.

[314] Inv. no. CAI.165 in the Victoria and Albert Museum, London, with a 38 cm. diameter image on a square panel. Kauffmann, *Catalogue of the Foreign Paintings*, 23–4, ill.

SODOMA

Vasari contrasted the positive, hardworking Beccafumi with the eccentric, careless Giovanni Antonio Bazzi called 'Il Sodoma', who like his foil spent most of his life in Siena and contributed to the history of the tondo in that city.[315] Less than a dozen tondi have been attributed to him. Sodoma's earliest unquestionable tondo usually has been dated before his Roman trip (c.1505) (Fig. A124) and can be linked with a Florentine period from c.1504.[316] Its five foreground figures are accompanied by vignettes that have led to it being called a Nativity, including the horse tamer present in many Adorations.[317] The Child looks as though he had been studied from life, as does the slightly giddy angel, which was once identified as a self-portrait, an idea that has been discounted. A second tondo by Sodoma with its more monumental gravity and softer modelling is Fig. A125.[318] Here, the narrative moments of the Nativity have been eliminated, although Joseph inventively scans the sky to ascertain auspicious celestial signs in preparation for their departure for Egypt. Another tondo by Sodoma (Fig. A126) can be connected with a document (of 13 October 1536) concerning litigation between the artist and the Arduini brothers.[319] Beneath the cozy scene lies a tragedy: with sad resignation the Madonna accepts John's cross-staff as an indication that her infant (asleep to foreshadow his death) has a tragic destiny to fulfil. As in Andrea del Sarto's *Barbadori Tondo* (Fig. A98), the two elders, Elizabeth and Joseph, function like bookends, supporting the composition and the stability of the family unit.

Other tondi have been less securely assigned to Sodoma and his assistants. A more iconographically and technically distinct tondo is the frescoed representation of the Man of Sorrows with three angels (variously identified as three disciples or three Maries). It has been attributed to the shop of Sodoma as well as to Bartolomeo Neroni, his student and son-in-law, whose later style is quite distinctive.[320]

BARTOLMEO NERONI

The mature style of Bartolomeo Neroni, Il Riccio, and his Sienese iconography appears in a tondo with the Madonna and Child, St Bernardino, and St Catherine of Siena (Fig. A127).[321] Neroni repeated this civic symbolism in a drawing for a tondo with the Madonna and Child and the same two saints in reverse (Fig. A128), underscoring that by the third and fourth decades of the century Sienese artists and patrons had developed their own iconographies from the Florentine example.[322]

[315] Vasari (Milanesi), vi. 379–405; Cust, *Sodoma*; Jacobsen, *Sodoma und das Cinquecento in Siena*; Hayum, *Giovanni Antonio Bazzi—'Il Sodoma'*; Siena, *Domenico Beccafumi*, 228–35.

[316] Inv. no. 512 in the Pinacoteca Nazionale, Siena, tempera *grassa* on panel with a 111 cm. diameter in its original frame (157 cm.). It has been suggested that Sigismondo Chigi was its patron. Carli, *Mostra delle opere di Giovanni Antonio Bazzi detto 'Il Sodoma'*, no. 4, ill.; Hayum, *Sodoma*, 89–91, ill.; Torriti, *Pinacoteca*, 358–9, ill. For its frame, Sabatelli, *La cornice italiana*, 104–5, ill. Zambrano, 'La "Deposizione" Cinuzzi del Sodoma', 88–9, discusses Sodoma's Florentine experience during this period.

[317] For the horse tamer, see Olson, 'Botticelli's Horsetamer: A Quotation from Antiquity which Reaffirms a Roman Date for the Washington *Adoration*'. It supports a post-Rome date.

[318] In the Museo Francesco Borgogna, Vercelli, oil on panel with a 98 cm. diameter. Carli, *Sodoma*, no. 4, ill.; Hayum, *Sodoma*, 123–4, ill.; Zambrano, 'La "Deposizione"', 89.

[319] Inv. no. 37.522 in the Walters Art Gallery, Baltimore, oil on panel of three planks with vertical grain, measuring 115.2 × 112 cm. with a c.3.7 cm. thickness. Zeri, *Italian Paintings*, ii. 345–6, no. 229, ill., mentions a copy with a c.104 cm. diameter now in the

Pinacoteca Ambrosiana, Milan, Attilio Brivio Bequest. Hayum, *Sodoma*, 263, quotes the document published in Milanesi (1856), 124; see Ch. 3 n. 58. Although I had already made the connection between the document and the Walters tondo, it was subsequently published by Loseries, 'Sodoma's "Holy Family"', who believes that St John is given emphasis over the Child because one of the Arduini brothers was named Giovanni. One finds a similar inverted emphasis in a few other tondi.

[320] In the Collegiata, Asciano, fresco with a 90 cm. diameter. Cust, *Sodoma*, 376, identifies the three figures as the disciples and attributes it to Neroni.

[321] Inv. no. P.53.45 in the Bob Jones University Museum and Gallery, Greenville, SC, oil on panel with a 61 cm. diameter. Pepper, *Bob Jones Collection*, 82, no. 84.1, ill. The representation of St Bernardino, another Sienese saint, is formally conducive to tondi because the saint's emblem was the IHS inside a sun or round gold disk (here on the saint's book).

[322] Inv. no. FC 129652 in the Istituto per la Grafica, Rome, in pen and brown ink measuring 130 × 117 mm. Siena, *Domenico Beccafumi*, 419, ill.

As an addendum, we turn to an autograph round allegorical work by Sodoma (Fig. A129). Its integral border/frame of grotteschi has a gold inner line which, together with the panel's dimensions and subject, suggest that it is a *desco da parto*.[323] It has been associated with the lost decoration of the Palazzo Chigi in Siena, c.1510–11, and its subject with the two Neoplatonic Venuses.[324] Assuredly, its theme involves love and a form of charity, both of which are appropriate to a domestic environment. Perhaps the dead tree at the left, on which hang a quiver, bow, and shield, provides a negative commentary on the female figure (Venus?) and Cupid or their type of love, whereas the figure at the right with a verdant tree looks like a blend of Charity and a positive form of love. The Louvre catalogue identifies the subject as Sacred and Profane Love with Anteros, Eros, and two other Cupids (or the Allegory of Love, a more fitting title), while De Carli identifies it as representing Love and Charity or an allegory of Charity.[325]

Girolamo del Pacchia

Girolamo del Pacchia, another Sienese painter who was probably trained by Fungai and Giacomo Pacchiarotti, with whom he is often confused, is mentioned within the commentary to Vasari's life of Sodoma.[326] His early manner is seen in a fifteenth-century Madonna and Child tondo with a meditating male saint (Francis or Bernardino?).[327] In a later tondo with the Holy Family (Fig. A130), Del Pacchia reflects a sixteenth-century aesthetic close to Sodoma as well as a native Sienese love of narrative.[328] In his most successful tondo, the artist left behind his drier style for a softer, more atmospheric, classical one (Fig. A131).[329] Its naturalistic Madonna reflects those of Raphael, Albertinelli, and Fra Bartolomeo, dating the work after an exposure to Florence and/or Rome, although her sympathetic countenance must have been studied from life. Its lovely pastoral landscape is also cinquecentesque.

Assorted Artists Associated with Siena

Several other Sienese artists executed tondi that frequently betray Florentine references. Among them was Girolamo Genga, an artist from Urbino active in Siena during the early Cinquecento.[330] His tondo with a Madonna of Humility also features Sts John and Antony of Padua adoring the Child, who sits on a pot of flowers (Fig. A132).[331] Its Franciscan iconography is emphasized by the fact that Antony is taller than the Madonna whom he adores, although the disparate scales of the figures suggests that two separate drawings were combined in this composition.

Although he was born in Brescia, Brescianino (Andrea Piccinelli) is considered a Sienese artist and was in Florence sometime c.1524.[332] A group of tondi have been assigned to him, including one with the Madonna and Child holding a small gold cross (Fig. A133).[333] This enigmatic work from the second or third decade

[323] Inv. no. R.F. 2106 in the Musée du Louvre, Paris, oil on panel with a 61 cm. diameter. Hayum, *Sodoma*, 132–5, ill.; Gowing, *Paintings*, 156, ill.; De Carli, *I deschi da parto*, 202–3, no. 61, ill.

[324] Hayum, *Sodoma*, 129, 133, neither confirms the identification of the subject nor does she consult primary sources, like Pico and Ficino, to support her conclusions which, however, hold some promise. Carli, *Sodoma*, no. 6, terms it an allegory of love; Cust, *Sodoma*, 102, 351, identifies it as a representation of *Caritas*.

[325] Gowing, *Paintings*, 156; De Carli, *I deschi da parto*, 202. Charity (and motherhood) rather than erotic love seems to be stressed because of the figures' placement.

[326] Vasari (Milanesi), vi. 391 ff., 428–32; Jacobsen, *Sodoma*, 79–87; Hauptmann, *Der Tondo*, 271; Berenson, *North and Central*, i. 306–8; Siena, *Domenico Beccafumi*, 276–83.

[327] Inv. no. 287 in the Chigi Saracini Collection, Siena, panel with a 46.3 cm. diameter. Sricchia Santoro, *Da Sodoma a Marco*

Pino, 62–3, no. 8, ill.

[328] Inv. no. A88 in the Ashmolean Museum, Oxford, oil on panel with a 102.5 cm. diameter and a ring of dark pigment outlining its circumference. Lloyd, *Earlier Italian Paintings*, 143, ill.

[329] Inv. no. 3441 in the Galleria della Accademia, Florence, oil on panel with an 89 cm. diameter. Florence, *Gli Uffizi*, 305, ill.; Siena, *Domenico Beccafumi*, 276–9, ill.

[330] For Genga, see ibid. 254–7.

[331] Inv. no. 433 in the Pinacoteca Nazionale, Siena, oil on panel with a 103 cm. diameter. Torriti, *Pinacoteca*, 327–8, ill.; Siena, *Domenico Beccafumi*, 264–5, no. 50, ill.

[332] For the artist, see Sricchia Santoro, *Da Sodoma a Marco Pino*, 64–82; Siena, *Domenico Beccafumi*, 290–5.

[333] In St John's Evangelical Lutheran Church, Allentown, Pa., formerly in the Samuel H. Kress Collection (K1733), panel with an 87 cm. diameter. Shapley, *Paintings*, ii. 112, ill.

postdates Pontormo's San Michele in Visdomini altarpiece, which Brescianino could have seen in Florence. Its figures do not conform to the format, while its casually drawn back curtain is a device used frequently by the artist in other tondi.[334] Among the panels convincingly attributed to him is a fascinating Madonna and Child with young St John and two angels holding up an escutcheon with a combined coat of arms—thus connecting tondi to marriage traditions and *deschi*, a phenomenon which enjoyed a vogue in Siena at precisely this time (Fig. A134).[335] Its polygonal frame in the illustration conceals its circumference and heightens this connection. In conclusion, these assorted masters of the late Sienese blossoming of tondi had an intermittent Florentine connection and produced adaptations of an originally Florentine form.

[334] For example, inv. no. 21 in the Chigi Saracini Collection, Siena, panel with a 70.5 cm. diameter. Sricchia Santoro, *Da Sodoma a Marco Pino*, 82, no. 13, ill.

[335] Whereabouts unknown, formerly in the Baron Boxhall Collection, London, oil on panel with a 57 cm. diameter. De Carli, *I deschi da parto*, 214–15, no. 67, ill., identifies it as a *desco* and the figure as Charity, demonstrating this late connection between the two forms.

APPENDIX PLATES

FIG. A1. Master of Daphne and Apollo, *Annunciation*, c.1485–90s. Whereabouts unknown

FIG. A2. Bartolomeo di Giovanni, *Adoration of the Magi*, 1488–90. M. H. De Young Memorial Museum, San Francisco

FIG. A3. Bartolomeo di Giovanni, *Madonna and Child with Young St John*, late fifteenth century. Museo Horne, Florence

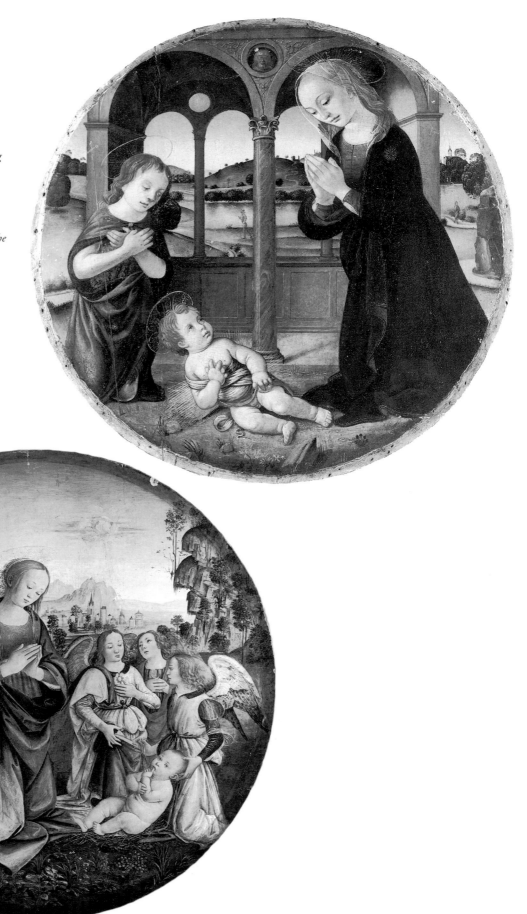

FIG. A4 (*right*). Biagio d'Antonio, *Madonna and Young St John Adoring the Child in a Loggia*. Whereabouts unknown

FIG. A5 (*below*). Master of Santo Spirito/Giovanni Graffione, *Holy Family with the Madonna Adoring the Child with Three Angels*, 1490s. National Gallery, London

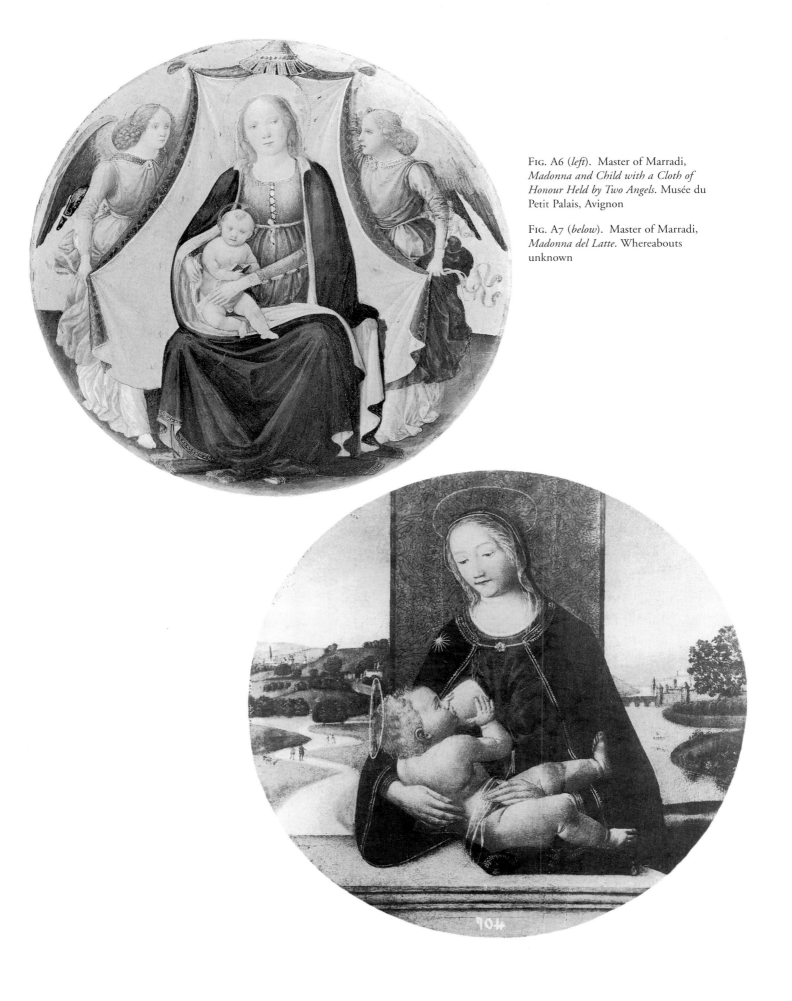

Fig. A6 (*left*). Master of Marradi, *Madonna and Child with a Cloth of Honour Held by Two Angels*. Musée du Petit Palais, Avignon

Fig. A7 (*below*). Master of Marradi, *Madonna del Latte*. Whereabouts unknown

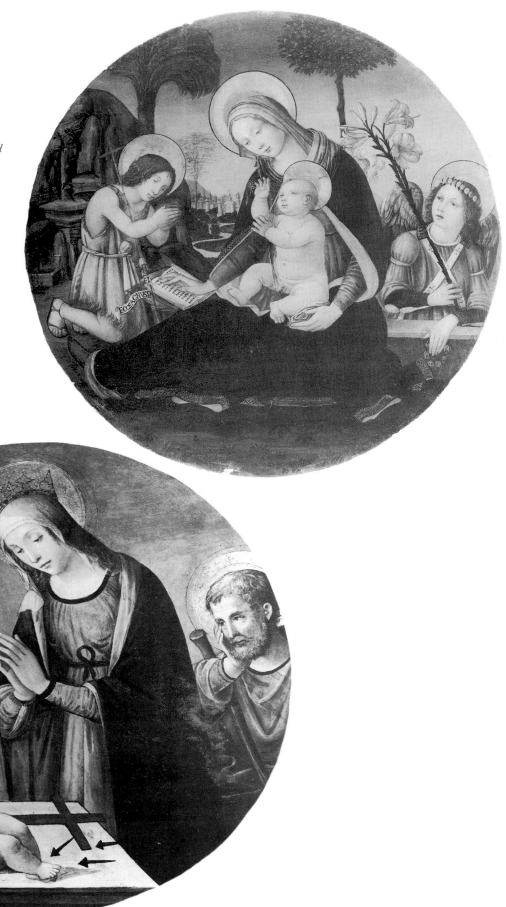

FIG. A8 (*right*). Master of Marradi,
*Madonna and Child with an Angel and
an Adoring Adolescent St John*.
Ashmolean Museum, Oxford

FIG. A9 (*below*). Master of Marradi,
*Holy Family with the Madonna and
Two Angels Adoring the Child*.
Whereabouts unknown

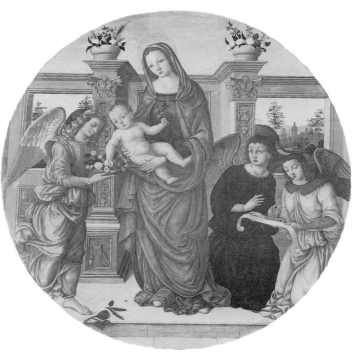

FIG. A10. Master of the Borghese Tondo, *Holy Family with the Madonna Adoring the Child, Young St John, and an Angelic Choir*. Whereabouts unknown

FIG. A11. Master of the Holden Tondo, *Standing Madonna and Child with Three Angels*, 1485–90s. The Courtauld Gallery, London

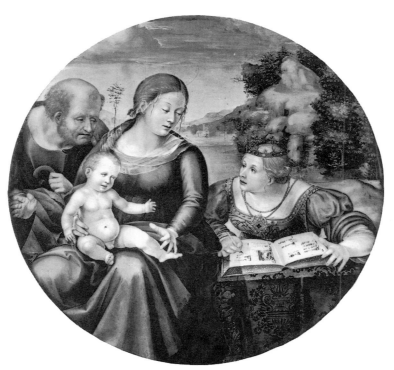

FIG. A12. Master of the Lathrop Tondo/Michelangelo di Pietro Mencherini, *Holy Family with St Catherine of Alexandria*, c.1503–4. Whereabouts unknown

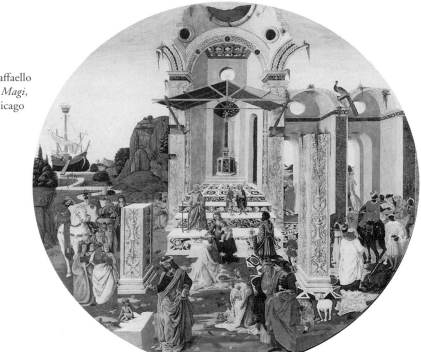

FIG. A13. Attributed to Raffaello Botticini, *Adoration of the Magi*, c.1495? Art Institute of Chicago

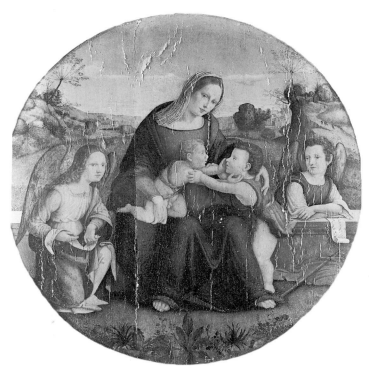

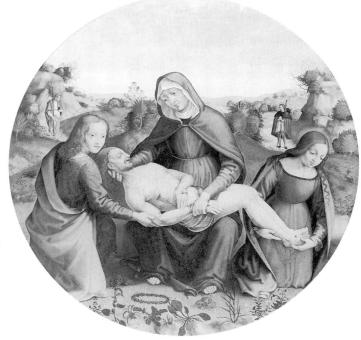

FIG. A14. Workshop of Raffaello Botticini (with Giuliano Bugiardini?), *Madonna and Child with Young St John and Two Angels with Musical Scrolls*. Whereabouts unknown

FIG. A15. Raffaello Botticini, *Lamentation with the Madonna, St John the Disciple, and St Mary Magdalene*, after 1504. Christ Church Picture Gallery, Oxford

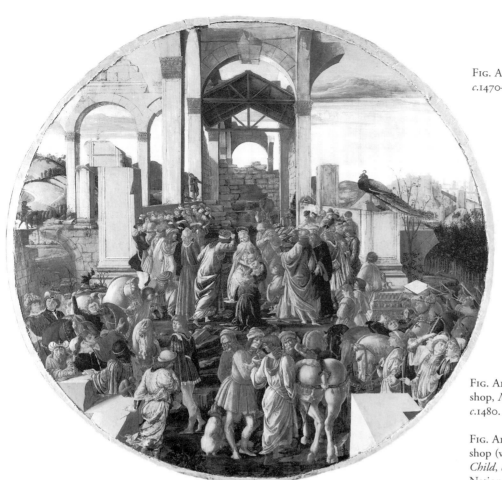

FIG. A16. Sandro Botticelli, *Adoration of the Magi*, c.1470–5. National Gallery, London

FIG. A17 (*below, left*). Sandro Botticelli and Workshop, *Madonna and Young St John Adoring the Child*, c.1480. Museo Civico, Piacenza

FIG. A18 (*below, right*). Sandro Botticelli and Workshop (with Jacopo del Sellaio?), *Madonna Adoring the Child*, c.1481–90. Samuel H. Kress Collection, National Gallery of Art, Washington, DC

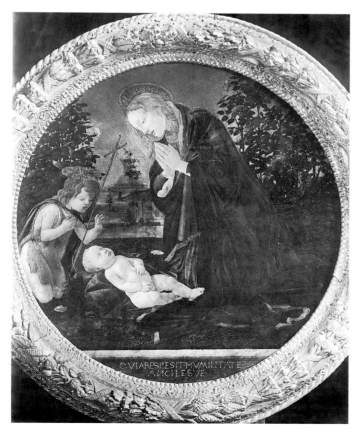

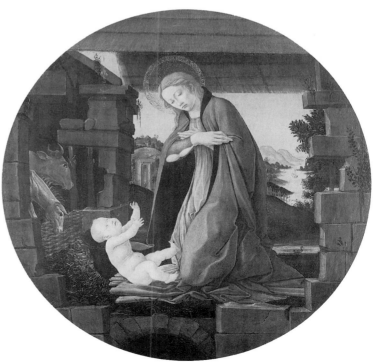

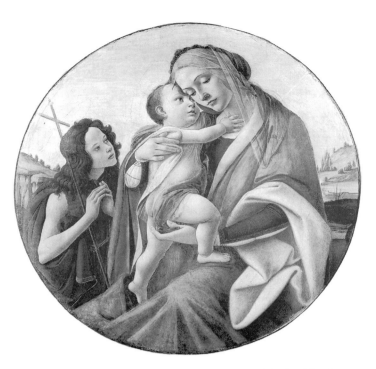

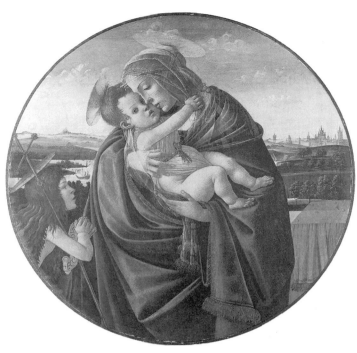

Fig. A19. Workshop of Botticelli, *Madonna and Child Adored by Young St John*, c.1488–90. Cleveland Museum of Art

Fig. A20. Workshop of Botticelli, *Standing Madonna Holding the Child Adored by Young St John*, c.1490. Sterling and Francine Clark Art Institute, Williamstown, Mass.

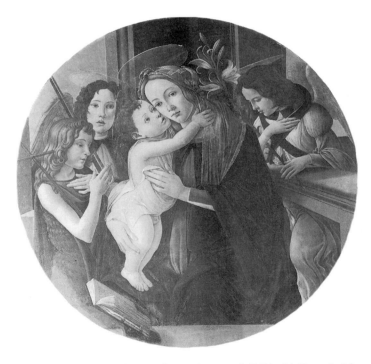

Fig. A21. Workshop of Botticelli, *Madonna and Child with Young St John and Two Angels (Michael and Gabriel)*, c.1490. Galleria Palatina di Palazzo Pitti, Florence

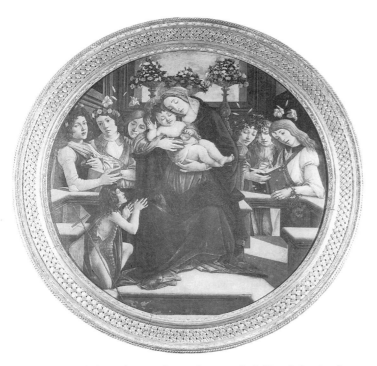

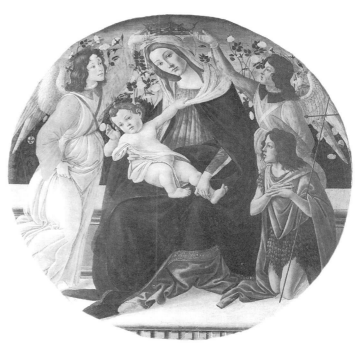

Fig. A22. Workshop of Botticelli, *Madonna and Child with Six Angels and Young St John*, c.1488–90. Galleria Borghese, Rome

Fig. A23. Workshop of Botticelli, *Madonna Crowned by Two Angels with the Child Adored by Young St John*, c.1490. Galleria Pallavicini, Rome

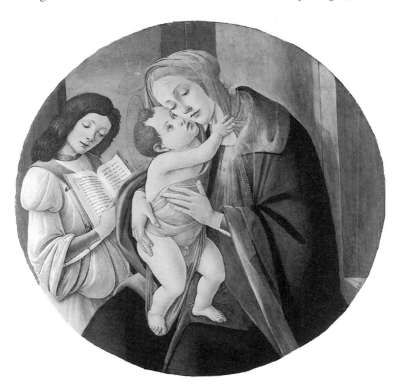

Fig. A24. Workshop of Botticelli, *Madonna and Child with an Angel Holding a Book with the 'Magnificat'*, 1490s. Bob Jones University Museum and Gallery, Greenville, SC

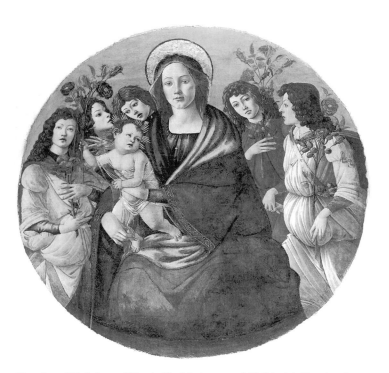

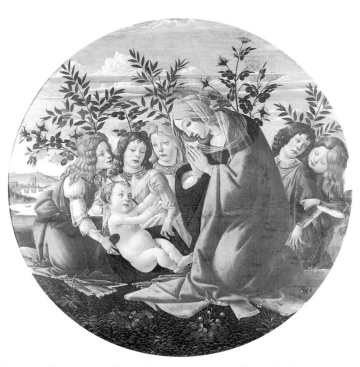

FIG. A25. Workshop of Botticelli, *Madonna and Child with Five Angels Holding Roses*, 1485–95. Gemäldegalerie, Dresden

FIG. A26. Workshop of Botticelli, *Madonna and Child with Five Angels Holding Roses and Olive Branches*, 1490s. Baltimore Museum of Art

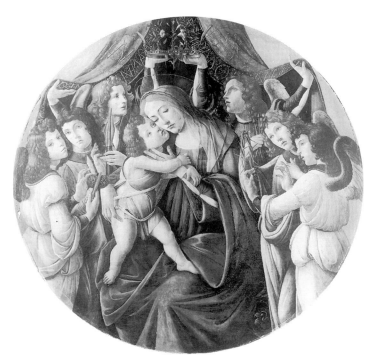

FIG. A27. Workshop of Botticelli, *Madonna and Child with Six Angels under a Baldacchino* (*Corsini Tondo*), c.1490. Galleria Corsini, Florence

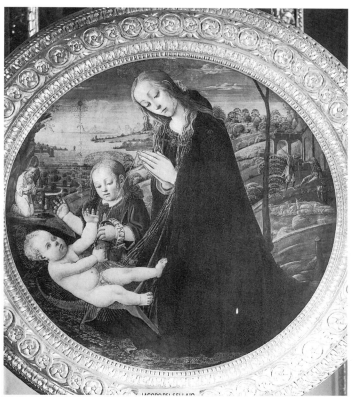

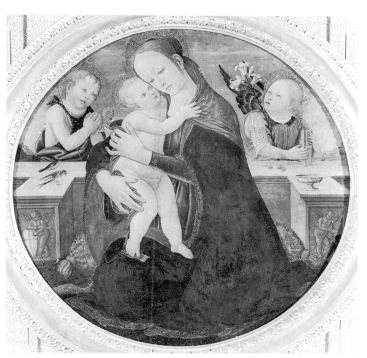

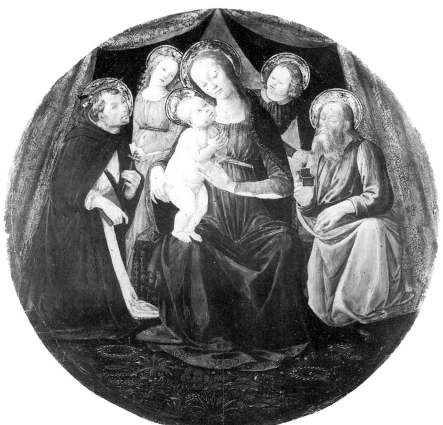

FIG. A28 (*above, left*). Jacopo del Sellaio, *Madonna Adoring the Child with Young St John*, 1473–80. Galleria Palatina di Palazzo Pitti, Florence

FIG. A29 (*above, right*). Jacopo del Sellaio, *Madonna and Child with Young St John and an Angel*, *c*.1480. Musée du Petit-Palais, Avignon

FIG. A30 (*left*). Jacopo del Sellaio, *Madonna and Child with Two Angels, St Peter Martyr, and Tobit*, *c*.1480. Museo del Bigallo, Florence

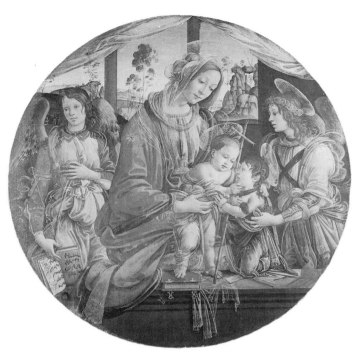

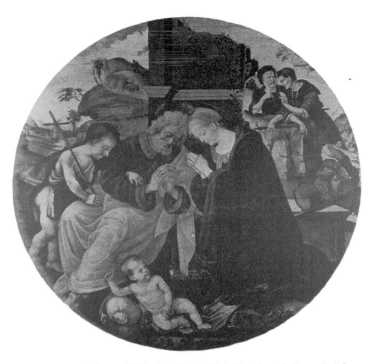

FIG. A31. Workshop of Filippino Lippi, *Madonna and Child with Young St John and Two Angels*. Glasgow Museums: Art Gallery and Museum, Kelvingrove

FIG. A32. Workshop of Filippino Lippi, *Holy Family with Young St John and Two Shepherds*. Whereabouts unknown

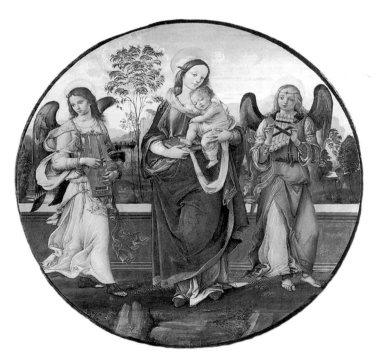

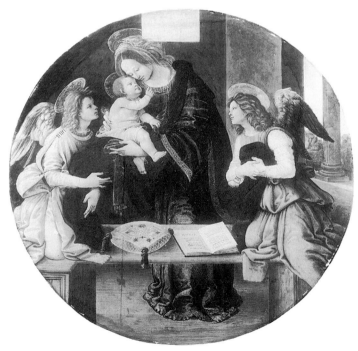

FIG. A33. Raffaellino del Garbo, *Standing Madonna and the Sleeping Child with Two Music-Playing Angels*, c.1495–9. Gemäldegalerie, Staatliche Museen zu Berlin—Preußischer Kulturbesitz

FIG. A34. Raffaellino del Garbo/Workshop of Filippino Lippi, *Madonna and Child with Two Angels*, 1490s. Formerly Kaiser Friedrich Museum, Berlin (destroyed)

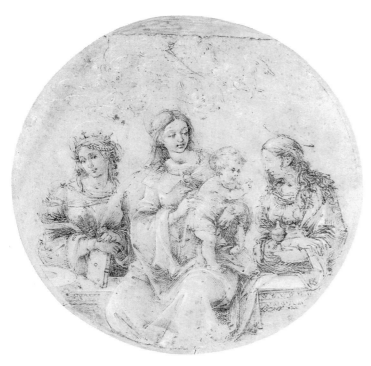

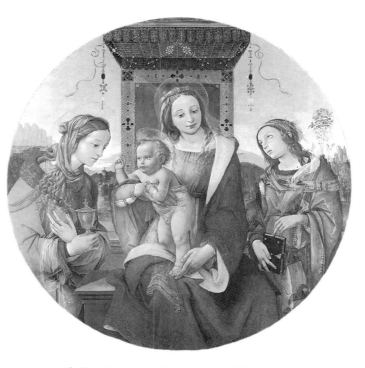

Fig. A35. Raffaellino del Garbo, *Drawing of the Madonna and Child with St Mary Magdalene and St Catherine of Alexandria*, 1495–1500. Christ Church Picture Gallery, Oxford

Fig. A36. Raffaellino del Garbo, *Madonna and Child Enthroned with St Mary Magdalene and St Catherine of Alexandria* (*Pucci Tondo*), c.1495–1500. National Gallery, London

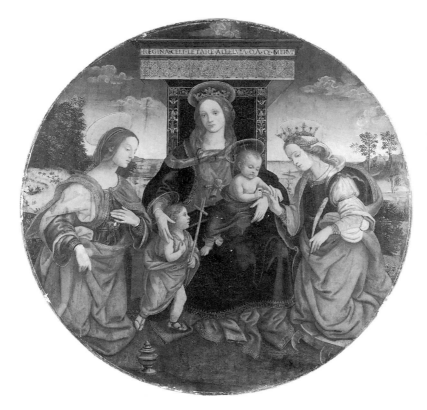

Fig. A37. Raffaellino del Garbo, *Madonna and Child Enthroned with the Mystical Marriage of St Catherine of Alexandria, Young St John, and St Mary Magdalene*, 1495–1500. Fogg Art Museum, Harvard University, Cambridge, Mass.

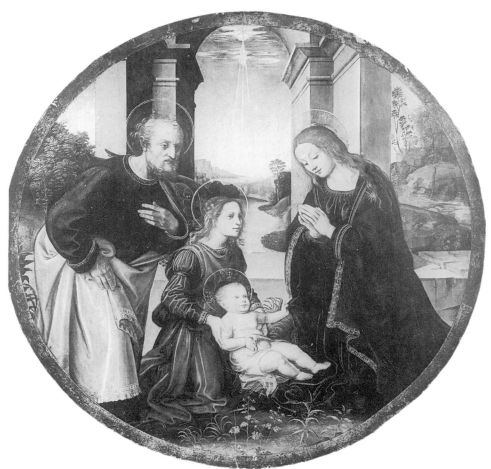

Fig. A38 (*left*). Raffaellino del Garbo and Assistant, *Holy Family with the Madonna Adoring the Child Held by an Angel*, *c*.1505–10. Museum of Fine Arts, Budapest

Fig. A39 (*below, left*). Attributed to Raffaellino del Garbo, *Madonna and Child with Young St John and an Angel*, *c*.1500–5. Whereabouts unknown

Fig. A40 (*below, right*). Master of the Naumberg Madonna, *Madonna and Child*. Whereabouts unknown

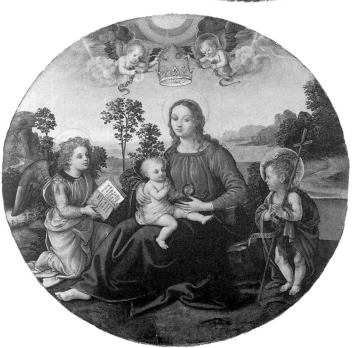

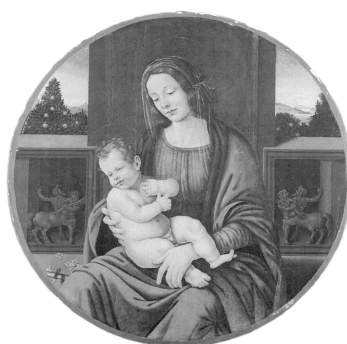

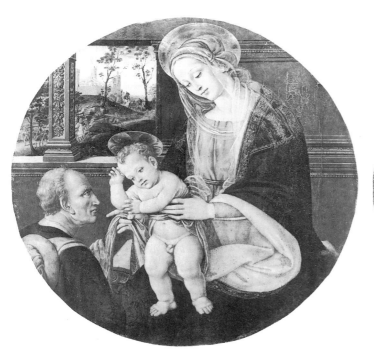

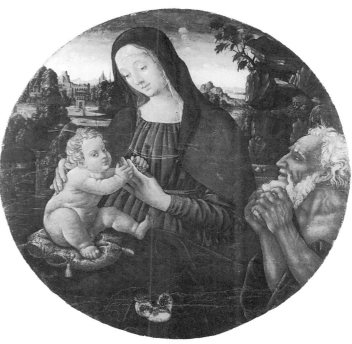

FIG. A41. Circle of Raffaellino del Garbo or the Master of San Filippo (?), *Madonna and Child Adored by a Kneeling Donor*, 1490–1500. Whereabouts unknown

FIG. A42. Circle of Raffaellino del Garbo or the Master of San Filippo (?), *Madonna and Child Adored by St Jerome*. Wawel Castle, Cracow

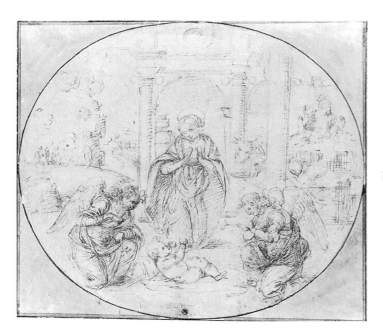

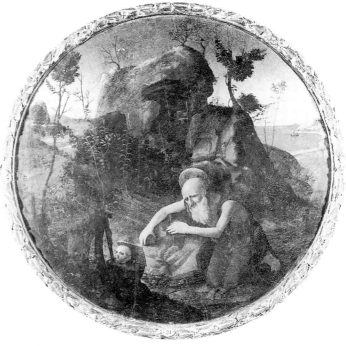

FIG. A43. Piero di Cosimo, *Drawing of the Madonna and Two Angels Adoring the Child*, c.1500. Graphische Sammlung Albertina, Vienna

FIG. A44. Piero di Cosimo, *St Jerome in the Wilderness*, c.1490–1500. Museo Horne, Florence

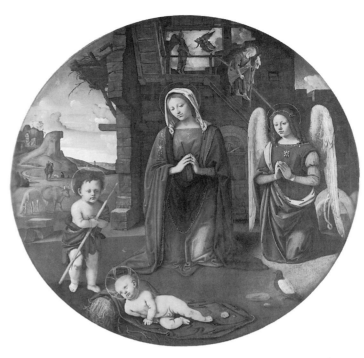

FIG. A45. Piero di Cosimo, *Madonna and Child with Young St John and an Angel*, c.1497–1507. Museu de Arte, São Paulo

FIG. A46. Piero di Cosimo, *Madonna, Young St John, and an Angel Adoring the Child*, 1495–1505. Samuel H. Kress Collection, National Gallery of Art, Washington, DC

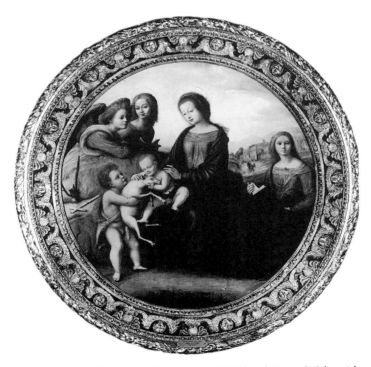

FIG. A47. Piero di Cosimo, *Madonna and Child with Young St John with a Lamb, St Margaret, and Two Angels*, c.1515–20. Philbrook Museum of Art, Tulsa

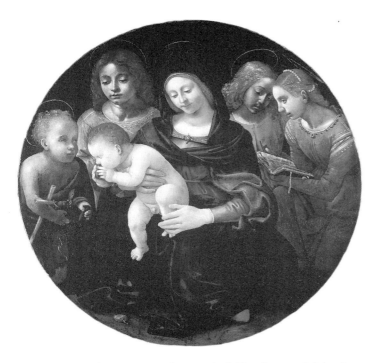

FIG. A48. Piero di Cosimo, *Madonna and Child with Young St John, St Cecilia, and Two Angels, c.*1495–1510. Private collection

FIG. A49. Workshop of Piero di Cosimo, *Madonna and Young St John Adoring the Child with Two Angels with Pipes, c.*1510. Hermitage, St Petersburg

FIG. A50. Piero di Cosimo and Workshop, *Adam and Eve: The Forefathers, c.*1505–15. Galleria Luigi Bellini, Florence

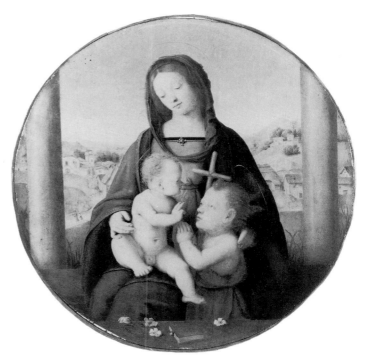

FIG. A51. Master of Serumido, *Madonna and Child Adored by Young St John, c.*1510–20. Whereabouts unknown

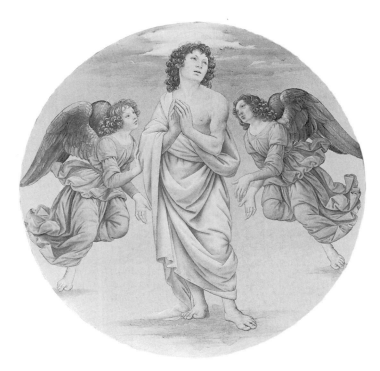

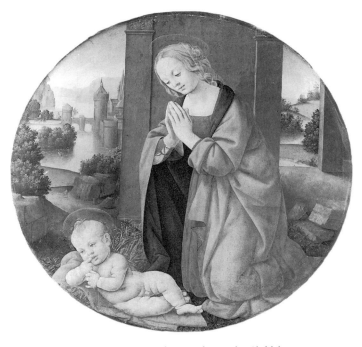

Fig. A52. Lorenzo di Credi, *Ascension of a Young Saint (St Louis of Toulouse?) between Two Angels*, *c*.1485. Huntington Art Gallery, San Marino, Calif.

Fig. A53. Lorenzo di Credi, *Madonna Adoring the Child*, late 1480s. Gemäldegalerie, Staatliche Museen zu Berlin — Preußischer Kulturbesitz

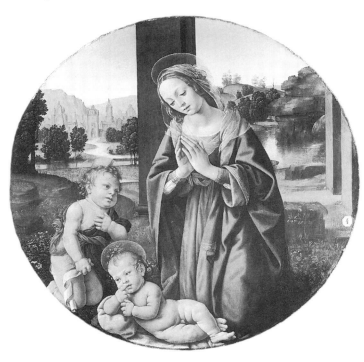

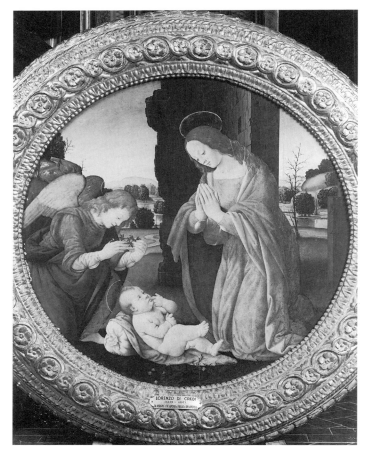

Fig. A54. Lorenzo di Credi, *Madonna and Child with Young St John*, *c*.1490. Galleria della Fondazione Querini Stampalia, Venice

Fig. A55. Lorenzo di Credi and Workshop, *Madonna Adoring the Child Crowned by an Angel*, *c*.1500–5. Galleria degli Uffizi, Florence

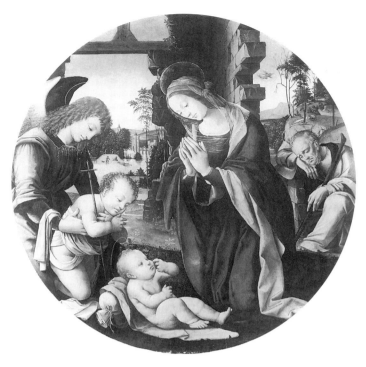

FIG. A56. Lorenzo di Credi and Workshop, *Holy Family with Young St John Held up by an Angel*, 1495. Galleria degli Uffizi, Florence (on deposit Museo Horne, Florence)

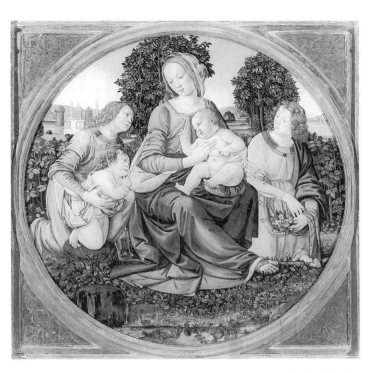

FIG. A57. Lorenzo di Credi Workshop, *Madonna and Child Adored by the Infant St John and Two Angels*, c.1490. The Joslyn Art Museum, Omaha, Nebr.

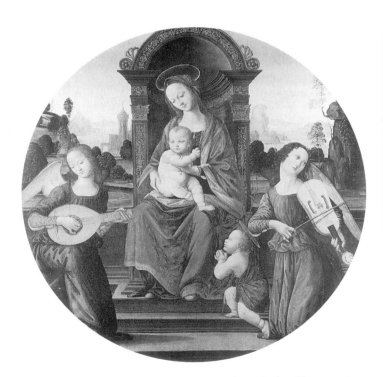

FIG. A58. Tommaso, *Madonna and Child Enthroned Adored by Young St John and Two Music-Playing Angels*. Hermitage, St Petersburg

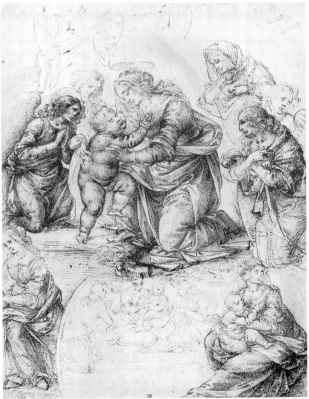

FIG. A59. Follower of Lorenzo di Credi ('The Master of the London Madonna Studies'), *Studies for Tondi*. British Museum, London

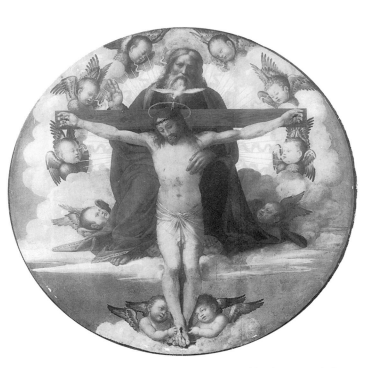

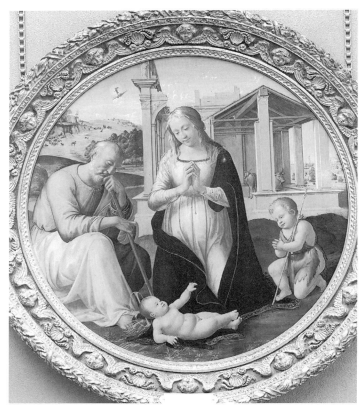

FIG. A60. Francesco Granacci, *Trinity*, c.1515. Gemäldegalerie, Staatliche Museen zu Berlin—Preußischer Kulturbesitz

FIG. A61. Francesco Granacci, *Holy Family with the Madonna and Young St John Adoring the Child*, c.1500. Honolulu Academy of Arts, Hawaii

FIG. A62. Florentine School, formerly F. Granacci, *Madonna and Child*. Whereabouts unknown

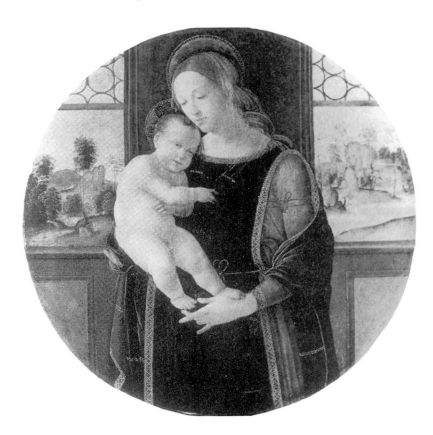

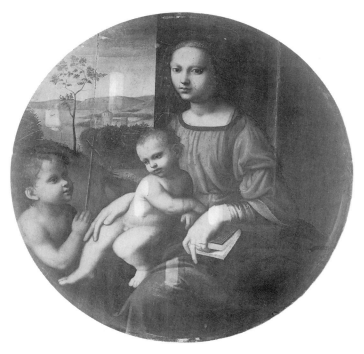

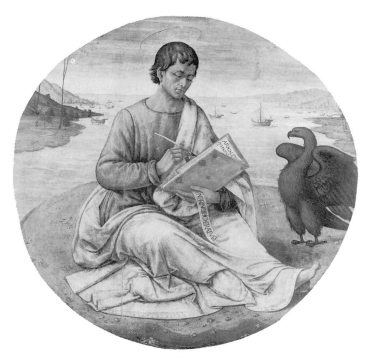

FIG. A63. Florentine School, formerly F. Granacci, *Madonna and Child Adored by the Young St John*, *c.*1510. Museum of Fine Arts, Budapest

FIG. A64. Domenico Ghirlandaio Workshop, formerly F. Granacci, *St John the Evangelist on Patmos with his Eagle*, *c.*1502–3. Museum of Fine Arts, Budapest

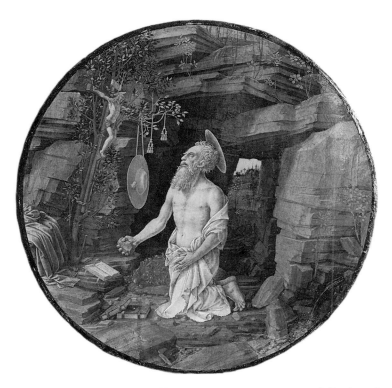

FIG. A65. Francesco Granacci (?), *St Jerome in Penitence*, *c.*1490. Collection of the Marquess of Bath, Longleat, Wiltshire

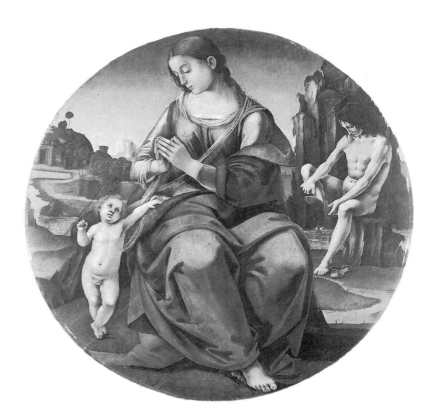

Fɪɢ. A66 (*right*). Luca Signorelli, *Madonna Adoring the Child with a Nude Youth (Munich Tondo)*, 1488–90. Alte Pinakothek, Munich

Fɪɢ. A67 (*below, left*). Luca Signorelli, *Madonna and Child with St Jerome and St Bernard (Corsini Tondo)*, 1490–1500. Galleria Corsini, Florence

Fɪɢ. A68 (*below, right*). Luca Signorelli and Workshop, *Holy Family with a Female Saint (Catherine?) Writing (Pitti Tondo)*, c.1495. Galleria Palatina di Palazzo Pitti, Florence

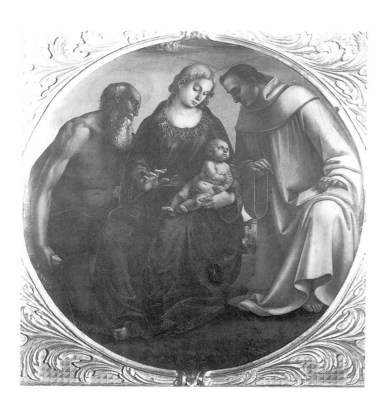

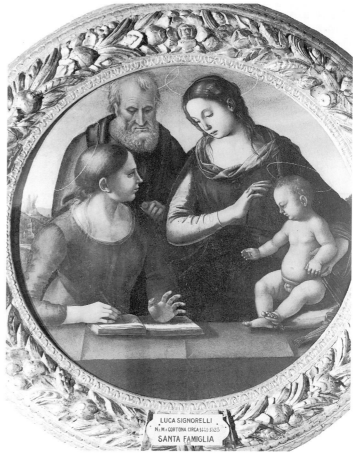

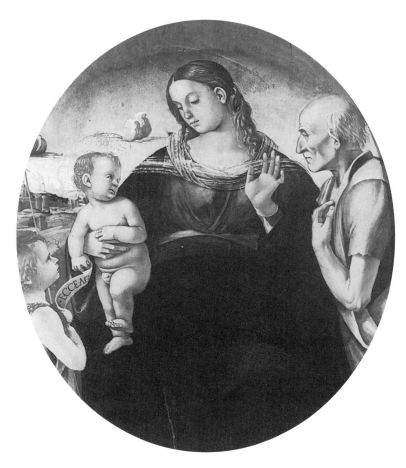

Fig. A69 (*left*). Luca Signorelli and Workshop, *Madonna and Child with Young St John and a Shepherd*, *c*.1490–5. Musée Jacquemart-André, Paris

Fig. A70 (*below*, *left*). Luca Signorelli and Workshop, *Holy Family with St Antony of Padua and St Bernard*. Whereabouts unknown

Fig. A71 (*below*, *right*). Signorelli Workshop (perhaps with Francesco Signorelli), *Sacra Conversazione* (*Prato Tondo*), 1510–20. Museo Civico, Prato

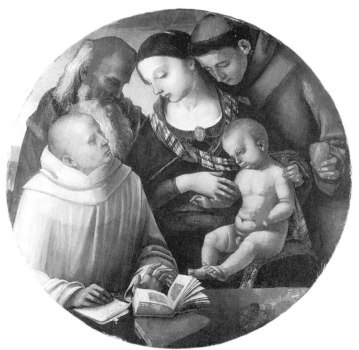

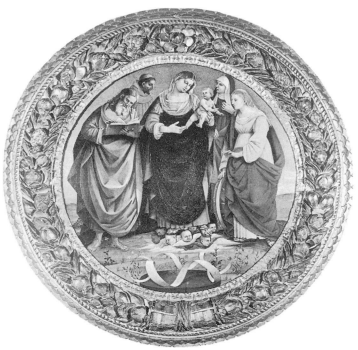

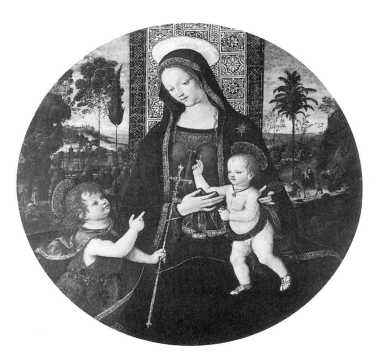

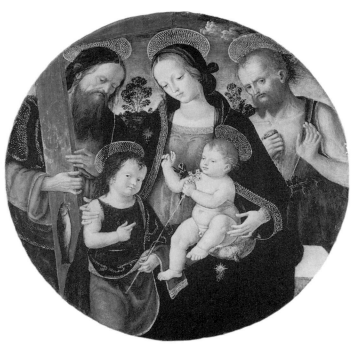

Fig. A72. Bernardino Pintoricchio, *Madonna and Child with Young St John and Scenes of the Flight into Egypt and the Journey of the Magi*, *c.*1480s. Museo Poldi Pezzoli, Milan

Fig. A73. Bernardino Pintoricchio and Workshop, *Madonna and Child with Young St John, St Andrew, and St Jerome*, after 1490. Davis Museum, Wellesley College, Wellesley, Mass.

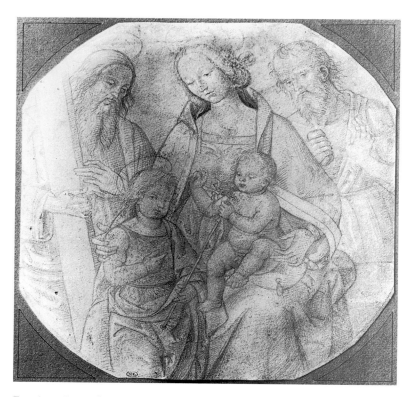

Fig. A74. Bernardino Pintoricchio Workshop, *Drawing for a Tondo*. Département des Arts Graphiques, Musée du Louvre, Paris

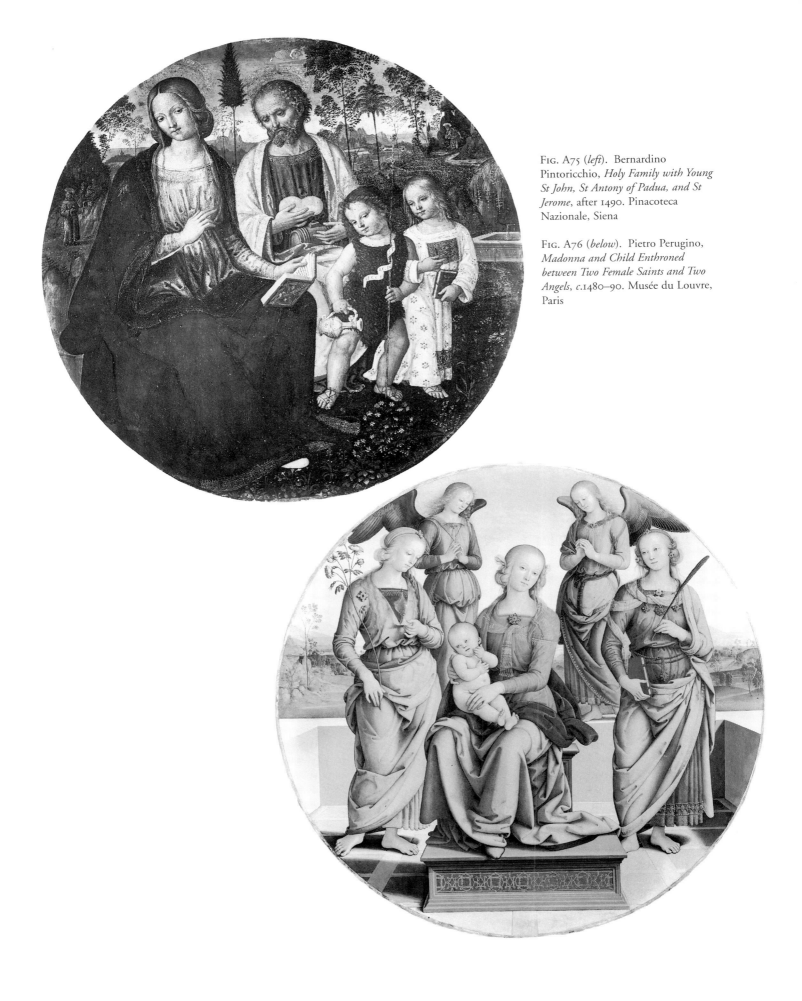

FIG. A75 (*left*). Bernardino
Pintoricchio, *Holy Family with Young
St John, St Antony of Padua, and St
Jerome*, after 1490. Pinacoteca
Nazionale, Siena

FIG. A76 (*below*). Pietro Perugino,
*Madonna and Child Enthroned
between Two Female Saints and Two
Angels*, c.1480–90. Musée du Louvre,
Paris

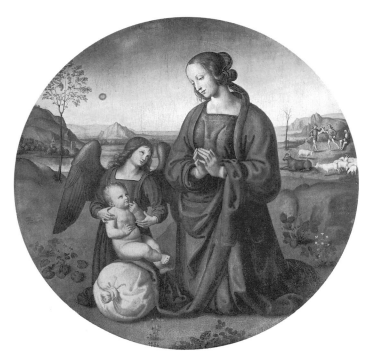

FIG. A77. Pietro Perugino and Workshop, *Madonna del Sacco*, *c*.1495–1500. Collections of the Prince of Liechtenstein, Vaduz Castle

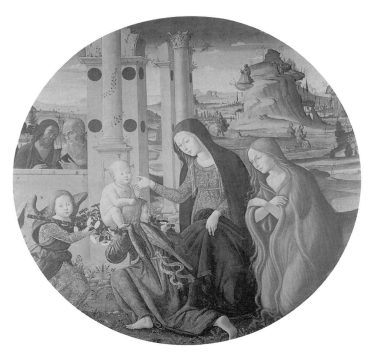

FIG. A78. Bernardino Fungai, *Madonna and Child with St Mary of Egypt, Two Angels, and Two Male Saints*, 1505–15. Lowe Art Museum, University of Miami, Coral Gables, Fla.

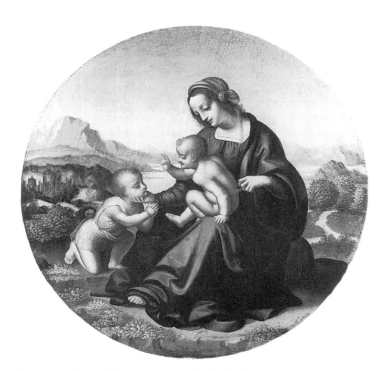

FIG. A79. Marco d'Oggiono (after a design by Leonardo?, *c*.1501–8), *Madonna of the Lake*, *c*.1519. Bob Jones University Museum and Art Gallery, Greenville, SC

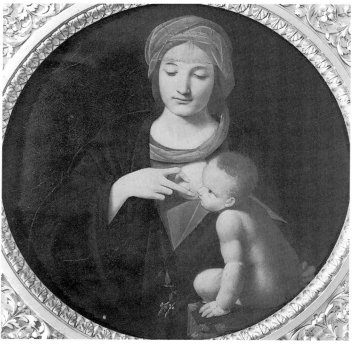

FIG. A80. Giovanni Antonio Boltraffio, *Madonna del Latte*, *c*.1520. Accademia Carrara, Bergamo

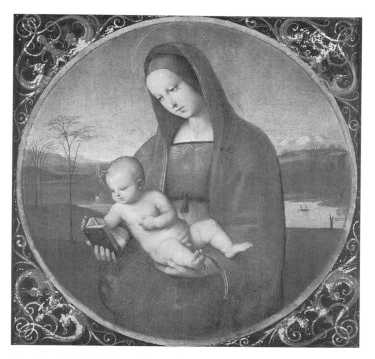

FIG. A81. Raphael, *Conestabile Madonna, c.*1503–4. Hermitage,
St Petersburg

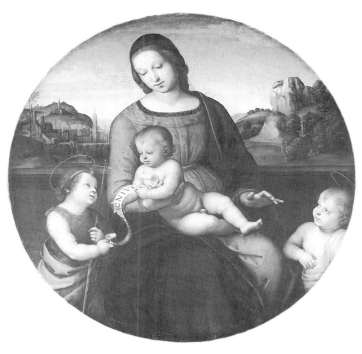

FIG. A82. Raphael, *Madonna Terranuova,* 1504–6. Gemäldegalerie,
Staatliche Museen zu Berlin — Preußischer Kulturbesitz

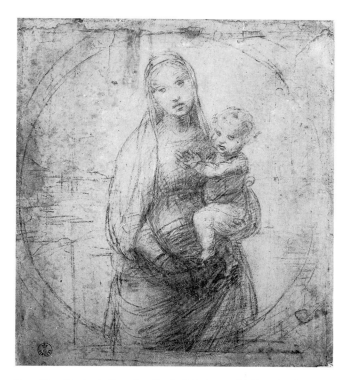

FIG. A83. Raphael, *Drawing for the 'Madonna del Granduca',*
1505–6. Gabinetto Disegni e Stampe degli Uffizi, Florence

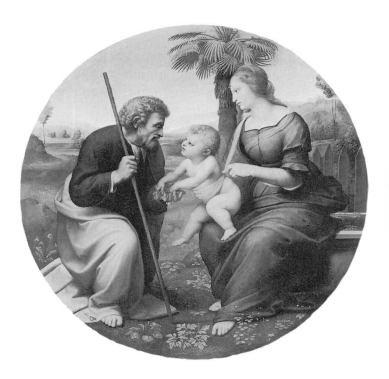

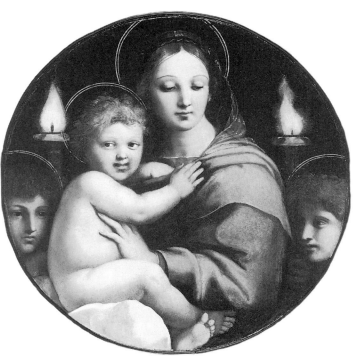

FIG. A84. Raphael, *Holy Family of the Palm*, 1506–8. Duke of Sutherland Collection, on loan to the National Gallery of Scotland, Edinburgh

FIG. A86. Raphael and Assistant, *Madonna of the Candelabra*, 1513–15. Walters Art Gallery, Baltimore

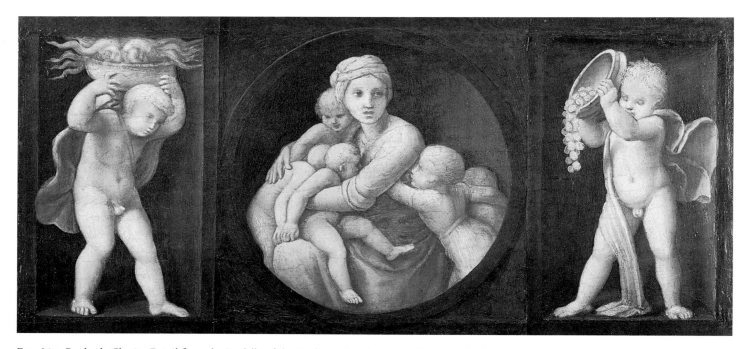

FIG. A85. Raphael, *Charity*, Detail from the Predella of the *Baglioni Altarpiece*, 1507. Pinacoteca Vaticana

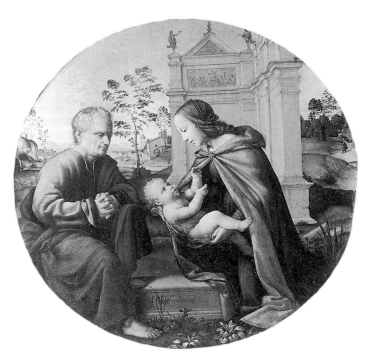

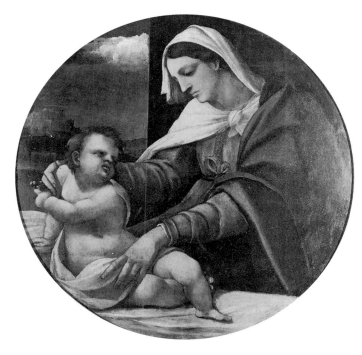

Fig. A87. Francesco Penni (Giovanni Sogliani?), *Holy Family*, 1522. Whereabouts unknown

Fig. A88. Sebastiano del Piombo, *Madonna and Child*, c.1513–20. Pouncey Collection, London

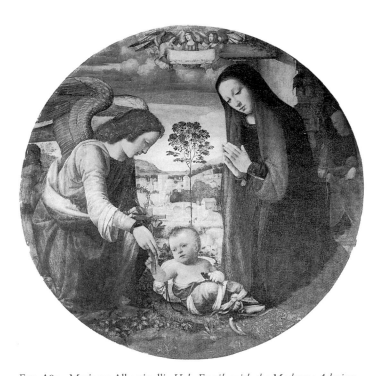

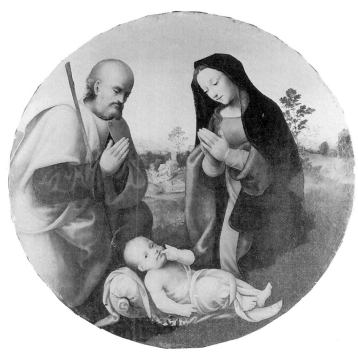

Fig. A89. Mariotto Albertinelli, *Holy Family with the Madonna Adoring the Child and an Angel*, c.1500–3. Galleria Palatina di Palazzo Pitti, Florence

Fig. A90. Mariotto Albertinelli, *Holy Family with the Adoration of the Child*, c.1505–8. Altomani Collection, Pesaro

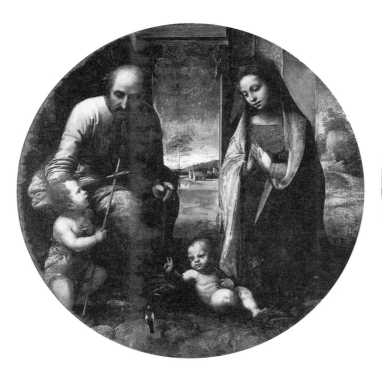 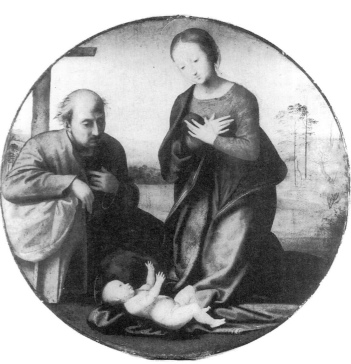

FIG. A91. Mariotto Albertinelli and Fra Bartolomeo, *Holy Family with the Madonna Adoring the Child and Young St John*, c.1509–10. John and Mable Ringling Museum of Art, Sarasota, Fla.

FIG. A92. Fra Bartolomeo, *Holy Family with the Adoration of the Child*, c.1504–6. Museo Poldi Pezzoli, Milan

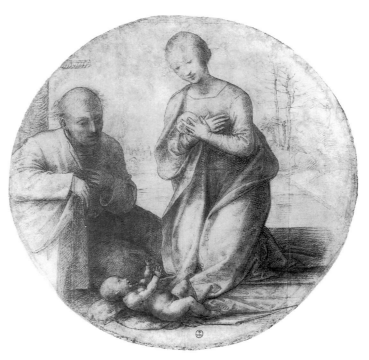

FIG. A93. Fra Bartolomeo, *Preparatory cartoon for the 'Holy Family with the Adoration of the Child'*, c.1504–6. Gabinetto Disegni e Stampe degli Uffizi, Florence

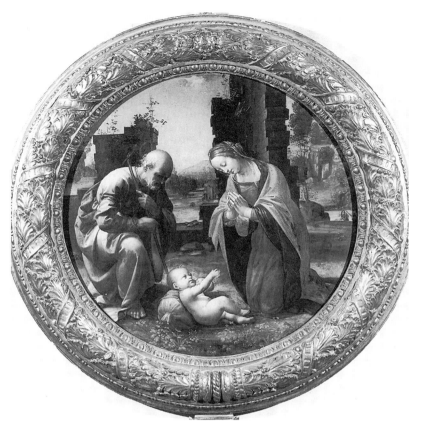

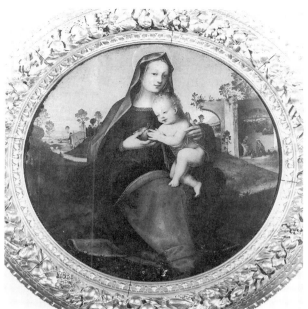

Fig. A94 (*above, left*). Fra Bartolomeo,
Borghese Tondo, c.1495–1500. Galleria
Borghese, Rome

Fig. A95 (*above, right*). Circle of Fra
Bartolomeo and Mariotto Albertinelli,
Madonna and Child with the Nativity,
1505–10. Private collection

Fig. A96 (*left*). Fra Bartolomeo, *Drawing of
the Madonna and Child with Five Kneeling
Angels and Young St John*, c.1504–5.
Collection of H. M. Queen Elizabeth II

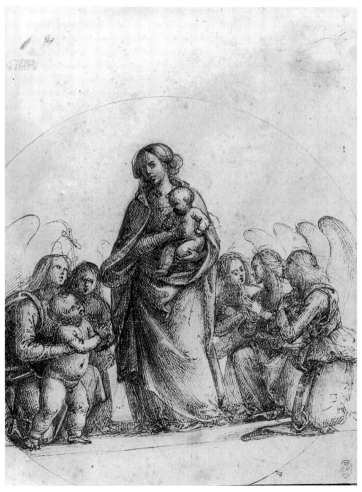

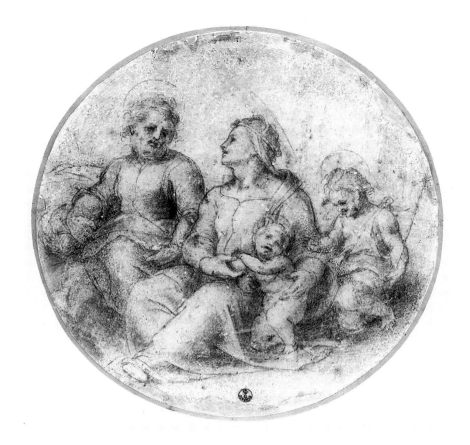

FIG. A97. Andrea del
Sarto, *Holy Family with
Young St John*, *c*.1509–11.
Gabinetto Disegni e
Stampe degli Uffizi,
Florence

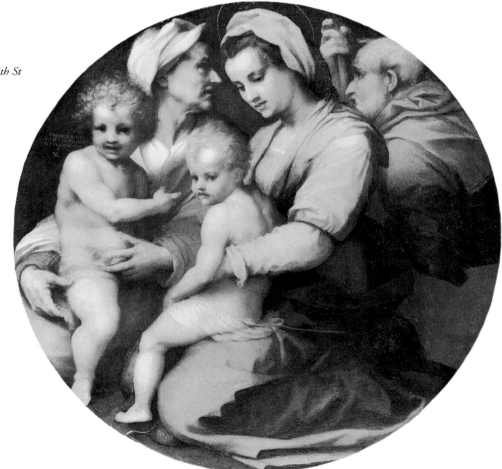

FIG. A98. Andrea del
Sarto, *Holy Family with St
John and St Elizabeth*
(*Barbadori Tondo*),
c.1516–17. Musée du
Louvre, Paris

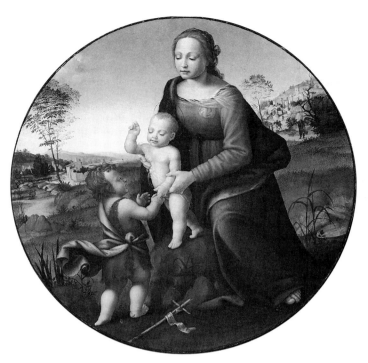

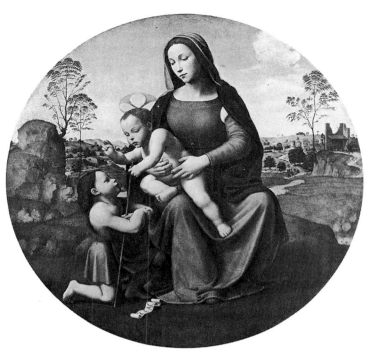

Fig. A99. Giuliano Bugiardini, *Madonna and Child Blessing Young St John*, c.1520. Indianapolis Museum of Art

Fig. A100. Giuliano Bugiardini, *Madonna and Child Blessing Young St John*, 1507–12. Nelson–Atkins Museum of Art, Kansas City, Mo.

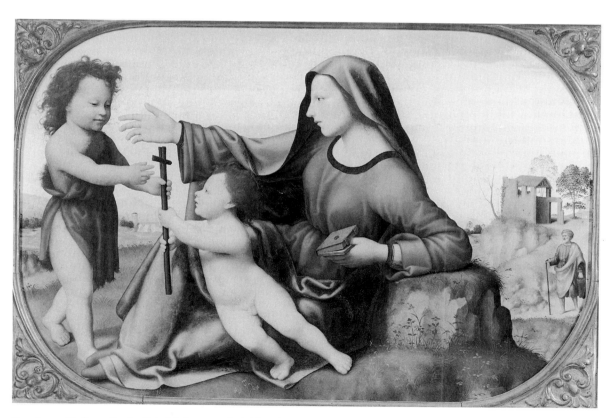

Fig. A101. Giuliano Bugiardini, *Madonna and Child with Young St John*, 1508–12. The Nivaagaard Picture Gallery, Denmark

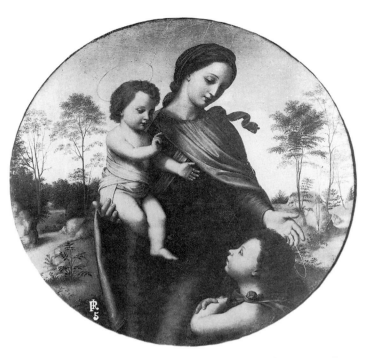

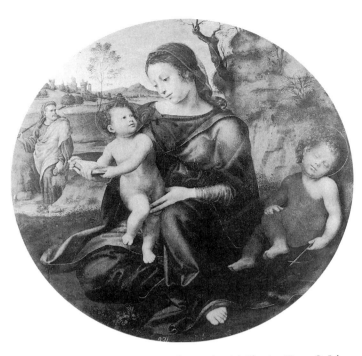

FIG. A102. Giuliano Bugiardini, *Madonna and Child Blessing Young St John*. Private collection, Florence

FIG. A103. Giuliano Bugiardini, *Holy Family with Sleeping Young St John*, *c.*1515. Hermitage, St Petersburg

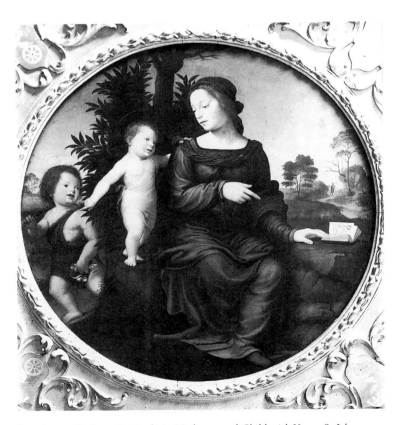

FIG. A104. Giuliano Bugiardini, *Madonna and Child with Young St John*. Pinacoteca Nazionale, Bologna

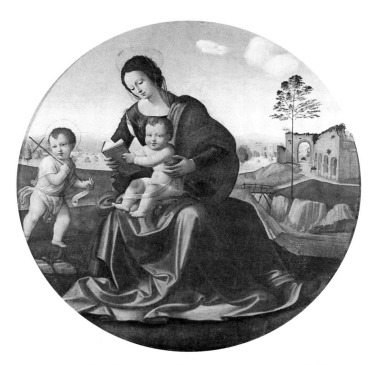

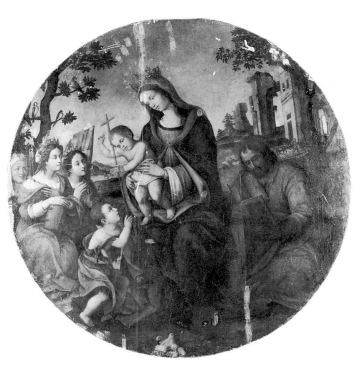

Fig. A105. Attributed to Giuliano Bugiardini, *Madonna and Child with Young St John* (*Rothermere Tondo*), *c.*1503–4. University Catholic Chaplaincy, Oxford

Fig. A106. Attributed to the Circle of Giuliano Bugiardini or Florentine School, *Holy Family with Young St John and Three Female Saints.* Martin von Wagner-Museum der Universität and Mainfränkisches Museum, Würzburg

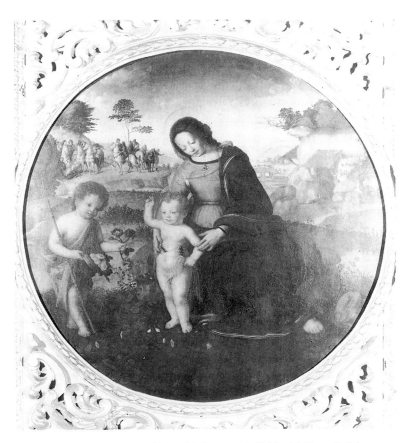

Fig. A107. Francesco Franciabigio, *Madonna and Child with Young St John*, *c.*1505–6. Galleria della Accademia, Florence

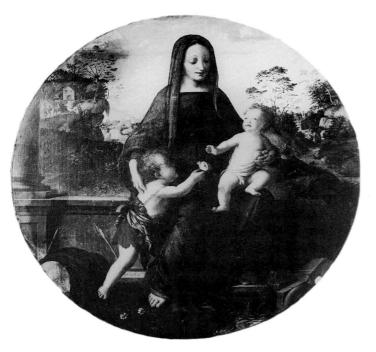

FIG. A108. Francesco Franciabigio, *Madonna and Child with Young St John*, *c*.1506–7. Ranieri Collection, Perugia

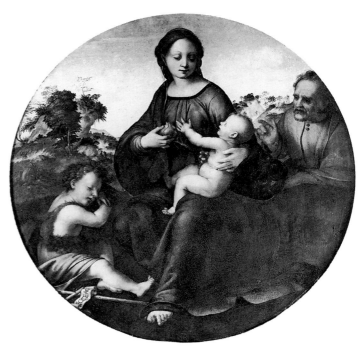

FIG. A109. Francesco Franciabigio, *Holy Family with Sleeping Young St John*, 1507–8. Galleria della Accademia, Florence

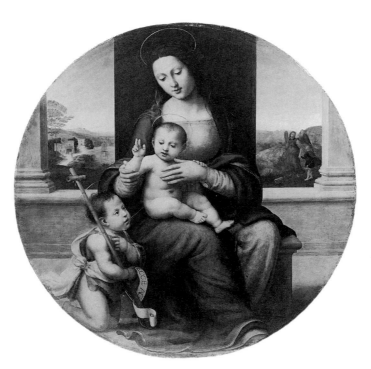

FIG. A110. Giovanni Sogliani, *Madonna and Child Blessing Young St John with a Scene with Tobias and the Angel*, *c*.1515. Walters Art Gallery, Baltimore

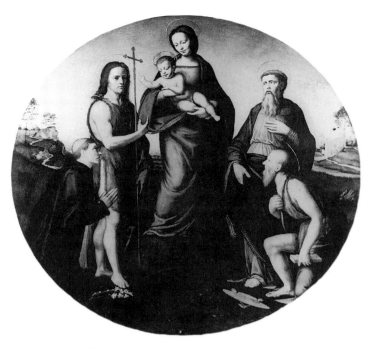

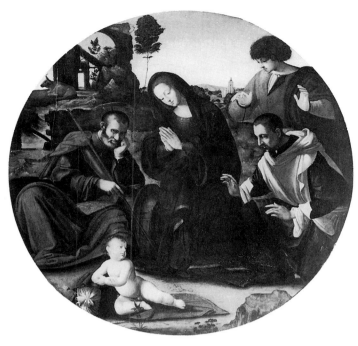

FIG. A111. Ridolfo Ghirlandaio (?), *Standing Madonna and Child with Saints John the Baptist, Dominic, Jerome, and an Unidentified Saint*, after 1506. Mint Museum of Art, Charlotte, NC

FIG. A112. Ridolfo Ghirlandaio, *Holy Family with the Madonna Adoring the Child and Two Shepherds/Donors (?)*, c.1505–10. Manchester City Art Galleries

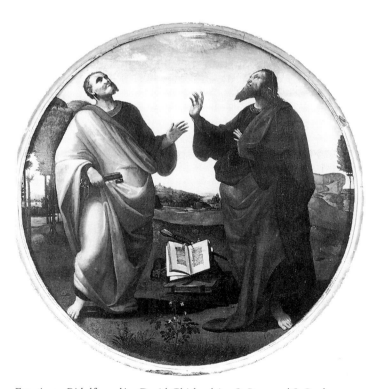

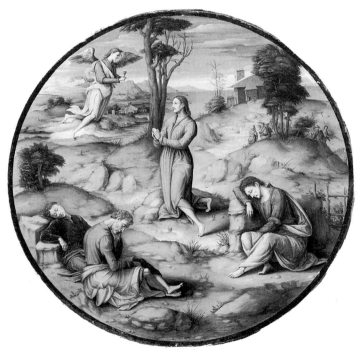

FIG. A113. Ridolfo and/or David Ghirlandaio, *St Peter and St Paul*, 1503. Galleria Palatina di Palazzo Pitti, Florence

FIG. A114. Bacchiacca, *Agony in the Garden*, c.1500. York City Art Gallery

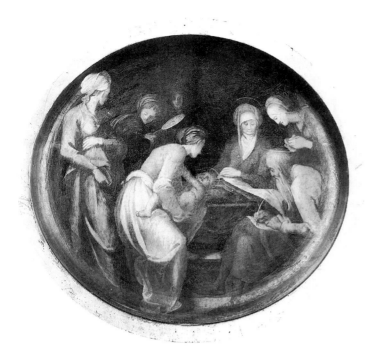

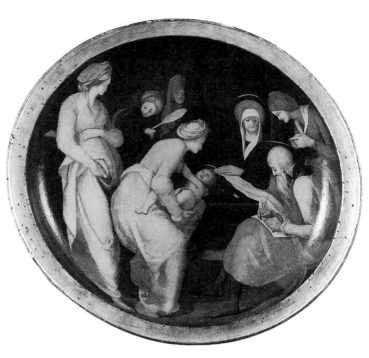

Fig. A115. Pontormo and Workshop (?), *Tafferia da parto* with the *Birth and Naming of St John the Baptist*, *c*.1526. Galleria degli Uffizi, Florence

Fig. A116. Pontormo Workshop, *Tafferia da parto* with the *Birth and Naming of St John the Baptist*, *c*.1526–8. Private collection, London

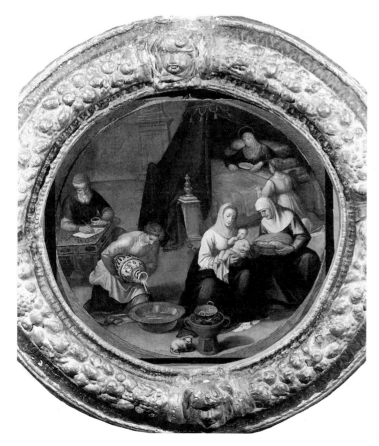

Fig. A117. Attributed to Maso di San Friano or Sienese School, *Desco da parto* with the *Birth and Naming of St John the Baptist*, *c*.1550. Private collection, Pordenone

Fig. A118. Pontormo, *Madonna and Child*, *c*.1525. Palazzo Capponi delle Rovinate, Florence

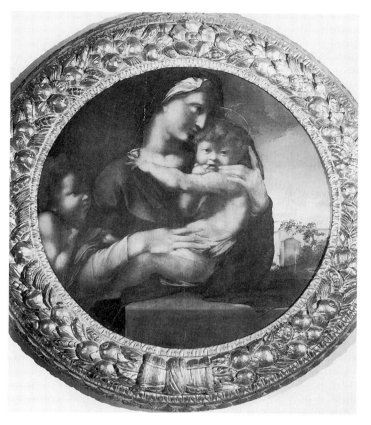

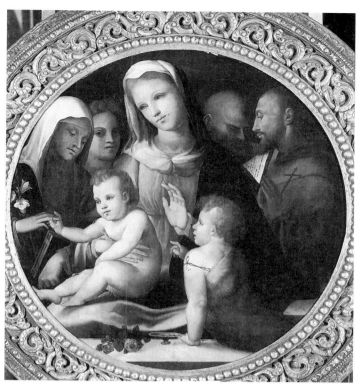

FIG. A119. Alonso Berruguete, *Madonna and Child with Young St John*, *c*.1514–15. The Loeser Collection, Palazzo Vecchio, Florence

FIG. A120. Domenico Beccafumi and Workshop, *Holy Family with the Mystic Marriage of St Catherine of Siena, St Francis, and an Angel (?)*, *c*.1530–5. Whereabouts unknown

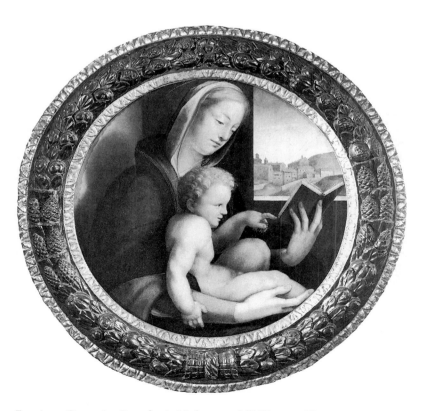

FIG. A121. Domenico Beccafumi, *Madonna and Child*, *c*.1514. Pinacoteca Nazionale, Siena

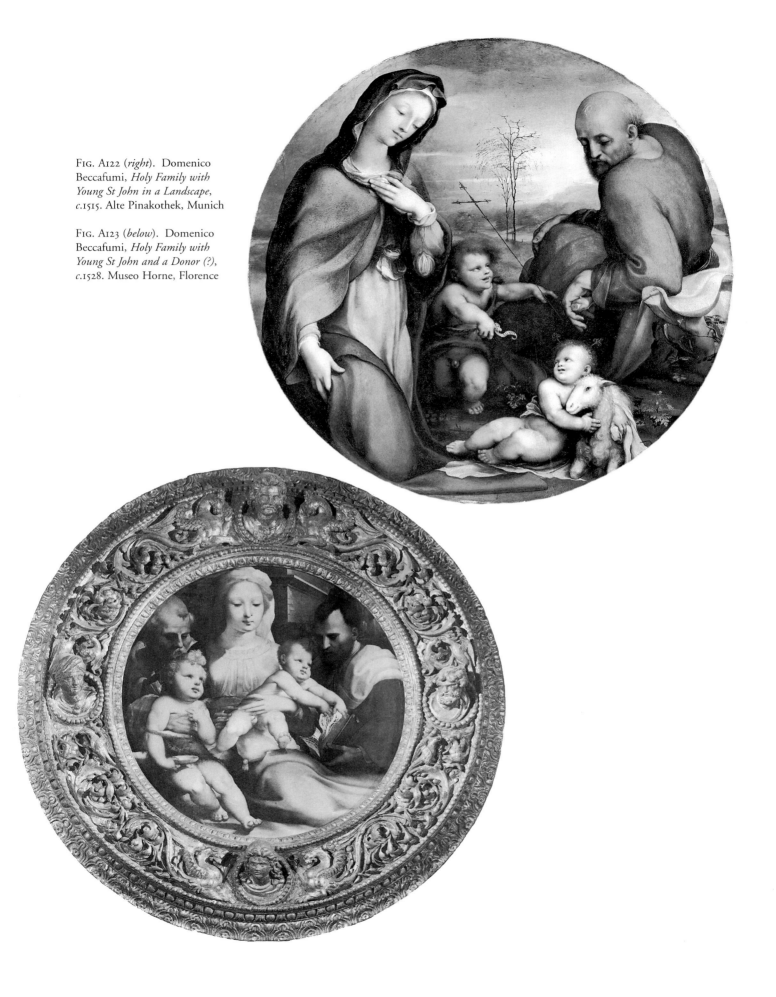

FIG. A122 (*right*). Domenico Beccafumi, *Holy Family with Young St John in a Landscape*, *c*.1515. Alte Pinakothek, Munich

FIG. A123 (*below*). Domenico Beccafumi, *Holy Family with Young St John and a Donor (?)*, *c*.1528. Museo Horne, Florence

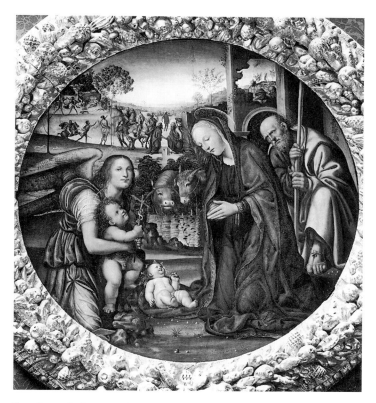

Fig. A124. Sodoma, *Holy Family with the Madonna Adoring the Child, an Angel, Young St John, and Episodes of the Nativity, c.1504–5.* Pinacoteca Nazionale, Siena

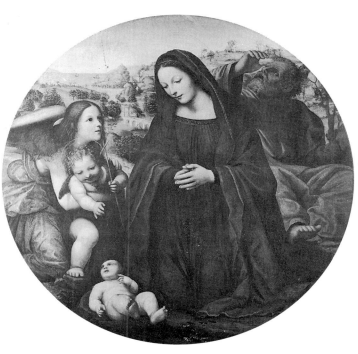

Fig. A125. Sodoma, *Holy Family with the Madonna Adoring the Child, an Angel, and Young St John, c.1505–10.* Museo Francesco Borgogna, Vercelli

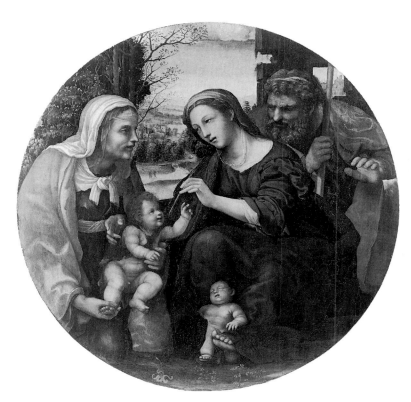

Fig. A126. Sodoma, *Holy Family with St Elizabeth and Young St John (Arduini Tondo), c.1532–6.* Walters Art Gallery, Baltimore

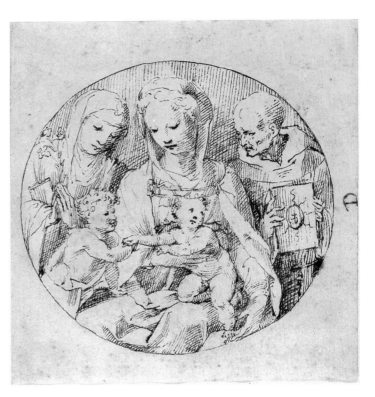

FIG. A127. Bartolomeo Neroni (Il Riccio), *Madonna and Child with St Bernardino and St Catherine of Siena*, after 1525. Bob Jones University Museum and Gallery, Greenville, SC

FIG. A128. Bartolomeo Neroni (Il Riccio), *Drawing for a Tondo of the Madonna and Child with Young St John, St Catherine of Siena, and St Bernardino*. Istituto Nazionale per la Grafica, Rome

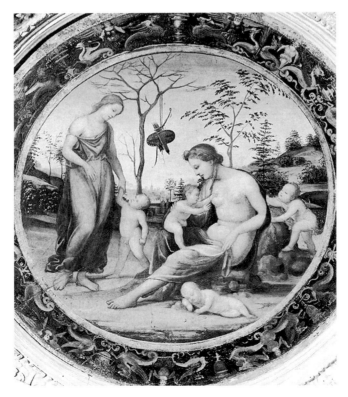

FIG. A129. Sodoma, *Allegory: Love and Charity (?)*, c.1510–12. Musée du Louvre, Paris

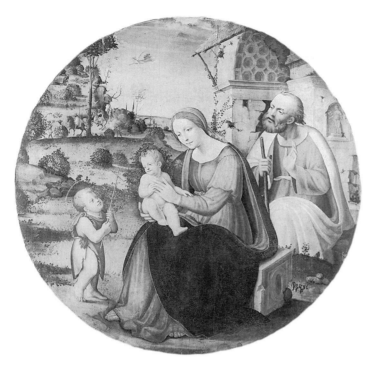

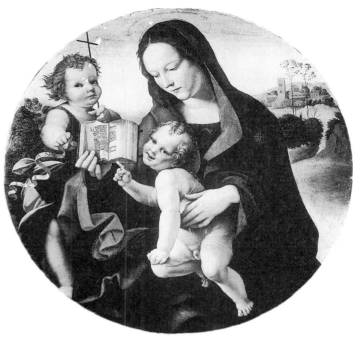

FIG. A130. Girolamo del Pacchia, *Holy Family with Young St John and Scenes of the Nativity*, before 1520. Ashmolean Museum, Oxford

FIG. A131. Girolamo del Pacchia, *Madonna and Child with Young St John*, *c.*1520. Galleria della Accademia, Florence

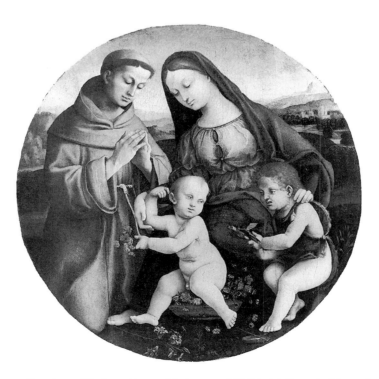

FIG. A132. Girolamo Genga, *Madonna and Child with Young St John and St Antony of Padua*, *c.*1510. Pinacoteca Nazionale, Siena

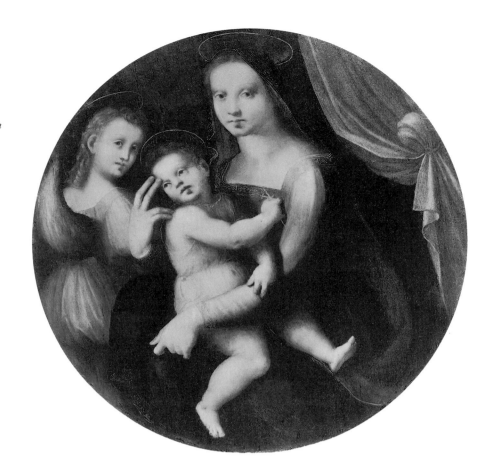

FIG. A133. Brescianino
(Andrea Piccinelli),
*Madonna and Child with an
Angel, c.1520.* St John's
Evangelical Lutheran
Church, Allentown, Pa.

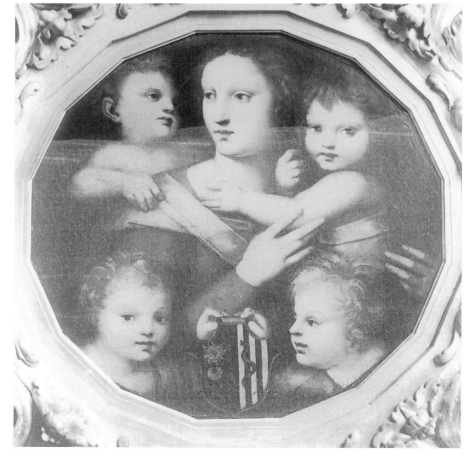

FIG. A134. Brescianino
(Andrea Piccinelli),
*Madonna and Child with
Young St John (?) and Two
Angels with an Escutcheon.*
Whereabouts unknown

BIBLIOGRAPHY

ACCADEMIA DELLA CRUSCA, *Vocabulario degli Accademici della Crusca* (Venice, 1612).

'Accessions by Purchase 1963–6', *The Cincinnati Art Museum Bulletin*, 8:2–3 (1968), 43.

ACKERMAN, J., *The Architecture of Michelangelo* (Chicago, 1986).

ADAMS, P. R., 'Fra Angelico's Virgin and Child', *Art News*, 65:8 (1966), 34–5, 76–7.

Aesop's Fables. English and Greek. The Medici Aesop: Spencer MS 50 from the Spencer Collection of the New York Public Library, trans. B. McTigue (New York, 1989).

AHL, D. C., *Benozzo Gozzoli* (New Haven and London, 1996).

—— 'Renaissance Birth Salvers and the Richmond Judgment of Solomon', *Studies in Iconography*, 7–8 (1981–2), 157–74.

AJMAR, M., and THORNTON, D., 'When is a Portrait not a Portrait? Belle Donne on Maiolica and the Renaissance Praise of Local Beauties', in N. Mann and L. Syson (eds.), *The Image of the Individual: Portraits in the Renaissance* (London, 1998), 138–53.

AINSWORTH, M. W., and MARTENS, M. P., *Petrus Christus: Renaissance Master of Bruges* (exh. cat., New York, 1994).

ALBERTI, L. B., *The Albertis of Florence: Leon Battista Alberti's Della Famiglia*, trans. G. A. Guarino (Lewisburg, Pa., 1971).

—— *L'Architettura/De Re Aedificatoria*, 2 vols., trans. G. Orlandi (Milan, 1966).

—— *The Family in Renaissance Florence*, trans. R. N. Watkins (Columbia, SC, 1969).

—— *On the Art of Building in Ten Books*, trans. J. Rykwert *et al.* (Cambridge, Mass., 1988).

—— *On Painting and On Sculpture*, ed. and trans. C. Grayson (London, 1972).

—— *Ten Books on Architecture (De re aedificatoria)*, trans. C. Bartoli and J. Leoni (London, 1955).

ALEXANDRE-BIDON, D., and RICHÉ, R., *L'Enfance au Moyen-Âge* (Paris, 1994).

ALLENEN, J. B., *Marsilio Ficino and the Phaedran Charioteer* (Berkeley, 1981).

AMES-LEWIS, F., *The Library and Manuscripts of Piero di Cosimo de' Medici* (New York and London, 1984).

—— (ed.), *Cosimo 'il Vecchio' de' Medici, 1389–1464: Essays in Commemoration of the 600th Anniversary of Cosimo de' Medici's Birth* (Oxford, 1992).

—— and ROGERS, MARY (eds.), *Concepts of Beauty in Renaissance Art* (Aldershot and Brookfield, Vt., 1998).

The Apocryphal New Testament, trans. M. R. James (Oxford, 1953).

ARIAS, P. E., and CRISTIANI, E., *Camposanto monumentale di Pisa: le antichità*, i (Pisa, 1977).

ARIÈS, P., *Centuries of Childhood: A Social History of Family Life*, trans. R. Baldick (New York, 1962).

ARMANI, E. P., *Perin del Vaga: l'anello mancante. Studi sul Manierismo* (Genoa, 1986).

ARRIGHI, G., *Il Nuovo Corriere*, 30 July 1955, 4.

AUGUSTINE, St, *Confessions*, trans. Henry Chadwick (Oxford, 1991).

AUSTIN, H. D., 'Dante and Mirrors', *Italica*, 21 (1944), 16–17.

AVERY, C., 'Donatello's Madonnas Revisited', in Cammerer (ed.), *Donatello-Studien*, 219–34.

—— *Florentine Renaissance Sculpture* (London, 1970).

BACCHESCHI, E., *L'opera completa di Beccafumi* (Milan, 1977).

—— *L'opera completa del Bronzino* (Milan, 1973).

BACCI, M., *L'opera completa di Piero di Cosimo* (Milan, 1976).

—— *Piero di Cosimo* (Milan, 1966).

—— 'La Porta Nord: le vetrate', in Bellosi *et al.*, *Lorenzo Ghiberti*, 156–60.

—— 'Le vetrate del tamburo della cupola; le vetrate della cupola', in Bellosi *et al.*, *Lorenzo Ghiberti*, 245–57.

BACCI, P., *Bernardino Fungai: pittore senese (1460–1516): appunti e documenti* (Siena, 1947).

BAETJER, K., *European Paintings in the Metropolitan Museum of Art*, 3 vols. (New York, 1980).

BALDI, R., *et al.*, *La cornice fiorentina e senese: storia e tecniche di restauro* (Florence, 1992).

BALDINI, U., *et al.*, *Brunelleschi e Donatello nella Sagrestia Vecchia di S. Lorenzo* (Florence, 1989).

BALDINUCCI, F., *Notizie dei professori del disegno . . .*, 5 vols. (Florence, 1845–7).

BALLERINI, I. L., 'The Celestial Hemisphere of the Old Sacristy and its Reconstruction', in 'Donatello at Close Range', *Burlington Magazine*, 129 (1987), 50–2.

—— 'Considerazioni a margine del restauro della "cupolina" dipinta nella Sagrestia Vecchia', in Cammerer (ed.), *Donatello-Studien*, 102–12.

—— 'Gli emisferi celesti della Sagrestia Vecchia e della Cappella Pazzi', *Rinascimento*, 28 (1988), 321–55.

—— 'Il planetario della Sagrestia Vecchia', in Baldini *et al.*, *Brunelleschi e Donatello*, 114–40.

BALTRUSAITIS, J., 'Cercles astrologiques et cosmographiques à la fin du Moyen Âge', *Gazette des Beaux-Arts*, 21 (1939), 65–84.

BANDERA VIANI, M. C., *Fiesole, Museo Bandini* (Bologna, 1981).

BARATTE, F., and METZGER, C., *Musée du Louvre: catalogue des sarcophages en pierre d'époques romaine et paléochrétienne* (Paris, 1985).

BARBINA, A. (ed.), *Concordanze de' Decameron*, 2 vols. (Florence, 1969).

BAROCCHI, P. (ed.), *Il giardino di San Marco: maestri e compagni del giovane Michelangelo* (exh. cat., Florence, 1992).

BARRIAULT, A. B., *Spalliera Paintings of Renaissance Tuscany: Fables of Poets for Patrician Homes* (University Park, Pa., 1994).

BASILE, G., *Giotto, la Cappella degli Scrovegni* (Milan, 1992).

BATTISTI, E., *Filippo Brunelleschi* (New York, 1981).

BAUMSTARK, R., *et al.*, *Schatzkammerstücke aus der Herbstzeit des Mittelalters: Das Regensburger Emailkästchen und sein Umkreis* (exh. cat., Munich, 1992).

BAXANDALL, M., *Painting and Experience in Fifteenth-Century Italy: A Primer in the Social History of Pictorial Style* (Oxford, 1972).

BECHERER, J. A., *et al.*, *Pietro Perugino: Master of the Italian Renaissance* (exh. cat., Grand Rapids, Mich., 1997).

BECK, J., 'Leon Battista Alberti and the "Night Sky" at San Lorenzo', *Artibus et Historiae*, 19 (1989), 9–35.

BEGUIN, S., 'A propos de la Sainte Famille en tondo d'Andrea del Sarto', in *Firenze e la Toscana dei Medici nell'Europa del '500*, iii: *Relazioni artistiche. Il linguaggio architettonico europeo* (Florence, 1983), 861–70.

BEISSEL, S., *Geschichte der Verehrung Marias in Deutschland während des Mittelalters* (1909; repr. Darmstadt, 1972).

BEK, L., 'Giovanni Santi's "Disputa de la pictura"—A Polemic Treatise', *Analecta romana instituti danici*, 5 (1969), 75–102.

BELLM, R., *Wolgemuts Skizzenbuch im Berliner Kupferstichkabinett* (Baden-Baden, 1959).

BELLOSI, L., *Francesco di Giorgio e il Rinascimento a Siena 1450–1500* (exh. cat., Milan, 1993).

—— 'Su alcuni disegni italiani tra la fine del Due e la metà del Quattrocento', *Bollettino d'arte*, 30 (1985), 1–42.

—— *et al.*, *Lorenzo Ghiberti: 'materia e ragionamenti'* (exh. cat., Florence, 1978).

BELTING, H., *Das Bild und sein Publikum im Mittelalter: Form und Funktion früher Bildtafeln der Passion* (Berlin, 1981).

—— *Likeness and Presence: A History of the Image Before the Era of Art*, trans. E. Jephcott (Chicago and London, 1994).

BELTING-IHM, C., 'Theophanic Images of Divine Majesty in Early Medieval Italian Church Decoration', in Tronzo (ed.), *Italian Church Decoration*, 43–60.

BENIVIENI, G., *Opere di Girolamo Benivieni fiorentino. Novissima* (Venice, 1522).

BENNETT, B. A., and WILKINS, D. G., *Donatello* (Oxford, 1984).

BERENSON, B., *The Drawings of the Florentine Painters*, 3 vols. (Chicago, 1938).

—— *Homeless Paintings of the Renaissance*, ed. H. Kiel (Bloomington, Ind., and London, 1969).

—— *Italian Pictures of the Renaissance* (Oxford, 1932).

—— *Italian Pictures of the Renaissance: Central Italian and North Italian Schools*, 3 vols. (London, 1968).

—— *Italian Pictures of the Renaissance: Florentine School*, 2 vols. (Greenwich, Conn., 1963).

—— 'Quadri senza casa. Il Quattrocento fiorentino, I and II', *Dedalo*, 12 (1932), 512–41, 665–702, 819–53.

BERGSTRÖM, I., 'Disguised Symbolism in "Madonna" Pictures and Still Life II', *Burlington Magazine*, 97 (1955), 342–9.

Berlin, *Beschreibendes Verzeichnis der Gemälde im Kaiser-Friedrich-Museum* (Berlin, 1912).

—— *Königliche Museen zu Berlin, Die Gemäldegalerie des Kaiser-Friedrich-Museums*, 2 vols. (Berlin, 1909).

—— *Staatliche Museen Preußischer Kulturbesitz, Picture Gallery, Berlin. Catalogue of Paintings*, trans. L. B. Parshall (Berlin-Dahlem, 1978).

BERNACCHIONI, A., 'Tradizione e arcaismi', in Gregori, Paolucci, and Acidini Luchinat (eds.), *Maestri e botteghe*, 171–80.

BERNARDINI, C., *et al.*, *Pinacoteca Nazionale di Bologna* (Bologna, 1987).

BERTELÀ, G. G., and PAOLOZZI STROZZI, B. (eds.), *Arti del Medio Evo e del Rinascimento. Omaggio ai Carrand, 1889–1989* (exh. cat., Florence, 1989).

BERTI, G., and TONGIORGI, L., *I bacini ceramici del Duomo di S. Miniato (ultimo quarto del XII secolo)* (Genoa, 1981).

BERTI, L., *L'opera completa del Pontormo* (Milan, 1973).

—— *Pontormo* (Florence, 1964).

—— and Baldini, U., *Filippino Lippi* (Florence, 1991).

—— and Foggi, R., *Masaccio* (Florence, 1988).

—— *et al.*, *Il Tondo Doni di Michelangelo e il suo restauro* (Gli Uffizi Studi e Ricerche, 2; Florence, 1984).

BEYER, A., 'Funktion und Repräsentation: Die Porphyr-rotae der Medici', in Beyer and Boucher (eds.), *Piero de' Medici*, 151–67.

—— and Boucher, B. (eds.), *Piero de' Medici, 'il Gottoso' (1416–1469)* (Berlin, 1993).

BIAGI, G., *Due corredi nuziali fiorentini 1320–1493, da un libro di ricordanze dei Minerbetti* (Florence, 1899).

BIALOSTOCKI, J., 'Man and Mirror in Painting: Reality and Transience', in I. Lavin and J. Plummer (eds.), *Studies in Late Medieval and Italian Renaissance Painting in Honor of Millard Meiss*, i (New York, 1977), 61–72.

—— and WALICKI, I. M., *Malarstwo Europejskie w Zbiorach Polskich, 1300–1800* (Cracow, 1955).

BISOGNI, F., and CIAMPOLINI, M., *Guida al Museo Civico di Siena* (Siena, 1985).

BLONDEL, N., 'Les Peintures italiennes de la Renaissance', *Gazette des Beaux-Arts*, 125:2 (1995), 139–48.

BLUMENTHAL, G., 'The Science of the Magi: The Old Sacristy of San Lorenzo and the Medici', *Source*, 6:1 (1986), 1–11.

BOBER, P. P., and RUBINSTEIN, R., *Renaissance Artists and Antique Sculpture: A Handbook of Sources* (London, 1986).

BOCCHI, F., *Le bellezze della città di Fiorenza* (Florence, 1591).

BOCK, H., *et al.*, *The Complete Catalogue of the Gemäldegalerie Berlin* (New York, 1986).

BODMER, H., 'Ein unbekanntes Werk des Franciabigio', *Pantheon*, 12 (1933), 270–5.

BOLTEN, J., *Die Imago Clipeata: Ein Beitrag zur Portrait- und Typengeschichte* (Paderborn, 1937).

BONAFOUX, P., *Portraits of the Artist: The Self-Portrait in Painting* (Geneva, 1985).

BONSANTI, G., *La Galleria della Accademia. Guide to the Gallery and Complete Catalogue*, trans. L. Clark (Florence, 1987).

BONAVENTURA, *The Franciscan Vision: Translation of St Bonaventure's 'Itinerarium Mentis in Deum'*, trans. Father James (London, 1937).

BORGHINI, R., *Il Riposo di Raffaello Borghini* (Florence, 1584).

BORGO, L., *The Works of Mariotto Albertinelli* (New York and London, 1976).

BORSI, F., and BORSI, S., *Paolo Uccello* (Milan, 1992).

BORSI, S., *Giuliano da Sangallo: i disegni di architettura e dell'antico* (Rome, 1985).

BORSOOK, E., 'Decor in Florence for the Entry of Charles VIII of France', *Mitteilungen des Kunsthistorischen Institutes in Florenz*, 10 (1961), 106–22.

—— 'Fra Filippo and the Murals for Prato Cathedral', *Mitteilungen des Kunsthistorischen Institutes in Florenz*, 19 (1975), 1–148.

—— and OFFERHAUS, J., *Francesco Sassetti and Ghirlandaio at Santa Trinita, Florence: History and Legend in a Renaissance Chapel* (Doornspijk, 1981).

BOSKOVITS, M., 'Attorno al Tondo Cook: precisazioni sul Beato Angelico e su Filippo Lippi e altri', *Mitteilungen des Kunsthistorischen Institutes in Florenz*, 39 (1995), 32–68.

—— *Pittura fiorentina alla vigilia del Rinascimento 1370–1400* (Florence, 1975).

BOUCHER, B., *The Sculpture of Jacopo Sansovino*, 2 vols. (New Haven and London, 1991).

BOWRON, E. P., *European Paintings before 1900 in the Fogg Art Museum* (Cambridge, Mass., 1990).

BRADLEY, R., 'Backgrounds of the Title "*Speculum*" in Medieval Literature', *Speculum*, 29 (1954), 100–15.

BRAHAM, A., 'The Bed of Pierfrancesco Borgherini', *Burlington Magazine*, 121 (1979), 754–65.

BRANDWOOD, L. (ed.), *A Word Index of Plato* (Leeds, 1976).

BREJON DE LAVERGNÉE, A., and THIÉBAUT, D., *Catalogue sommaire illustré des peintures du Musée du Louvre*, ii: *Italie, Espagne, Allemagne, Grande-Bretagne et divers* (Paris, 1981).

BRENTANO, R., *Rome before Avignon* (Berkeley and Los Angeles, 1990).

BREWER, R., *A Study of Lorenzo di Credi* (Florence, 1970).

BREYDENBACH, B. von, *Peregrinatio in Terram Sanctam* (Mainz, 1486).

BRIEGER, P., MEISS, M., and SINGLETON, C. S., *Illuminated Manuscripts of the Divine Comedy*, 2 vols. (Princeton, 1969).

BROCK, M., 'Sguardo pubblico, privato e intimo sulle immagini religiose del Quattrocento fiorentino', *Ricerche storiche*, 16 (1986), 551–64.

BROCKHAUS, H., *Michelangelo und die Medici-Kapelle* (Leipzig, 1909).

BROOKS, N. C., 'The Sepulcher of Christ in Art and Liturgy', *University of Illinois Studies in Language and Literature*, 7:2 (1921), 7–110.

BRUNETTI, G., 'Ghiberti orafo', in *Lorenzo Ghiberti nel suo tempo: atti del convegno internazionale di studi*, i (Florence, 1980), 223–44.

BUDNY, V., 'Benedetto da Maiano' (Ph.D. diss., New York University, Institute of Fine Arts, forthcoming).

—— 'The Sequence of Leonardo's Sketches for the Virgin and Child with Saint Anne and Saint John the Baptist', *Art Bulletin*, 65 (1983), 34–50.

BÜTTNER, F. O., *Imitatio Pietatis: Motive der christlichen Ikonographie als Modelle zur Verähnlichung* (Berlin, 1983).

BULE, S., DARR, A. P., and SUPERBI GIOFFREDI, F. (eds.), *Verrocchio and Late Quattrocento Italian Sculpture* (Florence, 1992).

BULL, D., 'The Iconography of the Sistine Chapel Ceiling', *Burlington Magazine*, 130 (1988), 597–605.

BULST, W. A., 'Die *Sala grande* des Palazzo Medici in Florenz, Rekonstruktion und Bedeutung', in Beyer and Boucher (eds.), *Piero de' Medici*, 89–127.

—— 'Uso e trasformazione del Palazzo Mediceo fino ai Riccardi', in G. Cherubini and G. Fanelli (eds.), *Il Palazzo Medici Riccardi di Firenze* (Florence, 1990), 98–129.

BURCKHARDT, J., *Vorträge*, ed. E. Durr (Basle, 1918).

BUREN, A. H. van, 'The Canonical Office in Renaissance Painting: Raphael's *Madonna at Nones*', *Art Bulletin*, 57 (1975), 41–52.

BURNS, H., 'Quattrocento Architecture and the Antique: Some Problems', in R. R. Bolgar (ed.), *Classical Influences on European Culture A.D. 500–1500* (Cambridge, 1971), 269–87.

BUTTERFIELD, A., 'The Funerary Monument of Cosimo de' Medici *Pater Patriae*', in F. Ames-Lewis (ed.), *The Early Medici and their Artists* (London, 1995), 152–68.

—— *The Sculptures of Andrea del Verrocchio* (New Haven and London, 1997).

—— 'Social Structure and the Typology of Funerary Monuments in Early Renaissance Florence', *Res*, 26:3 (1994), 47–67.

BUTTERS, S., *The Triumph of Vulcan: Sculptors' Tools, Porphyry, and the Prince in Ducal Florence*, 2 vols. (Florence, 1996).

BUTTRICK, G. D. (ed.), *The Interpreter's Dictionary of the Bible*, 4 vols. (New York, 1962).

BYNUM, C. W., 'The Body of Christ in the Middle Ages: A Reply to Leo Steinberg', *Renaissance Quarterly*, 39 (1986), 399–439.

CALKINS, R. G., *Monuments of Medieval Art* (New York, 1979).

CALLMANN, E., *Apollonio di Giovanni* (Oxford, 1974).

—— 'Apollonio di Giovanni and Painting for the Early Renaissance Room', *Antichità viva*, 27:3–4 (1988), 5–18.

—— *Beyond Nobility: Art for the Private Citizen in the Early Renaissance* (exh. cat., Allentown, Pa., 1980).

—— 'The Growing Threat to Marital Bliss as Seen in Fifteenth-Century Florentine Paintings', *Studies in Iconography*, 5 (1979), 73–92.

CAMESASCA, E., *L'opera completa del Perugino* (Milan, 1969).

CAMILLE, M., *The Gothic Idol: Ideology and Image-Making in Medieval Art* (Cambridge and New York, 1989).

CAMMERER, M. (ed.), *Donatello-Studien* (Munich, 1989).

CAMPBELL, L., *Renaissance Portraits: European Portrait-Painting in the 14th, 15th, and 16th Centuries* (New Haven and London, 1990).

CANEVA, C., 'La cornice del Tondo Doni: nota storico-critica', in L. Berti *et al.*, *Il Tondo Doni*, 44–52.

CAPLOW, H. M., *Michelozzo*, 2 vols. (New York and London, 1977).

CARDELLINI, I., *Desiderio da Settignano* (Milan, 1962).

CARDINI, F., 'Le insegne Laurenziane', in Ventrone (ed.), *Le tems revient*, 55–74.

CARL, D., 'Das Inventar der Werkstatt von Filippino Lippi aus dem Jahre 1504', *Mitteilungen des Kunsthistorischen Institutes in Florenz*, 31 (1987), 373–91.

CARLI, E., *Donatello a Siena* (Rome, 1967).

—— *Giovanni Pisano* (Pisa, 1977).

—— *Mostra delle opere di Giovanni Antonio Bazzi detto 'Il Sodoma'* (exh. cat., Vercelli, 1950).

—— *Il Pintoricchio* (Milan, 1960).

CAROLI, F., *Lorenzo Lotto e la nascita della psicologia moderna* (Milan, 1980).

—— *Sofonisba Anguissola e le sue sorelle* (Milan, 1987).

CARPANETO, M. G. 'Raffaellino del Garbo: I. Parte', *Antichità viva*, 9:4 (1970), 2–23.

—— 'Raffaellino del Garbo: II. Parte', *Antichità viva*, 10:1 (1971), 3–19.

CARROLL, B., 'Floral Symbolism in an Early Florentine Painting', *Baltimore Museum of Art News*, 18:2 (1954), 1–3.

CECCHI, A., 'Agnolo e Maddalena Doni committenti di Raffaello', in M. Sambucco Hamoud and M. L. Strocchi (eds.), *Studi su Raffaello: atti del Congresso Internazionale di Studi*, i (Urbino, 1987), 429–39.

—— 'Les Cadres ronds de la Renaissance florentine', *Revue de l'art*, 76 (1987), 21–4.

—— *La cornice fiorentina e senese: storia e tecniche di restauro* (Florence, 1992).

CECCHI, A., 'Il Tondo Doni agli Uffizi', in L. Berti *et al.*, *Il Tondo Doni*, 38–48.

CÈNDALI, L., *Giuliano and Benedetto da Maiano* (San Casciano Val di Pesa, 1926).

CHASTEL, A., *Art et humanisme à Florence au temps de Laurent le Magnifique* (Paris, 1959).

—— *Marsile Ficin et l'art* (Geneva, 1954).

CHIARELLI, C., and LEONCINI, G., *La Certosa del Galluzzo a Firenze* (Milan, 1982).

CHIARINI, M., 'Paintings by Raphael in the Palazzo Pitti, Florence', in J. Shearman and M. B. Hall (eds.), *The Princeton Symposium. Science in the Service of Art* (Princeton, 1990), 79–83.

—— *Pitti Palace* (Florence, 1988).

CHRISTIANSEN, K., 'Botticelli's Portrait of a Young Man with a Trecento Medallion', *Burlington Magazine*, 129 (1987), 744.

—— 'European Paintings', in *Notable Aquisitions 1982–1983: The Metropolitan Museum of Art* (New York, 1983), 37–40.

—— 'Lorenzo Lotto and the Tradition of Epithalamic Paintings', *Apollo*, 124 (1986), 166–73.

CIARDI DUPRÉ DAL POGGETTO, M. G., 'Il Buggiano scultore', in *Atti del Convegno su Andrea Cavalcanti detto 'il Buggiano'* (Bologna, 1979), 37–46.

—— 'Giovan Francesco Rustici', *Paragone, Arte*, 30:157 (1963), 29–50.

—— *et al.* (eds.), *La bottega di Giuliano e Benedetto da Maiano nel Rinascimento fiorentino* (exh. cat., Florence, 1994).

CIASCA, R., *L'Arte dei Medici e Speziali nella storia e nel commercio fiorentino dal secolo XII al XV* (Florence, 1927).

CIRLOT, J. E., *A Dictionary of Symbols* (New York, 1974).

CLARK, K., *The Drawings by Sandro Botticelli for Dante's Divine Comedy after the Originals in the Berlin Museums and the Vatican* (New York, 1976).

—— *Leonardo da Vinci*, ed. M. Kemp (Harmondsworth, 1988).

CLEARFIELD, J., 'The Tomb of Cosimo de' Medici in San Lorenzo', *Rutgers Art Review*, 2 (1981), 13–30.

Cleveland, The Cleveland Museum of Art, *Catalogue of European Paintings of the 16th, 17th, and 18th Centuries* (Cleveland, 1982).

—— *European Paintings before 1500* (Cleveland, 1974).

CLIFFORD, T., *et al.*, *Raphael: The Pursuit of Perfection* (exh. cat., Edinburgh, 1994).

COLDING, T. H., *Aspects of Miniature Painting, its Origins and Development* (Copenhagen, 1953).

COLE, B., *The Renaissance Artist at Work: From Pisano to Titian* (New York, 1983).

COLLARETA, M., 'Le "luci della fiorentina gloria"', *Artista: critica dell'arte in Toscana*, 3 (1991), 136–43.

COLLOBI RAGGHIANTI, L., *Il libro de' disegni del Vasari*, 2 vols. (Florence, 1974).

Cologne, Erzbischöfliches Diozesan-Museum, *500 Jahre Rosenkranz. 1475 Köln 1975* (exh. cat., Cologne, 1975).

COMSTOCK, M. B., and VERMEULE, C. C., *Sculpture in Stone: The Greek, Roman, and Etruscan Collection of the Boston Museum of Fine Arts* (Boston, 1976).

Comuni di Barberino di Mugello, *Echi e presenze donatelliane in Mugello* (Mugello, 1986).

CONTI, A., 'Andrea del Sarto e Becuccio Bicchieraio', *Prospettiva*, 33–6 (1984), 161–5.

CONTI DA FOLIGNO, S. dei, *Le storie de' suoi tempi dal 1475 al 1510* (Rome, 1883).

COONIN, A.V., 'New Documents Concerning Perugino's Worshop [*sic*] in Florence', *Burlington Magazine*, 141 (1999), 100–4.

—— 'Portrait Busts of Children in Quattrocento Florence', *Metropolitan Museum Journal*, 30 (1995), 61–71.

—— 'The Sculpture of Desiderio da Settignano' (Ph.D. diss., Rutgers University, 1995).

COOR, G., *Neroccio de' Landi, 1447–1500* (Princeton, 1961).

Coral Gables, Fla., Lowe Art Museum, *The Renaissance and Baroque Collection* (Coral Gables, Fla., 1989).

CORDELLIER, D., *Hommage à Andrea del Sarto* (exh. cat., Paris, 1986).

—— and MARINI, P. (eds.), *Pisanello: le peintre aux sept vertus* (exh. cat., Paris, 1996).

CORNELISON, S. J., 'The Tomb of Giovanni di Bicci de' Medici and the Old Sacristy of San Lorenzo', in S. Currie and P. Motture (eds.), *The Sculpted Object, 1400–1700* (Aldershot and Brookfield, Vt., 1997), 25–42.

CORNELL, H., *The Iconography of the Nativity of Christ* (Uppsala, 1924).

CORTI, L., *Vasari. Catalogo completo dei dipinti* (Florence, 1989).

COSTAMAGNA, P., *Pontormo* (Milan, 1994).

COVI, D. A., 'A Documented Tondo by Botticelli', in M. G. Ciardi Dupré Dal Poggetto and P. Dal Poggetto (eds.), *Scritti di storia dell'arte in onore di Ugo Procacci*, i (Milan, 1977), 270–2.

—— 'A Florentine Relief', *North Carolina Museum of Art Bulletin*, 7:4 (1968), 13–28.

—— *The Inscription in Fifteenth Century Florentine Painting* (New York and London, 1986).

COX-REARICK, J., *Dynasty and Destiny in Medici Art: Pontormo, Leo X, and the Two Cosimos* (Princeton, 1984).

CRAINZ, F., *La tazza del parto* (Rome, 1986).

Cracow, Muzeum Narodowe w Krakowie, *Malarstwo Włoskie XIV i XV Wieku* (exh. cat., Cracow, 1961).

CROWE, J., and CAVALCASELLE, G. B., *A History of Painting in Italy: Umbria, Florence and Siena, from the Second to the Sixteenth Century*, 6 vols. (London, 1903–14).

CRUTTWELL, M., *Luca Signorelli* (London, 1899).

CUST, R. H. H., *Giovanni Antonio Bazzi: Hitherto usually Styled 'Sodoma'. . .* (New York, 1906).

DABELL, F., 'The Illustrated Vasari' (forthcoming).

DACOS, N., *Il tesoro di Lorenzo il Magnifico: le gemme* (Florence, 1972).

D'AFFLITO, C., *et al.*, *L'età di Savonarola, Fra Paolino e la pittura a Pistoia nel primo '500* (exh. cat., Venice, 1996).

DALE, W. S. A., 'Donatello's *Chellini Madonna*: "Speculum sine macula" ', *Apollo*, 141:397 (1995), 3–9.

DALLI REGOLI, G., *Lorenzo di Credi* (Cremona, 1966).

DAL POGGETTO, P., and ZAMPETTI, P., *Lorenzo Lotto nelle Marche, il suo tempo, il suo influso* (exh. cat., Florence, 1981).

DAL PRÀ, L., *Bernardo di Chiaravalle nell'arte italiana dal XIV al XVIII secolo* (exh. cat., Milan, 1991).

D'ANCONA, P., and AESCHLIMANN, E., *Dictionnaire des miniaturistes du Moyen Âge et de la Renaissance* (Millwood, NY, 1982).

DARR, A. P., *et al.*, *Italian Renaissance Sculpture in the Time of Donatello* (exh. cat., Detroit, 1985) (also published as *Donatello e i suoi*, Milan, 1986).

DATI, G., *'L'istoria di Firenze' di Gregorio Dati dal 1380 al 1404 illustrata e pubblicata secondo il codice inedito stradiniano*, ed. L. Pratesi (Norcia, 1905).

DATINI, G., *Musei di Prato: Galleria di Palazzo Pretorio, Opera del Duomo, Quadreria Comunale* (Bologna, 1972).

DÄUBLER, C. S., ' "Deschi e Scodelle da Parto": Wöchnerinnengeschenke in der Kunst der italienischen Renaissance' (Ph.D. diss., University of Augsburg, forthcoming).

—— 'La tazza da parto nella Collezione Pringsheim', *Ceramica antica*, 4:6 (1994), 26–39.

DAVIES, C., 'I bassorilievi fiorentini di Giovan Francesco Rustici: esercizi di letteri', *Mitteilungen des Kunsthistorischen Institutes in Florenz*, 39 (1995), 92–133.

DAVIES, M., *The Earlier Italian Schools* (London, 1961).

DAY, H. T., and STURGES, H. (eds.), *Joslyn Art Museum: Paintings and Sculpture from the European and American Collections* (Omaha, Nebr., 1987).

DE ANGELIS D'OSSAT, G., 'Brunelleschi e il problema delle proporzione', *Filippo Brunelleschi, la sua opera e il suo tempo*, i (Florence, 1980), 217–55.

DE BENEDICTIS, C., 'Vicende e trasformazioni dell'Ospedale di Santa Maria di Orbatello', *Antichità viva*, 26:5–6 (1987), 28–34.

DE CARLI, C., *I deschi da parto e la pittura del primo rinascimento toscano* (Turin, 1997).

DE GANDILLAC, M., 'Neoplatonism and Christian Thought in the Fifteenth Century (Nicholas of Cusa and Marsilio Ficino)', in D. J. O'Meara (ed.), *Neoplatonism and Christian Thought* (Albany, NY, 1982), 143–68.

DEL BRAVO, C., 'Una natura morte Macchiaiola', in M. G. Ciardi Dupré Dal Poggetto and P. Dal Poggetto (eds.), *Scritti di storia dell'arte in onore di Ugo Procacci*, ii (Milan, 1977), 622–3.

DELLA PERGOLA, P., *Galleria Borghese: dipinti*, 2 vols. (Rome, 1955–9).

DEL SERRA, A., 'A Conversation on Painting Techniques', *Burlington Magazine*, 127 (1985), 4–16.

DEMPSEY, C., *The Portrayal of Love: Botticelli's 'Primavera' and Humanist Culture at the Time of Lorenzo the Magnificent* (Princeton, 1992).

DE NICOLA, G., 'Notes on the Museo Nazionale of Florence—I', *Burlington Magazine*, 28 (1915–16), 171–8.

DE VECCHI, P., *The Complete Paintings of Raphael* (New York, 1966).

DEZZI BARDESCHI, M., 'Sole in Leone. Leon Battista Alberti: astrologia, cosmologia, e tradizione eremetica nella facciata di Santa Maria Novella', *Psichon*, 1 (1974), 33–67.

DIETL, A., '"In Arte Peritus": Zur Topik mittelalterlicher Künstlerinschriften in Italien bis zur Zeit Giovanni Pisanos', *Römische Historische Mitteilungen*, 29 (1987), 75–125.

DI SCIPIO, G., *The Symbolic Rose in Dante's 'Paradiso'* (Ravenna, 1984).

DIXON, L. S., 'Giovanni di Paolo's Cosmology', *Art Bulletin*, 67 (1985), 604–13.

DOERING, O., *Christliche Symbole* (Freiburg im Breisgau, 1933).

DOMINICI, G., *Regola del governo di cura famigliare*, trans. A. B. Coté (Washington, DC, 1927).

DONI, A. F., *Disegno del Doni* (Venice, 1549).

DOUGLAS, R. L., *Piero di Cosimo* (Chicago, 1946).

DOWNEY, G., 'The Builders of the Original Church of the Apostles at Constantinople', *Dumbarton Oaks Papers*, 6 (1951), 53–80.

DUBY, G. (ed.), *A History of Private Life*, ii: *Revelations of the Medieval World*, trans. A. Goldhammer (Cambridge, Mass., and London, 1988).

DUSSLER, L., *Benedetto da Maiano, ein Florentiner Bildhauer des Späten Quattrocento* (Munich, 1924).

—— *Raphael: A Critical Catalogue of his Paintings, Wall-Paintings, and Tapestries*, trans. S. Cruft (London and New York, 1971).

—— *Signorelli: Des Meisters Gemälde . . .* (Stuttgart, 1927).

EDGERTON, S. Y., Jr., *The Heritage of Giotto's Geometry: Art and Science on the Eve of the Scientific Revolution* (Ithaca, NY, 1991).

—— *The Renaissance Rediscovery of Linear Perspective* (New York, 1975).

EGGER, H., 'Beiträge zur Andrea Bregno Forschung', in A. Weixlgartner and L. Planiscig (eds.), *Festschrift für Julius Schlosser zum 60. Geburtstage* (Vienna, 1927), 122–36.

EINEM, H. von, 'Bemerkungen zu Raffaels "Madonna di Foligno"', in I. Lavin and J. Plummer (eds.), *Studies in Late Medieval and Renaissance Painting in Honor of Millard Meiss*, i (New York, 1977), 131–42.

EISENBERG, M., *Lorenzo Monaco* (Princeton, 1989).

EISLER, C., 'The Athlete of Virtue: The Iconography of Asceticism', in M. Meiss (ed.), *De Artibus Opuscula, XL: Essays in Honor of Erwin Panofsky* (New York, 1961), 82–97.

—— *The Genius of Jacopo Bellini: The Complete Paintings and Drawings* (New York, 1989).

ELAM, C., 'Brunelleschi and Donatello in the Old Sacristy', in 'Donatello at Close Range', *Burlington Magazine*, 129 (1987), 9–10.

—— 'Cosimo de' Medici and San Lorenzo', in Ames-Lewis (ed.), *Cosimo 'il Vecchio'*, 157–80.

EMILE-MALE, G., 'La Restauration de la Sainte Famille d'Andrea del Sarto . . .', in *Firenze e la Toscana dei Medici nell'Europa del '500*, iii: *Relazioni artistiche: il linguaggio architettonico europeo* (Florence, 1983), 871–6.

ETTLINGER, L. D., *Antonio and Piero Pollaiuolo: Complete Edition with a Critical Catalogue* (Oxford, 1978).

—— and ETTLINGER, H. S., *Botticelli* (New York, 1977).

—— —— *Raphael* (Oxford, 1987).

EVANS, M., 'The Geometry of the Mind', *Architectural Association Quarterly*, 12:4 (1980), 32–55.

FABRICZY, C. VON, 'Giulianos da Sangallo figürliche Kompositionen', *Jahrbuch der Königlich Preußischen Kunstsammlungen*, 23 (1902), 197–204.

FAGIOLO DELL'ARCO, M., *Il Parmigianino: un saggio sull'ermetismo nel Cinquecento* (Rome, 1970).

FAHY, E., 'An Altarpiece by Cosimo Rosselli', *Quaderni di Emblema. Studi di storia dell'arte*, 2 (1973), 50–7.

—— 'Domenico Ghirlandaio' (forthcoming).

—— 'The Earliest Works of Fra Bartolommeo', *Art Bulletin*, 51 (1969), 142–54.

—— 'A Lucchese Follower of Filippino Lippi', *Paragone, Arte*, 16:185 (1965), 9–20.

—— Review of Laura Pagnotta, *Bugiardini*, in *Burlington Magazine*, 130 (1988), 704–5.

—— 'Some Early Italian Pictures in the Gambier–Parry Collection', *Burlington Magazine*, 109 (1967), 128–39.

—— *Some Followers of Domenico Ghirlandaio* (New York and London, 1976).

—— 'A Tondo by Sandro Botticelli', *Chicago Art Institute, Museum Studies*, 4 (1969), 14–25.

FALKENBURG, R. L., *The Fruit of Devotion: Mysticism and the Imagery of Love in Flemish Paintings of the Virgin and Child, 1450–1550*, trans. S. Herman (Amsterdam and Philadelphia, 1994).

FENZI, F., 'Di alcuni palazzi, cupole, e planetari nella letteratura classica e mediovale e nell' "Africa" del Petrarca', *Giornale storico della letteratura italiana*, 153 (1976), 186–229.

FERGUSON, G., *Signs and Symbols in Christian Art* (New York, 1966).

FERMOR, S., *Piero di Cosimo: Fiction, Invention, and 'Fantasia'* (London, 1993).

FERRANTE, J. M., 'Words and Images in the Paradiso: Reflections of the Divine', in A. S. Bernardo and A. L. Pellegrini (eds.), *Dante, Petrarch, Boccaccio: Studies in the Italian Trecento in Honor of Charles S. Singleton* (Binghamton, NY, 1983), 115–32.

FERRAZZA, R., *Palazzo Davanzati e le collezioni di Elia Volpi* (Florence, 1994).

—— and BRUSCHI, A., *Un Pontormo ritrovato* (exh. cat., Florence, 1992).

FICINO, M., *Commentary on Plato's Symposium on Love*, trans. S. R. Jayne (Dallas, 1985).

—— *The Letters of Marsilio Ficino*, 2 vols. (London, 1978).

—— *Theologia Platonica de immortalite animorum*, ed. P. O. Kristeller and M. Sancipriano (Turin, 1959).

FIELD, A., *The Origins of the Platonic Academy of Florence* (Princeton, 1988).

Figline Valdarno, Vecchio Palazzo Comunale, *Il lume del sole: Marsilio Ficino, medico dell'anima* (exh. cat., Florence, 1984).

FILAS, F. L., *The Man Nearest to Christ: The Nature and the Historic Devotion to St Joseph* (Milwaukee, Wisc., 1944).

FINESCHI, V., *Notizie storiche sopra la stamperia di Ripoli* (Florence, 1781).

FIOCCO, G., 'A Newly Discovered Tondo by Botticelli', *Burlington Magazine*, 57 (1930), 153–4.

FIORIO, M. T., *Bambaia: catalogo completo delle opere* (Florence, 1990).

FIRESTONE, G., 'The Sleeping Christ-Child in Italian Renaissance Representations of the Madonna', *Marsyas*, 2 (1942), 43–62.

FISCHEL, O., *Raphael*, trans. B. Rackham, 2 vols. (London, 1948).

FISCHER, C., *Disegni di Fra Bartolommeo e della sua scuola*, trans. S. B. Lanfranchi (exh. cat., Florence, 1986).

—— 'Fra Bartolomeo and Donatello—a "New" Tondo', in M. Cammerer (ed.), *Kunst des Cinquecento in der Toskana* (Munich, 1992), 10–20.

—— *Fra Bartolommeo, Master Draughtsman of the High Renaissance: A Selection from the Rotterdam Album and Landscape Drawings from Various Collections* (exh. cat., Rotterdam, 1990).

FITZGERALD, M. E., ' "Deschi da parto": Birth Trays of the Florentine "Quattrocento" ' (Ph.D. diss., Syracuse University, 1986).

Florence, Galleria degli Uffizi, *Gli Uffizi: catalogo generale* (Florence, 1979).

Florence, Museo Nazionale del Bargello, *Eredità del Magnifico 1492–1992* (exh. cat., Florence, 1992).

Florence, Palazzo Pitti, *Andrea del Sarto 1486–1530, dipinti e disegni a Firenze* (exh. cat., Milan, 1986–7).

—— *Mostra di dipinti restaurati delle gallerie* (exh. cat., Florence, 1969).

FORLANI TEMPESTI, A., *The Robert Lehman Collection*, v: *Italian Fifteenth-Century to Seventeenth-Century Drawings* (Princeton, 1991).

—— and CAPRETTI, A., *Piero di Cosimo: catalogo completo* (Florence, 1996).

FORSYTH, I. H., 'Children in Early Medieval Art: Ninth through Twelfth Centuries', *Journal of Psychohistory*, 4 (1976), 31–70.

FORTI, G., *et al.*, 'Un planetario del XV secolo', *L'Astronomia*, 9:62 (1987), 5–14.

FORTINI BROWN, P., '*Laetentur Caeli*: The Council of Florence and the Astronomical Fresco in the Old Sacristy', *Journal of the Warburg and Courtauld Institutes*, 44 (1981), 176–80.

FOSKETT, D., *British Portrait Miniatures: A History* (London, 1963).

—— *Collecting Miniatures* (Woodbridge, 1979).

FOVILLE, J. DE, 'Le Mino de Fiesole de la Bibliothèque Nationale', *Gazette des Beaux-Arts*, 5 (1911), 149–56.

FRANCOVICH, G. DE, 'David Ghirlandaio—I', *Dedalo*, 11 (1930), 64–88, 133–51.

FREDERICKSEN, B. B., *Catalogue of the Paintings in the J. Paul Getty Museum* (Malibu, 1972).

FREEDBERG, D., *The Power of Images: Studies in the History and Theory of Response* (Chicago and London, 1989).

FREEDBERG, S. J., 'Andrea and Lucrezia: Two New Documents in Paint for their Biography', *Chicago Art Institute, Museum Studies*, 1 (1966), 15–27.

—— *Andrea del Sarto*, 2 vols. (Cambridge, Mass., 1963).

—— *Painting of the High Renaissance in Rome and Florence*, 2 vols. (Cambridge, Mass., 1961).

—— *Parmigianino: His Works in Painting* (Cambridge, Mass., 1950).

FREEDMAN, L., 'Once more Luca Signorelli's *Pan Deus Arcadiae*', *Konsthistorisk Tidskrift*, 59 (1985), 152–9.

FRENCH, D. R., 'Journeys to the Center of the Earth: Medieval and Renaissance Pilgrimages to Mount Calvary', in B. N. Sargent-Baur (ed.), *Journeys toward God: Pilgrimage and Crusade* (Kalamazoo, 1992), 45–82.

FREY, K., 'Studien zu Michelagniolo Buonarotti und zur Kunst seiner Zeit', *Jahrbuch der Königlich Preußischen Kunstsammlungen*, 30 (1909), 103–80.

FREYHAN, R., 'The Evolution of the Caritas Figure in the Thirteenth and Fourteenth Centuries', *Journal of the Warburg and Courtauld Institutes*, 11 (1948), 68–86.

FRIEDLAENDER, M. J., and ROSENBERG, J., *The Paintings of Lucas Cranach* (Ithaca, NY, 1978).

FRIEDMAN, H., 'The Plant Symbolism of Raphael's *Alba Madonna* in the National Gallery of Art, Washington', *Gazette des Beaux-Arts*, 36 (1949), 213–20.

—— *The Symbolic Goldfinch, its History and Significance in European Devotional Art* (Washington, DC, 1946).

—— 'Two Paintings by Botticelli in the Kress Collection', *Studies in the History of Art: Dedicated to William E. Suida on His Eightieth Birthday* (Washington, DC, 1959), 116–23.

GABELENTZ, H. VON DER, *Fra Bartolommeo und die florentiner Renaissance*, 2 vols. (Leipzig, 1922).

GABRIELE, M., *Le incisioni alchemico-metallurgiche di Domenico Beccafumi* (Florence, 1988).

GABRIELLI, N., *Galleria Sabauda: maestri italiani* (Turin, 1971).

GARDNER VON TEUFFEL, C., 'Raphael's Portrait of Valero Belli: Some New Evidence', *Burlington Magazine*, 129 (1987), 663–6.

GEIGER, G., *Filippino Lippi's Carafa Chapel: Renaissance Art in Rome* (Kirkville, Mo., 1986).

GENTILINI, G. (ed.), *I Della Robbia e l''arte nuova' della scultura invetriata* (exh. cat., Florence, 1998).

—— *I Della Robbia: la scultura invetriata del Rinascimento*, 2 vols. (Florence, 1992).

—— *Museo Nazionale del Bargello: Andrea della Robbia*, i: *Madonne* (Florence, 1983).

GIBSON, W. S., 'Hieronymus Bosch and the Mirror of Man', *Oud Holland*, 87:4 (1973), 205–26.

GILBERT, C., 'The Earliest Guide to Florentine Architecture', *Mitteilungen des Kunsthistorischen Institutes in Florenz*, 14 (1969), 32–46.

—— (ed.), *Italian Art, 1400–1500: Sources and Documents* (Englewood Cliffs, NJ, 1980).

—— 'What Did the Renaissance Patron Buy?', *Art Quarterly*, 51 (1998), 392–450.

GILBERT, F., 'Florentine Political Assumptions in the Period of Savonarola and Soderini', *Journal of the Warburg and Courtauld Institutes*, 20 (1957), 187–214.

GIONONI-VISANI, M., *Giorgio Giulio Clovio: Miniaturist of the Renaissance* (New York, 1980).

GIOSEFFI, D., 'Complimenti di prospettiva, 2', *Critica d'arte*, 5 (1958), 102–39.

GIULIANO, A., *Museo Nazionale Romano: le sculture*, i/2 (Rome, 1981).

GIZZI, C. (ed.), *Botticelli e Dante* (Milan, 1990).

GODOLI, A., 'Il Tondo Doni fra impianto compositivo ambientazione originaria e museografia', in L. Berti *et al.*, *Il Tondo Doni*, 52–6.

GOFFEN, R., 'The Virgin's Bare Arms', CAA talk, February, 1994.

GOFFIN, A., *Pinturicchio: biographie critique* (Paris, n.d.).

GOHEEN, E. R., *The Collections of the Nelson–Atkins Museum of Art* (New York, 1988).

GOLDNER, G. R., and BAMBACH, C. C., *The Drawings of Filippino Lippi and his Circle* (exh. cat., New York, 1997).

GOLDTHWAITE, R. A., *The Building of Renaissance Florence: An Economic and Social History* (Baltimore and London, 1980).

—— 'The Florentine Palace as Domestic Architecture', *American Historical Review*, 77 (1972), 977–1012.

—— *Private Wealth in Renaissance Florence: A Study of Four Families* (Princeton, 1968).

—— *Wealth and the Demand for Art in Italy, 1300–1600* (Baltimore and London, 1993).

GOMBRICH, E. H., 'Raphael's *Madonna della Sedia*', in id., *Norm and Form* (London and New York, 1971), 64–80.

—— 'The Renaissance and the Golden Age', *Journal of the Warburg and Courtauld Institutes*, 24 (1961), 306–9.

GOWING, L., *Paintings in the Louvre* (New York, 1987).

GRABAR, A., *Christian Iconography: A Study of its Origins* (Princeton, 1968).

GRABSKI, J. (ed.), *Opus Sacrum: Catalogue of the Exhibition from the Collection of Barbara Piasecka Johnson* (exh. cat., Warsaw, 1990).

GRANT, E., *Planets, Stars, and Orbs: The Medieval Cosmos, 1200–1687* (Cambridge, 1993).

GREENHALGH, M., *Donatello and his Sources* (London, 1982).

GREGORI, M., PAOLUCCI, A., and ACIDINI LUCHINAT, C. (eds.), *Maestri e botteghe: pittura a Firenze alla fine del Quattrocento* (exh. cat., Florence, 1992).

—— *et al.*, *Sofonisba Anguissola e le sue sorelle* (exh. cat., Cremona, 1994).

GRISWOLD, W., 'The Drawings of Piero di Cosimo' (D.Phil. thesis, Courtauld Institute of Art, University of London, 1988).

—— 'Early Drawings by Ridolfo Ghirlandaio', *Master Drawings*, 27 (1989), 215–22.

GROSCHWITZ, G. VON, 'Botticini', *Cincinnati Art Museum Bulletin*, 4:2 (1956), 11–13.

GUASTI, C., *La cupola di Santa Maria del Fiore, illustrata con i documenti dell'archivio dell'opera secolare* (Florence, 1857).

GURRIERI, F., and AMENDOLA, A., *Il fregio robbiano dell'Ospedale del Ceppo a Pistoia* (Pontedera, 1982).

HAFTMANN, W., 'Ein Mosaik der Ghirlandaio-Werkstatt aus dem Besitz des Lorenzo Magnifico', *Mitteilungen des Kunsthistorischen Institutes in Florenz*, 6 (1940), 98–108.

HALE, J. R. (ed.), *The Thames and Hudson Encyclopedia of the Italian Renaissance* (New York and London, 1981).

HALL, E., *The Arnolfini Betrothal: Medieval Marriage and the Enigma of van Eyck's Double Portrait* (Berkeley, 1994).

—— and UHR, H., '*Aureola* and *Fructus*: Distinctions of Beatitude in Scholastic Thought and the Meaning of Some Crowns in Early Flemish Painting', *Art Bulletin*, 60 (1978), 249–70.

—— —— '*Aureola super Auream*: Crowns and Related Symbols of Special Distinction for Saints in Late Gothic and Early Renaissance Iconography', *Art Bulletin*, 67 (1985), 567–603.

HALL, J., *Dictionary of Subjects and Symbols* (New York, 1979).

HALL, M. B., *After Raphael: Painting in Central Italy in the Sixteenth Century* (Cambridge, New York, and Melbourne, 1999).

—— (ed.), *Raphael's School of Athens* (Cambridge, New York, and Melbourne, 1997).

—— 'Savonarola's Preaching and the Patronage of Art', in Verdon and Henderson (eds.), *Christianity and the Renaissance*, 493–522.

HALL, O., 'Kreis', *Lexikon der christlichen Ikonographie*, ii (Freiburg, 1970), 560–2.

HANFMANN, G. M. A., *The Season Sarcophagus in Dumbarton Oaks*, 2 vols. (Cambridge, Mass., 1951).

HANKINS, J., *Plato in the Italian Renaissance*, 2 vols. (Leiden, 1990).

HARTHAN, J., *Books of Hours* (New York and London, 1977).

HARTLAUB, G., *Zauber des Spiegels: Geschichte und Bedeutung des Spiegels in der Kunst* (Munich, 1951).

HARTT, F., *History of Italian Renaissance Art* (Englewood Cliffs, NJ, 1981).

—— *History of Italian Renaissance Art*, ed. D. Wilkins (Englewood Cliffs, NJ, 1994).

—— CORTI, G., and KENNEDY, C., *The Chapel of the Cardinal of Portugal, 1434–1459, at San Miniato in Florence* (Philadelphia, 1964).

HATFIELD, R., *Botticelli's Uffizi 'Adoration': A Study in Pictorial Content* (Princeton, 1976).

—— 'The Compagnia de' Magi', *Journal of the Warburg and Courtauld Institutes*, 33 (1970), 107–61.

—— 'The Three Kings and the Medici: A Study in Florentine Art and Culture During the Quattrocento', 2 vols. (Ph.D. diss., Harvard University, 1966).

HAUPTMANN, M., *Der Tondo: Ursprung, Bedeutung und Geschichte des italienischen Rundbildes in Relief und Malerei* (Frankfurt, 1936).

HAUSMANN, M., 'Die Kappelle des Kardinals von Portugal in S. Miniato al Monte: Ein dynastisches Grabmonument in der Zeit Piero de' Medici', in Beyer and Boucher (eds.), *Piero de' Medici*, 291–316.

HAYUM, A., *Giovanni Antonio Bazzi—'Il Sodoma'* (New York and London, 1976).

—— 'Michelangelo's *Doni Tondo*: Holy Family and Family Myth', *Studies in Iconography*, 7–8 (1981–2), 209–51.

HEIKEL, I. A., *Kritische Beiträge zu den Constantin-Schriften des Eusebius* (Eusebius Werke, 1; Leipzig, 1911).

HEINTZE, H. F. VON, '*Imago Clipeata*' (Ph.D. diss., University of Hamburg, 1949).

HENDERSON, J., 'Penitence and the Laity in Fifteenth-Century Florence', in Verdon and Henderson (eds.), *Christianity and the Renaissance*, 229–49.

—— *Piety and Charity in Late Medieval Florence* (Oxford, 1994).

HENDY, P., *European and American Paintings in the Isabella Stewart Gardner Museum* (Boston, 1974).

HENINGER, S. K., *The Cosmological Glass: Renaissance Diagrams of the Universe* (San Marino, Calif., 1977).

HENRY, T., KANTER, L., and TESTA, G., *Luca Signorelli* (Milan, 1999, forthcoming).

HERLIHY, D., 'Medieval Children', *Essays in Medieval Civilization: The Walter Prescott Webb Memorial Lectures*, 12 (Austin and London, 1978), 109–41.

—— and KLAPISCH-ZUBER, C., *Tuscans and their Families: A Study of the Florentine Catasto of 1427* (New Haven, 1985).

HESS, C., *Italian Maiolica: Catalogue of the Collection of the J. Paul Getty Museum* (Malibu, 1988).

HEYDENREICH, L. H., and LOTZ, W., *Architecture in Italy, 1400–1600* (Harmondsworth, 1974).

HILL, G. F., *A Corpus of Italian Medals of the Renaissance before Cellini*, 2 vols. (London, 1930).

HIRN, Y., *The Sacred Shrine: A Study of the Poetry and Art of the Catholic Church* (Boston, 1957).

HIRST, M., *Michelangelo, Draftsman* (exh. cat., Milan, 1988).

—— *Michelangelo and his Drawings* (New Haven and London, 1988).

—— *Sebastiano del Piombo* (Oxford, 1980).

HÖFLER, J., 'New Light on Andrea Sansovino's Journey to Portugal', *Burlington Magazine*, 134 (1992), 234–8.

HOFFMANN, V., *Martin von Wagner Museum der Universität Würzburg: Gemäldekatalog* (Würzburg, 1986).

HOLT, E., *Literary Sources of Art History* (Princeton, 1947; or the 1965 edition, *A Documentary History of Art* in 2 vols.).

HOOD, W., *Fra Angelico at San Marco* (New Haven and London, 1993).

HOPE, C., 'Altarpieces and the Requirements of Patrons', in Verdon and Henderson (eds.), *Christianity and the Renaissance*, 537–71.

HORNE, H. P., *Alessandro Filipepi, commonly Called Sandro Botticelli, Painter of Florence* (London, 1908).

HÜLSEN, C., *Il libro di Giuliano da Sangallo: Codice Vaticano Barberiniano Latino 4424, riprodotto in fotocopia*, 2 vols. (Turin, 1910).

HUMFREY, P., and LUCCO, M., 'Dosso Dossi in 1513: A Reassessment of the Artist's Early Works and Influences', *Apollo*, 147:432 (1998), 22–30.

HUNTER, J., 'The Drawings and Draughtsmanship of Girolamo Siciolante da Sermoneta', *Master Drawings*, 26:1 (1988), 3–40.

HUNTLEY, G. H., *Andrea Sansovino: Sculptor and Architect of the Italian Renaissance* (Cambridge, Mass., 1935).

INGENDARY, M., 'Rekonstruktionsversuch der "Pala Bichi" in San Agostino Siena', *Mitteilungen des Kunsthistorischen Institutes in Florenz*, 23 (1979), 109–26.

JACOBSEN, E. I. L., *Sodoma und das Cinquecento in Siena: Studien in der Gemäldegalerie zu Siena; mit einem Anhang über die nichtsienesischen Gemälde* (Strasburg, 1910).

JANSON, H., *A History of Art* (Englewood Cliffs, NJ, 1986).

—— *The Sculpture of Donatello*, 2 vols. (Princeton, 1957).

JENKINS, M., 'The Iconography of the Hall of the Consistory in the Palazzo Pubblico, Siena', *Art Bulletin*, 54 (1972), 430–51.

JOANNIDES, P., *The Drawings of Raphael* (Berkeley and Los Angeles, 1983).

JOHNSON, G. A., 'Art or Artifact? Madonna and Child Reliefs in the Early Renaissance', in S. Currie and P. Motture (eds.), *The Sculpted Object, 1400–1700* (Aldershot and Brookfield, Vt., 1997), 1–24.

JOLLY, A., *Madonnas by Donatello and his Circle* (Frankfurt, 1998).

JONES, R., and PENNY, N., *Raphael* (New Haven and London, 1983).

JORET, C., *La Rose dans l'antiquité et au moyen âge: histoire, légendes et symbolisme* (Paris, 1892).

KAFTAL, G., *Iconography of the Saints in Tuscan Painting* (Florence, 1952).

Kansas City, *The William Rockhill Nelson Collection and Mary Atkins Museum of Fine Arts* (Kansas City, 1949).

KANTER, L., 'Francesco Signorelli', *Arte cristiana*, 82:762 (1994), 199–212.

—— 'The Late Works of Luca Signorelli and his Followers, 1498–1559' (Ph.D. diss., The Institute of Fine Arts, New York University, 1989).

—— and FRANKLIN, D., 'Some Passion Scenes by Luca Signorelli after 1500', *Mitteilungen des Kunsthistorischen Institutes in Florenz*, 35 (1991), 171–92.

—— *et al.*, *Painting and Illumination in Early Renaissance Florence, 1300–1450* (exh. cat., New York, 1994).

KAUFFMANN, C. M., *The Victoria and Albert Museum. Catalogue of the Foreign Paintings*, i: *Before 1800* (London, 1973).

KECKS, R. G., *Ghirlandaio: catalogo completo*, trans. N. Zilli (Florence, 1995).

—— *Madonna und Kind: Das häusliche Andachtsbild im Florenz des 15. Jahrhunderts* (Berlin, 1988).

KELBER, W., *Raphael von Urbino: Leben und Werk* (Stuttgart, 1979).

KEMP, M., *Behind the Picture: Art and Evidence in the Italian Renaisssance* (New Haven and London, 1997).

—— 'The Taking and Use of Evidence, with a Botticellian Case Study', *Art Journal*, 44 (1984), 207–15.

KENDALL, R. (ed.), *Monet by Himself: Paintings, Drawings, Pastels, Letters* (Boston, 1989).

KENT, F., *Household and Lineage in Renaissance Florence: The Family Life of the Capponi, Ginori, and Rucellai* (Princeton, 1977).

KERN, G., 'Eine perspektivische Kreiskonstruktion bei Sandro Botticelli', *Jahrbuch der Königlich Preußischen Kunstsammlungen*, 26 (1905), 137–44.

KIEL, H., *Il Museo del Bigallo a Firenze* (Milan, 1977).

KING, C. E., *Renaissance Women Patrons: Wives and Widows in Italy c.1300–1500* (Manchester and New York, 1998).

KIRSCH, W., *Handbuch des Rosenkranzes* (Vienna, 1950).

KLAPISCH, C,. 'L'Enfance en Toscane au début du xvᵉ siècle', *Annales de démographie historique*, 1973, 99–127.

KLAPISCH-ZUBER, C., *Women, Family, and Ritual in Renaissance Italy*, trans. L. Cochrane (Chicago, 1985).

KNAB, E., *et al.*, *Raphael: Die Zeichnungen* (Stuttgart, 1983).

KNAPP, F., *Fra Bartolommeo della Porta und die Schule von San Marco* (Halle, 1903).

—— *Piero di Cosimo: Ein Übergangsmeister vom florentiner Quattrocento zum Cinquecento* (Halle, 1899).

KOCH, R., 'Flower Symbolism in the Portinari Altarpiece', *Art Bulletin*, 46 (1964), 70–7.

KOERNER, J. L., *The Moment of Self-Portraiture in German Renaissance Art* (Chicago and London, 1993).

KOEPPLIN, D., and FALK, T., *Lukas Cranach: Gemälde, Zeichnungen, Druckgraphik: Ausstellung im Kunstmuseum Basel* (exh. cat., Basle, 1974–6).

KOSEGARTEN, A., 'Einige sienesische Darstellungen der Muttergottes aus dem frühen Trecento', *Jahrbuch der Berliner Museen*, 8 (1966), 96–118.

KRANZ, P., *Jahreszeiten-Sarkophage: Entwicklung und Ikonographie des Motivs der vier Jahreszeiten auf kaiserzeitlichen Sarkophagen und Sarkophagdeckeln* (Berlin, 1984).

KRAUTHEIMER, R., *Early Christian and Byzantine Architecture* (Baltimore, 1965).

—— 'Introduction to an "Iconography of Medieval Architecture"', *Journal of the Warburg and Courtauld Institutes*, 5 (1942), 1–33.

—— *Lorenzo Ghiberti*, 2 vols. (Princeton, 1956).

—— *Studies in Early Christian, Medieval, and Renaissance Art*, trans. A. Frazer *et al.* (New York and London, 1969).

KREYTENBERGER, G., 'Bemerkungen zum Fresko der Vertreibung des Duca d'Atene', in R. G. Kecks (ed.), *Musagetes: Festschrift für Wolfram Prinz, zu seinem 60. Geburtstag am 5. Februar 1989* (Berlin, 1991), 151–65.

KRISTELLER. P. O., *Marsilio Ficino and his Work after Five Hundred Years* (Florence, 1987).

KROHN, D. L., 'The Framing of Two Tondi in San Gimignano Attributed to Filippino Lippi', *Burlington Magazine*, 136 (1994), 160–3.

KÜPPERS, P. E., *Die Tafelbilder des Domenico Ghirlandaio* (Strasburg, 1916).

KUNSTMANN, J., *The Transformation of Eros* (Edinburgh, 1964).

KUPFER, M., 'The Lost Wheel Map of Ambrogio Lorenzetti', *Art Bulletin*, 78 (1996), 286–310.

KURY, G., *The Early Work of Luca Signorelli: 1465–1490* (New York and London, 1978).

KUSTODIEVA, T. K., *The Hermitage Catalogue of Western European Painting. Italian Painting, Thirteenth to Sixteenth Centuries* (Moscow and Florence, 1995).

LACLOTTE, M., and MOGNETTI, E., *Avignon, Musée du Petit Palais: peinture italienne* (Paris, 1987).

LAMBERINI, D., LOTTI, M., and LUNARDI, R. (eds.), *Giuliano e la bottega dei da Maiano: atti del convegno internazionale di studio, Fiesole, 13–15 giugno 1991* (exh. cat., Florence, 1994).

LA MOUREYRE-GAVOTY, F. DE, *Sculpture italienne. Musée Jacquemart-André* (Paris, 1975).

LANGEDIJK, K., *The Portraits of the Medici: 15th–18th Centuries*, 3 vols. (Florence, 1981–7).

LANGE-TÜBINGEN, K., *Verzeichnis der Gemäldesammlung im Klg. Museum der bildenden Künste zu Stuttgart* (Stuttgart, 1907).

LASLETT, P., and WALL, R., *Household and Family in Past Time* (Cambridge, 1972).

LAVIN, I., 'The Sculptor's "Last Will and Testament"', *Allen Memorial Bulletin*, 35 (1977), 4–39.

LAVIN, M. A., 'Giovannino Battista: A Study in Renaissance Religious Symbolism', *Art Bulletin*, 37 (1955), 85–101.

—— 'Giovannino Battista: A Supplement', *Art Bulletin*, 43 (1961), 319–26.

LEHMANN, K., 'The Dome of Heaven', *Art Bulletin*, 27 (1945), 1–27.

LEIN, E., *Benedetto da Maiano* (Frankfurt, 1988).

Leipzig, Museum der bildenden Künste Leipzig, *Katalog der Gemälde* (Leipzig, 1979).

LEVI D'ANCONA, M., 'The *Doni Madonna* by Michelangelo: An Iconographic Study', *Art Bulletin*, 50 (1968), 43–50.

—— *The Garden of the Renaissance: Botanical Symbolism in Italian Painting* (Florence, 1977).

—— *The Iconography of the Immaculate Conception in the Middle Ages and the Early Renaissance* (New York, 1957).

—— 'The Medici Madonna by Signorelli', in B. Maracchi Biagiarelli and D. E. Rhodes (eds.), *Studi offerti a Roberto Ridolfi direttore de La bibliofilia* (Florence, 1972), 321–46.

LEWIS, C. T., and SHORT, C. (eds.), *A Latin Dictionary* (Oxford, 1969).

LIEBERT, R., *Michelangelo: A Psychoanalytic Study of his Life and Images* (New Haven and London, 1983).

LIGHTBOWN, R., *Donatello and Michelozzo: An Artistic Partnership and its Patrons in the Early Renaissance*, 2 vols. (London, 1980).

—— 'Michelangelo's Great Tondo: Its Origins and Setting', *Apollo*, 89 (1969), 22–31.

—— *Sandro Botticelli*, 2 vols. (Berkeley and Los Angeles, 1978).

—— *Sandro Botticelli: Life and Work* (New York, 1989).

LILLIE, A., 'The Patronage of Villa Chapels and Oratories near Florence: A Typology of Private Religion', in E. Marchand and A. Wright (eds.), *With and Without the Medici: Studies in Tuscan Art and Patronage 1434–1530* (Aldershot and Brookfield, Vt., 1998), 19–46.

LING, R., *Roman Painting* (Cambridge and New York, 1991).

LIPPINCOTT, K., 'Giovanni di Paolo's "Creation of the World" and the Tradition of the "Thema Mundi" in Late Medieval and Renaissance Art', *Burlington Magazine*, 132 (1990), 460–8.

LIPPMANN, F., *Drawings by Sandro Botticelli for Dante's Divina Commedia: Reduced Facsimiles of the Originals in the Royal Museum, Berlin, and in the Vatican Library* (London, 1896).

LITTA, P., *Famiglie celebri italiane*, 12 vols. (Milan, 1819–1911).

LLOYD, C., *A Catalogue of the Earlier Italian Paintings in the Ashmolean Museum* (Oxford, 1977).

——, *Italian Paintings before 1600 in the Art Institute of Chicago: A Catalogue of the Collection*, ed. M. Wolff (Princeton, 1993).

LOMBARDI, S., *Jean Fouquet* (Florence, 1983).

L'Orange, H. P., *Apotheosis in Ancient Portraiture* (Oslo, 1947).

—— 'Eros psychophoros et sarcophages romaines', *Acta ad Archaeologiam et Artium Historiam Pertinentia*, 1 (1962), 41–7.

—— *Likeness and Icon: Selected Studies in Classical and Early Medieval Art* (Odense, 1973).

—— *Studies in the Iconography of Cosmic Kingship in the Ancient World* (Oslo, 1953).

Loseries, W., 'Sodoma's "Holy Family" in Baltimore: The "Lost" Arduini Tondo', *Burlington Magazine*, 136 (1994), 168–70.

Loud, P. C., and Jordan, B., *In Pursuit of Quality: The Kimbell Art Museum* (New York, 1987).

Lovera, L., *et al.* (eds.), *Concordanza della Commedia di Dante Alighieri* (Turin, 1975).

Luchs, A., *Tullio Lombardo and Ideal Portrait Sculpture in Renaissance Venice, 1490–1530* (Cambridge, New York, and Melbourne, 1995).

Lurker, M., *Der Kreis als Symbol im Denken, Glauben, und künstlerischen Gestalten der Menschheit* (Tübingen, 1981).

Lusanna, E. N., and Faedo, L., *Il Museo Bardini a Firenze*, ii: *le sculture* (Milan, 1986).

Lydecker, J. K., 'The Domestic Setting of the Arts in Renaissance Florence' (Ph.D. diss., The Johns Hopkins University, 1987).

—— 'Il patriziato fiorentino e la committenza artistica per la casa', in *I ceti dirigenti nella Toscana del Quattrocento* (Impruneta, 1987), 209–21.

McCann, A. M., *Roman Sarcophagi in the Metropolitan Museum of Art* (New York, 1978).

McKillop, S. R., 'Dante and *Lumen Christi*: A Proposal for the Meaning of the Tomb of Cosimo de' Medici', in Ames-Lewis (ed.), *Cosimo 'il Vecchio'*, 244–303.

—— *Franciabigio* (Berkeley and Los Angeles, 1974).

Malaguzzi-Valeri, F., *Gio. Antonio Amadeo, scultore e architetto lombardo (1447–1522)* (Bergamo, 1904).

—— 'Sculture del Rinascimento a Bologna', *Dedalo*, 3 (1922), 341–72.

Mallett, M., and Mann, N. (eds.), *Lorenzo the Magnificent: Culture and Politics* (London, 1996).

Manchester, City Art Galleries, *A Century of Collecting, 1882–1982: A Guide to Manchester City Art Galleries* (Manchester, 1982).

Mancini, F. F., 'Signorelli, Francesco', in *La pittura in Italia: il Cinquecento*, ii, ed. G. Briganti (Milan, 1992), 838.

Mancini, G., *Vita di Leon Battista Alberti* (Rome, 1967).

—— *Vita di Luca Signorelli* (Florence, 1903).

Mandel, G., *The Complete Paintings of Botticelli* (Milan, 1967).

Manetti, A., *Vita di Filippo Brunelleschi*, ed. G. Tanturli and D. De Robertis (Florence, 1976).

—— *The Life of Brunelleschi*, ed. H. Saalman, trans. C. Engass (University Park, Pa., 1970).

Manni, D. M., *Vita di Luca Signorelli, pittore cortonese* (Milan, 1756).

Marchini, G., 'Ghiberti pittore di vetrate', in P. Massimiliano and G. Rosito (eds.), *Ghiberti e la sua arte nella Firenze del '3–'400* (Florence, 1979), 139–57.

Marcora, C., *Marco d'Oggiono: tradizione e rinnovamento in Lombardia tra Quattrocento e Cinquecento* (Oggiono, 1976).

Marcotti, G., *Un mercante fiorentino e la sua famiglia nel secolo XV* (Florence, 1881).

Marrai, B., 'La sepoltura di Lemmo Balducci in Firenze', *Arte e storia*, 13:2 (1894), 17–19.

Marquand, A., *Andrea della Robbia and his Atelier*, 2 vols. (Princeton, 1922).

—— *Benedetto and Santi Buglioni* (Princeton, 1921).

—— *The Brothers of Giovanni della Robbia: Fra Mattia, Luca, Girolamo, Fra Ambrogio*, ed. F. J. Mather and C. R. Morey (Princeton, 1928).

—— *Della Robbias in America* (Princeton, 1912).

—— *Giovanni della Robbia* (Princeton, 1920).

—— *Luca della Robbia* (Princeton, 1914).

—— *Robbia Heraldry* (Princeton, 1919).

MARTINELLI, G., *The World of Renaissance Florence*, trans. W. Darwell (New York, 1964).

MARTINES, L., 'The Family: The Significance of a Tradition', in A. Molho (ed.), *Social and Economic Foundations of the Renaissance* (New York, 1969), 152–8.

—— *The Social World of the Florentine Humanists, 1390–1460* (Princeton, 1963).

MATTHIAE, G., *Pittura romana del medioevo*, 2 vols. (Rome, 1987–8).

MATTOX, P., 'The Domestic Chapel in Renaissance Florence, 1400–1530' (Ph.D. diss., Yale University, 1996).

MATZ, F., *Die Dionysischen Sarkophage*, 4 vols. (Berlin, 1968–75).

MAZZI, M. C., *Museo Civico di Pistoia: catalogo delle collezioni* (Pistoia, 1982).

MEERSSEMAN, G. G., *Ordo Fraternitatis: confraternite e pietà dei laici nel Medioevo*, iii (Italia sacra. Studi e documenti di storia ecclesiastica, 26–7; Rome, 1977).

MIDDELDORF, U., 'A Forgotten Florentine Tomb of the Quattrocento', *Antichità viva*, 15:3 (1976), 11–13.

—— *Sculptures from the Samuel H. Kress Collection: European Schools XIV–XIX Century* (London, 1976).

MIDDELDORF-KOSEGARTEN, A., 'Nicola und Giovanni Pisano, 1268–1278', *Jahrbuch der Berliner Museen*, 11 (1969), 36–80.

Milan, Gilberto Algranti, *Antologia di dipinti di cinque secoli. 5–10 maggio 1971, Circolo della stampa, Palazzo Serbelloni, Milano* (sale cat., Milan, 1971).

Milan, *Museo Poldi Pezzoli*, i: *Dipinti* (Milan, 1982).

MILANESI, G., *Documenti per la storia dell'arte senese*, 3 vols. (Siena, 1854–6).

MINUCCI, I., and CARLI, E., *L'Abbazia di Monteoliveto* (Siena, 1961).

MITCHELL, P., 'Italian Picture Frames 1500–1825: A Brief Survey', *Furniture History*, 20 (1984), 18–27.

MIZIOLEK, J., 'The Lanckoronski Collection in Poland', *Antichità viva*, 34:3 (1995), 27–49.

—— 'When Our Sun is Risen: Observations on the Eschatological Visions in the Art of the First Millennium, II', *Arte cristiana*, 83:766 (1995), 3–22.

MOLMENTI, P., and LUDWIG, G., 'Arte retrospettiva: La Madonna degli Alberetti', *Emporium*, 20 (1904), 109–20.

MONGAN, A., and SACHS, P. J., *Drawings in the Fogg Museum of Art*, 3 vols. (Cambridge, Mass., 1940).

MONTI, G., *et al.*, *L'architettura di Lorenzo il Magnifico* (exh. cat., Florence, 1992).

MONTI, R., *Andrea del Sarto* (Milan, 1981).

MOORE, E., 'The Astronomy of Dante', *Studies in Dante*, 3 (Oxford, 1968–9), 1–108.

MORELLO, G. (ed.), *Raffaello e la Roma dei Papi* (exh. cat., Rome, 1986).

MORIONDO, M., *Mostra di Luca Signorelli, Cortona, maggio–agosto, Firenze, settembre–ottobre, 1953: catalogo* (exh. cat., Florence, 1953).

MOROLLI, G., and RUSCHI, P. (eds.), *San Lorenzo, 393–1993: l'architettura; le vicende della fabbrica* (Florence, 1993).

MOROZZI, G., *Santa Reparata: L'antica cattedrale fiorentina, i risultati dello scavo condotto dal 1965 al 1974* (Florence, 1978).

MORSECHECK, C. R., *Relief Sculpture for the Facade of the Certosa di Pavia, 1473–1499* (New York and London, 1978).

MORTARI, L., *Francesco Salviati* (Rome, 1992).

MÜNTZ, E., *Les Collections des Médicis au XVᵉ siècle: le musée, la bibliothèque, le mobilier (appendice aux precurseurs de la Renaissance)* (Paris, 1888).

Munich, *Alte Pinakothek Munich*, trans. K. Perryman (Munich, 1986).

MURDOCH, J. E., *Album of Science: Antiquity and the Middle Ages* (New York, 1984).

MURRAY, L., *Michelangelo: His Life, Work, and Times* (London, 1984).

MUSACCHIO, J., 'The Art & Ritual of Childbirth in Renaissance Italy' (Ph.D. diss., Princeton University, 1995), forthcoming as *The Art & Ritual of Childbirth in Renaissance Italy* (New Haven and London, 1999).

—— '*The Medici-Tornabuoni Desco da Parto* in Context', *The Metropolitan Museum of Art Journal*, 33 (1998), 137–51.

NAGLER, G. K., *Neues allgemeines Künstler Lexikon*, 16 vols. (Linz, 1910).

NATALE, M., 'Note sulla pittura lucchese alla fine del Quattrocento', *J. Paul Getty Museum Journal*, 8 (1980), 35–62.

NATALI, A., *Andrea del Sarto: maestro della 'maniera moderna'* (Milan, 1998).

—— 'L'Antico, le scritture, e l'occasione: ipotesi sul Tondo Doni', in L. Berti *et al.*, *Il Tondo Doni*, 21–37.

—— 'Dating the Doni Tondo through Antique Sculpture and Ancient Texts', in Montreal, The Montreal Museum of Fine Arts, *The Genius of the Sculptor in Michelangelo's work* (exh. cat., Montreal, 1992), 306–21.

—— and CECCHI, A., *Andrea del Sarto: catalogo completo dei dipinti* (Florence, 1989).

—— and DEL SERRA, A., *Capolavori e restaurazione* (Florence, 1986).

NEILSON, K., *Filippino Lippi* (Cambridge, Mass., 1938).

NELSON, J., 'Aggiunte alla cronologia di Filippino Lippi', *Rivista d'arte*, 43 (1991), 33–57.

New Catholic Encyclopedia, 15 vols. (New York, 1967).

New York, Haboldt & Co., *Tableaux anciens des écoles du nord, françaises et italiennes* (sale cat., Paris, 1990).

NEWALL, C., *The Art of Lord Leighton* (London, 1990).

NEWBERRY, T. J., BISACCA, G., and KANTER, L. B., *Italian Renaissance Frames* (exh. cat., New York, 1990).

NILGEN, U., 'The Epiphany and the Eucharist: On the Interpretation of Eucharistic Motifs in Medieval Epiphany Scenes', *Art Bulletin*, 49 (1967), 311–16.

NIKOLENKO, L., *Francesco Ubertini called 'Il Bacchiacca'* (Locust Valley, NY, 1966).

NORMAN, D. (ed.), *Siena, Florence, and Padua: Art, Society, and Religion 1280–1400*, 2 vols. (New Haven, 1995).

Nova Vulgata Bibliorum Sacrorum (Rome and Vatican City, 1979).

OBERBUBER, K., *Raphael, the Paintings* (Munich, 1999).

—— (ed.), *The Works of Marcantonio Raimondi and his School* (*The Illustrated Bartsch*, 26–7; New York, 1978).

OERTEL, R., *Frühe italienische Malerei in Altenburg: Beschreibender Katalog der Gemälde des 13. bis 16. Jahrhunderts im Staatlichen Lindenau-Museum* (Altenburg, 1961).

—— *Italienische Malerei zum Ausgang der Renaissance—Meisterwerke der Alten Pinakothek* (Munich, 1960).

OERTZEN, A. VON, *Maria die Königin des Rosenkranzes* (Augsburg, 1925).

OLSON, R. J. M., '. . . And They Saw Stars: Renaissance Representations of Comets and Pretelescopic Astronomy', *Art Journal*, 44 (1984), 216–24.

—— 'Botticelli's Horsetamer: A Quotation from Antiquity which Reaffirms a Roman Date for the Washington *Adoration*', *Studies in the History of Art*, 8 (1978), 7–21.

—— 'Brunelleschi's Machines of Paradise and Botticelli's *Mystic Nativity*', *Gazette des Beaux-Arts*, 97 (1981), 183–8.

—— *Fire and Ice: A History of Comets in Art* (New York, 1985).

—— 'Giotto's Portrait of Halley's Comet', *Scientific American*, 240 (1979), 160–70.

—— *Italian Renaissance Sculpture* (London, 1992).

—— 'Lost and Partially Found: The Tondo, a Significant Florentine Art Form, in Documents of the Renaissance', *Artibus et Historiae*, 27 (1993), 31–65.

—— 'An Old Mystery Solved: The 1487 Payment Document to Botticelli for a Tondo', *Mitteilungen des Kunsthistorischen Institutes in Florenz*, 39:2–3 (1995), 393–6.

—— 'The Rosary and its Iconography', *Arte cristiana* 86: 787–8 (1998), 263–76, 334–42.

—— 'Signorelli's *Berlin Tondo*: New Information (Technical, Stylistic, and Iconographic)', *Arte cristiana*, 85:779 (1997), 99–108.

—— 'Studies in the Later Works of Sandro Botticelli' (Ph.D. diss., Princeton University, 1976).

—— and BARBOUR, D., 'More than a Baker's Dozen? Chronology and Authenticity in a Group of Della Robbia Tondo Reliefs', forthcoming.

—— and PASACHOFF, J. M., 'New Information on Comet P/Halley as Depicted by Giotto di Bondone and Other Western Artists', *Astronomy and Astrophysics*, 187:1–2 (1987), 1–11 (reprinted in *20th ESLAB Symposium, Exploration of Halley's Comet*, 3 (Berlin, 1988), 1–11).

OPIE, I., and OPIE, P., *The Oxford Dictionary of Nursery Rhymes* (Oxford, 1951).

OPPÉ, A. P., *Raphael*, ed. C. Mitchell (London, 1970).

ORIGO, I., *The Merchant of Prato: Francesco di Marco Datini, 1333–1410* (London, 1957).

ORLANDI, S., *Libro del Rosario della gloriosa Vergine Maria* (Rome, 1965).

ORMOND, L., and ORMOND, R., *Lord Leighton* (London, 1975).

OUDENDIJK PIETERSE, F. H. A. van den, *Dürers Rosenkranzfest en de ikonografie der Duitse rozenkransgroepen van de XV^e en het begin der XVI^e eeuw* (Amsterdam, 1939).

Oxford Dictionary of the Christian Church, ed. F. L. Cross and E. A. Livingstone (London, 1974).

Oxford English Dictionary, ed. J. A. Simpson and E. S. C. Weiner, 20 vols. (Oxford, 1989).

OY-MARRA, E., *Florentiner Ehrengrabmäler der Frührenaissance* (Berlin, 1994).

PAATZ, W., *The Arts of the Italian Renaissance: Painting, Sculpture, and Architecture* (New York, 1974).

—— *Die Kunst der Renaissance in Italien* (Stuttgart, 1953).

—— and PAATZ, E., *Die Kirchen von Florenz*, 6 vols. (Frankfurt, 1940–54).

PACCAGNINI, G. (ed.), *Pisanello alla corte dei Gonzaga* (Milan, 1972).

PADOA RIZZO, A., 'Firenze e l'Europa nel Quattrocento: La "Vergine del Rosario" di Cosimo Rosselli', *Studi di storia dell'arte in onore di Mina Gregori*, ed. E. Acanfora and M. Sambucco Hamoud (Milan, 1994), 64–9.

PADOVANI, S., et al., *L'età di Savonarola. Fra' Bartolomeo e la Scuola di San Marco* (exh. cat., Venice, 1996).

PAGE, CHRISTOPHER, 'Reading and Reminiscence: Tinctoris on the Beauty of Music', *Journal of the American Musicological Society*, 49 (1996), 1–31.

PAGNOTTA, L., *Giuliano Bugiardini* (Turin, 1987).

PALLADIO, A., *Quattro libri dell'architettura*, eds. L. Magagnato and P. Mariani (Milan, 1980).

PANOFSKY, E., *Albrecht Dürer*, 2 vols. (Princeton, 1943).

—— *Tomb Sculpture: Four Lectures on its Changing Aspects from Ancient Egypt to Bernini*, ed. H. W. Janson (New York, 1964).

PAOLUCCI, A., *Luca Signorelli* (New York, 1990).

—— *Il Museo della Collegiata di S. Andrea in Empoli* (Florence, 1985).

—— (ed.), *Il Battistero di San Giovanni a Firenze*, 2 vols. (Florence, 1994).

PARIGI, L., *Laurentiana: Lorenzo dei Medici cultore della musica* (Florence, 1954).

Paris, Centre culturel du Marais, *Claude Monet at the Time of Giverny* (exh. cat., Paris, 1983).

PARKER, K. T., *Catalogue of the Collection of Drawings in the Ashmolean Museum*, i (Oxford, 1956).

PARRONCHI, A., 'L'emisfero della Sacrestia Vecchia: Giuliano Pesello?', *Scritti di storia dell'arte in onore di Federico Zeri*, i, ed. M. Natale (Milan, 1984), 134–6.

PECORI, L., *Storia della terra di San Gimignano* (Florence, 1853).

PEDRETTI, C., *Leonardo architetto* (Milan, 1981).

—— *Leonardo: A Study in Chronology and Style* (Berkeley and Los Angeles, 1973).

PELLEGRINI, L., 'La produzione di camini a Firenze nel primo Rinascimento', in Lamberini, Lotti, and Lunardi (eds.), *Giuliano e la bottega dei da Maiano*, 211–12.

PENNY, N., 'The Study and Imitation of Old Picture Frames', *Burlington Magazine*, 140 (1998), 375–82.

PEPPER, D. S., *Bob Jones University Collection of Religious Art. Italian Painting* (Greenville, SC, 1984).

PETERS, F. E., *Jerusalem: The Holy City in the Eyes of Chroniclers, Visitors, Pilgrims, and Prophets from the Days of Abraham to the Beginnings of Modern Times* (Princeton, 1985).

PETERSEN, R. T., *A Field Guide to the Birds of Britain and Europe* (Boston, 1974).

PICCOLPASSO, C., *The Three Books of the Potters' Art*, trans. R. Lightbown and A. Caiger-Smith (London, 1980).

PIERLINGIERI, I. S., *Sofonisba Anguissola: The First Great Woman Artist of the Renaissance* (New York, 1992).

PIETRANGELI, C., *et al.*, *The Vatican Collections: The Papacy and Art* (exh. cat., New York, 1982).

PLANISCIG, L., *Bernardo and Antonio Rossellino* (Vienna, 1942).

—— 'Pietro Lombardo ed alcuni bassirilievi veneziani del '400', *Dedalo*, 10 (1929–30), 461–81.

PLATO, *The Dialogues of Plato*, 5 vols., trans. B. Jowett (Oxford, 1924).

—— *Plato*, 10 vols., trans. H. N. Fowler (Cambridge, Mass., and London, 1914–29).

POGGI, G., *Il Duomo di Firenze: documenti sulla decorazione della chiesa e del campanile tratti dall'archivio dell'opera*, 2 vols., ed. M. Haines (Florence, 1988).

—— 'La "maschera" di Filippo Brunelleschi nel Museo dell'Opera del Duomo', *Rivista d'arte*, 12 (1930), 533–40.

—— 'Un tondo di Benedetto da Maiano', *Bollettino d'arte*, 2 (1908), 1–5.

PONS, N., 'Bartolomeo, Gherardo, e Monte di Giovanni', in Gregori, Paolucci, and Acidini Luchinat (eds.), *Maestri e botteghe*, 106–7.

—— 'La pala del Sellaio per il Carmine: un ritrovamento', *Antichità viva*, 29:2–3 (1990), 5–10.

—— 'Piero e Polito del Donzello', in Gregori, Paolucci, and Acidini Luchinat (eds.), *Maestri e botteghe*, 100–1.

—— 'Il pittore Filippo d'Antonio e la sua attività tra Valdesa e Val di Pesa (II parte)', *Antichità viva*, 31:1 (1992), 23–8.

—— 'Precisazioni su tre Bartolomeo di Giovanni: il cartolaio, il sargiaio, e il dipintore', *Paragone, Arte*, 41:479–81 (1990), 115–28.

POPE-HENNESSEY, J., *Catalogue of Italian Sculpture in the Victoria and Albert Museum*, 3 vols. (London, 1964).

—— *Donatello Sculptor* (New York, London, and Paris, 1993).

—— *Essays on Italian Sculpture* (London and New York, 1968).

—— 'The Healing Arts: The Loggia di San Paolo', *FMR*, 8 (1985), 117–27.

—— *Italian Renaissance Sculpture*, 3 vols. (New York, 1985).

—— *Luca della Robbia* (Ithaca, NY, and New York, 1980).

—— *The Portrait in the Renaissance* (London and New York, 1966).

—— *Raphael: The Wrightsman Lectures, Delivered under the Auspices of the New York University Institute of Fine Arts* (New York, 1970).

POPE-HENNESSEY, J., *Renaissance Bronzes from the Samuel H. Kress Collection: Reliefs, Plaquettes, Statuettes, Utensils, and Mortars* (London, 1965).

—— *The Robert Lehman Collection*, i: *Italian Painting* (New York, 1986).

—— *The Study and Criticism of Italian Sculpture* (New York, 1980).

—— and CHRISTIANSEN, K., 'Secular Painting in Fifteenth-Century Tuscany: Birth Trays, Cassone Panels, and Portraits', *Metropolitan Museum Bulletin*, 38:1 (1980), 1–64.

POPHAM, A. E., and POUNCEY, P., *Italian Drawings in the Department of Prints and Drawings of the British Museum: XIV and XV Centuries*, 2 vols. (London, 1950).

PREUSSNER, I., *Ellipsen und Ovale in der Malerei des 15. und 16. Jahrhunderts* (Weinheim, 1987).

PROTO PISANI, R. C., 'L'arredo sepolcrale del Vescovo Antonio degli Agli', in *Il Tesoro di Santa Maria all'Impruneta* (Florence, 1996), 54–60.

PSEUDO-BONAVENTURA, *Meditations on the Life of Christ: An Illuminated Manuscript of the Fourteenth Century. Paris, Bibliothèque Nationale, MS Ital. 115*, ed. I. Ragusa and R. B. Green, trans. I. Ragusa (Princeton, 1961).

PUDELKO, G., 'Per la datazione delle opere di Fra Filippo Lippi', *Rivista d'arte*, 18 (1936), 44–76.

—— 'Studien über Domenico Veneziano', *Mitteilungen des Kunsthistorischen Institutes in Florenz*, 4 (1934), 145–200.

RACKHAM, B., *Victoria and Albert Museum. Catalogue of Italian Maiolica*, 2 vols. (London, 1977).

—— *Victoria and Albert Museum. Guide to Italian Maiolica* (London, 1933).

RADCLIFFE, A., and AVERY, C., 'The *Chellini Madonna* by Donatello', *Burlington Magazine*, 118 (1976), 377–87.

RAGGHIANTI, C. L., *Arte, fare e vedere—dall'arte al museo* (Florence, 1974).

—— 'Il pittore dei Guinigi', *Critica d'arte*, 2 (1955), 137–44.

RAINEY, R., 'Sumptuary Legislation in Renaissance Florence' (Ph.D. diss., Columbia University, 1985).

RANDOLPH, A. W. B., 'Performing the Bridal Body in Fifteenth-Century Florence', *Art History*, 21 (1998), 182–200.

RÉAU, L., *Iconographie de l'art chrétien*, 3 vols. (Paris, 1955–9).

REBORA, P. (ed.), *Cassell's Italian Dictionary* (New York, 1983).

REDIG DE CAMPOS, D., 'La Madonna e il Bambino nella scultura di Michelangelo', in *Studi offerti a Giovanni Incisa della Rocchetta* (Rome, 1973), 449–71.

—— 'La "Madonna di Foligno" di Raffaello', *Miscellanea Bibliotecae Hertzianae* (Munich, 1961), 184–97.

—— *Raffaello nelle Stanze* (Milan, 1965).

—— *Wanderings among the Vatican Paintings*, trans. M. E. Stanley (Rome, 1953).

Rennes, Musée des Beaux-Arts de Rennes, *Disegno: actes du colloque du Musée des Beaux-Arts de Rennes* (Rennes, 1991).

RETI, L., *The Unknown Leonardo* (New York and Maidenhead, 1974).

RETTICH, E., KLAPPROTH, R., and EWALD, G., *Staatsgalerie Stuttgart. Alte Meister* (Stuttgart, 1992).

REYNOLDS, B. (ed.), *Cambridge dizionario italiano-inglese, inglese-italiano Signorelli* (Cambridge, 1985).

RHODA, A., 'Florentine Villas in the Fifteenth Century: A Study of the Strozzi and Sassetti Country Properties' (D.Phil. thesis, London University, 1986).

RICHARDSON, E. C., *Materials for a Life of Jacopo de Voragine*, 2 vols. (New York, 1935).

RICHTER, J. P. (ed.), *The Literary Works of Leonardo da Vinci*, 2 vols. (London, 1883).

RINGBOM, S., 'Devotional Images and Imaginative Devotions: Notes on the Place of Art in Late Medieval Private Piety', *Gazette des Beaux-Arts*, 73 (1969), 159–70.

—— *Icon to Narrative: The Rise of the Dramatic Close-up in Fifteenth-Century Devotional Painting* (Doornspijk, 1983).

ROBB, N., *Neoplatonism of the Italian Renaissance* (New York, 1968).

ROBERT, K., *Die antiken Sarkophag-Reliefs im Auftrage des Kaiserlich Deutschen Archäologischen Instituts*, 2 vols. in 4 (Berlin, 1890–1919).

ROBERTS, J., *Italian Master Drawings: Leonardo to Canaletto: From the British Royal Collection* (London, 1987).

ROCHE, S., *et al.*, *Mirror* (Tübingen, 1985).

ROETTGEN, S., *Italian Frescoes*, 2 vols., trans. R. Stockman (New York, 1996).

Rome, Accademia dei Lincei, *Convegno internazionale indetto nel V centenario di Leon Battista Alberti* (Rome, 1974).

ROSENAUER, A., 'Proposte per il Verrocchio Giovane', in Bule, Darr, and Superbi Gioffredi (eds.), *Verrocchio*, 101–5.

ROSENTHAL, G. (ed.), *Italian Paintings, XIV–XVIIIth Centuries, from the Collection of the Baltimore Museum of Art* (Baltimore, 1981).

ROSS, J. B., 'The Middle-Class Child in Urban Italy, Fourteenth to Early Sixteenth Century', in *The History of Childhood*, ed. L. de Mause (New York, 1974), 183–228.

ROSSI, FILIPPO, *Il Museo del Bargello: con 70 illustrazioni* (Milan, 1932).

—— *Il Museo Horne a Firenze* (Milan, 1967).

ROSSI, FRANCESCO, *Accademia Carrara, Bergamo: catalogo dei dipinti* (Bergamo, 1979).

ROWLAND, I. D., *The Culture of the High Renaissance: Ancients and Moderns in Sixteenth-Century Rome* (Cambridge, New York, and Melbourne, 1998).

ROWLANDS, E. W., *Italian Paintings 1300–1800: The Collection of the Nelson–Atkins Museum of Art* (Kansas City, Mo., 1996).

RUBIN, P. L., and WRIGHT, A. (eds.), *Renaissance Florence: The Art of the 1470s* (exh. cat., London, 1999, forthcoming).

RUBINSTEIN, N., *The Palazzo Vecchio, 1298–1532: Government, Architecture, and Imagery in the Civic Palace of the Florentine Republic* (New York and Oxford, 1995).

—— (ed.), *Florentine Studies: Politics and Society in Renaissance Florence* (Evanston, Ill., 1968).

RUDA, J., *Filippo Lippi Studies: Naturalism, Style, and Iconography in Early Renaissance Art* (New York and London, 1982).

—— *Fra Filippo Lippi: Life and Work, with a Complete Catalogue* (London and New York, 1993).

RUMPF, A., *Die Meerwesen auf den antiken Sarkophagreliefs* (Berlin, 1939).

RUSCHI, P., 'Andrea di Lazzaro Cavalcanti nella Sacrestia Vecchia di San Lorenzo: un'esperienza come eredità', *Atti del convegno su Andrea Cavalcanti detto 'il Buggiano'* (Bologna, 1979), 79–88.

—— 'Una collaborazione interrotta: Brunelleschi e Donatello nella Sagrestia Vecchia di San Lorenzo', in Cammerer (ed.), *Donatello-Studien*, 68–87.

—— 'Il Monumento di Piero e Giovanni', in Morolli and Ruschi (eds.), *San Lorenzo*, 100–1.

—— 'La Sagrestia Vecchia', in Morolli and Ruschi (eds.), *San Lorenzo*, 41–6.

—— et al., *Donatello e la Sagrestia Vecchia di San Lorenzo* (Florence, 1986).

SAALMAN, H., *Filippo Brunelleschi: The Buildings* (London, 1993).

SABATELLI, F. (ed.), *La cornice italiana dal Rinascimento al neoclassicismo* (Milan, 1992).

SACROBOSCO, J., *'On the Sphere': A Source Book in Medieval Science*, ed. E. Grant (Cambridge, Mass., 1974).

SALMI, M., 'Chiosa Signorelliana', *Commentari*, 4 (1953), 107–18.

—— *Luca Signorelli* (Novara, 1953).

SALVINI, R., *The Complete Works of Michelangelo* (New York, n.d.).

San Diego, Fine Arts Society, *A Catalogue of European Paintings, 1300–1870 [in] the Fine Arts Gallery, Balboa Park* (San Diego, 1947).

SCARPELLINI, P., *Luca Signorelli* (Milan, 1964).

—— *Perugino* (Milan, 1984).

SCHAEFER, C., *Jean Fouquet* (Basel, 1994).

SCHARF, A., *Filippino Lippi* (Vienna, 1935).

SCHEDEL, H., *Liber cronicarum cum figuris et ymaginibus ab inizio mundi* (Nuremberg, 1493).

SCHENK, M. K., ' "Et Verbum Caro Factum Est": The Madonna and Child in Fifteenth-Century Florentine Painting' (Ph.D. diss., University of Texas at Austin, 1994).

SCHER, S. K., *The Currency of Fame: Portrait Medals of the Renaissance* (exh. cat., New York, 1994).

SCHEVILL, F., *History of Florence from the Founding of the City through the Reniassance* (New York, 1936).

SCHIAPARELLI, A., *La casa fiorentina e i suoi arredi nei secoli XIV e XV* (Florence, 1908; repr. 1983).

SCHILLER, G., *Iconography of Christian Art*, 2 vols., trans. J. Seligman (New York and Greenwich, Conn., 1972).

SCHILLER, G., *Ikonographie der christlichen Kunst*, 4 vols. (Kassel, 1966–8).

SCHLEICHER, B., 'Relazione sul restauro della cornice del Tondo Doni', in L. Berti *et al.*, *Il Tondo Doni*, 71–6.

SCHOTTMÜLLER, F., *Beschreibung der Bildwerke der christlichen Epochen*, v: *Die italienischen und spanischen Bildwerke der Renaissance und des Barock* (Berlin, 1913).

—— *Bildwerke des Kaiser-Friedrich-Museums: Die italienischen und spanischen Bildwerke der Renaissance und des Barock*, i: *Die Bildwerke in Stein, Holz Ton und Wachs* (Berlin and Leipzig, 1933).

SCHRADER, D. R., 'Francesco di Simone Ferrucci, 1437–1493' (Ph.D. diss., University of Virginia, 1994).

SCHUBRING, P., *Illustrationen zu Dantes göttlicher Komödie: Italien, 14. bis 16. Jahrhundert* (Zurich, 1931).

SCHÜTZ-RAUTENBERG, G., *Künstlergrabmäler des 15. und 16. Jahrhunderts in Italien: Ein Beitrag zur Sozialgeschichte der Künstler* (Cologne and Vienna, 1978).

SCHULZ, A. M., *Antonio Rizzo: Sculptor and Architect* (Princeton, 1983).

—— 'Glosses on the Career of Desiderio da Settignano', in Bule, Darr, and Superbi Gioffredi (eds.), *Verrocchio*, 179–82.

—— *The Sculpture of Bernardo Rossellino and his Workshop* (Princeton, 1977).

SCHWARZ, H., 'The Mirror in Art', *Art Quarterly*, 15 (1952), 96–118.

—— 'The Mirror of the Artist and the Mirror of the Devout', in *Studies in the History of Art: Dedicated to William E. Suida on his Eightieth Birthday* (London, 1959), 90–105.

SCIOLLA, G. C., *La scultura di Mino da Fiesole* (Turin, 1970).

SCUDIERI, M., *Il Museo Bandini a Fiesole* (Florence, 1993).

—— and ROSARIO, G. (eds.), *Savonarola e le sue 'reliquie' a San Marco: Itinerario per un percorso savonaroliano nel Museo* (exh. cat., Florence, 1999).

SEDINI, D., *Marco d'Oggiono: tradizione e rinnovamento in Lombardia tra Quattrocento e Cinquecento* (Milan and Rome, 1989).

SEGALL, B., 'Two Hellenistic Gold Medallions from Thessaly', *Record of the Museum of Historic Art, Princeton University*, 4:2 (1945), 2–11.

SEIDEL, L., *Jan van Eyck's Arnolfini Portrait: Stories of an Icon* (Cambridge and New York, 1993).

SEIDEL, M., 'Die Fresken des Francesco di Giorgio in S. Agostino Siena', *Mitteilungen des Kunsthistorischen Institutes in Florenz*, 23 (1979), 1–108.

—— 'Signorelli um 1490', *Jahrbuch der Berliner Museen*, 26 (1984), 181–256.

SEWARD, B., *The Symbolic Rose* (New York, 1960).

SHAPLEY, F. R., *Paintings from the Samuel H. Kress Collection. Italian Schools*, 3 vols. (London, 1966–73).

SHAW, J. B., *Drawings by Old Masters at Christ Church, Oxford*, 2 vols. (Oxford, 1976).

—— *Paintings by Old Masters at Christ Church, Oxford* (Oxford, 1967).

SHEARD, W. S., 'Verrocchio's Medici Tomb and the Language of Materials; with a Postscript on his Legacy in Venice', in Bule, Darr, and Superbi Gioffredi (eds.), *Verrocchio*, 63–90.

SHEARMAN, J., *Andrea del Sarto*, 2 vols. (Oxford, 1965).

—— 'The Collections of the Younger Branch of the Medici', *Burlington Magazine*, 117 (1975), 12–27.

—— *The Early Italian Pictures in the Collection of Her Majesty the Queen* (Cambridge and New York, 1983).

—— *Only Connect: Art and the Spectator in the Italian Renaissance* (Princeton, 1992).

—— 'The Vatican Stanze: Functions and Decoration', *Proceedings of the British Academy*, 57 (1971), 369–424.

SHOEMAKER, I. H., 'Drawings after the Antique by Filippino Lippi', *Master Drawings*, 16 (1978), 35–43.

SICHTERMANN, H., *Die mythologischen Sarkophage*, 2 vols. (Berlin, 1992).

Siena, Comune di Siena, *Domenico Beccafumi e il suo tempo* (exh. cat., Milan, 1990).

SILL, G., *A Handbook of Symbols in Christian Art* (New York, 1975).

SIMONS, P., 'Portraiture and Patronage in Quattrocento Florence, with Special Reference to the Tornaquinci and their Chapel in S. Maria Novella', 2 vols. (Ph.D. diss., University of Melbourne, 1985).

SIMPSON, D. P. (ed.), *Cassell's New Latin Dictionary* (New York, 1960).

SINDING-LARSEN, S., 'Some Functional and Iconographic Aspects of the Centralized Church in the Italian Renaissance', *Acta ad Archaeologiam et Artium Historiam Pertinentia*, 2 (1965), 203–52.

SIRÉN, O., *Dessins et tableaux de la Renaissance italienne dans les collections de Suède* (Stockholm, 1902).

—— 'Das florentinischen Knabenporträt in Stockholm', *Monatshefte für Kunstwissenschaft*, 3 (1910), 430–3.

SMITH, E. B., *The Dome: A Study in the History of Ideas* (Princeton, 1950).

SMITH, G., 'A Medici Source for Michelangelo's Doni Tondo', *Zeitschrift für Kunstgeschichte*, 38 (1975), 84–5.

SMITH, W., 'On the Original Location of the *Primavera*', *Art Bulletin*, 57 (1975), 31–40.

SORDINI, G., 'La tomba di Fra Filippo Lippi nel Duomo di Spoleto', *L'illustratore fiorentino per l'anno 1905*, 2 (1904), 134–44.

SPALLANZANI, M. (ed.), *Inventari Medicei, 1417–1465: Giovanni di Bicci, Cosimo e Lorenzo di Giovanni, Piero di Cosimo* (Florence, 1996).

—— and BERTELÀ, G. G. (eds.), *Libro d'inventario dei beni di Lorenzo il Magnifico* (Florence, 1992).

SPARKS, T. M., 'Cajetan on Saint Joseph', *Cahiers de Joséphologie*, 24 (1974), 255–82.

—— 'St Antonius of Florence on St Joseph', *Cahiers de Joséphologie*, 19 (1971), 429–55.

SPARROW, J., *Visible Words: A Study of Inscriptions in and as Books and Works of Art* (London and Cambridge, 1969).

SPATE, V., *Claude Monet: Life and Work* (New York, 1992).

SPERANZA, L., 'La Madonna del Rosario: origine della devozione e diffusione del tema nell'arte del territorio aretino', in A. M. Maetke (ed.), *Mater Christi: altissime testimonianze del culto della Vergine nel territorio aretino* (exh. cat., Arezzo, 1996), 28–34.

SPERLING, C. M., 'Verrocchio's Medici Tombs', in Bule, Darr, and Superbi Gioffredi (eds.), *Verrocchio*, 51–61.

SPIKE, J. T., *Italian Paintings in the Cincinnati Art Museum* (Cincinnati, 1993).

SPINOSA, N. (ed.), *Museo e Gallerie Nazionali di Capodimonte* (Naples, 1994).

SPITZ, E. H., *Art and Psyche: A Study in Psychoanalysis and Aesthetics* (New Haven and London, 1985).

SPRETI, V., et al., *Enciclopedia storico-nobiliare italiana*, 9 vols. (Milan, 1928–35).

SRICCHIA SANTORO, F. (ed.), *Da Sodoma a Marco Pino: pittori a Siena nella prima metà del Cinquecento* (exh. cat., Siena, 1988).

STAGNI, S., 'Alcuni ampliamenti per Ercole Banci', *Paragone, Arte*, 41:479–81 (1990), 93–9.

STAPLEFORD, R., 'Botticelli's Portrait of a Young Man Holding a Trecento Medallion', *Burlington Magazine*, 129 (1987), 428–36.

—— 'Intellect and Intuition in Botticelli's *St Augustine*', *Art Bulletin*, 76 (1994), 68–80.

STECHOW, W., *Catalogue of the European and American Paintings and Sculpture in the Allen Memorial Art Museum* (Oberlin, Ohio, 1967).

STEINBERG, L., 'Concerning the *Doni Tondo*: The Boys at the Back', CAA talk, February, 1994.

—— 'Michelangelo's Doni Tondo', *Vogue*, 164:6 (1974), 138–9.

—— *The Sexuality of Christ in Renaissance Art and Modern Oblivion* (New York, 1983).

STEINBERG, R. M., 'Fra Bartolomeo, Savonarola, and a Divine Image', *Mitteilungen des Kunsthistorischen Institutes in Florenz*, 18 (1974), 319–28.

—— *Fra Girolamo Savonarola, Florentine Art, and Renaissance Historiography* (Athens, Ohio, 1977).

STEINMANN, E., *Ghirlandaio* (Bielefeld and Leipzig, 1897).

—— *Die Sixtinische Kapelle*, 2 vols. (Munich, 1901).

STENS, B. H., 'L'arrivo del trittico Portinari a Firenze', *Commentari*, 19 (1968), 315–19.

STEPHENS, J. N., *The Fall of the Florentine Republic 1512–1530* (Oxford, 1983).

STIX, A., and STROHMER, E. V., *Die Fürstlich Liechtensteinische Gemäldegalerie in Wien* (Vienna, 1938).

Strasburg, *Musée des Beaux-Arts de la Ville de Strasbourg. Catalogue des peintures anciennes* (Strasburg, 1938).

STRIEDER, P., *Albrecht Dürer* (New York, 1982).

STRONG, E., *La scultura romana da Augusto a Costantino* (Florence, 1923).

STUBBLEBINE, J. H., *Assisi and the Rise of Vernacular Art* (New York, 1985).

TÁTRAI, V. (ed.), *Museum of Fine Arts Budapest: Old Masters Gallery* (London and Budapest, 1991).

TAZARTES, M. 'Michele Angelo (del fu Pietro "Mencherini"): Il Maestro del Tondo Lathrop', *Richerche di storia dell'arte*, 26 (1985), 28–39.

TERNI DI GREGORY, W., *Pittura artigiana lombarda del Rinascimento* (Milan, 1958).

TESSARI, A. S., 'Benedetto da Maiano tra il 1490 e il 1497', *Critica d'arte*, 143 (1975), 39–52.

THIÉBAUT, D., *Ajaccio, Musée Fesch: les primitifs italiens* (Paris, 1967).

THOMPSON, D., *Raphael: Literature and Legacy* (London, 1983).

THORNDIKE, L., *History of Magic and Experimental Science during the First Thirteen Centuries* (New York, 1941).

THORNTON, D., *The Scholar in His Study: Ownership and Experience in Renaissance Italy* (New Haven and London, 1998).

THORNTON, P., *The Italian Renaissance Interior 1400–1600* (New York, 1991).

TODINI, F., 'Un'opera romana di Giotto', *Studi di storia dell'arte*, 3 (1993), 9–43.

Toledo, *The Toledo Museum of Art. European Paintings* (University Park, Pa., and London, 1976).

TOLNAY, C. DE, *The Medici Chapel* (Princeton, 1958).

—— 'Remarques sur la sainte Anne du Léonard', *Revue des arts*, 6 (1956), 161–6.

—— *The Youth of Michelangelo* (Princeton, 1943).

TOMEI, A., *Iacobus Torriti Pictor: una vicenda figurativa del tardo Duecento romano* (Rome, 1990).

TOMORY, P., *The John and Mable Ringling Museum of Art. Catalogue of Italian Paintings Before 1800* (Sarasota, Fla., 1976).

TORRITI, PIERO, *Beccafumi* (Milan, 1998).

—— *La Pinacoteca Nazionale di Siena: i dipinti* (Genoa, 1990).

TREXLER, R. C., *Dependence in Context* (Binghampton, NY, 1994).

—— *Public Life in Renaissance Florence* (New York, 1980).

—— 'Ritual in Florence: Adolescence and Salvation in the Renaissance', in C. Trinkhaus and H. A. Oberman (eds.), *The Pursuit of Holiness in Late Medieval and Renaissance Religion. Papers from the University of Michigan Conference* (Leiden, 1974), 200–64.

TRONZO, W., 'Apse Decoration, the Liturgy and the Perception of Art in Medieval Rome: S. Maria in Trastevere and S. Maria Maggiore', in id. (ed.), *Italian Church Decoration*, 167–93.

—— (ed.), *Italian Church Decoration of the Middle Ages and Early Renaissance* (Bologna, 1989).

—— *The Via Latina Catacomb: Imitation and Discontinuity in Fourth-Century Roman Painting* (University Park, Pa., 1986).

TROUTMAN, P., *The Painting Collections of the Courtauld Institute of Art* (Chicago and London, 1979).

UCCELLI, G. B., *Il Palazzo del Potestà* (Florence, 1865).

VALENTINER, W. R., *Catalogue of an Exhibition of Italian Gothic and Early Renaissance Sculpture. 19th Loan Exhibition of Old Masters. The Detroit Institute of Arts* (exh. cat., Detroit, 1938).

—— *The Samuel H. Kress Collection: North Carolina Museum of Art* (Raleigh, NC, 1960).

VAN MARLE, R., *The Development of the Italian Schools of Painting*, 19 vols. (The Hague, 1923–38).

VARCHI, B., *Storia fiorentina*, 3 vols. (Florence, 1857–8).

VASARI, G., *Le vite de' più eccellenti pittori scultori ed archittetori . . .*, 9 vols., ed. G. Milanesi (Florence, 1906).

—— *Le vite de' più eccellenti pittori scultori e architettori: nelle redazioni del 1550 e 1568*, 7 vols., eds. R. Bettarini and P. Barocchi (Florence, 1971).

Venice, Ca' d'Oro, *La R. Galleria Giorgio Franchetti alla Ca' d'Oro. Guida catalogo* (Venice, 1929).

VENTRONE, P. (ed.), *Le tems revient: 'l tempo si rinuova: feste e spettacoli nella Firenze di Lorenzo Il Magnifico* (exh. cat., Florence, 1992).

VENTURI, A., 'Francesco di Simone Fiesolano', *Archivio storico dell'arte*, 5 (1892), 371–86.
—— *Luca Signorelli* (Florence, 1921–2).
—— *Storia dell'arte italiana*, 25 vols. (Milan, 1901–40).

VENTURINI, L., 'Un altro pittore fiorentino nell'Appartamento Borgia: il Maestro del Tondo Borghese', in Gregori, Paolucci, and Acidini Luchinat (eds.), *Maestri e botteghe*, 282–9.
—— 'Bastiano Mainardi, pittore di San Gimignano e altri problemi di pittura fiorentina tra la fine del Quattrocento e l'inizio del Cinquecento', 3 vols. (tesi di laurea, Università di Firenze, 1988–9).
—— 'I Botticini', in Gregori, Paolucci, and Acidini Luchinat (eds.), *Maestri e botteghe*, 102–3.
—— *Francesco Botticini* (Florence, 1994).
—— 'I Ghirlandaio', in Gregori, Paolucci, and Acidini Luchinat (eds.), *Maestri e botteghe*, 109–13.
—— 'Il Maestro del 1506: la tarda attività di Bastiano Mainardi', *Studi di storia dell'arte*, 5–6 (1994–5), 123–83.
—— 'Modelli fortunati e produzione di serie', in Gregori, Paolucci, and Acidini Luchinat (eds.), *Maestri e botteghe*, 147–63.
—— 'I Rosselli', in Gregori, Paolucci, and Acidini Luchinat (eds.), *Maestri e botteghe*, 104–5.
—— 'Tre tabernacoli di Sebastiano Mainardi', *Kermes*, 15:6 (1992), 41–8.
—— and SCARPELLI, S., *Studio del Tondo di Piero di Cosimo 'I Progenitori'* (exh. cat., Forlì, 1997).

VERDIER, P., 'A Medallion of the "Aracoeli" and Netherlandish Enamels of the Fifteenth Century', *Journal of the Walters Art Gallery*, 24 (1961), 9–37.
—— 'La Naissance à Rome de la vision de l'Ara Coeli', *Mélanges de l'ecole française de Rome—Moyen âge—temps moderne*, 94:1 (1982), 85–119.
—— *The Walters Art Gallery. Catalogue of the Painted Enamels of the Renaissance* (Baltimore, 1967).

VERDON, T., 'Greek Love and Jewish Marriage in Michelangelo's *Doni Tondo*', CAA talk, February, 1994.
—— 'Amor ab Abspectu: Maria nel Tondo Doni e l'umanesimo cristiano', *Vivens Homo*, 5:2 (1994), 531–52.
—— and HENDERSON, J. (eds.), *Christianity and the Renaissance: Images and Religious Imagination in the Quattrocento* (Syracuse, NY, 1990).

VERMEULE, C. C., III, CAHN, W., and HADLEY, R. VAN N., *Sculpture in the Isabella Stewart Gardner Museum* (Boston, 1977).

VERTOVA, L., 'La mano tesa: contributo alle ipotesi di ricostruzione dell'altare di Donatello a Padova', in Cammerer (ed.), *Donatello-Studien*, 209–18.

VESPASIANO DA BISTICCI, *Le vite . . .* , 2 vols., ed. A. Greco (Florence, 1976).

VIAGGINI, S., *La miniatura fiorentina* (Milan, 1952).

VINES, G. C., 'Desiderio da Settignano' (Ph.D. diss., University of Virginia, 1981).

VIRGIL, *Works*, 2 vols., trans. H. Rushton Fairclough (Cambridge, Mass., and London, 1986).

VISCHER, R., *Luca Signorelli und die italienische Renaissance* (Leipzig, 1879).

VOLBACH, W. F., *Early Christian Art* (New York, 1961).

VON HOLST, C., 'Fra Bartolomeo und Albertinelli', *Mitteilungen des Kunsthistorischen Institutes in Florenz*, 18 (1974), 273–318.
—— *Francesco Granacci* (Munich, 1974).
—— 'Ein Marmor Relief von Pontormo', *Jahrbuch der Berliner Museen*, 8 (1966), 204–36.
—— 'Michelangelo in der Werkstatt Botticellis?', *Pantheon*, 25 (1967), 329–35.

VORAGINE, J. DE, *The Golden Legend*, 2 vols., ed. G. Ryan and M. Ripperger (London, 1941).
—— *The Golden Legend: Readings on the Saints*, 2 vols., trans. W. G. Ryan (Princeton, 1993).
—— *The Golden Legend or Lives of the Saints as Englished by William Caxton*, 7 vols., ed. F. S. Ellis (London, 1906).

WACKERNAGEL, M., *Der Lebensraum des Künstlers in der florentinischen Renaissance: Aufgaben und Auftraggeber, Werkstatt und Kunstmarkt* (Leipzig, 1938).

—— *The World of the Florentine Renaissance Artist: Projects and Patrons, Workshop and Art Market*, trans. A. Luchs (Princeton, 1981).

WARBURG, A., 'Eine astronomische Himmelsdarstellung in der Alten Sakristei von S. Lorenzo in Florenz', in *Gesammelte Schriften*, i (Leipzig and Berlin, 1932), 169–72, 366–7.

—— 'Berichte über die Sitzungen des Instituts. März bis Mai 1911', *Mitteilungen des Kunsthistorischen Institutes in Florenz*, 2 (1912–17), 34–8.

WARNER, M., *Alone of all her Sex: The Myth and the Cult of the Virgin Mary* (New York, 1976).

WARREN, J., 'Bode and the British', *Jahrbuch der Berliner Museen*, 38 (1996), 121–42.

—— 'Fortnum and the Della Robbia', *Apollo*, 145: 423 (1999), 55–7.

—— 'Francesco Francia and the Art of Sculpture in Renaissance Bologna', *Burlington Magazine*, 141 (1999), 216–25.

WASSERMAN, J., 'The Genesis of Raphael's *Alba Madonna*', *Studies in the History of Art*, 8 (1978), 35–61.

WATERHOUSE, E., 'Earlier Paintings in the Earlier Years of the Art Institute: The Role of Private Collectors', *The Art Institute of Chicago Centenniel Lectures. Museum Studies*, 10 (Chicago, 1983), 79–91.

WATSON, P. F., 'The Queen of Sheba in Christian Tradition', in J. B. Pritchard (ed.), *Solomon and Sheba* (London, 1974), 115–45.

—— '*Virtù* and *Voluptas* in Cassone Painting' (Ph.D. diss., Yale University, 1970).

WEBSTER, T. B. L., 'Tondo Composition in Archaic and Classical Greek Art', *Journal of Hellenic Studies*, 59 (1939), 103–23.

WEIL-GARRIS BRANDT, K., 'Cosmological Patterns in Raphael's Chigi Chapel in S. M. del Popolo', in *Raffaello a Roma: il convegno del 1983* (Rome, 1986), 127–56.

WEINSTEIN, D., 'The Myth of Florence', in Rubinstein (ed.), *Florentine Studies*, 15–44.

—— *Savonarola and Florence: Prophecy and Patriotism in the Renaissance* (Princeton, 1970).

WELCH, E., *Art and Society in Italy 1350–1500* (Oxford and New York, 1997).

WENTZEL, H., 'Mittelalterliche Gemmen in den Sammlungen Italiens', *Mitteilungen des Kunsthistorischen Institutes in Florenz*, 7 (1956), 239–80.

WESCHER, P. R., *Jean Fouquet und seine Zeit* (Basle, 1945).

WESTER, U., and SIMON, E., 'Die Reliefmedallions im Hofe des Palazzo Medici zu Florenz', *Jahrbuch der Berliner Museen*, 7 (1965), 15–91.

WESTFALL, C. W., *In This Most Perfect Paradise: Alberti, Nicholas V, and the Invention of Conscious Urban Planning in Rome, 1447–55* (University Park, Pa., and London, 1974).

WIECK, R. S., *Time Sanctified: The Book of Hours and Medieval Art and Life* (exh. cat., New York and Baltimore, 1988).

WILDE, J., 'Eine Studie Michelangelos nach der Antike', *Mitteilungen des Kunsthistorischen Institutes in Florenz*, 4 (1932), 41–64.

WILPERT, J., *I sarcofagi cristiani antichi*, 3 vols. in 5 (Rome, 1929–36).

WILKINS, E., *The Rose-Garden Game: A Tradition of Beads and Flowers* (New York, 1969).

WILLAM, F. M., *The Rosary: Its History and Meaning*, trans. E. Kaiser (New York, 1953).

WILSON, T., *Ceramic Art of the Italian Renaissance* (Austin, Tex., 1987).

—— *et al.*, *La donazione Galeazzo Cora: Museo Internazionale delle Ceramiche in Faenza* (Milan, 1985).

WINKES, R., *Clipeata Imago: Studien zu einer römischen Bildnisform* (Bonn, 1969).

WINNER, D., *Raffaello a Roma* (Rome, 1986).

WINSTON-ALLEN, A., *Stories of the Rose: The Making of the Rosary in the Middle Ages* (University Park, Pa., 1997).

WINTERNITZ, E., *Musical Instruments and their Symbolism in Western Art: Studies in Musical Iconology* (New Haven and London, 1979).

WITTKOWER, R., 'The Centrally Planned Church and the Renaissance', in id., *Architectural Principles in the Age of Humanism* (New York, 1965), 1–32.

—— 'A Symbol of Platonic Love in a Portrait Bust by Donatello', *Journal of the Warburg and Courtauld Institutes*, 1 (1937–8), 260–1.

WOERMAN, K., *Katalog der königlichen Gemäldegalerie zu Dresden* (Dresden, 1896).

WOHL, H., *The Paintings of Domenico Veneziano, ca. 1410–1461: A Study in Florentine Art of the Early Renaissance* (New York and London, 1980).

WOHL, H., Review of *Donatello-Studien*, in *Art Bulletin*, 73 (1991), 315–23.

—— 'Two Cinquecento Puzzles', *Antichità viva*, 30:6 (1991), 42–8.

WOLF, J., *Geschichte der Mensuralnotation von 1250–1460*, i: *Geschichtliche Darstellungen* (Leipzig, 1904; repr. Hildesheim and Wiesbaden, 1965).

WOLLESEN-WISCH, B., *Italian Renaissance Art: Selections from the Piero Corsini Gallery* (exh. cat., University Park, Pa., 1986).

WOODS-MARSDEN, J., *Renaissance Self-Portraiture: The Visual Construction of Identity and the Social Status of the Artist* (New Haven and London, 1998).

XIMENES, L., *Del vecchio e nuovo gnomone fiorentino* (Florence, 1757).

York, York City Art Gallery, *Catalogue of Paintings. Foreign Schools 1350–1800* (York, 1961).

YUEN, T., 'New Aspects of Botticelli's Late Works: A Suggestion for the Dating of the Dante Illustrations', *Marsyas*, 12 (1966), 22–34.

ZAHLTEN, J., *'Creatio Mundi': Darstellungen der sechs Schöpfungstage und naturwissenschaftliche Weltbild im Mittelalter* (Stuttgart, 1979).

ZAMARCHI GRASSI, P., CHIARINI, M., and SPALLETTI, E., *Opere d'arte della Cassa di Risparmio di Firenze* (Florence, 1990).

ZAMBRANO, P., 'La "Deposizione" Cinuzzi del Sodoma: una proposta di datazione', *Paragone, Arte*, 41:479–81 (1990), 83–93.

ZERI, F., 'Eccentrici fiorentini—II', *Bollettino d'arte*, 47 (1962), 314–26.

—— *Italian Paintings in the Walters Art Gallery*, 2 vols., ed. U. E. McCracken (Baltimore, 1976).

—— *Pittura e controriforma: l'arte senza tempo di Scipione da Gaeta* (Turin, 1957).

—— 'Raffaello Botticini', *Gazette des Beaux-Arts*, 72 (1968), 159–70.

—— 'The Second Volume of the Kress Catalogue', *Burlington Magazine*, 111 (1969), 454–6.

—— NATALE, M., and MOTTOLA MOLFINO, A., *Dipinti toscani e oggetti d'arte dalla collezione Vittorio Cini* (Venice, 1984).

ZERVAS, D. F., *The Parte Guelfa, Brunelleschi, and Donatello* (Locust Valley, NY, 1987).

ZIMMER, W., 'The Tondo', *Art Journal*, 50 (1991), 60–3.

ZLAMALIK, V., *Strossmayerova Galerija Starih Majstora Jugoslavenske Akademije Znanosti i Umjetnosti* (Zagreb, 1982).

ZUCKER, M., *Early Italian Masters* (The Illustrated Bartsch, 24:1; New York, 1993).

ZURAW, S. E., 'The Sculpture of Mino da Fiesole 1429–1484', 4 vols. (Ph.D. diss., The Institute of Fine Arts, New York University, 1993).

INDEX

Individuals mentioned in the text and notes are indexed. Every figure and plate appears in the index, whenever possible under an artist's name (including workshop productions unless the workshop is listed as a sub-category). Otherwise figures are listed by location, school, or topic. References to figures and plates are in bold. Figure numbers preceded by 'A' refer to an illustration in the Appendix. Works cited frequently are listed separately under the artist's name. Iconographic elements, as well as some frequently noted saints, such as St John the Baptist, are indexed selectively.